Peter. L. Folkes
1997

Salvador Dali

FOLKES
61 ETHELBURT AVENUE
SWAYTHLING
SOUTHAMPTON SO2 3DF
TEL. 0703 556918

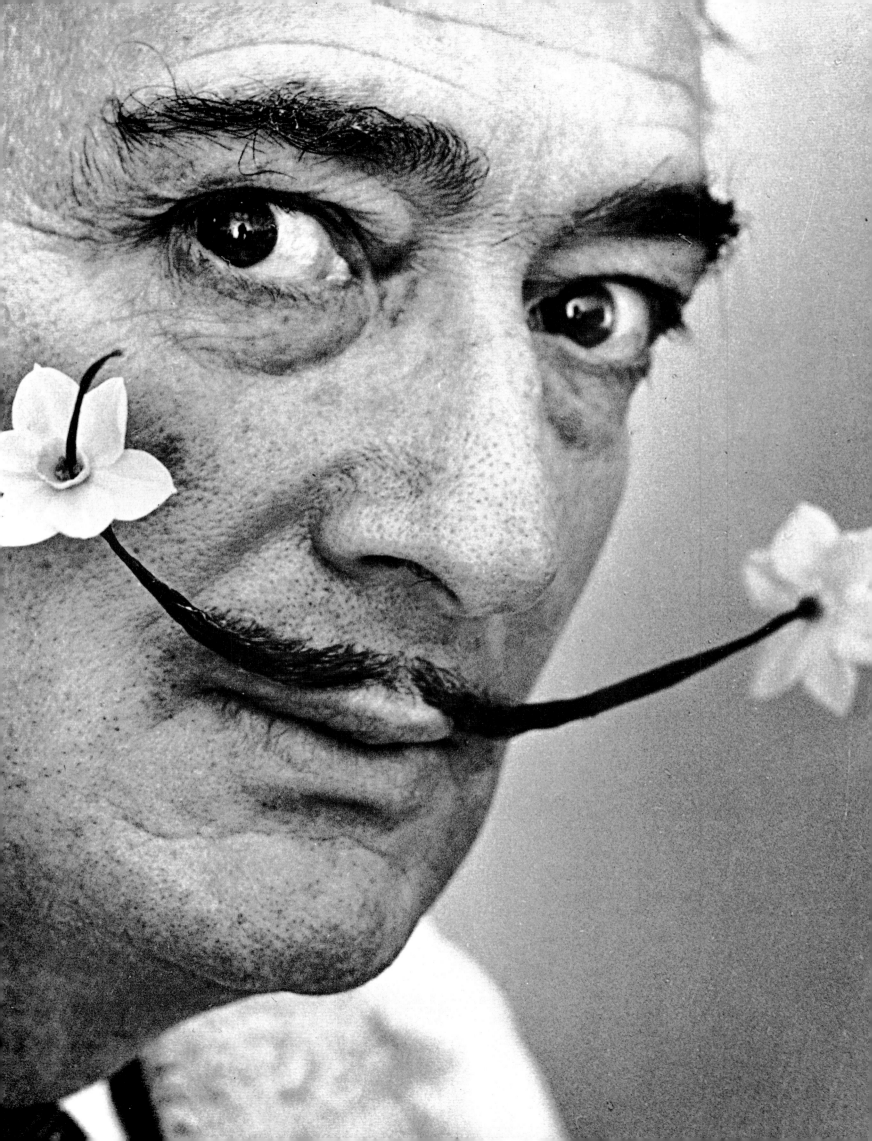

Robert Descharnes/Gilles Néret

Salvador DALÍ

1904–1989

The Paintings
1904–1946

Conception: Gilles Néret

TASCHEN

KÖLN LISBOA LONDON NEW YORK PARIS TOKYO

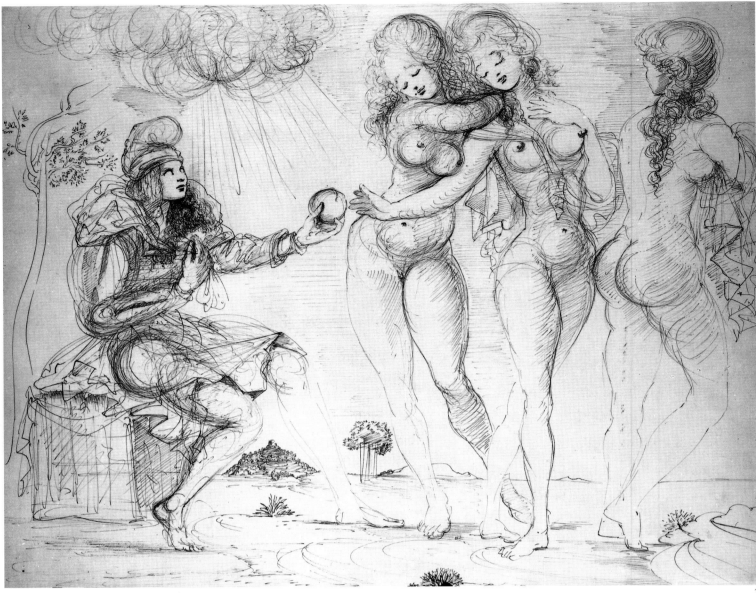

2

Endpapers:
Coccyx Women, 1938 Δ (cf. p. 307)

**This book was printed on 100 % chlorine-free
bleached paper in accordance with the
TCF standard.**

© 1997 Benedikt Taschen Verlag GmbH
Hohenzollernring 53, D-50672 Köln
© DEMART PRO ARTE B.V. 1993
© for the reproductions, except where otherwise
specified: Descharnes & Descharnes
Concept and design: Gilles Néret, Paris
English translation: Michael Hulse, Cologne
Cover design: Angelika Taschen, Cologne;
Mark Thomson, London
Typesetting: Utesch Satztechnik GmbH, Hamburg

Printed in Italy
ISBN 3-8228-8263-1
GB

1 **Dalí, photograph by Philippe
 Halsman, from "Dalí's Moustache",**
 1954 ☆

2 **The Judgement of Paris,** 1950 Δ
 Le jugement de Pâris

This work was originally published
in two volumes.

Symbols used in the captions:
❏ Oil paintings
Δ Drawings, watercolours, gouaches,
 mixed media works and engravings
◑ Sculptures and objets d'art
☆ Photographs and documents

Content

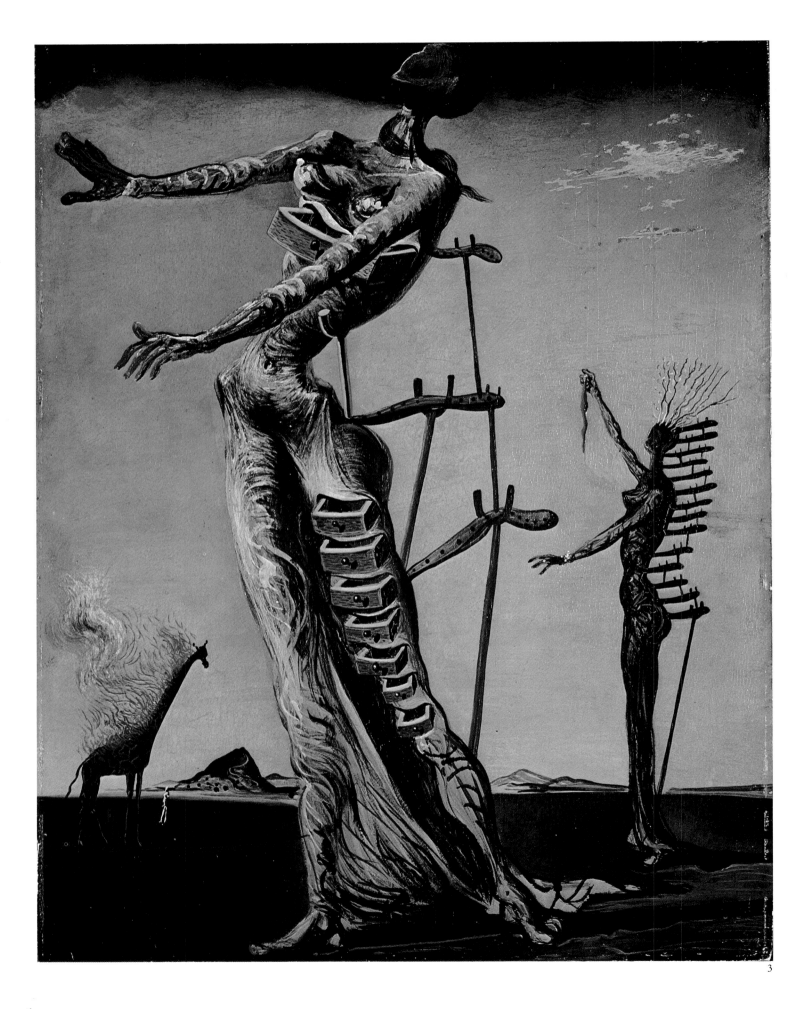

3

"L'œuvre peint complet" – L'œuvre "pain complet"

It is Sunday afternoon. The Lord God brings His festive repast to a close with essence of violets, passes a wind of inexpressibly holy fragrance, and summons His angels to perform His favourite air by Bach. Salvador Dalí turns up, on parole from purgatory, sets up his easel, and resumes work on his portrait of the Lord. Dalí is the only modern painter from whom the Lord God has commissioned work. Though He feels for the great veteran of Surrealism and admires his skill and enjoys his conversation, He cannot, however, defy His own law: for the rest of the week, Dalí, though spared hell, is confined to purgatory. True, he led a fine life on earth, and was a painter of genius, but the fact is that he also rejoiced in his sins. Dalí is not excessively downcast at his punishment. After all, he is familiar with purgatory, knows his Dante, indeed illustrated the *Divine Comedy*; and as for the time he is compelled to spend there, till his soul has been cleansed, he knows (as does everyone in the post-Einsteinian era) that it is relative. A few million years in purgatory are as nothing.

Dalí is just busy painting every hair in the Lord God's majestic beard with photographic precision when a little angel flutters up in a state and announces that two human creatures have called and wish to present a gift. "A gift?" exclaims the painter in delight. "Dalí loves presents!" Whereupon enter Messrs. Robert Descharnes and Gilles Néret, followed by two bearers carrying a large box. "A present!" cries Dalí. "You dear people! What is it?" The two visitors reply as one: "The two volumes of *Dalí: The Paintings.*" They say it in French, as befits visitors to heaven, and when he hears *L'œuvre peint complet* Dalí promptly puns in typical fashion: "Ah, *l'œuvre pain complet.*" The complete bread! "A lovely title. I am the most generous of painters, and there is always a place at my table, where I serve the most delicious dishes to the age. On earth I never knew what I was doing, but I always knew what I was eating."

Once Dalí has unpacked his present, looked through the 1648 illustrations in the two volumes and read the commentary, he confesses that even while on earth he dreamt of an edition like this, but never had the time to tackle the task. In passing he remarks that geniuses ought to live a hundred thousand years, but dunces should die young. Then he turns to his callers, who are eagerly awaiting his verdict. "Yes, the books are satisfactory. They might have been a bit thicker and heavier, but I like them. And I am deeply touched by the love and respect that went into their making. But there are one or two things seriously wrong with them." Descharnes and Néret exchange alarmed glances. Dalí continues: "The first is that I did not do it myself. But that is not the main thing. More serious is the fact that it is not plastic! Given the advances made by modern science, I am amazed that you did not contrive to reproduce my works in holograph. Instead of leafing reverently through books, Dalí lovers could have sat down at table to feast on me! To start, a dead donkey. As a main, pomegranate with female nude. And as dessert, a small portion of the hallucinogenic torero, to guarantee sweet

3 **The Burning Giraffe**, 1936–1937 ❏
Girafe en feu

dreams in their digestive snooze. That would have been Dalí à la carte, as at Maxim's. Still worse is the absence of smells! Of all the five senses, only smell can horrify us. Smell is the locomotive that pulls the train to immortality. Along with taste, it is smell that assures the persistence of memory. This two-volume Dalí sandwich ought to smell of Dalí's twenty-five-kilometre white loaf, and include the most intimate of fragrances."

But let us return to earth, and see how *Dalí: The Paintings* actually came about. At the outset, things did not look good. Dalí had doubtless drawn upon the systematic confusion in which he lived as a lifelong source of inspiration; but for those who came after, trying to make sense of it all, it was distinctly unhelpful. Dalí had confounded the dates and titles of his works as utterly as he had the tales he told about his life. Robert Descharnes, who was Dalí's companion for almost forty years and is better placed than anyone to present the artist's complete work, points out that this is the first study of Dalí to include all the known paintings, with only a very few exceptions. The two volumes are not merely a *catalogue raisonné*, though. The reproductions are accompanied by drawings, writings and other documents, and work Dalí did in film, fashion, objets d'art, and other areas. Without these "crutches", the paintings would perhaps be no more than a series of pictures. Robert Descharnes' intimate knowledge of the Dalí oeuvre has informed the selection procedure – a knowledge derived partly from Dalí himself and partly from vast archive material collected over the years. Some of the paintings not reproduced here have been deliberately excluded because their authenticity is in question or they were repudiated by the artist himself.

Dalí: The Paintings was produced by three people: Robert Descharnes, Gilles Néret and Nicolas Descharnes. Néret, a Dalí lover since 1964, was responsible for the overall orchestration of the two volumes, principally through his layout work. Nicolas Descharnes, Robert's son, gave Gilles Néret unfailing assistance, drawing on his own knowledge of the archives to locate the aptest documentary material.

Particular thanks must go to three major bodies without whose support this study could never have been as complete as it is. First, the Spanish state, Dalí's heir, provided constant and invaluable help through the person of Ana Beristain Diez. Second, the Fundación Gala-Salvador Dalí, and third, the Salvador Dalí Foundation in Saint Petersburg, Florida, and its founders Mr. and Mrs. A. Reynolds Morse, were untiring in their support of this venture. To all, the deep gratitude of the editors and publishers.

4 **Hallucinogenic Toreador,**
1968–1970 ❏
Le torero hallucinogène

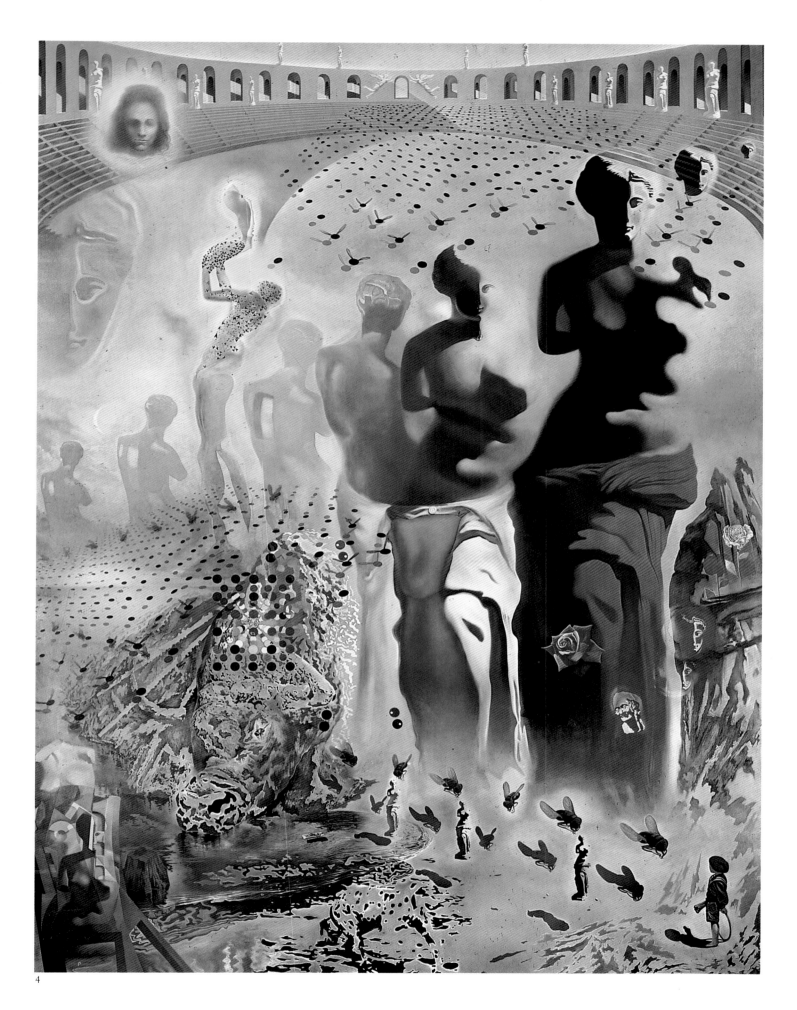

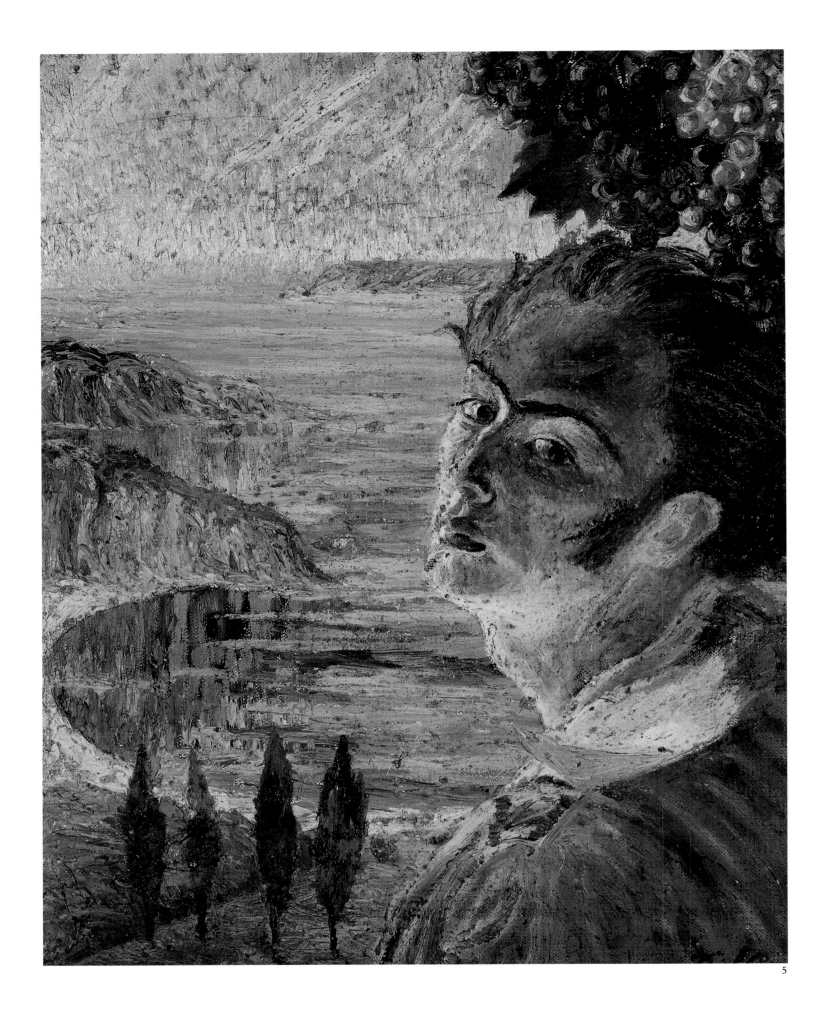

5

1. If You Act the Genius, You Will Be One!

"Painters, do not fear perfection. You will never achieve it! If you are mediocrities, you may try as you will to paint terribly badly, but people will still see that you are mediocre."

Salvador Dalí

E very morning when I awake," wrote the artist of the soft watches and burning giraffes, "the greatest of joys is mine: that of being Salvador Dalí…" The Catalonian artist, so famous and so rich, was prolific not only in his art. He talked nonstop too; and his favourite topic was how to be a genius. "Oh Salvador," he concluded, "now you know the truth: that if you act the genius, you will be one!"

Had he lived during the Renaissance, Dalí would have been recognized sooner as a genius; his copious talent might indeed have been considered normal. In our own age, though, which he felt was growing increasingly stupid, Dalí represented a constant provocation. Today he is ranked alongside Picasso, Matisse, Duchamp and Malevich as one of the Modernist greats, and the general public quite clearly loves his art as well; so that it is difficult to grasp why he should still be seen as so provocative (not least by intellectuals), and why certain quarters should still incline to damn him as a lunatic. It may be that (as with Leonardo da Vinci) no one cares to gaze too deep into so searing a mirror. Dalí himself declared: "The sole difference between myself and a madman is the fact that I am not mad!" Just as the only artist to have remained an Impressionist from the start of his career to the close (while the rest shifted to Cubism, Pointillism or Fauvism) was Monet, so too the one true Surrealist, the most constant of them all, was Salvador Dalí. And he remained a true Surrealist even when he avowed: "The mills of his mind grind continuously, and he possesses the universal curiosity of Renaissance man."

In his foreword to Dalí's *Diary of a Genius*, writer Michel Déon observes: "It is tempting to suppose we know Dalí because he has had the courage to enter the public realm. Journalists devour every syllable he utters. But the most surprising thing about him is his earthy common sense, as in the scene where a young man who wants to make it to the top is advised to eat caviar and drink champagne if he does not wish to fret and toil to the end of his days. What makes Dalí so appealing is his roots and his antennae. Roots that reach deep into the earth, absorbing all the 'earthiness' (to use one of Dalí's favourite notions) that has been produced in four thousand years of painting, architecture and sculpture. Antennae that are picking up things to come, tuned to the future, anticipating it and assimilating it at lightning speed. It cannot be sufficiently emphasized that Dalí is a man of tireless scientific curiosity. Every discovery and invention enters into his work, reappearing there in barely changed form." One might say that Dalí was typical of his age: he had grasped how to make himself a star.

Man, said Blaise Pascal, is "half angel, half animal". His whole life long, and throughout his work, Dalí was as obsessed with sexuality as he was with the quest for the absolute. When he saw the shaven armpit of a woman for the first time, he declared, he was looking for heaven, just as he was looking for heaven when he poked a rotting hedgehog with a crutch. Sexuality and death are close companions in Dalí.

6

5 **Self-Portrait**, c. 1921 ❏
Autoportrait – Autorretrato

6 **Self-Portrait**, 1922 △
Autoportrait

1910

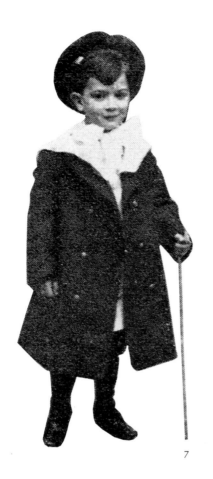

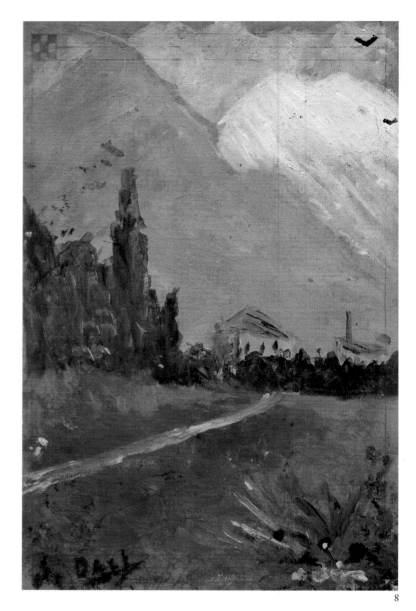

7

8

7 **Dalí at the age of six**, 1910 ✰

8 **Landscape near Figueras**, 1910 ❑
Paysage (Une vue des environs de Figueras)

9 **Vilabertrán**, 1913 ❑

9

A Cook or Napoleon

The six-year-old Salvador wanted to be a cook, and insisted that he must be a female mistress of the cuisine. We can relate the wish directly to one of the salient characteristics of the true Catalonian, in Dalí's pithy definition: "I know what I'm eating. I don't know what I'm doing." At the same time, he produced his first picture: the six-year-old, dressed at that age in sailor costume, painted a landscape (p. 12). Aged seven, he decided he wanted to be Napoleon instead. In the drawing

11

10

10 **Dutch Interior (Copy after Manuel Benedito)**, 1914 ❏
Intérieur hollandais

11 **Landscape near Ampurdán**, c. 1914 ❏
Paysage de l'Ampurdán

12 **Head of Athene**, 1914 △
Tête d'Athena à la ciste

room on the third floor of his parental home there was a small keg in the image of the French emperor, which contained the maté tea his family were in the habit of taking at six in the evening. "Napoleon's image, reproduced on the maté keg, meant everything to me," Dalí wrote in *The Secret Life of Salvador Dalí*; "for years his attitude of Olympian pride, the white and well-fed strip of his smooth belly, the feverish pink flesh of those imperial cheeks, the indecent, melodic, and categorical black of the spectral outline of his hat, corresponded exactly to the ideal model I had chosen for myself, the king. [...] I would in turn sip the tepid liquid, which to me was sweeter than honey, that honey which, as is known, is sweeter than blood itself – for my mother, my blood, was always present. My social fixation was sealed by the triumphal and sure road of the erogenous zone of my own mouth. I wished to sip Napoleon's liquid! [...] Thus I frantically established hierarchies in the course of a year; from wanting to be a cook I had awakened the very person of a Napoleon from my impersonal costume of an obscure king." Dalí famously declared that since boyhood his ambition had grown ever greater, till all he could aim for was to be Salvador Dalí.

Dalí insisted in the *Secret Life* that he had "intra-uterine memories". These were visual memories of the life before birth, and he claimed: "It was divine, it

12

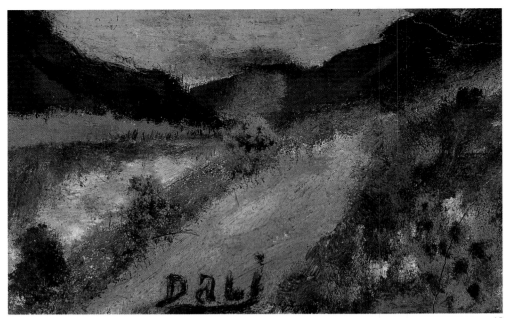

15

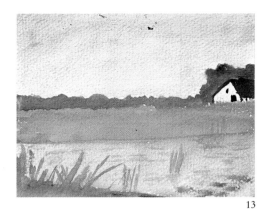

13

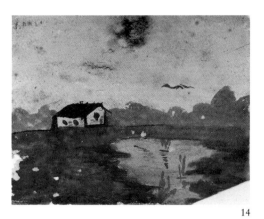

14

13 Untitled – Landscape, 1914 △
Sans titre – Paysage

14 Untitled – House by a Lake,
1914 △
Sans titre – Maison au bord du lac

15 River Landscape, c. 1916 ❏
Paysage à la rivière

was paradise." Dalí held it was the source of "that perturbation and that emotion" which he had felt throughout his life when confronted with the "ever-hallucinatory image" of two fried eggs: "The fried eggs on the plate without the plate, which I saw before my birth were grandiose, phosphorescent and very detailed in all the folds of their faintly bluish whites." His intra-uterine memories provided Dalí with the essential foundations of his lifelong pursuits: "It seems increasingly true that the whole imaginative life of man tends to reconstitute symbolically by the most similar situations and representations that initial paradisaical state, and especially to surmount the horrible 'traumatism of birth' by which we are expulsed from the paradise, passing abruptly from that ideally protective and enclosed environment to all the hard dangers of the frightfully real new world, with the concomitant phenomena of asphyxiation, of compression, of blinding by the sudden outer light and of the brutal harshness of the reality of the world [...]"

Let All the Bells Ring!

Expelled from his intra-uterine paradise, Salvador Felipe Jacinto was born on 11 May 1904 in Figueras in the province of Gerona. His father, Don Salvador Dalí y Cusi, then aged forty-one, was from Cadaqués in the same province of Gerona; he had a notary's practice in Figueras, and lived at 20 Calle Monturiol. His Barcelona-born wife Doña Felipa Dome Domenech was then thirty. The place of her son's birth was to enter art history: time and again, the artist Salvador painted the beloved flatland of Ampurdán, in his eyes the loveliest landscape in the world, and a leitmotiv in his early pictures. The Catalonian coastal strip from Cape Creus to Estartit (with Cadaqués midway) afforded Dalí both the natural scenery and the unique Mediterranean light of many of his most famous works; and in the crags and cliffs, torn by the elements, he found the originals of the morphological curiosities – the vast realm of fossils, bones, and anthropomorphic projections – that were to keep his creative imagination in thrall. From the very outset, he scarcely painted a landscape, portrait or abstract composition that was not unmistakably Catalonian in character, through its distinctive rocky landscape, in which anthropomorphic shapes counterpointed the human figures Dalí painted. Dalí's oft nightmarish visions were not the product of innate psychological dis-

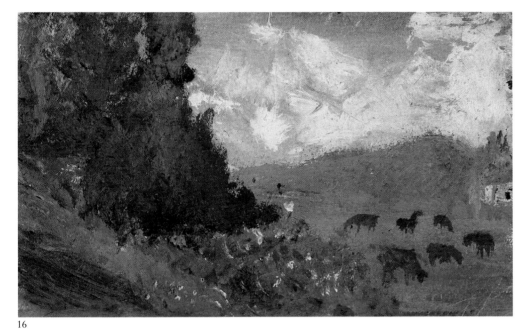

16

18

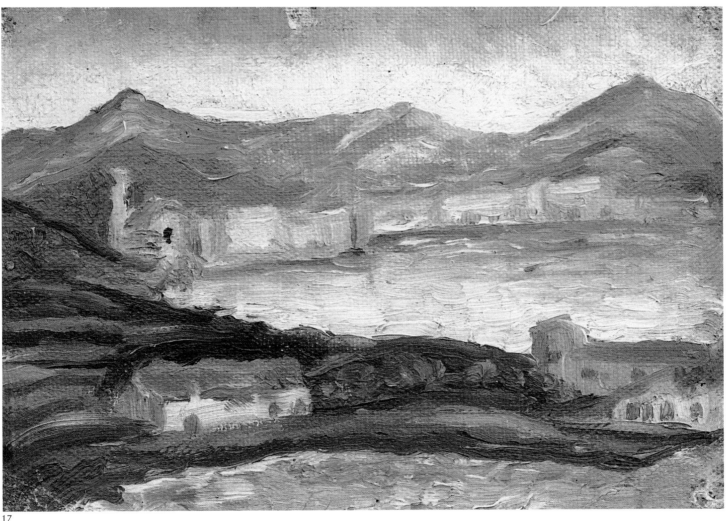

17

16 **Untitled – Landscape with Animals,** c. 1916 ❏
Sans titre – Paysage aux animaux

17 **Cadaqués,** c. 1917 ❏

18 **Untitled,** 1914 △
Sans titre

1918

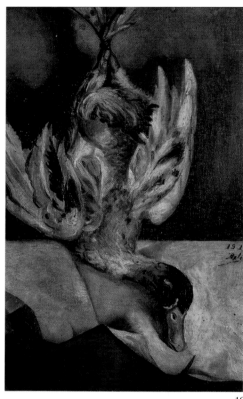

19

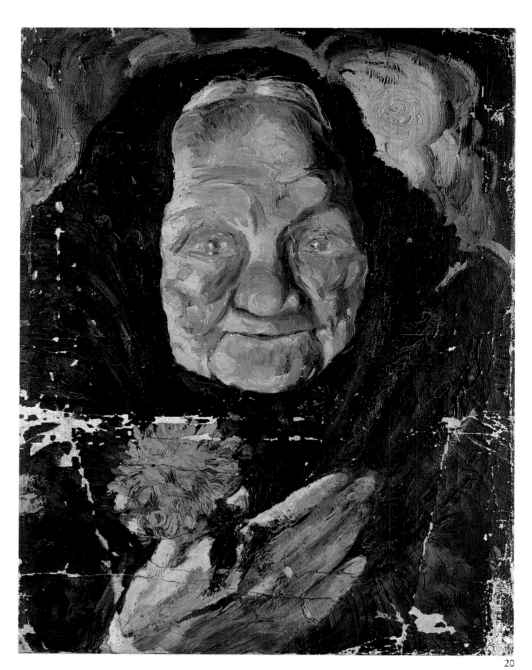

20

19 **Duck**, 1918 ❏
Pato

20 **Portrait of Lucia**, 1918 ❏
Portrait de Lucia

21 **Old Man at Twilight**, 1918 ❏
Vieillard crépusculaire

22 **Still Life**, 1918 ❏
Nature morte

23 **Couple near the Fortress,**
1918–1921 △
Pareja delante del baluarte – Couple
devant la forteresse

turbance; rather, they drew directly upon happenings and facts he had observed and remembered.

In the *Secret Life*, Dalí waxed ecstatic on the subject of his own birth: "Let all the bells ring! Let the toiling peasant straighten for a moment the ankylosed curve of his anonymous back, bowed to the soil like the trunk of an olive tree, twisted by the tramontana, and let his cheek, furrowed by deep and earth-filled wrinkles, rest in the hollow of his calloused hand in a noble attitude of momentary and meditative repose. Look! Salvador Dalí has just been born! [. . .] It is on mornings such as this that the Greeks and the Phoenicians must have disembarked in the bays of Rosas and of Ampurias, in order to come and prepare the bed of civilization and the clean, white and theatrical sheets of my birth, settling the whole in the very centre of this plain of Ampurdán, which is the most concrete and the most objective piece of landscape that exists in the world."

Why did Dalí's parents name him Salvador? The artist himself, needless to say, roundly declared that he was destined to save art from the threat of the isms – from Dadaism, from academic Surrealism, from abstract art. Salvador, the saviour of art.

21

22

23

The Anti-Faust

Dalí was a tireless observer of all that surrounded him. His particular attention was given to Lucia, his old nurse, who filled his head with stories, and his grandmother. "Lucia and my grandmother were two of the neatest old women," he recalled, "with the whitest hair and the most delicate and wrinkled skin I have ever seen. The first was immense in stature and looked like a pope. The second was tiny and resembled a small spool of white thread. I adored old age!"

Once he came to write his *Secret Life*, Dalí was elaborating that childhood adoration in characteristic fashion: "I became, I was and I continue to be the living incarnation of the Anti-Faust. As a child I adored that noble prestige of old people, and I would have given all my body to become like them, to grow old immediately! I was the Anti-Faust. Wretched was he who, having acquired the supreme science of old age, sold his soul to unwrinkle his brow and recapture the unconscious youth of his flesh! Let the labyrinth of wrinkles be furrowed in my brow with the red-hot iron of my own life, let my hair whiten and my step become vacillating, on condition that I can save the intelligence of my soul – let

1918

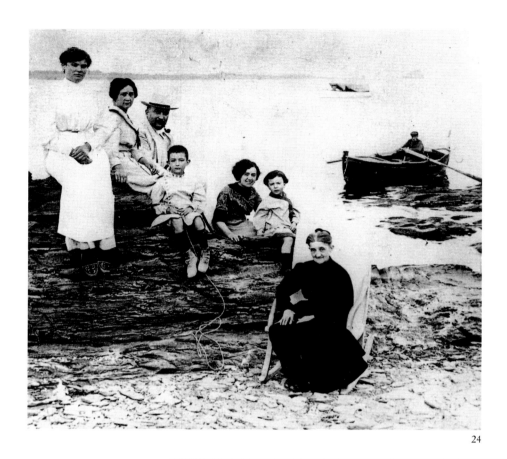

24

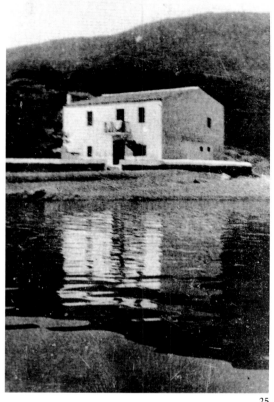

25

26

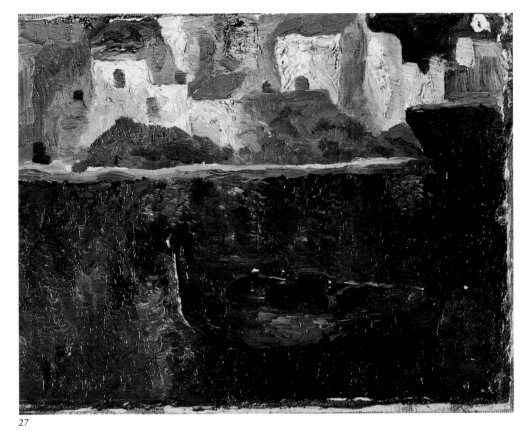

27

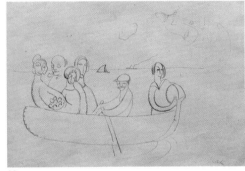

29

24 The Dalí family outside their home, on the rocky beach at Llané. Left to right: Aunt María Teresa; the artist's mother and father; Salvador Dalí; Tiéta, his mother's sister, who married the notary after the mother's death; Ana María, Salvador's sister; and grandmother Ana. In the boat is El Beti, the fisherman who looked after the family boats. ✫

25 The Dalí family home at Cadaqués, c. 1910 ✫

26 Sea View, 1918–1919 ❑
Marine

27 Punta es Baluard de la Riba d'en Pitxot, Cadaqués, 1918–1919 ❑

28 Port of Cadaqués (Night), 1919 ❑
Port de Cadaqués, de nuit

29 Family in a Boat, c. 1923 ∆
Famille en bateau

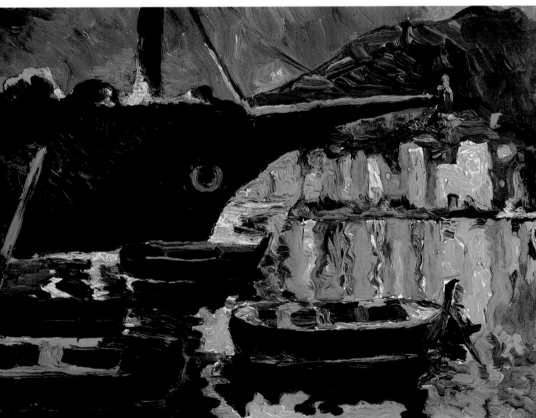

my unformed childhood soul, as it ages, assume the rational and esthetic forms of an architecture, let me just learn everything that others cannot teach me, what only life would be capable of marking deeply in my skin! […] In each of Lucia's or my grandmother's wrinkles I read this force of intuitive knowledge brought to the surface by the painful sum of experienced pleasures […]"

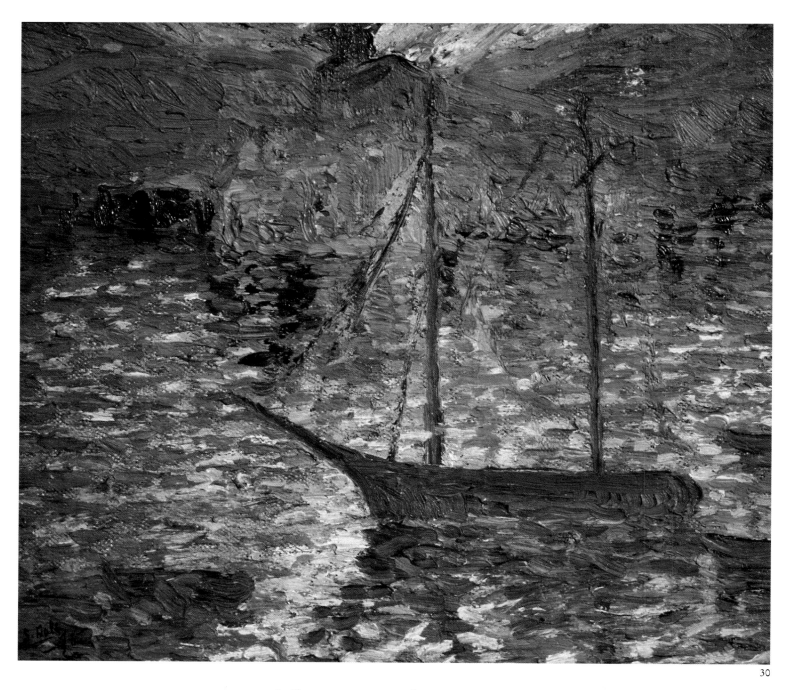

30

30 **Boat (Commercial Sailboat Riding at Anchor in the Bay of Cadaqués),** c. 1919 ❑
Bateau (Voilier de commerce au mouillage dans la baie de Cadaqués)

The Crystal Stopper

At ten, Dalí discovered the Impressionists; and, at fourteen, the *pompiers* – the academic genre painters of the 19th century. When the family informed him of their wish to employ a drawing teacher for the lad, he retorted: "No! I don't want any drawing teacher, because I'm an 'Impressionist' painter!" Not that he clearly understood what was meant by the word "Impressionist"; but he felt his reply was a logical one, and was nonplussed when it provoked a peal of laughter: "Well,

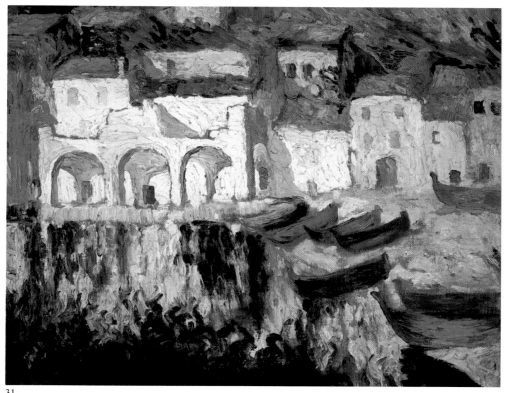

31

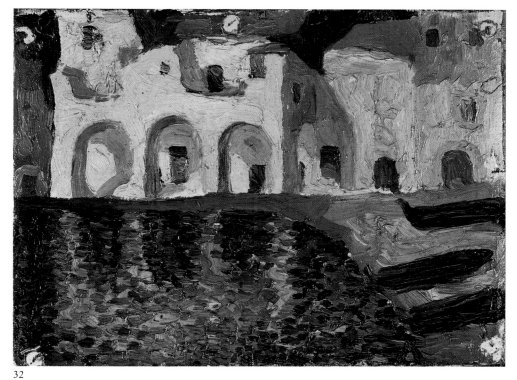

32

will you look at that child, coolly announcing that he's an 'Impressionist' painter!"

In the *Secret Life*, Dalí left a meticulous account of the background that under-pinned the logic of his own development in art. When the lad breakfasted on toast and honey, he reported, he was surrounded by oils and etchings, while at school he could see Millet's *Angelus*, which was to have such impact on his adult work. The work adorning the parental walls was mainly by Ramón Pichot (1872–1925), a neighbour and friend from a family of artists, who at that time was living in

31 **View of Port Dogué (Port Alguer), Cadaqués**, 1918–1919 ❏
Vue de Port Dogué (Port Alguer), Cadaqués

32 **Port Dogué, Cadaqués**, 1918–1919 ❏

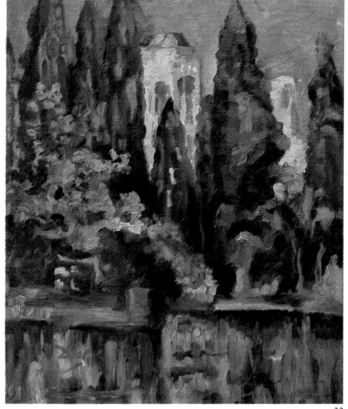

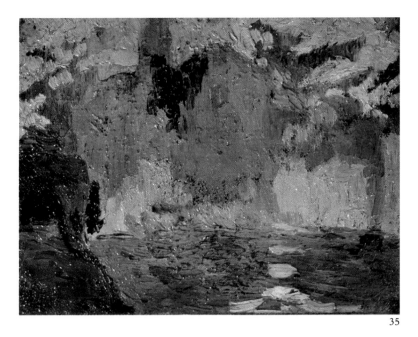

35

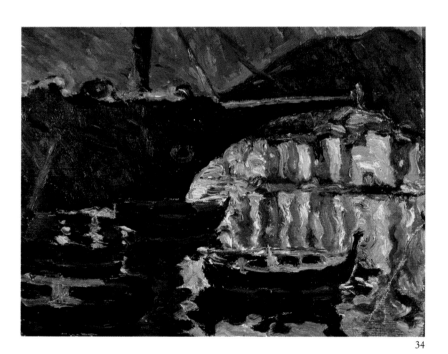

34

36

1919

33 **Vilabertrán Church Tower,**
1918–1919 ❏
Le clocher de Vilabertrán

34 **The Port of Cadaqués**, c. 1919 ❏
Port de Cadaqués

35 **Playa Port Alguer de la Riba
d'en Pitxot**, 1918–1919 ❏

36 **Llané Beach, Cadaqués**, 1919 ❏
Plage du Llané, Cadaqués

Paris. Around the turn of the century he was associated with Picasso; in 1905 he exhibited at the autumn Salon in Paris with the Fauves. Pichot's technique recalled that of Toulouse-Lautrec. When a large exhibition was devoted to his work in Paris in 1910, Guillaume Apollinaire wrote in his *Chronique d'Art*: "Ramón Pichot is one of the stars among Spanish artists now continuing the tradition of a Goya, even of a Velázquez, in Paris. Like Pablo Picasso, he is one of those who, building on the foundations of their high and powerful culture, have applied their genius and their exacting demands to the visual arts, in which sphere they are producing works whose influence is continuously growing throughout the world. […] Ramón Pichot's wonderful coloured etchings in particular attest him of the Spanish school. They show gypsies, old sailors, fans and pomegranate blossom." All of these subjects, treated by Pichot in his own way, were later to be

37

39

38

40

found in Dalí too, who gladly conceded: "I squeezed from these pictures all the literary residue of 1900, the eroticism of which burned deep in my throat like a drop of Armagnac swallowed the wrong way. I remember especially a dancer of the Bal Tabarin dressing. Her face was perversely naïve and she had red hairs under her arms."

In all, it seems fair to say that it was Impressionism that made the greatest impact on Dalí at the earliest stage of his life in art. For the impressionable youngster, it represented a first contact with an aesthetic he would be questing for his whole life long: anti-academic, revolutionary. "I did not have eyes enough to see all that I wanted to see in those thick and formless daubs of paint, which seemed to splash the canvas as if by chance, in the most capricious and nonchalant fashion. Yet as one looked at them from a certain distance and squinting one's

1919

37 **The Church at Cadaqués and the Beach at Port Alguer Seen from Riba d'en Pitxot**, 1919–1920 ❏
L'église de Cadaqués et la plage de Port Alguer vues de la Riba d'en Pitxot

38 **Calá Pianc**, c. 1919 ❏

39 **Port Alguer**, 1919–1920 ❏

40 **Port Dogué – Cadaqués**, 1919 ❏

1919

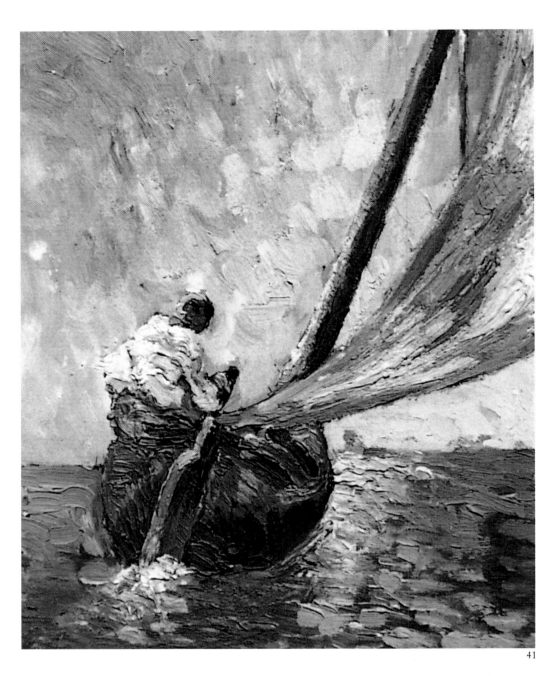

41

42

43

eyes, suddenly there occurred that incomprehensible miracle of vision by virtue of which this musically colored medley became organized, transformed into pure reality. The air, the distances, the instantaneous luminous moment, the entire world of phenomena sprang from the chaos!"

To re-invent Impressionism for himself, to grasp its principles of light and colour, Dalí took to carrying around with him a crystal carafe stopper that was in the dining room, apparently unneeded. He would observe the daily scene through this stopper, "impressionistically" transforming it: "[…] the paintings that filled me with the greatest wonder were the most recent ones, in which de-

44

liquescent Impressionism ended in certain canvases by frankly adopting in an almost uniform manner the *pointilliste* formula. The systematic juxtaposition of orange and violet produced in me a kind of illusion and sentimental joy like that which I had always experienced in looking at objects through a prism, which edged them with the colors of the rainbow."

In 1918 Dalí's enthusiasm extended to include the academic *pompiers*, especially Mariano Fortuny (1838–1874). The inventor of Spanish colourism had left a vast oeuvre that included *The Battle of Tetuán*, a painting which had brought him not only fame but also the respect of Théophile Gautier, the friendship of Meissonier, and, in due course, the admiration of Dalí. Dalí was to retain this liking for Fortuny throughout his life, and it even resulted in his own version of *The Battle of Tetuán*.This period, the war years of 1914 to 1918, was one of unusual contentment for Dalí. Spain, remaining neutral, was enjoying a euphoric

41 **The Tartan "El Son" (The Artist at the Rudder of the "El Son")**, 1919 ❑
La tartane «El Son» (L'artiste à la barre d' «El Son»)

42 **Sailboat with figure. Study for the boat in "El Son"**, 1919 △
Barca de vela con figura

43 **Es Poal – Pianque**, 1919–1920 ❑

44 **Landscape**, 1919–1920 ❑
Paysage

45

46

45 Portrait of Mr. Pancraci,
c. 1919 ❏
Retrat del senyor Pancraci – Portrait
du sieur Pancrace

46 My Cousin Montserrat,
1919–1920 ❏
Ma cousine Montserrat

47 Self-Portrait in the Studio,
c. 1919 ❏
Autoportrait dans l'atelier

boom: people were dancing the tango and sardana, or singing German songs to the guitar. It seemed one glorious party. The young Salvador had no interest whatsoever in his schoolwork, and damned the teachers as "idiots"; small wonder, then, that his school performance was far from satisfactory. Painting was of far greater interest to him than tuition by Figueras' Marist Brothers. As early as 1918 he was exhibiting with other local artists in the Teatro Municipal. He was also writing a regular art column for *Studium*, a magazine published by the Instituto de Figueras, in which he sang the praises of artists he revered, such as Michelangelo, El Greco, Velázquez, Dürer, Goya and Leonardo da Vinci. They were, of course, a young person's essays on art, and inevitably somewhat clumsy; yet even at fifteen Dalí was evidencing highly developed thinking on art. Thus he wrote of Velázquez: "Our painter was also extraordinarily skilful in his technique. His works are put before us with an unarguable seriousness; thus, for instance, his genre pictures, such as the *Meninas* and the *Weavers*, which display an enviable and unequalled skill. His application of paint and arrangement of colours sometimes seem veritably Impressionist. Velázquez must be considered as one of the greatest, perhaps indeed *the* greatest, of Spanish painters, and furthermore as one of the foremost artists the world has seen." Superior as Dalí always felt himself to be over his contemporaries, he yet invariably felt small and humble beside his illustrious predecessors. In the *Secret Life* he wrote: "If I look toward the past, beings like Raphael appear to me as true gods; I am perhaps the only one today to know why it will henceforth be impossible even remotely to

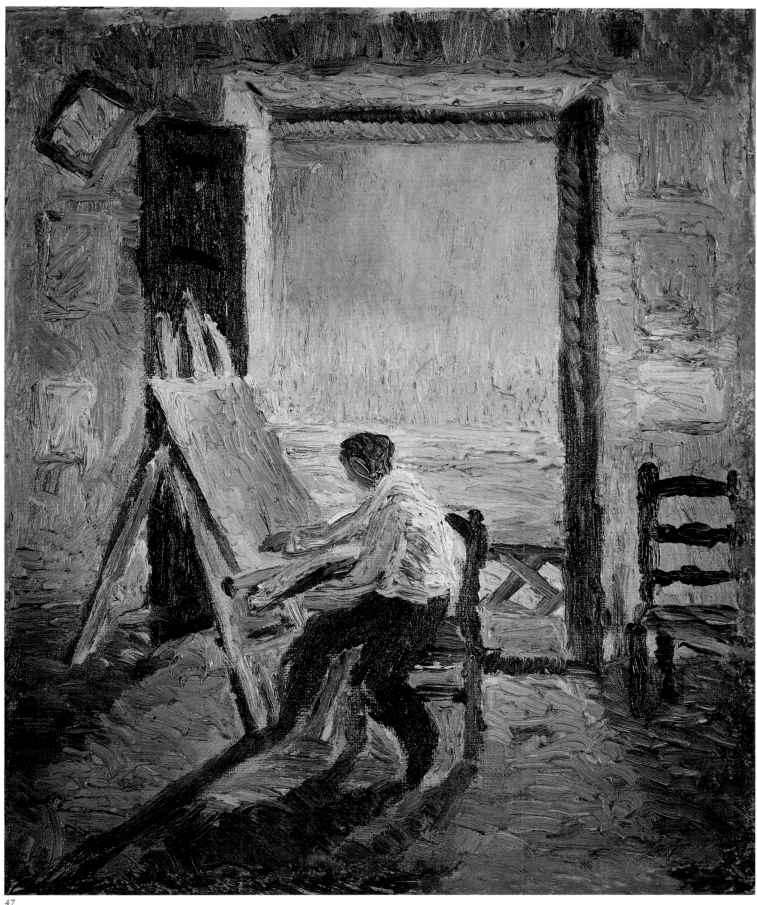

47

1919

48

49

48 **The Three Pines**, c. 1919 ❑
Les trois pins

49 **Cadaqués – Garden of Llané**,
1919–1920 ❑
Cadaqués – La horta del Llané

50

51

52

50 **Landscape, 1919–1920** ❏
Paysage

51 **Cadaqués, 1920–1921** ❏

52 **Orchard at Llané (Cadaqués),**
1919–1920 ❏
Allée du verger à Cadaqués

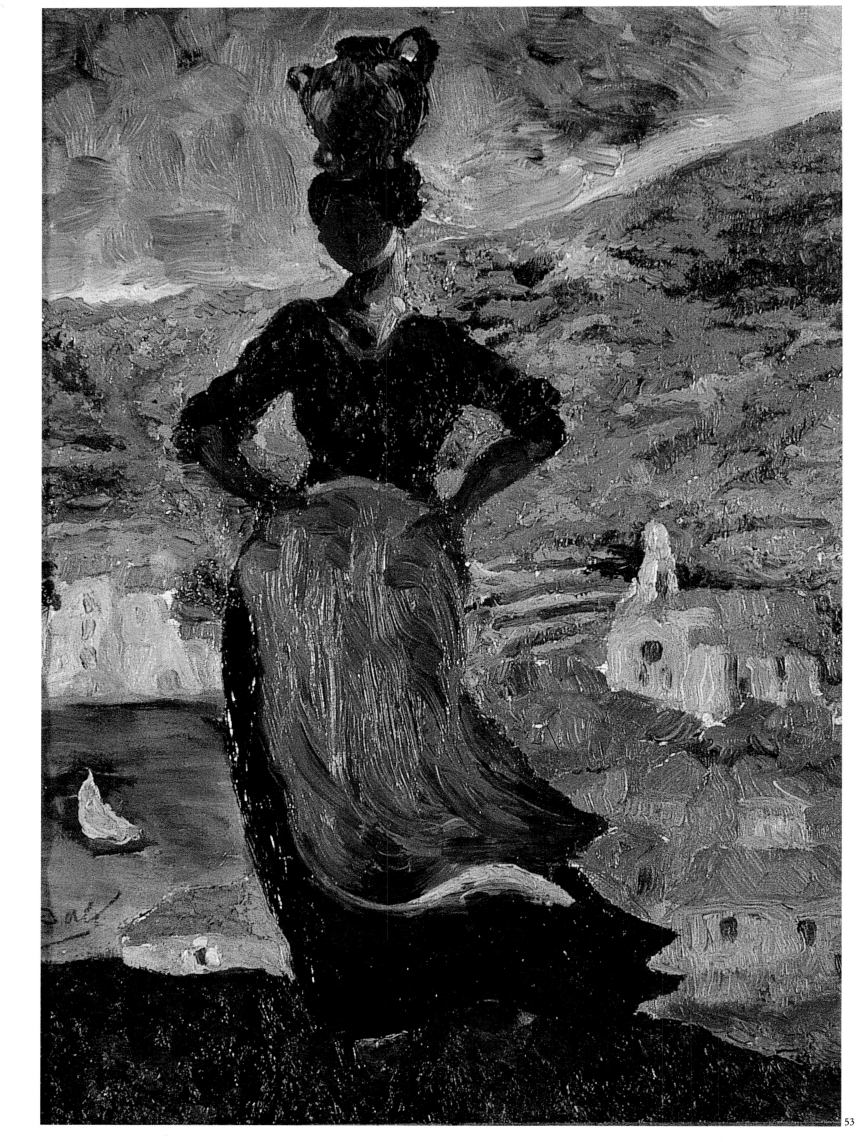

54

55

approximate the splendors of Raphaelesque forms. And my own work appears to me a great disaster, for I should like to have lived in an epoch during which nothing needed to be saved! But if I turn my eyes toward the present, although I do not underestimate specialized intelligences much superior to my own […] I would for nothing in the world change places with anyone, with anyone whomsoever among my contemporaries."

Dalí was by now intending to go to the Academy of Fine Arts in Madrid, and moreover planning "a struggle to the death" with the professors there. He had already been attending Professor Juan Nuñez's drawing course at the Escuela Municipal de Grabado, and delighted in doing the very opposite of whatever Nuñez instructed – using heavy black pencils when advised to use soft, scratching and blotching when advised to tone gently. Dalí, needless to say, decided that he was in the right: "I came to the conclusion that only the relief of the color itself, deliberately piled on the canvas, could produce luminous effects satisfying to the eye. This was the period my parents and myself baptized 'The Stone Period'. I used stones, in fact, to paint with. When I wanted to obtain a very luminous cloud or an intense brilliance, I would put a small stone on the canvas, which I would thereupon cover with paint. One of the most successful paintings of this kind was a large sunset with scarlet clouds." This picture, studded with stones, hung for a

53 **Portrait of Hortensia, Peasant Woman from Cadaqués,** 1920 ❑
Portrait d'Hortensia, paysanne de Cadaqués

54 **Tiéta – Portrait of my Aunt,** 1920 ❑
Tiéta – Portrait de ma tante (Portrait de Catalina Domenech Ferrer)

55 **A Ball on the Patio of the Mariona,** 1919–1920 Δ
Bal de nuit dans le patio de la Mariona

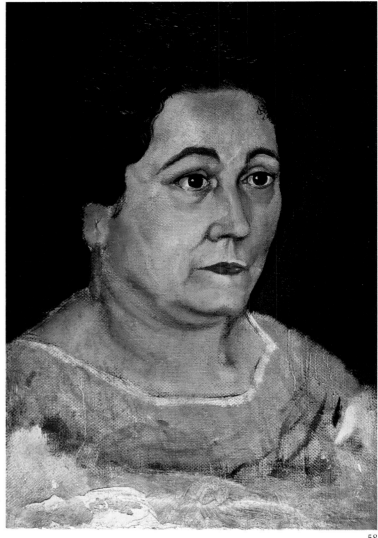

56

58

57

time in his parents' dining room: "I remember that during the peaceful family gatherings after the evening meal we would sometimes be startled by the sound of something dropping on the mosaic. My mother would stop sewing for a moment and listen, but my father would always reassure her with the words, 'It's nothing – it's just another stone that's dropped from our child's sky!'" Dalí senior would add with a mildly worried expression: "The ideas are good, but who would ever buy a painting which would eventually disappear while their house got cluttered up with stones?" We might compare *Old Man at Twilight* (p. 17), where the cloudy sky also consists of small stones stuck to the canvas and painted over.

Dalí's principal subjects in his earliest work, from 1910 to 1921, were landscapes and portraits, for which he readily found sitters. The most striking thing about this early phase – and one which places Dalí's work in stark contrast to the early work of other painters – is that, far from being dark and desolate, his paintings were bright and luminous. He moved on from Impressionism to Pointillism, from Pointillism to Fauvism, exuberantly and even obsessively painting everything he could see in Cadaqués or Portdogué, the olive groves and fishermen and boats. He painted portraits of his own family, the Pichots, his cousin Montserrat, his grandmother – and himself. For this last he used a finely nuanced palette of what he called "voluptuous colours", applied in thick pastose.

There is a photograph taken in 1910 (p. 18) that shows the entire family: from the left, his aunt María Teresa, his mother, his father, then Salvador himself, his mother's sister Tiéta (who was to marry the notary after the death of Dalí's mother), the boy's sister Ana María, and grandmother Ana. Out in the boat is El

contd. on p. 39

59

60

56 **Grandmother Ana Sewing,**
c. 1920 ❏
La grand-mère Ana cousant

57 **Circus Acrobats,** 1920–1921 △
Saltimbanques

58 **Portrait of the Artist's Mother,
Doña Felipa Dome Domenech de
Dalí,** 1920 ❏
Portrait de la mère de l'artiste Doña
Felipa Dome Domenech de Dalí

59 **Portrait of José M. Torres,**
c. 1920 ❏
Portrait de José M. Torres

60 **Boxer,** c. 1920 ❏
Boxeur

61 **Portrait of Joaquín Montaner
(Allegory of the Navigator),**
1919–1920 △
Portrait de Joaquín Montaner (Alego-
ria del navegante)

61

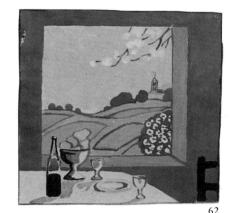

62

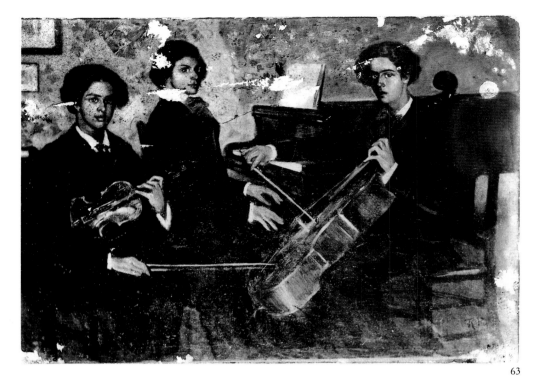

63

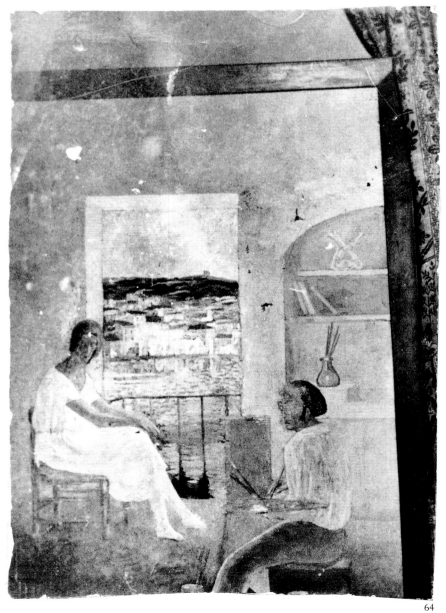

64

65

62 Still life for the cover of "Per la Musica, Poems", 1921 △
Nature morte pour la couverture de «Per la Musica, poèmes»

63 The Pichot-Costa Trio painted by Ramón Pichot. Left to right: Luis (Violin), Costa (Piano) and Ricardo (Cello), 1920 ✩

64 Untitled – The Artist in his Studio in Riba d'en Pitxot in Cadaqués, 1920–1921 ❏
Sans titre – L'artiste dans son atelier de la Riba d'en Pitxot, à Cadaqués

65 Cover of "Per la Musica, Poems", 1921 △

66 Portrait of the Cellist Ricardo Pichot, 1920 ❏
Portrait du violoncelliste Ricardo Pichot

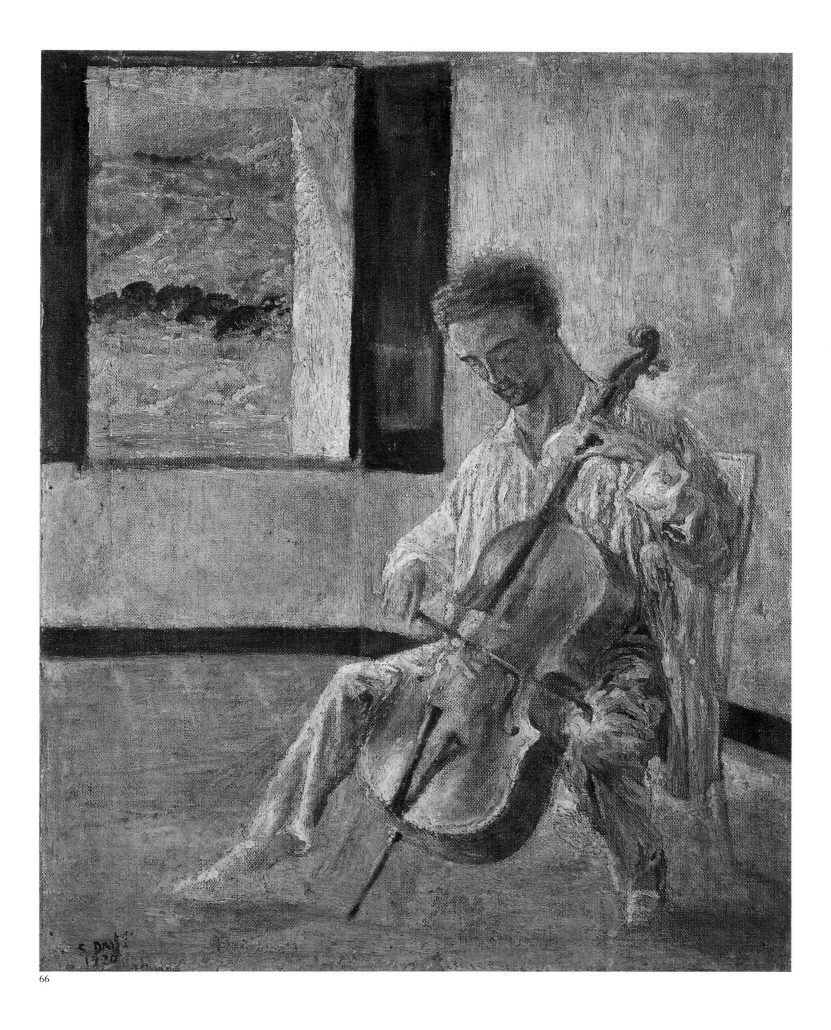

66

1920

67 **Still Life,** c. 1920 ❏
Nature morte

68 **Still Life by a Window,** c. 1920 ❏
Nature morte

69 **Still Life: Pomegranates,** c. 1919 ❏
Pomme-grenade rubis

67

68

70 **The Lake at Vilabertrán,** 1920 ❏
Le lac de Vilabertrán

71 **The Bay of Nans (Cadaqués),**
c. 1920 ❏
Calanque Nans (Cadaqués)

72 **The Cove at Joncals (Cadaqués),**
1920 ❏
Calanque Joncals (Cadaqués)

73 **The Kitchen Garden at Little
Llané,** 1920 ❏
Le potager du Llané-Petit

69

70

73

71

72

1920

74

75

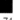

76

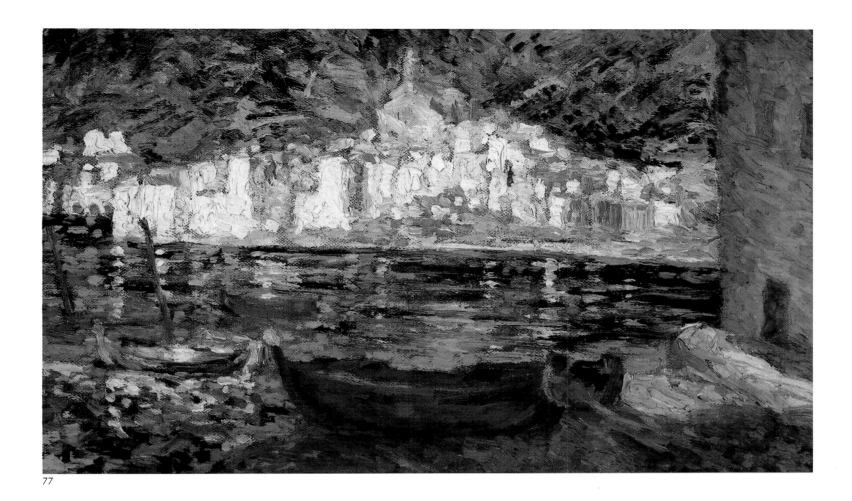

77

Beti, a fisherman who looked after the family boats. Life in his youth was unquestionably a carefree thing for Salvador Dalí: he was, by his own confession, royally spoilt, his every extravagant notion indulged. And for this reason, no doubt, his father was beginning to worry. What was to become of the boy?

Dalí, by his own account, was always not merely an immodest person but also deeply contrary, opposed to everything "on principle". As he put it: "The Child-King became an anarchist." It was perhaps inevitable, therefore, that when a group of students burnt the flag of Spain it was Dalí who was accused of the offence. A schoolboy still, he was acquitted on grounds of age, but the incident "made a deep impression on public opinion".

He was cultivating an image already. "I had let my hair grow as long as a girl's, and looking at myself in the mirror I would often adopt the pose and the melancholy look which so fascinated me in Raphael's self-portrait" (cf. *Self-Portrait with the Neck of Raphael*, p. 45). Dalí was determined "to compose a masterpiece with my head", and was impatient for the day when he would be able to grow sideburns (which in due course he did, earning the local nickname of Señor Patillas). He would make up using his mother's powder and pencil, and was delighted to hear people in the street cry out, "That's the son of Dalí the notary. He's the one who burned the flag!"

The young Salvador passed his first year exams at the Marist Brothers' school without distinction. He was relieved that he had failed none, since resits would have spoilt his summer in beloved Cadaqués: "This is the spot which all my life I have adored with a fanatical fidelity which grows with each passing day. I can say without fear of falling into the slightest exaggeration that I know by heart each contour of the rocks and beaches of Cadaqués, each geological anomaly of its unique landscape and light, for in the course of my wandering solitudes these outlines of rocks and these flashes of light clinging to the structure and the aes-

74 **The Bay at Cadaqués, with Cucurucuc Rock and the Sortell Peninsula**, 1920 ❏
L'entrée de la baie de Cadaqués avec le rocher de Cucurucuc et la presqu'île du Sortel – Vus de la Fica Pichot

75 **Moonlight over the Bay at Cadaqués**, c. 1920 ❏
Clair de lune sur la baie de Cadaqués

76 **Port Dogué and Mount Pani from Ayuntamiento**, 1920 ❏

77 **View of Cadaqués from Playa Poal**, 1920 ❏

39

1920–1921

78 **Landscape near Cadaqués,**
1920–1921 ❑
Paysage de Cadaqués

79 **Landscape near Cadaqués,**
c. 1921 ❑
Paysage de Cadaqués

80 **Landscape near Cadaqués,**
1920–1921 ❑
Paysage de Cadaqués

81 **The Bay of Nans with
Cypresses,** 1920–1921 ❑
Calanque Nans embellie de cyprès

82 **Moonlight at Little Llané,**
1921 ❑
Clair de lune à El Llané-Petit

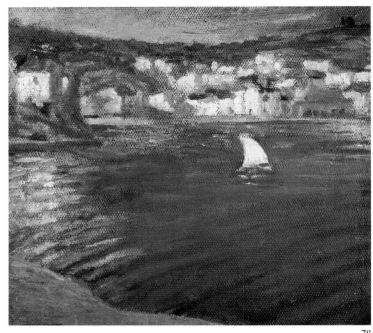

78

79

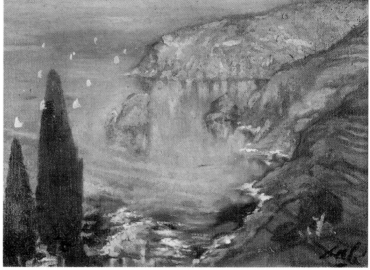

81

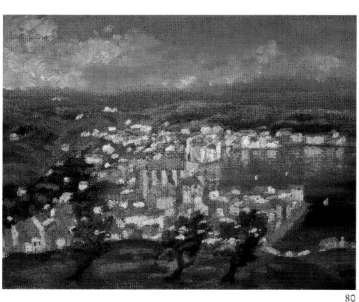

80

82

thetic substance of the landscape were the unique protagonists on whose mineral impassiveness, day after day, I projected all the accumulated and chronically unsatisfied tension of my erotic and sentimental life. I alone knew the exact itinerary of the shadows as they traced their anguishing course around the bosom of the rocks, whose tops would be reached and submerged by the softly lapping tides of the waxing moon when the moment came. […] Just as on a human head […] there is only one nose, and not hundreds of noses growing in all directions and on all its surfaces, so on the terrestrial globe that phemonenal thing which a few of the most cultivated and discriminating minds in this world have agreed to call a 'landscape', knowing exactly what they mean by this word, is so rare that innumerable miraculous and imponderable circumstances – a combination of geological mold and of the mold of civilization – must conspire to produce it. […] But the most curious of all is that where this landscape becomes best, most beautiful, most excellent and most intelligent is precisely in the vicinity of Cadaqués, which by my great good fortune (I am the first to recognize it) is the exact spot where Salvador Dalí since his earliest childhood was periodically and successively to pass the 'esthetic courses' of all his summers. […] Each hill, each rocky contour might have been drawn by Leonardo himself!"

83 **The Garden at Llané,**
1920–1921 ❏
L'Horta del Llané – Le jardin de Llané

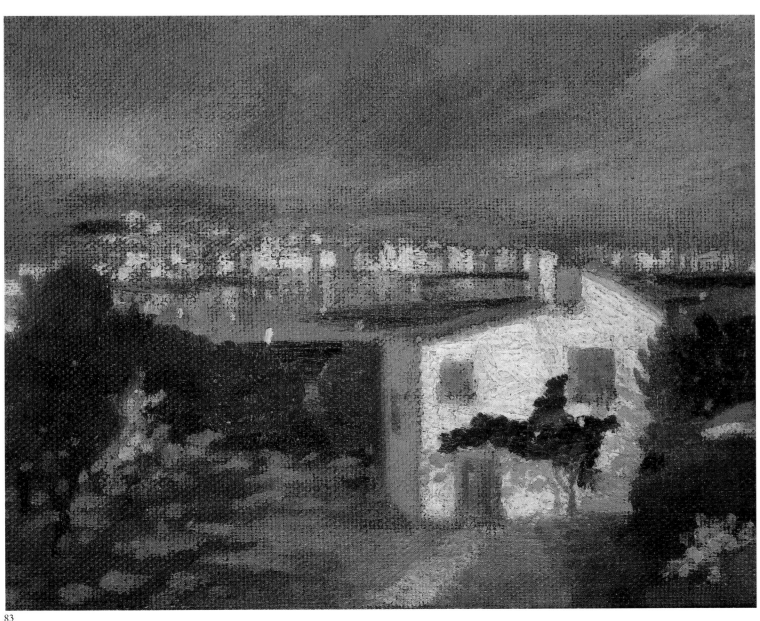

83

1920–1921

84 **Dalí's father, Don Salvador Dalí y Cusi,** c. 1904 ☆

85 **The Artist's Father at Llané Beach,** 1920 ❏
Le père de l'artiste à Llané

86 **Portrait of my Father,** 1920–1921 ❏
Portrait de mon père

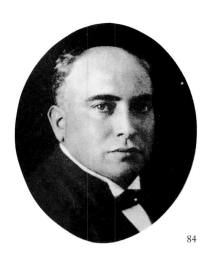

84

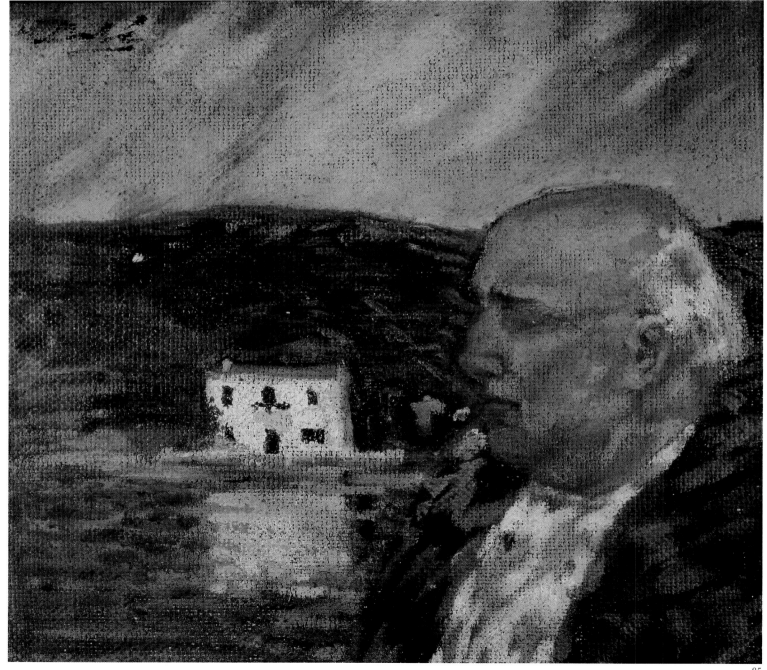

85

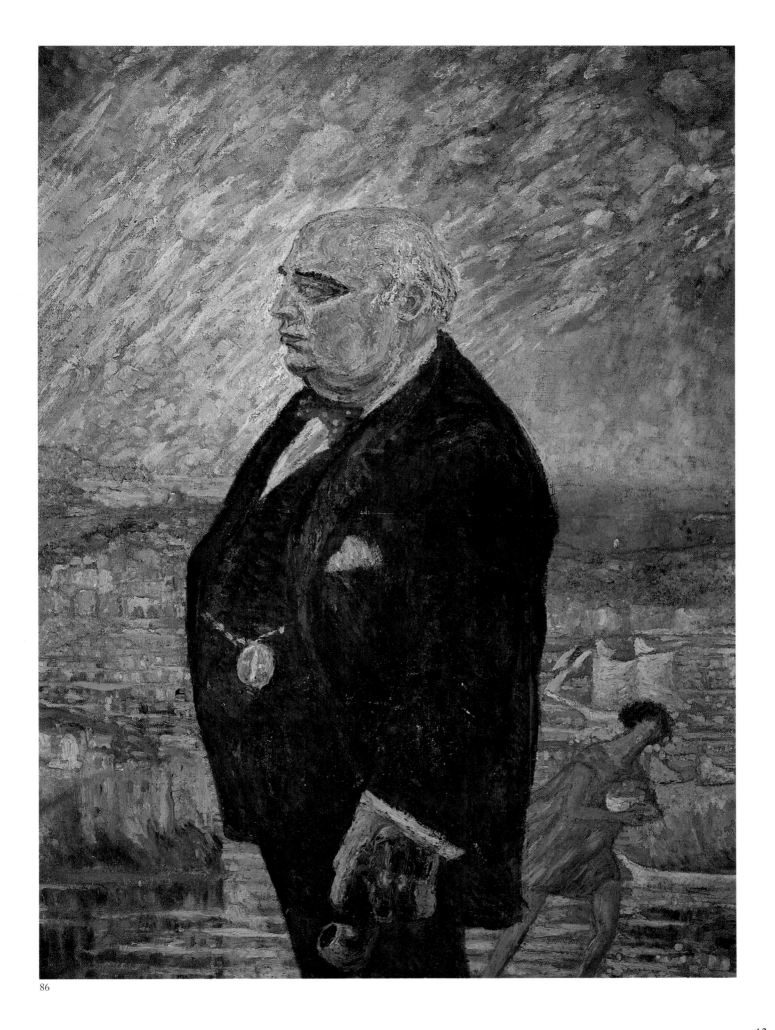

1921

Dandyism

The dandy must live and sleep in front of the mirror." Thus Baudelaire. The pronouncement might have been the motto of Salvador Dalí's entire life. Soon a mirror was not enough, and by his early manhood Dalí needed the attention of adulation of all; the thought that he might go unnoticed became unbearable to him. On his first visit to New York, at Christmas time, he walked the streets ringing a bell to ensure people would register his presence. In this self-infatuation he remained true to himself till the very end, and during his final days in hospital in Barcelona delighted in following the television bulletins on the state of his health, learning from them whether he was well or was shortly to die…

Dalí entered the San Fernando Academy of Painting, Sculpture and Graphic Arts in Madrid, and quickly earned the reputation of a madman among his fellow students. It was not difficult to amaze them, presumably, if he spent three full hours putting his hair up in a net and then coiffing it with the picture varnish painters use for treating canvases. (This had the unpleasant side-effect that he had to immerse his head in a tub of turpentine to remove the varnish afterwards.) Dalí was out to get attention, even if it meant making his hair look like shellac; people turned to look as he went by, and that was enough to make him happy. "Instead of inspiring sarcasm, I now released an admiration and intimidated curiosity. On coming out from the School of Fine Arts I ecstatically savored the homage of that street, so intelligent and full of wit, in which spring was already seething. I stopped to buy a very flexible bamboo cane from whose leather-sheathed handle dangled a shiny strap of folded leather. After which, sitting down at the terrace of the Café-Bar Regina, and drinking three Conzano vermouths with olives, I contemplated in the compact crowd of my spectators passing before me the whole future that the anonymous public already held in reserve for me [...]" Dalí the narcissist was in the process of re-inventing himself as a Wagnerian dandy, a

contd. on p.53

87 **Dalí as a college student in Figueras**, 1921 ✰

88 **Self-Portrait**, c. 1921 ❏
Autoportrait

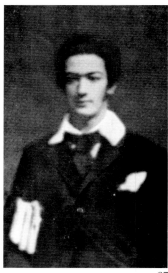

87

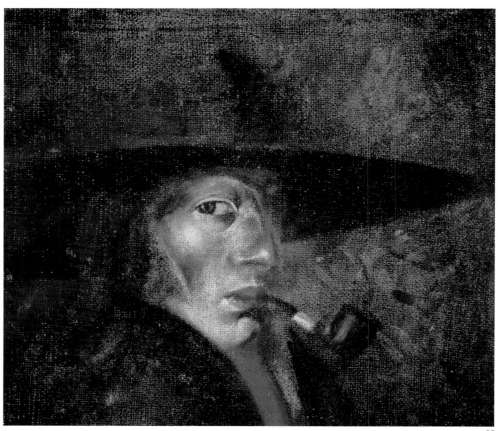

88

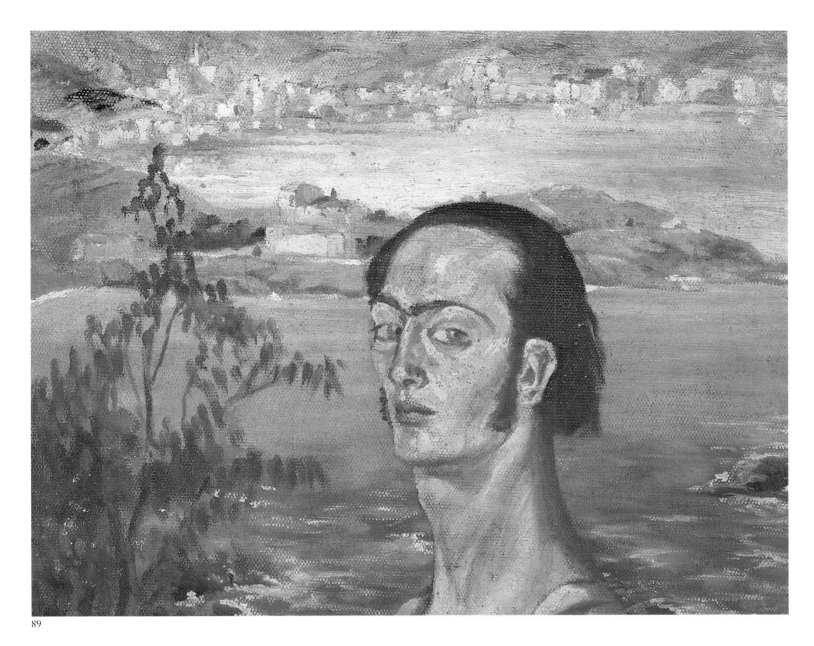

89

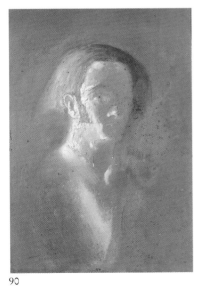

90

91

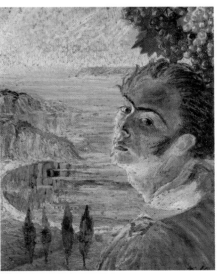

92

89 **Self-Portrait with the Neck of Raphael**, 1920–1921 ❏
Autoportrait au cou de Raphaël

90 **Self-Portrait**, 1921 ❏
91 **Self-Portrait**, 1921 ❏
Autoportrait

92 **Self-Portrait**, c. 1921 ❏
Autoportrait – Autorretrato

93

94

93 **Back View of Cadaqués**, 1921 ❏
Cadaqués de dos

94 **View of Cadaqués from Mount Pani**, c. 1921 ❏
Vue de Cadaqués depuis le mont Pani

95 **Girls in a Garden (The Cousins)**, 1921 ❏
Jeunes filles dans un jardin

96 **Portrait of Grandmother Ana Sewing**, c. 1921 ❏
Portrait de la grand-mère Ana cousant

97 **The Bay at Cadaqués**, c. 1921 ❏
Baie de Cadaqués

95

96

97

1921

98 **Festival in Figueras**, 1921 ❏
Fête à Figueras

99 **Santa Creus Festival in Figueras
– The Circus**, 1921 Δ
Fête de la Santa Creus à Figueras – Le
cirque

100 **Festival at San Sebastián**, 1921 Δ
Fête de l'hermitage de San Sebastián

101 **The Picnic**, 1921 Δ
Merienda en el campo – Goûter à la
campagne

98

99

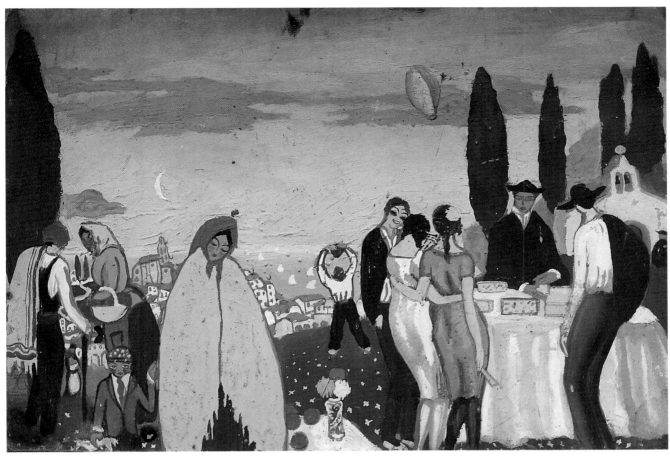

100

101

1921

102 **Man Holding up a Baby as though he Were Drinking from a Bottle**, c. 1921 △
Homme soulevant un bébé comme s'il buvait à la régalade

103 **Festival of St. Lucia at Villamalla**, 1921 △
Fête de sainte Lucie à Villamalla

104 **Nymphs in a Romantic Garden**, 1921 △
Nymphes dans un jardin romantique

105 **A Seated Man and a Dancing Couple**, 1921 △
Personnage assis avec au second plan un couple dansant

106 **Romería – Pilgrimage**, 1921 △
Romería – Pélerinage

107 **Man with Porrón**, 1921 △
L'homme au porrón

108 **Voyeur**, 1921 △
Voyeur

109 **Old Man of Port Dogué**, 1921 △
Le vieux de Port Dogué

110 **Muse of Cadaqués**, 1921 △
Musa de Cadaqués

102

103

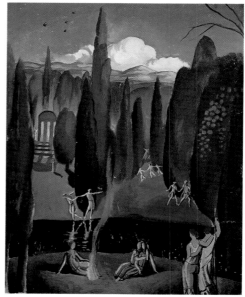

104

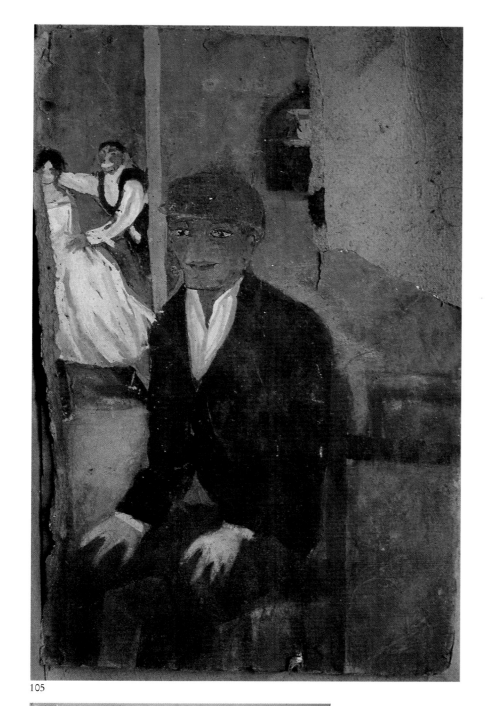

105

107

108

109

106

110

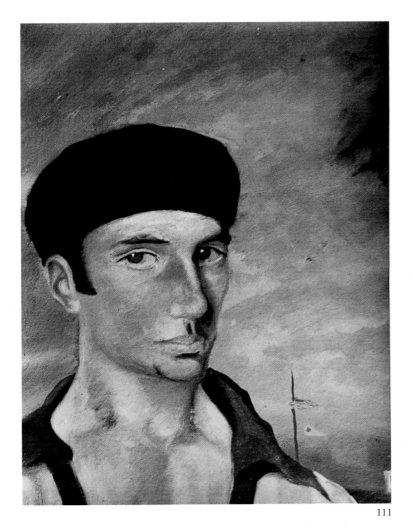

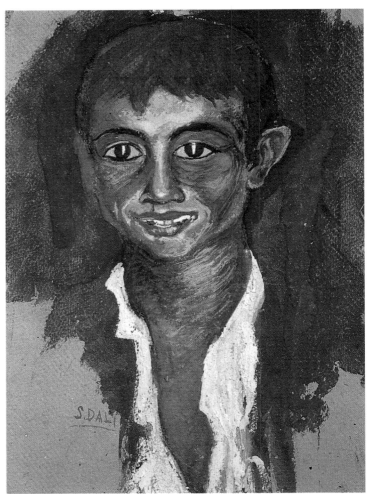

111

111 **Portrait of Jaume Miravitlles,**
1921–1922 ❏
Portrait de Jaume Miravitlles

112 **Head of a Gypsy,** 1919–1920 Δ
Tête de gitan – Cabeza de gitano

113 **Fishermen at Cadaqués,** 1922 ❏
Pêcheurs de Cadaqués

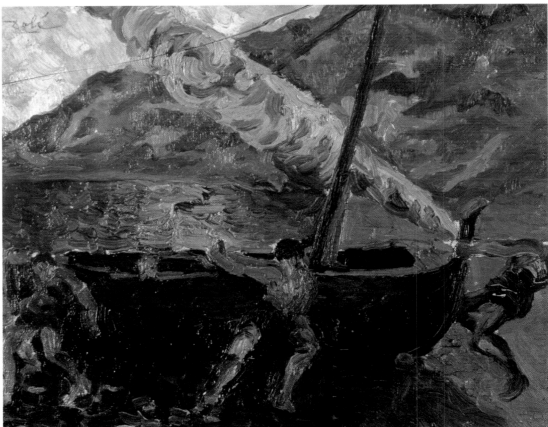

113

Parsifal: "My 'Parsifal' required that I make myself very handsome. I took a long shower, gave myself a very close shave, glued down my hair as much as possible, putting paint-varnish on it again! I knew the serious inconveniences of this, and even that it would spoil my hair a little, but my Parsifal was worth this sacrifice, and more! I applied powdered lead around my eyes; this made me look particularly devastating in the 'Argentine tango' manner. Rudolph Valentino seemed to me at that time to be the prototype of masculine beauty."

Gaolbird Salvador

Dalí was busy exploring his own potential. He had discovered Cubism, Futurism and Purism. He was familiar with the work of Picasso, Juan Gris, Severini, Morandi, de Chirico and Carrà; and his personal friends included Luis Buñuel and Federico Garcia Lorca. Lorca, the leading spirit of an avant-garde group and a brilliant young man, "darkened the virginal originality of [Dalí's] spirit". The Andalusian poked fun at the Catalonian's overdone classicism – but only until another fellow student, Pepin Bello, discovered Dalí's Cubist paintings in his studio. Dalí continued to paint portraits and landscapes, but he also spent a good deal of time in bars and night clubs with friends, tasting low and high life alike and rapidly grasping the power of snobbery.

Presently Dalí became involved, as he had at school, in a political controversy. Students at the Academy protested at the election of a professor they considered unfit for the position, and Dalí, who had played a key role in the creation of their mood, was suspended for a year. He returned to Figueras, where the Civil Guard promptly arrested him and put him in prison. It was a period of widespread revolutionary unrest in Spain; and Dalí was transferred to the prison at Gerona before finally being set free in the absence of adequate charges. "This period of

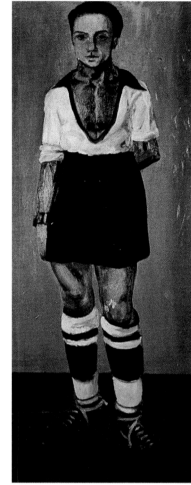

115

114 **Fishing Folk at Cadaqués,** 1922 ❏
Pescadores de Cadaqués – Pêcheurs de Cadaqués

115 **Portrait of Jaume Miravitlles as a Footballer,** 1921–1922 ❏
Portrait de Jaume Miravitlles en joueur de football

114

1922

117

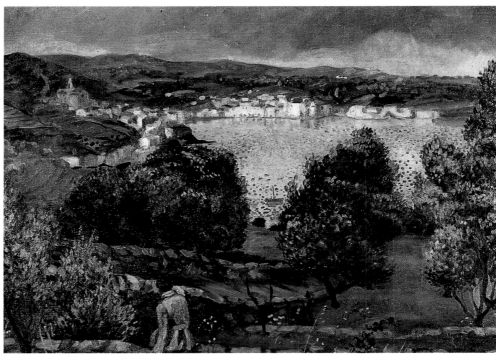

118

116 **Landscape – Cadaqués**, 1922 ❏
Paysage – Cadaqués

117 **The Lane to Port Lligat with
View of Cape Creus**, 1922-1923 ❏
Le chemin de Port Lligat avec vue sur
le Cap Creus

118 **Landscape near Cadaqués**,
1922 ❏
Paysage à Cadaqués

119 **Jug**, 1922–1923 ❏
Canti – Cruche

imprisonment," wrote Dalí, "pleased me immeasurably. I was naturally among the political prisoners, all of whose friends, co-religionists and relatives showered us with gifts. Every evening we drank very bad native champagne […] I was happy, for I had just rediscovered the landscape of the Ampurdán plain, and it was while looking at this landscape through the bars of the prison of Gerona that I came to realize that at last I had succeeded in aging a little. This was all I wished […] It was fine to feel a little older, and to be within a 'real prison' for the first time. And finally, as long as it lasted, it would be possible for me to let my mind relax." What Dalí did not mention in the *Secret Life* was that political motives connected with intrigues against his father were involved in his imprisonment. Be that as it may, after thirty-five days in prison, the youthful gaolbird was released, apparently delighted with everything. After all, could he not now claim the status of the politically persecuted?

Culinary Delirium

The most striking obsessions visible in Dalí's work from the very start were closely connected with his Catalonian background. The Catalonians are popularly said to believe only in things they can eat, smell, touch, hear or see. And Dalí himself repeatedly avowed, "I know what I'm eating. I don't know what I'm doing." In similar mood he liked to quote the comparison his fellow Catalonian, the philosopher Francesco Pujols, had made, between the spread of the Catholic church and the fattening of a pig for the slaughter and subsequent eating. Adapting the words of St. Augustine, Dalí furthermore remarked that "Christ is like cheese, or, to be more precise, like mountains of cheese." This obsession with food recurs in his paintings, in soft watch works such as *The Persistence of Memory* (p. 163), which originated in a dream of runny Camembert; in the many paintings of fried eggs (cf. pp. 183 to 185); and in *Anthropomorphic Bread* (p. 178). Dalí's still lifes of this period, the early 1920s, seem to anticipate the obsessional works to come. But, equally, if the *Secret Life* can be believed, his fixation on food was one that went back to childhood, and which had even led to his being banned

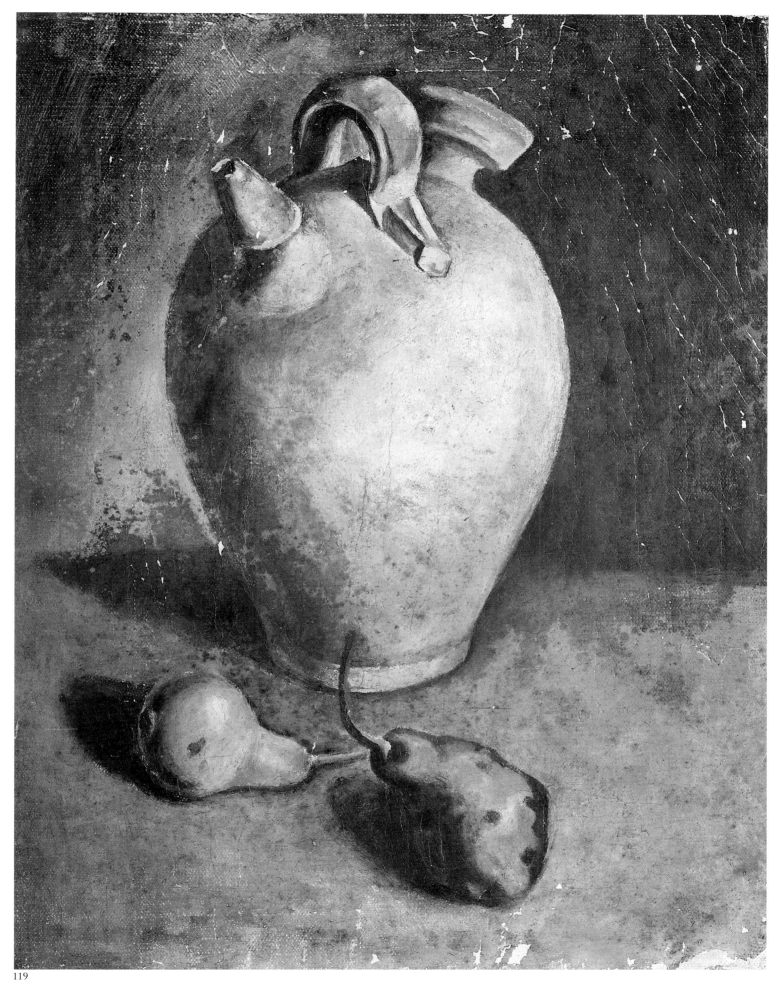

119

1922

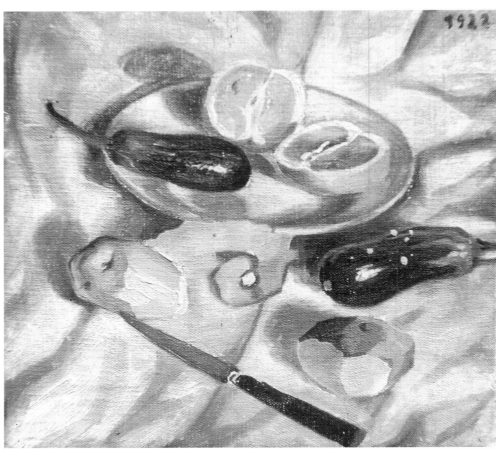

121

120 **Still Life**, 1922 ❏
Nature morte

121 **Still Life with Aubergines,**
1922 ❏
Nature morte aux aubergines

122 **Still Life**, 1922 ❏
Nature morte

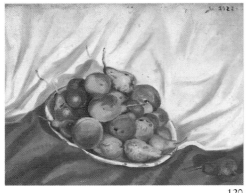

120

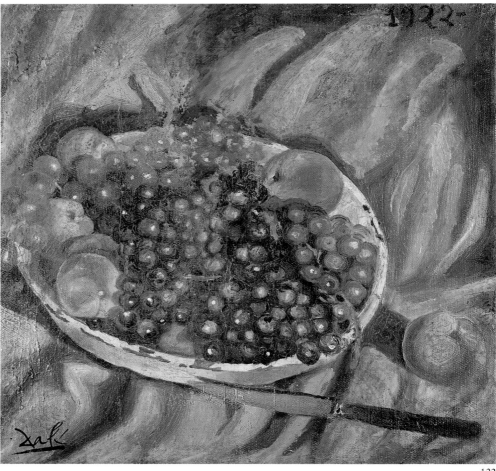

122

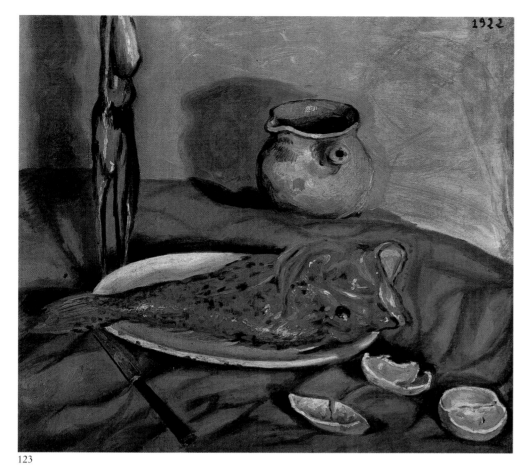

123

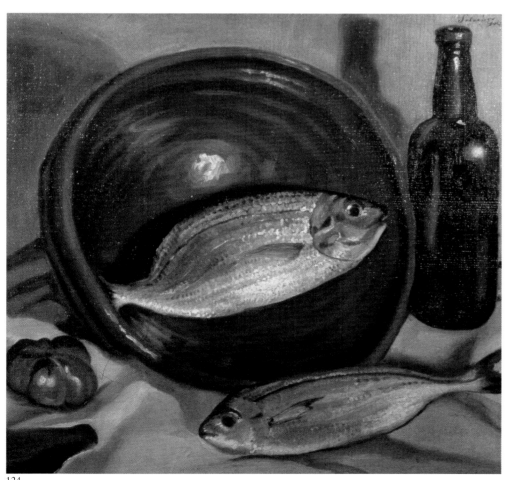

124

123 **Still Life – Pulpo y scorpa,** 1922 ❏
Pulpo y scorpa – Nature morte à la rascasse

124 **Still Life – Fish with Red Bowl,** 1922 ❏
Nature morte

125

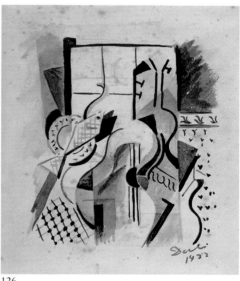

126

125 **Still Life – Fish,** 1922 ❏
Saupe – Saupa

126 **Cubist Composition – Still Life with Guitar,** 1922 Δ
Composition cubiste – Nature morte à la guitare

1922

127

128

129

130

131

127 **Untitled – Scene in a Cabaret in Madrid**, 1922 △
Sans titre – Scène de cabaret à Madrid

128 **Brothels**, 1922 △
Bordels

129 **Summer Night**, 1922 △
Nuit d'été

130 **Drinker**, 1922 △
Ivrogne

131 **Scene in a Cabaret**, 1922 ❏
Scène de cabaret

132 **Villa Pepita (before restoration)**, 1922 ❏

133 **Horse**, 1922 ❏
Caballo – Cheval

from the kitchen as a boy. "I would stand around for hours," he recalled, "my mouth watering, till I saw my chance to sneak into that place of enchantment; and while the maids stood by and screamed with delight I would snatch a piece of raw meat or a broiled mushroom on which I would nearly choke [...]" Dalí's culinary delirium, like so much else in his life, was always inseparable from sensual and erotic thrills. As he continues, in fact, he supplies us with an important key to the understanding of his mind and art: "Behind the partly open kitchen door I would hear the scurrying of those bestial women with red hands; I would catch glimpses of their heavy rumps and their hair straggling like manes; and out of the heat and confusion that rose from the conglomeration of sweaty women, scattered grapes, boiling oil, fur plucked from rabbits' armpits, scissors spattered with mayonnaise, kidneys, and the warble of canaries – out of that whole conglomeration the imponderable and inaugural fragrance of the forthcoming meal was wafted to me, mingled with a kind of acrid horse smell. The beaten white of egg, caught by a ray of sunlight cutting through a whirl of smoke and flies, glistened exactly like froth forming at the mouths of panting horses rolling in the dust and being bloodily whipped to bring them to their feet. As I said, I was a spoiled child."

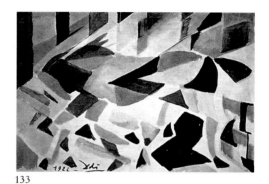

133

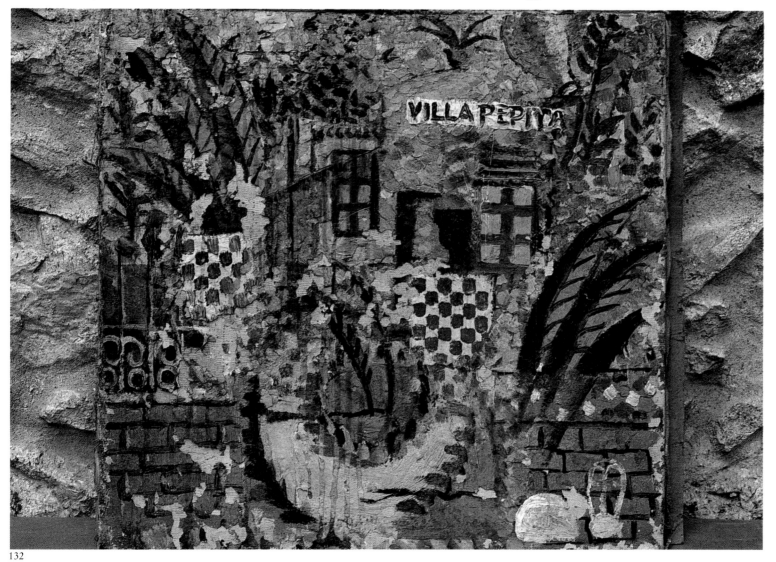

132

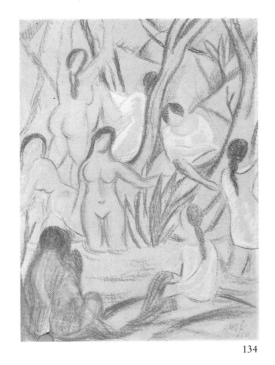

134

137

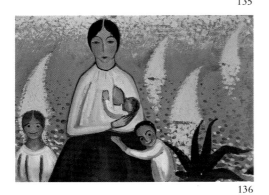

135

136

138

134 **Bathers**, 1918–1919 △
Baigneuses

135 **Seated Woman**, c. 1922 △
Femme assise

136 **Motherhood**, c. 1921 ❏
Maternité

137 **Untitled – Landscape near Madrid**, 1922–1923 ❏
Sans titre – Paysage à Madrid

138 **Madrid, Architecture and Poplars**, 1922 ❏
Madrid, architecture et peupliers

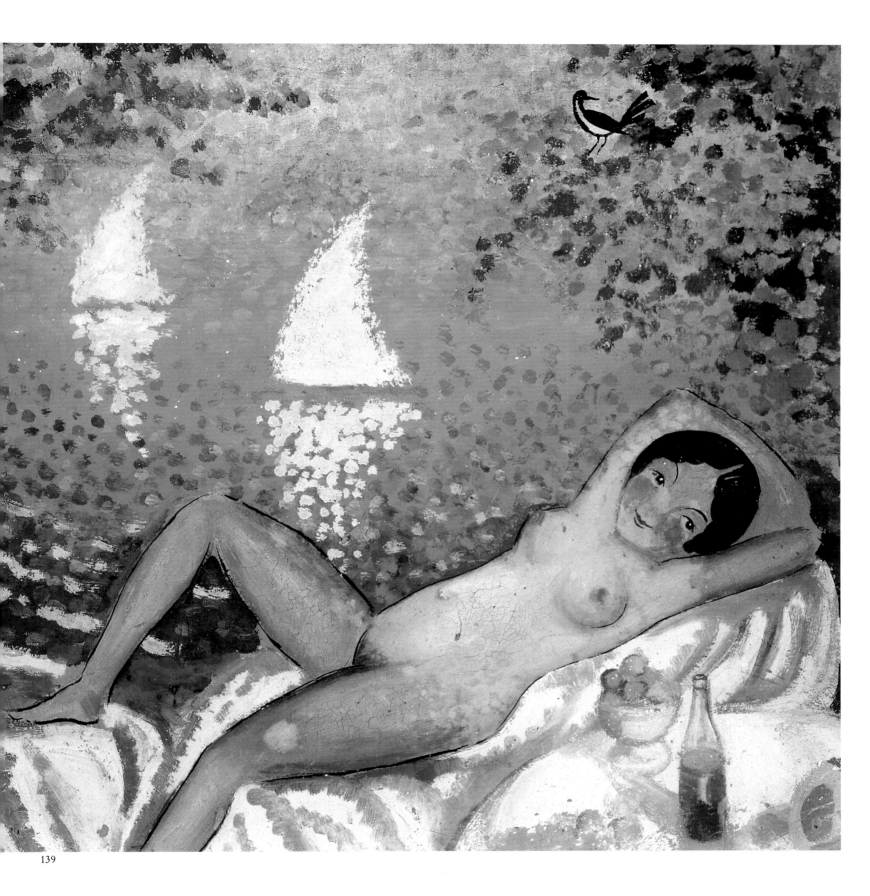

139

139 **Nude in a Landscape,**
1922–1923 ❏
Nu dans un paysage

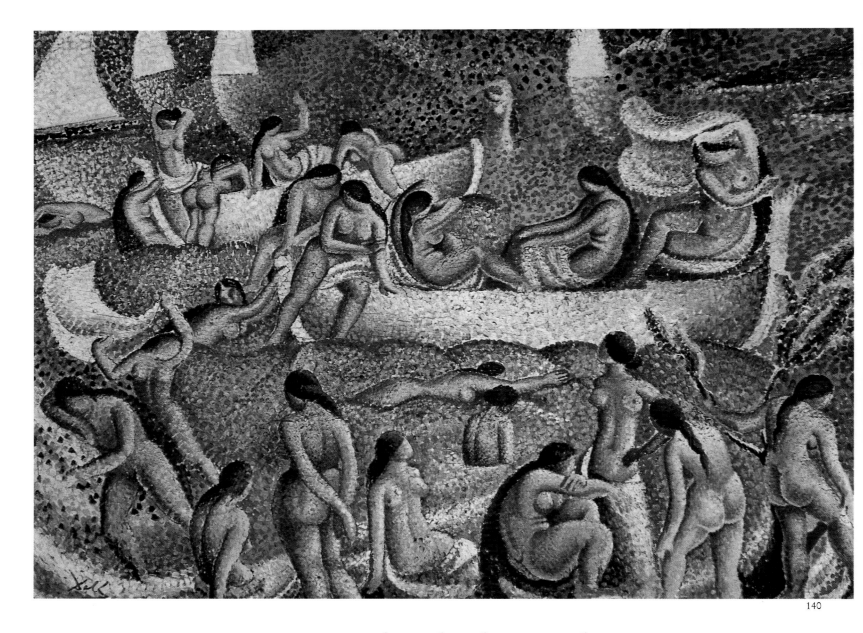

140

Work, Salvador, Work

Dalí continued his five finger exercises, coming to terms with the major aesthetic movements of the Modernist era, with the art of Seurat and Picasso, Matisse and Bonnard and Juan Gris, and many other contemporaries and mentors. His approach was imbued with his characteristic humour, though: playful, indeed mocking, he imitated and burlesqued Picasso, Matisse, himself. Above all, he worked constantly. Dalí told the story that, even before he went to the Academy, he used to go walking with a girl to whom he showed off with copies of *L'Esprit Nouveau*, a magazine edited by Le Corbusier and Fernand Léger: "she would humbly bow her forehead in an attentive attitude over the Cubist paintings. At this period I had a passion for what I called Juan Gris' 'Categorical imperative of mysticism'. I remember often speaking to my mistress in enigmatic pronouncements, such as, 'Glory is a shiny, pointed, cutting thing, like an open pair of scissors'. She would drink in all my words without understanding them, trying to remember them." This girl brought out the cruelty in Dalí, that cruelty which

140 **Bathers of the Costa Brava – Bathers of Llané**, 1923 ❏
Baigneuses de la Costa Brava – Baigneuses de Llané

141 **The Sick Child – Self-Portrait in Cadaqués**, c. 1923 ❏
L'enfant malade – Autoportrait à Cadaqués

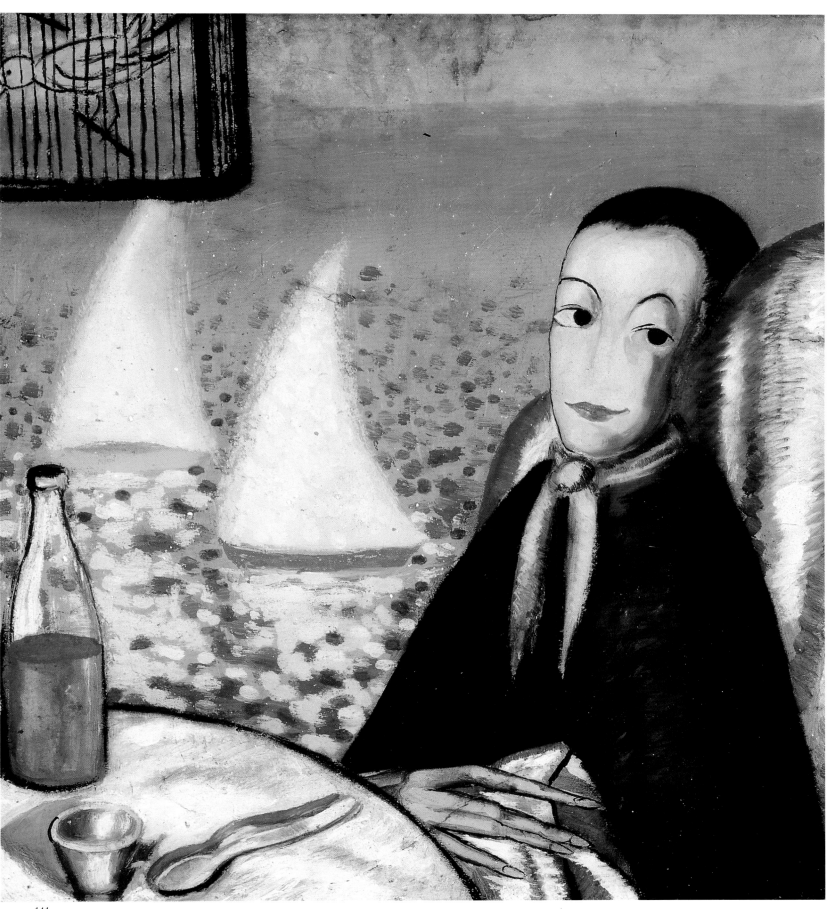

141

1923

so repelled George Orwell when he reviewed the *Secret Life*: when Dalí commanded the girl to show him her breasts, and she did, he promptly announced that when he went to Madrid he would never write to her again, and rejoiced in the girl's tears. "Work, Salvador, work," he told himself; "for if you were endowed for cruelty, you were also endowed for work."

The obsessive dedication to his work, which had caused Dalí's parents to worry that he was not living his youth to the full, remained with him at the Academy, where he pursued every ism with the thoroughness that lay in his nature. One day, he recalled, he took in a monograph on Georges Braque, to show his fellow students. "No one had ever seen Cubist paintings, and not a single one of my classmates envisaged the possibility of taking that kind of painting seriously. The professor of anatomy, who was much more given to the discipline of scientific methods, heard mention of the book in question, and asked me for it. He confessed that he had never seen paintings of this kind, but he said that one must respect everything one does not understand. Since this has been published in a book, it means that there is something to it. The following morning he had read the preface, and had understood it pretty well; he quoted to me several types of non-figurative and eminently geometrical representations in the past. I

142

143

145

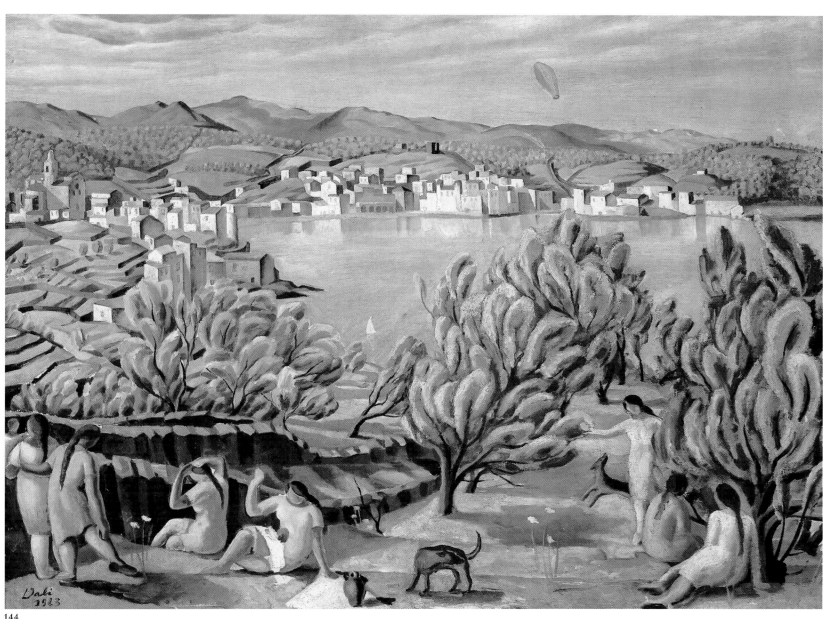

144

146

147

146 La Jorneta, 1923 ❏
La Jorneta

**147 Cadaqués (Seen from the Tower
at Cape Creus)**, 1923 ❏
Cadaqués vu depuis la tour de Cap
Creus

told him that this was not exactly the idea, for in Cubism there was a very manifest element of representation. The professor spoke to the other professors and all of them began to look upon me as a supernatural being."

Dalí's unflappable confidence in his own superior understanding made him contemptuous of his tutors and fellow students. He felt he was "the only painter in Madrid to understand and execute Cubist paintings", that he had already outstripped the others: "The students thought me reactionary, an enemy of progress and of liberty. They called themselves revolutionaries and innovators, because they were allowed to paint as they pleased, and because they had just eliminated black from their palettes, calling it dirt, and replacing it with purple! Their most recent discovery was this: everything is made iridescent by light – no black; shadows are purple. This revolution of Impressionism was one which I had gone through at the age of twelve, and even at that time I had not committed the elementary error of suppressing black from my palette. A single glance at a small Renoir which I had seen in Barcelona would have been ample for me to understand all this in a second. They would mark time in their dirty, ill digested rainbows for years and years. My God, how stupid people can be!"

Contemptuous though he was, Dalí had the application of the true artist; and his early work is not to be despised, even if it remains true that the greatness of the mature Dalí was a product of 1929. Dalí had begun to paint (and behave) as a Surrealist even before 1929. Guillermo de Torre, who got to know Dalí in a student residence in Madrid in 1923, wrote in the Madrid periodical *Arte* in 1933: "His adventurous mind and hunger for discovery took him within five years, between adolescence and the full bloom of youth, through vast areas of the visual arts, different not only in their tendencies but indeed in their very natures." Later the same year, he added: "The path Dalí took, new and unique as it was, none-

148

148 **The Windmill – Landscape near Cadaqués**, 1923 ❑
El Moli – Paysage de Cadaqués

149 **Figures in a Landscape at Ampurdán**, 1923 △
Personnages dans un paysage d'Ampurdán

150 **Untitled – Group of Women**, 1923 △
Sans titre – Personnages dans un paysage

151 **Cottages**, 1923 △
Bicoques

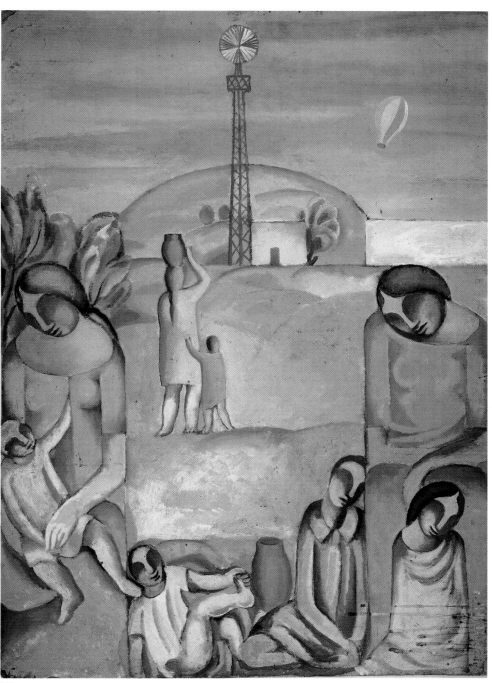

149

150

151

1923

152

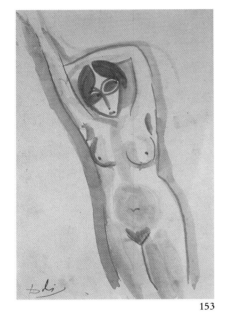

153

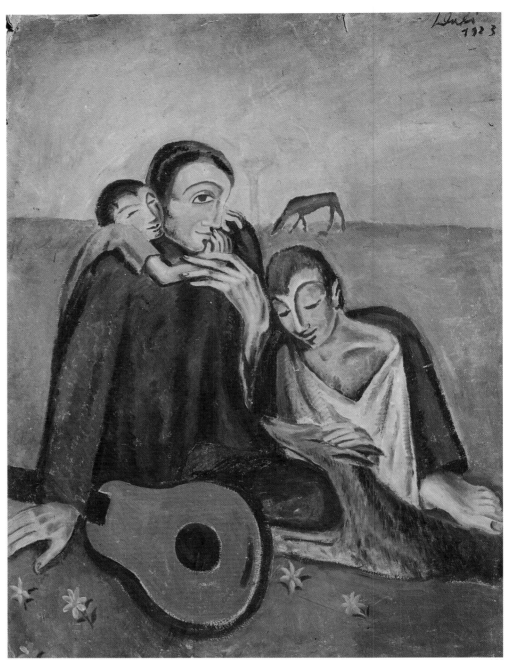

155

154

156

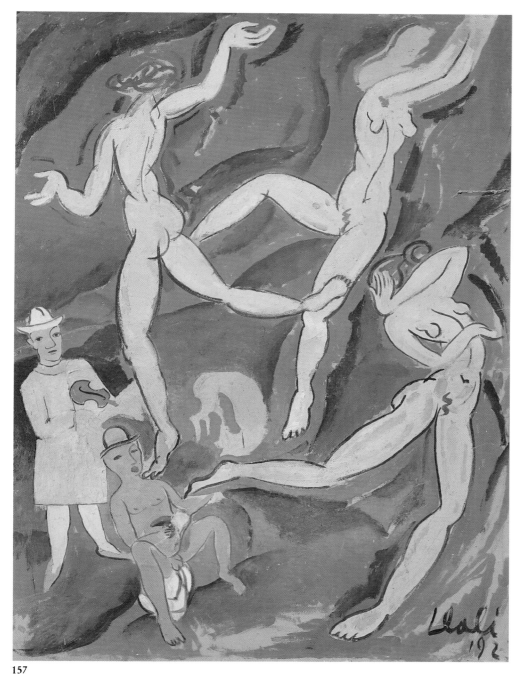

152 **Head of a Man with a Child,**
1924–1925 △
Tête d'homme avec enfant

153 **Venus and Memory of Avino,**
1923–1924 △
Vénus et réminiscences d'Avino

154 **Luis Buñuel with a Toreador,**
1923 △
Luis Buñuel avec un torero

155 **Family Scene,** 1923 ❑
Scène familiale

156 **Woman Nursing her Son,**
1923 ❑
Femme allaitant son fils

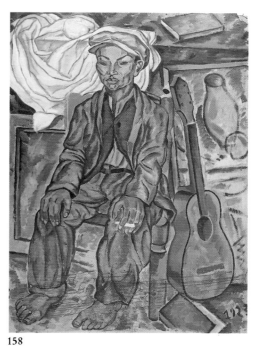

157

158

theless was implied in what went before, and was not so utterly unpredictable. In him, even more than in his pictures, there is an instinctual force, a leaning to emotionalism, an uninhibited predilection for all things mysterious and adventurous, all so deep-rooted in him that he was inevitably predestined for the awe-inspiring, imaginative fragmentation that Surrealism stands for. His rebellious spirit led him to force open the door to an unforeseen dimension, nor did he flinch from plunging headfirst into the Freudian realm of the dream." De Torre added: "In order to put this matter to the test, Salvador Dalí was willing to dispense with delicate brushwork and his customary virtuosity. Or rather, he grasped how to adapt them to the new structure and meaning of his pictures."

Venus was early established as one of Dalí's favourite subjects, culminating in the 1936 *Venus de Milo with Drawers* (p.279). It was Venus he saw on the beach at El Llané when the bashful girls and strapping madams stripped before his hungering eyes, exposing flesh that was normally kept from sight. It was Venus he took apart and re-assembled in his carefully observed early paintings of women, in which the goddess is generally seen from the rear. He painted women

157 **Satirical Composition ("The Dance" by Matisse),** 1923 △
Composition satirique

158 **Gypsy of Figueras,** 1923 ❑
Gitan de Figueras

in the style of Seurat, Picasso or Matisse; he painted them in his Cubist phase, in classical mood, in pre-Surrealist manner, and on, till the time came when his Venus invariably bore the features of Gala. Still a student, he painted *Bathers of the Costa Brava – Bathers of Llané* (p.62), a vision of twenty-four girls – or, to be more precise, of the same girl in twenty-four different positions. It was the Wagnerian dream vision of Dalí as Parsifal, a vision of physical opulence in which even the coils of thick glossy hair have the sensual fullness of breasts and buttocks. Sailboats are out on the Pointillist sea; the waves lap with carefree abandon; all things conduce to the pleasuring dance of naked bodies. The painting is a cocktail of Picasso and Matisse, with a dash of Seurat.

It is worth noting that Dalí's eye lingers over the derrière, and in his art he returns time and again to the rear view. In his sister, and Gala, and women in general, it is the posterior that interests him most. As Luis Romero has observed: "He painted a vast array of derrières, in the most various of positions, of every shape and size and significance. Men's behinds, women's behinds, behinds of indeterminate sex, angelic behinds, shapeless behinds, a resplendent array of chaste or lascivious bottoms, expressionist or harmonic or demure, even strangely reduplicated, abstract bottoms with four cheeks. The hind parts of his horses, too; the shape and colour of certain fruits; and other things, all come in eloquent, anthropomorphic forms. One might well see Salvador Dalí as the first painter of behinds in the history of art, and in the history of the human derrière."

Until Gala entered his life, Dalí was clearly afraid of young women, with the fear of fascination. In his *Secret Life* he recalls (doubtless with the aid of fantasy) a scene at Cambrils when he was five years old and out walking with "three very beautiful grown women" – one of them, who wore a veil, "miraculously beautiful". At a deserted spot, the women began to titter and whisper, and urged the boy to run off and play – he did, "but only to find a point of vantage from which

159 **Grandfather Clock**, 1923 △
El rellotge de caixa – L'horloge

160 **Cubist Composition – Portrait of a Seated Person Holding a Letter**, 1923 ❏
Composition cubiste – Portrait d'un personnage assis tenant une lettre

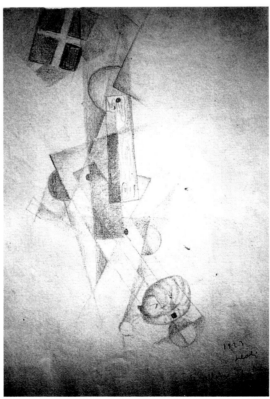

159

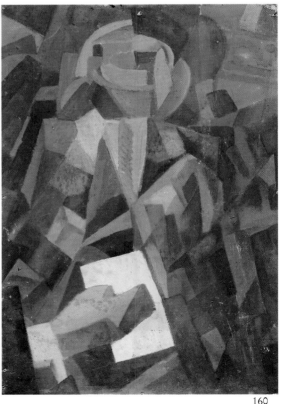

160

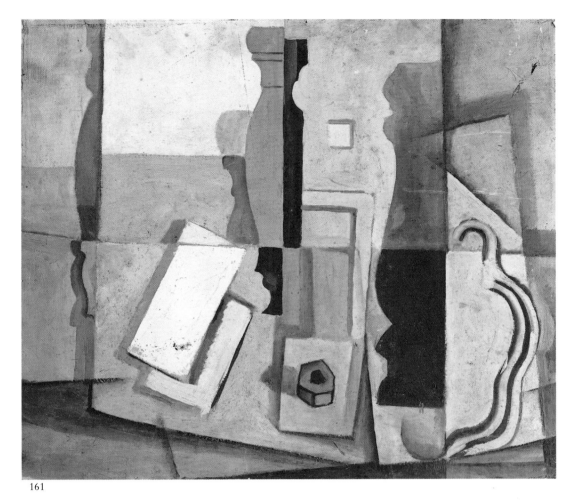

161

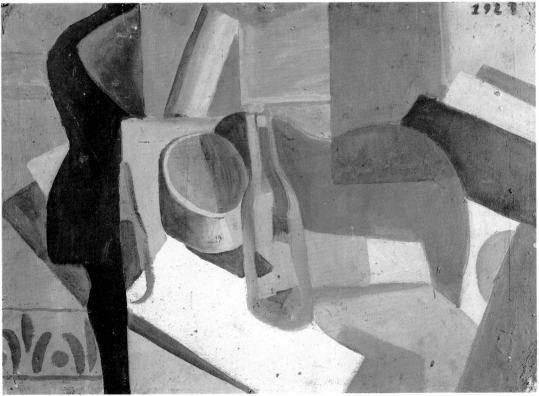

162

161 **Still Life**, 1923 ❑
Nature morte

162 **Still Life**, 1923 ❑
Nature morte

163 **All Shapes Derive from the
Square**, 1923 Δ
Toutes les formes dérivent du carré

164 **Harlequin Sitting at a Table,**
1923 Δ
Arlequin assis à une table

163

164

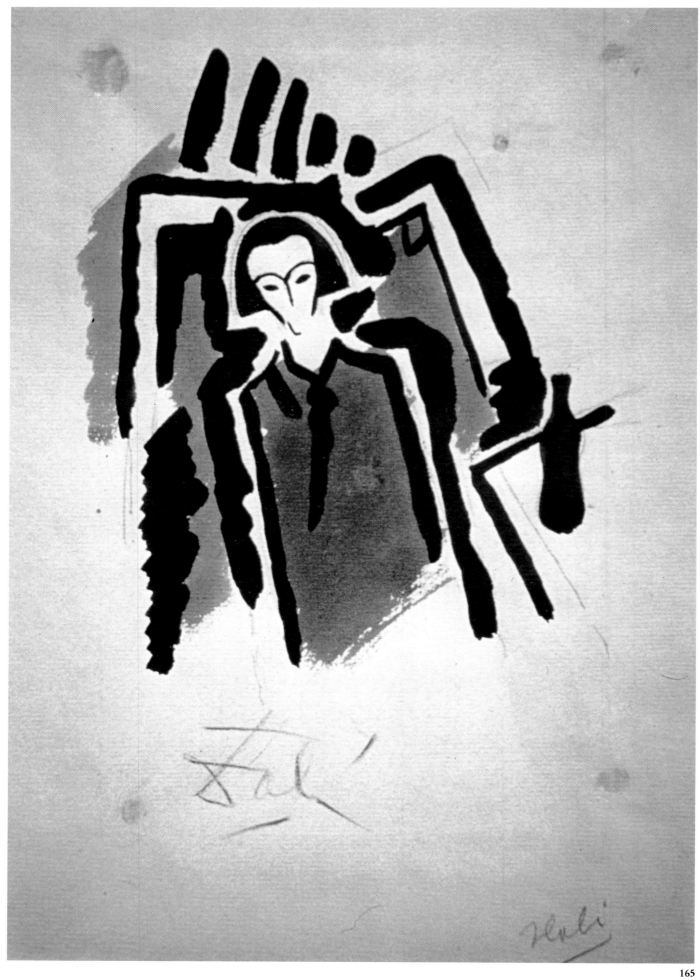

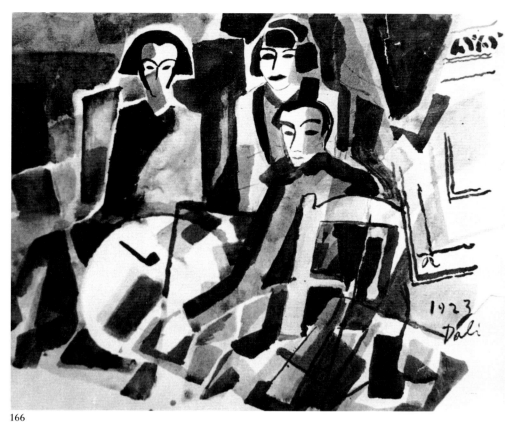

166

165 **Self-Portrait**, 1923 Δ
Autoportrait

166 **Coffee House Scene in Madrid,**
1923 Δ
Scène de café à Madrid

167 **Dalí (below, middle) at the San
Fernando Academy of Art, Madrid,
in the academic year 1922–1923. He
was finally sent down in October
1926.** ✰

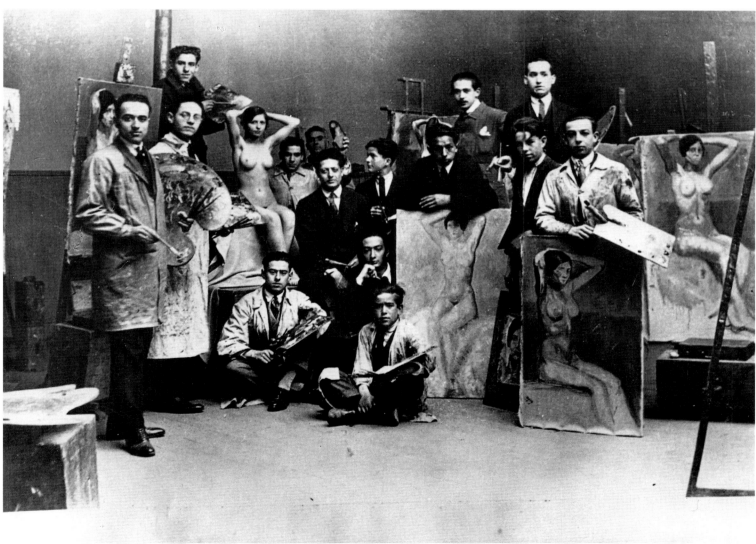

167

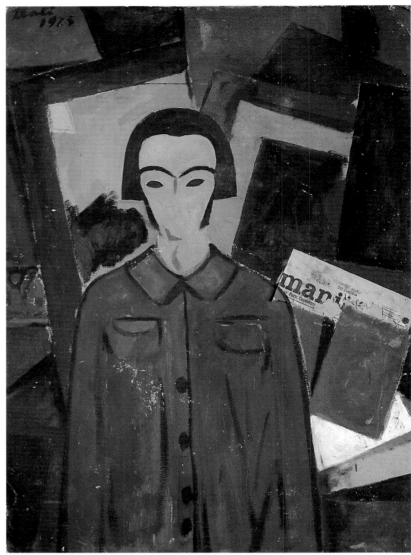

168

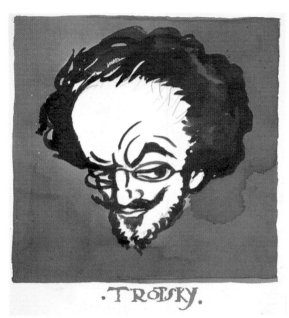

168

168 **Satirical Portrait of Trotsky,**
c. 1923 △
Portrait satirique de Trotsky

169 **Self-Portrait,** 1923 ❏
Autoportrait à «L'Humanité»

170 **Cubist Self-Portrait,** 1923 △
Autoportrait cubiste

169

to spy on them". Dalí reports: "The most beautiful one was in the center, silently observed from a distance of a few feet by the other two. With a strange look of pride, her head slightly lowered, her legs very rigid and outspread, her hands by her hips delicately and imperceptibly she raised her skirt, and her immobility seemed to convey the expectation of something that was about to happen. A stifling silence reigned for half a minute, when suddenly I heard the sound of a strong liquid jet striking the ground and immediately a foaming puddle formed between her feet. The liquid was partially absorbed by the parched earth, the rest spreading in the form of tiny snakes that multiplied so fast that her white-colored shoes did not escape them in spite of her attempts to extend her feet beyond their reach. A grayish stain of moisture rose and spread on the two shoes, the whiting acting as blotting paper. Intent on what she was doing, the 'woman with the veil' did not notice my paralyzed attention. When she raised her head and found herself looking right into my face she tossed me a mocking smile and a look of unforgettable sweetness, which appeared infinitely troubling, seen through the purity of her veil. Almost at the same moment she cast a glance at her two friends with an expression that seemed to say: 'I can't stop now, it's too late.' Behind me the two friends burst out laughing, and again there was silence. This time I immediately understood, and my heart beat violently." This scene is followed by the notorious one in which Dalí bites into a wounded bat crawling with ants – as a kind of vengeance directed at the woman in the veil, whom he by some obscure childish logic blames for the bat's condition.

170

The instinctual force and adventurousness attested by De Torre, the sensual preoccupations, the quirkiness and perversity, can all arguably be traced to the confusions and psychological turmoil of Dalí's childhood, then. What this implies is that we must make a tolerant effort of understanding – and must also be prepared to find that even the weirdest elements of Dalí's art have an origin in real, uninvented fact. Dalí tended merely to translate or metamorphose what memory furnished forth. His art and life alike seethe with displacement: in his behaviour to the young woman who showed him her breasts, for instance, we see that cruelty that Freud considered an inseparable component of the sex drive. He kept this woman at his beck and call, but without sexual intimacy, for five years (his "five-year plan", as he called it), in order to savour all the variations on "sentimental perversity". He would arouse her but deny her any fulfilment, driving her to the brink of breakdown in the process: "Unconsummated love has appeared to me since this experience to be one of the most hallucinatory themes of sentimental mythology. Tristan and Isolde are the prototypes of one of those

171 **Portrait of my Sister and Picasso Figure (added in 1924),** 1923 ❏
Portrait de ma sœur et personnage picassien

171

76

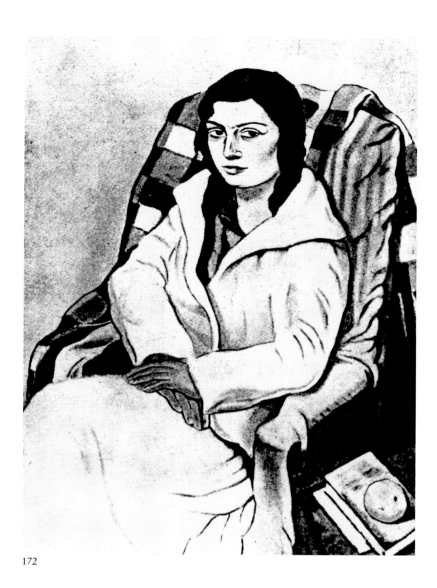

172

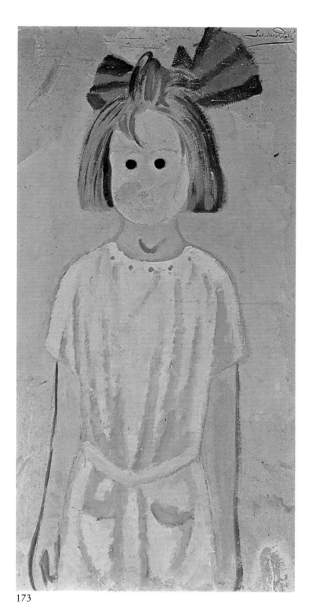

173

172 Portrait of my Sister (original state), 1923–1924 ❏
Retrato de mi hermana

173 Portrait of my Cousin Ana María Domenech, c. 1923 ❏
Ana María Domenech

tragedies of unconsummated love which in the realm of the sentiments are as ferociously cannibalistic as that of the praying mantis actually devouring its male on their wedding day, during the very act of love." Thus the author of the *Secret Life*. "'Show them to me,' I said. She undid her blouse and showed them to me. They were incomparably beautiful and white; their tips looked exactly like raspberries; like them they had a few infinitely fine and minute hairs. [...] Finally I said, 'Come on.' She buttoned up her blouse again and got up, smiling feebly. I took her tenderly by the hand and began the walk home. 'You know,' I said, 'when I go to Madrid I won't ever write to you again.' And I walked on another ten steps. I knew that this was exactly the length of time it would take for her to start crying. I was not mistaken. I then kissed her passionately, feeling my cheek burn with her boiling tears, big as hazelnuts." George Orwell, shocked like many by the ethical dereliction of passages such as this, tried in his essay "Benefit of Clergy" to relate the moral delinquencies of Dalí to the premises underlying his art, and fastened on ambition as the key: "And suppose that you have nothing in you except your egoism and a dexterity that goes no higher than the elbow; suppose that your real gift is for a detailed, academic, representational style of drawing, your real *métier* to be an illustrator of scientific text-books. How then do you become Napoleon? There is always one escape: *into wickedness.* Always do the thing that will shock and wound people. At five, throw a little boy off a bridge, strike an old doctor across the face with a whip and break his spectacles – or, at any rate, dream about doing such things. Twenty years later, gouge the eyes out of dead donkeys with a pair of scissors. Along those lines you can always feel yourself original. And, after all, it pays!"

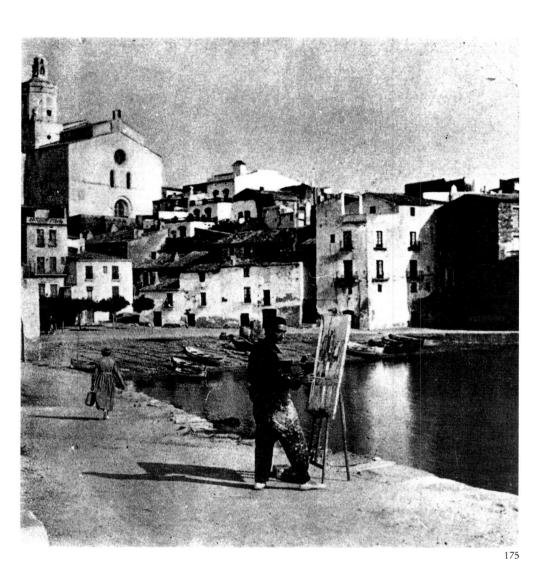

175

174

Salvador Dalí y Domenech, Apprentice Painter

Whatever one's position on Dalí's conduct, the fact remains that even before he entered the Academy in Madrid he was so industrious a worker that his father, compelled to respect his son's efforts, started to paste material relating to his son in a scrapbook. Dalí senior even wrote a preface, presumably for the benefit of posterity, under the title *Salvador Dalí y Domenech, Apprentice Painter*:

"After twenty-one years of cares, anxieties and great efforts I am at last able to see my son almost in a position to face life's necessities and to provide for himself. […] We, his parents, did not wish our son to dedicate himself to art, a calling for which he seems to have shown great aptitude since his childhood. […] We knew the bitterness, the sorrows and the despair of those who fail. […] We did all we could to urge our son to exercise a liberal, scientific or even literary profession. At the moment when our son finished his baccalaureate studies, we were already convinced of the futility of turning him to any other profession than that of a painter, the only one which he has genuinely and steadfastly felt to be his vocation. I do not believe that I have the right to oppose such a decided vocation, especially as it was necessary to take into consideration that my boy would have wasted his time in any other discipline or study, because of the 'intellectual laziness' from which he suffered as soon as he was drawn out of the circle of his predilections. When this point was reached, I proposed to my son a compromise:

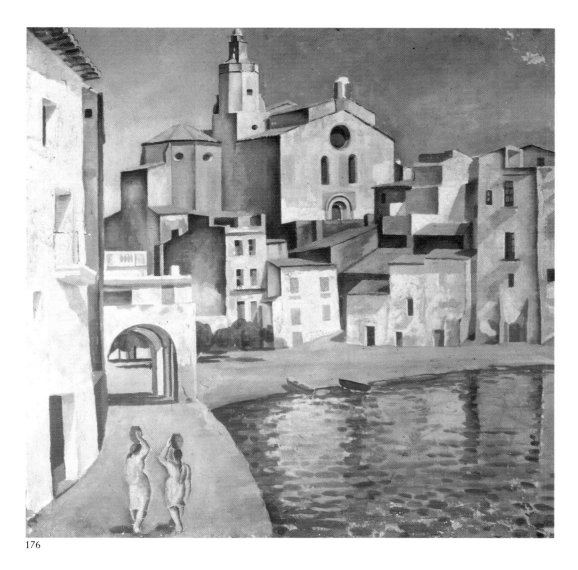

176

174 Dalí's student identity card at
the Madrid Academy for the year
1924-1925 ✩

175 Salvador Dalí painting "Port
Alguer" 1924 ✩

176 **Port Alguer, Cadaqués,** 1924 ❏
Port Alguer

177 **The Station at Figueras,** 1924 ❏
La station de Figueras

177

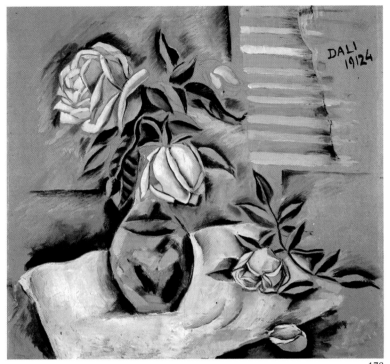

178

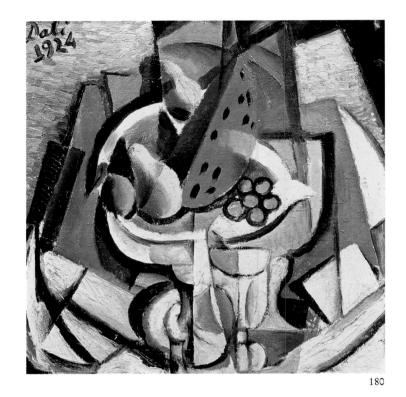

180

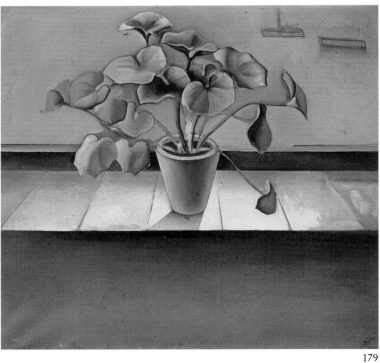

179

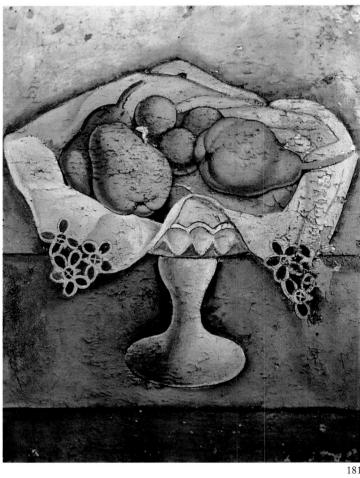

181

178 **Bouquet of Flowers – "The important thing is the rose"**, 1924 ❏
Bouquet – L'important c'est la rose

179 **Plant**, 1924 ❏
Plante verte

180 **Still Life – Watermelon**, 1924 ❏
Nature morte – Sandia

181 **Still Life**, 1924 ❏
Bodegón – Nature morte

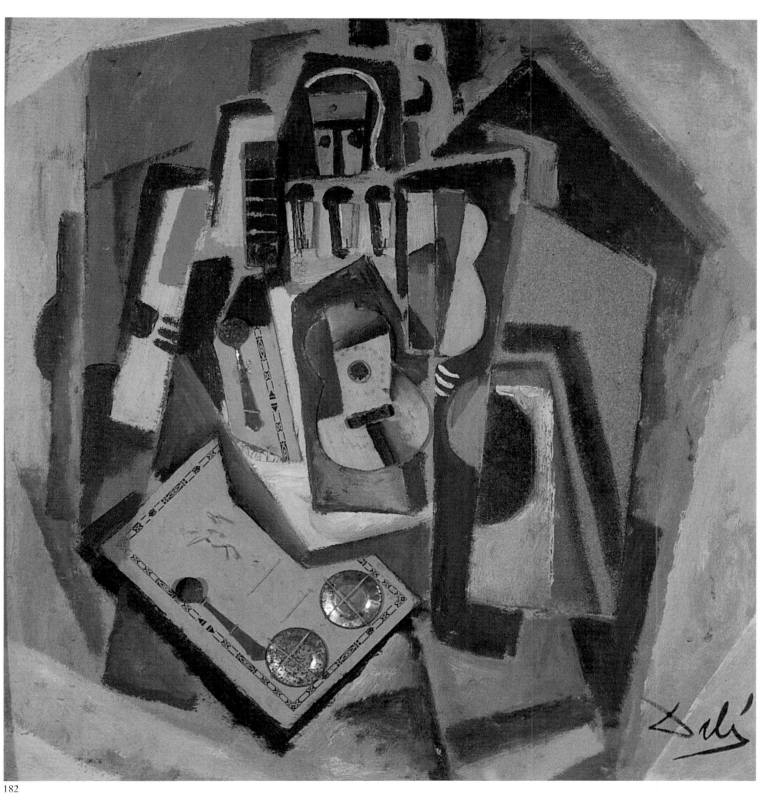

182

182 Pierrot and Guitar, 1924 ❑
Pierrot au guitare

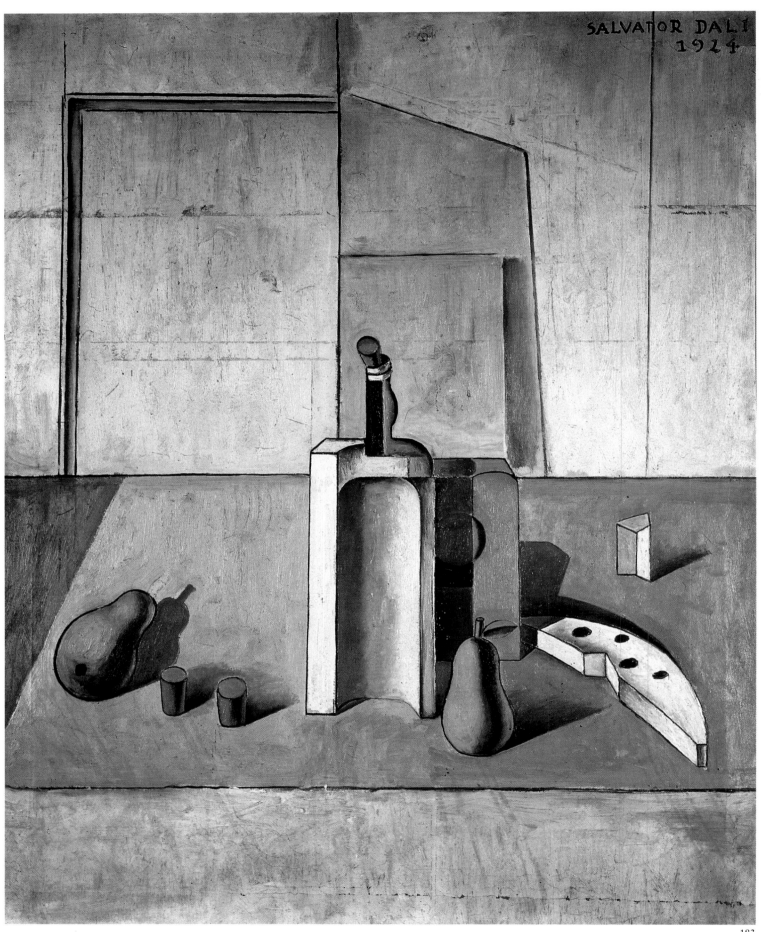

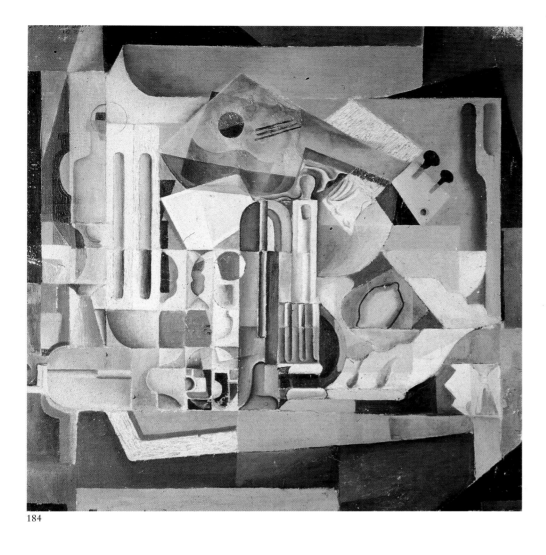

184

183 **Still Life**, 1924 ❑
Nature morte

184 **Purist Still Life**, 1924 ❑
Nature morte puriste

185 **Still Life (one part of the four into which the work was cut)**, 1924 ❑
Nature morte

186 **Siphon and Rum Bottle with Cork**, 1924 ❑
Siphon et bouteille de rhum avec bouchon

185

186

that he should attend the school of painting, sculpture and engraving in Madrid, that he should take all the courses that would be necessary for him to obtain the official title of professor of art, and that once he had completed his studies he should take the competitive examination in order to be able to use his title of professor in an official pedagogical center, thus securing an income that would provide him with all the indispensable necessities of life and at the same time permit him to devote himself to art as much as he liked during the free hours which his teaching duties left him. [...] This is the point we have now reached! I have kept my word, making assurance for my son that he shall not lack anything that might be needed for his artistic and professional education. The effort which this has implied for me is very great, if it is considered that I do not possess a personal fortune, either great or small, and that I have to meet all obligations with the sole honorable and honest gain of my profession, which is that of a notary, and that this gain, like that of all notaryships in Figueras, is a modest one. For the moment my son continues to perform his duties in school, meeting a few obstacles for which I hold the pupil less responsible than the detestable disorganization of our centers of culture. But the official progress of his work is good. My son has already finished two complete courses and won two prizes, one in the history of art and the other in 'general apprenticeship in color painting'. I say his 'official work', for the boy might do better than he does as a 'student of the school', but the passion which he feels for painting distracts him from his official studies more than it should. He spends most of his hours in painting pictures on

1924

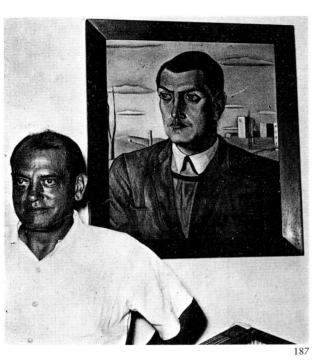

187

his own which he sends to expositions after careful selection. The success he has won by his paintings is much greater than I myself could ever have believed possible. But, as I have already mentioned, I should prefer such success to come later, after he had finished his studies and found a position as a professor. For then there would no longer be any danger that my son's promise would not be fulfilled. In spite of all that I have said, I should not be telling the truth if I were to deny that my son's present successes please me, for if it should happen that my son would not be able to win an appointment to a professorship, I am told that the artistic orientation he is following is not completely erroneous, and that however badly all this should turn out, whatever else he might take up would definitely be an even greater disaster, since my son has a gift for painting, and only for painting.

Figueras, December 31, 1925
Salvador Dalí, Notary."

In February 1922, Dalí exhibited at a group show at Dalmau's Gallery in Barcelona; the eight paintings he had in the show were especially praised by reviewers. In 1923 he exhibited at the Figueras municipal library, and in June 1925 exhibited the portrait of Buñuel, and *Siphon and Rum Bottle with Cork* (p. 83),

188

187 Luis Buñuel in front of Dalí's portrait of him, 1924 ☆

188 Study for "Manuel de Falla", 1924–1925 △

189 Bather (Juan Xirau), 1924 ❑
Bañista – Baigneur (Portrait de Juan Xirau)

190 Portrait of Luis Buñuel, 1924 ❑
Portrait de Luis Buñuel

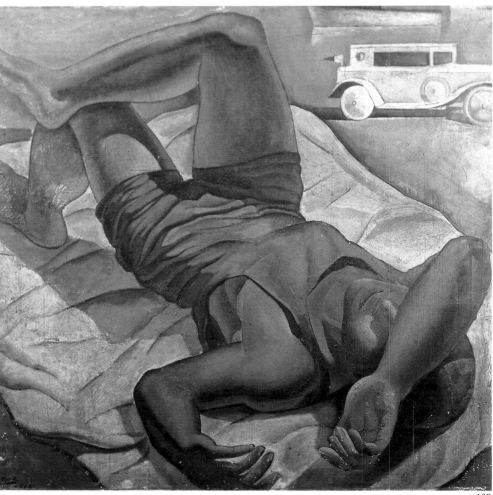

189

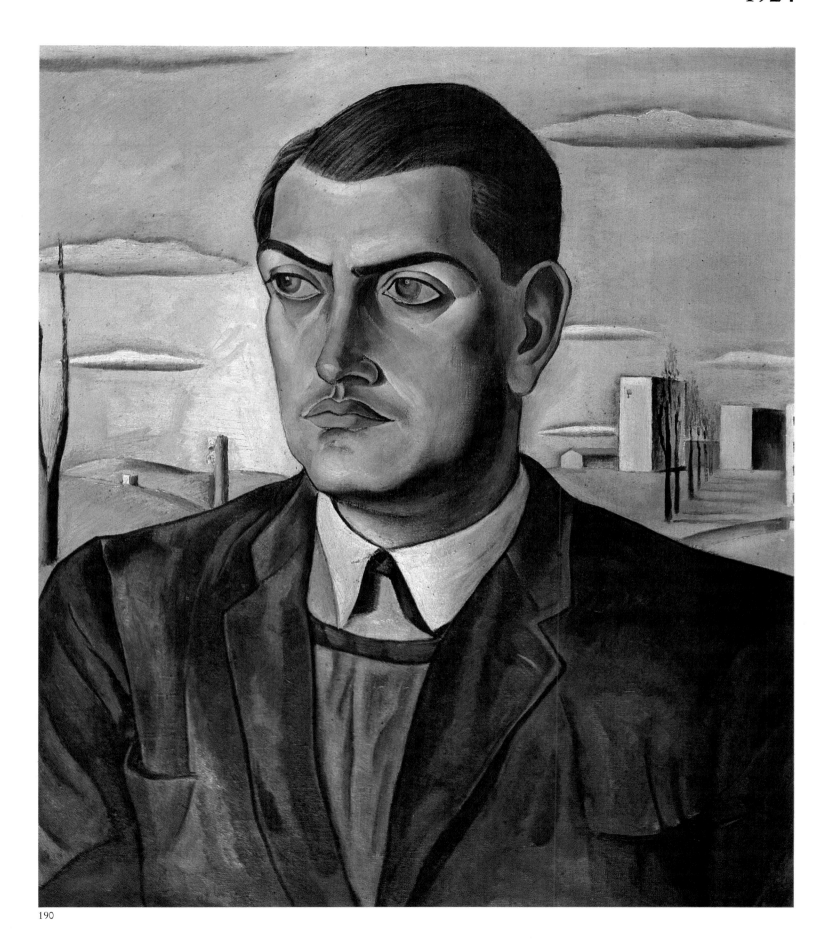

190

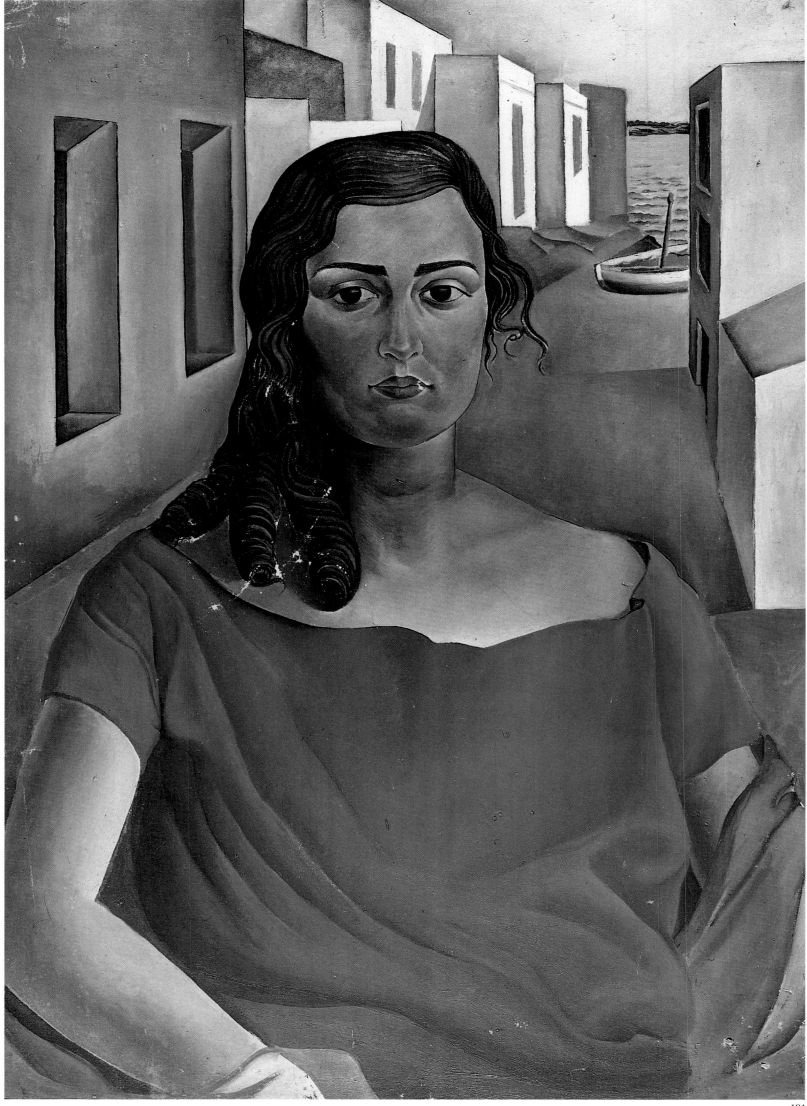

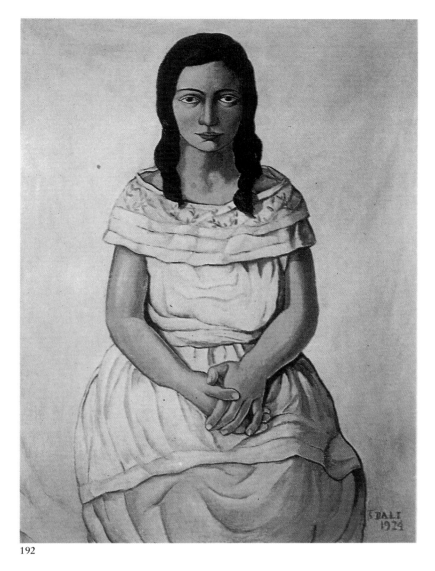

192

194

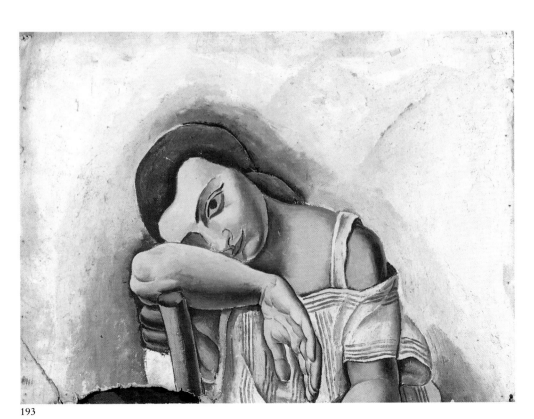

193

191 **Portrait of a Girl in a Land-scape (Cadaqués)**, 1924–1926 ❏
Portrait de jeune fille dans un paysage de Cadaqués

192 **Portrait of Ana María**, 1924 ❏
Ana María

193 **Portrait of Ana María**, c. 1924 ❏
Portrait d'Ana María

194 **Portrait of a Woman**, c. 1924 ❏
Portrait de femme

1925

in Madrid. Finally, from 14 to 27 November 1925, he had his first solo show at Dalmau's in Barcelona. It included one painting done in 1917 (*Landscape near Cadaqués*, p.111); two 1924 still lifes (in Cubist style); and fourteen pictures painted in 1925, among them the *Portrait of my Father* (p.93), two portraits of his cousin Montserrat, and the famous *Venus and a Sailor* (p.101). In January 1926, the magazine *Gaseta de les Arts* ran a lengthy article on him, while another appeared in *D'ací, d'allá*. His father duly clipped the articles and pasted them into the scrapbook recording the doings of the apprentice painter.

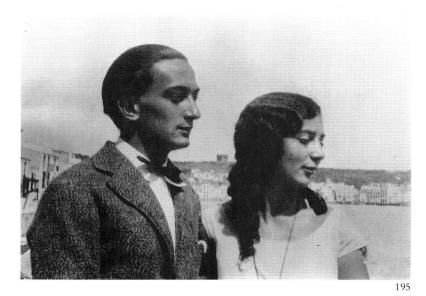

195

195 **Dalí with his sister Ana María in Cadaqués**, 1925–1926 ☆

196 **Girl Resting on her Elbow – Ana María Dalí, the Artist's Sister**, 1925 ❏
Jeune fille accoudée – Ana María, la sœur de l'artiste

197 **Portrait of the Artist's Sister**, 1925 ❏
Portrait de la sœur de l'artiste

196

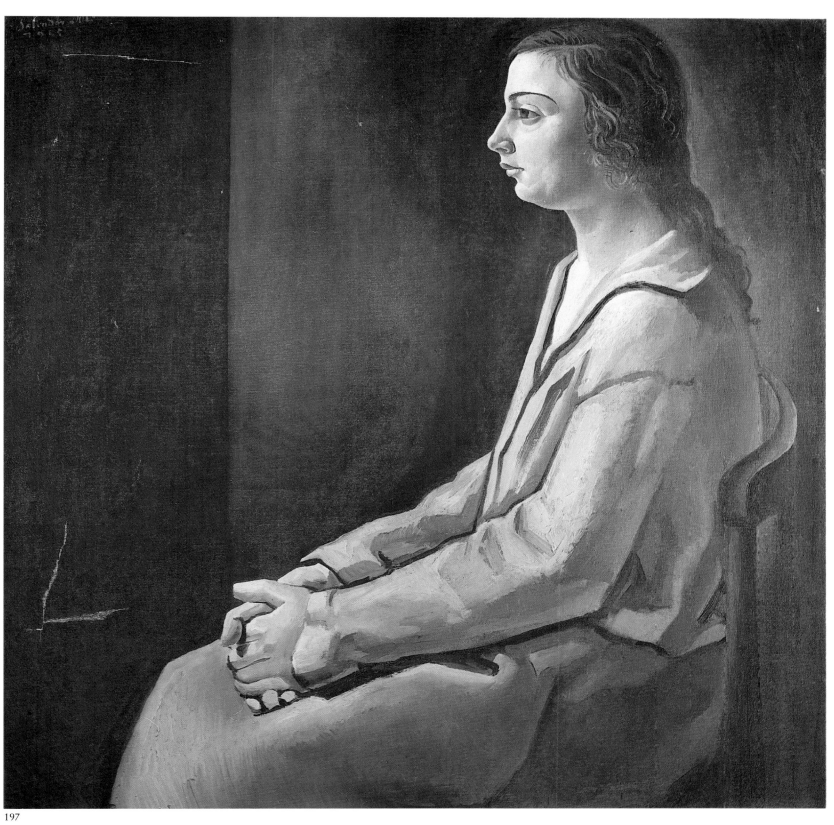

197

1925

Ana's Beautiful Behind

Ana María, his sister, and his cousin Montserrat, were Dalí's favourite models at that time, and of course also the most accessible. Doubtless Dalí felt more at ease in their company, and freer to indulge libidinous instincts. His tendency to present them from the rear is eloquent of his desires and aversions; he himself said little of an explanatory nature on the subject, but the rear views range from that of his sister, *Figure at a Window* (p. 91), to the 1954 *Young Virgin Autosodomized by her Own Chastity* (p. 478). Relations during the modelling sessions, and the nature of the portrayal, may explain why relations between brother and sister were poor for so long. Ana María published an account of the artist – *Dalí, Seen by his Sister* – which Dalí never forgave her, and in it she wrote: "At that time my brother painted countless portraits of me. Many of them were simply studies of

198

198 Poster for Salvador Dalí's exhibition at Dalmau Gallery in Barcelona, 1925 ✰

199 **Seated Girl from the Back,** 1925 ❑
Jeune fille assise de dos – Noia d'Esquena

200 **Figure at a Window,** 1925 ❑
Personnage à une fenêtre (Jeune fille debout à la fenêtre)

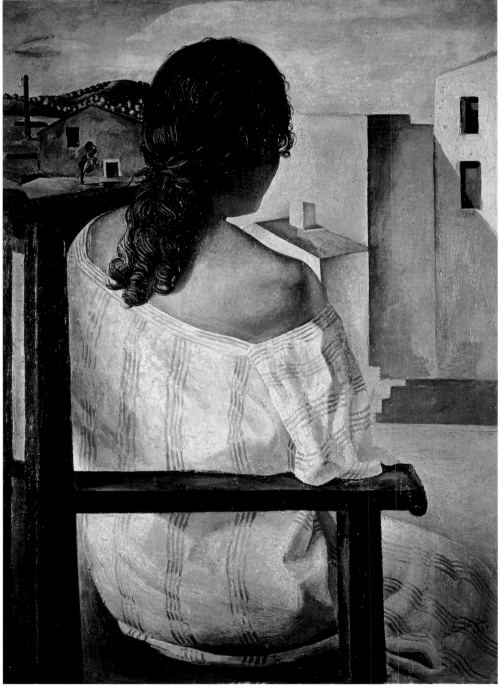

199

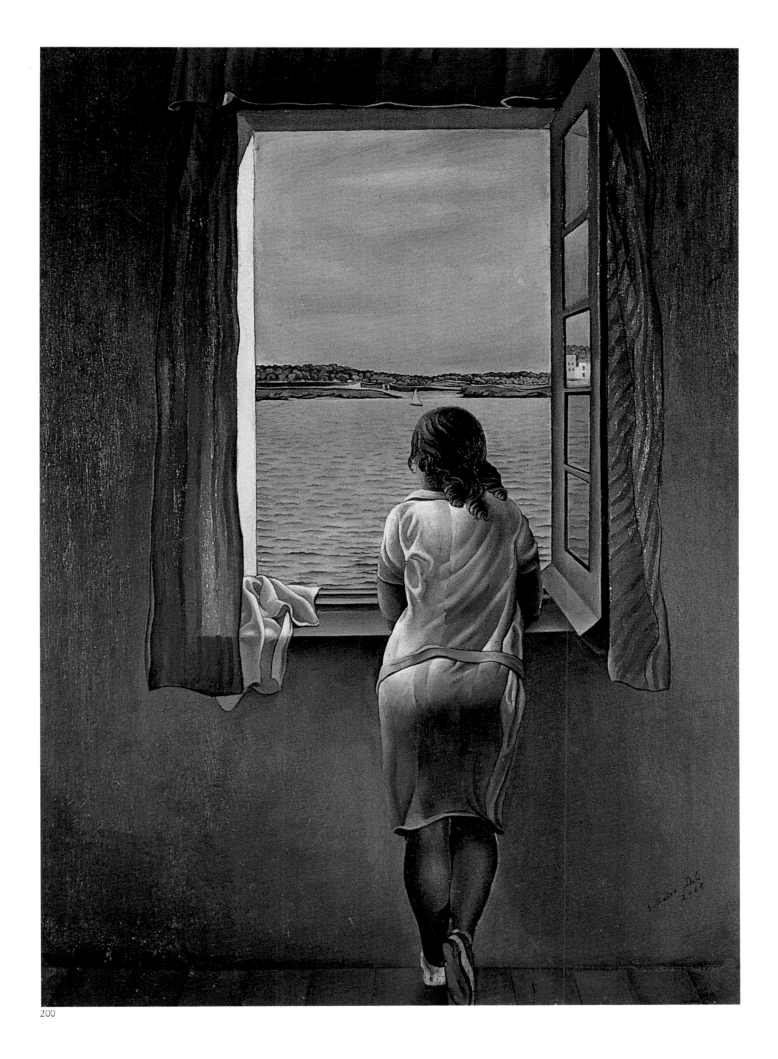

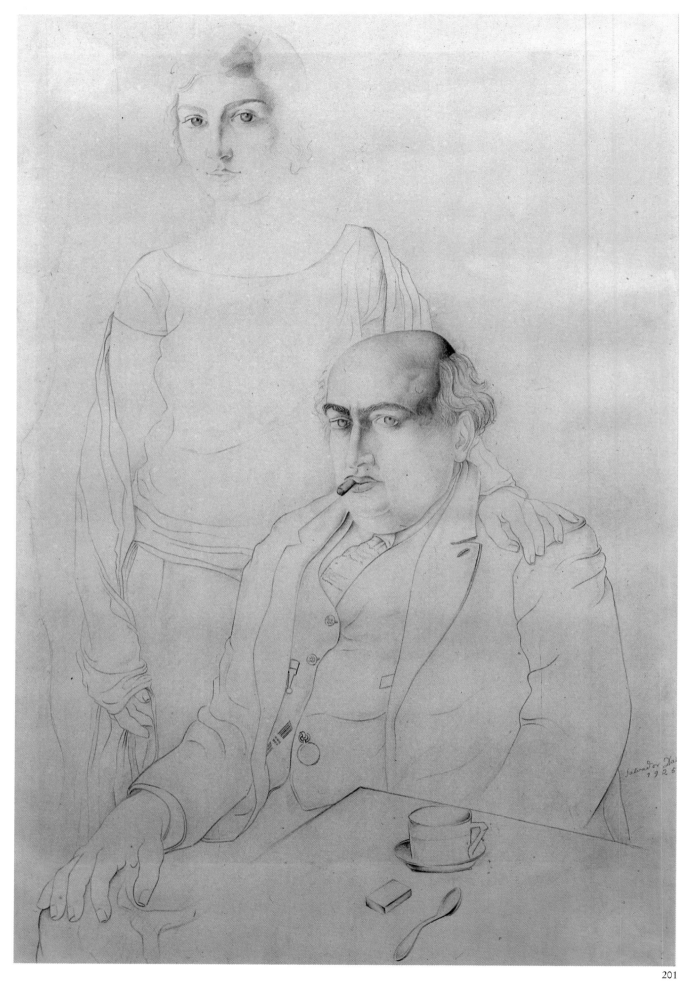

92 201 **Don Salvador and Ana María Dalí (Portrait of the Artist's Father and Sister)**, 1925 ∆

Retrato del padre y la hermana –
Portrait du père et de la sœur
de l'artiste

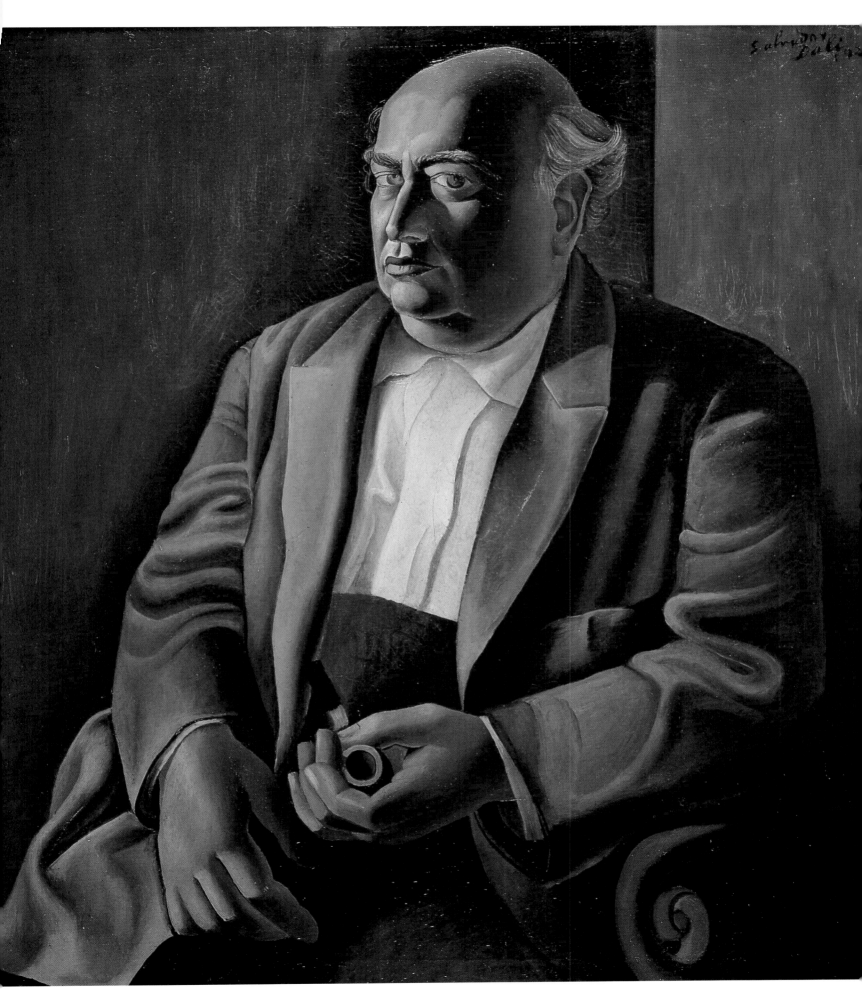

202 Portrait of my Father, 1925 ❏
Portrait de mon père

1925

203

hair and a bared shoulder." She recalled sitting for hours, gazing out at the countryside – "which has now become a part of me for all time" – as she held her pose. "The fact is that Salvador invariably painted me at the window." In one of his letters to the young woman, Lorca wrote: "My stay at Cadaqués was so wonderful that it now seems almost a beautiful dream, especially waking up to that view from the window."

It was Dalí's Ingres period. "The line drawing has a greater integrity than any other art," Ingres had stated, and Dalí valued the pronouncement highly. It was also the time when Dalí was sent down from the Academy, and he tried to repair relations with his father by drawing and painting him (pp. 92 and 93). In his *Secret Life* he wrote (of the drawing): "On my arrival in Figueras I found my father thunderstruck by the catastrophe of my expulsion, which had shattered all his hopes that I might succeed in an official career. With my sister, he posed for a pencil drawing which was one of my most successful of this period. In the expression of my father's face can be seen the mark of the pathetic bitterness which my expulsion from the Academy had produced on him. At the same time that I was doing these more and more rigorous drawings, I executed a series of mythological paintings in which I tried to draw positive conclusions from my Cubist experience by linking its lesson of geometric order to the eternal principles of tradition." The oil portrait of his father clearly reveals the powerful affection between artist and sitter, and indeed a certain sense of complicity between the bull (the father) and the matador (the son). Dalí's portrait is at once realistic and psychological, and is impressive for its forceful expressiveness, which fully con-

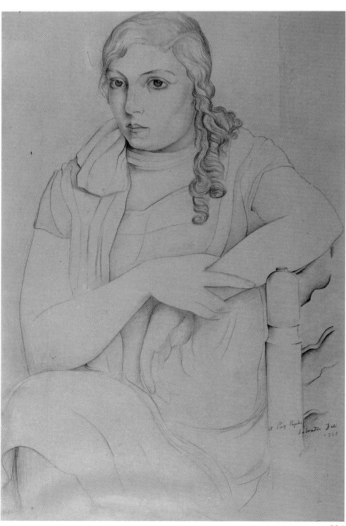

204

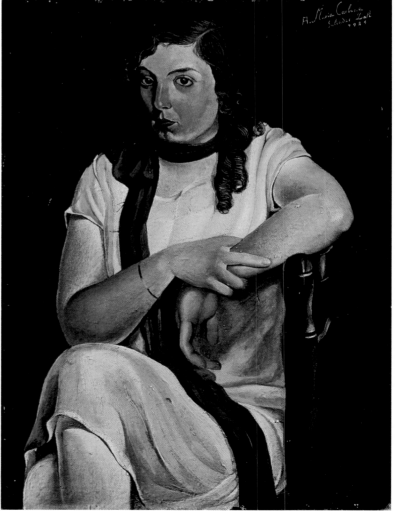

205

94

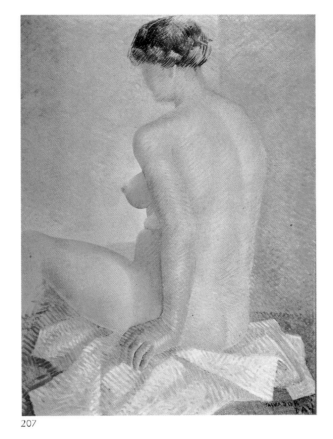

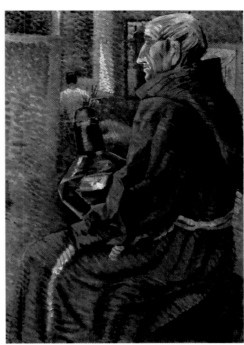

207

208

203 **Study**, 1925 ❏

204 **Study for "Portrait of María Carbona"** (dedicated to Puig Pujades), 1925 △

205 **Portrait of María Carbona,** 1925 ❏
Portrait de María Carbona

206 **Female Nude,** 1925 ❏
Nu féminin

207 **Female Nude,** 1925 ❏
Nu féminin

208 **Seated Monk,** 1925 ❏
Moine assis

206

veys the powerful personality of the Figueras notary. Sternly aloof though the father is in this portrait, it is not difficult to see in his gaze something of that Catalonian malice that had bristled on so many occasions in his dealings with his son. The family were seemingly unsure about the position of the right hand; but the artist insisted that his worthy progenitor should place his hand wherever he wished, even if it was at his genitals. This, no doubt, was a little joke on Dalí's part; but there was no humour in their relations a mere five years later when he was out to marry Gala the divorcée at all costs, and had to fight his father – to the death (in the Freudian sense).

In his portrait work of this period, Dalí took his bearings from the composition, light and neo-realist technique of Derain – a realist approach that he was to continue later in his Surrealist work. Vermeer was another of his godfathers at this stage, as were Ingres and Picasso. The connection with Ingres and Picasso is a cogent one: Picasso had then just emerged from his own Ingres phase of large, realistic nudes, and they were a point of reference for the nudes and derrières so frequent in Dalí's work of the period. For his exhibition at Dalmau's in 1925, Dalí glossed these paintings with an observation of Ingres: "Beautiful form consists of even surfaces with curvatures. Form is beautiful when it is both firm and full, and when the details do not impair the overall impact of the large body mass." The interest in Picasso visible in *Venus and Amorini* (p. 97) was apparently mutual. In the *Secret Life*, Dalí wrote: "the polemics aroused by my works reached the attentive ears of Paris. Picasso had seen my *Girl from the Back* in Barcelona, and

209

210

209 Study for "Woman with a Child", 1923 △

210 Girl Reclining on a Bed (Ana María Dalí), 1925 △
Jeune fille allongée sur un lit

211 Nude in the Water, 1925 ❏
Nu dans l'eau

211

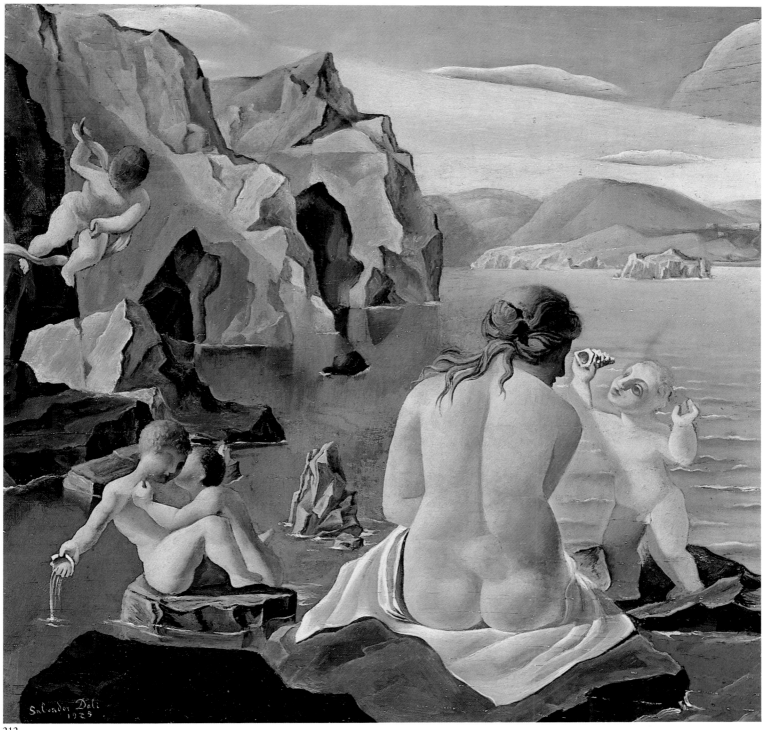

212

212 **Venus and Amorini,** 1925 ❑
Venus y cupidillos – Vénus et amours

213 **Venus and Amorini** (detail) –
This is one of Dalí's first dual images.
The derrière of the model looks like a
reclining nude with her thighs
drawn up. ✭

213

214 **Landscape near Ampurdán,**
1925 ❏
Paysage de l'Ampurdán

215 **Landscape near Ampurdán,**
1925 ❏
Paysage de l'Ampurdán

216 **Still Life,** c. 1925 ❏
Nature morte

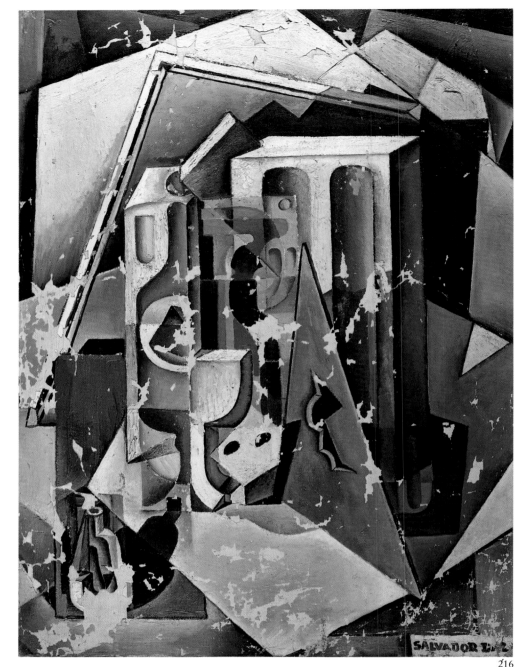

216

214

215

praised it. [...] I knew that the day I arrived in Paris I would put them all in my bag with one sweep."

Dalí was also beginning to play with double images, and *Venus and Amorini* contains one in the lower part of the bather's back, which can also be seen as a frontal view of legs drawn up from an adumbrated pubis. Dalí was taking a great interest in naked women seen against the craggy coastline at Cadaqués. In the same catalogue, he quoted Elie Faure in order to define his own position more clearly: "A great painter may only pick up the tradition once more when he has first passed through a phase of revolution – which is nothing other than a quest for his own reality."

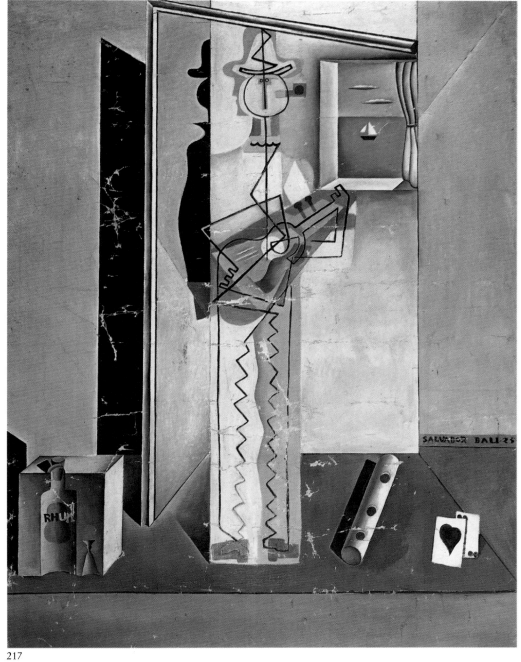

217

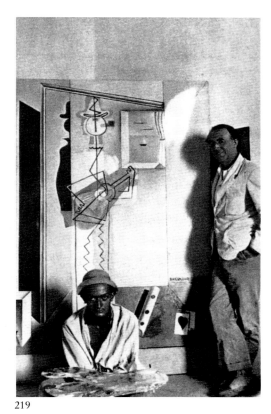

219

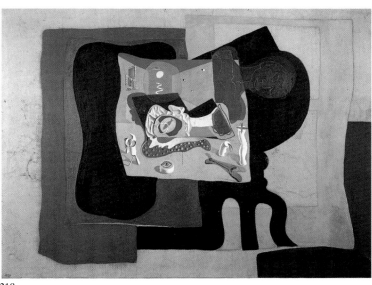

218

217 Pierrot Playing the Guitar (Harlequin with Small Bottle of Rum), 1925 ❑
Pierrot tocant la guitarra – Pierrot jouant de la guitare (Arlequin et petite bouteille de rhum)

218 Still Life and Mauve Moonlight, 1925 ❑
Nature morte au clair de lune mauve

219 Dalí with his uncle Anselmo Domenech, a well-known bookseller in Barcelona, in front of the painting "Harlequin with Small Bottle of Rum", 1925 ✩

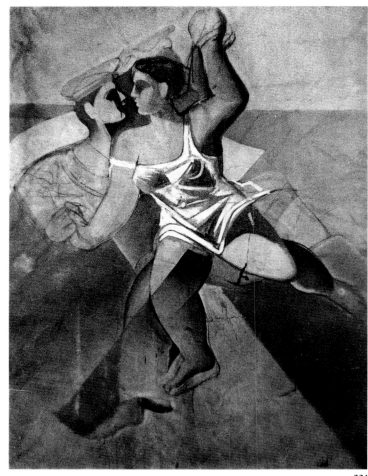

1925–1926

Trossos de Coniam

In autumn 1925 Dalí returned to the San Fernando Academy in Madrid, only to be finally sent down on 20 October the following year. In attempting to continue his education, however, he very quickly came to feel he had nothing to learn from his teachers. What interested him – since he mastered whatever he touched within months – was to multiply and mix genres, to experiment with various techniques simultaneously. He painted on card; he mixed gouache and oils; and he changed from luminous colours to more muted tonalities mixed with grey. This change had followed the death of his mother in 1921, articulating his sense of loss: "I swore to myself that I would snatch my mother from death and destiny with the swords of light that some day would savagely gleam around my glorious name!" Seurat, Picasso, Juan Gris, and Italian *pittura metafisica* strongly influenced Dalí's palette in his Cubist phase, dictating black, white, burnt sienna and olive green in place of the glowing colours of the years before.

Dalí had no patience with the Academy. He was a painter; he received favourable notices when his work was exhibited. The January 1926 issue of *D'ací, d'allá*, for example, declared: "Rarely does a young painter make his appearance on the scene with the audacity and aplomb of Salvador Dalí, from Figueras […] If he is now looking to France, it is because he has what it takes to make his way there and because his God-given talent as an artist still needs to mature. What does it matter if Dalí, in order to fan his own flames, uses the pencil of an Ingres or the rough-cut wood of Picasso's Cubist work?"

André Breton was surely mistaken when he wrote, in *Surrealism and Painting*: "When Dalí embraced Surrealism in 1929, the work he had done up to that time was innocent of any personal signature." The only defence that can be offered

220 **Study for "Venus and Sailor"**, 1925 △

221 **Venus and Sailor (Girl and Sailor; unfinished)**, 1926 ❏
Vénus et marin (Fille et marin)

222 **Venus and a Sailor – Homage to Salvat-Papasseit**, 1925 ❏
Vénus et un marin – Hommage à Salvat-Papasseit

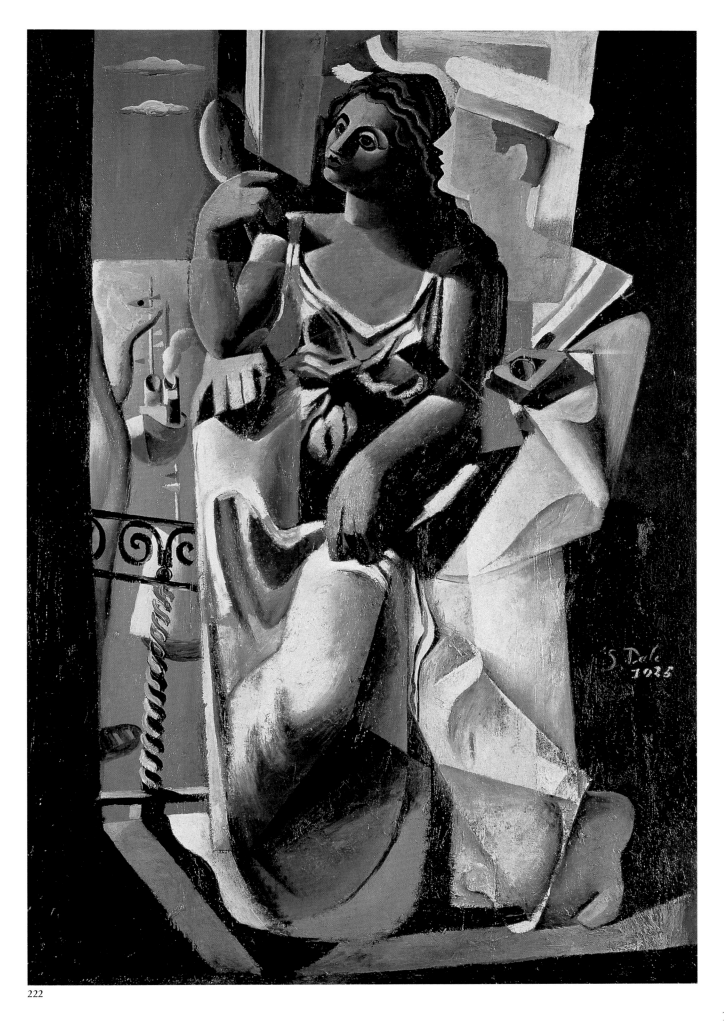

222

here is to point out that Breton had in fact hardly seen any of Dalí's early work. His bias, and his determination to subsume Dalí into the Surrealist stream, derived from a radical misconception of the Catalonian's personality. The fact was that, from the mid-1920s on, Dalí had been combining all the main styles of Modernism – from Impressionism to Neo-Cubism – with a realistic technique of which he had a sovereign command. We see this method at work in the portrait of his father (p. 93) and in *Figure at a Window* (p. 91), the paintings which aroused the interest of Picasso and Miró. The method is itself proof of Dalí's clear-sightedness; but it was precisely this that Breton was at pains to deny. That clear-sightedness can also be seen in the fact that initially Dalí avoided introducing *all* his new-found skills, at a given moment, into a single picture; it would be years before he attained the absolute mastery visible in *Tuna Fishing* (pp. 568/569), which synthesizes in one great work all that a great artist has learnt in a lifetime. In the 1920s, he was primarily concerned to adjust his stylistic resources to the requirements of the theme; to vary his brushwork; to suit his colour harmonies

223

223 **Sailor and his Family**, c. 1926 ❏
Marin et sa famille

224 **Venus and a Sailor**, 1925 ❏
Vénus et un marin

225 **The Girl of Ampurdán**, 1926 ❏
La noia dels rulls – Jeune fille
de l'Ampurdán

226 **Sheets of Studies (double-sided
drawing)**, 1926 △

227 **Female Nude**, 1926 △
Nu

228 **The Girl – Study for "The Girl
of Ampurdán"**, 1926 △
La noia – La jeune fille

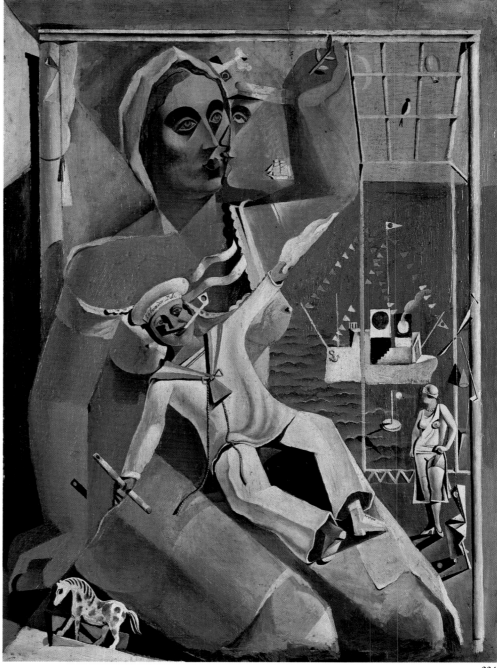

224

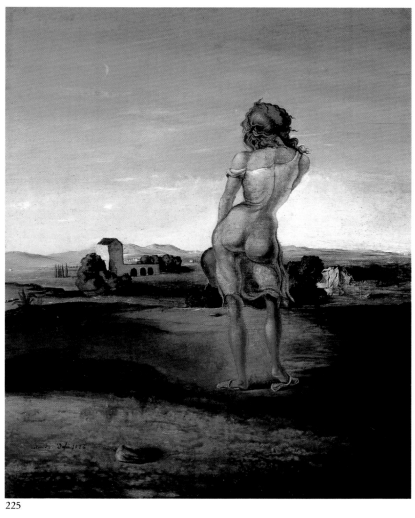

225

228

226

227

1926

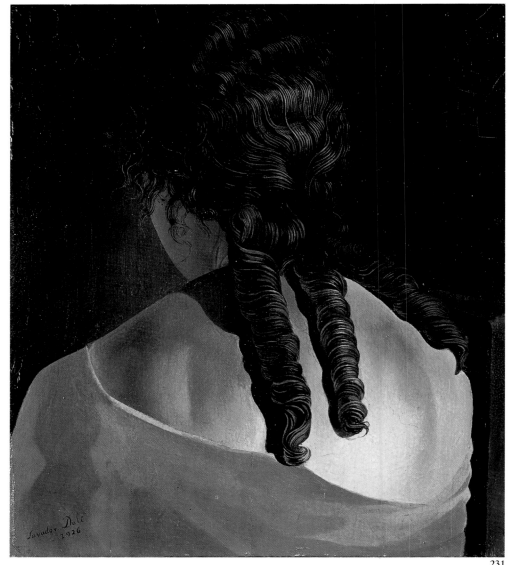

231

229

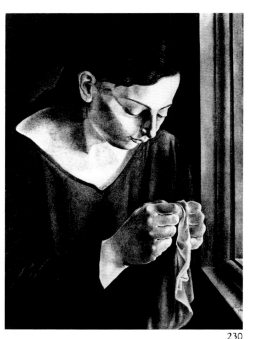

230

to the subject; to record detail precisely; in a word, to make progress with every painting, without squandering time, energy and paint. One result of this concentration was that he painted every work with an eye to maximum impact. The influences on his style, which he made no attempt to hide, served as a aid in expressing his own concerns; his borrowings from other artists engaged his attention for a week or so, and then he had already moved on.

1926 was a key year for Dalí. It was about then that the butterfly emerged from the chrysalis. It was a Neo-Cubist butterfly that painted geological formations along the Catalonian coastline and other regional landscapes, as often as not as a backdrop for portraits of young women, nude or not. Dalí painted women sewing (pp. 104, 106, 107); he painted *Venus and a Sailor* (p. 101); but he also painted *The Basket of Bread* (p. 113), one of the pictures influenced by both Picasso and Ingres, a highly accomplished and striking piece of realist art. *Venus and a Sailor* and *Women Lying on the Beach* (p. 108) show him in a transitional phase. Because of the amorphous shapes in these pictures, Ana María and her friend Lorca dubbed them "Trossos de Coniam" – a term used for people not in command of their faculties, who lead a physical, indeed vegetable existence. It was a term Dalí himself liked to use.

104

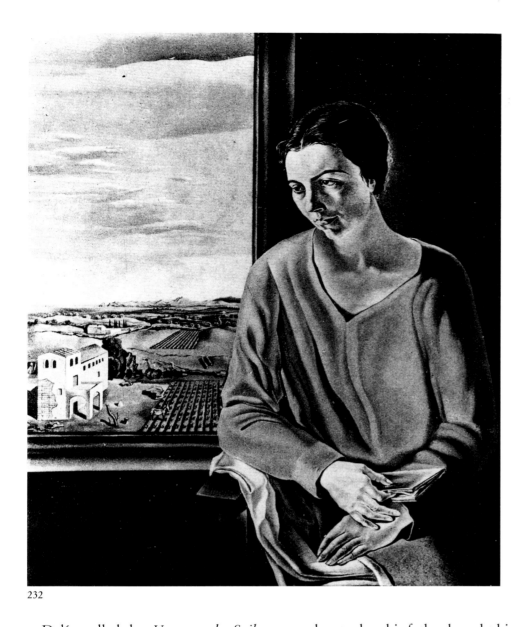

232

232 **Portrait of Señora Abadal de Argemi**, c. 1926 ❏
Portrait de la Sra. Abadal de Argemi

233 **Portrait of a Woman (unfinished)**, 1926 ❏ Portrait de femme

234 **Study for "Ana María". Cover of the catalogue for Dalí's second exhibition at the Dalmau Gallery in Barcelona**, 1926 △

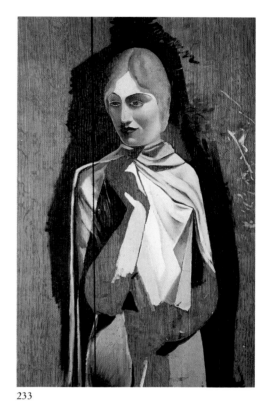

233

Dalí recalled that *Venus and a Sailor* came about when his father bought him a large painting showing a snakecharmer. First Dalí overpainted an impressionist scene on it; then he overpainted a portrait of Andrea, a girl he was then fond of; then he portrayed his Figueras friends; then another subject, in tempera; and finally he painted the Venus. The same approach resulted in the *Figure on the Rocks* (p.108). The painting is clearly indebted to Picasso's neo-realist period of 1920 to 1922; Dalí had reproductions of Picassos on his studio walls, including a reproduction torn from the periodical *Art d'aujourd'hui* of a well-known painting showing two women running along a beach, a painting probably intended originally as design work for Diaghilev's Ballets Russes. Dalí was soon designating this style of work as "Neo-Cubist Academic". In his own work, he was not content with absorbing the influence, but rather set out to extend its formal implications, exploring his own love of structural line and contour to the full. The picture is radially composed: the diagonals intersect at the center of the painting, close to the woman's navel, and the lines radiate from that point.

EXPOSICIÓ
S. DALÍ

GALERIES DALMAU
BARCELONA

234

1926

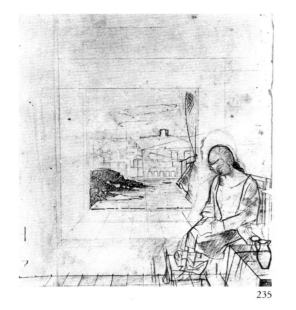

235

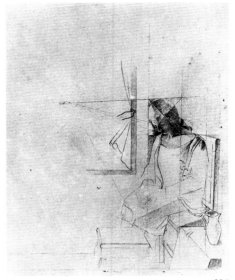

236

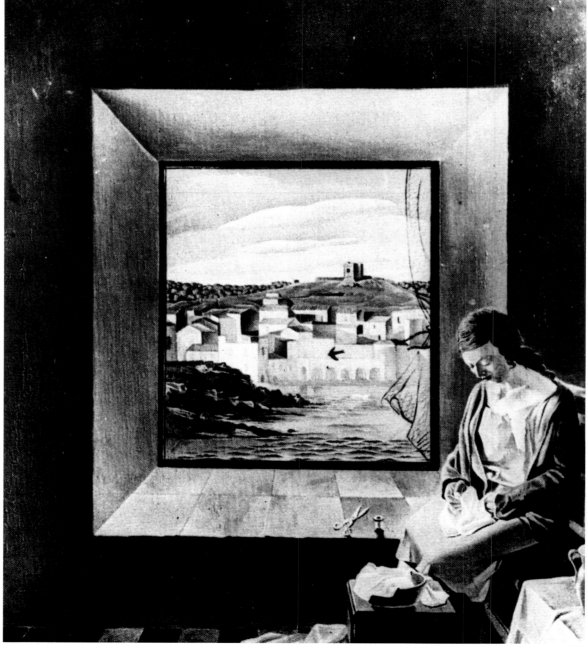

237

238

235 **Study for "Girl Sewing"**, 1926 △

236 **Study for "Girl Sewing"**, 1926 △

237 **Girl Sewing**, 1926 ❑
Noia cusint

238 **Study for "Girl Sewing"**, 1925 △

239 **Woman at the Window at Figueras**, 1926 ❑
Femme à la fenêtre à Figueras

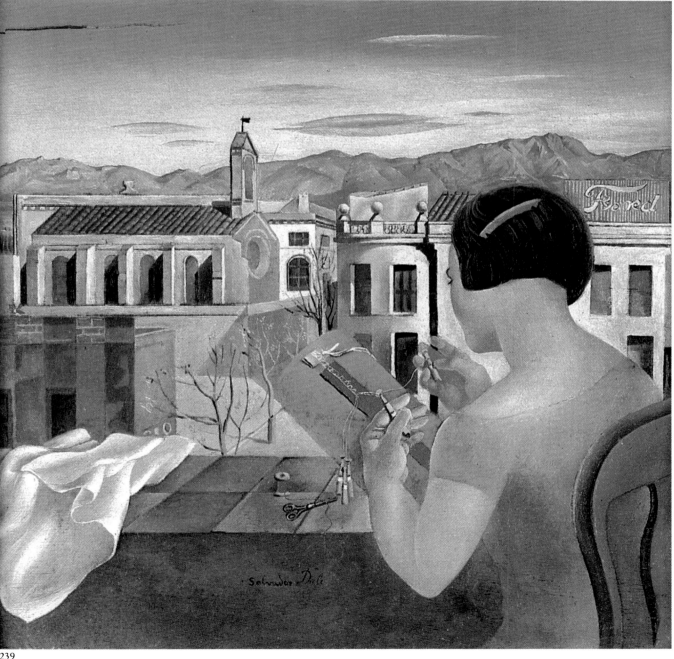

239

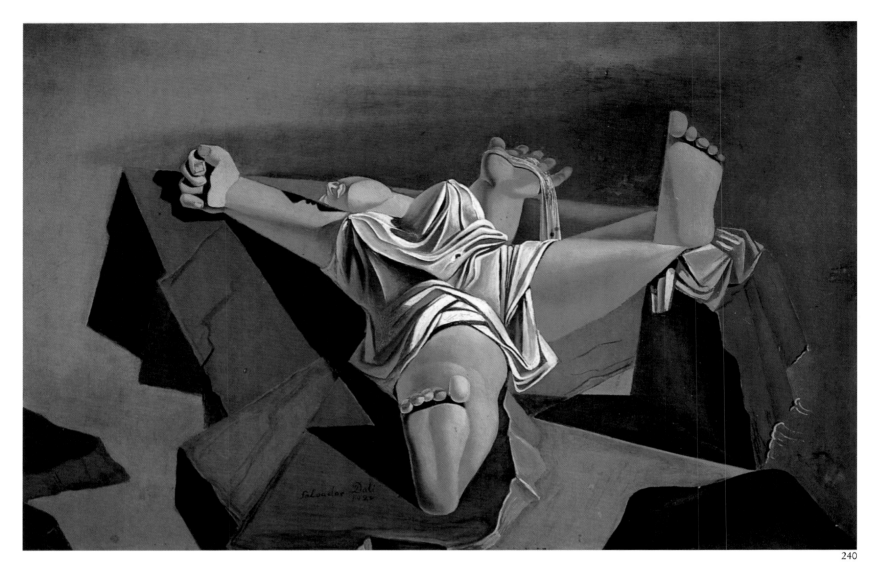

240

240 **Figure on the Rocks (Sleeping Woman),** 1926 ❏
Femme couchée

241 **Women Lying on the Beach,** 1926 ❏
Femmes couchées sur la plage

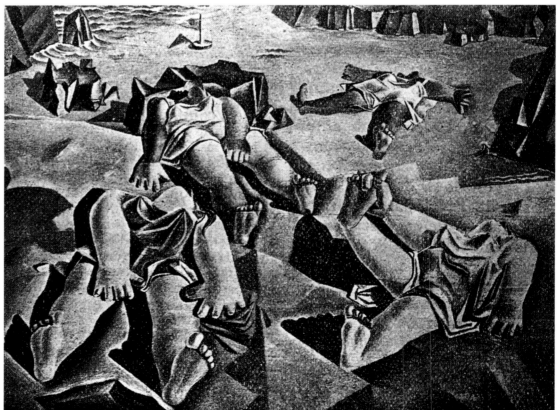

241

242

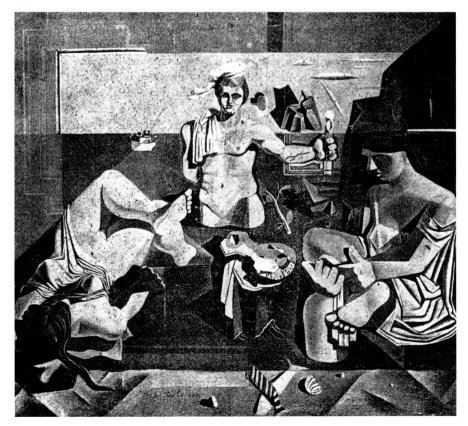

242 **Woman in a Chemise, Lying (Study for "Women Lying on the Beach")**, c. 1926 △

243 **Neo-Cubist Academy (Composition with Three Figures)**, 1926 ❏
Académie néocubiste

244

244 **Rocks at Llané (first state)**, 1926 ❑
Rochers du Llané

245 **Rocks at Llané (Landscape near Cadaqués)**, 1926 ❑
Rochers du Llané (Paysage à Cadaqués)

246 **Penya-Segats (Woman on the Rocks)**, 1926 ❑
Penya-Segats (Femme devant les rochers)

247 **Photograph of the rocks at Cape Creus, which Dalí never tired of painting** ☆

245

247

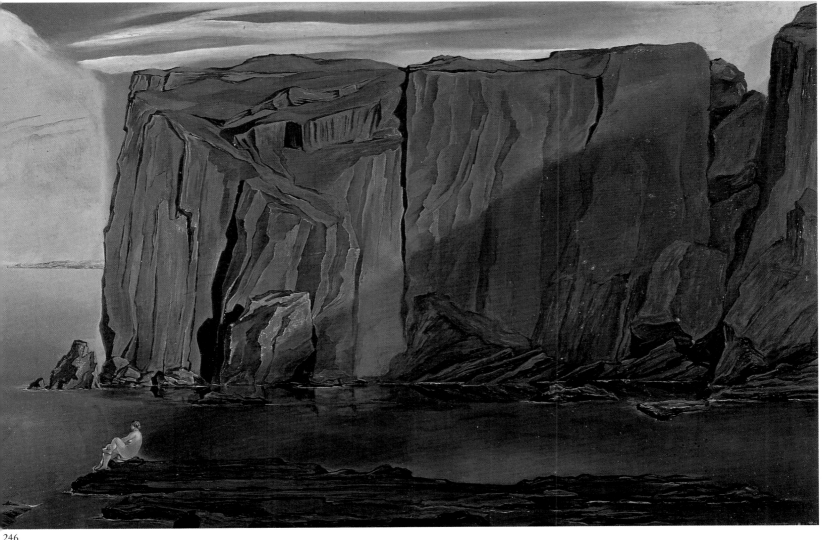

246

Realism and Beyond

The notion of realism, when applied to Dalí's painting technique, is far from being as exact or stable as we might prefer or assume. Like Don Quixote, one of his favourite (anti-)heroes, Dalí did not perceive things in the same way as, say, the servant or priest. Magritte's programmatic inscription beneath a painting of a pipe, declaring that it is *not* a pipe (but an image of one), might be extended to Dalí's art throughout: his things are merely paintings of things and not the things themselves. This is of course a banality; and Dalí's approach is subtler. When we pause in admiration over one of his paintings, we are likely to find that he compels us to look (imaginatively) at the far, unrevealed side of his subjects. His art is rich in ambiguities, and the famous double images can explode our way of seeing when we least expect it.

The Basket of Bread (p.113) is painted in minute, almost photorealist detail. Bread, Dalí declared, no matter how heterogeneous, must be enclosed in the liturgy of the basket, despite the mounting anarchy of the age. Twenty years later, when Gala already had the meaning for him that La Fornarina had for Raphael, he painted a further version of the picture: *Galarina* (p.378). If we analyse the painting closely, we see that Gala's folded arms resemble the rim of a bread basket and her breast the heel of a loaf. Dalí had already painted Gala with two pork

248 **Still Life with Two Lemons,**
c. 1926 ❏
Nature morte aux deux citrons

248

249

chops on her shoulder (he later recalled), to suggest he wanted to eat her up (cf. p.200). That, he declared, was when raw meat played an important part in his imaginative world; but by the time he painted *Galarina* Gala had advanced in his heroic, aristocratic hierarchy, to become his bread basket.

This, then, is a strain of symbolic ambiguity present in Dalí's realist work. His double-image paintings are different in character. Their origins lay in his Academy days in Madrid, and in his eternal contrariety. One day, in the drawing class, the professor set his students the task of painting a Gothic statuette of the Virgin – instructing them to paint precisely what they saw. The professor had scarcely left but Dalí set about painting… a set of scales. From a catalogue. With meticulous precision. His fellow students thought he had taken leave of his

249 **Basket of Bread**, 1926 ❏
Corbeille de pain

113

senses. At the end of the week, when the professor came to assess their work, he froze at the sight of Dalí's. "You may see a Virgin as everyone else does," Dalí told him, "but what I see is a set of scales!" Looking back on this moment in his *Secret Life*, Dalí noted the coincidence that both a virgin (Virgo) and scales (Libra) feature in the zodiac, and suggested that this was the point at which his philosophy of painting was formulated – which called for sudden, instantaneous recording of the image that occurred to his imagination.

As Dalí left the period of his experiments behind, and ceased to be merely a gifted beginner, he had already programmed himself to become "the greatest sorcerer of all" – one who, like Ariosto or Calderón, could even hold himself in thrall. Quite deliberately, Dalí slipped gradually into "the nets of his imagination's high and magical art" (in Marcel Brion's phrase). Dalí's talent for visual invention is unequalled today; his magical inspiration and furious black comedy are second to none in the centuries since Hieronymus Bosch. Often he painted the thing that was not, with the selfsame pedantic and photorealist precision that Bosch brought to his visions of hybrid monsters. Doubtless it was this coupling of fantasy with exact scruple that led to his being so frequently misrepresented as an "academic Surrealist" or, for a change, a "Surreal academician". In fact Dalí

252

250 **Self-Portrait Splitting into
Three**, 1927 ❏
Autoportrait se dédoublant en trois

251 **Untitled**, 1926 △
Sans titre

252 **Harlequin**, 1927 ❏
Arlequin – Arlequi

253 **Three Figures**, 1926 ❏
Trois personnages

253

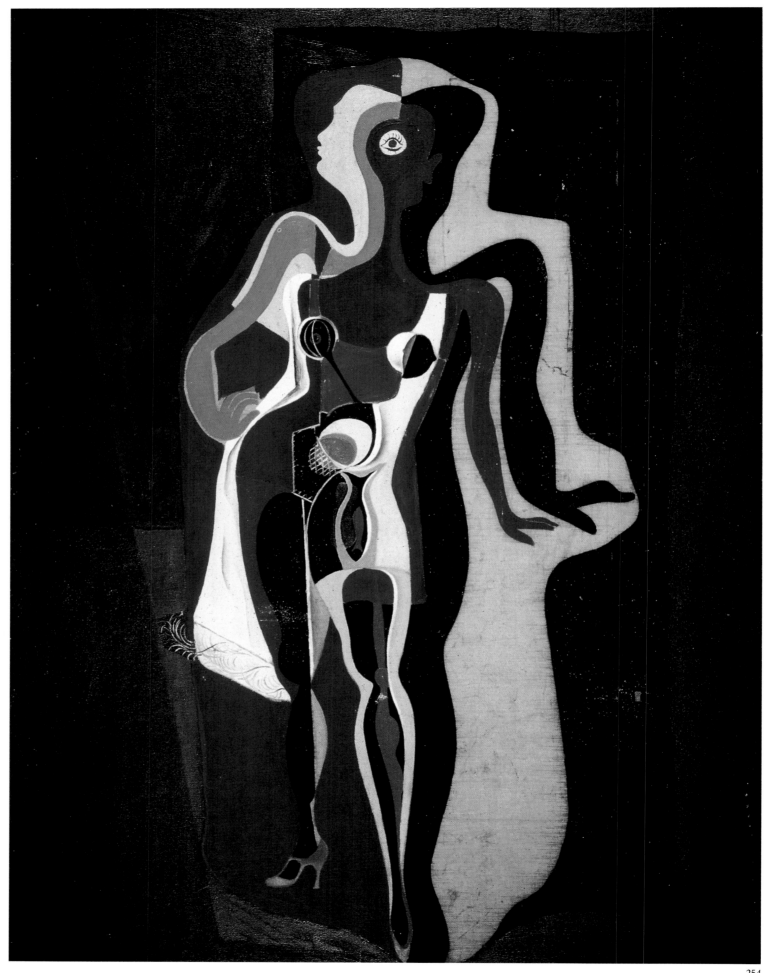

was merely perfecting the magical objectivity and miraculous realism visible in some of the illustrious artists he acknowledged as his predecessors, particularly great German visionary artists such as Grünewald, Altdorfer and Dürer.

The photorealist strain was not yet generally so well developed in Dalí's works of 1926 and 1927, though, in which the Cubist influence was still strongly apparent. What we do feel throughout is the compelling attraction of Surrealism. It is interesting, in this context, to compare the *Harlequin* (p. 115) with the *Soft Self-*

256

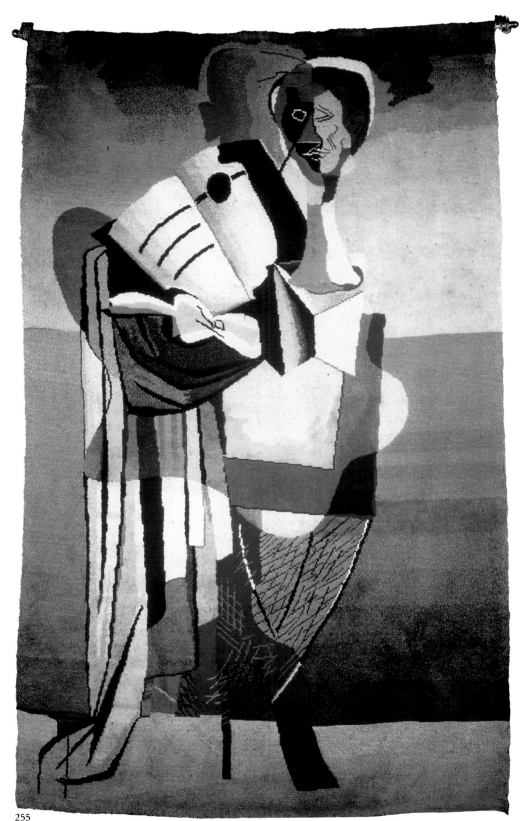

255

254 Mannequin (Barcelona Mannequin), 1926–1927 ❏
Le mannequin (Mannequin barcelonais)

255 Cubist Figure, 1926 ❏
Figura cubista – Personnage cubiste

256 Figure Edged in Flames, 1927 △
Figure en flamme

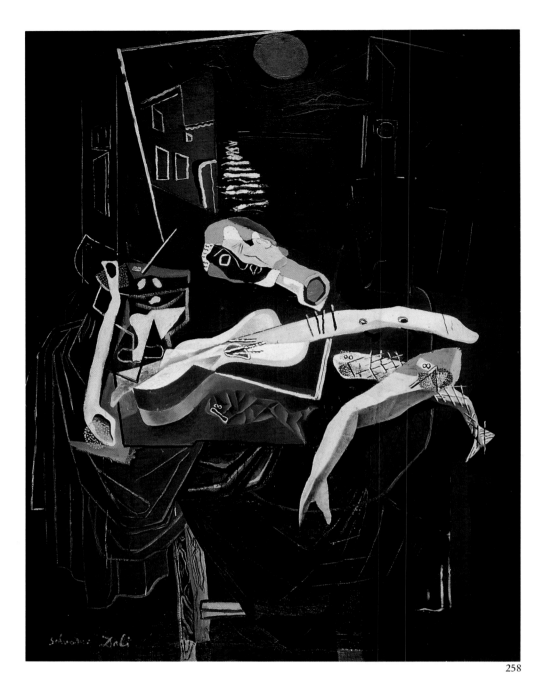

257 **Study for "Still Life by the Light of the Moon"**, 1927 Δ

258 **Still Life by the Light of the Moon**, 1927 ❏
Nature morte au clair de lune

259 **Abstract Composition**, 1926 Δ
Composition abstraite

258

257

259

Portrait with Fried Bacon (p. 342) done about fifteen years later. The harlequin, in Dalí's own terms, is epidermic and superficial. Its skin is like crumpled paper. Its eyes are empty – like those of the later self-portrait, which Dalí described as an "anti-psychological self-portrait". Instead of painting the soul, what was within him, he was painting what was without, the mere shell or glove of self. According to Dalí, that glove was both edible and even slightly rotten already; hence the ants on the bacon.

In his *Secret Life*, Dalí described his approach to the act of painting in the later 1920s: "I would awake at sunrise, and without washing or dressing sit down before the easel which stood right beside my bed. Thus the first image I saw on awakening was the painting I had begun, as it was the last I saw in the evening when I retired. [...] I spent the whole day seated before my easel, my eyes staring fixedly, trying to 'see', like a medium (very much so indeed), the images that would spring up in my imagination. Often I saw these images exactly situated in the painting. Then, at the point commanded by them, I would paint, paint with the hot taste in my mouth that panting hunting dogs must have at the moment when they fasten their teeth into the game killed that very instant by a well-aimed shot. At times I would wait whole hours without any such images occurring. Then, not painting, I would remain in suspense, holding up one paw, from which

261

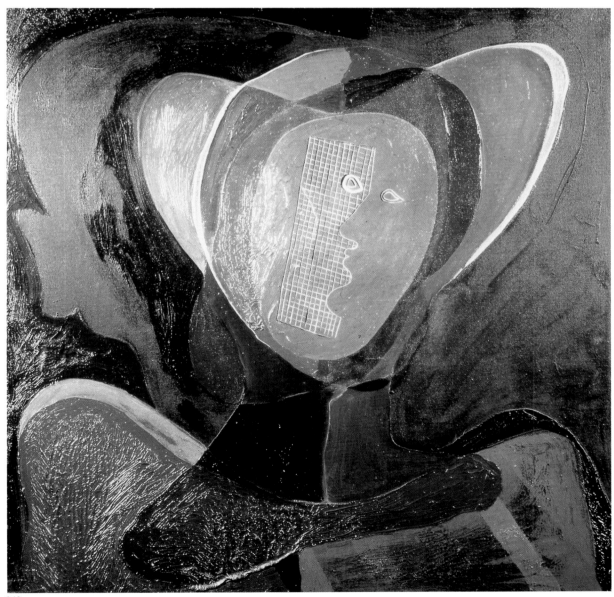

260

260 **Woman's Head, 1927** ❑
Tête de femme

261 **Head (Draft of a Double Image), 1927** △
Dibuix – Tête

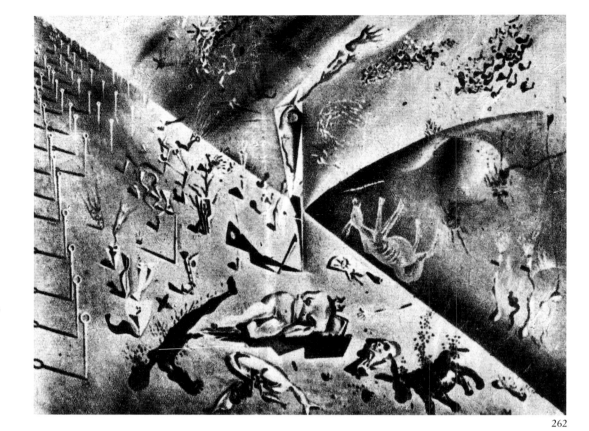

262 **Honey Is Sweeter than Blood,**
1927 ❑
Le miel est plus doux que le sang

263 **Study for "Honey Is Sweeter than Blood", 1926** ❑

264 **Apparatus and Hand, 1927** ❑
Appareil et main

262

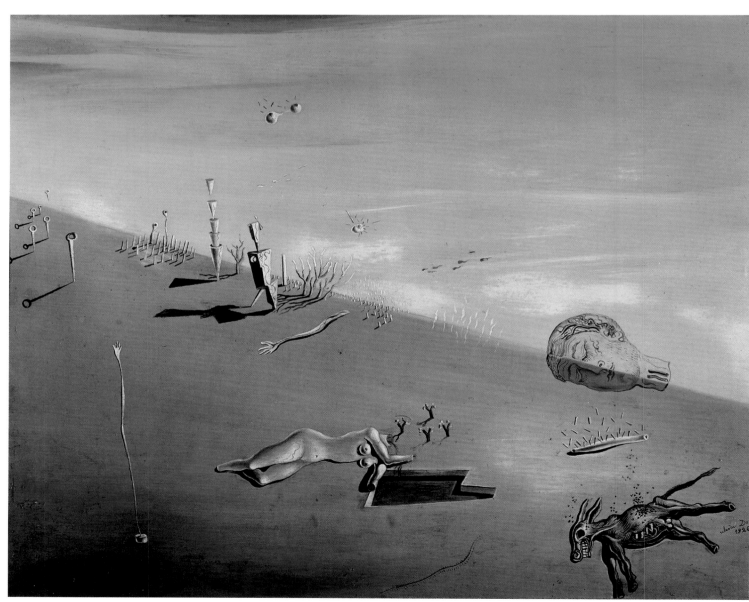

263

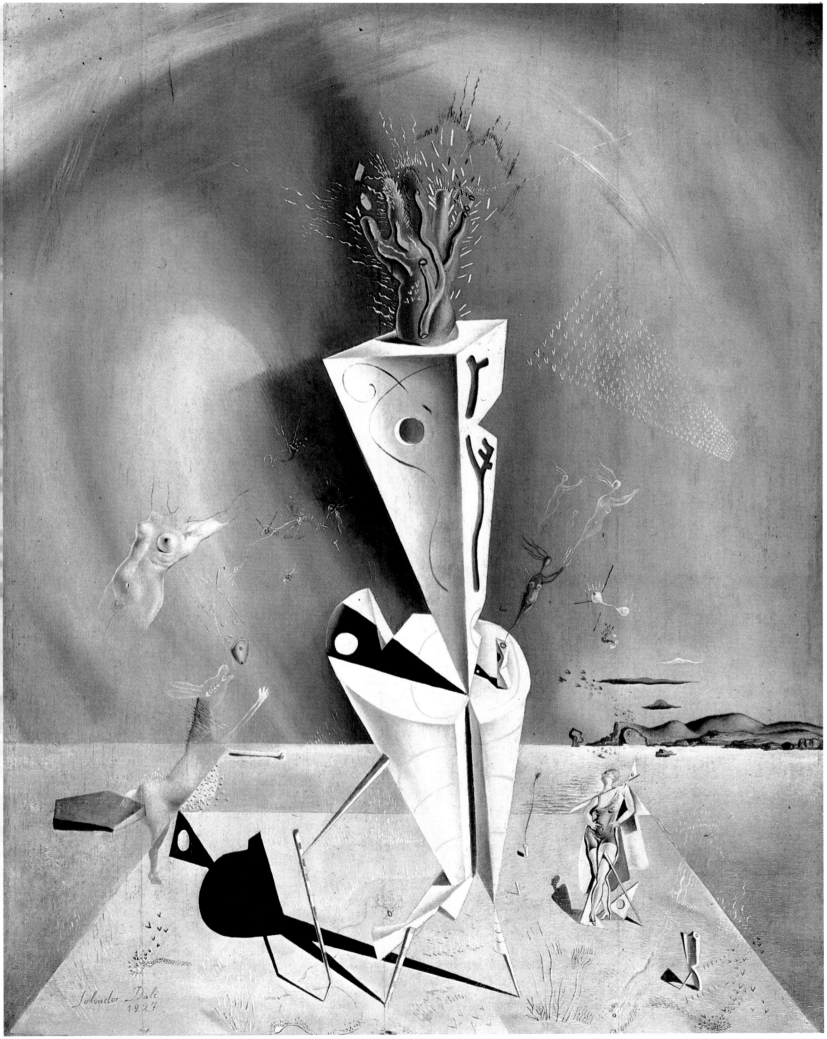

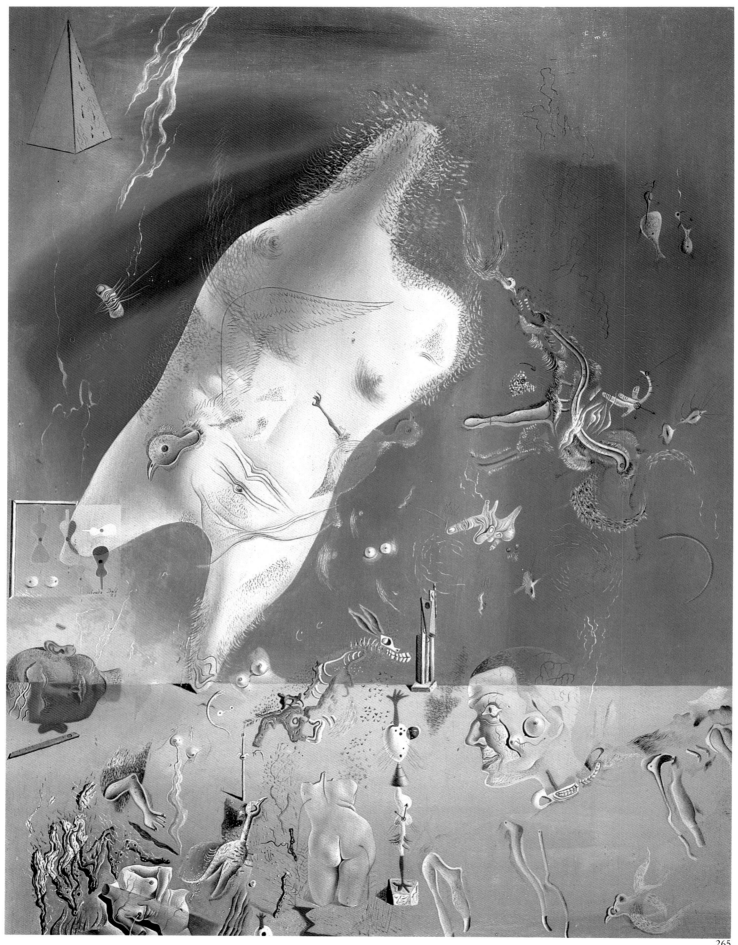

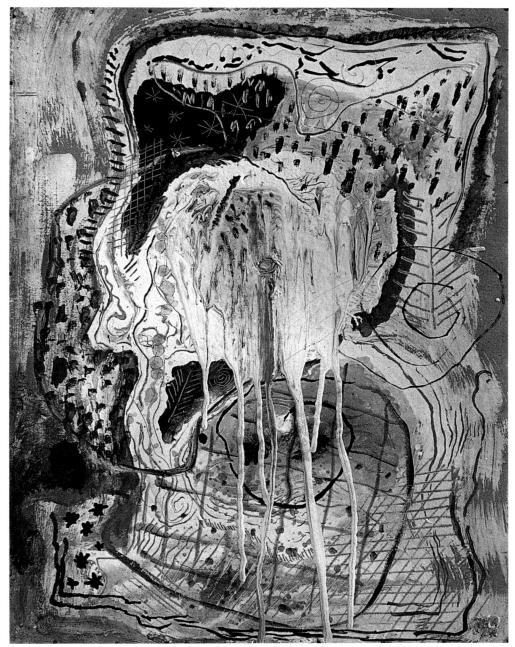

266

267

the brush hung motionless, ready to pounce again upon the oneiric landscape of my canvas the moment the next explosion of my brain brought a new victim, of my imagination bleeding to the ground. [...] A violent pecking would occur inside my brow, and sometimes I would have to scratch myself with my two hands. One would have said that the colored parasols, the little parrots' heads and the grasshoppers formed a seething mass just back of the skin, like a gay nest of worms and ants. When the pecking was over, I felt anew the calm severity of Minerva pass the cool hand of intelligence over my brow [...]"

265 **Little Cinders (Cenicitas),**
1927–1928 ❏
Petites cendres – Cenicitas

266 **Nude Woman Seated in an
Armchair,** 1927–1928 ❏
Femme nue assise dans un fauteuil

267 **Untitled,** 1927 ❏
Sans titre

Caesar or Nothing

Dalí's friendship with Lorca deepened, and at a crucial point in Dalí's life, as man and artist, the answering echo of his beloved Lorca helped him define his own quest and identity. Presently, however, the friendship was displaced by a more amorous interest on the part of the poet from Granada, and Dalí later recalled: "When García Lorca wanted to possess me, I spurned him in revulsion." Given Dalí's penchant for fabrication, we shall never know what really happened between the two constant companions. We can only say that shaking Lorca's hand was then apparently Dalí's most frequent physical contact with any other person; his experience of women seems still to have been limited, and he always claimed that he was a virgin when he met Gala.

Until that meeting, which changed Dalí's life, he and Lorca had been inseparable, affectionately drawing each other's portraits and sharing enthusiasms. For example, there was a portrait of an Ampurdán officer and politician, Josep Margarit (p. 125), in the hall of Dalí's parental home, and both he and Lorca were entranced by it, not least on account of the subject's outrageous moustaches, which they envied. The closer Dalí became to the Surrealists, however, the cooler the friendship with Lorca grew; and, despite the fact that the poet even wrote an ode to him, Dalí put a brutal end to the friendship. And indeed, the man who preached the destruction of intellectual life at an event at the Barcelona Athenaeum in 1930, the man who announced the time had come to trample on finer

268 **Federico García Lorca: Imaginary Portrait of Dalí (very poor state),** 1928 ⚄
Portrait imaginaire de Dalí, par Lorca

269 **Portrait of Federico García Lorca,** 1928 △
Federico García Lorca dessiné par Dalí

268

269

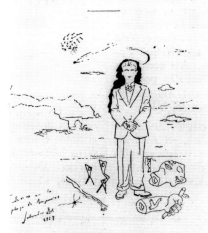

271

270 Self-Portrait, dedicated to Federico García Lorca, 1928 Δ
Autoportrait, dédié à Federico García Lorca
271 The Poet on the Beach of Ampurias – Federico García Lorca, 1927 Δ
Le poète sur la plage d'Ampurias – Federico García Lorca

272

272 Old copper engraving showing the Ampurdán officer and politician Josep Margarit. The engraving hung in the hall of Dalí's parental home. Along with those of Velázquez, we are surely not wrong to trace Dalí's moustaches to this portrait's example. ☆

273, 274 The inseparable Lorca and Dalí ☆

273

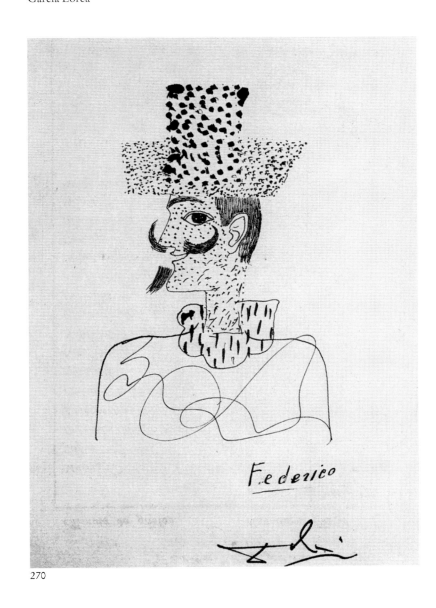

270

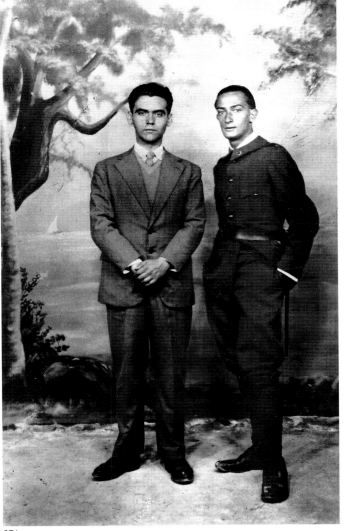

274

1927–1928

275

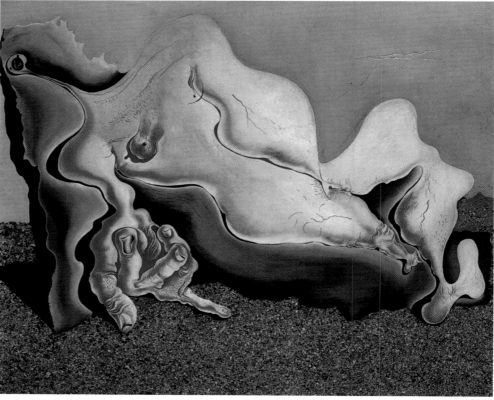

277

276

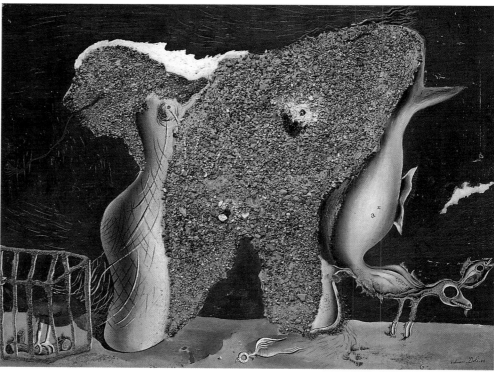

278

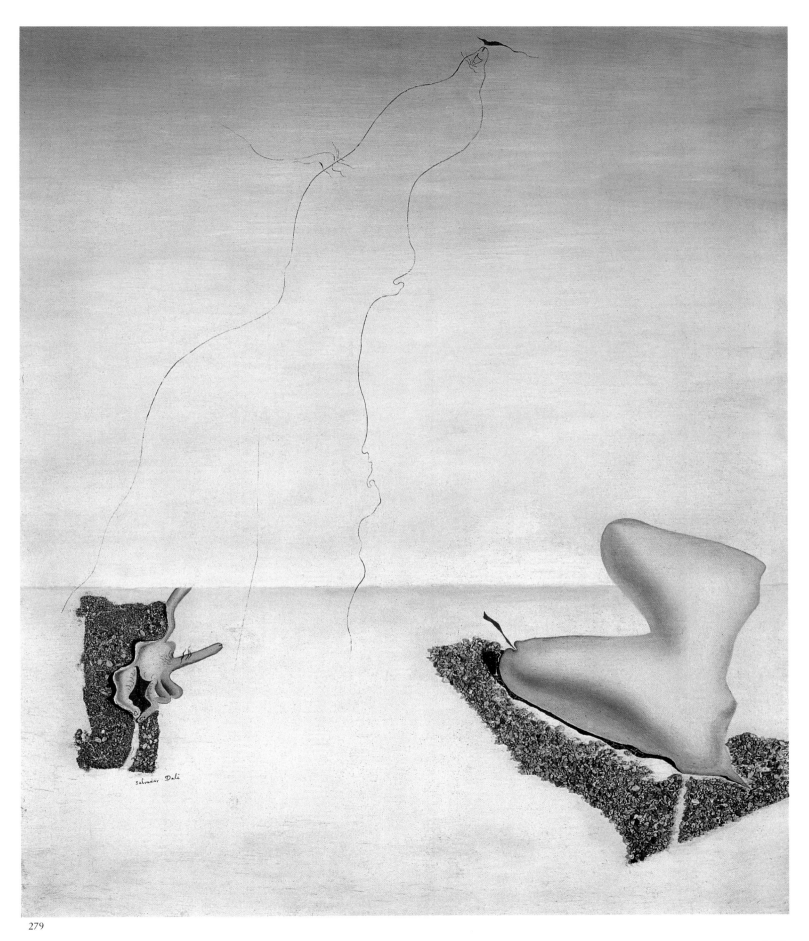

279

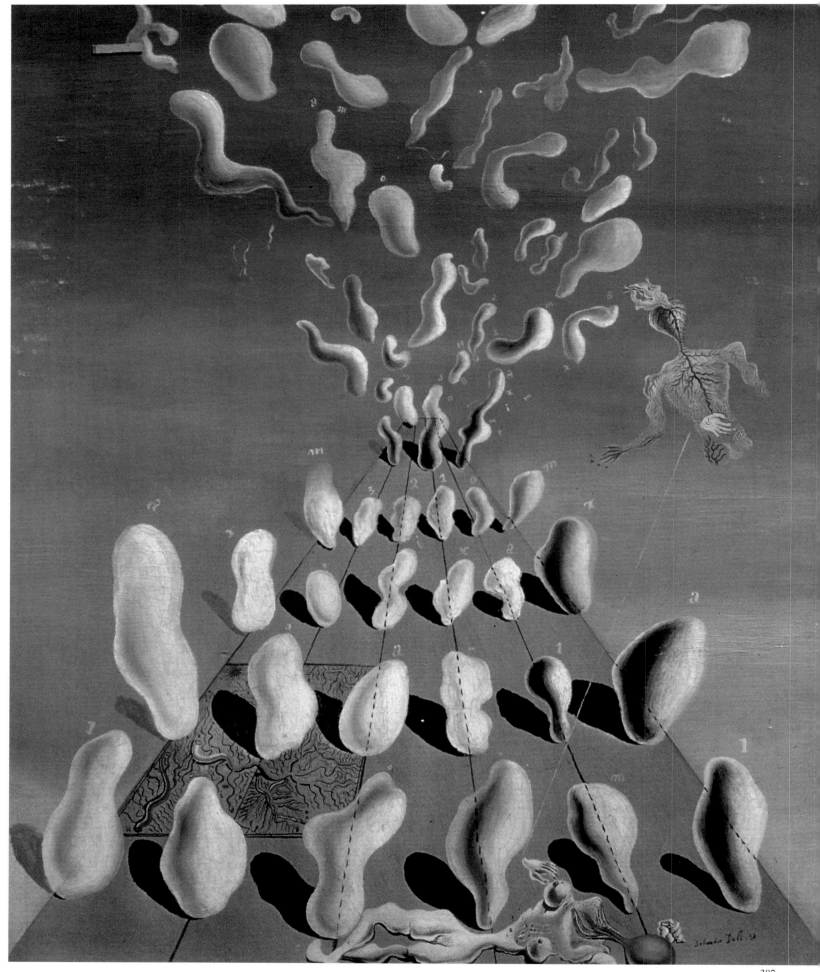

281

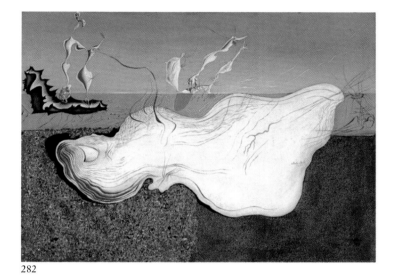

282

283

feelings and humanitarian instincts, no longer had much in common with the sensitive poet. Even so, Dalí wrote handsomely of Lorca in the *Secret Life*: "At the very outbreak of the revolution my great friend, the poet of *la mala muerte*, Federico García Lorca, died before a firing squad in Granada, occupied by the fascists. His death was exploited for propaganda purposes. This was ignoble, for they knew as well as I that Lorca was by essence the most apolitical person on earth. Lorca did not die as a symbol of one or another political ideology, he died as the propitiatory victim of that total and integral phenomenon that was the revolutionary confusion in which the Civil War unfolded." It is true that Dalí, when asked once by a journalist whether he was much affected by the shooting of Lorca, replied, "It satisfied me deeply." But Dalí, of course, made a career of intentionally shocking people.

In the 1920s, Dalí was still concentrating on proving to the world that he was a genius, and conquering Paris. In 1926 he refused to sit the Academy examinations, declaring the San Fernando professors incompetent to assess him; and this position resulted in his final expulsion from the Academy. Paris remained. Paris, in Dalí's imagination, beckoned. Joan Miró, Catalonian, an elder and already established artist, helped persuade Dalí's father that Paris was the right course, making the trip to Figueras with art dealer Pierre Loeb for the purpose. The notary was impressed, and began to wonder whether Paris might not indeed be the wisest strategy for his son; Miró admired Dalí's most recent work, and offered his assistance; while Pierre Loeb, for his part, remained more sceptical. At one point, Dalí reported, Miró took him aside and whispered that Parisians were far greater asses than they (the Catalonians) imagined, and that Dalí would find that things in Paris were not so easy after all. Once Miró had himself returned to the French capital, he wrote to Dalí *père* urging that a visit to Paris would be invalu-

1928

280 **Inaugural Goose Flesh (Surrealist Composition)**, 1928 ❏
Composition surréaliste, baptisée chair de poule inaugurale

281 **Composition (unfinished)**, 1928 ❏
Composition

282 **Bather**, 1928 ❏
Baigneur

283 **Untitled**, 1928 ❏

284

286

285

284 **Anthropomorphic Beach
(first state)**, 1928 ❏
Plage anthropomorphique

285 **Untitled**, 1928 ❏

286 **Anthropomorphic Beach
(final state)**, 1928 ❏
Plage anthropomorphique

287 **Feminine Nude (final state)**,
1928 ❏
Nu féminin

288 **Feminine Nude (first state)**,
1928 ❏
Nu féminin

289 **Moonlight**, c. 1928 ❏
Clair de lune

SALVADOR DALÍ

287

288

289

able and closing with the flattering words: "I am absolutely convinced that your son's future will be brilliant!"

Dalí's first one-week visit to Paris seems to have been around the beginning of 1927. "During this brief sojourn I did only three important things. I visited Versailles, the Musée Grevin, and Picasso. I was introduced to the latter by Manuel Angeles Ortiz, a Cubist painter of Granada, who followed Picasso's work to within a centimetre. Ortiz was a friend of Lorca's and this is how I happened to know him. When I arrived at Picasso's on Rue de la Boétie I was as deeply moved and as full of respect as though I were having an audience with the Pope. 'I have come to see you,' I said, 'before visiting the Louvre.' 'You're quite right,' he answered. I brought a small painting, carefully packed, which was called *Girl of Ampurdán* (p.103). He looked at it for at least fifteen minutes, and made no comment whatever. After which we went up to the next story, where for two hours Picasso showed me quantities of his paintings. He kept going back and forth, dragging out great canvases which he placed against the easel. Then he went to fetch others among an infinity of canvases stacked in rows against the wall. I could see that he was going to enormous trouble. At each new canvas he cast me a glance filled with a vivacity and an intelligence so violent that it made me tremble. I left him without having made the slightest comment either. At the end, on the landing of the stairs, just as I was about to leave we exchanged a glance

290

291

292

293

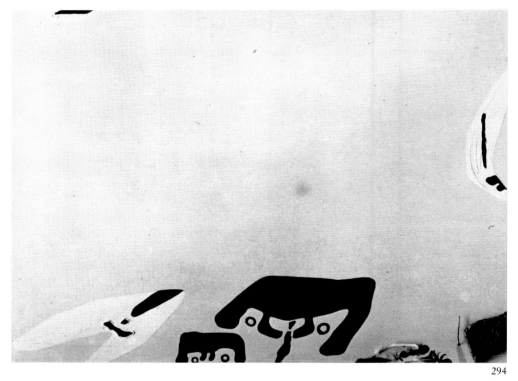

294

which meant exactly, 'You get the idea?' 'I get it!'" Dalí's second visit to Paris, in winter 1928, by no means began as successfully as he hoped. *Le Chien Andalou* (The Andalusian Dog), the film he had made in Figueras with his friend Luis Buñuel and for which he had designed the famous scene in which an eyeball is slit with a razor blade, struck him as mediocre in its finished state. Dalí the provincial was unsettled by the metropolis, which seemed full of traps.

In the *Secret Life* he wrote: "I had not succeeded in finding an elegant woman to take an interest in my erotic fantasies – even any kind of woman, elegant or not elegant! […] I arrived in Paris saying to myself, quoting the title of a novel I had read in Spain, 'Caesar or Nothing!' I took a taxi and asked the chauffeur, 'Do you

295

296

297

know any good whorehouses?' [...] I did not visit all of them, but I saw many, and certain ones pleased me immeasurably. [...] Here I must shut my eyes for a moment in order to select for you the three spots which, while they are the most diverse and dissimilar, have produced upon me the deepest impression of mystery. The stairway of the 'Chabanais' is for me the most mysterious and the ugliest 'erotic' spot, the Theatre of Palladio in Vicenza is the most mysterious and divine 'esthetic' spot, and the entrance to the tombs of the Kings of the Escorial is the most mysterious and beautiful mortuary spot that exists in the world. So true it is that for me eroticism must always be ugly, the esthetic always divine, and death beautiful."

290 **Untitled (The Sea and the Fishermen)**, 1928 ❏
Sans titre (La mer et pêcheurs)

291 **Fishermen in the Sun**, 1928 ❏
Pêcheurs au soleil

292 **Soft Nude (Nude Watch)**, c. 1928 ❏
Le nu mou (Le nu montre)

293 **Abstract Composition**, 1928 ❏
Composition abstraite

294 **Fishermen in Cadaqués**, 1928 ❏
Pêcheurs de Cadaqués

295 **Untitled**, 1928 ❏

296 **Sun, Four Fisherwomen of Cadaqués**, 1928 ❏
Soleil, quatre femmes de pêcheurs à Cadaqués

297 **Shell**, 1928 ❏ Coquillage

1928

298 **The Wounded Bird**, 1928 ❑
L'oiseau blessé

299 **Bird and Fish**, 1928 ❑
Guerrier pêcheur – Ocell-Peix
(Oiseau-poisson)

300 **Big Thumb, Beach, Moon and
Decaying Bird**, 1928 ❑

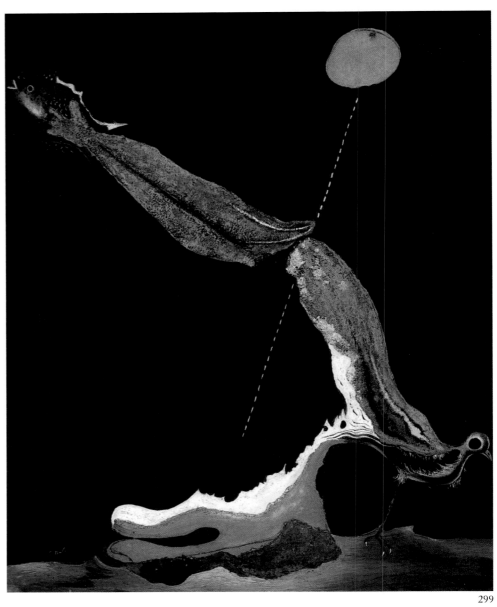

299

298

300

301

301 **Putrefied Bird**, 1928 ❑
Oiseau putrifié

302 **Bird**, 1928 ❑
Oiseau

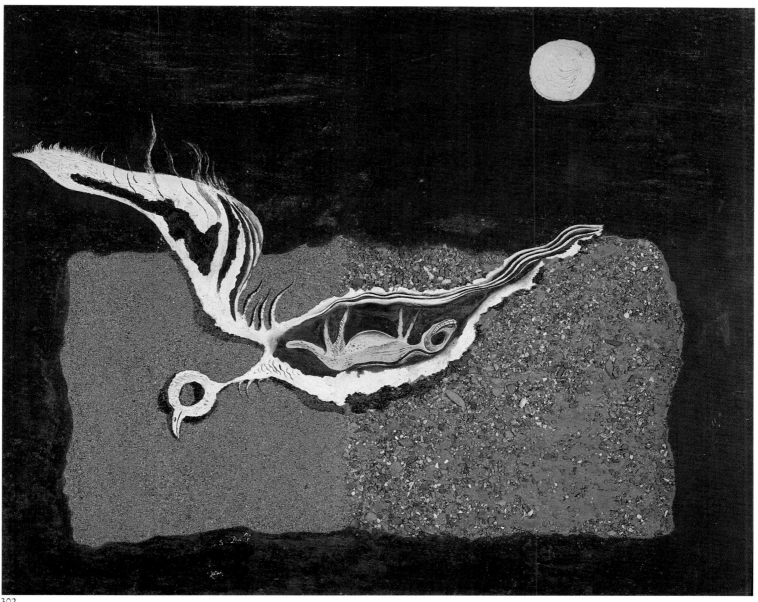

302

1928

303

303 **The Spectral Cow**, 1928 ❏
La vache spectrale

304 **The Ram**, 1928 ❏
Vache spectrale

305 **The Stinking Ass**, 1928 ❏
L'âne pourri

304

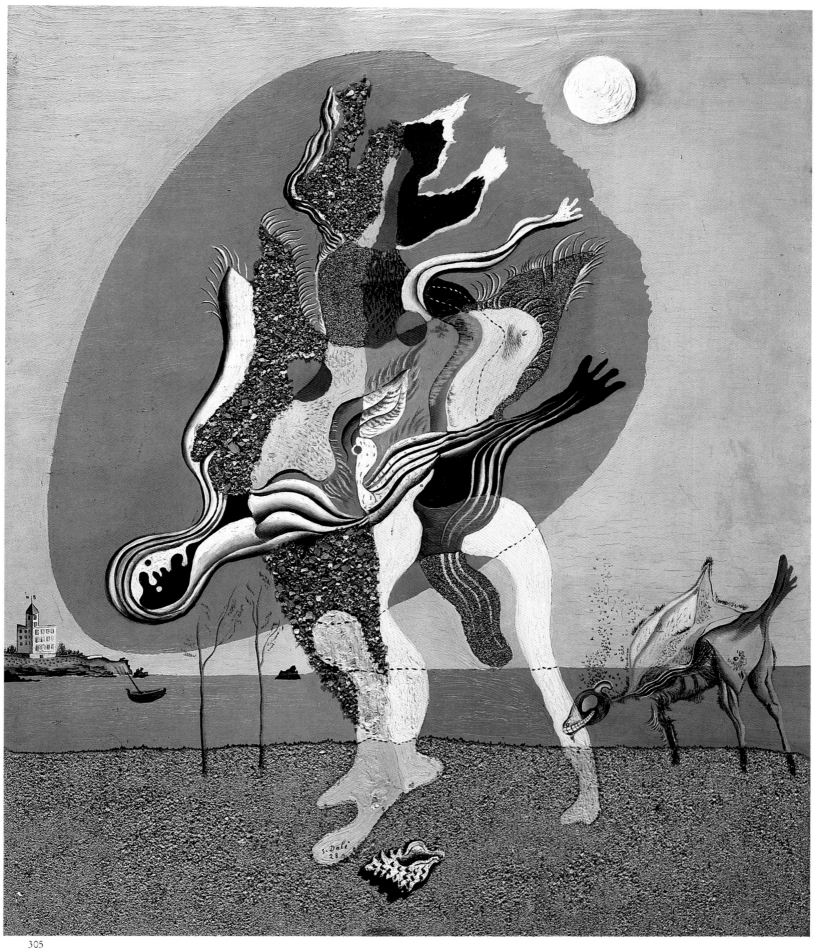

305

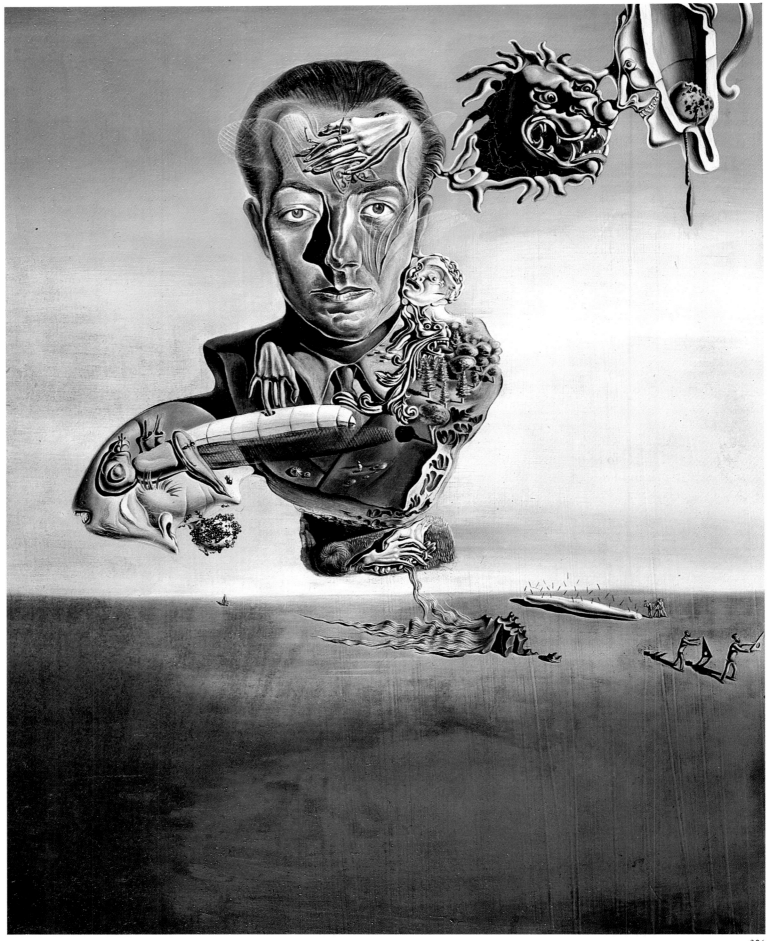

2. The Proof of Love

The year 1929 was a decisive year for Dalí. It marked the turning point at which he was recognized as a paid-up card-carrying Surrealist. Not that this would have gone so smoothly had it not been for the skilful assistance of Miró. "It's going to be hard for you," he had told Dalí. "Don't talk too much" – at this point, Dalí noted in the *Secret Life*, he understood that perhaps Miró's silence was a tactic – "and try to do some physical culture. I have a boxing instructor, and I train every evening. […] Tomorrow we'll go and visit Tristan Tzara, who was the leader of the Dadaists. He is influential. He'll perhaps invite us to go to a concert. We must refuse. We must keep away from music as from the plague. […] The important thing in life is to be stubborn. When what I'm looking for doesn't come out in my paintings I knock my head furiously against the wall till it's bloody." (Dalí had a vision of Miró's bloody wall, and noted: "It was the same blood as my own.")

While Dalí was waiting for *Un Chien Andalou* "to plunge right into the heart of witty, elegant and intellectualized Paris", Buñuel was in fact still busy editing the film. In 1929, Eugenio Montés wrote that the film was "an event in the history of the cinema, writ in blood as Nietzsche would have wished and as has always been the Spanish way." And he continued: "Buñuel and Dalí have just placed themselves resolutely beyond the pale of what is called good taste, beyond the pale of the pretty, the agreeable, the epidermal, the frivolous, the French." For his part, Dalí fled Paris once again, for the soothing familiarity of Catalonia. Pleased as he was to be back in the light of Cadaqués, though, he still sensed that a change was happening within him. He had not yet had much contact with the Surrealists, but now he set out to paint "*trompe l'œil* photographs", making skilful use of all the tricks he had mastered by then. Dalí was a quarter of a century ahead of his time, using techniques that later made him the patron saint of the American photorealists. Dalí's photographic precision was used for his own distinctive ends, though – to transcribe dream images. It was a method that was to become a constant in his work; the first products, dating from this period, may be considered forerunners of his Surrealist paintings proper. As late as 1973, by which time his definition of his own art had been clarified, he was still declaring: "My art is handmade photography of extra-fine, extravagant, super-aesthetic images of the concrete irrational."

Even if Dalí had not yet conquered Paris, white-washed Cadaqués offered him memories of his childhood and adolescence. Now grown to manhood, he felt that he was "trying by every possible means to go mad". Before his departure he had painted all his phantasmagoric private images in a single picture, *Little Cinders* (p.122); and now on his return he found that his fetishist vision was a steadfast thing. The images in that painting meant a great deal to Dalí: they represented memories, fetishist obsessions, love-hate likenesses (including the head of Lorca), hallucinations. It was the first in a series of paintings that were to lead Dalí to the absolute freedom of his "paranoiac-critical" approach; it was also the only one Dalí mentions having painted during his military service. He seems to have fin-

307

306 **Portrait of Paul Eluard**, 1929 ❏
Portrait de Paul Eluard

307 **Retrospective Bust of a Woman**, 1933 ○
Buste de femme rétrospectif

1929

308

310

309

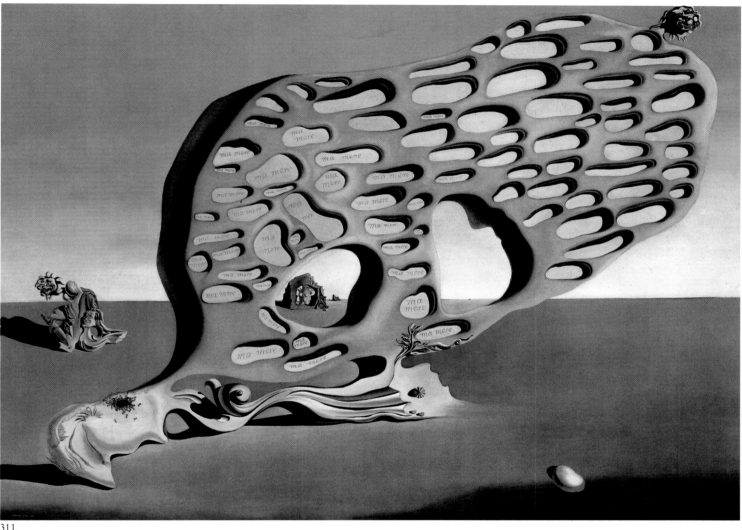

311

ished it in 1928. Dalí identified the items in the picture as a metre ruler, signifying the obsession of a liberating imbalance; the ass's cadaver, pure as mica; the bird-cum-fish, standing for illusions that contain within them the diversity of concrete fact; a hand, for a woman friend seen in a waking dream; a severed head, for melancholy caused by space-time; an anatomical head, for corrosive reality; a thumb, for rare and disturbing things; ambivalent shapes, for the intervention of desire; flies as God's way of pointing mankind to the most hidden laws of the universe; blood, for the independent process of becoming; the guitars and geometrical figures, for spatial presentation of pre-natal memories and mythic childhood. Thus Dalí.

At the time of *The Stinking Ass* (p. 137) – which he considered far superior to Buñuel's film – and *Nude Woman Seated in an Armchair* (p.123), which he painted violently, poking a finger into the canvas to mark the navel and impishly calling the dribble of paint down the canvas a nude woman, Dalí worked in a state of exalted tension punctuated with "spasmodic explosions of laughter". In his *Secret Life* he reported that he could be heard out in the garden, where his father,

308 **Amalgam – Sometimes I Spit on the Portrait of my Mother for the Fun of it**, 1929 △
L'amalgame – Parfois je crache par plaisir sur le portrait de ma mère

309 **Study for "The Enigma of Desire – My Mother, my Mother, my Mother"**, 1929 △

310 **Studies for "The Enigma of Desire" and "Memory of the Child-Woman"**, 1929 △

311 **The Enigma of Desire – My Mother, my Mother, my Mother**, 1929 ❏
L'énigme du désir – ma mère, ma mère, ma mère

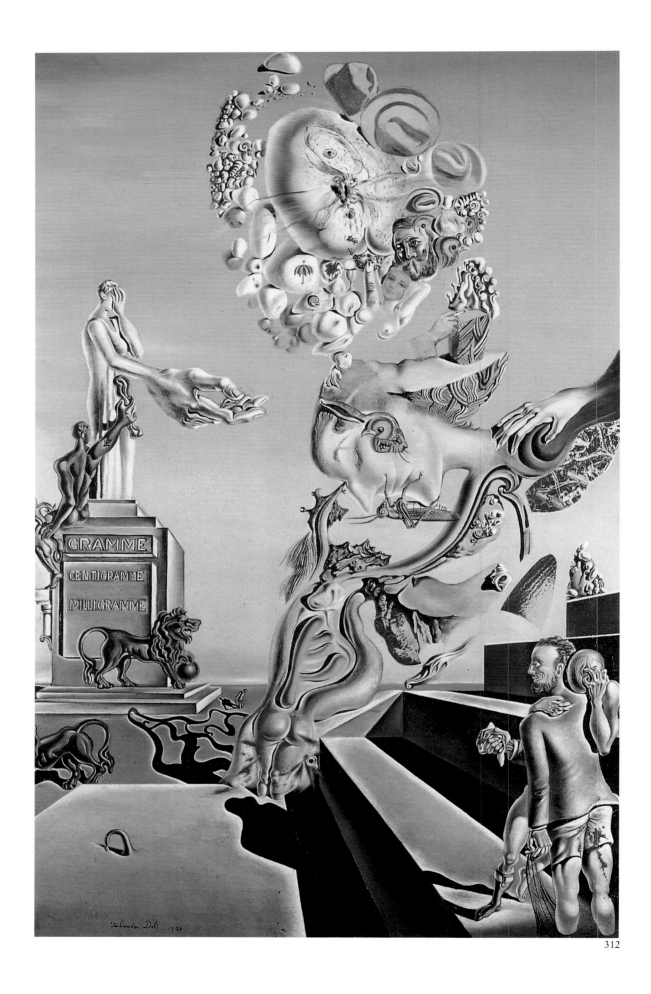

GRAMME

CENTIGRAMME

MILLIGRAMME

Salvador Dali 1929

312

313

312 **The Lugubrious Game**, 1929 ❏
Le jeu lugubre

313 **Study for "The Lugubrious
Game"**, 1929 △

314 **Print and comment by Georges
Bataille for his article "The Lugu-
brious Game"**, 1929 ☆

314

The Lugubrious Game

Dalí's title **The Lugubrious Game** can be
taken as an explicit pointer to the meaning of the
painting, which presents castration and the con-
flicting reactions to it in great detail and with
extraordinary expressive power. Without
claiming to be able to analyse all the elements
in the picture, I wish only to adumbrate the
thematic outline. The act of castration is ex-
pressed through figure **A**, the body of which is
slit from the belly. The provocation prompted
by this bloody act is expressed in **B** through
male dreams of boyish, burlesque recklessness
(the male elements are expressed not only in the
bird head but also in the red umbrella, the fe-
male in the hats). But the deep, age-old reason
for the punishment is none other than the dis-
gusting dirt on the underpants of **C**, a dirt for
which there seems no occasion, for this figure
finds a new, true masculinity in disgrace and
horror. The statue at the left (**D**) personifies the
unusual satisfaction given by the sudden castra-
tion, and betrays a need for the none too male
poetic extension of the game. The hand cover-
ing the statue's face breaks the rules of Dalí's
art, in which people who have lost their heads
normally only find them again if they pull hor-
rified faces. We may therefore ask in all ser-
iousness how it must be for those for whom the
mind's windows are opened wide for the first
time and who see castrated, poetic pleasure
where there is no more than an urgent need to
recourse to shame.

Georges Bataille

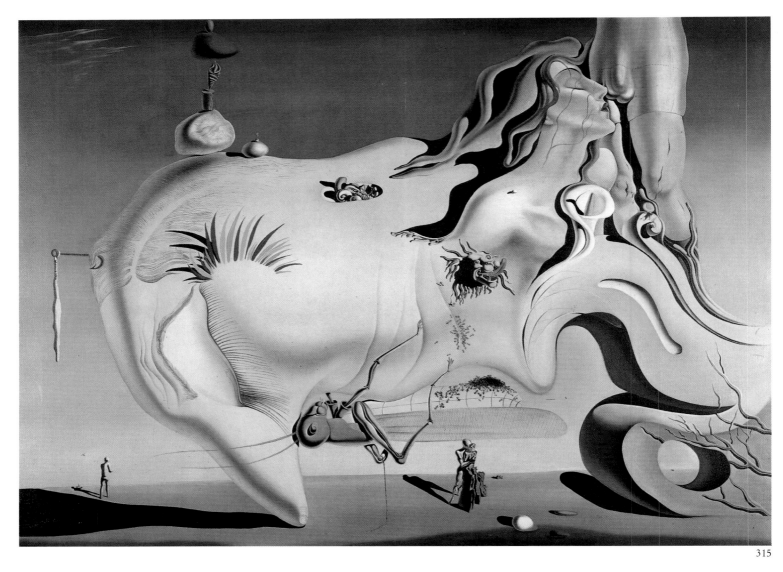

315

316

317

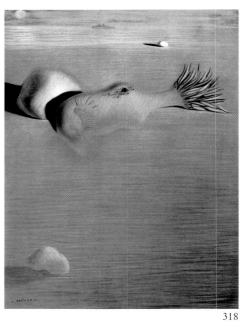

318

319

"amused and preoccupied as he watered a skeletal rosebush wilting in the heat", would observe: "That child laughing again!"

Dalí set to work on two paintings that inaugurated his Surrealist period: *The Enigma of Desire – my Mother, my Mother, my Mother* (p. 141) and *The Lugubrious Game* (p. 142). The latter took its title from the French poet Paul Eluard. The figure wearing shit-stained underpants made the painting notorious in Barcelona even before the scandal shocked the Surrealists. In the former painting, the baroque superstructure emblazoned with the words *ma mère* is taken from the windblown geological rock formations of Cape Creus, with a little imaginative help from the architectural genius of Antoni Gaudí.

At the very moment he finished this painting, Dalí came across a coloured lithograph of the Sacred Heart at the Rambla in Figueras, and wrote on it: "Sometimes I spit on the picture of my mother for the fun of it." In his view (he subsequently explained in justification) it was perfectly possible to love one's mother wholeheartedly and still dream of spitting on her; indeed, he pointed out, in some religions spitting was a sacred act!

Parallel to the painting of *The Enigma of Desire*, Dalí began work on *The Great Masturbator* (p. 144), using a colour photograph bought at a fairground, of a woman smelling a lily. Once Dalí's brush got to work, of course, it was no longer a lily that the woman was taking to her nose and mouth. His main obsession at that time can best be termed desire. In Paris he had not succeeded in finding the elegant woman he sought, or even a not so elegant woman to comply

320

321

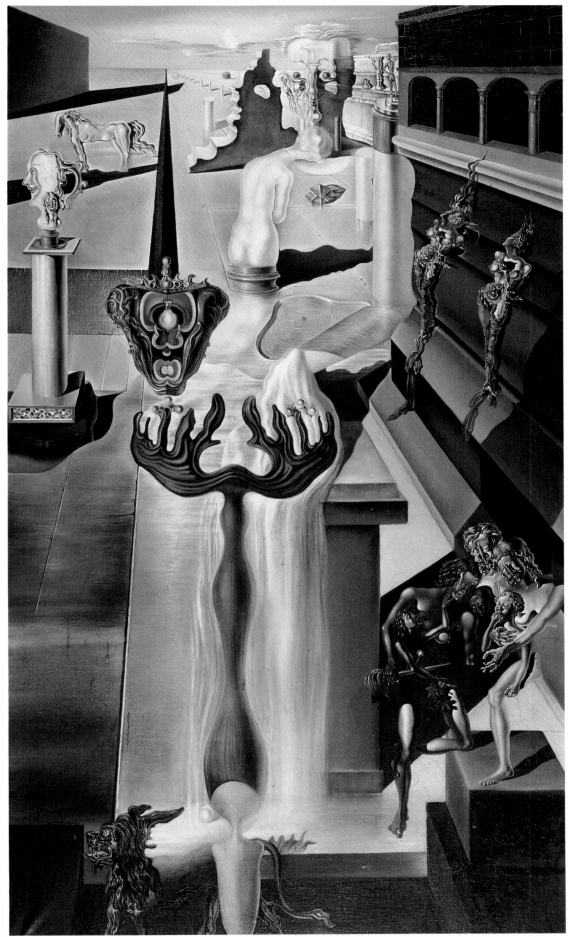

322

323

321 **Study for "The Invisible Man"**, 1929 △

322 **The Invisible Man,** 1929 ❑
L'homme invisible

323 **Gradiva (Study for "The Invisible Man")**, 1930 △
Gradiva

325

**324 Accommodations of Desire,
1929** ❏
L'accommodation du désir

**325 Man of Sickly Complexion
Listening to the Sound of the Sea,
or, The Two Balconies**, 1929 ❏
Homme d'une complexion malsaine
écoutant le bruit de la mer ou Les deux
balcons

with his every erotic fantasy. He had roamed the streets like a dog looking for a
bitch, he recalled; but when he *did* happen across a suitable woman, "timidity"
prevented him from talking to her. It was, he declared in retrospect, pitiful that
the young artist who set out to conquer Paris could not even conquer a plain Jane.

When he was painting these first Surrealist works, and particularly *The Great
Masturbator*, Dalí's mind went back to the unattainable women of Paris: "With
my hand, before my wardrobe mirror, I accomplished the rhythmic and solitary
sacrifice in which I was going to prolong as much as possible the incipient pleas-
ure looked forward to and contained in all the feminine forms I had looked at
longingly that afternoon, whose images, now commanded by the magic of my
gesture, reappeared one after another by turn, coming by force to show me of
themselves what I had desired in each one! At the end of a long, exhausting and
mortal fifteen minutes, having reached the limit of my strength, I wrenched out
the ultimate pleasure with all the animal force of my clenched hand, a pleasure
mingled as always with the bitter and burning release of my tears – this in the
heart of Paris, where I sensed all about me the gleaming foam of the thighs of
feminine beds. Salvador Dalí lay down alone in his bed [...]"

But presently there was good news, for Dalí's desires and his bank balance
alike. First an enthusiastic telegram arrived from the dealer Camille Goemans, to
the effect that, in addition to buying three paintings (to be chosen by Dalí) for
3,000 francs, he would exhibit all his work at his Paris gallery once Dalí returned
to the French capital. Then a group of Surrealists descended upon him, no doubt
attracted partly by the Catalonian's eccentricity and partly by the sexual and
scatological extravagance of his work. Among them were René Magritte and his
wife, Luis Buñuel, and above all Paul Eluard and his wife Gala. It was a visit that
changed Dalí's life.

Dalí felt flattered that Paul Eluard should have come to see him. With André
Breton and Louis Aragon, Eluard was one of the leading lights of the Surrealist

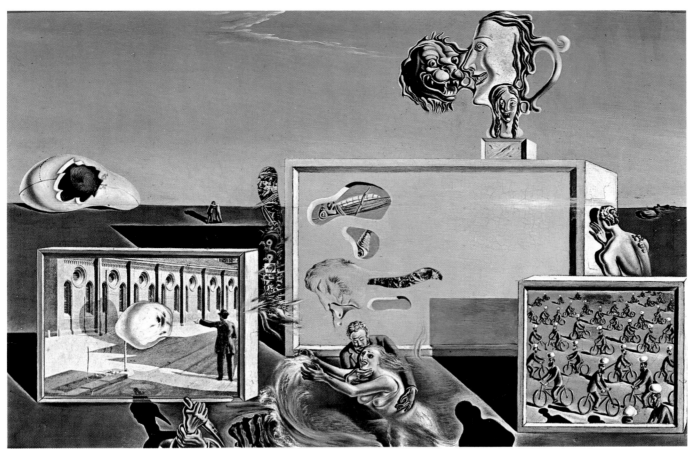

326

movement. As for Gala, she was a revelation – the revelation Dalí had been waiting for, indeed expecting. She was the personification of the woman in his childhood dreams to whom he had given the mythical name Galuchka and for whom various young and adolescent girls had already stood in. He recognized her by her naked back; the proof that Gala was the woman was provided by the fact that her physique was precisely that of the women in most of his paintings and drawings. In the *Secret Life* he later described her in these terms: "Her body still had the complexion of a child's. Her shoulder blades and the sub-renal muscles had that somewhat sudden athletic tension of an adolescent's. But the small of her back, on the other hand, was extremely feminine and pronounced, and served as an infinitely svelte hyphen between the wilful, energetic and proud leanness of her torso and her very delicate buttocks which the exaggerated slenderness of her waist enhanced and rendered greatly more desirable."

The problem was that whenever Daí tried to talk to her, he went into a fit of laughter. *The Lugubrious Game* (p.142), featuring the underpants stained with excrement, was painted with such enthusiastic realism that friends and visitors wondered whether Dalí had coprophagic tendencies. Gala decided to put an end to the speculation and met Dalí for a walk along the cliffs, in the course of which the painter managed to restrain his laughter for once. In response to her question, he hesitated: "If I admitted to her that I was coprophagic, as they had suspected, it would make me even more interesting and phenomenal in everybody's eyes [...]" But Dalí opted for the truth: "I swear to you that I am not 'coprophagic'. I consciously loathe that type of aberration as much as you can possibly loathe it. But I consider scatology a terrorizing element, just as I do blood, or my phobia for grasshoppers." The Surrealists were alarmed by the picture because of the excrement, and Georges Bataille saw "an appalling ugliness" in it. Bataille detected fears of castration in the painting: the body of the figure in the centre, intent on male dreams, has been torn apart. To its right, a besmirched figure is just

327

326 **Illuminated Pleasures**, 1929 ❏
Les plaisirs illuminés

327 **The First Days of Spring**, 1929 ❏
Les premiers jours du printemps

1929

328

329

328 **The Butterfly Chase**, 1929 △
La chasse aux papillons

329 **Phantasmagoria**, 1929 ❏
Phantasmagora

330 **Profanation of the Host**, 1929 ❏
Profanation de l'hostie

331 **Imperial Monument to the
Child-Woman**, 1929 ❏
Monument impérial à la femme-enfant

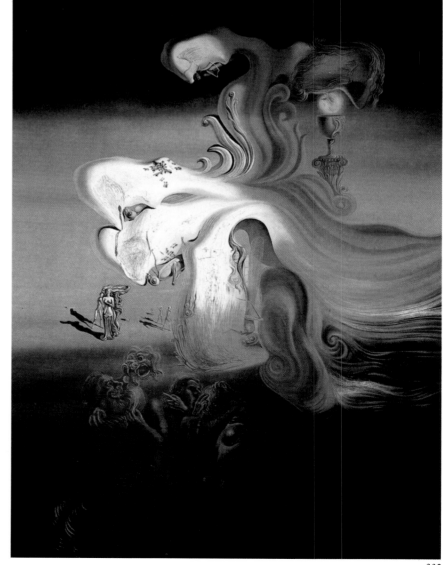

330

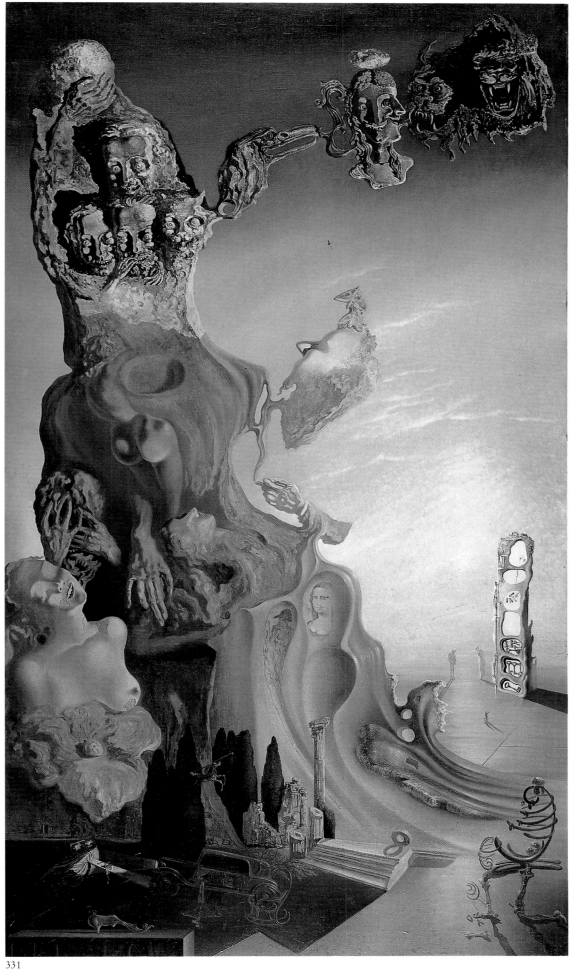

331

332

333

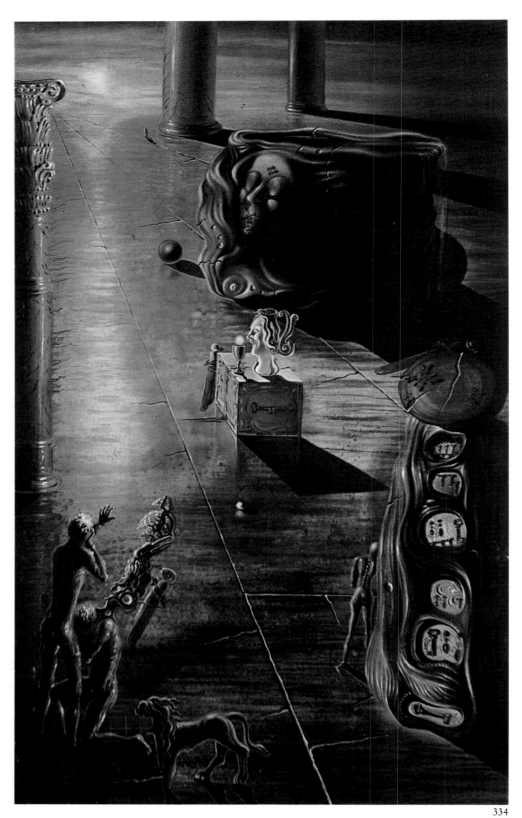

334

332 **Pyre. Poster design for the 10th anniversary of the French Communist Party**, 1930 △
333 **Combinations (or The Complete Dalinian Phantasms: Ants, Keys, Nails)**, 1931 △
Combinaisons
334 **The Font**, 1930 ❑
La fontaine

escaping castration by "shameful and repellent" behaviour, while the figure on the left is "enjoying his own castration" and seeking a "poetic dimension". Dalí rejected this interpretation, and indeed it led to a break between Bataille and the Surrealists.

In the course of the long walks Dalí and Gala were now regularly taking along the cliffs at Cape Creus, an intensely melancholy spot, Dalí told her he loved her. He did so in the interval between two fits of laughter; it did not come easily. The woman everyone called Gala – her name was Helena Devulina Diakanoff, and she

was the daughter of a Moscow lawyer – was a fascinating, charming, self-confident person, and she made quite an impression on Dalí. To have her body so close to his own took his breath away. "Did not the fragile beauty of her face of itself vouch for the body's elegance?" he noted later. As a girl, Gala had been treated for a lung complaint. "I looked at her proud carriage as she strode forward with the intimidating gait of victory, and I said to myself, with a touch of my budding humor, 'From the esthetic point of view victories, too, have faces darkened by frowns. So I had better not try to change anything!'"

"I want you to kill me!"

Despite his "timidity", Dalí did contrive to put an arm around Gala's waist – though it was her hand then that took his. "This was the time to laugh, and I laughed with a nervousness heightened by the remorse which I knew beforehand the vexing inopportuneness of my reaction would cause me. But instead of being wounded by my laughter, Gala felt elated by it. For, with an effort which must have been superhuman, she succeeded in again pressing my hand, even harder than before, instead of dropping it with disdain as anyone else would have done. With her medium-like intuition she had understood the exact meaning of my laughter, so inexplicable to everyone else. She knew that my laughter was altogether different from the usual 'gay' laughter. No, my laughter was not scepticism; it was fanaticism. My laughter was not frivolity; it was cataclysm, abyss, and terror. And of all the terrifying outbursts of laughter that she had already heard from me this, which I offered her in homage, was the most catastrophic, the one in which I threw myself to the ground at her feet, and from the greatest height! She said to me, 'My little boy! We shall never leave each other.'"

Dalí himself provided the key, both historical and Freudian in character, to their love, which was born that very moment and lasted until death: "She was destined to be my Gradiva, 'she who advances', my victory, my wife. But for this she had to cure me, and she did cure me […] solely through the heterogeneous, indomitable and unfathomable power of the love of a woman, canalized with a biological clairvoyance so refined and miraculous, exceeding in depth of thought and in practical results the most ambitious outcome of psychoanalytical methods." Not long before, Dalí had read Wilhelm Jensen's novel *Gradiva*, which Sigmund Freud had analyzed in *Delusion and Dreams*. The heroine of the title, Gradiva, heals the male protagonist psychologically. "I knew," wrote Dalí, "that I was approaching the 'great trial' of my life, the trial of love."

At this time, of such crucial importance in his emotional life, Dalí was primarily engaged on another painting on the subject of desire: *Accommodations of Desire* (p. 148). In it, desire is symbolized by lions' heads. Trembling, he asked Gala: "'What do you want me to do to you?' Then Gala, transforming the last glimmer of her expression of pleasure into the hard light of her own tyranny, answered, 'I want you to kill me!'" Dalí noted: "One of the lightning-ideas that flashed into my mind was to throw Gala from the top of the bell-tower of the Cathedral of Toledo." But Gala, as we might predict, proved the stronger of the two: "Gala thus weaned me from my crime, and cured my madness. Thank you! I want to love you! I was to marry her. My hysterical symptoms disappeared one by one, as by enchantment. I became master again of my laughter, of my smile, and of my gestures. A new health, fresh as a rose, began to grow in the centre of my spirit."

Dalí saw Gala off at the station in Figueras, where she took a train to Paris. Then he retired to his studio and resumed his ascetic life, completing the *Portrait of Paul Eluard* (p. 138) which the writer had been sitting for. He also worked very hard to complete *The Great Masturbator* (p. 144), which was to achieve notoriety in due course. "It represented a large head, livid as wax, the cheeks very pink, the

335

337

N° 12 Cinquième année 15 Décembre 1929

LA RÉVOLUTION SURRÉALISTE

QUELLE SORTE METTEZ-VOUS
D' DANS
ESPOIR L'AMOUR?

SOMMAIRE

336

338

335, 338, 339, 340 Sequences from
the first film by Buñuel and Dalí:
"Un chien andalou". Buñuel strop-
ping his razor; the cut eye; the but-
tocks changing into breasts; the dead
donkey, 1929 ✫

336 Front cover of the edition of
"La Révolution Surréaliste", in
which "Un chien andalou" was pub-
lished, 1929 ✫

337 Tactile Cinema, 1930–1931 △
Le cinéma tactile

A Dagger in the Heart of Paris

The film *Un chien andalou* made Buñuel and Dalí famous overnight. They had planned to plunge it "right into the heart of witty, elegant and intellectualized Paris" – and even if Dalí felt the audience that applauded the film was a jaded one, willing to applaud anything novel or bizarre, he was still happy to note the success in his *Secret Life:* "The film produced the effect that I wanted, and it plunged like a dagger into the heart of Paris as I had foretold. Our film ruined in a single evening ten years of pseudo-intellectual post-war advance-guardism. That foul thing which is figuratively called abstract art fell at our feet, wounded to the death, never to rise again, after having seen a girl's eye cut by a razor blade – this was how the film began. There was no longer room in Europe for the little maniacal lozenges of Monsieur Mondrian."

339

340

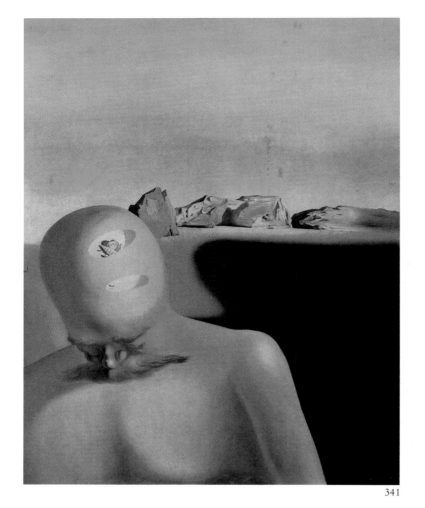

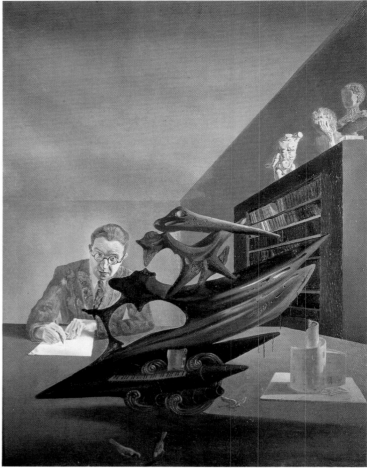

341

343

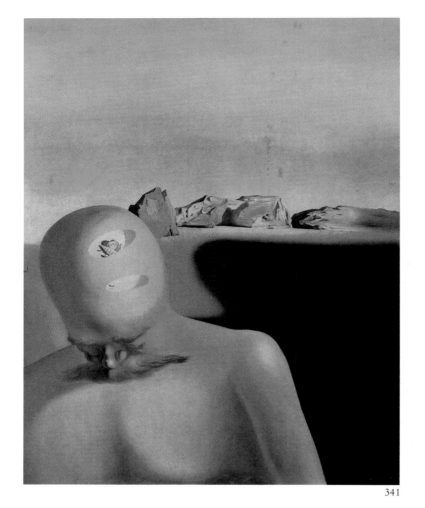

342

341 **The Average Bureaucrat, 1930** ❏
Le bureaucrate moyen

342 **Photomontage by Dalí for the frontispiece of his book "L'amour et la mémoire" (Love and Memory). Buñuel took the photo of Dalí in 1929 and Dalí took that of Gala in 1931.** ✭

343 **Portrait of Emilio Terry (unfinished), 1930** ❏
Portrait de Monsieur Emilio Terry

344 **The Hand – Remorse, 1930** ❏
La main – Les remords de conscience

345, 346 **Stills from the second Buñuel and Dalí film, "L'Age d'Or" (The Golden Age), 1930** ✭

1930–1931

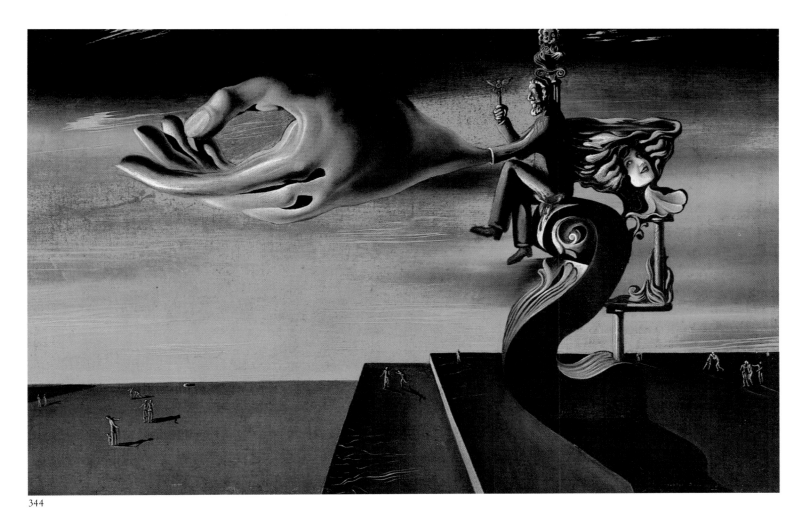

344

eyelashes long, and the impressive nose pressed against the earth," Dalí wrote in his *Secret Life*. "This face had no mouth, and in its place was stuck an enormous grasshopper. The grasshopper's belly was decomposed, and full of ants. Several of these ants scurried across the space that should have been filled by the non-existent mouth of the great anguishing face, whose head terminated in architecture and ornamentations of the style of 1900."

This painting was a kind of "soft" self-portrait of the artist after his Gradiva experience. Dalí had a complete theory of "softness" and "hardness". In the picture he is visibly exhausted, soft as rubber, with ants and a grasshopper on his face. It looks the very image of misery – but there is an explanation in the female face positioned for fellatio: that summer, Dalí had known his ecstasy, of a kind he was to represent again on the ceiling of a room in the Figueras theatre-museum. Dalí frequently claimed to be "totally impotent", but the fact is that he appears a perfectly good performer in certain pictures. We need only think of the 1934 *Atmospheric Skull Sodomizing a Grand Piano* (p. 234), or of *Average Fine and Invisible Harp* (p. 186), painted in 1932 after a photograph he himself took at Port Lligat. Gala can be seen in the latter painting, walking away, her derrière still exposed, while in the foreground the "erectile, budding head" of the foremost figure is resting on a crutch. The crutch, and the monstrous outgrowth of mental sexuality sublimated in art, also serve as symbols of death and resurrection – like the act of love itself.

345

346

1930–1931

347 Title page of "La Femme visible" with Gala's eyes, 1930 ☆
348 The Immaculate Conception, by André Breton and Paul Eluard, with illustrations by Dalí, 1930 ☆

347

348

349

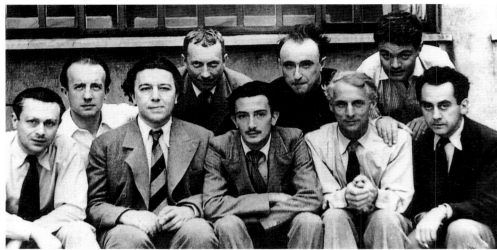

350

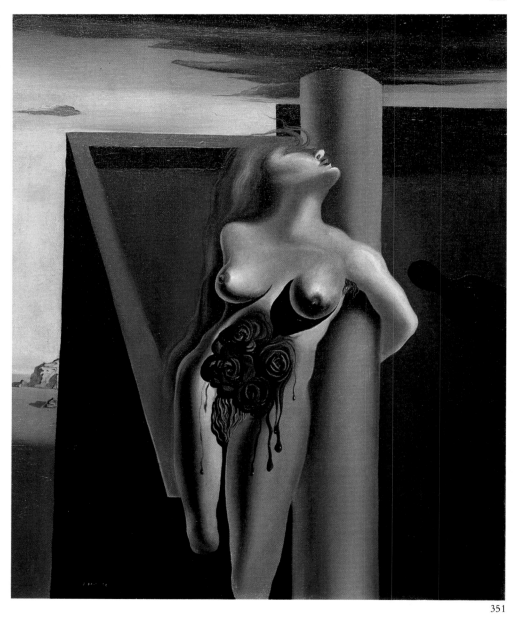

351

349 André Breton, The Great Anteater, 1929–1931 Δ
André Breton le Tamanoir

350 The Surrealist Group in Paris, c. 1930. Left to right: Tristan Tzara, Paul Eluard, André Breton, Hans Arp, Salvador Dalí, Yves Tanguy, Max Ernst, René Crevel, Man Ray ☆

351 The Bleeding Roses, 1930 ❑
Les roses sanglantes

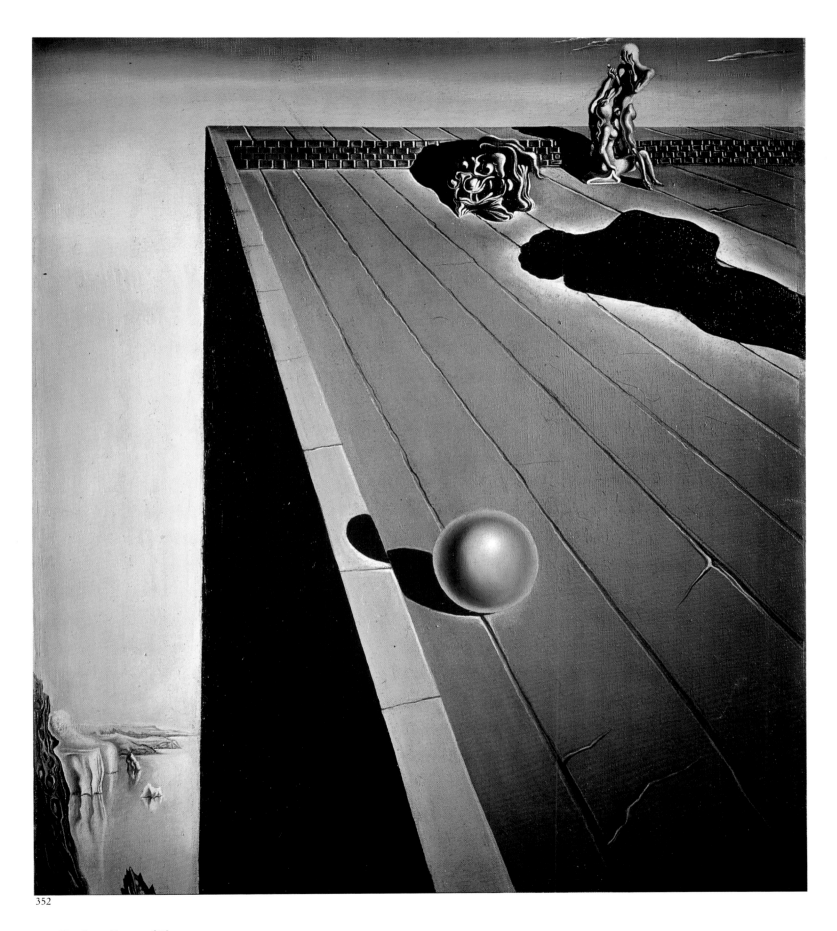

352

352 Vertigo – Tower of Pleasure,
1930 ❏
Vertige – Tour du plaisir

159

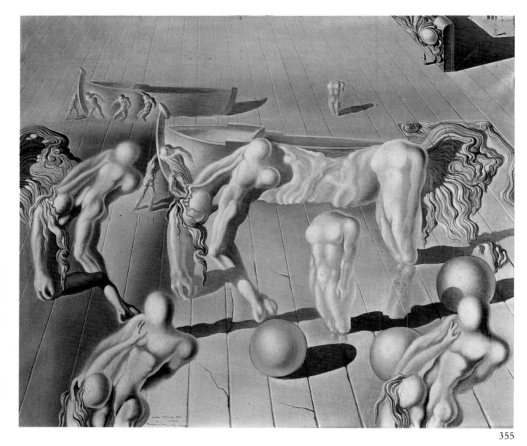

353

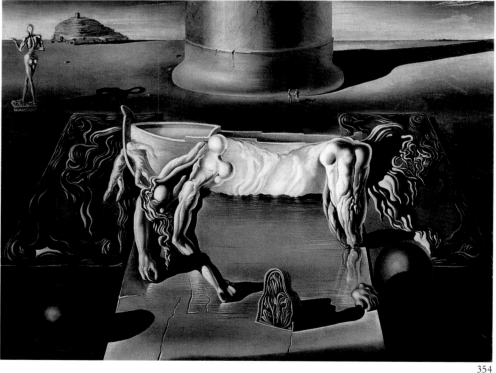

355

354

353 Study for "Invisible Sleeping Woman, Horse, Lion" and for "Paranoiac Woman-Horse", 1929–1930 △

354 Paranoiac Woman-Horse, 1930 ❑
Femme-cheval paranoïaque

355 Invisible Sleeping Woman, Horse, Lion, 1930 ❑
Dormeuse, cheval, lion invisibles

356 Invisible Sleeping Woman, Horse, Lion, 1930 ❑
Dormeuse, cheval, lion invisibles

357 Study for "Invisible Sleeping Woman, Horse, Lion", 1930 △

358 Study for "Invisible Sleeping Woman, Horse, Lion", c. 1930 △

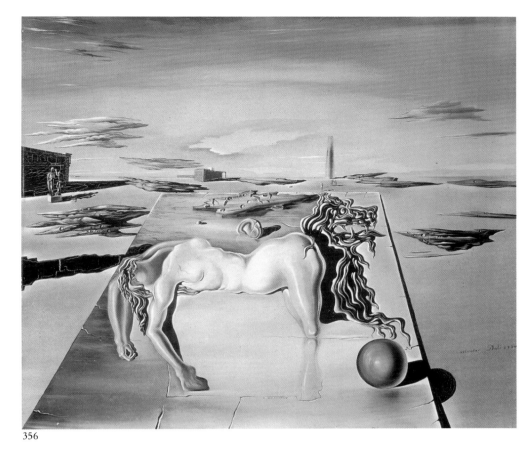

356

357

358

Dalí worked hard for a month, and then hired a joiner to crate his pictures for despatch to Paris, monitoring the work himself; the Goemans gallery was due to exhibit his work from 20 November to 5 December. Then, without a thought for the opening, he went to fetch Gala. Crazed with love, they left Paris two days before the opening and travelled to Barcelona, and then on to Sitgès, a small seaside town. The most ambitious of contemporary artists, Dalí had not even seen his work hung; and, indeed, he recalled that, on their travels, he and Gala were so busy with their own, physical exhibition that they had not a thought to spare for his exhibition of paintings.

Disowned

But clouds were gathering in the sky above the idyll. First Dalí left Gala for the time being, to collect money from Goemans: most of his pictures had been sold, for prices between 6,000 and 12,000 francs. Then he had to face the family storm that was brewing back in Figueras.

For a long time, Dalí was secretive about the origins of the breach with his family, the reasons why he was expelled from their midst; and doubtless the motive for his secrecy was consideration for his father. His 1933 picture *The Enigma of William Tell* (p. 201) suggests an explanation: "William Tell is my father and the little child in his arms is myself; instead of an apple I have a raw cutlet on my head. He is planning to eat me. A tiny nut by his foot contains a tiny child, the image of my wife Gala. She is under constant threat from this foot. Because if the foot moves only very slightly, it can crush the nut." The painting shows Dalí settling accounts with his father, who had disowned him because he was living with a divorcée (i.e. Eluard's ex-wife, as Gala was by then). A second reason for Dalí's breach with his father was doubtless the picture of the Sacred Heart on which he had written, "Sometimes I spit on the picture of my mother

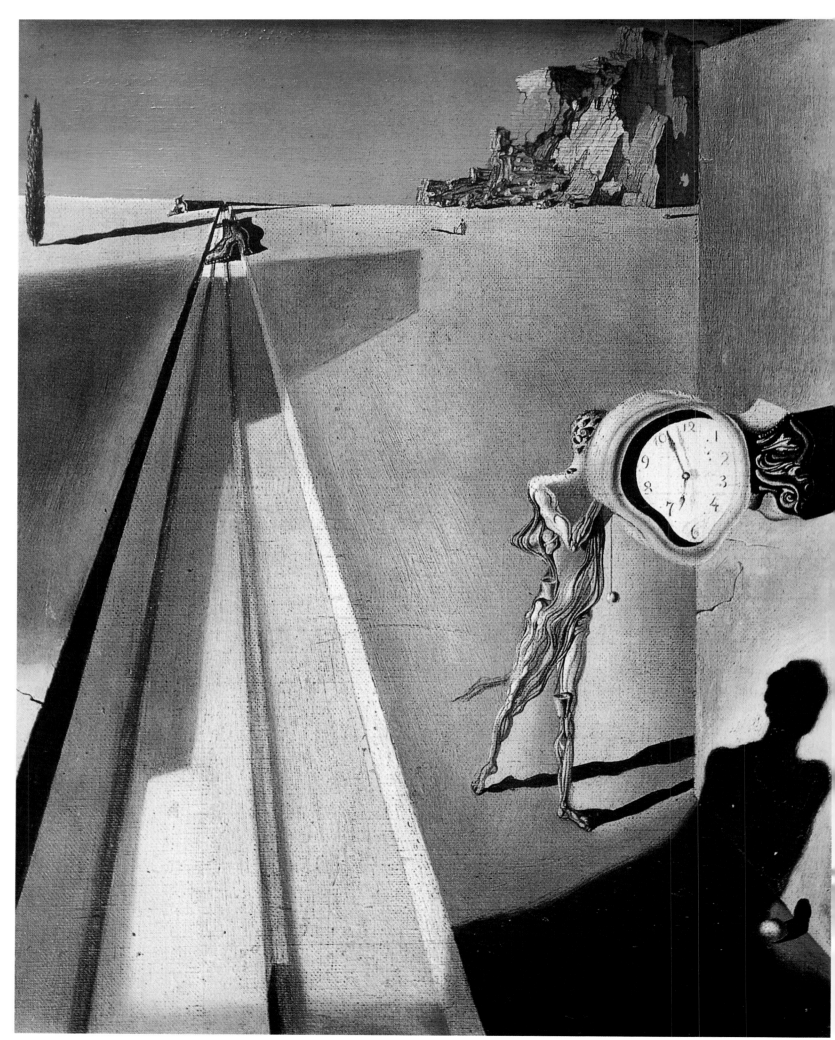

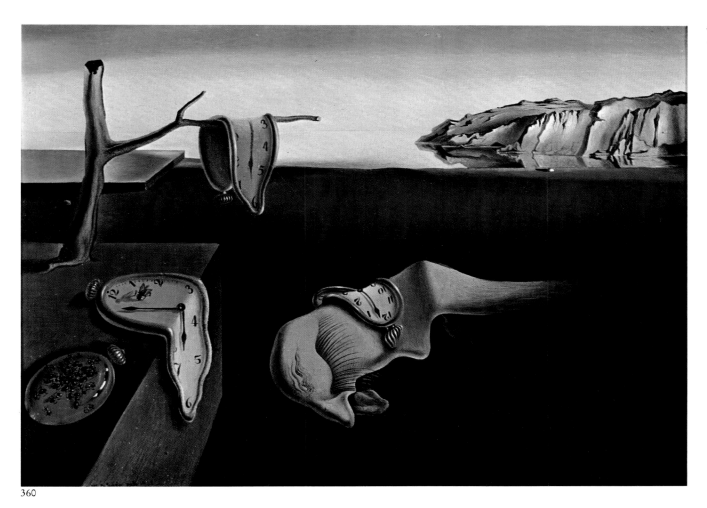

360

for the fun of it." Eugenio d'Ors, a Spanish art critic, described this sacrilege in an article he published in a Barcelona daily paper. Dalí's father, outraged by the blasphemy and by the insult offered to the memory of a dead, beloved wife and mother, never forgave his son.

The Hero and Victor

In his *Diary of a Genius*, one of Dalí's chapter headings is a quotation from Freud: "The hero is the man who resists his father's authority and overcomes it." Greatly though Dalí admired his charismatic and humane father, he had to make the break and turn his back on the years of his youth. However, he loved his chalk-white village in the sun more than anywhere else and refused even to look at other landscapes – which meant he had to return as soon as possible. With the proceeds of *The Old Age of William Tell* (p. 175) he bought a tumbledown fisherman's hut in a sheltered bay near Cadaqués, at Port Lligat (the name means "harbour secured with a knot"), planning to move there with Gala. It was to be the landscape Dalí most frequently painted.

Once he knew that an irreparable breach had been made and that he must be a stranger to his father's house, Dalí reacted by cutting his hair – his way of going in sackcloth and ashes. "But I did more than this – I had my head completely shaved. I went and buried the pile of my black hair in a hole I had dug on the beach for this purpose, and in which I interred at the same time the pile of empty shells of the urchins I had eaten at noon. Having done this I climbed up on a small hill from which one overlooks the whole village of Cadaqués, and there, sitting under the olive trees, I spent two long hours contemplating that panorama of my childhood, of my adolescence, and of my present."

361

359 Premature Ossification of a Railway Station, 1930 ❑
Ossification prématurée d'une gare

360 The Persistence of Memory (Soft Watches), 1931 ❑
Persistance de la mémoire

361 Figure Clock, 1931 △
Figure-horloge

163

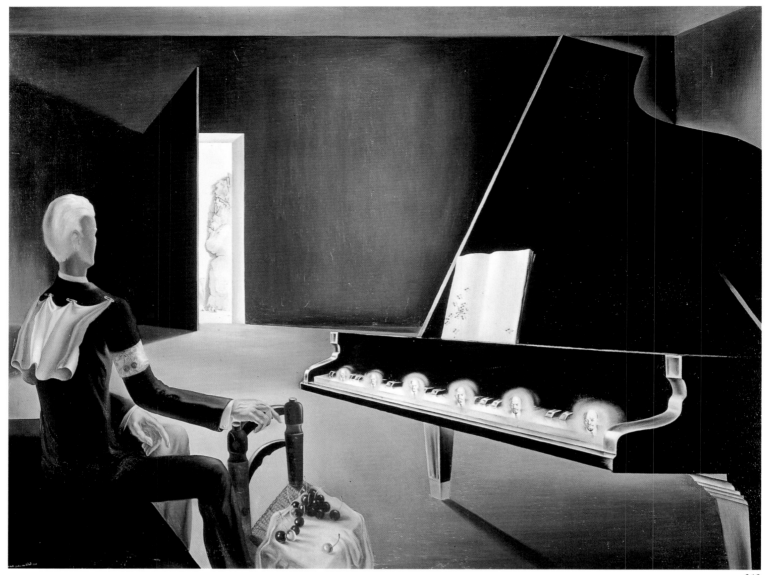

362

363

Dalí's father, for his part, declared that within a week his son would be back in Figueras, in need of a good de-lousing, to beg forgiveness. But he had reckoned without Gala and her clear-eyed capacity to sit things out. And when Dalí did finally return, it was crowned with laurels: the hero who had won a victory over his father, in classic Freudian style.

Hard Rocks and Soft Watches

Great masterworks are born of pain. In his cottage at Port Lligat, Dalí now set about painting like one possessed. *Invisible Sleeping Woman, Horse, Lion* (p. 160) was surely the major work of this period; while *The Invisible Man* (p. 147) is the first double-image picture of a man and a woman, a fetish to protect the two lovers, Dalí and Gala, from Dalí's father and other dangers. *Invisible Sleeping Woman, Horse, Lion* not only examines Dalí's recurring theme of the persistence of desire, but is also an investigation of multiple-image possibilities such as the artist was to explore over and over again in the sequel. The multiple image, to Dalí's way of thinking, could extend the "paranoiac" process by adding a second and even third visual dimension: the set of possible dimensions or associations was limited only by the "paranoiac" capacity of thought itself. If there are obvious erotic meanings in the groups of figures busy at fellatio, the absence of bright colours in the picture and the geological character of the figures have an

362 **Partial Hallucination. Six Apparitions of Lenin on a Grand Piano**, 1931 ❏
Hallucination partielle. Six apparitions de Lénine sur un piano

363 **Head of Hair**, 1930 △
La chevelure

364 **Study for "The Dream"**, 1930 △

365 **The Dream**, 1931 ❏
Le rêve

364

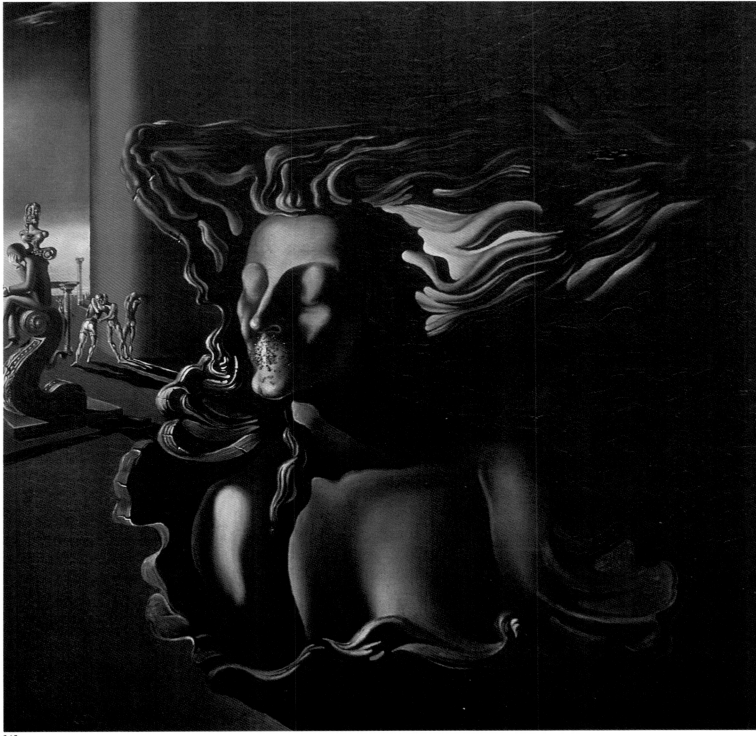

365

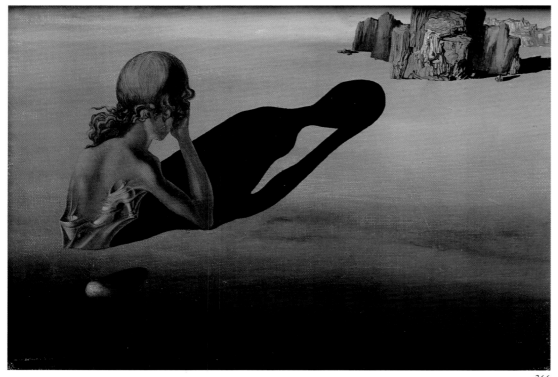

366

367

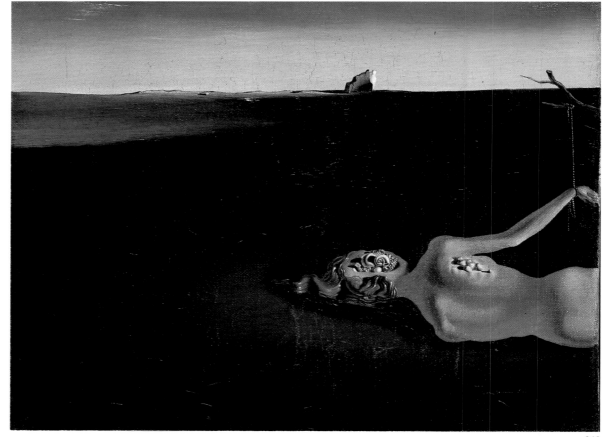

369

368

366 **Remorse, or, Sunken Sphinx,** 1931 ❑
Remords ou Sphynx enlisé

367 **Untitled – Erotic Drawing,** 1931 Δ Sans titre – Dessin érotique

368 **Erotic Drawing,** 1931 Δ
Dessin érotique

369 **Woman Sleeping in a Land-scape,** 1931 ❑
Femme dormant dans un paysage

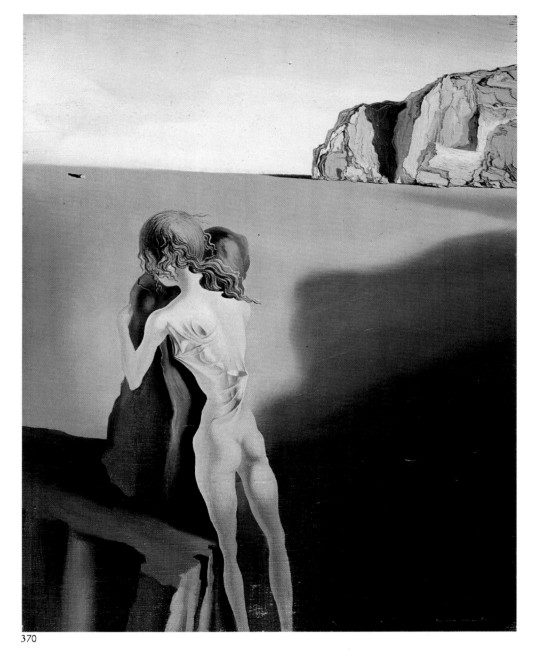

370

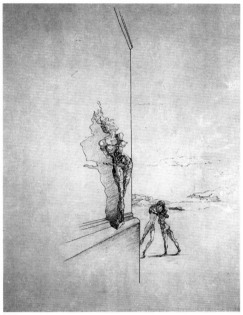

371

372

oddly contrapuntal effect. Dalí commented that his models looked like boats being hawled by weak, fossilized fishermen.

Invisible Sleeping Woman, Horse, Lion, the product of Dalí's contemplative retreat at Cape Creus, was exhibited at the Galerie Colle. Dalí had just signed a new contract with dealers George Keller and Pierre Colle. The picture was bought by the Vicomte de Noailles. Dalí in fact did three versions of it, since he attached considerable importance to the subject; but he gave different titles to them. One of the three was destroyed in 1930 during the demonstrations that accompanied the première of the film *L'Age d'Or* at Studio 28 in Paris.

This was also the period of Dalí's famous soft watches. The painting *Soft Watches*, subsequently retitled *The Persistence of Memory* (p.163), can stand as an illustration of Dalí's theory of "hardness" and "softness", which was central to his thinking at that time. The principle of "hardness" involved such things as the rocks and cliffs at Cape Creus, where the Pyrenees meet the sea. It was there that Dalí and Gala withdrew from the turmoil of the age. "The long, meditative contemplation of those rocks" played a vital part in the development of his "morphological esthetics of soft and hard" – which corresponds to the aesthetic of

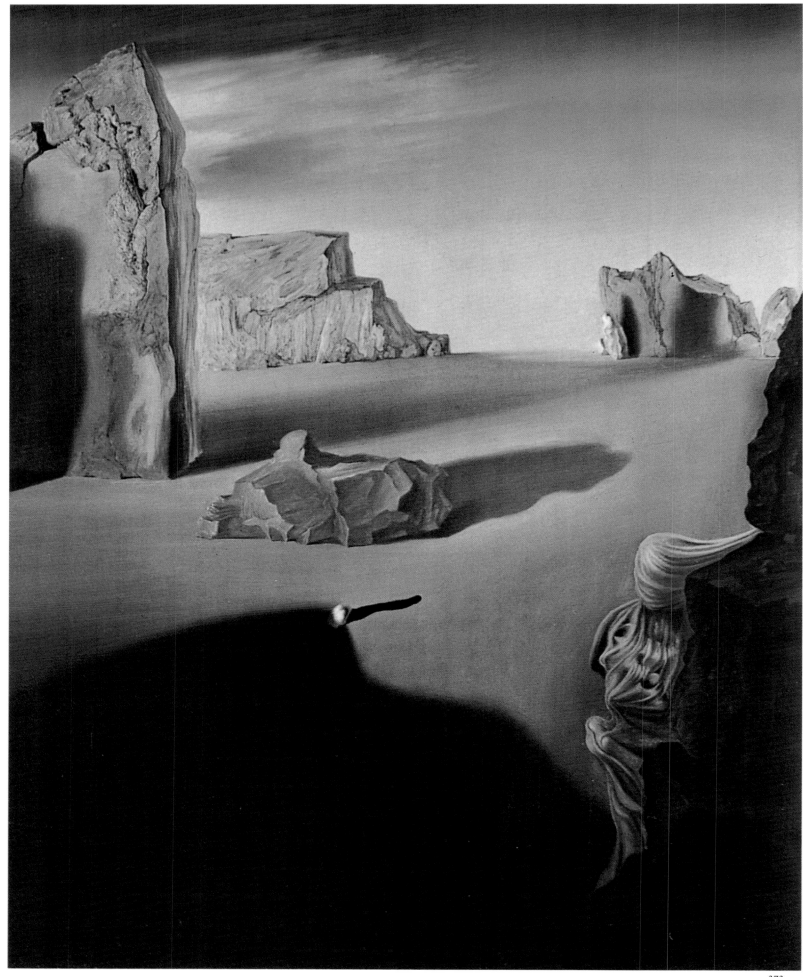

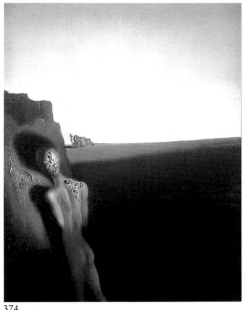

374

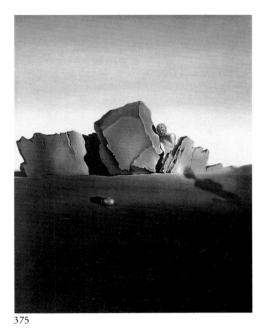

375

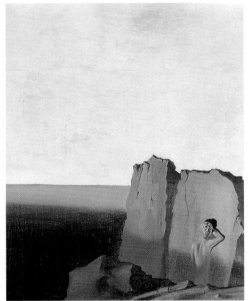

376

1931

373 **Shades of Night Descending,** 1931 ❏
Ombres de la nuit descendante

374 **Solitude – Anthropomorphic Echo,** 1931 ❏
Solitude, l'écho anthropomorphe

375 **Symbiosis of a Head of Seashells,** 1931 ❏
Symbiose de la tête aux coquillages

376 **Solitude,** 1931 ❏
La solitude

377 **The Dream Approaches,** 1931 ❏
Le rêve approche

378 **Olive,** 1931 ❏
Olive

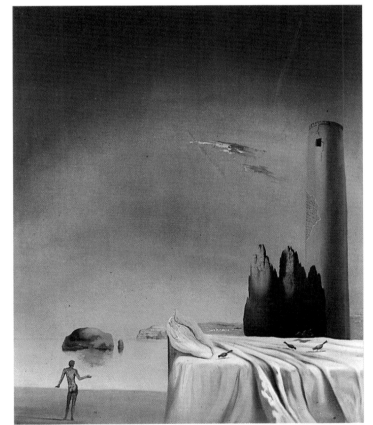

377

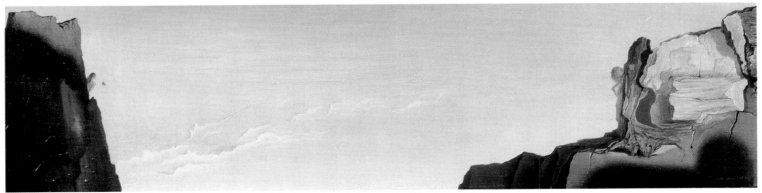

378

1931

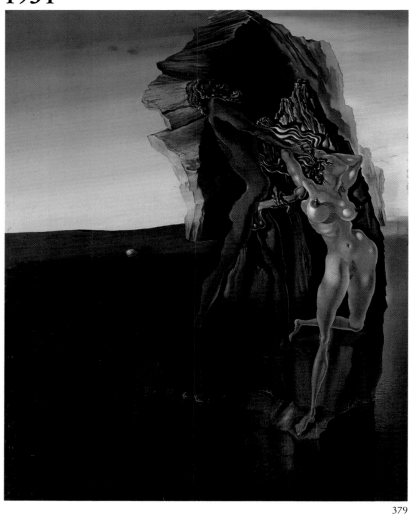

379

380

379 **Untitled (William Tell and Gradiva)**, 1931 ❑
Sans titre (Guillaume Tell et Gradiva)

380 **First Portrait of Gala**, 1931 ❑
Premier portrait de Gala

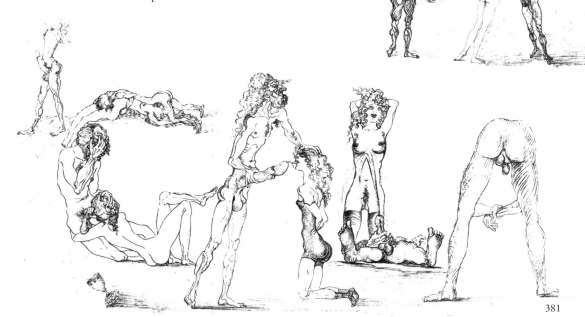

381

381 **Erotic Fantasia on the Names Paul (Eluard) and Gala. Drawing given by Dalí to Eluard,** 1931 ∆

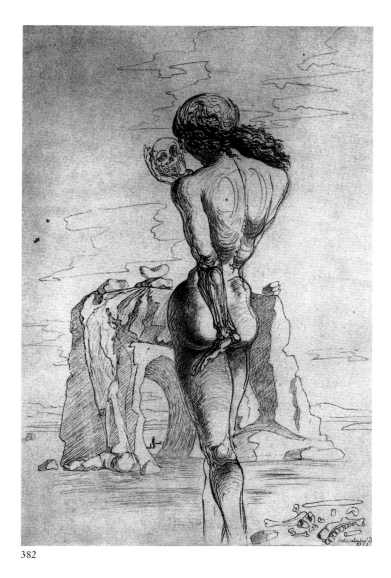

382

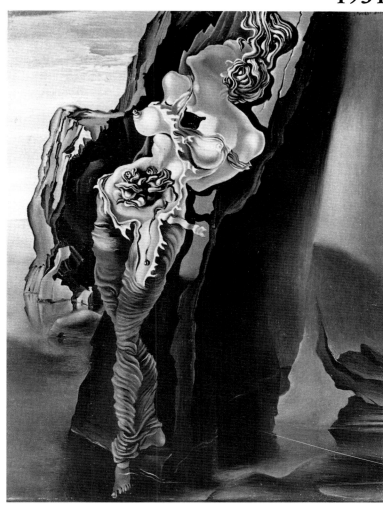

383

382 **Gradiva**, 1933 △

383 **Gradiva**, 1931 ❑

384 **Gradiva**, 1932 △

Gaudí's Mediterranean Gothic. If we compare Dalí's beloved landscape with Gaudí's Sagrada Familia church or Güell Park in Barcelona, it is difficult to imagine that the architectural genius, Dalí's fellow Catalonian, should not have seen the tattered, craggy rocks and cliffs of Cape Creus too. Dalí saw in them his "principle of paranoiac metamorphosis" in tangible form. "All the images capable of being suggested by the complexity of their innumerable irregularities appear successively and by turn as you change your position. This was so objectifiable that the fishermen of the region had since time immemorial baptized each of these imposing conglomerations – the camel, the eagle, the anvil, the monk, the dead woman, the lion's head. [...] I discovered in this perpetual disguise the profound meaning of that modesty of nature which Heraclitus referred to in his enigmatic phrase, 'Nature likes to conceal herself'. [...] Watching the 'stirring' of the forms of those motionless rocks, I meditated on my own rocks, those of my thought. I should have liked them to be like those outside – relativistic, changing at the slightest displacement in the space of the spirit, becoming constantly their own opposite, dissembling, ambivalent, hypocritical, disguised, vague and concrete, without dream, without 'mist of wonder', measurable, observable, physical, objective, material and hard as granite. In the past there had been three philosophic antecedents of what I aspired to build in my own brain: the Greek Sophists, the Jesuitical thought of Spain, founded by Saint Ignatius of Loyola, and the dialectics of Hegel in Germany – the latter, unfortunately, lacked irony, which is the essentially esthetic element of thought; moreover it 'threatened revolution' [...]"

What better way could there be of illustrating the principle of "softness" in

384

385

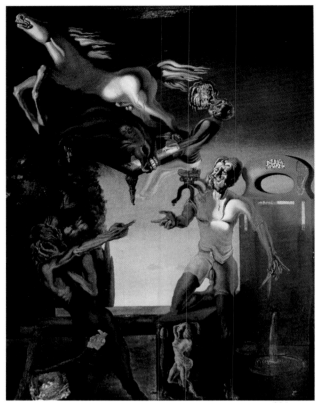

386

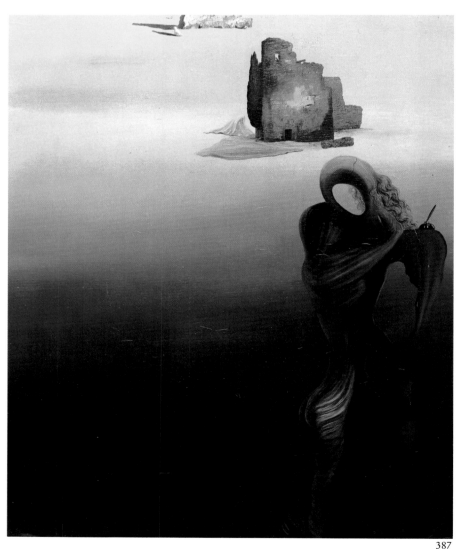

387

388

contrast to "hardness" than by examining the history of the soft watches – which is at once a history of Dalí's personality: "Instead of hardening me, as life had planned, Gala […] succeeded in building for me a shell to protect the tender nakedness of the Bernard the Hermit that I was, so that while in relation to the outside world I assumed more and more the appearance of a fortress, within myself I could continue to grow old in the soft, and in the supersoft. And the day I decided to paint watches, I painted them soft. It was on an evening when I felt tired, and had a slight headache, which is extremely rare with me. We were to go to a moving picture with some friends, and at the last moment I decided not to go. Gala would go with them, and I would stay home and go to bed early. We had topped off our meal with a very strong Camembert, and after everyone had gone I remained for a long time seated at the table meditating on the philosophic problems of the 'supersoft' which the cheese presented to my mind. I got up and went into my studio, where I lit the light in order to cast a final glance, as is my habit, at the picture I was in the midst of painting. This picture represented a landscape near Port Lligat, whose rocks were lit by a transparent and melancholy twilight; in the foreground an olive tree with its branches cut, and without leaves. I knew that the atmosphere which I had succeeded in creating with this landscape was to serve as a setting for some idea, for some surprising image, but I did not in the least know what it was going to be. I was about to turn out the light, when instantaneously I 'saw' the solution. I saw two soft watches, one of them hanging lamentably on the branch of the olive tree. In spite of the fact that my headache had increased to the point of becoming very painful, I avidly prepared my palette

389

390

and set to work. When Gala returned from the theatre two hours later the picture, which was to be one of my most famous, was completed." Not long after, the American dealer Julien Levy bought *Soft Watches* (as the painting was then called). And it was Levy who was destined to make Dalí famous in the United States – and thus lay the foundation stone of his later fortune. He found the picture unusual – but not to the public taste, and therefore unsaleable. It turned out that in this he was completely wrong: the painting changed hands time after time, finally ending up in the Museum of Modern Art in New York.

Edible Beauty

Avida Dollars was not always rolling in money. There was a period (brief, admittedly) between his father's allowance and the income from sales of pictures when he was distinctly short of a peseta. The couple's financial circumstances were always to remain complicated. The Dalís would make considerable sums and promptly spend the money. Their "secretaries" would see to it that large amounts disappeared into their own pockets. When Dalí died, his legacy to the Spanish state was, of course, staggering – but he himself was personally poor and his bank account stood at zero, just as his father had always predicted.

When the money ran out – because the Goemans gallery went bankrupt, or rather, because its patron, Viscount Charles de Noailles, took somewhat too lively an interest in abstract art – the Dalís sought refuge in Cadaqués, leaving Paris behind "as one leaves a bucket of offal". Dalí later wrote: "But before our departure we would prepare the dishes that we would leave cooking for two or three months. I would sow among the Surrealist group the necessary ideological slogans against subjectivity and the marvellous." Dalí listed the various "firecrackers" he had tossed in on departure, the demoralizing effect of which he hoped to see upon his return: he had taken the side of Raymond Roussel against Rimbaud; art nouveau objects against African artefacts; *trompe l'œil* still lifes against sculpture; imitation against interpretation. All of this, as he well knew, would do nicely for several years; he deliberately gave very few explanations. At that time he had not yet become "talkative"; he only said what was absolutely necessary, with the sole aim of unsettling everybody. But at this time he was already rebelling against polite French conversation, which, as he described it, was so nicely spiced with *esprit* and common sense, countering it with his "terribly uncouth" remarks that were "full of Spanish fanaticism". Thus, for instance, to one art critic who talked incessantly of "matter", of Courbet's "matter" and his treatment of that "matter", he replied: "Have you ever tried to eat it? When it comes to sh--, I still prefer Chardin's."

At that time, Gala was everything to him. Gala followed him everywhere, defended him, and protected him against others and against himself. He could hardly believe it: "The idea that in my own room where I was going to work there might be a woman, a real woman who moved, with senses, body hair and gums, suddenly struck me as so seductive that it was difficult for me to believe this could be realized." He was hardly in Paris but he was itching to leave again. However, he had to go to Paris and let loose "thunder and rain. But this time it's going to be gold! We must go to Paris and get our hands on the money we need to finish the work on our Port Lligat house!" It was a strategy that Dalí was to employ his whole life long; and he gave his own explanation of it in his *Secret Life*. On the one hand, there was the aristocracy, consisting of a particular kind of flamingo standing on one leg, "an attitude by which they wish to show that, while having to remain standing in order to continue to see everything from above, they like to touch the common base of the world only by what is strictly necessary." To them he offered his crutches: "Crutches, crutches, crutches, crutches. I even in-

391

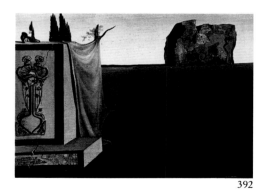

392

391 **Untitled**, 1931 ❏

392 **Landscape**, 1931 ❏
Paysage

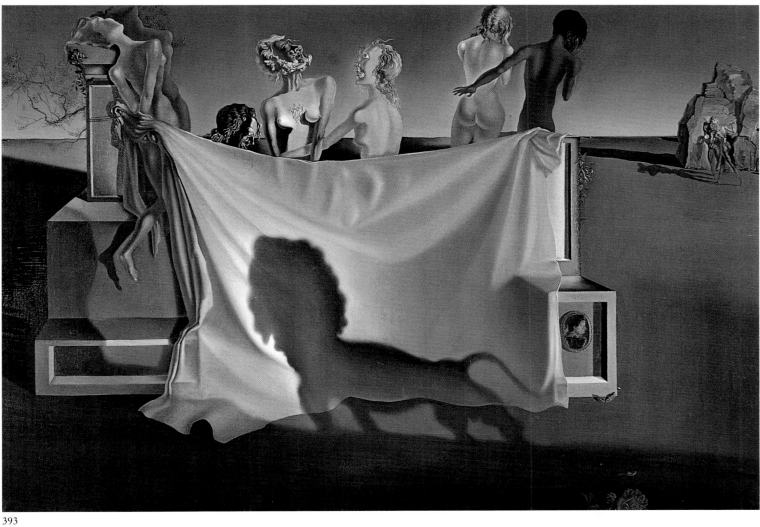

393

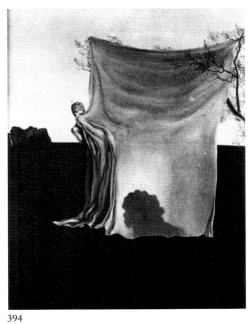

394

395

393 **The Old Age of William Tell,**
1931 ❏
La vieillesse de Guillaume Tell

394 **The Feeling of Becoming,** 1930 ❏
Le sentiment du devenir

395 **On the Beach,** 1931 ❏
Au bord de la mer

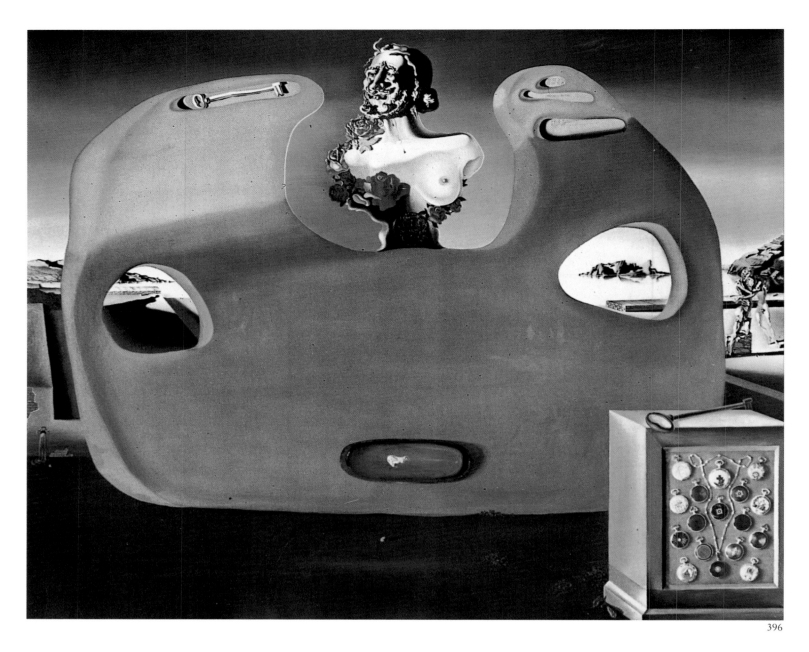

396

396 Memory of the Child-Woman,
1932 ❏
La mémoire de la femme-enfant

vented a tiny facial crutch of gold and rubies. Its bifurcated part was flexible and was intended to hold up and fit the tip of the nose. The other end was softly rounded and was designed to lean on the central hollow above the upper lip. It was therefore a nose crutch, an absolutely useless kind of object to appeal to the snobbism of certain criminally elegant woman." Thanks to Dalí and his myriad crutches, the aristocracy stayed upright. "With the pride of your one leg and the crutches of my intelligence, you are stronger than the revolution that is being prepared by the intellectuals, whom I know intimately." On the other hand there were the social climbers – petty sharks frantically chasing success. Dalí had resolved to use both kinds of people, all the people who made up so-called society; to get ahead and become famous he would turn their amateurish, envious slanders to his own advantage. The first group, the aristocracy, relied on him, while the second, the gossiping and intriguing upstarts, provided an inexhaustible supply of material which he was always able to put to good use.

In response to the primitive black artefacts lauded by Picasso and the Surrealists, Dalí urged the claims of decadent European art nouveau. He even rediscovered the Métro entrances that dated from the turn of the century, and saw to it that the Musée de la Ville de Paris bought one of them. (Nowadays the museum considers itself lucky that it made the purchase when it did.) With profound logic

397

398

397 **Study for "Memory of the Child-Woman"**, 1932 Δ

398 **Untitled**, 1932 Δ

399 **The Birth of Liquid Desires**, 1932 ❏
Naissance des désirs liquides

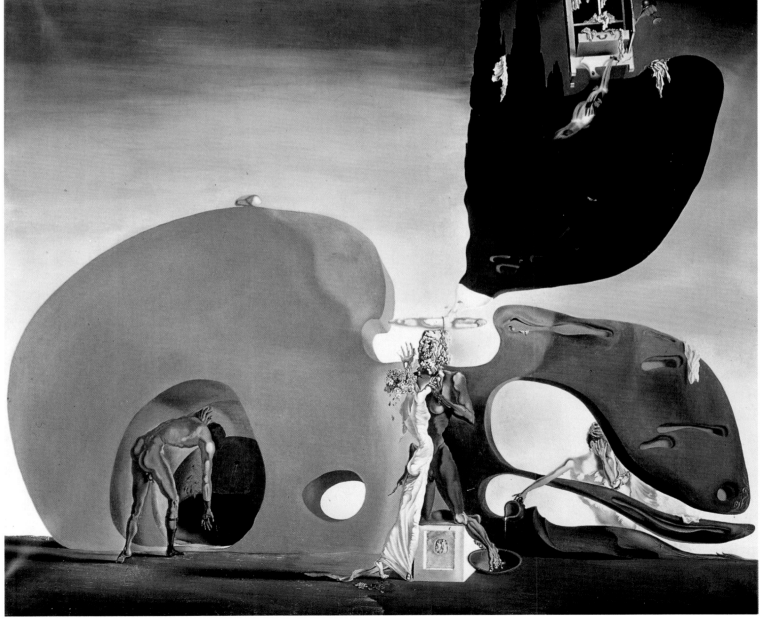

399

400

401

he declared: "I have always considered the 1900 period as the psycho-pathological end-product of Greco-Roman decadence. I said to myself: since these people will not hear of aesthetics and are capable of becoming excited only over 'vital agitations', I shall show them how in the tiniest ornamental detail of an object of 1900 there is more mystery, more poetry, more eroticism, more madness, perversity, torment, pathos, grandeur and biological depth than in their innumerable stock of truculently ugly fetishes possessing bodies and souls of a stupidity that is simply and uniquely savage!"

Dalí's insistence, and his perfectly art nouveau portrait of the Vicomtesse Marie-Laure de Noailles (p. 188), revived interest in an artistic trend that had long been out of fashion. People began to search out art nouveau artefacts at flea markets. Maxim's, which was on the point of modernizing the premises, cancelled the work and restored its art nouveau look instead. Even in New York, windows were being dressed in the style of yesteryear. But, as always, Dalí's influence went beyond his person and took on a life of its own; and "I can no longer canalize it, or even profit by it. I found myself in a Paris which I felt was beginning to be dominated by my invisible influence. When someone […] spoke disdainfully of functional architecture, I knew that this came from me. If someone said in any connection, 'I'm afraid it will look modern', this came from me. People could not make up their minds to follow me, but I had ruined their convictions! And the modern artists had plenty of reason to hate me. I myself, however, was never able to profit by my discoveries, and in this connection no one has been more constantly robbed than I. Here is a typical example of the drama of my influence. The moment I arrived in Paris, I launched the 'Modern Style' […] and I was able to perceive my imprint here and there merely in walking about the streets […] Everyone managed to carry out my ideas, though in a mediocre way. I was unable to carry them out in any way at all!"

Maybe from fear of deprivation, maybe because of his frightful Catalonian atavism, Dalí now set about frantically making Surrealist artefacts out of bread.

402

403

400 **Anthropomorphic Bread –
Catalonian Bread**, 1932 ❏
Pain anthropomorphe – Pain catalan

401 **The Knight at the Tower,**
1932 ❏
Le chevalier à la tour

402 **Untitled – Female Figure with
Catalonian Bread**, 1932 ❏
Sans titre – Figure féminine avec pain
catalan

403 **Anthropomorphic Bread,**
c. 1932 ❏
Pain anthropomorphe

1932

405

404

406

404 The Shoe – Surrealist Object Functioning Symbolically, 1932 ○
Le soulier – Objet surréaliste à fonctionnement symbolique

405 Average French Bread with Two Fried Eggs without the Plate, on Horseback, Trying to Sodomize a Heel of Portuguese Bread, 1932 ❑
Pain français moyen avec deux œufs sur le plat sans le plat, à cheval, essayant de sodomiser une mie de pain portugais

406 The Invisible Man, 1932 ❑
L'homme invisible

He had already had an especial liking for bread. In his museum at Figueras he papered the walls with round Catalonian loaves. Often he would take a loaf, hug it and lick it and nibble it, and then stand it up as if it were his latest invention. "Nothing could be simpler than to cut out two neat, regular holes on the back of the loaf and insert an inkwell in each one. What could be more degrading and aesthetic than to see this bread-inkstand become gradually stained in the course of use with the involuntary spatterings of 'Pelican' ink? A little rectangle of the bread-inkstand would be just the thing to stick the pens into when one was through writing. And if one wanted always to have fresh crumbs, fine pen-wiper-crumbs, one had only to have one's bread-inkwell-carrier changed every morning […] Upon arriving in Paris, I said to everyone who cared to listen, 'Bread, bread and more bread. Nothing but bread'. This they regarded as the new enigma which I was bringing them from Port Lligat. Has he become a Communist, they would

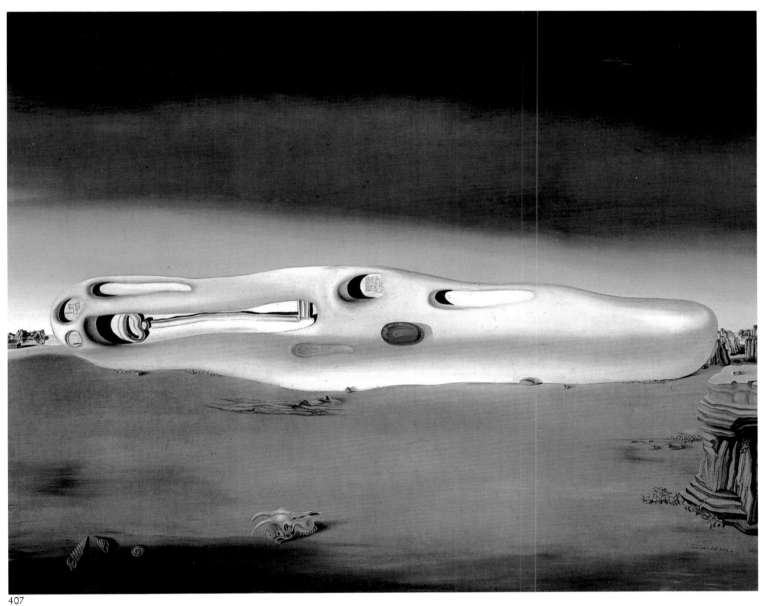

407

407 **Diurnal Fantasies**, 1932 ❏
Fantaisies diurnes

wonder jokingly. For they had guessed that my bread, the bread I had invented, was not precisely intended for the succor and sustenance of large families. My bread was a ferociously anti-humanitarian bread, it was the bread of the revenge of imaginative luxury on the utilitarianism of the rational practical world, it was the aristocratic, aesthetic, paranoiac, sophisticated, Jesuitical, phenomenal, paralyzing, hyper-evident bread […] One day I said, 'There is a crutch!' Everybody thought it was an arbitrary gesture, a stroke of humour. After five years they began to discover that 'it was important'. Then I said, 'There is a crust of bread!' And immediately it began in turn to assume importance. For I have always had the gift of objectifying my thought concretely, to the point of giving a magic character to the objects which, after a thousand reflections, studies and inspirations, I decided to point to with my finger." In the light of these explanations, we can easily imagine the feelings that the other Surrealists, loyal to Moscow at the

contd. on p. 187

408

410

409

411

408 **Untitled – Cyclist with a Loaf
of Bread on his Head,** 1932 Δ
Sans titre – Cycliste avec un pain sur la
tête
409 **Drawing,** 1932 Δ
Dessin
410 **Babaouo – Publicity an-
nouncement for the publication of
the scenario of the film,** 1932 Δ
411 **Babaouo,** 1932 ○
412 **Surrealist Object, Gauge of
Instantaneous Memory,** 1932 ❑
Objet surréaliste indicateur de la
mémoire instantanée

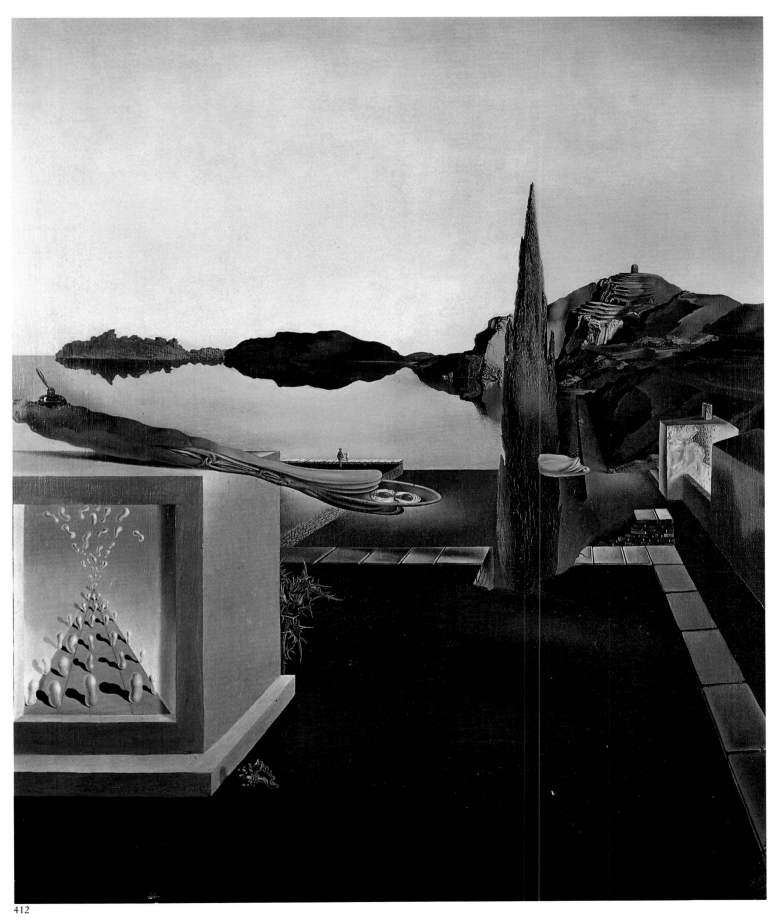

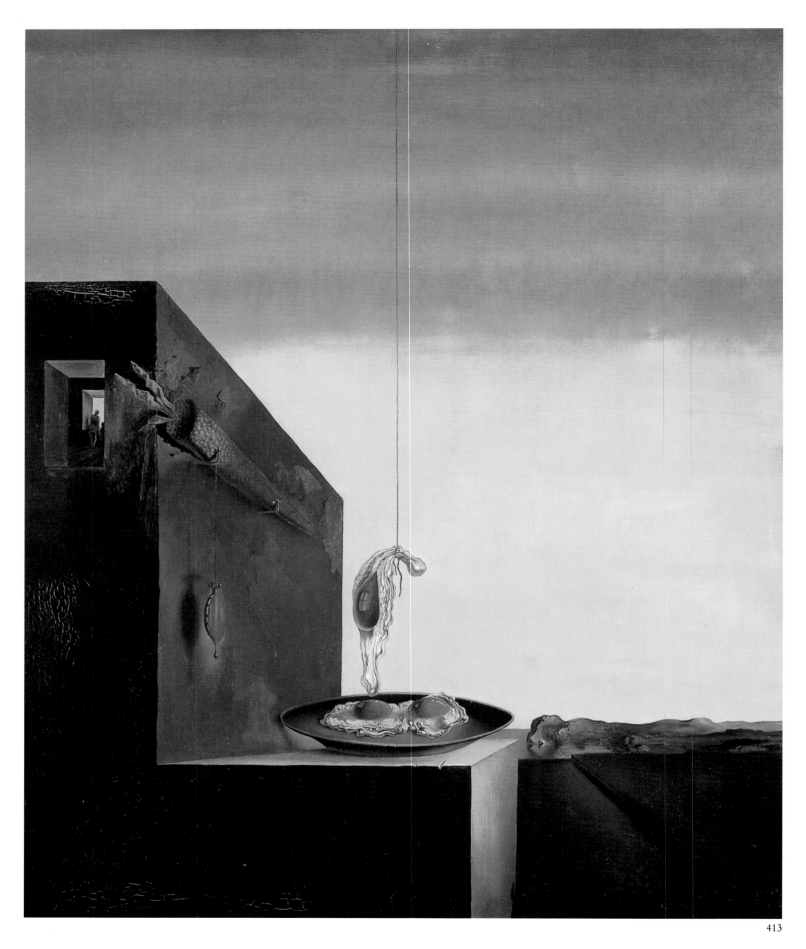

413

413 **Fried Eggs on the Plate without
the Plate**, 1932 ❑
Œufs sur le plat sans le plat

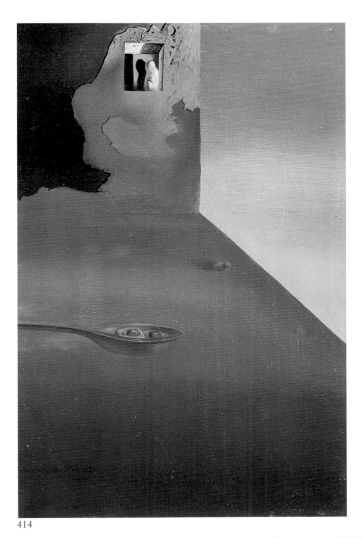

414

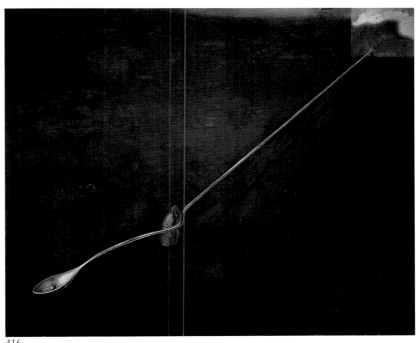

416

414 **The Meeting of the Illusion and the Arrested Moment – Fried Eggs Presented in a Spoon**, 1932 ❏
Œufs frits présentés dans une cuillère – La rencontre de l'illusion et du moment arrêté

415 **Surrealist Architecture**, c. 1932 ❏
Architecture surréaliste

416 **Agnostic Symbol**, 1932 ❏
Symbole agnostique

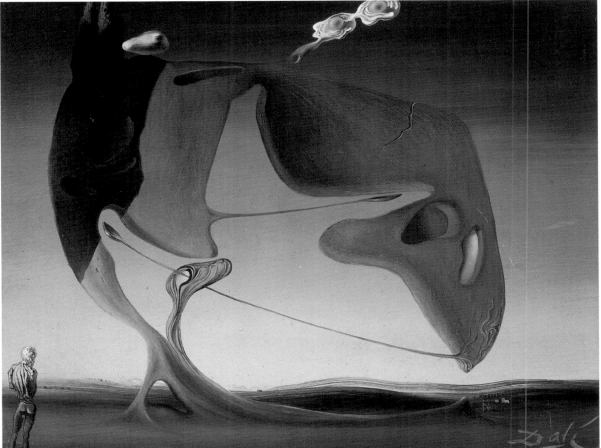

415

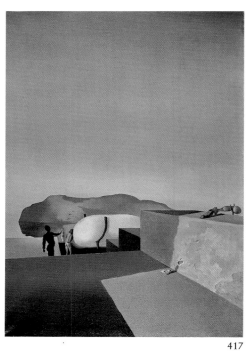

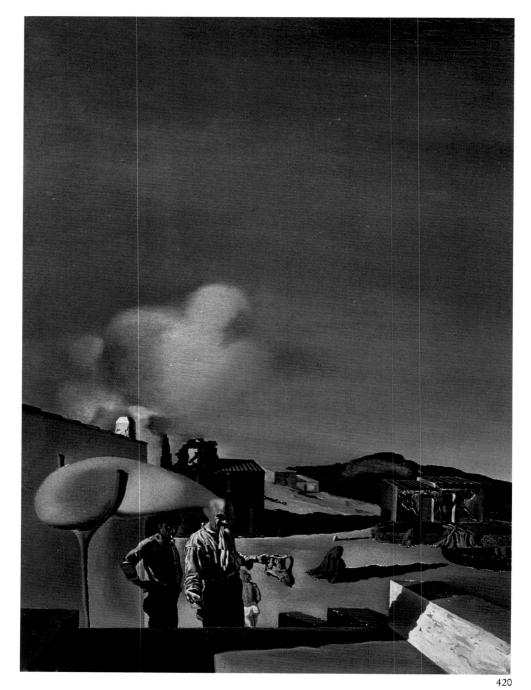

417

420

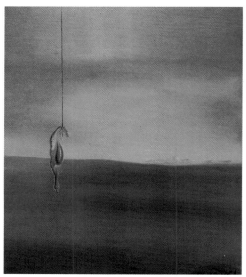

418

419

417 **Persistence of Fair Weather,**
c. 1932–1934 ❏
Persistance du beau temps

418 **Fried Egg on the Plate
without the Plate,** 1932 ❏
Œuf sur le plat sans le plat

419 **Fried Egg on the Plate
without the Plate,** 1932 ❏
Œuf sur le plat sans le plat

420 **The Average Fine and
Invisible Harp,** 1932 ❏
La harpe invisible, fine et moyenne

time, had towards the iconoclastic and blasphemic Dalí. To add insult to injury, the loaves in his paintings naturally had a hard, phallic look to them.

Throughout this time, Dalí was extremely active. He had exhibitions in America, wrote poems, and was involved in the periodicals *Le Surréalisme au Service de la Révolution* and *Minotaure*; in the latter he published his famous article "On Gruesome and Edible Beauty, on Art Nouveau Architecture", which concluded with his equally famous pronouncement: "Beauty will be edible or there will be no such thing at all." Above all, though, the film *L'Age d'Or* (The Golden Age), for which he wrote the screenplay together with Luis Buñuel, provoked another scandal. Action Française militants fired revolvers and threw stink bombs and teargas grenades at the film's première, and the violence added anew to the aura of dangerous controversy about Dalí's name.

Dalí decided never again to collaborate with anyone. If there had to be scandals, he preferred to provoke them single-handed, with ideas that were purely his

422

423

421 **Meditation on the Harp,**
1932–1934 ❏
Méditation sur la harpe

422 **Detail showing that Dalí saw naked bodies everywhere, even in the clouds** ☆

423 **Study for "Meditation on the Harp",** 1932–1933 Δ

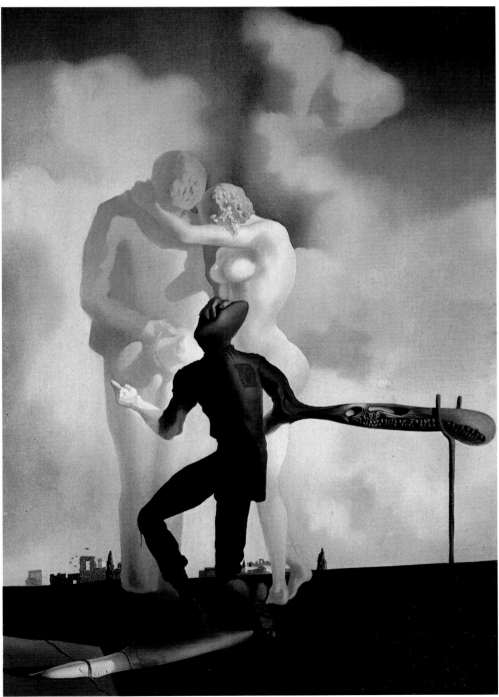

421

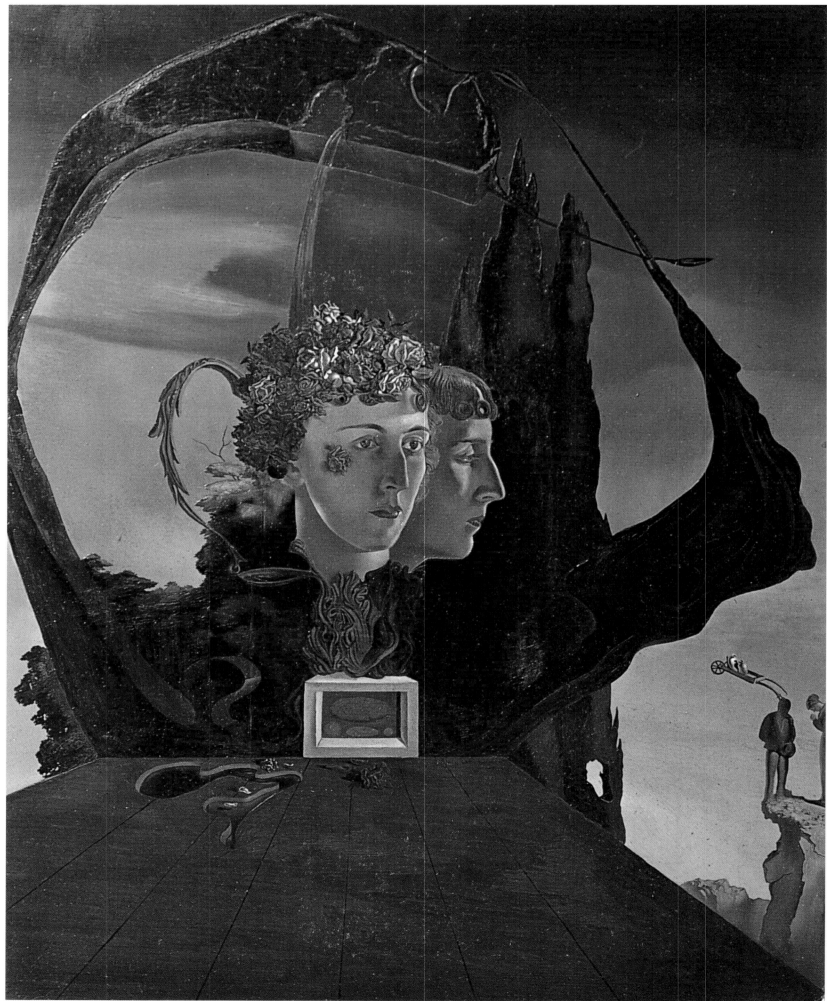

424

own. "I should have been willing to cause a scandal a hundred times greater, but for 'important reasons' – subversive rather through excess of Catholic fanaticism than through naïve anticlericalism. As foreseen, Buñuel had betrayed me, and in order to express himself, had chosen images that made the Himalayas of my ideas into little paper boats." Dalí was well aware "that my disavowal of the film would have been understood by no one […] I had just made *L'Age d'Or*. I was going to be allowed to make *The Apology of Meissonier in Painting*." From that time on, people got into the habit of granting him considerable licence and simply saying: "That's just Dalí!"

426

424 Portrait of the Vicomtesse Marie-Laure de Noailles, 1932 ❑
Portrait de la vicomtesse Marie-Laure de Noailles

425 Preliminary study for "Portrait of Vicomtesse Marie-Laure de Noailles", 1932 △

426 Reverie – Password: Mess up all the Slate, 1933 △
Rêverie – Consigne: gâcher l'ardoise totale

425

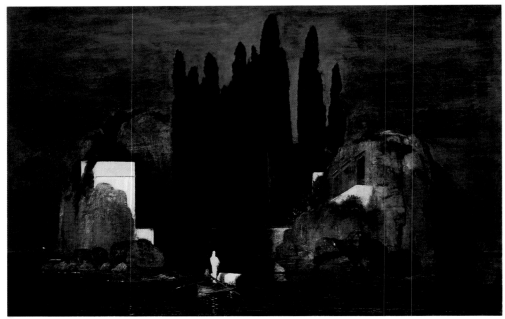

428

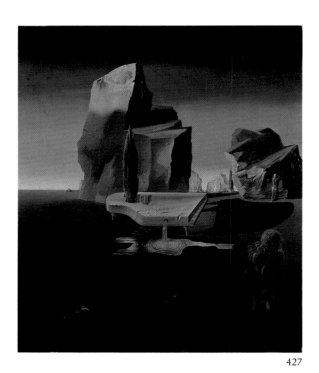

427

**427 The Mysterious Sources of
Harmony**, 1932–1933 ❏
Les sources mystérieuses de l'harmonie

**428 Arnold Böcklin: The Isle of the
Dead**, 1880 ☆
Arnold Böcklin: L'île des morts

**429 The True Painting of "The Isle
of the Dead" by Arnold Böcklin at
the Hour of the Angelus**, 1932 ❏
Vrai tableau de «L'île des morts» d'Arnold Böcklin à l'heure de l'Angélus

The Tragic Myth of Millet's Angelus

At the height of the frenzy over Surrealist objects," Dalí recalled in his *Secret
Life*, "I painted a few apparently very normal paintings, inspired by the congealed
and minute enigma of certain snapshots, to which I added a Dalinian touch of
Meissonier. I felt the public, which was beginning to grow weary of the continuous cult of strangeness, instantly nibble at the bait. Within myself I said,
addressing the public, 'I'll give it to you, I'll give you reality and classicism. Wait,
wait a little, don't be afraid.'"

It was not only Meissonier who ghosted these paintings. Dalí took his bearings
from Arnold Böcklin and Jean-François Millet as well – as in *The True Painting
of "The Isle of the Dead" by Arnold Böcklin at the Hour of the Angelus* (p. 191).
This period in the early Thirties was under the sign of Millet's *Angelus*, which,
with the soft watches, was to play the second major, obsessive role in Dalí's art.
Millet's painting, which is in the Louvre, had erotic significance for Dalí, and in
an essay, *The Tragic Myth of Millet's Angelus*, he declared: "In June 1932, without
advance warning of any kind or any conscious association that might have made
an explanation possible, Millet's *Angelus* (cf. p. 213) appeared before my mind's
eye. The image was very clear and colourful. It made its appearance practically
instantaneously, displacing all other images. It made a deep impression on me,
indeed devastated me; because, although everything in my vision of the picture
precisely 'matched' the reproductions I have seen of it, it nonetheless seemed
totally transformed, fraught with so powerful a latent intent that Millet's *Angelus*
suddenly struck me as the most bewildering, enigmatic, compact picture, the
richest in unconscious ideas, that had ever been painted." Dalí painted numerous
versions of the picture's subject, one transposing the wheelbarrow into an outgrowth of the man's skull (*Atavism at Twilight*, p. 213), another introducing a
coffin since he claimed to have discovered that Millet's farmer and his wife were
mourning at the grave of their dead child. (Interestingly, X-ray examinations of
the layers of paint on Millet's work later revealed the dark shape of a coffin.)
Dalí's premonitory intuitions had already been expressed in a 1911/1912 drawing
of a graveyard scene, compositionally inspired by Millet's painting. Certainly his

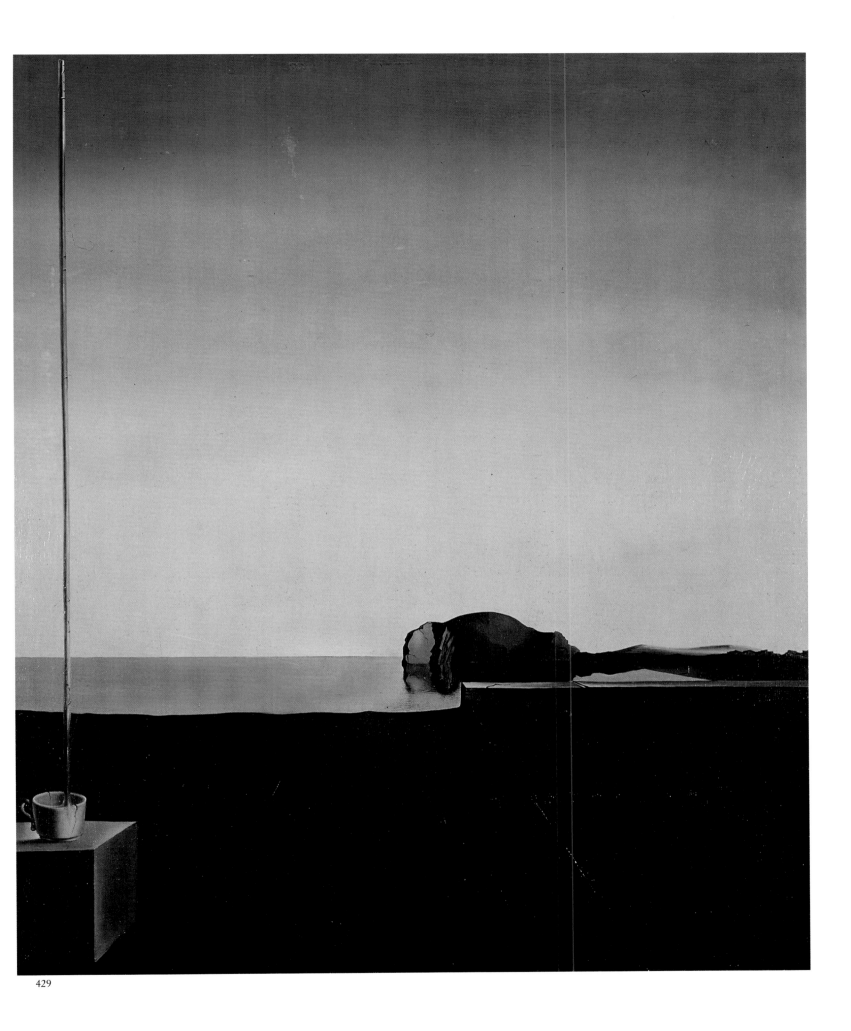

429

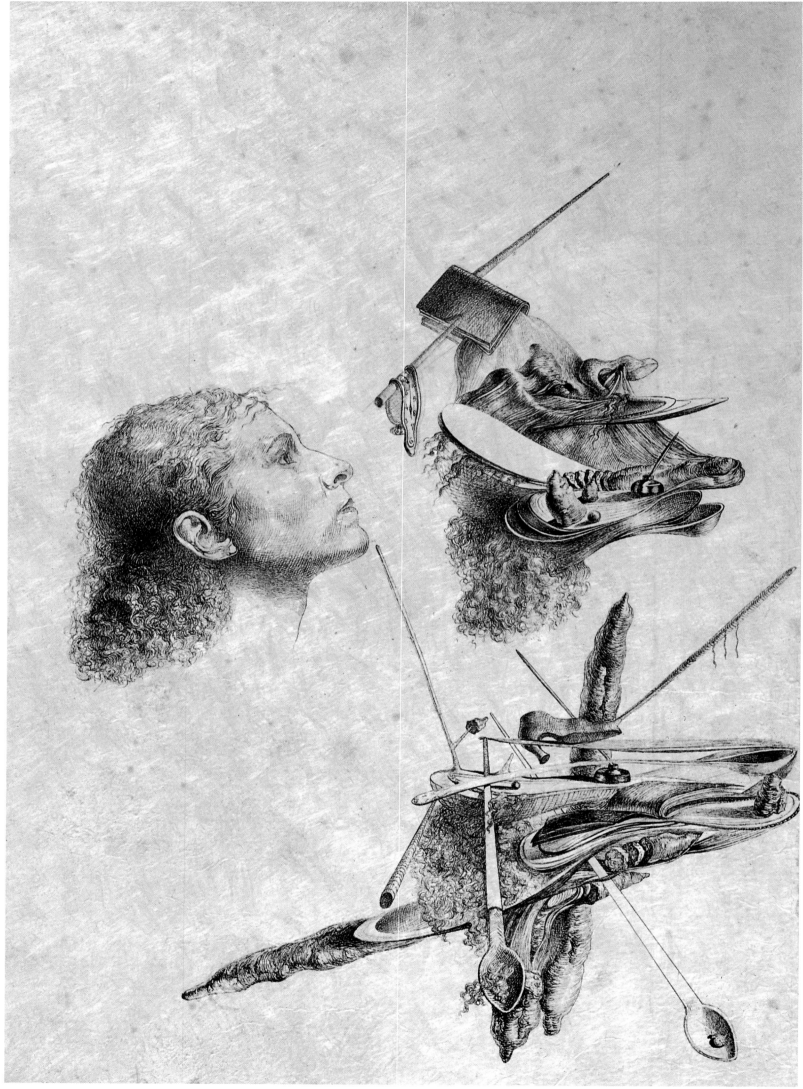

430

faculties were sharp; Ezra Pound's watchword – that artists are "the antennae of the race" – was never truer than in Dalí's case.

Dalí's misprisions of Millet included *The Architectural Angelus of Millet* (p.208) and a treatment including a portrait of Gala, *Gala and the Angelus of Millet Preceding the Imminent Arrival of the Conical Anamorphoses* (p.199). He even located his motif in the Catalonian cliffs (*Archaeological Reminiscence of Millet's "Angelus"*, p.247). "In a brief fantasy," Dalí wrote, "I indulged in a walk to Cape Creus, the stony landscape of which is a true geological delirium, I imagined the two sculptured figures [...] hewn out of the highest cliffs [...] but furrowed with deep fissures [...] Time had worn particularly hard on the man,

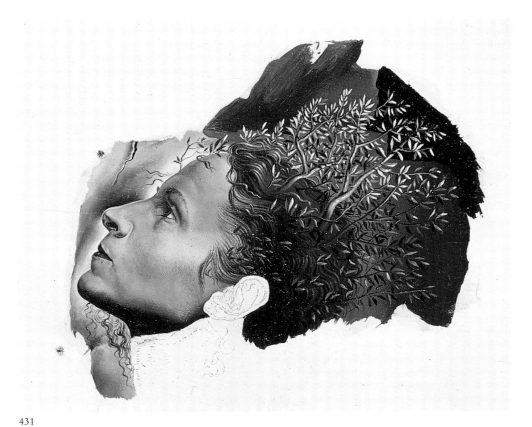

432

430 **Paranoiac Metamorphosis of Gala's Face**, 1932 Δ
Métamorphose paranoïaque du visage de Gala

431 **Automatic Beginning of a Portrait of Gala (unfinished)**, 1932 ❏
Commencement automatique d'un portrait de Gala

432 **Portrait of Gala**, 1933 ❏
Portrait de Gala

431

rendering him unrecognizable, leaving only the vague, shapeless block of the silhouette, which thus became alarming and especially frightening." And all because the young Salvador, when still a schoolboy, could see through the window in the classroom door to where a calendar reproduction of the fateful picture hung in the corridor.

In *The Tragic Myth of Millet's Angelus*, written in 1933 though not published till 1963, Dalí gave an account of how he arrived at his hallucinatory images of phallic loaves, fried eggs in suspension, faces of Lenin (to nettle the Surrealists), and other bizarre trademarks. He recalled (for example) that one night in 1932, as he turned in, he beheld a brightly lit grand piano, in foreshortened perspective, with a number of busts of Lenin on the keys, with phosphorescent yellow aureoles. The picture came to him complete as he was going to bed, even before he had put out the light. It was not prompted by other images he had seen, nor did it lead on to others. The painting that resulted in this case was of course *Partial Hallucination. Six Apparitions of Lenin on a Grand Piano* (p.164). Dalí similarly reported that in the late summer of 1932, as he was rising from table intending to lie down on the sofa, he saw a row of inkwells alternating with fried eggs on plates (without the plates). This image he painted against a landscape setting, and it became *Nostalgia of the Cannibal* (p.173).

1932-1934

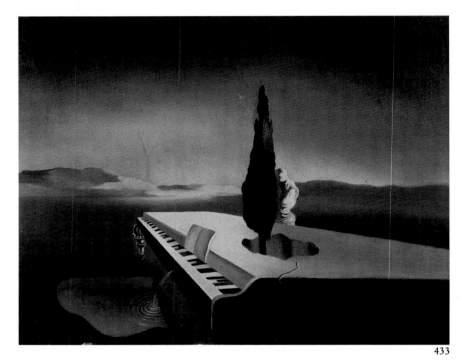

433

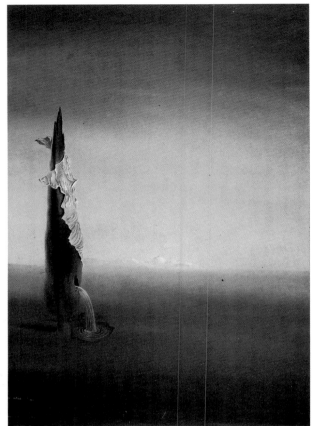

435

434

436

433 Necrophiliac Fountain Flowing from a Grand Piano, 1933 ❏
Fontaine nécrophilique coulant d'un piano à queue

434 Suez, 1932 ❏

435 The Birth of Liquid Fears, 1932 ❏
Naissance des angoisses liquides

436 Surrealist Essay, 1932 ❏
Essai surréaliste

437 Masochistic Instrument, 1933–1934 ❏
Instrument masochiste

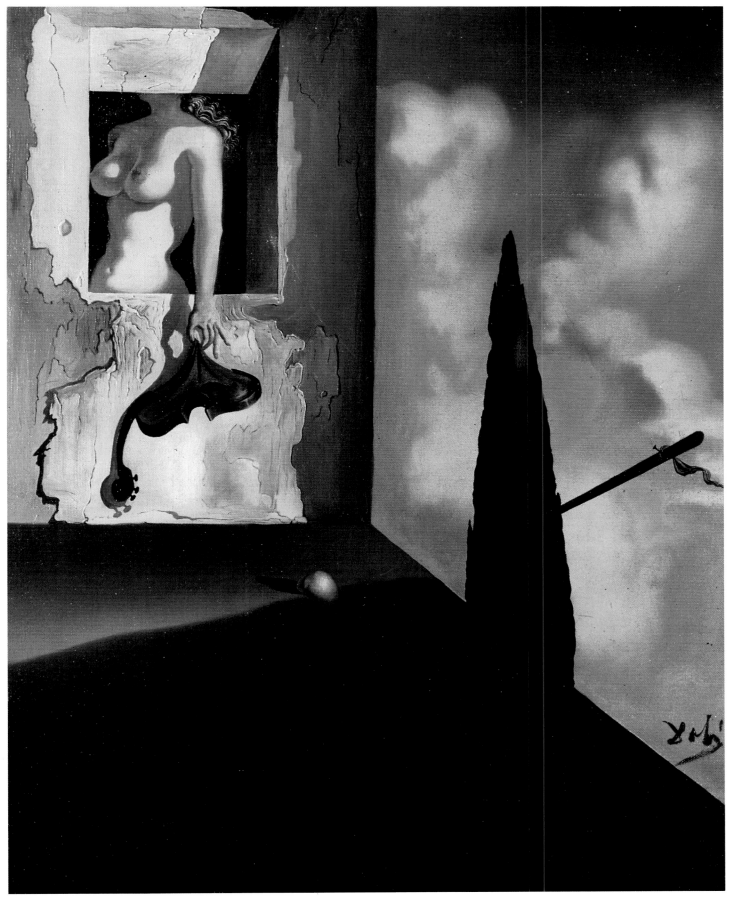

438 **The Veiled Heart**, 1932 ❑
Le cœur voilé
439 **Phosphene of Laporte – Homage to the Italian Physicist Giambattista Della Porta**, 1932 ❑
Phosphène de Laporte – En hommage au physicien italien Giambattista della Porta
440 **Ambivalent Image**, 1933 ❑
Image ambivalente

All of his work at this period was steeped in sexuality – in the form of Gala, of phallic or erectile shapes, of hard rhinoceros horns. Dalí was in fact articulating a sublimated fear of sex; he was both narcissist and exhibitionist, and delighted in scandal, albeit without ever being taken in by his own extravagant indulgences. With the arrival of Gala in his life, his sexual vision acquired focus, as an eloquent footnote in the *Secret Life* suggests: "I call my wife: Gala, Galuchka, Gradiva (because she has been my Gradiva), Olive (because of the oval of her face and the

438

440

439

color of her skin), Olivette, the Catalonian diminutive of olive; and its delirious derivatives, Olihuette, Orihuette, Buribette, Burihueteta, Sulihueta, Solibubulete, Oliburibuleta, Cihueta, Lihuetta. I also call her Lionète (little lion), because she roars like the Metro-Goldwyn-Meyer lion when she gets angry; Squirrel, Tapir, Little Negus (because she resembles a lively little forest animal); Bee (because she discovers and brings me all the essences that become converted into the honey of my thought in the busy hive of my brain). She brought me the rare book on magic that was to nourish my magic, the historic document irrefutably proving my thesis as it was in the process of elaboration, the paranoiac image that my subconscious wished for, the photograph of an unknown painting destined to reveal a new esthetic enigma, the advice that would save one of my too subjective images from romanticism. I also call Gala Noisette Poilue – Hairy Hazelnut (because of the very fine down that covers the hazelnut of her cheeks); and also 'Fur Bell' (because she reads to me aloud during my long sessions of painting, making a murmur as of a fur bell by virtue of which I learn all the things that but for her I should never know)."

Dalí's hymn to Gala in this passage, with his first portraits of her (pp. 193, 200, 207, 209), constitute an arresting statement of love. The beauty of Gala was hence-

forth to be one of the bedrocks of Dalí's subject matter. In *Gala and the Angelus of Millet Preceding the Imminent Arrival of the Conical Anamorphoses* (p.199) she is seen wearing a smile and a richly embroidered jacket, on her head a white cap with transparent visor, then in fashion. The figure seated at the table with his back to us, resting a hand by the precariously balanced cube and ball, is Lenin, while the moustached man at left, eavesdropping at the door, is Maxim Gorky. The latter has a lobster on his head. Dalí frequently placed lobsters in his works

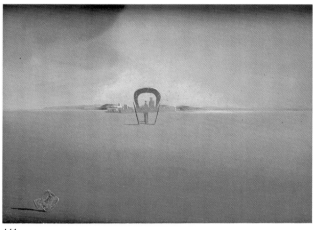

441

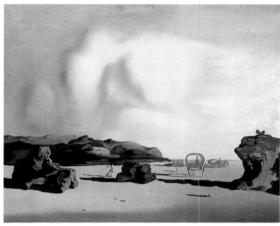

442

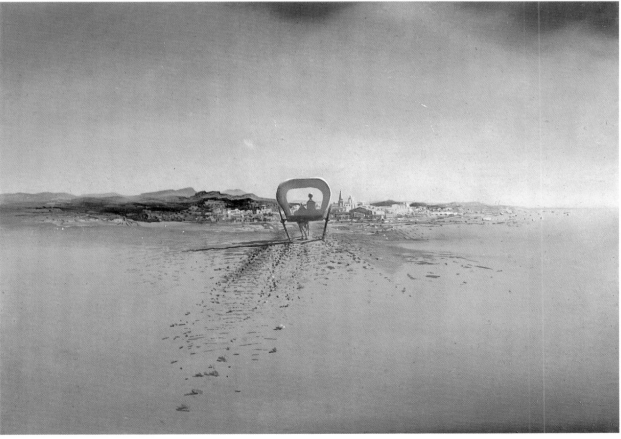

443

at that period, in anomalous positions – famously in the 1936 *Lobster Telephone* (p.275). The 1933 painting also includes Millet's *Angelus*, above the door.

The erectile, budding heads and other famous outgrowths in Dalí's work of this period, like the hard rhinoceros horns, likewise express sexual concerns. We should not, however, forget that for Dalí these anatomical oddities were associ-

1933

444

444 Sugar Sphinx, 1933 ❏
Le sphynx de sucre

**445 Gala and the Angelus of Millet
Preceding the Imminent Arrival of
the Conical Anamorphoses**, 1933 ❏
Gala et l'Angélus de Millet précédant
l'arrivée imminente des anamorphoses
conique

ated with a hydrocephalic young man he had seen in his childhood, and with his own brother, who had died of meningitis before Dalí was born. That brother – also called Salvador – "gave signs of alarming precocity" and was described by the artist as "a first version of myself, but conceived too much in the absolute". Dalí saw himself as an example of the "polymorphous perverse", which (in the *Secret Life*) plainly translates as a preoccupation with sexuality, genius, masturbation, and exhibitionism. All of these, as Roumeguère has pointed out, are present in the swollen, proto-phallic growths, which are at once hard and soft. These sublimations of the artist's obsessions anticipate aspects of Jean-Paul Sartre's work, in Roumeguère's view; while Jean Bobon, writing in the *Acta Neurologica et Psychiatrica Belgica* in 1957, observes: "Dalí's crutch symbolizes first and foremost reality, an earthbound relation to the real, which checks and balances the hyper-development of an intellectualized sexuality and of an imaginative and sexually-laden intellect. It is a vessel, and at the same time signifies the vessel's content. Its experiential meaning draws upon memories of childhood in which the crutch, for Dalí, stands for fame, love and death. But the crutch also symbolizes tradition, which offers support and so perpetuates essential human values."

The crutch, that quintessentially Dalinian symbol, was defined by the artist in his *Dictionnaire abrégé du Surréalisme* (1938) as a "wooden support derived from Cartesian philosophy. Generally used for the support of soft, tender parts." In one of the tales interpolated in the *Secret Life*, "The Story of the Linden Blossom Picking and the Crutch", Dalí wrote: "The second object, which struck me as being terribly personal and overshadowing everything else, was a crutch! It was the first time in my life that I saw a crutch, or at least I thought it was. Its aspect appeared to me at once as something extremely untoward and prodigiously striking. I immediately took possession of the crutch, and I felt that I should never again in my life be able to separate myself from it, such was the fetishistic fanaticism which seized me at the very first without my being able to explain it. The superb crutch! Already it appeared to me as the object possessing the height of authority and solemnity. […] The upper bifurcated part of the crutch intended for the armpit was covered by a kind of felt cloth, extremely fine, worn, brownstained, in whose suave curve I would by turns pleasurably place my caressing cheek and drop my pensive brow. Then I victoriously descended into the garden, hobbling solemnly with my crutch in one hand. This object communicated to me an assurance, an arrogance even, which I had never been capable of until then. […] since then that anonymous crutch was and will remain for me, till the end of my days, the 'symbol of death' and the 'symbol of resurrection'!" In this, the crutch clearly has a sexual function. Dalí's crutches, like the soft and hard outgrowths, were to be found repeatedly in his work of the 30s, as in *The Enigma of William Tell* (p.201), *Average Atmospherocephalic Bureaucrat in the Act of Milking a Cranial Harp* (p.203), *The Invisible Harp* (p.214), *The Javanese Mannequin* (p.214), *The Spectre of Sex Appeal* (p.215) and other paintings.

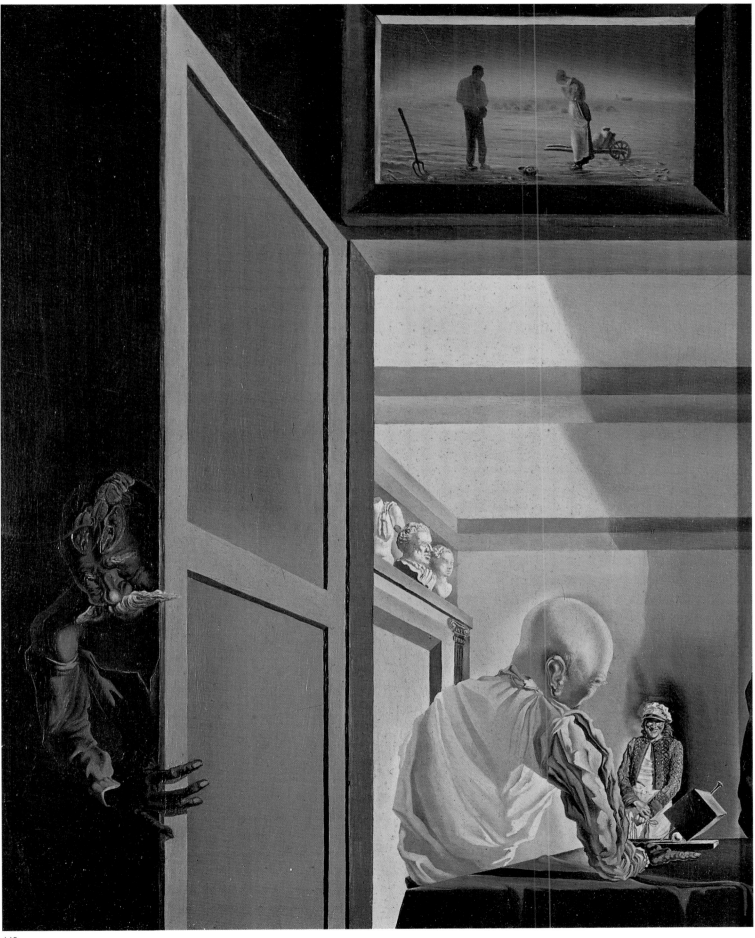

445

1933

446 Photograph of the well at Port Lligat, 1933 ✭

447 Gala and Dalí. Photograph of 1933 ✭

448 Portrait of Gala with Two Lamb Chops Balanced on her Shoulder, 1933 ❏
Portrait de Gala avec deux côtelettes d'agneau en équilibre sur l'épaule

449 The Enigma of William Tell, 1933 ❏
L'énigme de Guillaume Tell

450 Study for "The Enigma of William Tell", 1933 △

446

447

448

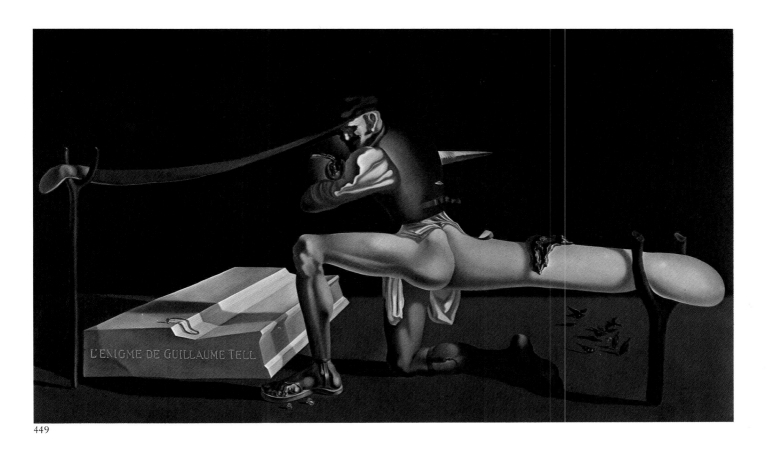

449

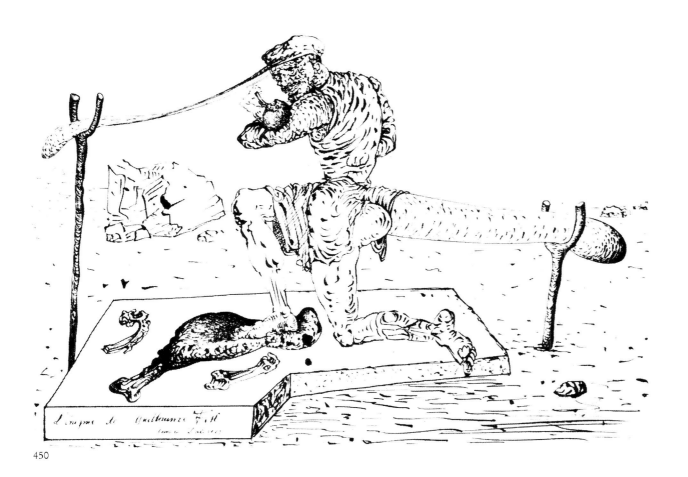

450

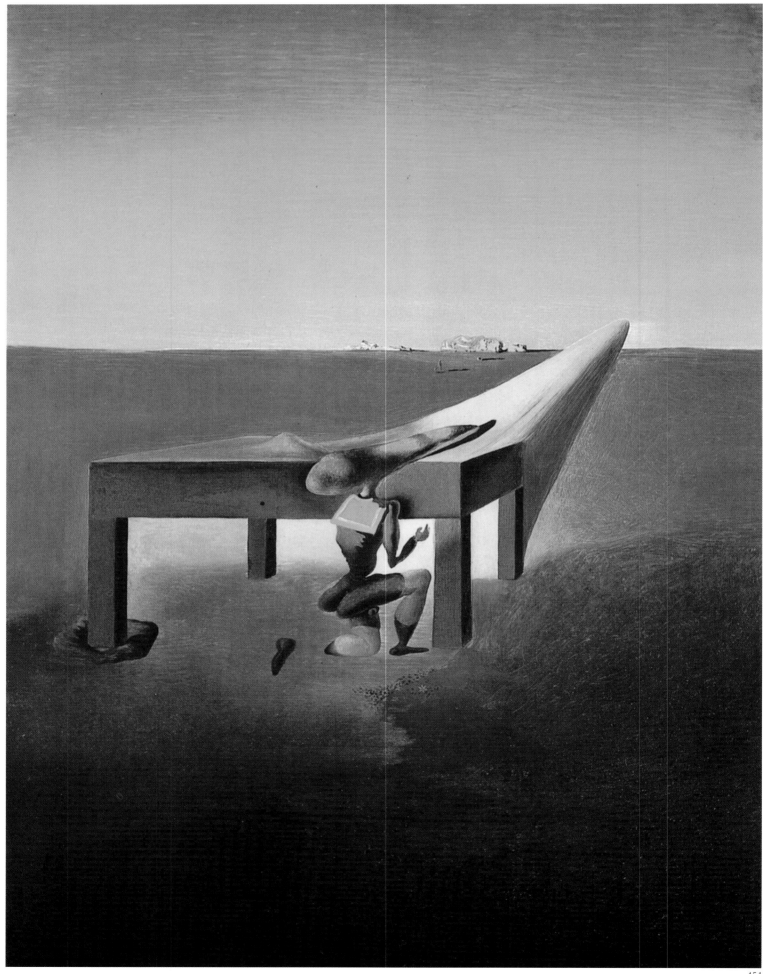

451

Virtue and Vice

When André Breton was still well disposed towards the Catalonian, he praised Dalí to the skies; but even at that point he warned him against the temptation to deviate. For Breton, Dalí was an artist who was torn between talent and genius – or between virtue and vice. Dalí (declared Breton) was an artist who took his place immediately, in a system of interferences, and the moths who attached themselves to his clothes would promptly declare that the man in shit-stained underpants in *The Lugubrious Game* (p. 142) was worth ten well-dressed men elsewhere, or a hundred naked men. Breton had his reservations about that controversial painting, to which Dalí responded in the *Secret Life*: "I, then, and only I was the true Surrealist painter, at least according to the definition which its chief, André Breton, gave of Surrealism. Nevertheless, when Breton saw this painting he hesitated for a long time before its scatological elements – for in the picture appeared a figure seen from behind whose drawers were bespattered with excrement. The involuntary aspect of this element, so characteristic in psychopathological iconography, should have sufficed to enlighten him. But I was obliged to justify myself by saying that it was merely a simulacrum. No further questions were asked. But had I been pressed I should certainly have had to answer that it was the simulacrum of the excrement itself. This idealistic narrowness was from my point of view the fundamental 'intellectual vice' of the early period of Surrealism. Hierarchies were established where there was no need for any. [...] And these were the men who denied the hierarchies of tradition!"

Breton declared that the art of Dalí – in his view the most hallucinatory yet created – represented a serious threat. It was an art that unleashed creatures unknown, with evil intentions: creatures that could be observed with dark joy as they went upon their way, multiplying, merging, concerned solely with themselves. This was a viable way of seeing Dalí, surely; and before long the breach between them was complete. By 1949, Breton was adding these words to an anthology entry on Dalí: "It should be understood that this entry relates only to the first Dalí, who disappeared around 1935, to be replaced by a person better known as Avida Dollars, a society portrait painter who has recently turned anew to the Catholic faith and the 'artistic ideal of the Renaissance' and now declares the Pope to be an admirer and supporter of his work." (We shall be returning in due course to relations between Dalí and Breton.)

Dalí was busy. He was exhibiting at Julien Levy's in New York. He published *Vive le Surréalisme* and was involved in the periodical *Minotaure*. His role in the Surrealist movement was a militant one, and was to have greater impact than that of any other Surrealist artist. He himself declared himself one hundred per cent a Surrealist: this, indeed, was to be the substance of the recriminations later levelled by Breton and the others. For Dalí's efforts were not only going into paintings, films with Buñuel, texts, and *objets d'art* – in other words, his purely personal work; his energies were also being spent on the theoretical and practical group

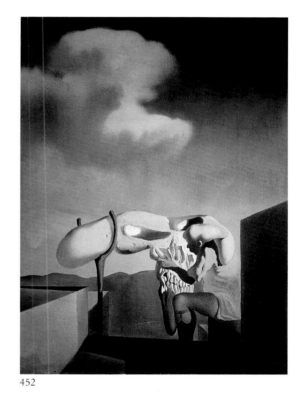

452

451 **Myself at the Age of Ten When I Was the Grasshopper Child – Castration Complex**, 1933 ❏
Moi-même à dix ans, lorsque j'étais l'enfant-sauterelle – Complexe de castration

452 **Average Atmospherocephalic Bureaucrat in the Act of Milking a Cranial Harp**, 1933 ❏
Bureaucrate moyen atmosphérocéphale, dans l'attitude de traire du lait d'une harpe crânienne

1933

453

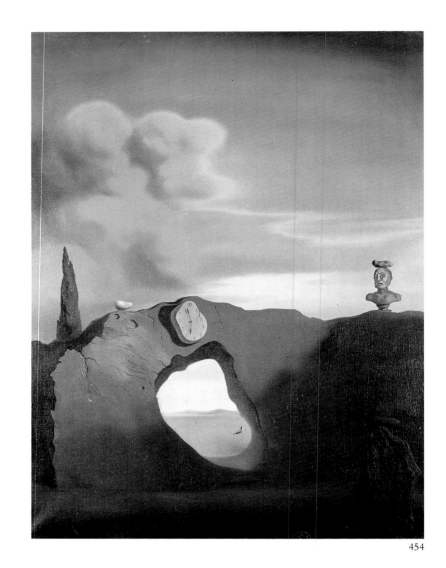

454

453 **Bureaucrat and Sewing
Machine – Illustration for "Les
Chants de Maldoror"**, 1933 Δ
Bureaucrate et machine à coudre

454 **The Triangular Hour**, 1933 ❑
L'heure triangulaire

455 **Soft Watches**, 1933 ❑
Montres molles

456 **Geological Destiny**, 1933 ❑
Le devenir géologique

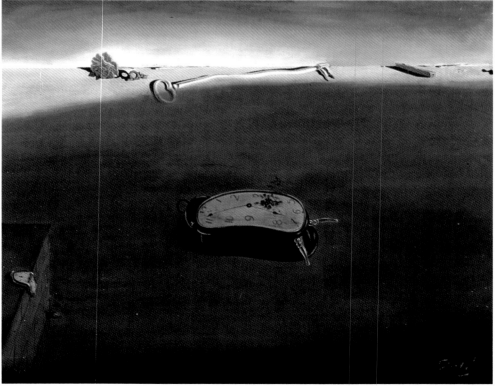

455

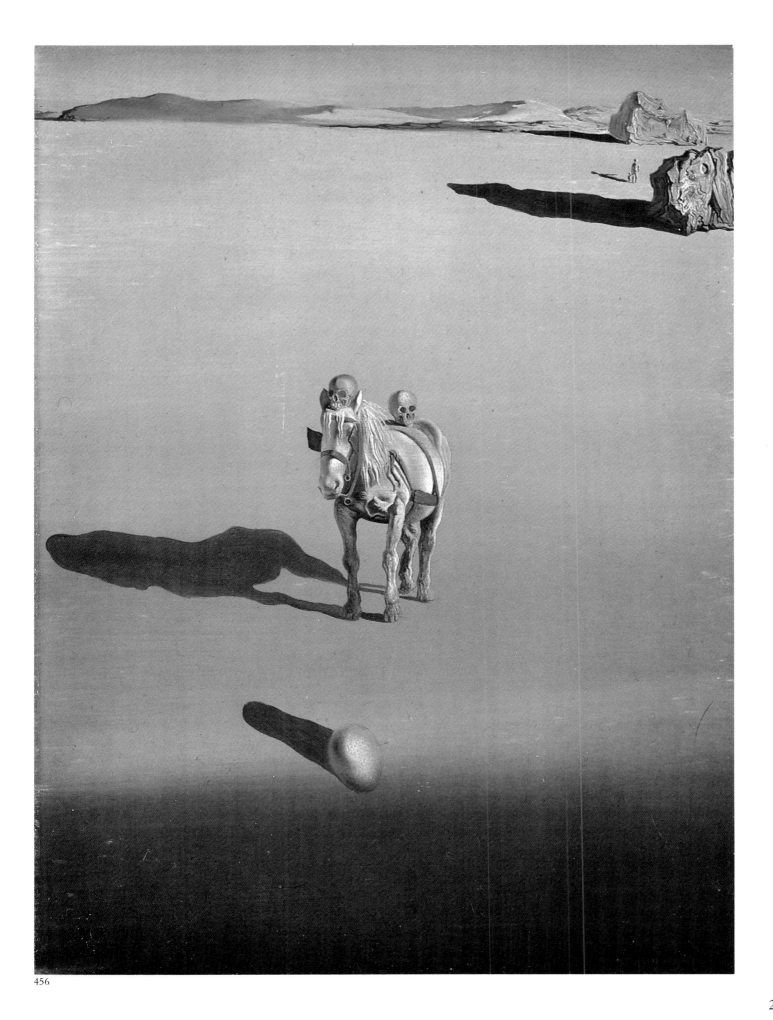

457

activities undertaken by the Surrealists. Breton himself conceded that for three or four years Dalí epitomized the spirit of Surrealism, and gave it the appeal only someone who was not present at the critical hour of the movement's birth could have endowed it with. He and Dalí still saw eye to eye at that time, and when Breton proclaimed at the close of his *Nadia* that beauty must be convulsive, or not be at all, he might have been taking the words out of Dalí's mouth. Dalí's "paranoiac-critical method" owed a significant amount to the widespread theory of convulsive creation; and the "spirit of Surrealism" referred to by Breton was closely connected with sexual provocativeness. Responding in 1932 to a questionnaire sent out by Yugoslavian Surrealists on the subject of lust and desire, Dalí wrote that secret desires constituted the true future, and the true life of the mind.

458

No lust, he asserted, could be sinful. It could only be wrong to suppress desire. And Dalí claimed that his own desires, far from being noble, were solely base and contemptible, and that the desires he himself considered noblest were the most perverse. He declared lust to be humanity's means of defence against the reality principle, and added that the Marquis de Sade struck him as the most suitable role model for the unleashed desires of the young.

Dalí's fame was growing apace, and business with it. He was sure of selling at least a portion of his output to a group of collectors who sometimes called themselves the Zodiac. Caresse Crosby gave the names of these twelve people to Julien Green, who wrote in his diary (28 February 1933): "To Dalí the day before yesterday, to pick up my painting, since it is my month. Twelve of us have agreed to pay the artist a kind of modest allowance this year, in return for which each receives either one large painting or a small painting and two drawings. We drew lots to decide which month we got. To my delight I had February, so that I did not have long to wait. I have a choice between a large painting with a wonderful rocky landscape in the background and in the foreground some sort of bearded Russian general, naked, his head bowed in sadness so that one can see the mussels and pearls crammed into his skull; or a small picture in splendid shades of grey

457 **The Phenomenon of Ecstasy,** 1933 △
Le phénomène de l'extase

458 **Two Faces of Gala,** 1933–1934 △
Deux visages de Gala

459

460

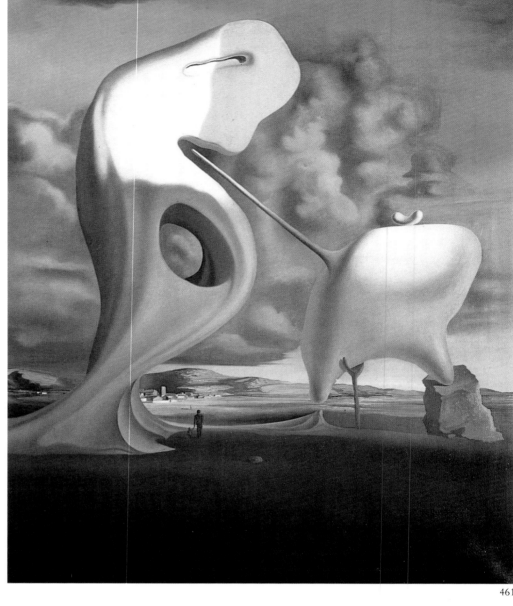

461

462

463

459 Poster advertising the regular meetings of the Surrealists, 1935 △

460 Untitled – Death outside the Head/Paul Eluard, c. 1933 ❏
Sans titre – Cette mort hors de la tête/Paul Eluard

461 The Architectural Angelus of Millet, 1933 ❏
L'Angélus architectonique de Millet

462 James Pradier: "Feminine Nude". Model for "Hysterical and Aerodynamic Nude" ☆

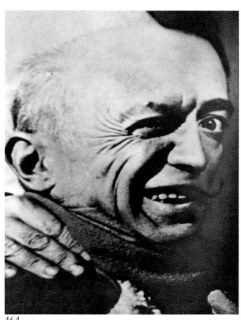

464

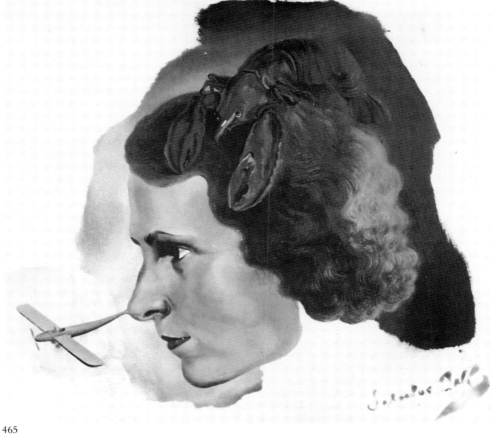

465

466

463 Hysterical and Aerodynamic Nude – Woman on the Rock, 1934 ○
Nu féminin hystérique et aérodynamique – La femme au rocher

464 Picasso/Dalí. Photographic double portrait by Philippe Halsman, 1933 ○

465 Portrait of Gala with a Lobster (Portrait of Gala with Aeroplane Nose), c. 1934 ❏
Portrait de Gala au homard

466 Surrealist Figures, joint drawing by Dalí and Picasso, c. 1933 △
Figures surréalistes

1933–1934

467 Cannibalism of Objects (inscribed: Meat Glass, Meat Aeroplane, Meat Spoon, Meat Watch, Meat Head), 1933 △ Cannibalisme des objets

468 Cannibalism. Illustrations for "Les Chants de Maldoror" by Lautréamont, 1933 △

469 The Temple of Love, 1933 ❏ Le temple de l'amour

467

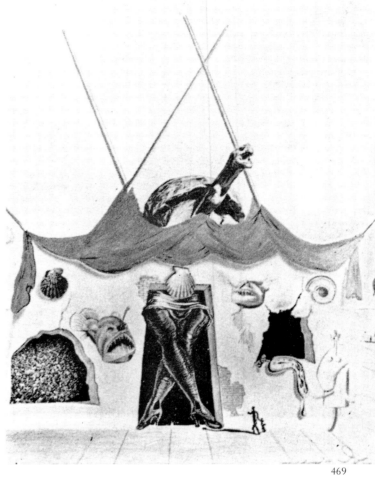

469

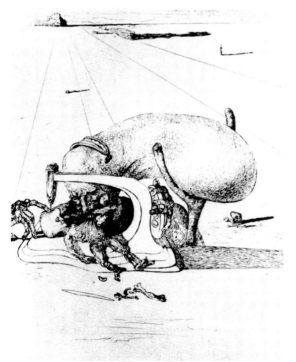

468

and lilac, as well as two drawings. I settle for the small picture. Dalí talks of Crevel, who is ill but 'stoical'. He expatiates on the beauty of his own art, and carefully explains to me the meaning of my picture, which is entitled *Geological Destiny* (p. 205) and which shows a horse in a desert, in the process of metamorphosing into a rock. Dalí is going to Spain, and he talks with horror of the customs formalities and the thousand petty vexations of a journey by *ferrocaril*, for he is somewhat like a child afraid of life."

Dalí was presently able to write to Charles de Noailles announcing that that very afternoon he was to sign a contract with Albert Skira, to provide forty engravings for Lautréamont's *Les Chants de Maldoror*. This task of illustrating Lautréamont was one Dalí found irresistible. The edition was to appear in the same series that had already featured Ovid's *Metamorphoses* illustrated by Picasso, and Mallarmé's poems illustrated by Matisse. Dalí told de Noailles that he would be starting on the Maldoror illustrations (the deadline for which lay a full year in the future) as soon as he arrived in Port Lligat. It was in fact Picasso who had introduced Dalí to Skira and proposed him as an illustrator; and the two artists met again when Dalí was at work on the Maldoror pictures at the Lacourière studio. In their breaks, they amused themselves with an engraving done jointly, working on the plate alternately and producing the *Surrealist Figures* (p. 209).

470 Cannibalism of the Praying
Mantis of Lautréamont, 1934 ❏
Cannibalisme de la mante religieuse de
Lautréamont

471 Melancholy – To Marcel Remy
in Friendship, Salvador Dalí, 1934 ❏
La mélancolie

472 Flesh Aeroplane. Illustration
for "Les Chants de Maldoror" by
Lautréamont, 1933 △

470

471

At the Galerie Colle, Dalí had a show which included a staggering collection of early masterpieces: *The Invisible Man* (p. 147), *The Lugubrious Game* (p. 142), *Accommodations of Desire* (p. 148), *Portrait of Paul Eluard* (p. 138), *Invisible Sleeping Woman, Horse, Lion* (p. 160), *The Enigma of William Tell* (p. 201), *Memory of the Child-Woman* (p. 176) and *The Persistence of Memory* (p. 163). André Lhote wrote of this exhibition, in the *Nouvelle Revue Française*: "S. Dalí is at once the Lalique and the Gustave Moreau of dream description. With precision tools he chisels shapes of high inspiration from those of the modern style we so liked in our infancy. His harmonies are often those of anatomy, where blood is king. The acrid hues of sulphur mixes with the purple of cold membranes and the blue of veins shimmering through dead skin. To be candid: what we see on these canvases are sadistically mutilated limbs, headless trunks, seething entrails and hopeless genitals. Like M. W. George, Salvador Dalí directs us to his impure spring; but, being clearer sighted than the apostle of Rome, he is aware of the impurity: 'decorative art above all, highly stereotyped decorative art, particularly the art that employs once again, with but little conviction, the memories of far-off and different styles, mixing them, not without a certain imaginative power,' he writes in the foreword to his catalogue. And again: 'in an ugly street, the fantastic and wonderful ornamentation of Métro entrances done in the modern style strikes us as the perfect symbol of spiritual dignity'."

472

211

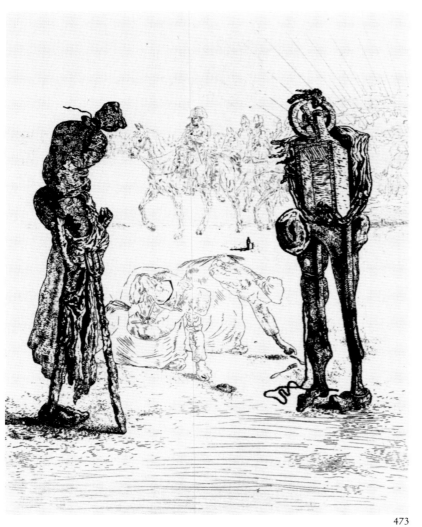

473

474

473 Illustration for "Les Chants de Maldoror", 1933–1934 △

474 Homage to Millet – For Cécile, in Friendship, 1934 △
Hommage à Millet – Dessin dédicacé à Cécile amicalement

475 The Spectre of the Angelus, c. 1934 ❑
Le spectre de l'Angélus

476 Untitled – Girl with a Skull, 1934 △
Sans titre – Jeune fille au crâne

475

476

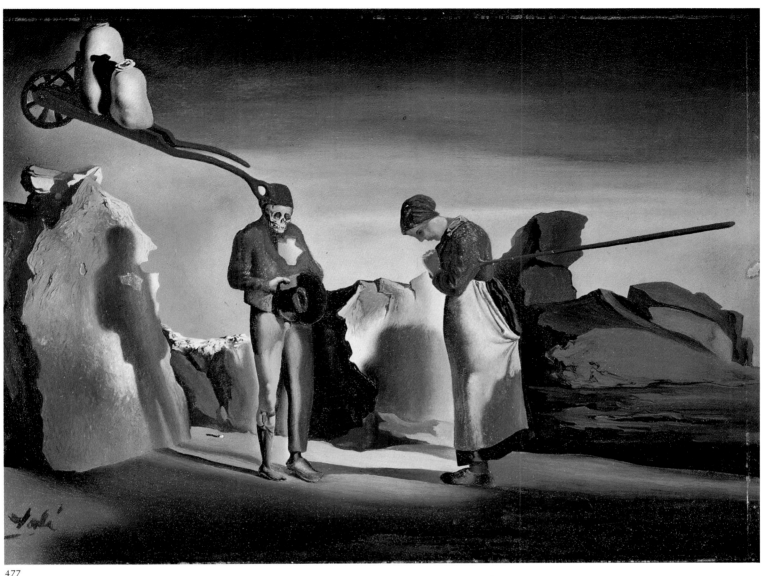

477

New York, New York

Exhibition followed hard upon exhibition. Dalí was out to reach as wide a public as possible. On 2 February 1934 he exhibited *The Enigma of William Tell* (p. 201) at the Salon des Indépendants. To Charles de Noailles he wrote gleefully of his decision to do so, observing that from a strictly experimental point of view it would be of great use for him to place his work before the broader public, out in the real world. At the same time he had shows of the drawings and graphics for Albert Skira's illustrated edition of Lautréamont's *Chants de Maldoror* at Julien Levy's in New York and the Librairie des Quatre Chemins in Paris. Looking ahead, he accepted a commission to illustrate Georges Hugnet's *Onan*. He covered the plate with automatic writing, and then wrote on it: "Espamographiphism, done with the left hand while I masturbate with the right, to the blood, to the bone, to the propellers of the chalice!"

On 20 June, commenting on another Dalí show at the Galerie Jacques Boujeau in Paris, Louis Chéronnet wrote in *Art et Décoration*: "Astounding painting, which has the cruel rawness of colour prints, or the clean-shaven shamelessness of eunuchs. Sickly tendrils and sexual deformities, inspired by the art of 1900, are seen in combat with complex monsters that seem straight from the pages of Re-

478

477 **Atavism at Twilight,**
1933–1934 ❏
Atavisme du crépuscule

478 **Jean-François Millet: The
Angelus,** 1859 ✶

213

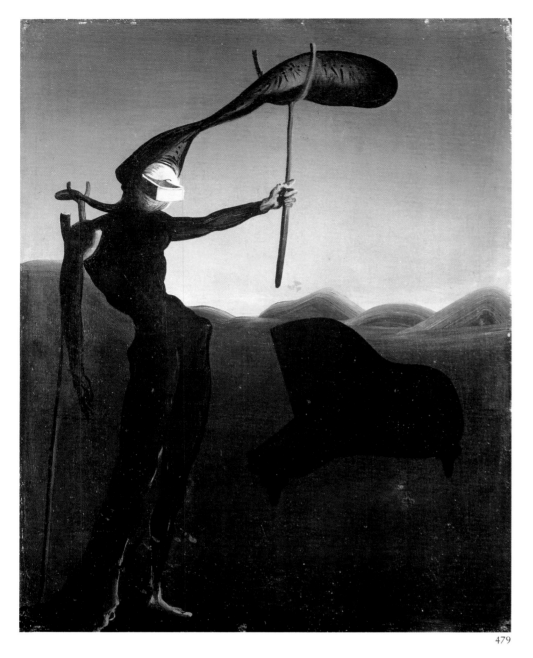

479

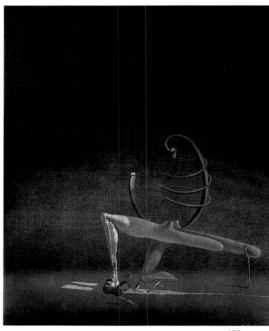

480

naissance books. And to paint all this, Dalí dreams of using the brush of Millet or Meissonier. The impressive thing is that this coup seems to come off. Not even Dante had greater cosmic imagination than this painter. The Musée Dupuytren holds no greater horror than do his works. And nonetheless, once one reaches these shores where whitened bones lie scattered, slack bodies are crawling with obscene insects, various things are rotting in the stifling heat, a heat so palpable one feels one might touch it with a feverish finger; once one reaches that isle of the dead with its immutably clear weather, its monumental cypresses and its perverse serenity; once one is there, one is enthralled by a strange magic…"

Dalí was winning awards as well. At "The 1934 International Exhibition of Paintings" at the Carnegie Institute in Pittsburgh, he received an honourable mention for *Enigmatic Elements in the Landscape* (p. 225). Then in London he had his first solo show at Zwemmer's, and Douglas Goldring noted in *The Studio* that the fame of the Parisian Spaniard had gone before him, preceding public familiarity with his work: hence the considerable interest in the exhibition at Zwemmer's. Goldring was reminded of paintings by William Holman Hunt and

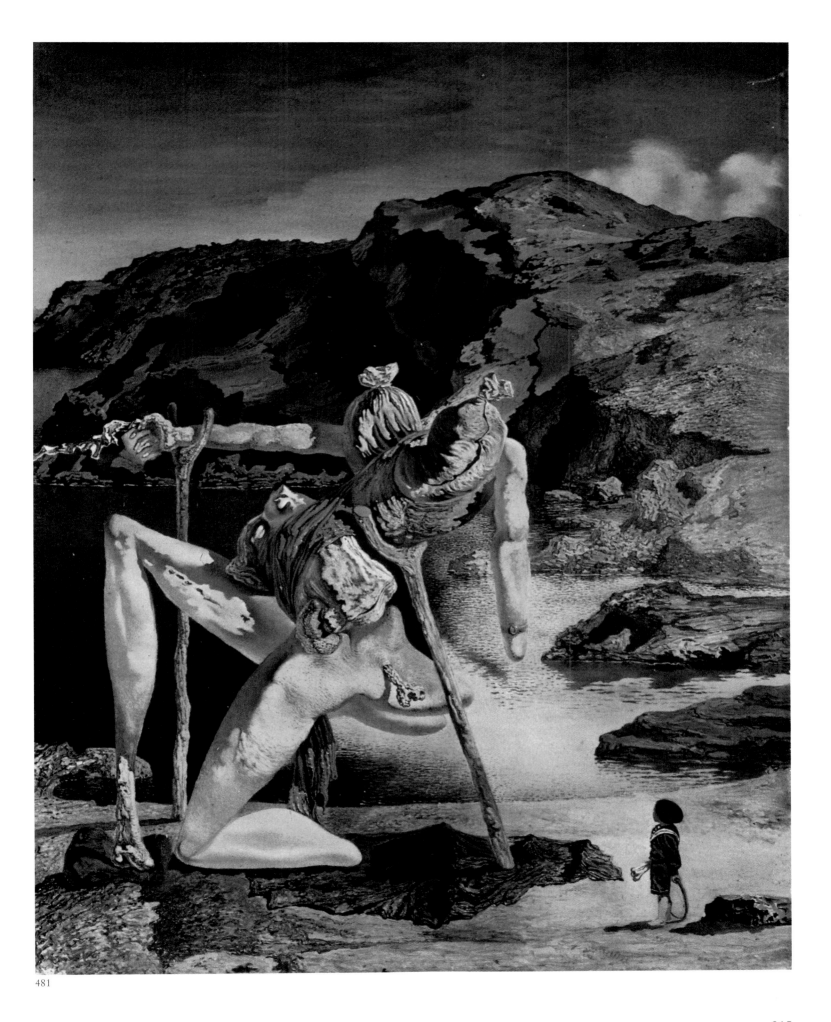

483

484

485

486

487

488

489

482-489 Consequences, c. 1934 Δ
Cadavre exquis (or, more simply, con-
sequences) is the well-known game in
which a text – or, if preferred, a draw-
ing – is continued on a piece of paper
folded down in such a way that the
player whose turn it is cannot see what
has gone before. The players in this
game were Valentine Hugo, André
Breton, Gala Eluard and Salvador Dalí.

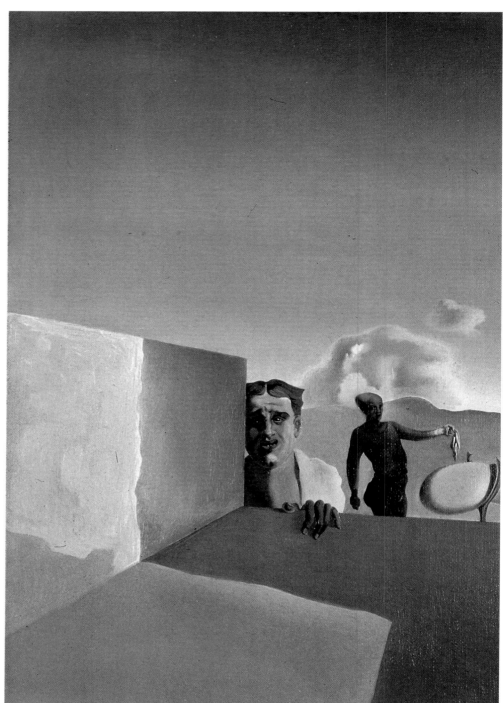

490

491

490 **Portrait of René Crevel (Dedicated to Julien Green)** , 1934 △
Portrait de René Crevel – Dédicacé à
Julien Green

491 **Barber Saddened by the
Persistence of Good Weather
(The Anguished Barber)**, 1934 ❏
Le coiffeur attristé par la persistance
du beau temps

Millais (and Orwell, some time later, found Dalí positively Edwardian) – it was
only when one considered Dalí's subject matter, rather than his technique (Goldring astutely noted), that he seemed surprising or revolutionary. Goldring meant
this as a compliment, adding that Dalí's was one of those few exhibitions one
wanted to visit again, and which exerted a compelling fascination. Herbert Read,
noting the analogies that were often drawn with Bosch, was less convinced. In
The Listener he conceded that both artists had drawn upon deep strata of the
unconscious for their inspiration, but questioned whether Dalí was (as the more
enthusiastic followers claimed) more intense than Bosch, and suggested that, once
the unconscious had been admitted as a source for art, what was done with it by
the artist was no longer of great significance. Read, one of the most influential art

492

493

critics of his time, was to remain a Dalí sceptic, and in his seminal *Concise History of Modern Painting* (1959) consigned Dalí to the margins, and accused him of cynicism, sentimentality and sensationalism (in his later, religious works), exhibitionism, and "an ultra-retrograde technique" which, by the time Read was writing, had become "an Academicism which calls itself Classicism on its own authority alone". The serious reservations expressed by many in Britain over the years, not only Orwell and Read, could do little to stop the popular impact of showman Dalí, of course.

The thorn in Breton's flesh, and in that of all the Surrealists, was the fact that Dalí was coming to be seen worldwide as the sole authentic Surrealist. The key to Dalí's supreme success was his recognition of the great importance of America.

492 **Bust of Joella Lloyd**, 1934 ○
Buste de Joella Lloyd

493 **Portrait of René Crevel (Man with a Cigarette)**, 1934 △
L'homme à la cigarette – Portrait de René Crevel

494

495

496

494 **The Isle of the Dead – Centre Section – Reconstructed Compulsive Image, after Böcklin**, 1934 ❑
L'île des morts – Cour centrale – Obsession reconstitutive d'après Böcklin

495 **Night Spectre on the Beach**, 1934 ❑
Spectre du soir sur la plage

496 **Paranoiac Astral Image**, 1934 ❑
Image paranoïaque-astrale

497 **Atavistic Vestiges after the Rain**, 1934 ❑
Vestiges ataviques après la pluie

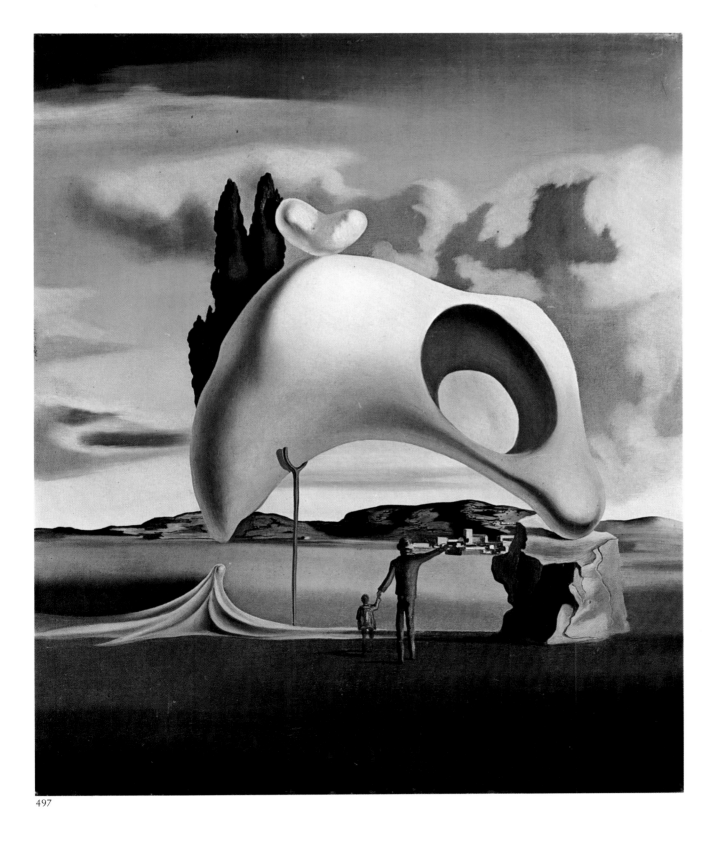

497

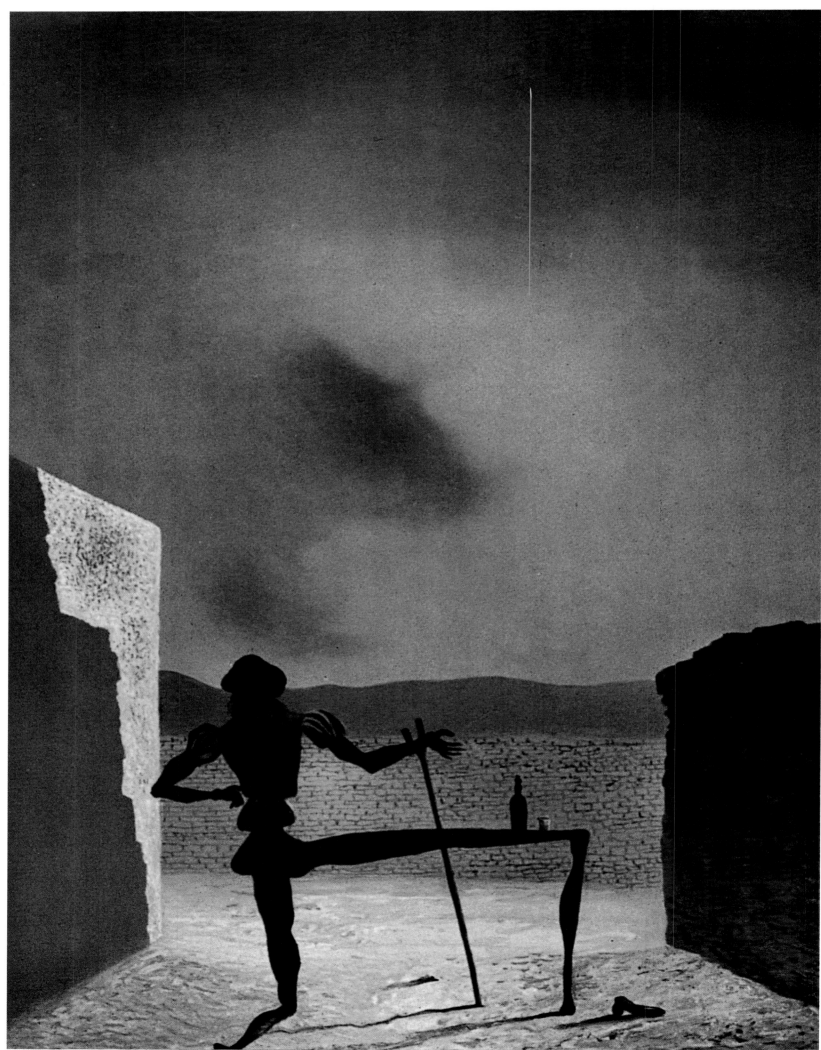

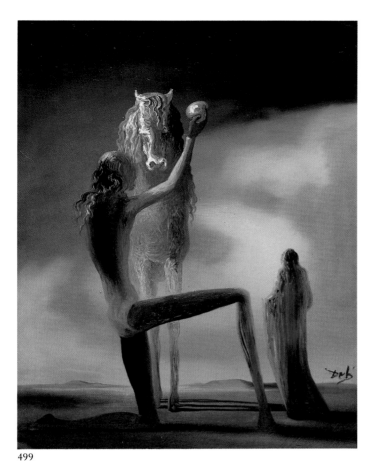

499

498 **The Ghost of Vermeer van Delft which Can Be Used as a Table,** 1934 ❏
Le spectre de Vermeer de Delft pouvant être utilisé comme table

499 **The Knight of Death,** 1934 ❏
Le chevalier de la mort

500

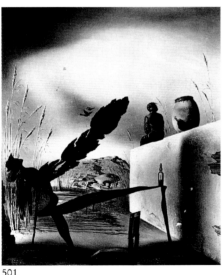

501

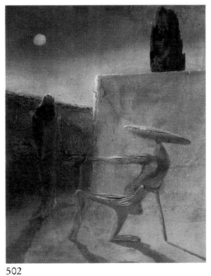

502

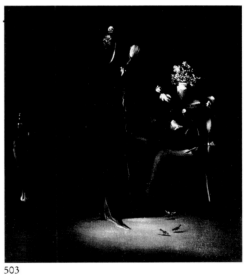

503

He decided that "what was going to make the most impression on them was precisely myself, the most partisan, the most violent, the most imperialistic, the most delirious, the most fanatical of all. Europeans," he wrote in the *Secret Life*, "are mistaken in considering America incapable of poetic and intellectual intuition. It is obviously not by tradition that they are able to avoid mistakes, or by a perpetual sharpening of 'taste'. No, America does not choose with the atavistic prudence of an experience which she has not had, or with the refined speculation of a decadent brain which it does not possess, or even with the sentimental effusion of its heart which is too young [...] No, America chooses better and more surely than it would with all these things combined. America chooses with all the unfathomable and elementary force of her unique and intact biology."

500 **The Ghost of Vermeer van Delft,** c. 1934 ❏
Spectre de Vermeer

501 **The Ghost of Vermeer van Delft,** 1934 ❏
Le spectre de Vermeer de Delft

502 **The Ghost of Vermeer van Delft,** c. 1934 ❏
Le spectre de Vermeer de Delft

503 **Title unknown – Ghost,** c. 1934 ❏
Titre inconnu – Spectre

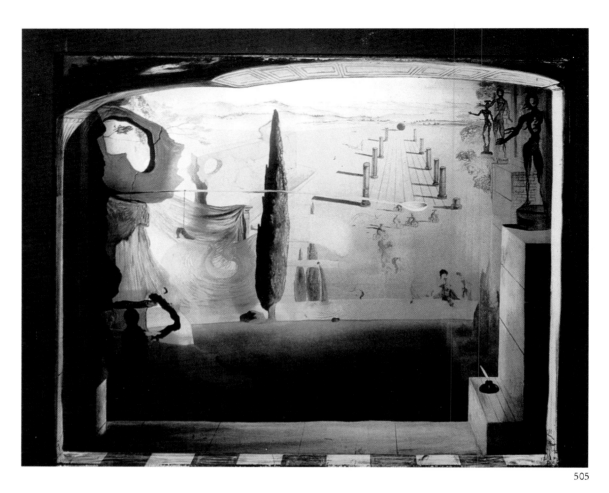

504 The Tower, 1934 ❏
La tour

505 The Little Theatre, 1934 ○
Le petit théâtre

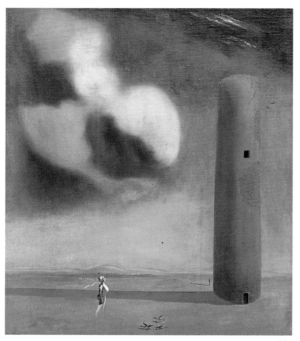

504

The desire to go to the U.S.A. became an obsession with Dalí. The problem was that he did not have the money for the Atlantic crossing. His contract with Pierre Colle was not renewed because Colle was in financial difficulty. The collectors who were loyal to Dalí had his work all over their walls already; and Port Lligat had already devoured all the proceeds of his sales. "I thus found myself at a moment when I was simultaneously at the height of my reputation and influence and at the low point of my financial resources." In a rage, Dalí went knocking at doors – and "after three days of furiously jerking fortune's cock it ejaculated in a spasm of gold!" And Dalí and Gala had their fare. On this occasion, Fortune had appeared in the guise of Pablo Picasso. Dalí later admitted that he never paid back the money he borrowed – nor did his fellow artist from Málaga ever ask for it back.

Caresse Crosby accompanied Dalí and Gala, and later described their inauspicious departure and arrival in her book *The Passionate Years*. Once Julien Levy had left for the States, she recalled, the steam seemed to go out of Dalí, and he lost the energy to tackle an Atlantic crossing, least of all with his precious pictures. Not till a year later when Crosby offered to escort Dalí and Gala aboard the *Champlain*, and to deliver them in person to Levy, did the artist take courage to go ahead. Crosby recalled the morning they met at the station, to depart for the coast and embarkation. She found Dalí pale and quaking in a third class carriage near the locomotive, crouched behind stacks of pictures that were tied to his person with cord. He had chosen a seat near the engine, he told her, in order to arrive the sooner. The pathetic Dalí even refused to lunch on the way, for fear that someone might make off with one or two of his soft watches.

When at last the party arrived at New York, Caresse Crosby and Gala were on deck to see the Statue of Liberty and the Empire State Building; but Dalí refused

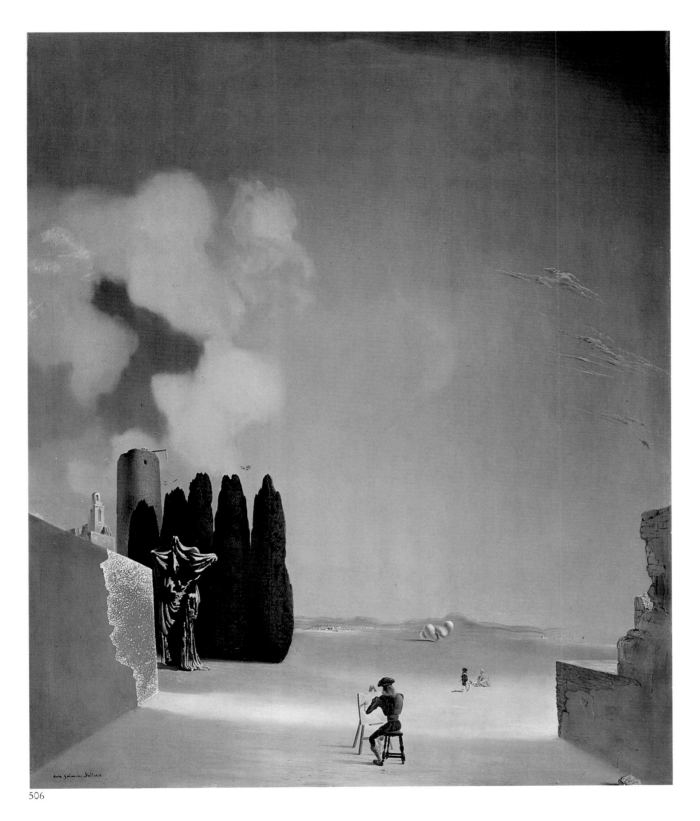

506

506 **Enigmatic Elements in the
Landscape**, 1934 ❏
Paysage avec éléments énigmatiques

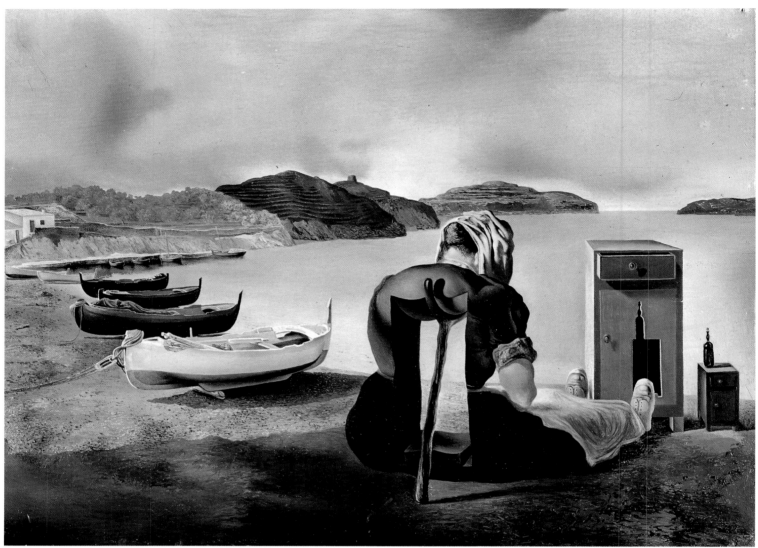

<div style="text-align: right">507</div>

508

**507 The Weaning of Furniture-
Nutrition**, 1934 ❏
Le sevrage du meuble-aliment

**508 Study for the nurse in "The
Weaning of Furniture-Nutrition"**,
c. 1932–1933 △

to leave his cabin. He had had his cases packed on the third day of the crossing,
and "felt that the boat was too large and too complex to be able to make the
crossing without a catastrophe," as he himself remembered later. "I attended all
the life-saving drills and I was always on the spot minutes ahead of time, my
life-belt attached with all the regulation straps. [...] I continually drank cham-
pagne, to give myself courage and in anticipation of seasickness, which, however,
did not occur."

When the liner reached New York, the press came out on the pilot's boat, and
Caresse Crosby, posing for the photographers, urged the journalists to talk to
Dalí. They found him emplaced anew amidst his paintings. Crosby gave the
gentlemen of the press an introduction to Surrealism, then whispered to Dalí in
French that the ball was now in his court – whereupon the Dalí show began with
a vengeance. During the crossing, he and Crosby had talked the captain of the
Champlain into having a fifteen-metre loaf baked for him when they arrived in
New York. Or, to be exact, a two-and-a-half metre loaf – since the oven on board
could not handle anything longer. Dalí proposed to distribute the bread to the
waiting journalists as St. Francis had scattered it to the birds. Things went differ-
ently, though. "It may appear astonishing," he wrote in the *Secret Life*, "but it is
a fact that not one of the reporters asked me a single question about the loaf of
bread which I held conspicuously during the whole interview [...] On the other
hand, all these reporters were amazingly well informed as to who I was. Not only

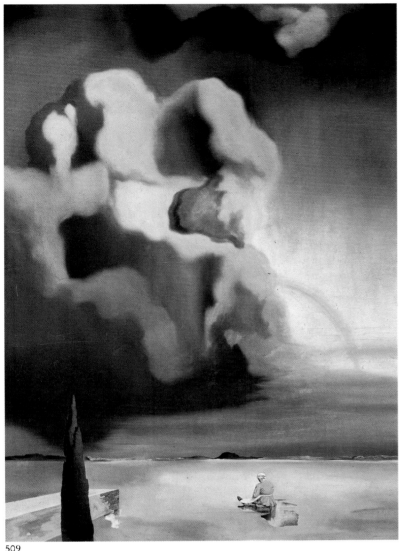

509

510

this. They knew stupefying details about my life. They immediately asked me if it was true that I had just painted a portrait of my wife with a pair of fried chops balanced on her shoulder. I answered yes, except that they were not fried, but raw. Why raw? they immediately asked me. I told them that it was because my wife was raw too. But why the chops together with your wife? I answered that I liked my wife, and that I liked chops, and that I saw no reason why I should not paint them together."

To Dalí's eyes, New York looked like "an immense Gothic Roquefort cheese". (He was careful to add that he loved Roquefort.) He saluted New York as a new Egypt: "But an Egypt turned inside out. For she erected pyramids of slavery to death, and you erect pyramids of democracy." In his pamphlet *New York Salutes Me*, which was handed out at his exhibition at the Julien Levy gallery, Dalí quoted André Breton's definition of Surrealism: "Pure psychic automatism, by which it is intended to express, whether verbally or in writing, or in any other way, the real process of thought. Thought's dictation, free from any control by the reason, independent of any esthetic or moral preoccupation." In the pamphlet, describing the wave of Surrealism then flooding the art world, Dalí saw Surrealists as the mediums of an unknown world, adding that he himself had never had the slightest idea what his own paintings meant. He simply transcribed his thoughts, he insisted – specifying his most intense, most fleeting of visions, giving form to all things mysterious and personal and unique that came to mind. A painting, he

509 **The Spectre and the Phantom,** 1934 ❑
Le spectre et le fantôme

510 **Figure with Drawers,** c. 1934 ❑
L'homme aux tiroirs

declared, must be a snapshot in colour, recording the incredible, delirious irrationality of the unconscious with obsessive precision.

Both Dalí's show and his pamphlet were a triumphant success. Henry McBride in *The Sun* acclaimed his art as controversial and difficult, while Edward Alden Jewell wrote in *Time* that as a craftsman, artist and magus of the brush, Dalí's place was among the greatest. Jewell added that he saw Dalí as a miniaturist, and that the larger format works seemed less persuasive. The impact of Dalí's charisma, Jewell remarked, led one to overlook whatever was mannered or banal in his art – and the fact remained that the Spaniard was a masterful colourist and draughtsman.

While the Americans were deciding what they thought of Dalí, Dalí was deciding what he thought of America. New York brought out the most astonishingly lyrical, almost expressionistically incoherent strain in Dalí: "New York, granite sentinel facing Asia, resurrection of the Atlantic dream, Atlantis of the subconscious. New York, the stark folly of whose historic wardrobes gnaws away at the earth around the foundations and swells the inverted cupolas of your thousand new religions. What Piranesi invented the ornamental rites of your Roxy Theatre? And what Gustave Moreau apoplectic with Prometheus lighted the venomous colors that flutter at the summit of the Chrysler Building?

New York, your cathedrals sit knitting stockings in the shadow of gigantic banks, stockings and mittens for the Negro quintuplets who will be born in Virginia, stockings and mittens for the swallows, drunk and drenched with Coca-Cola, who have strayed into the dirty kitchens of the Italian quarter and hang over the edges of tables like black Jewish neckties soaked in the rain and waiting for the snappy, sizzling stroke of the iron of the coming elections to make them edible, crisp as a charred slice of bacon. [...]

And on Fifth Avenue Harpo Marx has just lighted the fuse that projects from the behinds of a flock of explosive giraffes stuffed with dynamite. They run in all directions, sowing panic and obliging everyone to seek refuge pell-mell within the shops. All the fire alarms of the city have just been turned on, but it is already too late. Boom! Boom! Boom! Boom! I salute you, explosive giraffes of New York, and all you forerunners of the irrational – Mack Sennett, Harry Langdon, and you too, unforgettable Buster Keaton, tragic and delirious like my rotten and mystic donkeys, desert roses of Spain! [...]

No, a thousand times no – the poetry of New York was not what they had tried in Europe to tell us it was. The poetry of New York does not lie in the pseudo-esthetics of the rectilinear and sterilized rigidity of Rockefeller Center. The poetry of New York is not that of a lamentable frigidaire in which the abominable European esthetes would have liked to shut up the inedible remains of their young and modern plastics! No!

The poetry of New York is old and violent as the world; it is the poetry that has always been. Its strength, like that of all other existing poetry, lies in the most gelatinous and paradoxical aspects of the delirious flesh of its own reality. Each evening the skyscrapers of New York assume the anthropomorphic shapes of multiple gigantic Millet's *Angeluses* of the tertiary period, motionless and ready to perform the sexual act and to devour one another, like swarms of praying mantes before copulation. [...]

The poetry of New York is not serene esthetics; it is seething biology. The poetry of New York is not nickel; it is calves' lungs. And the subways of New York do not run on iron rails; they run on rails of calves' lungs! The poetry of New York is not pseudo-poetry; it is true poetry. The poetry of New York is not mechanical rhythm; the poetry of New York is the lions' roar that awakened me the first morning. The poetry of New York is an organ, Gothic neurosis, nostalgia of the Orient and the Occident, parchment lampshade in the form of a musical

contd. on p. 235

511

512

511 **Surrealist Knight,** c. 1934 ❑
Cavalier surréaliste

512 **Study for "Cardinal,
Cardinal!",** 1934 △

513 **Cardinal, Cardinal!,** 1934 ❑
Cardinal, cardinal !

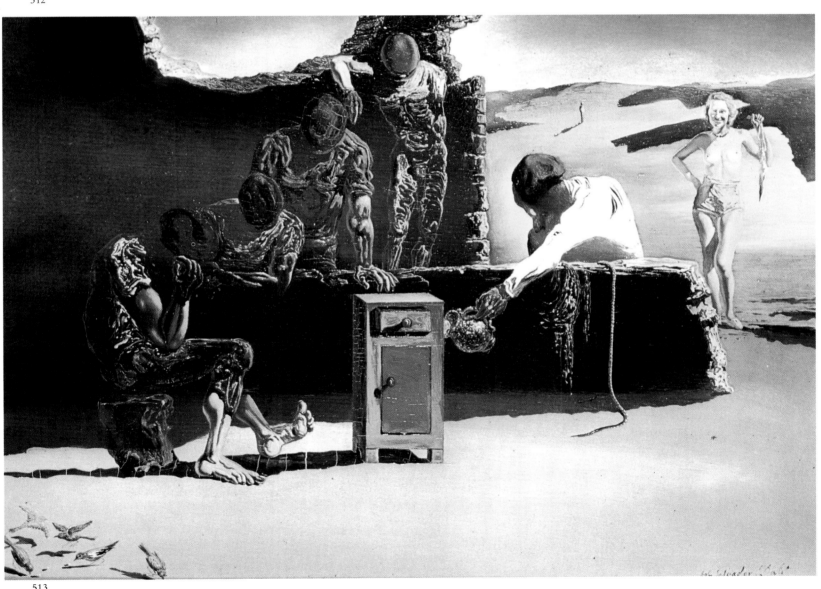

513

514

514 Omelettes with Dynamic Mixed Herbs, 1934 △
Omelettes fines herbes dynamiques

515 Untitled, 1933–1934 ❑

515

516

518

517

516 **Untitled (Desert Landscape),**
1934 ❑
Sans titre (Paysage désertique)

517 **Omelette about to Be Irrepar-
ably Crushed by Hands,** 1934 △
Omelette allant irrésistiblement à
l'écrasement par les mains

518 **Figure-Omelettes,** 1934 △
Figures-omelettes

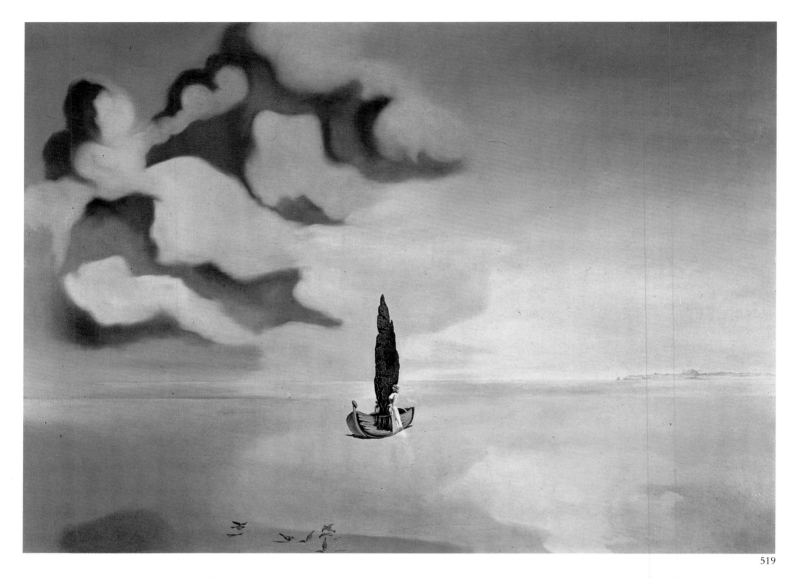

519

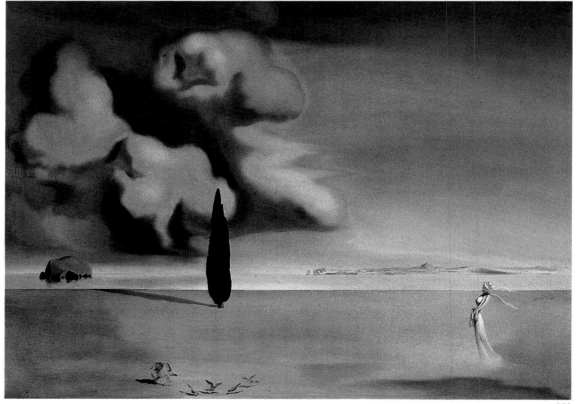

520

519 **Apparition of my Cousin Carolinetta on the Beach at Rosas – Fluid Premonition**, 1934 ❑
Apparition de ma cousine Carolinetta sur la plage de Rosas – Pressentiment fluidique

520 **Apparition of my Cousin Carolinetta on the Beach at Rosas**, 1934 ❑
Apparition de ma cousine Carolinetta sur la plage de Rosas

521 **Photo of a cypress seeming to rise suddenly from a boat** ✩

522 **Morning Ossification of the Cypress**, 1934 ❑
Ossification matinale du cyprès

523 **Fossil Cloud (Lion, Woman and Cypress)**, 1934 ❑
Nuage fossile (Lion, femme et cyprès)

521

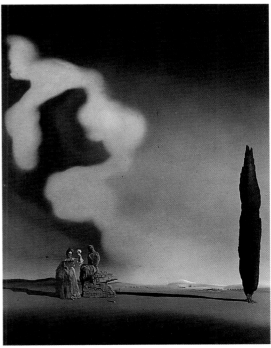

523

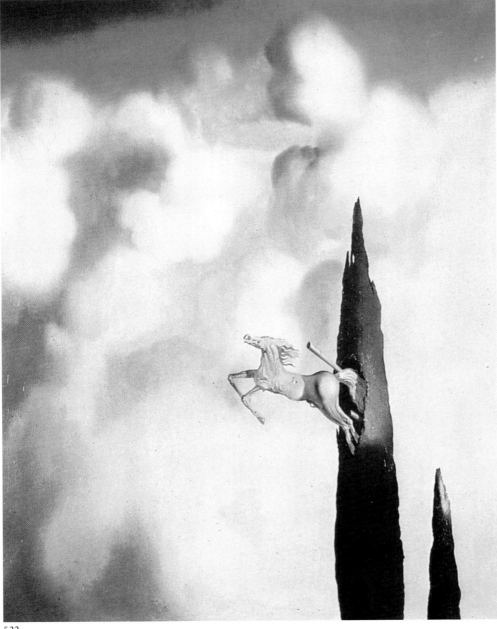

522

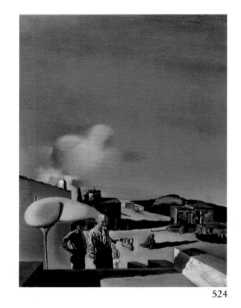

524

525

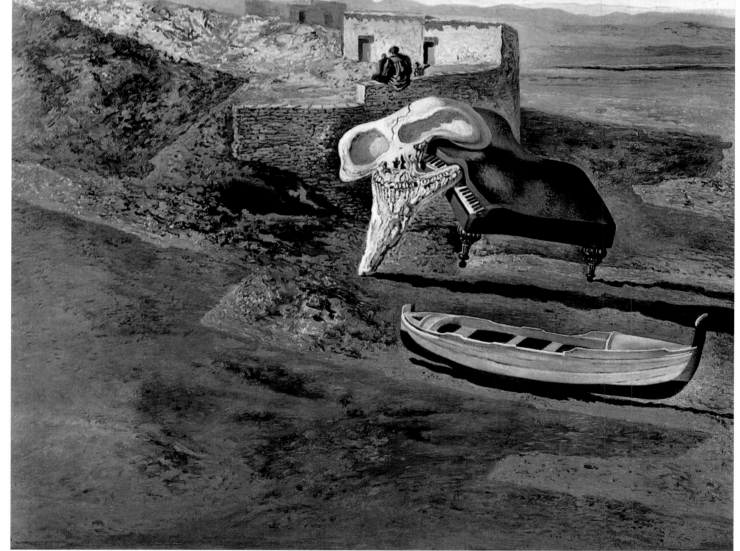

526

527

528

partition, smoked façade, artificial vampire, artificial armchair. The poetry of New York is Persian digestion, sneezing golden bronze, organ, suction-grip trumpet for death, gums of thighs of glamor girls with hard cowrie-shell vulvas. The poetry of New York is organ, organ, organ, organ of calves' lungs, organ of nationalities, organ of Babel, organ of bad taste, of actuality; organ of virginal and history-less abyss. The poetry of New York is not that of a practical concrete building that scrapes the sky; the poetry of New York is that of a giant many-piped organ of red ivory – it does not scrape the sky, it resounds in it, and it resounds in it with the compass of the systole and the diastole of the visceral canticles of elementary biology. New York is not prismatic; New York is not white. New York is all round; New York is vivid red. New York is a round pyramid. New York is a ball of flesh a little pointed toward the top, a ball of millennial and crystallized entrails; a monumental ruby in the rough – with the organ-point of its flashes directed toward heaven, somewhat like the form of an inverted heart – before being polished!"

Dalí liked going into drugstores with an immense loaf tucked under his arm, ordering fried eggs, and then eating them with a small piece of bread cut off the loaf – to the great amusement of anyone who happened to be there at the time. His paintings sold well: eight in New York, three of them to museums. For the return trip, the Dalís were able to treat themselves to a luxury cabin on the *Normandie*. Before they departed, Caresse Crosby threw a Dream Ball in Dalí's honour. The Americans vied fiercely to out-Dalí each other. Dalí confessed that even he (who was so rarely impressed by anything) was astounded by the riotousness of the ball at the "Coq Rouge". Simply to please Dalí, ladies would appear with

524 The Invisible Harp, Fine and Medium, 1932 ❏
La harpe invisible, fine et moyenne

525 Untitled – Study for parts of "The Invisible Harp, Fine and Medium" and parts of "Skull with its Lyric Appendage Leaning on a Bedside Table…", c. 1933 △

526 Atmospheric Skull Sodomizing a Grand Piano, 1934 ❏
Crâne atmosphérique sodomisant un piano à queue

527 Skull with its Lyric Appendage Leaning on a Bedside Table which Should Be the Exact Temperature of a Cardinal's Nest, 1934 ❏
Crâne avec son appendice lyrique reposant sur une table de nuit qui devrait avoir la même température que le nid d'un cardinal

528 Soft Cranias and Skull Harp, 1935 △
Crânes mous et harpe crânienne

529

531

530

532

533

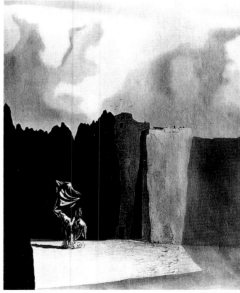

534

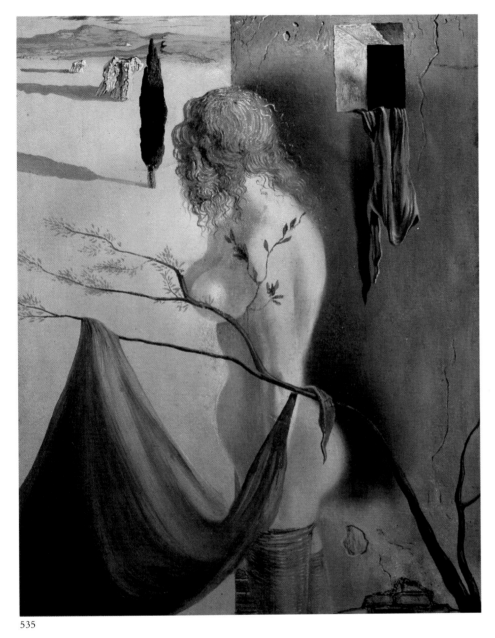

529 **The Sense of Speed**, 1934 ❏
Le sentiment de la vitesse

530 **Eclipse and Vegetable Osmosis,**
1934 ❏
Eclipse et osmose végétales

531 **The Hour of the Cracked
Visage,** 1934 ❏
L'heure du visage craquelé

532 **Vegetable Metamorphosis,**
c. 1934 ❏
Métamorphose végétale

533 **Untitled (Dreams on the
Beach),** 1934 ❏
Sans titre (Sueños en la playa)

534 **West Side of the Isle of the
Dead – Reconstructed Compulsive
Image after Böcklin,** 1934 ❏
Cour ouest de l'île des morts – ob-
session reconstitutive d'après Böcklin

535 **The Sign of Anguish,** 1934 ❏
Le signal de l'angoisse

536 **Morphological Echo,**
1934–1936 ❏
Echo morphologique

537 **Aerodynamic Chair,** 1934 ❏
Chaise aérodynamique

535

536

537

1933–1935

a birdcage on their heads, say, and otherwise practically naked. Others pretended to be wounded or mutilated in frightful ways, or stuck safety pins through their skin to do cynical violence to their own beauty. One young woman – slender, pale, cerebral – wore a satin dress with a "living" mouth. On her cheeks and back and in her armpits she had eyes like terrible tumours. A man wearing a bloody nightshirt had a bedside table balanced on his head. When he opened the door of the bedside table, a flock of hummingbirds flew out. On the staircase there was a bathtub filled with water, so shaky that it threatened to tip over and flood the merrymakers at any moment. In the course of the evening a huge flayed ox was dragged into the ballroom; its slit belly was supported on crutches and contained a dozen gramophones. Gala was done up as a "choice corpse": on her head she had a doll (which made a very real impression) that looked like a baby with its belly eaten away by ants, its head in the claws of a phosphorescent lobster.

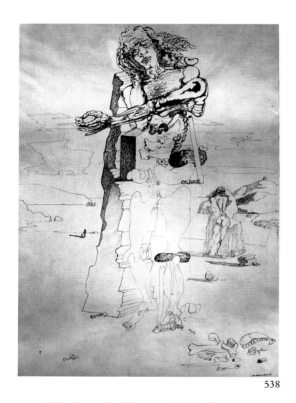

538

538 **Surrealist Figure in the Land-scape of Port Lligat**, 1933 Δ
Personnage surréaliste dans le paysage de Port Lligat

539

539 **The Judges**, c. 1933 Δ
Les juges

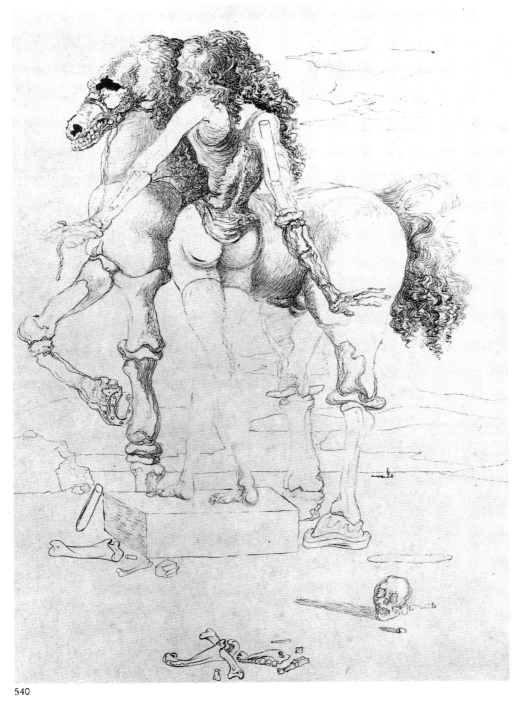

540

540 **Surrealist Horse – Woman-Horse**, 1933 Δ
Cheval surréaliste – Femme-cheval

541 **The Knight of Death (Horse-man)**, 1934 Δ
Chevalier de la mort, dit aussi Cavalier

542 **Culleró rock, Cape Creus, the shape of which recalls a knight mounted on a horse** ☆

543 **Don Quixote**, 1935 Δ
Don Quichotte

541

542

543

544

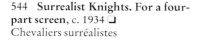

545

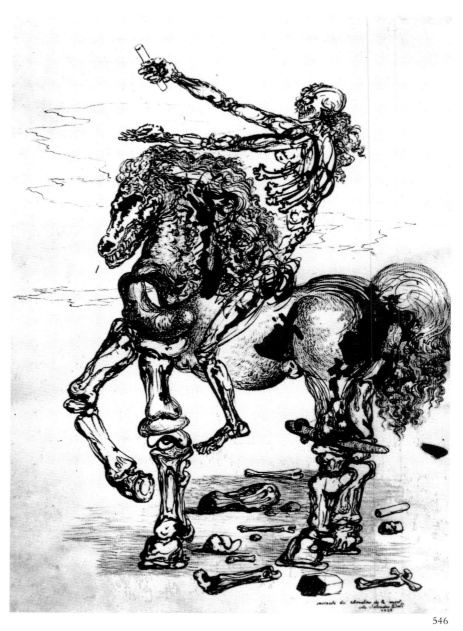

546

544 Surrealist Knights. For a four-part screen, c. 1934 ❏
Chevaliers surréalistes

545 Surrealist Warriors. For a four-part screen, c. 1934 ❏
Guerriers surréalistes

546 Knight of Death, 1933 △
Variante du Chevalier de la mort

547 The Horseman of Death, 1935 ❏
Le cavalier de la mort

Rebelling against Father Breton

Dalí's enemies and allies tend to have one thing in common: they largely ignore his own writings. Yet when Dalí availed himself of the written or spoken word, he did so with all his extravagance and bravado, with his core reticence and his embarrassed revelations, and above all with the man's unique brilliance – and often his statements contain vital information on his evolution as a painter, the tempestuous ups and downs of his life, his tenderness and cruelty, and the stern logic that governed the apparent contradictions in his thought. Eccentric though Dalí was, through it all there ran an exemplary continuity. *The Secret Life of Salvador Dalí* gives us the first steps the child took, the youth's quest for identity, the upheavals in his life, and the hidden, passionate sides of a provocative and free-thinking mind that caused scandals from the outset, cared nothing for the opinions of others, and tended to thrive on people's stupidity.

The Diary of a Genius (the continuation of his autobiography) expressed his personality as Dalí – that is to say, the public persona that used a kind of delirium to achieve effects. In the book we witness Dalí grappling with art and with his own formidable abilities. It is fascinating to follow the relentless logic with which

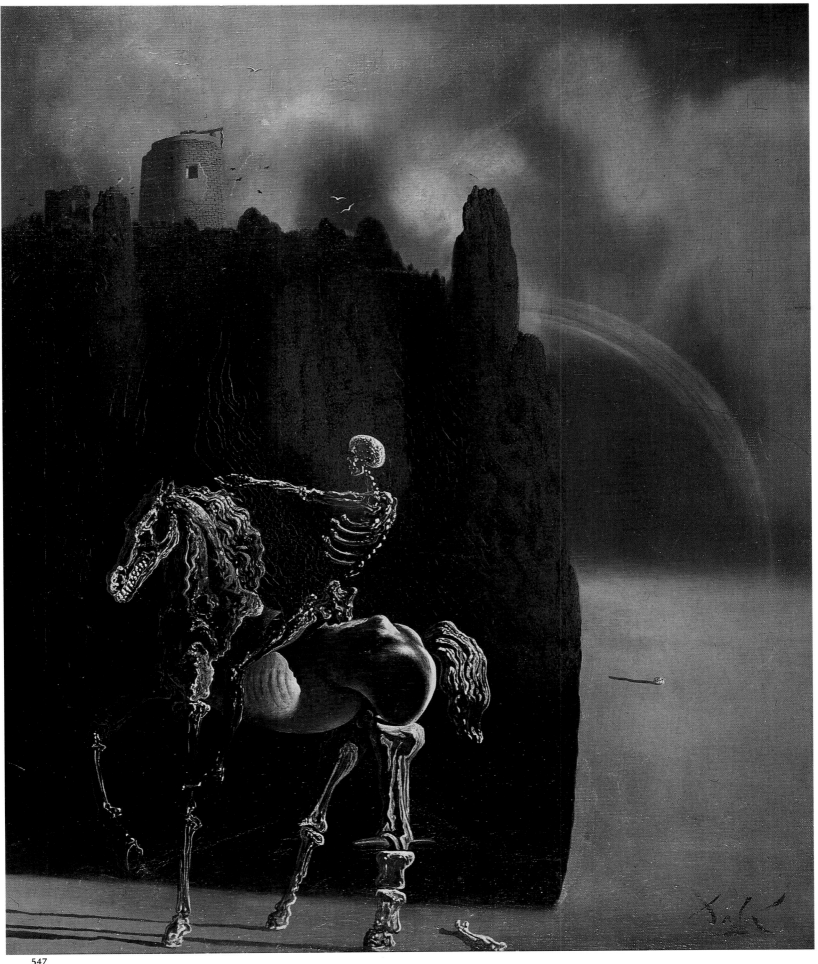

547

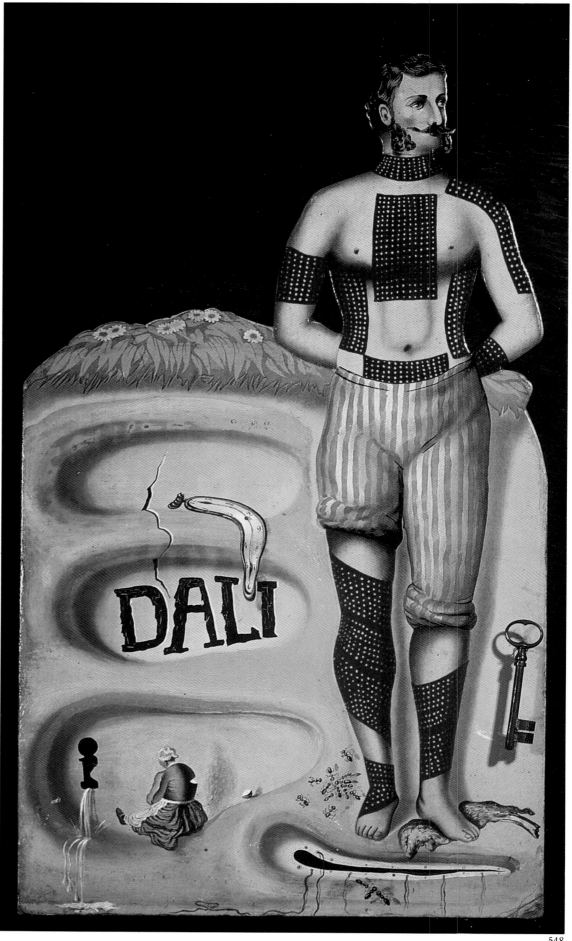

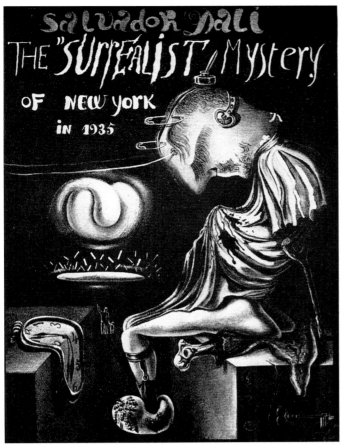

549

550

551

his way of thinking develops, the steps in his conquest of the irrational. And no one describes Dalí's relations with Surrealism better than Dalí himself. He was a Surrealist "from birth," writes Dalí. He explains the reasons for the breach with Breton – who (he concedes) was after an aesthetic of the unconscious, but who imposed limits and would accept neither the full, alarming risk of the enterprise nor the lack of control. Dalí, by contrast, was naturally inclined to total, untram-melled Surrealism. If Breton closed the movement's doors to Dalí, that was un-derstandable: he himself had founded it, only to have Dalí declare himself the truest, most absolute Surrealist and expect Breton to acknowledge himself as the master of the movement.

But for all his magalomania and conceit, his contradictions and absurdities, the traps he laid for the public, his arrant lack of shame, and in spite of his idiom of delirium, Dalí as a writer must be taken just as seriously as Dalí the painter.

In the *Diary of a Genius*, Dalí explicitly states that he was aware from the very start that the Surrealists, whose "slogans and subjects [he] had already studied closely and taken apart minutely" when he joined the movement, would try to impose restrictions on him just as his family had done. Gala had warned him that he "would have to put up with the same restrictions among the Surrealists as he would anywhere else, and that basically they were all Philistines."

Dalí begins his book with a quotation from Sigmund Freud – "The hero is the man who resists his father's authority and overcomes it" – and then, having dealt with the most important writer of his times, goes on to settle scores with his new father, André Breton.

Approaching his subject with a "quite Jesuitical" honesty, yet "always with the thought at the back of my mind that I would soon become the leader of the Surrealists," Dalí "took Surrealism quite literally, rejecting neither the blood nor the excrement that was in their manifestoes. Just as I had once endeavoured to become a perfect atheist by reading my father's books, I now became so diligent

548 Surrealist Poster, 1934 ❑
Affiche surréaliste

549 The Surrealist Mystery of New York in 1935 ❑

550 Woman in a Hat Sitting on a Beach. Drawing for "American Weekly", 1935 △
Femme au chapeau assise sur la plage

551 Invitation to the Dream Ball given by Caresse Crosby, 1934 ☆

243

552

553

552 **Mae West Lips Sofa,**
1936–1937 ○

553 **Photo of Mae West used by Dalí for "Mae West's Face",** 1934 ☆

554 **Mae West's Face which May Be Used as a Surrealist Apartment,** 1934–1935 △
Visage de Mae West pouvant être utilisé comme appartement surréaliste

a *stud. surr.* that I was soon the only full Surrealist. So much so, that in the end I was expelled from the group because I was overly-Surrealistic."

It was not difficult to be expelled by Breton – many others travelled the same road, and they tended to be the best, the most independent-minded. Small wonder: a gardener wants his shrubs trained in the style he has chosen, after all. "When Breton discovered my art he was horrified at the scatological elements that stained it," Dalí reports in the *Diary of a Genius*. "I was surprised. The very first steps I took were taken in sh--, which, psychologically speaking, could be interpreted as an auspicious token of the gold that was fortunately to rain down on me later. I tried craftily to persuade the Surrealists that those scatological elements could bring the movement good fortune. In vain I referred to the emphatically digestive iconography found in all eras and cultures; the hen that laid the golden eggs, the intestinal delirium of Danaë, Grimm's fairy tales. But they wouldn't have it. My decision was taken at the moment. If they didn't want the sh-- I was generously offering them, I would keep my treasures and gold to myself. The famous anagram Breton thought up twenty years later, Avida Dollars, could just as well have been prophetically proclaimed then and there."

Gala was right: up to a certain point the scatological elements were tolerated, but an excess was taboo. "Once again I came up against the same prohibition as my family had imposed. I was permitted blood. A little crap was all right. But just crap was not on. Depicting genitals was approved, but no anal fantasies. They looked very askance at anuses! They liked lesbians very much indeed, but not pederasts. One could have sadism in dreams to one's heart's content, and umbrellas and sewing machines, but no religion on any account, not even if it was of a mystical nature. And to dream of a Raphael Madonna, quite simply, without apparent blasphemy, was strictly prohibited."

Dalí continually boasted of having initiated dissent among the Surrealists. He said he agonized over how he could get them to accept an idea or picture that was totally at odds with their taste. To this end he resorted to that "Mediterranean, paranoiac hypocrisy" which he thought himself capable of only in cases of perversity. "They didn't like anuses! Craftily I sneaked masses of them past them, in disguise – Machiavellian anuses for preference. Whenever I made a Surrealist object in which no such apparition was to be seen, the whole object had the symbolic function of an anus. Thus I used my famous active method of paranoiac-critical analysis to counter pure, passive automatism – and the ultra-reactionary, subversive technique of Meissonier to counter enthusiasm for Matisse and ab-

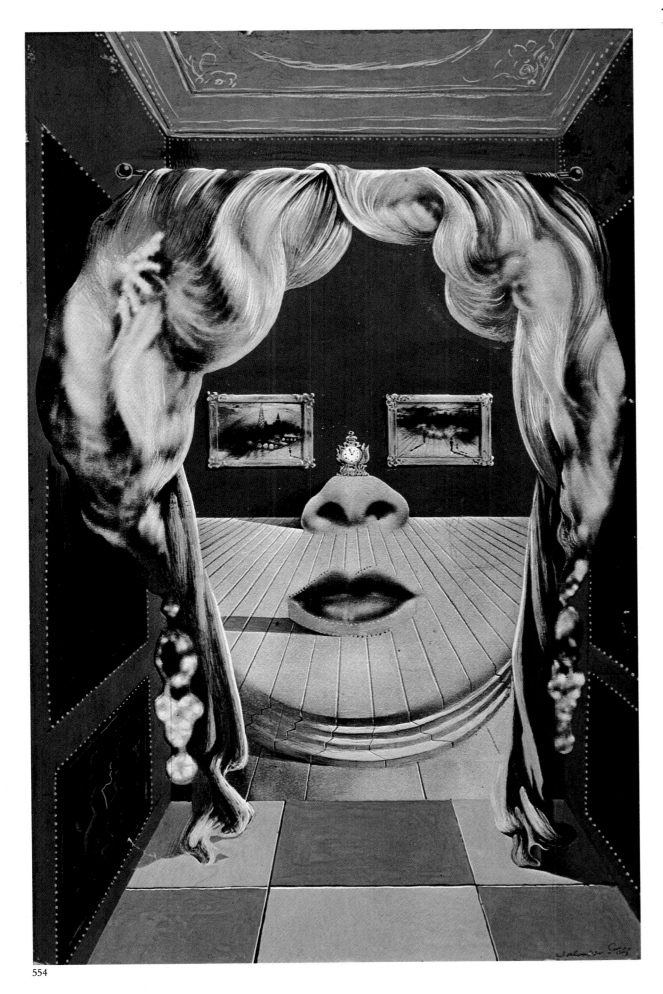

554

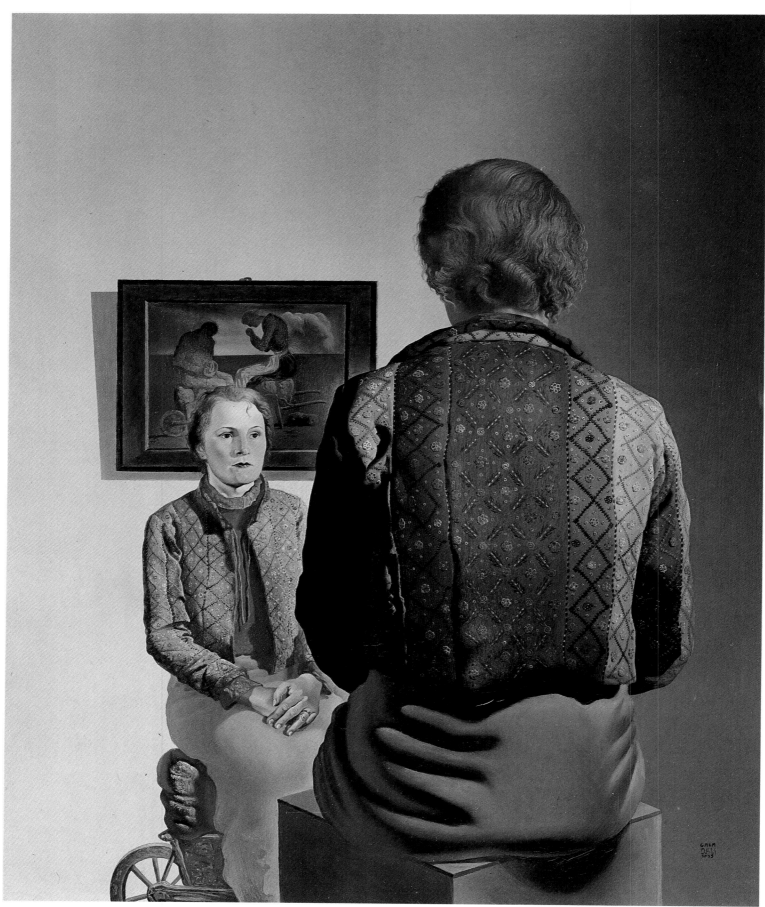

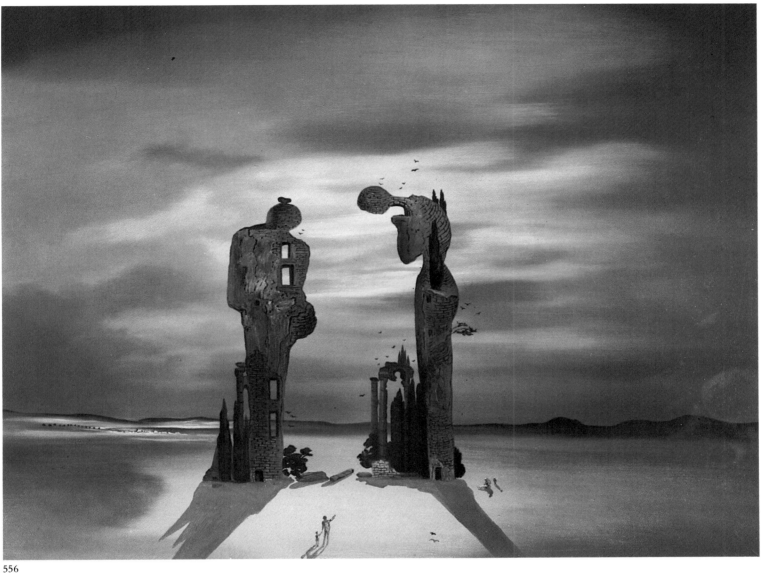

556

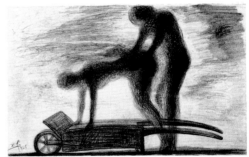

557

stract trends. To check the cult of primitive objects I singled out the supersophisticated objects of the modern style, which we were collecting together with Dior and which were one day to be revived as a 'new look'."

Breton was an atheist. Dalí thought it would be deliciously ironic if Surrealism were elevated to become a new, true religion – sadistic, masochistic, dreamlike and paranoiac – with Auguste Comte as its Messiah and Breton as its great preacher. We must bear in mind that Dalí was a mystic, as he was to demonstrate amply later in life when he decided to return to the aesthetic of the Italian Renaissance and paint works such as *The Madonna of Port Lligat* (p. 443) and *Leda Atomica* (p. 424). In these works, Dalí was not only processing the golden section and ideas borrowed from modern physics; the paintings also reflect the development of the artist's mind, with his (typical) dual allegiance to agnosticism and to Roman Catholicism. The shamelessness he was accused of was in fact his way of protecting his inmost self – by flinging firecrackers at his pursuers' feet to ensure he could make a getaway, so to speak. He was attacking in order not to be overwhelmed: a response essentially modest and chaste, the response of the unbending savage or of the Catalonian peasant. Even the controversial scatology derived

555 **The Angelus of Gala**, 1935 ❏
L'Angélus de Gala
556 **Archaeological Reminiscence of Millet's "Angelus"**, 1935 ❏
Réminiscence archéologique de l'«Angélus» de Millet
557 **Homage to Millet – Study for "The Perpignan Railway Station"**, 1965 △ Hommage à Millet

558

560

558 **Figure and Drapery in a Land-scape**, c. 1935 ❏
Figure et drapé dans un paysage

559 **The Echo of the Void**, 1935 ❏
L'écho du vide

560 **Landscape after de Chirico (unfinished)**, 1935–1938 ❏
Paysage à la Chirico

from "angelic" inspiration, and expressed the painful awareness of a man terrified by the evidence of his own mortality – the processes of excretion. Though he did not speak of them much, he certainly did not turn away from them "as a cat turns away from its excrement." Disease and decay fascinated him, as he himself said. And he was equally obsessed by death. Dalí had to keep a cold eye on the things he hated.

This was the origin of his countless acts of provocation, such as the three-metre-long backside supported on a crutch which he gave Lenin (cf. p.201). To his intense disappointment, the painting did not spark a controversy amongst the Surrealists. "But I was encouraged by this disappointment. It meant I could go still further […] and attempt the impossible. Only Aragon was outraged by my thought machine with breakers of warm milk. 'Dalí has gone far enough!' he roared angrily. 'From now on, milk is only for the children of the unemployed.'" It was a point for Dalí: he had lured Aragon into his trap. He was delighted, and took the opportunity to take a swipe at his despised opponent. "Breton, thinking he saw a danger of obscurantism in the communist-sympathizing faction, decided to expel Aragon and his adherents – Buñuel, Unic, Sadoul, and others – from the Surrealist group. I considered René Crevel the only completely sincere communist among those I knew at the time, yet he decided not to follow Aragon along what he termed 'the path of intellectual mediocrity' […] and shortly afterward committed suicide, despairing of the possibility of solving the dramatic contradictions of the ideological and intellectual problems confronting the Post-War generation. Crevel was the third Surrealist who committed suicide, thus corroborating their affirmative answer to a questionnaire that had been circulated in one of its first issues by the magazine *La Révolution Surréaliste*, in which it was asked, 'Is suicide a solution?' I had answered no, supporting this negation with the affirmation of my ceaseless individual activity."

LA MACHINE A PENSER

561 **Postcard sent by Picasso to
Dalí**, 1931 ☆

562–563 **Paranoiac Visage – The
Postcard Transformed**, 1935 ❏
Visage paranoïaque

564 **Thought Machine – Illustration
for "The Secret Life of Salvador
Dalí"**, 1935 △
La machine à penser

564

561

562

563

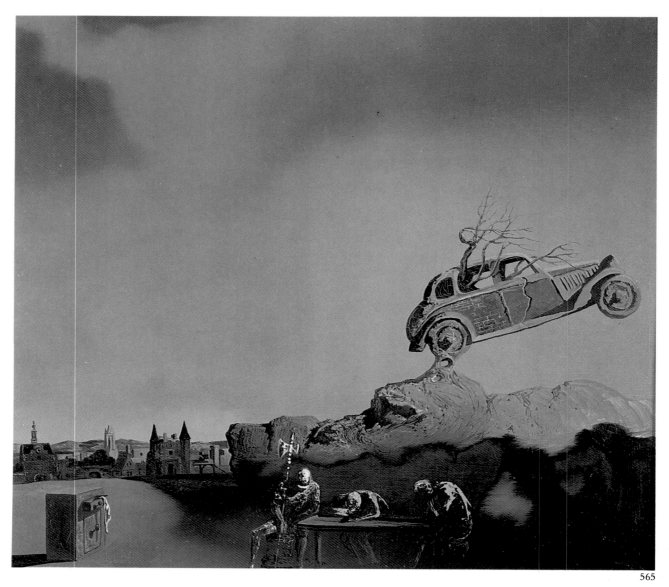

565

1935–1936

566

567

568

565 **Apparition of the Town of Delft**, 1935–1936 ❏
Apparition de la ville de Delft

566 **Autumn Puzzle**, 1935 ❏
Puzzle d'automne

567 **Paranoiac-Critical Solitude**, 1935 ❏
Solitude paranoïaque-critique

568 **The Fossilized Automobile of Cape Creus**, 1936 ❏
L'automobile fossile du Cap Creus

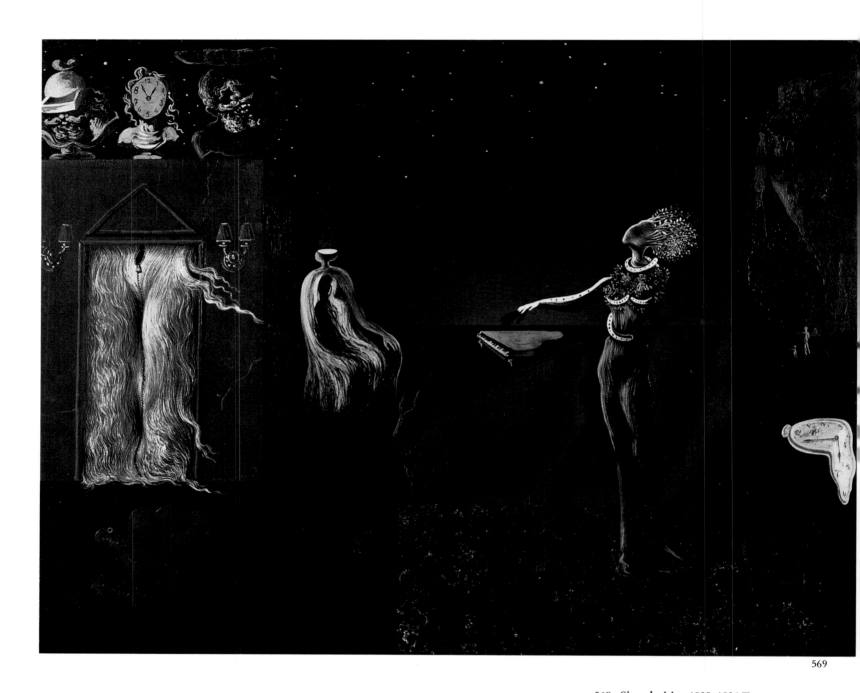

569

569 **Singularities**, 1935–1936 ❏
Singularitats

570 **Woman with the Head of Roses**, 1935 ❏
Femme à la tête de roses

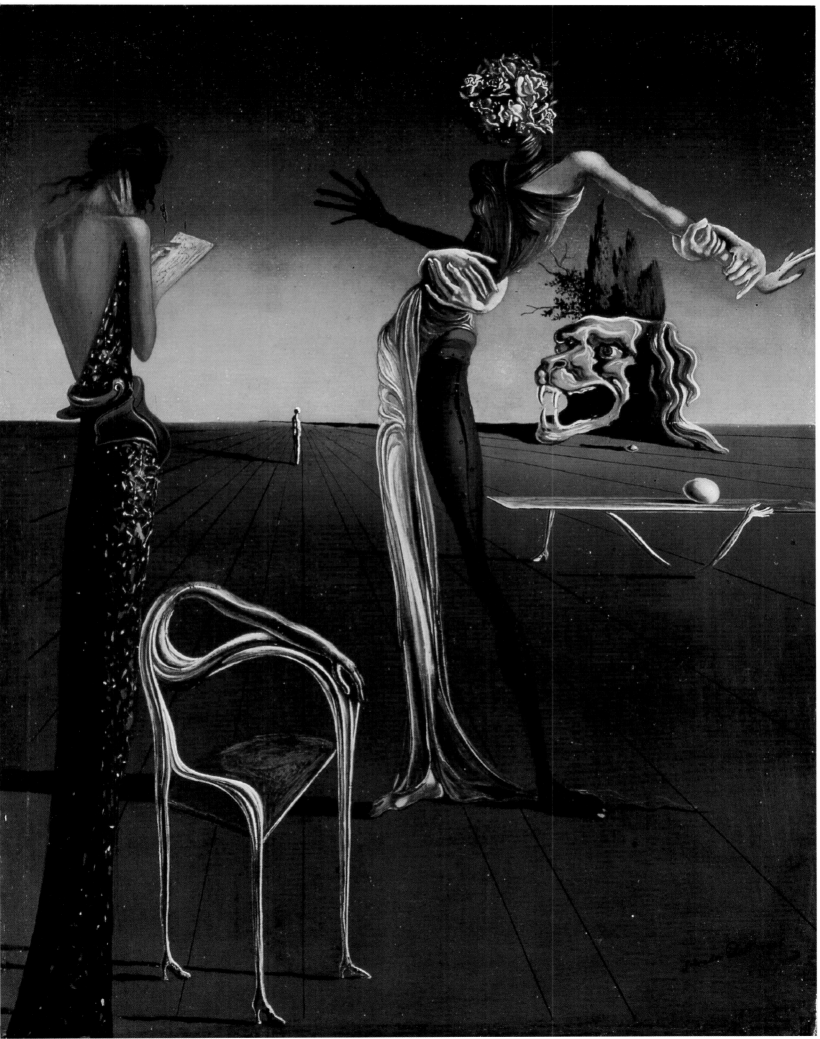

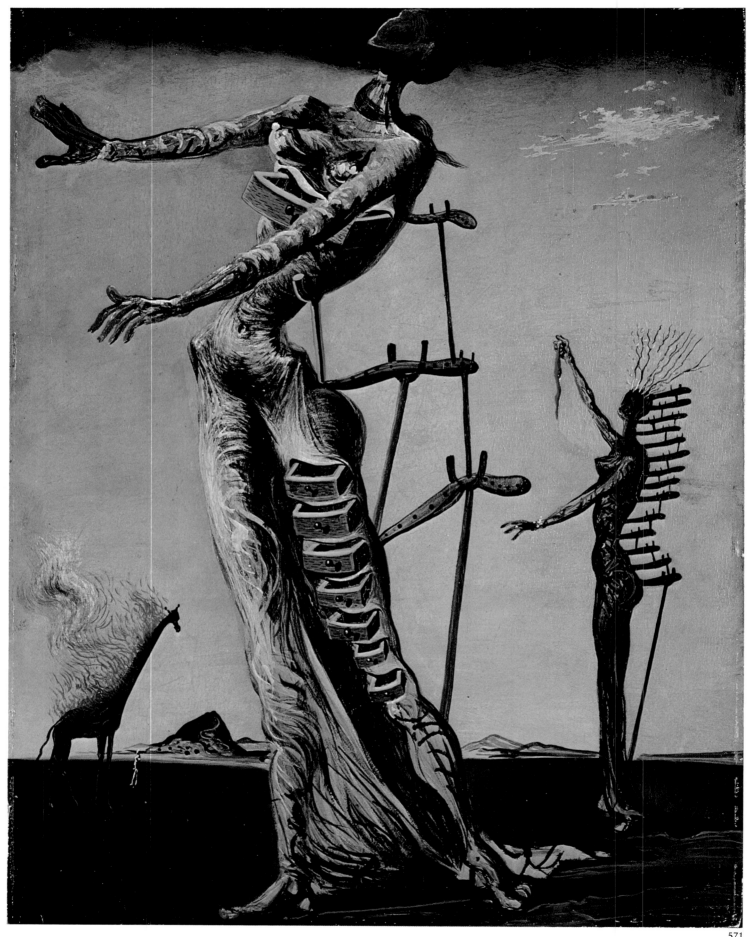

Breton viewed Dalí's choice of political subjects more seriously. It was startling and scandalous, and compromised the Surrealists, who did not understand that Dalí was quite logically giving preference to regimes that clung to elites, hierarchical structures, pomp and public ceremony – regimes which espoused rituals, liturgies, splendour, and the rousing presence of a majestic army. Monarchies were plainly more magnificent than republican democracies (and Dalí – preverse creature! – preferred them to totalitarian regimes, too). His aim was to confer an aura of the miraculous on Surrealism; and he found the political Left drab and prosaic – in his view it was trivial, wretched, and even a threat, and he found it unacceptable. On the other hand, he did give extensive attention to the history of religions, in particular of Catholicism, which he increasingly came to see as a "complete architectural structure." To the Surrealists he confessed: "Very rich people have always impressed me; very poor people, like the fishermen of Port Lligat, have likewise impressed me; average people, not at all." He regretted that the Surrealists were attracting "a whole fauna of misfit and unwashed petty bourgeois […] society people every day and almost every night. Most society people were unintelligent, but their wives had jewels that were hard as my heart, wore extraordinary perfumes, and adored the music that I detested. I remained always the Catalonian peasant, naïve and cunning, with a king in my body. I was bumptious, and I could not get out of my mind the troubling image, post-card style, of a naked society woman loaded with jewels, wearing a sumptuous hat, prostrating herself at my dirty feet."

To fantasize about Hitler wearing women's clothing is doubtless not altogether innocuous; nor is painting a "Hitlerian wet nurse" with a swastika. Dalí's Surrealist associates had not the slightest doubt that obsession with Hitler had its political side, and did not believe for a moment that this ambiguous portrayal of the Nazi Führer might simply be an exercise in black humour like his paintings of William Tell and Lenin. People were to tell Dalí in accusing tones that Hitler would have liked the "weakness, solitude, megalomania, Wagnerism and Hieronymus-Boschism" of his pictures at this time. "I was fascinated by Hitler's soft, fleshy back, which was always so tightly strapped into the uniform," Dalí observed in his own defence. "Whenever I started to paint the leather strap that crossed from his belt to his shoulder, the softness of that Hitler flesh packed under his military tunic transported me into a sustaining and Wagnerian ecstasy that set my heart pounding, an extremely rare state of excitement that I did not even experience during the act of love."

The Surrealists had no patience with his "innately contrary spirit" and were outraged. Dalí responded by challenging Breton to convene the group for an emergency meeting "at which the mystique of Hitler shall be debated from Nietzsche's irrational standpoint and from that of the anti-Catholics"; he was hoping that the anti-Catholic aspect would lure Breton. "Furthermore, I saw Hitler as a masochist obsessed with the *idée fixe* of starting a war and losing it in heroic style. In a word, he was preparing for one of those *actes gratuits* which were then highly approved of by our group. My persistence in seeing the mys-

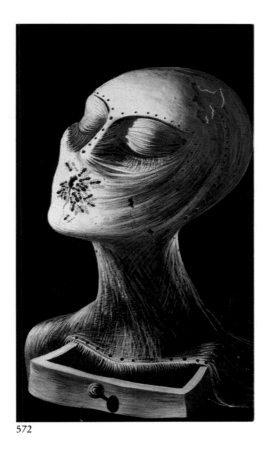

572

571 The Burning Giraffe,
1936–1937 ❑
Girafe en feu

572 Ant Face. Drawing for the catalogue jacket of Dalí's exhibition at the Alex Reid and Lefevre Gallery in London, 1936 △
Visage aux Fourmis

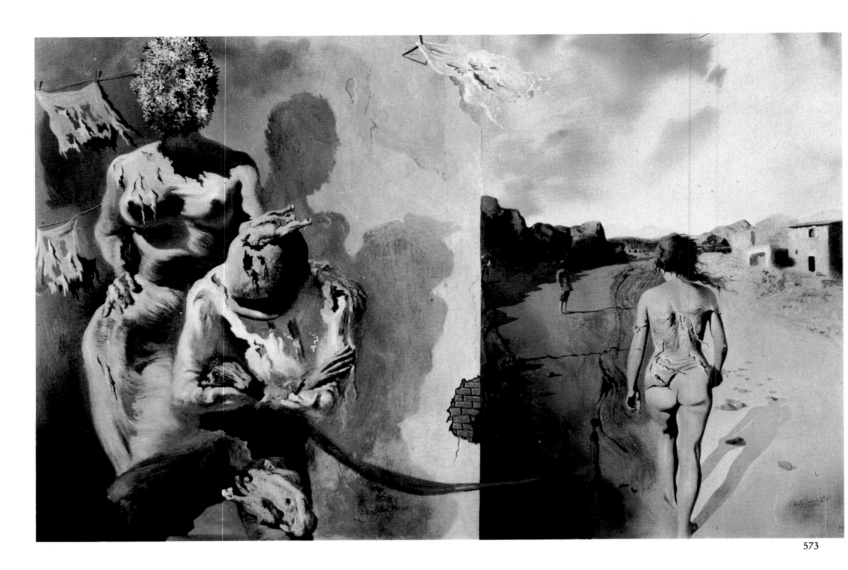

573

574

**573 The Dream Places a Hand on a
Man's Shoulder**, 1936 ❑
Le rêve porte la main sur l'épaule d'un
homme

**574 Untitled – Woman with a
Flower Head**, 1937 △
Sans titre – Femme à la tête de fleur

tique of Hitler from a Surrealist point of view and my obstinacy in trying to
endow the sadistic element in Surrealism with a religious meaning (both exacerbated by my method of paranoiac-critical analysis, which threatened to destroy
automatism and its inherent narcissism) led to a number of wrangles and occasional rows with Breton and his friends. The latter, incidentally, began to waver
between the boss and me in a way that alarmed him."

In fact they had long gone beyond mere dispute. Contrary to Dalí's wishes, the
Surrealists remained devoted to Breton, their iron-fisted leader whose every order
had to be obeyed. When required to appear before the group, Dalí showed up with
a thermometer in his mouth, claiming he felt ill. He was supposedly suffering from
a bout of 'flu, and was well wrapped up in a pullover and scarf. While Breton reeled
off his accusations, Dalí kept checking his temperature. When it was his turn for
a counter-attack, he began to remove his clothing article by article. To the accompaniment of this striptease, he read out an address he had composed previously,
in which he urged his friends to understand that his obsession with Hitler was
strictly paranoiac and at heart apolitical, and that he could not be a Nazi "because
if Hitler were ever to conquer Europe, he would do away with hysterics of my
kind, as had already happened in Germany, where they were treated as *Entartete*
(degenerates). In any case, the effeminate and manifestly crackpot part I had cast
Hitler in would suffice for the Nazis to damn me as an iconoclast. Similarly, my
increased fanaticism, which had been heightened by Hitler's chasing Freud and
Einstein out of Germany, showed that Hitler interested me purely as a focus for

256

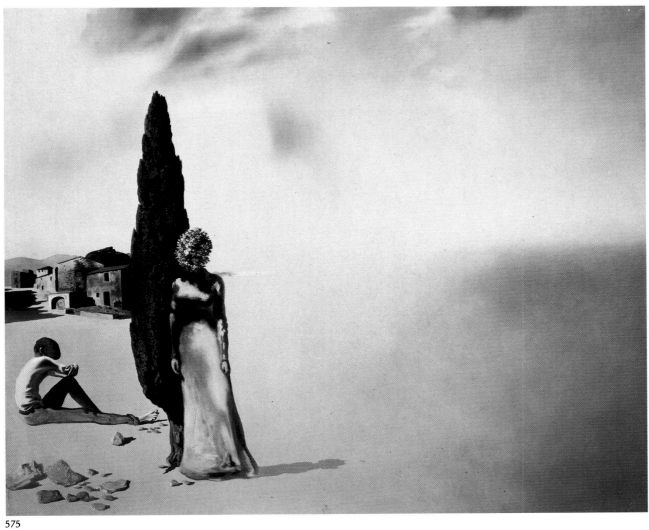

575

576

575 **Necrophiliac Springtime,**
1936 ❑
Printemps nécrophilique

576 **The Man with the Head of
Blue Hydrangea,** 1936 ❑
L'homme avec une tête d'hortensia
bleu

1936

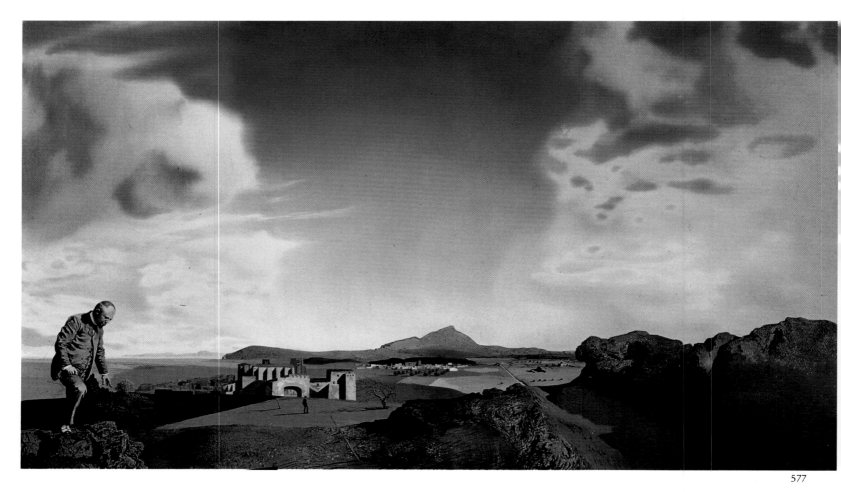

577 **The Chemist of Ampurdán
in Search of Absolutely Nothing,**
1936 ❑
Le pharmacien d'Ampurdán ne
cherchant absolument rien

578 **A Chemist Lifting with
Extreme Precaution the Cuticle
of a Grand Piano,** 1936 ❑
Pharmacien soulevant avec une
extrême précaution le couvercle
d'un piano à queue

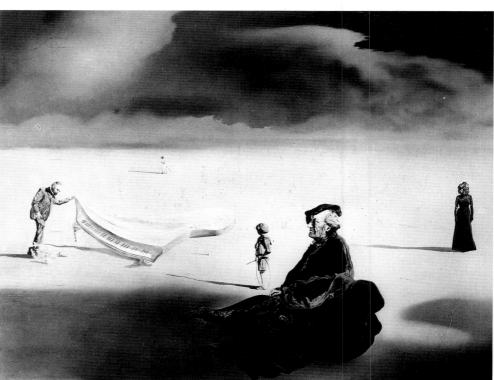

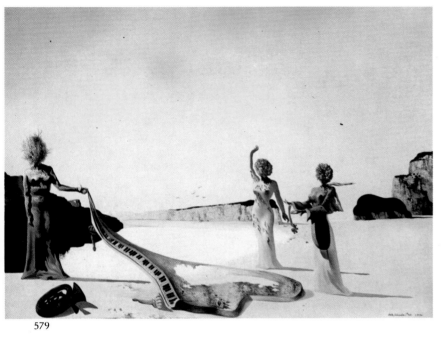

579

579 **Three Young Surrealist Women Holding in their Arms the Skins of an Orchestra**, 1936 ❑
Femmes aux têtes de fleurs retrouvant sur la plage la dépouille d'un piano à queue

580 **Landscape with a Girl Skipping**, 1936 ❑
Paysage avec jeune fille sautant à la corde

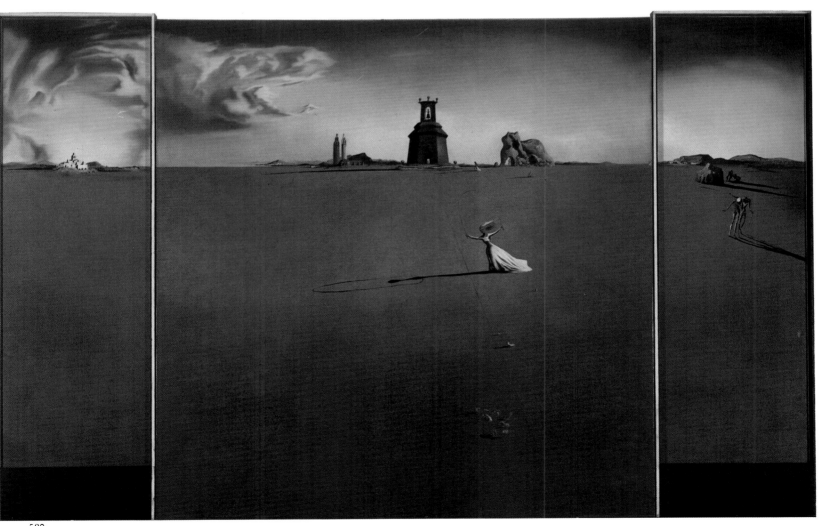

580

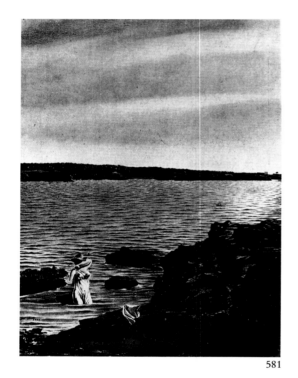

581

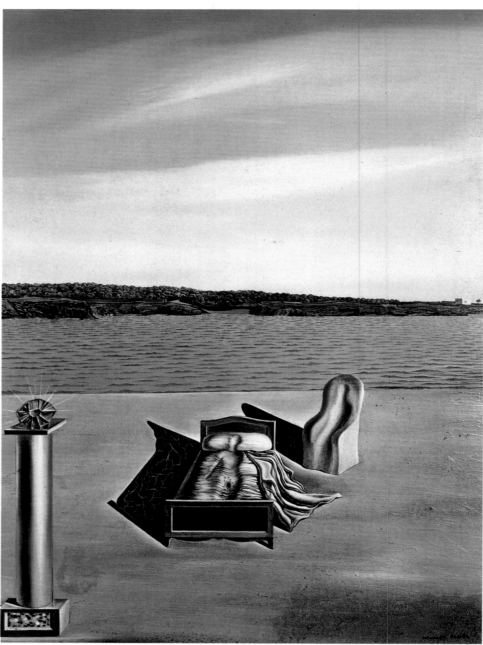

582

581 **Rocks of Llané (first version),**
1926 ❏
Rochers du Llané

582 **Surrealist Composition with
Invisible Figures (second version of
"Rocks of Llané"),** c. 1936 ❏
Composition surréaliste avec person-
nages invisibles

583 **Morphological Echo,** 1936 ❏
Echo morphologique

584 **Beach Scene (detail study),**
1936 △
Beach Scene

my own mania and because he struck me as having an unequalled disaster value."
Was it his fault if he dreamt about Hitler or Millet's *Angelus* (p.213)? When Dalí
came to the passage where he announced, "In my opinion, Hitler has four testicles
and six foreskins," Breton shouted: "Are you going to keep getting on our nerves
much longer with your Hitler!" And Dalí, to general amusement, replied: "…if I
dream tonight that you and I are making love, I shall paint our best positions in
the greatest of detail first thing in the morning." Breton froze and, pipe clenched
between his teeth, murmured angrily: "I wouldn't advise it, my friend." It was a
confrontation that once again pointed up the two men's rivalry and power
struggle. Which of them was going to come out on top?

Following his confrontation, Dalí was given a short-lived reprieve, but then
notified of his expulsion. "Since Dalí had repeatedly been guilty of counter-re-
volutionary activity involving the celebration of fascism under Hitler, the under-
signed propose […] that he be considered a fascist element and excluded from the
Surrealist movement and opposed with all possible means." After he had been
expelled, Dalí continued to participate in Surrealist exhibitions; after all, the

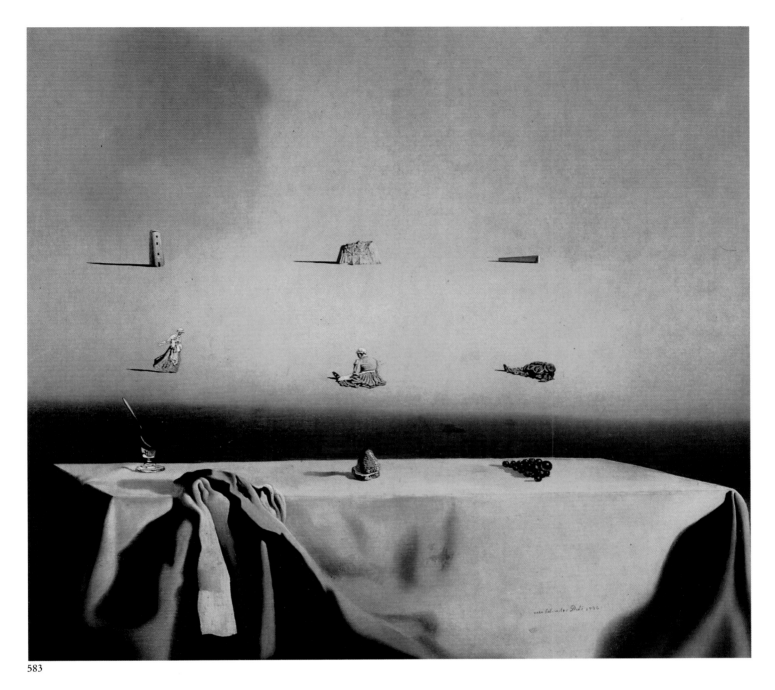

583

movement needed Dalí's magnetic hold on the public, as Breton well knew. Thus in 1936 Dalí made his appearance at the New Burlington Galleries in London wearing a diving suit – to illustrate the thesis stated in his lecture concerning art's function of revealing the depths of the subconscious. At one point he appeared to be suffocating in it – and a panting Dalí was hastily freed of his suit and helmet, to the enthusiastic applause of the audience, who supposed it was a well-rehearsed act.

In Paris, Dalí exhibited at the Surrealist show in the Galerie des Beaux-Arts. There was a shock in store for art lovers in the entrance hall: in his *Histoire de la Peinture Surréaliste*, Marcel Jean reports that "Dalí's *Rainy Taxi* (p. 304) was on display there: an ancient boneshaker of a car, with an ingenious system of pipes pouring showers onto two dummies, a chauffeur with a shark's head and, in the back seat, a blonde in an evening gown, hair tousled, reclining amidst lettuce and chicory, with fat snails leaving their wet, slimy trails across her."

At this time, Dalí published a number of key texts. The most important was his seminal essay *The Conquest of the Irrational* (1935), which appeared simultan-

584

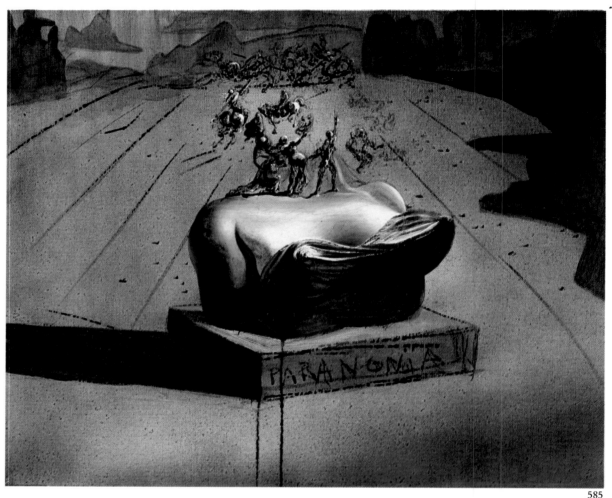

585

586

587

588

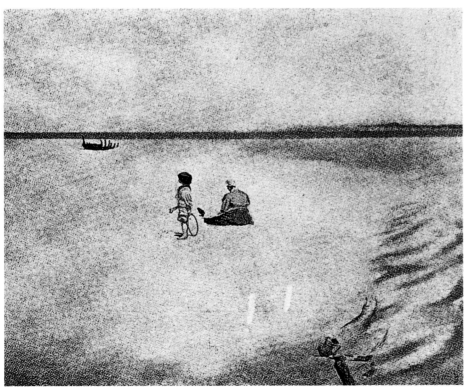

589

585 **Paranoia**, 1936 ❑
Paranoïa

586 **Ampurdán Yang and Yin,**
1936 ❑
Yin et Yang ampurdanais

587 **Hypnagogic Monument**, 1936 ❑
Monument hypnagogique

588 **Sun Table**, 1936 ❑
Table solaire

589 **South (Noon)**, 1936 ❑
Midi

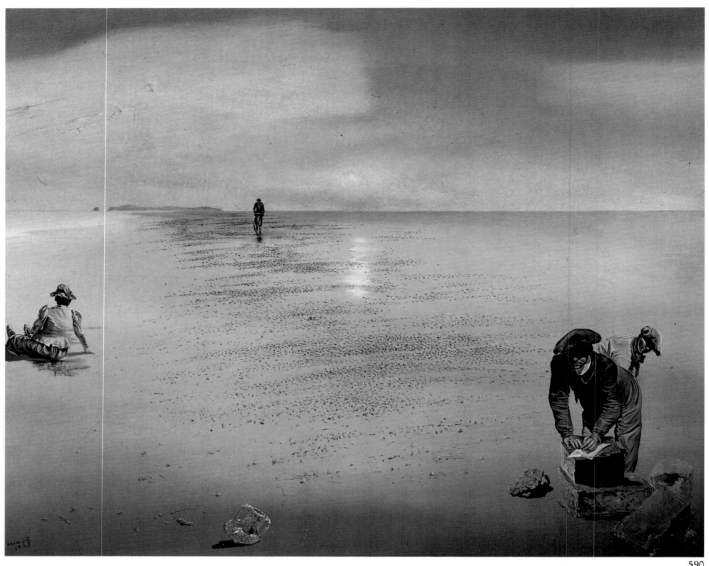

590

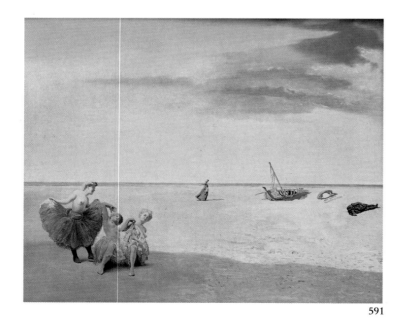

591

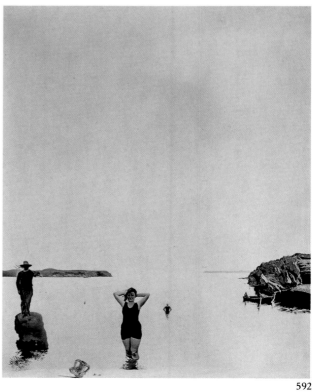

592

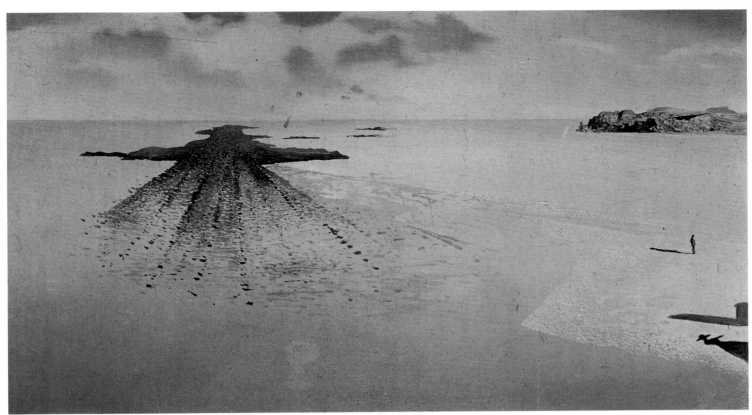

593

eously in Paris and New York and was also reprinted in an appendix to the *Secret Life* a few years later. (Dalí had realised that if he was to achieve real fame it would have to be via America.) In it he described his quest, and wrote: "My whole ambition in painting is to manifest the images of concrete irrationality in terms of authoritative precision [...] images which for the moment can neither be explained nor reduced by logical systems or rational approaches." He stressed: "Paranoiac-critical activity: spontaneous method of irrational knowledge based upon the interpretive-critical association of delirious phenomena;" every one of these phenomena includes an entire systematic structure "and only becomes objective *a posteriori* by critical intervention." The infinite possibilities available to this method can only originate in obsession. Dalí concluded by seeming to do an about-turn, though in fact what he said was a warning, and clearly anticipated the consumer society and its atavistic need for whatever is edible: his imponderable, chimerical images concealed nothing other than "the familiar, bloody, irrational, grilled cutlet that will devour us all." That selfsame cannibal cutlet was to be rediscovered later by Pop Art and appropriated as its very own when Andy Warhol, Allen Jones, Claes Oldenburg, Tom Wesselmann and others sang the praises of Coca Cola, Campbell's soup and so forth.

André Breton had to admit that Dalí's paranoiac-critical method had provided Surrealism with "an instrument of prime importance." Even André Thirion, who was one of the dogmatic hard-liners of the group, later conceded: "Dalí's contribution to Surrealism was of immense importance to the life of the group and the evolution of its ideology. Those who have maintained anything to the contrary have either not been telling the truth or have understood nothing at all. Nor is it true that Dalí ceased to be a great painter in the Fifties, even though it was distinctly discouraging when he turned to Catholicism [...] In spite of everything, what we are constantly seeing in his work is exemplary draughtsmanship, a startlingly inventive talent, and a sense of humour and of theatre. Surrealism owes a great deal to his pictures."

If Breton and the other Surrealists had difficulty swallowing Dalí's attitude to

594

1935–1936

590 **Mediumnistic-Paranoiac Image,** 1935 ❏
Image médiumnique-paranoïaque

591 **The Forgotten Horizon,** 1936 ❏
L'horizon oublié

592 **White Calm,** 1936 ❏
Le calme blanc

593 **Geological Justice,** 1936 ❏
La justice géologique

594 **The Phantom Cart,** 1933 ❏
La charrette fantôme

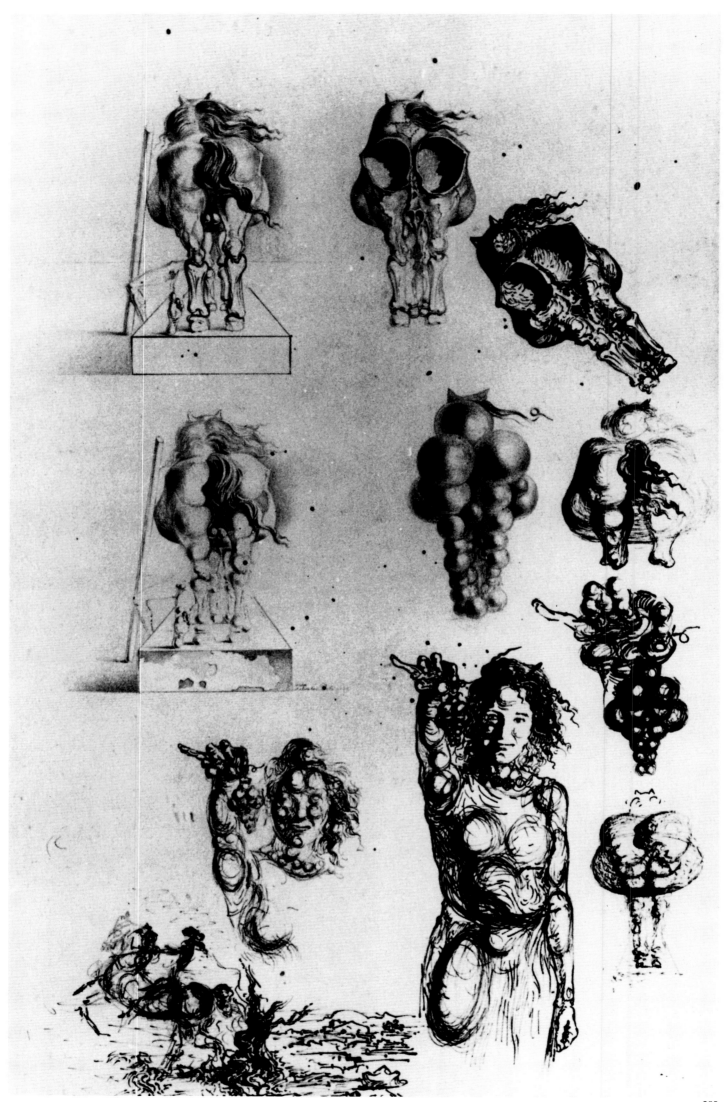

266

596

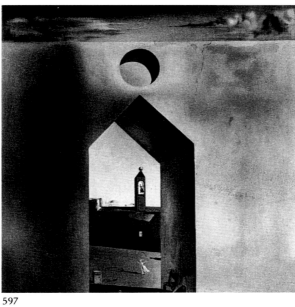

597

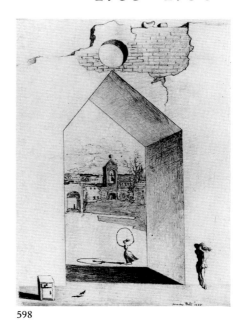

598

595 Study for "Suburbs of a
Paranoiac-Critical Town", 1935 △

596 **Bread on the Head of the
Prodigal Son**, 1936 ❑
Pain sur la tête du fils prodigue

597 **Nostalgic Echo**, 1935 ❑
Echo nostalgique

598 **Nostalgic Echo**, 1935 △
Echo nostalgique

599 **Suburbs of a Paranoiac-Critical
Town: Afternoon on the Outskirts
of European History**, 1936 ❑
Banlieue de la ville paranoïaque-
critique: après-midi sur la lisière de
l'histoire européenne

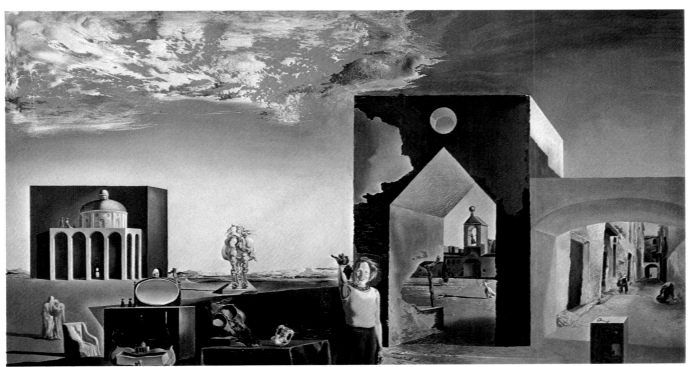

599

1936

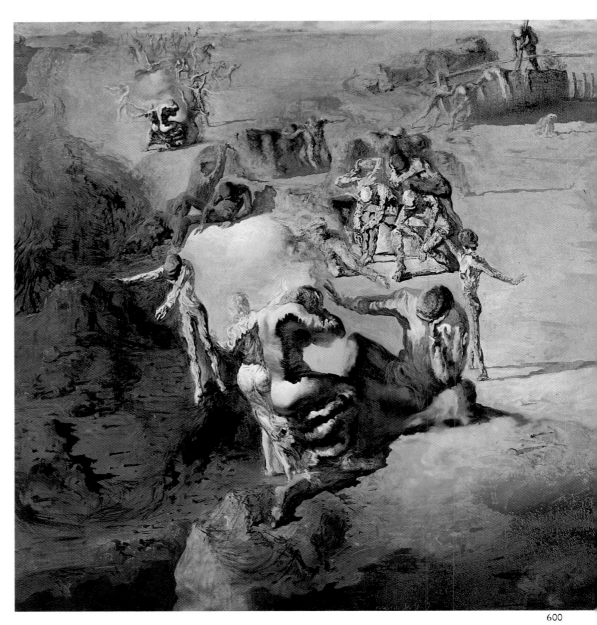

600 **The Great Paranoiac,** 1936 ❑
Le grand paranoïaque

601 **Messenger in a Palladian
Landscape,**1936 Δ
Messager dans un paysage palladien

602 **Study of Horsemen,** 1936 Δ
Etude de cavaliers

600

601

602

603

604

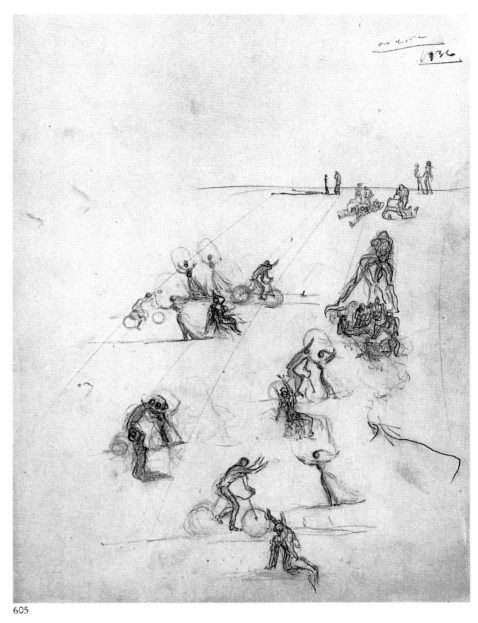

605

Hitler, their fellow artist's steadily growing popularity was even more of a problem. He was the art hero of the world. People loved his constant provocations and his increasingly manneristic, detailed style of painting – a style for which he cited the Pompiers and above all their master, Meissonier, as the principal source. Dalí quite unashamedly wanted money. He said so, loudly, and didn't care a toss for social revolution.

Many people wanted his recipe for success. To one young man who asked, Dalí replied: "Then you must become a snob. Like me. [...] For me, snobbery – particularly in Surrealist days – was a downright strategy, because I [...] was the only one who moved in society and was received in high-class circles. The other Surrealists were unfamiliar with the milieu. They had no entrée. Whereas I could get up from their midst at any time and say: 'I have an engagement,' and let slip the fact or allow people to guess (next day they would know or, better still, would hear from a third party) that I had been invited to the Faucigny-Lucinges' or other people that the group eyed as if they were forbidden fruit because they were never invited there. But the moment I arrived at the society people's homes I adopted a different, more pronounced kind of snobbery. I would say: 'Right after coffee I have to go, to see the Surrealists.' I would make out that the Surrealists had far greater shortcomings than the aristocracy, than all the people one knew

603 **Head of a Woman in the Form of a Battle – Study for "Spain"**, 1936 ❏
Tête de femme ayant la forme d'une bataille

604 **The Horseman of Death**, 1936 ❏
Le cavalier de la mort

605 **Our Love**, 1936 △

606

607

in society, because the Surrealists wrote abusive letters to me in which they said high society was nothing but arseholes who understood absolutely nothing […] In those days, snobbery was saying: 'Now I must be off to the Place Blanche. There's a very important Surrealist meeting.' The effect of saying this was terrific. On the one hand I had society, politely astonished that I was going somewhere that they could not go, and on the other hand, the Surrealists. I was always off to where the rest couldn't go. Snobbery consists in going to places that others are excluded from – which produces a feeling of inferiority in the others. In all human relations there is a way of achieving complete mastery of a situation. That was my policy where Surrealism was concerned."

Dalí was forever recounting the dream visions of his childhood, and his attention might equally be on Hitler's soft, fleshy back or on that of his nurse, say. In so doing, he drew on a repertoire of gimmicks in order to provoke the scandal that guaranteed publicity. Dalí was asked by a journalist about *The Weaning of Furniture-Nutrition* (p. 226), which shows the nurse with a window through her crutched body and at her feet a bedside table with a second, church-shaped table and bottle "cut out" of it. The journalist knew that the public was expecting a psychoanalytic or indeed pornographic theory about the bedside table, and had a right to a lyrical (and of course Surrealist) poem ending with an explanation of the bedside table in the terms physics used to describe space, from Euclid via Newton to Einstein. And of course the account Dalí provided was provocative, scatological – everything that was expected of him. In the *Secret Life* it appears as

608

a recollection of childhood, and includes the landscape of Cadaqués and the fant-
asy girl, Galuchka, who by the 30s had become one in Dalí's mind with Gala,
who informed everything he did: "I pressed myself closer and closer against the
infinitely tender, unconsciously protective, back of the nurse, whose rhythmic
breathing seemed to me to come from the sea, and made me think of the deserted
beaches of Cadaqués. [...] I wanted, I desired only one thing, which was that
evening should fall as quickly as possible! At twilight and in the growing darkness
I would no longer feel ashamed. I could then look Galuchka in the eye, and she
would not see me blush. Each time I stole a furtive glance at Galuchka to assure
myself with delight of the persistence of her presence I encountered her intense
eyes peering at me. I would immediately hide; but more and more, at each new
contact with her penetrating glance, it seemed to me that the latter, with the
miracle of its expressive force, actually pierced through the nurse's back, which
from moment to moment was losing its corporeality, as though a veritable win-
dow were being hollowed out and cut into the flesh of her body, leaving me more
and more in the open and gradually and irremissibly exposing me to the devour-
ing activity of that adored though mortally anguishing glance. This sensation
became more and more acute and reached the point of a hallucinatory illusion. In
fact I suddenly saw a real window transpierce the nurse. Yet through this mad-
dening aperture, of frantically material and real aspect, I no longer saw the crowd
which ought to have been there and in the midst of which Galuchka standing on
a chair ought to have been in the act of looking at me. On the contrary, through

606 **Study for "Geodesic Portrait of
Gala"**, 1936 △

607 **Gala's Head – Rear View**, 1936 △
Tête de Gala – vue de dos

608 **Geodesic Portrait of Gala**,
1936 ❑
Portrait géodésique de Gala

271

611

609

612

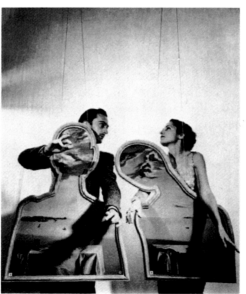

610

609 **Man with his Head Full of Clouds**, 1936 ❏
Homme à la tête pleine de nuages

610 **Gala and Dalí with "A Couple with their Heads Full of Clouds".**
Photograph: Cecil Beaton, 1936 ☆

611 **Study for "A Couple with their Heads Full of Clouds"** (detail), 1936 △

612 **A Couple with their Heads Full of Clouds**, 1936 ❏
Couple aux têtes pleines de nuages

613 **A Couple with their Heads Full of Clouds**, 1936 ❏
Couple aux têtes pleines de nuages

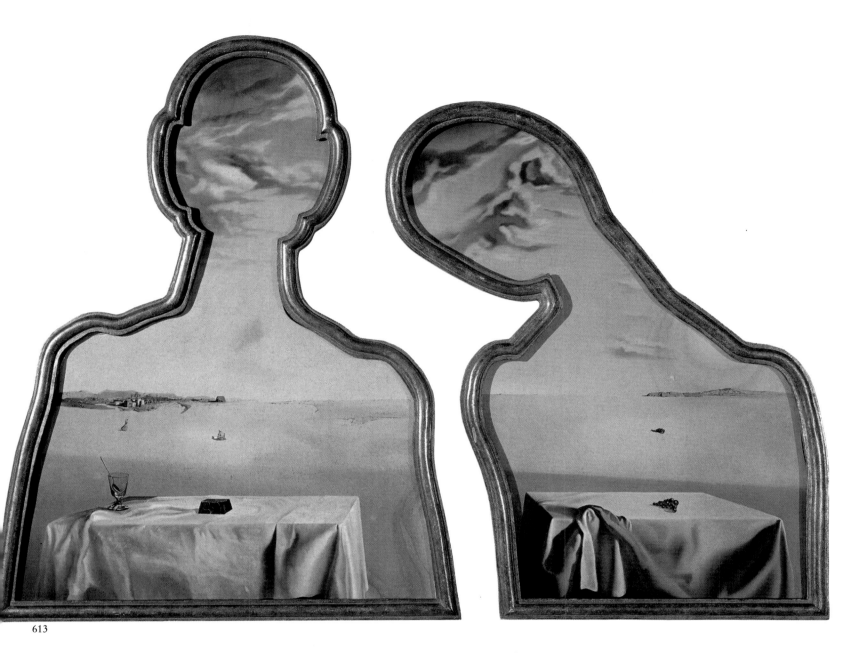

613

this window opened in the nurse's back, I distinguished only a vast beach, utterly deserted, lighted by the criminally melancholy light of a setting sun."

Dalí's preeminent intellectual and artistic integrity surely consisted in never going through aesthetic or mannerist motions in order to assimilate disparate, bizarre features to his paintings. We need only consider the *Sun Table* (p.263). When he was painting the picture, Dalí had no idea why he was introducing a camel into a Cadaqués scene. Not until later did he realize that an internal rationale of kinds had been at work in his conception; for there is a discarded Camel cigarette packet at the feet of the youth (perhaps Dalí himself) in silhouette in the foreground. The effect is to emphasize the alien magic of the camel's presence. In his book *Ten Recipes for Immortality* Dalí was subsequently to declare (in bizarre echo of Hamlet?) that if a camel is examined through an electron microscope it proves to be far less precise than a cloud.

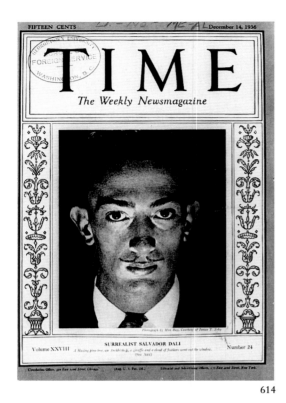

614

615

614 Dalí on the cover of "Time",
14 December 1936. Photograph: Man
Ray ☆

615 Aphrodisiac Dinner Jacket,
c. 1936 ○
Veston aphrodisiaque

616 Exhibition of Surrealist objects
at Charles Ratton's, May 1936.
Right: Dalí's "Aphrodisiac Dinner
Jacket", 1936 ☆

617 Some of the extravagant Dalí-
inspired hats for Elsa Schiaparelli,
1936: the cutlet hat, inkwell hat and
shoe hat ☆

618 Lobster Telephone, 1936 ○
Téléphone-homard

619 Gala with the Elsa Schiaparelli
shoe hat, after designs by Dalí,
1936 ☆

616

617

618

619

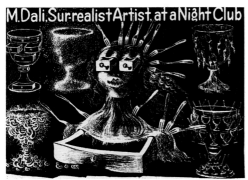

621

622

1936

620 The Surrealist Artist at a Night Club. The picture was published in "American Weekly" on 3 January 1937 ☆

621 Study for the cover of "Minotaure", no. 8, 1936 △

622 Woman with Drawers. Design for the cover of the catalogue of the Dalí exhibition at the Julien Levy Gallery in New York, 1936 △

623 Cover of "Minotaure", 1936 △

The Secret Drawers of the Unconscious

The drawers that open out of Dalí's human and other figures have become as universally familiar as his soft watches. The *Venus de Milo with Drawers* (p.279) or *The Anthropomorphic Cabinet* (p.278) have imprinted indelibly Dalinian images on the visual memories of millions. Before painting the latter, Dalí did a number of detailed preparatory pencil and ink drawings. The painting was conceived as a homage to the psychoanalytic theories of Freud, whom Dalí (unsurprisingly) revered. Dalí viewed his own subject matter as an allegorical means of tracing the countless narcissistic fragrances that waft up from every one of our drawers (as he put it). And he declared that the sole difference between immortal Greece and the present day was Sigmund Freud, who had discovered that the human body, purely neo-Platonic at the time of the Greeks, was now full of secret drawers which only psychoanalysis could pull open. Dalí was familiar with the furniture figures made by the 17th century Italian Mannerist Giovanni Battista Bracelli, and they doubtless influenced his own figures with drawers. For Bracelli, though, furniture figures were a game played with geometry and space, sheer *jeu d'esprit*, while for Dalí, three centuries later, a similar approach expressed the central, obsessive urge to understand human identity.

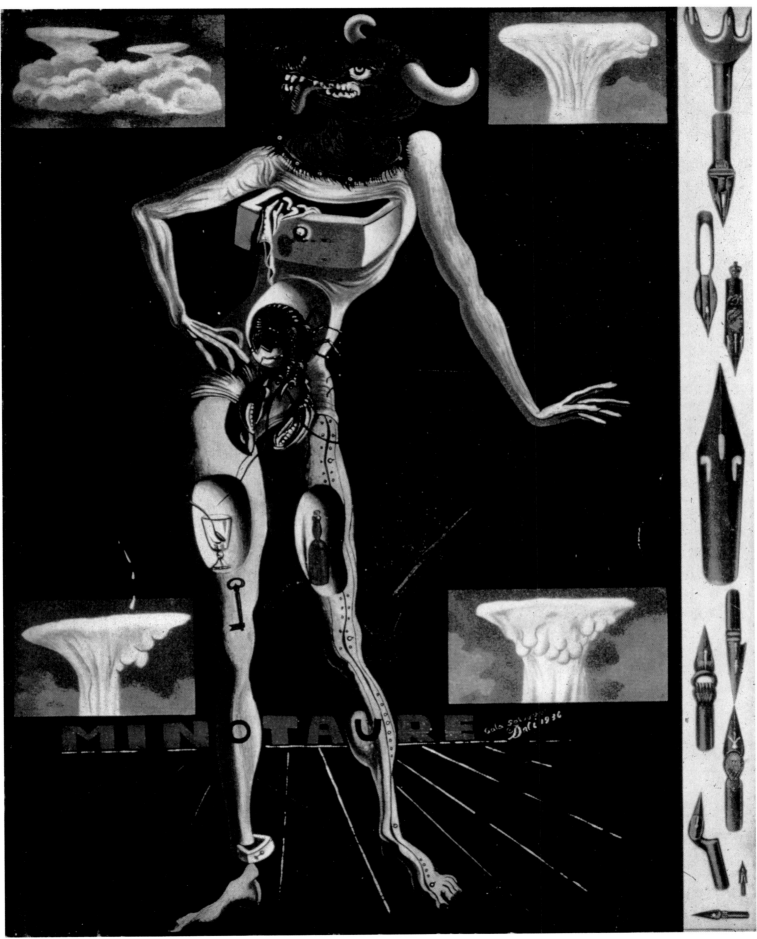

MINOTAURE

623

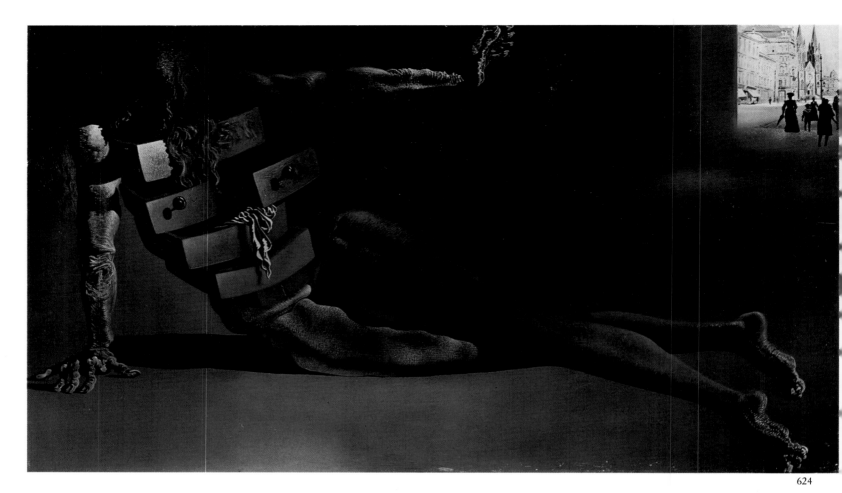

624

625

626

627

Dalí's Surrealist dream objects bore the unmistakable hallmark of his own unique personality, and took the Parisian art scene by storm. Items such as the *Aphrodisiac Dinner Jacket* (p. 274) were first exhibited at Charles Ratton's in May 1936, then at the International Surrealist Exhibition in London that July, and at Julien Levy's in New York in December. At the same time Dalí designed the cover for the eighth issue of *Minotaure* (p. 277) – a typically feminine Dalinian minotaur, complete with drawer and lobster – and contributed key writings on art and aesthetics to the magazine. In "Le Surréalisme spectral de l'éternel féminin préraphaélite" (a title which incorporated Goethe's "eternal feminine" and 19th century English art into Dalí's compass), he insisted that the aesthetic well-being of the mind could only come from the body's health, from touching, eating and chewing. Though the women in English Pre-Raphaelite art were at once the most desirable and the most terrifying imaginable, they were nonetheless creatures one might eat up – with the greatest of fear. To Dalí, they recalled "that legendary necrophiliac spring" of Botticelli, which he considered acceptable in that it represented "the healthy flesh of myth" but debatable in its failure to establish the splendour and material pomp of occidental legend. Dalí went on to assert that Pre-Raphaelite morphology was a standing invitation to steep oneself in the bloody entrails of the soul's aesthetic depths, and described Cézanne as "a kind of Platonic mason" who "refused to recognise geodesic curvature".

At this point Dalí went on to address his theory of geodesic lines, declaring that Egyptian mummies had valuable lessons to teach and going on to write of the art of clothing, which marks the transitional point of access from the outer surface to the inner realm of muscle and ultimately bone. *Night and Day Clothes of the Body* (p. 280), an illustration intended for *Harper's Bazaar* or *Vogue*, highlights Dalí's meeting of various tensions: we cannot say for certain where the body, clothing, or indeed wardrobe or window, begin and end. The smock has a zip which enables two wing doors to be opened. Dalí was subsequently to remark that the tragic constant in human life was fashion, which was why he so much enjoyed working with Chanel and Schiaparelli. He believed that the concept of dressing was a consequence of the most powerful trauma of all, the trauma of birth. Furthermore, he felt that to watch models parading on show, and marching by, was to watch angels of death heralding the approach of war.

"Le Surréalisme spectral de l'éternel féminin préraphaélite" was a core text at the time. Dalí went on: "it is natural, then, that when Salvador Dalí speaks of his paranoiac-critical discoveries in the field of visual representation, the Platonic beholders of the eternal Cézanne apple do not take seriously what they consider a frenetic way of wanting to touch everything (even the immaculate conception of their apple) and, even worse, really to eat and chew everything, in one way or another. But Salvador Dalí will not stop crusading for this hypermaterialist view, which is crucial to any and every epistemological process in aesthetics that include the flesh and bone of biology – a view of vast outsiderdom, a view of hegemonic disillusionment and of sentimental exaltation."

628

624 **The Anthropomorphic Cabinet**, 1936 ❏
Le cabinet anthropomorphique

625 **The City of Drawers – Study for the "Anthropomorphic Cabinet"**, 1936 △
La cité des tiroirs

626 **The City of Drawers – Study for the "Anthropomorphic Cabinet"**, 1936 △
La cité des tiroirs

627 **Bust with Drawers**, 1936 △
Buste à tiroirs

628 **Venus de Milo with Drawers. Dalí designed the drawers and his friend Marcel Duchamp made the sculpture**, 1936 ○
Vénus de Milo aux tiroirs

1936–1937

629 **Night and Day Clothes of the
Body**, 1936 △
Jour et nuit du corps

630 **Anatomical Studies – Transfer
Series**, 1937 ❑
Anatomies – Série décalcomanie

631 **The Vertebrate Grotto –
Transfer Series**, 1936 △
La grotte vertébrée – Série décalco-
manie

631

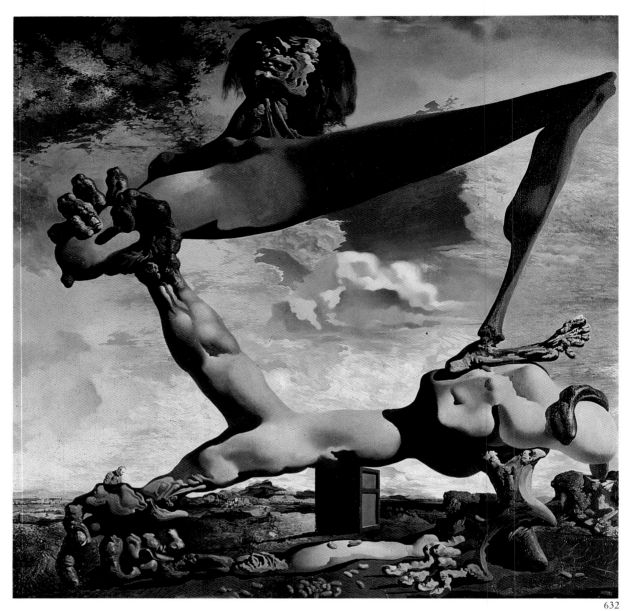

632

633

634

635

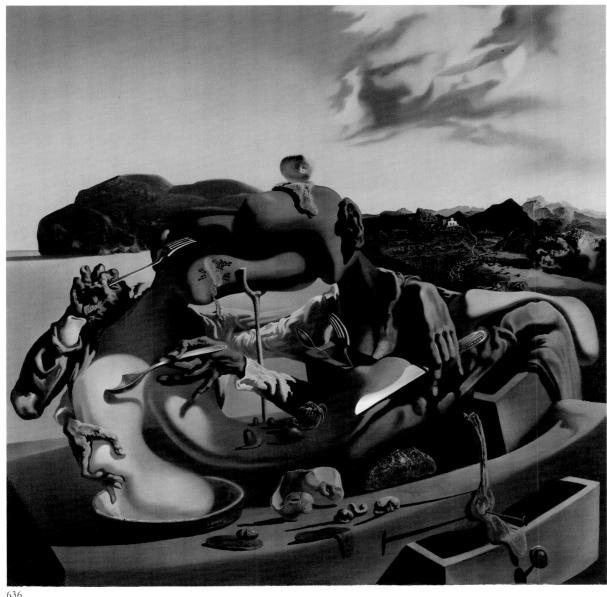

636

Civil War in Spain

In 1936, Spain was being torn apart by civil war. Dalí and Gala had to do without their retreats to Port Lligat. Instead they travelled around Europe, and spent some time living in Italy. The influence of the Renaissance masters Dalí saw in the great art galleries of Florence and Rome is clearly apparent in the groups of figures he subsequently used in his paintings in order to establish multiple images, as in *Spain* (p.312) or *The Invention of the Monsters* (pp.292–293). The latter is one of his paintings on the subject of "premonitions of war": the artist explained that the foreground double figure holding a butterfly and hourglass was the Pre-Raphaelite version of the double portrait of Dalí and Gala immediately behind it. True to his principle of taking no interest in politics, Dalí viewed the civil war that was tormenting his country merely as a delirium of edibles. He observed it as an entomologist might observe ants or grasshoppers. To him it was natural history; to Picasso, by contrast, it was political reality. What *Guernica* was for Picasso, *The Burning Giraffe* (p.254) and *Soft Construction with Boiled Beans – Premonition of Civil War* (p.282) were for Dalí. Dalí was not interested in the war as such. His only interest was in the premonitions recorded in his paintings: "Six months before the outbreak of the Spanish Civil War, being a painter of intestinal paroxysms, I completed my 'Premonition with boiled beans'" – Dalí's references to

632 **Soft Construction with Boiled Beans – Premonition of Civil War,** 1936 ❏
Construction molle avec haricots bouillis – Prémonition de la guerre civile

633, 634, 635 **Studies for "Premonition of Civil War"**, 1935 △

636 **Autumn Cannibalism**, 1936 ❏
Cannibalisme de l'automne

1936–1937

637 **Perspectives**, 1936–1937 ❏
Perspectives

food come to seem compulsive – "which shows a huge human body, all arms and legs deliriously squeezing each other." Cooking is always associated with smells. In the *Secret Life* Dalí wrote eloquently of smells: "From all parts of martyred Spain rose a smell of incense, of chasubles, of burned curates' fat and of quartered spiritual flesh, which mingled with the smell of hair dripping with the sweat of promiscuity from that other flesh, concupiscent and as paroxysmally quartered, of the mobs fornicating among themselves and with death."

But in respect of his political stance, Dalí did concede: "I was definitely not a historic man. On the contrary, I felt myself essentially anti-historic and apolitical. Either I was too much ahead of my time or much too far behind, but never contemporaneous with ping-pong-playing men." Dalí wrote: "The Spanish Civil War changed none of my ideas. On the contrary, it endowed their evolution with a decisive rigor. Horror and aversion for every kind of revolution assumed in me an almost pathological form. Nor did I want to be called a reactionary. This I was

637

not: I did not 'react' – which is an attribute of unthinking matter. For I simply continued to think, and I did not want to be called anything but Dalí. But already the hyena of public opinion was slinking around me, demanding of me with the drooling menace of its expectant teeth that I make up my mind at last, that I become Stalinist or Hitlerite. No! No! No! and a thousand times no! I was going to continue to be as always and until I died, Dalinian and only Dalinian! I believed neither in the communist revolution nor in the national-socialist revolution, nor in any other kind of revolution. I believed only in the supreme reality of tradition [...] If revolutions are interesting it is solely because in revolutionizing they dis-inter and recover fragments of the tradition that was believed dead because it had been forgotten, and that needed simply the spasm of revolutionary convulsions to make them emerge, so that they might live anew. And through the revolution of the Spanish Civil War there was going to be rediscovered nothing less than the authentic Catholic tradition peculiar to Spain [...] All – atheists, believers, saints,

638 **Average Pagan Landscape,**
1937 ❏
Paysage païen moyen

638

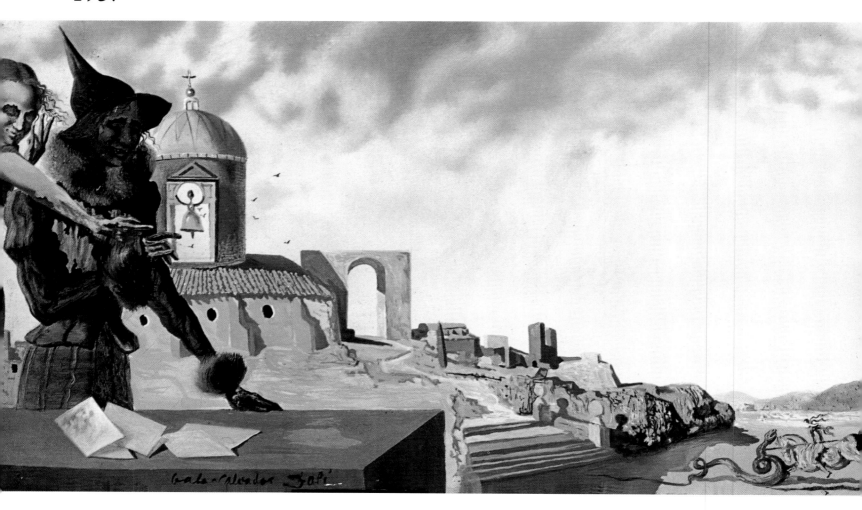

640

criminals, grave-openers and grave-diggers, executioners and martyrs – all fought with the unique courage and pride of the crusaders of faith. For all were Spaniards."

His friend García Lorca was shot in his hometown of Granada which was under occupation by Franco's forces. ("This was ignoble, for they knew as well as I that Lorca was by essence the most apolitical person on earth. Lorca did not die as a symbol of one or another political ideology, he died as the propitiatory victim of that total and integral phenomenon that was the revolutionary confusion.") Meanwhile, Dalí was studying the Renaissance. He planned to be the first advocate of the Renaissance after the war. "The disasters of war and revolution in which my country was plunged only intensified the wholly initial violence of

639 **Anthropomorphic Echo**, 1937 ❑
Echo anthropomorphique

640 **Untitled (Vision of Eternity)**, 1936–1937 ❑
Sans titre (Vision de l'éternité)

641 **Enchanted Beach (Long Siphon)**, 1937 ❑
La plage enchantée (Siphon long)

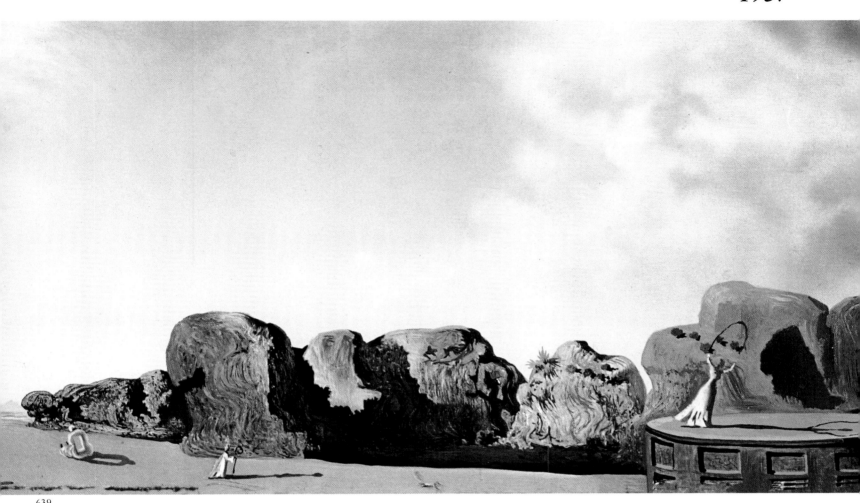

639

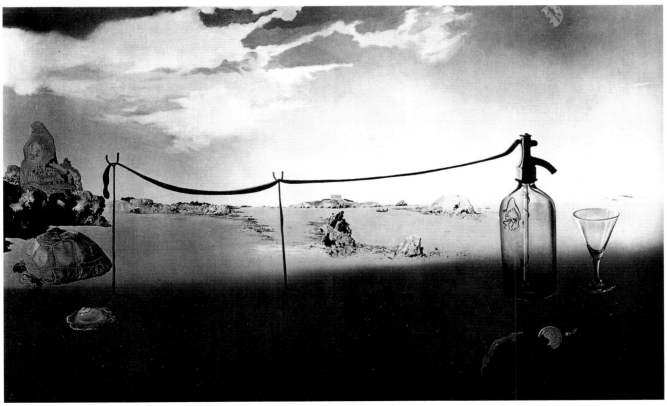

641

my aesthetic passion, and while my country was interrogating death and destruction, I was interrogating that other sphinx, of the imminent European 'becoming', that of the Renaissance." His attitude was interpreted as typical Dalí: superficial and frivolous. In fact, when anarchists shot three of his Port Lligat fisherman friends, Dalí wondered: "Would I finally have to make up my mind to return to Spain, and share the fate of those who were close to me?" It has to be admitted that, once he had slept on the question, Dalí decided that he *wouldn't* have to return.

Narcissus and the Bulb

The *Metamorphosis of Narcissus* (p.289) was Dalí's first painting to be done entirely in accordance with the paranoiac-critical method. Breton, in *What is Surrealism?*, paid tribute to Dalí's method, seeing it as an instrument of the first importance, capable of use in painting, poetry, film, the making of Surrealist artefacts, fashion, sculpture, art history, and indeed any form of interpretation.

The painting meant a great deal to Dalí. He observed that if one gazed at the figure of Narcissus for some time, at a slight distance, he gradually disappeared; and at that moment the metamorphosis of the myth occurred. Suddenly, Narcissus was a hand, rising out of his own reflection. That hand was holding in its fingertips the egg, seed or bulb from which the new narcissus (or: the daffodil) would be born. Beside it was a stone sculpture of a hand holding a narcissus

642

contd. on p.299

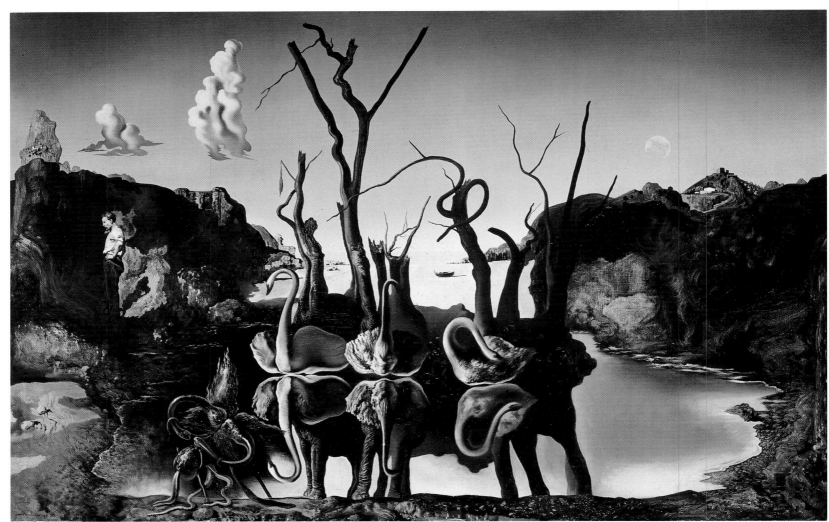

643

644

642　Untitled, 1938 ❏

643　**Swans Reflecting Elephants,**
1937 ❏
Cygnes réflétant des éléphants

644　**Study for "The Metamorphosis**
of Narcissus", 1937 △

645　**The Metamorphosis of**
Narcissus, 1937 ❏
Métamorphose de Narcisse

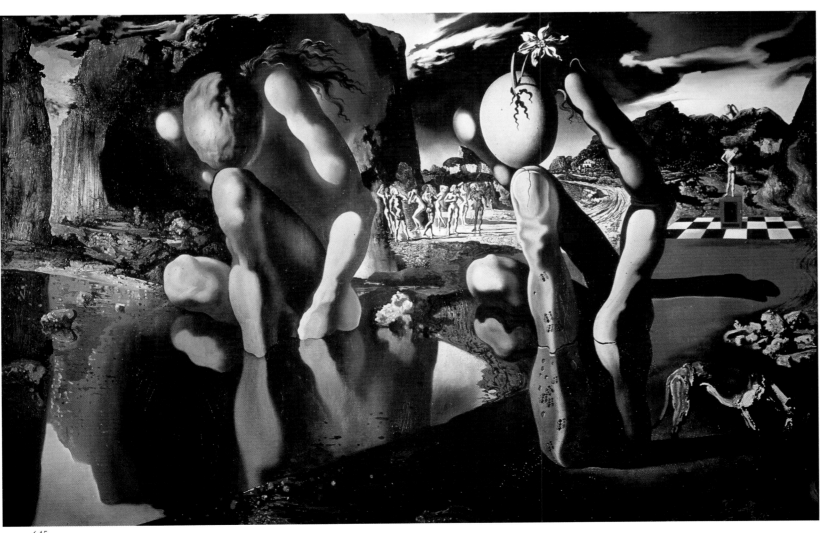

645

646

647

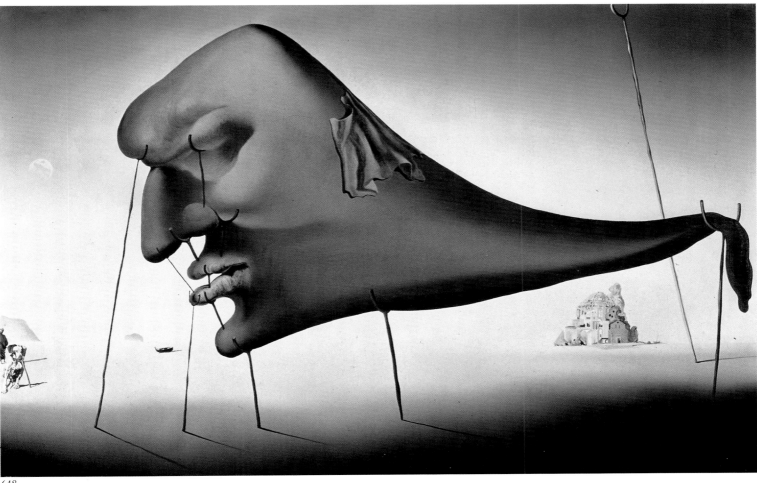

648

646 **The rock at Cape Creus known as the sleeping rock. Geology sleeps without cease,** 1937 ✫

647 **Drawers Cannibalism (Composition with Drawers),** 1937 Δ
Cannibalisme des tiroirs (Composition aux tiroirs)

648 **Sleep,** 1937 ❏
Le sommeil

649 **Untitled – Hysterical Scene,** 1937 Δ
Sans titre – Scène hystérique

649

1937

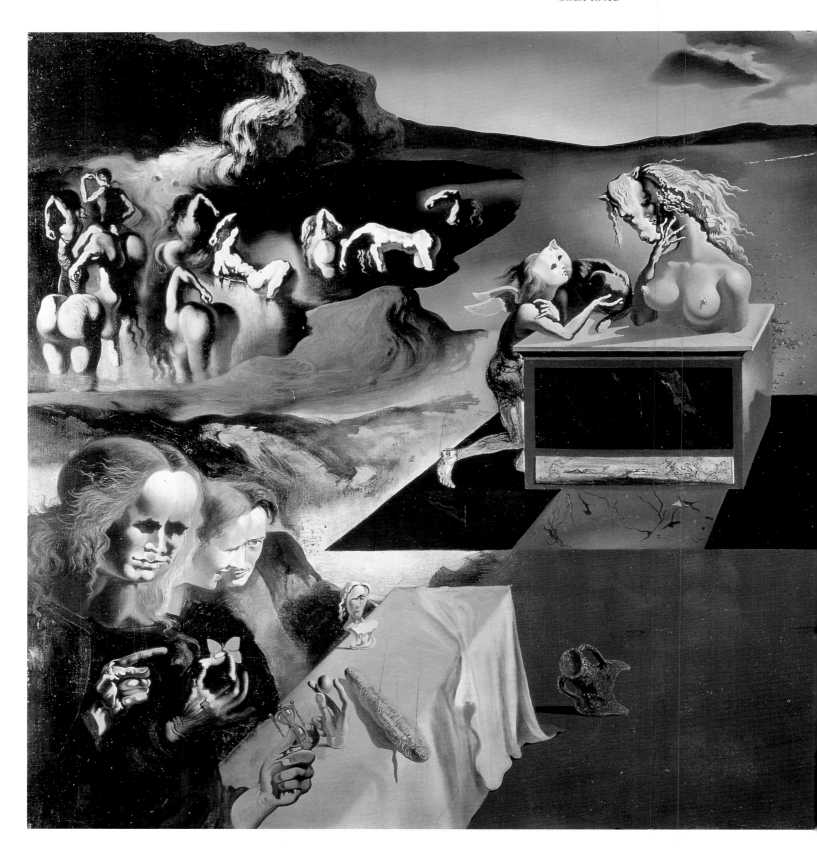

650

651

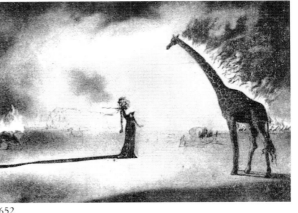

652

653 **Queen Salomé**, 1937 Δ
La reine Salomé

654 **Herodias**, 1937 ❏
Hérodiade

655 **Cannibalism of Objects –
Woman's Head with Shoe**, 1937 Δ
Cannibalisme des objets – Tête de
femme avec soulier

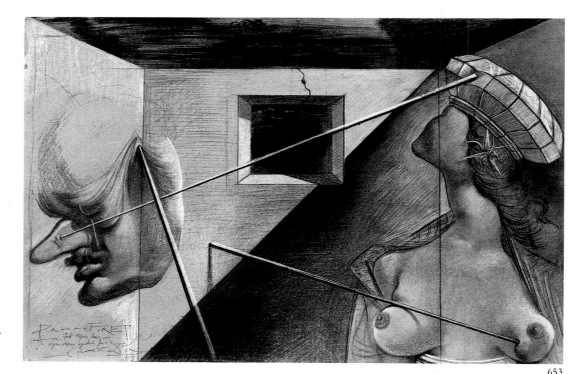

653

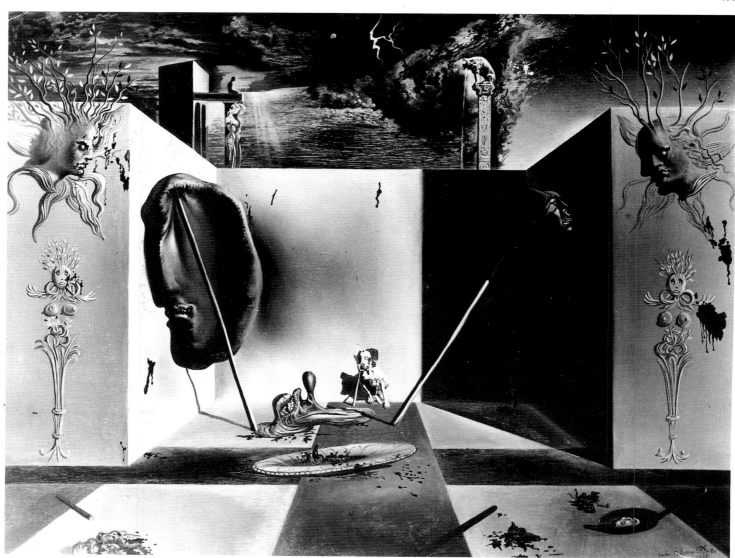

654

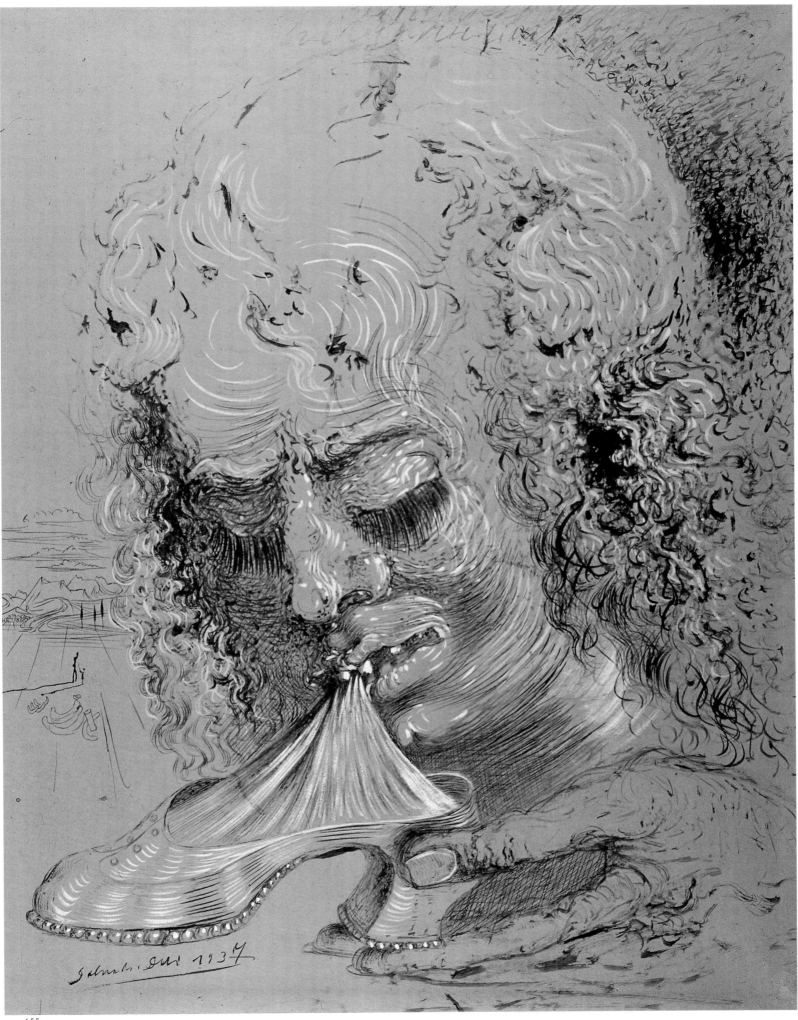

655

1937

656 **Dinner in the Desert Lighted by Giraffes on Fire**, 1937 Δ
Dîner dans le désert éclairé par les girafes en feu

657 **Surrealist Gondola above Burning Bicycles (Drawing for a film project with the Marx Brothers)**, 1937 Δ
Gondole surréaliste sur bicyclettes en feu

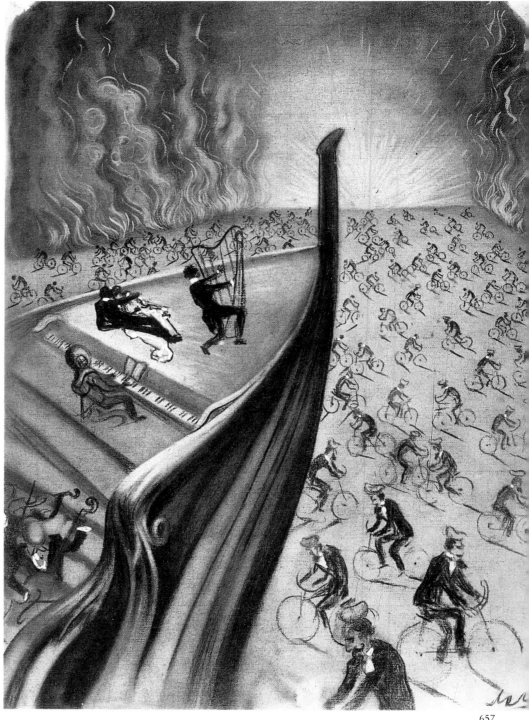

657

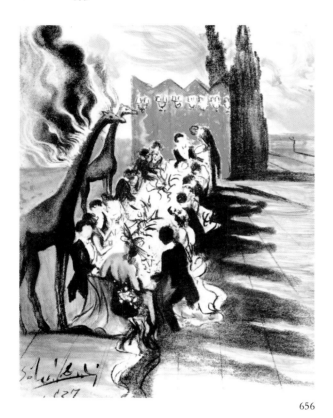

656

658 **Surrealist Dinner on a Bed (Drawing for a film project with the Marx Brothers)**, 1937 Δ
Dîner surréaliste sur un lit

659 **How Skyscrapers Will Look in 1987 (Drawing for "American Weekly")**, 1937 Δ

660 **Untitled – Lamp with Drawers (Drawing for an interior)**, c. 1937 Δ
Sans titre – Lampe aux tiroirs

661 **Untitled – Standard Lamp with Crutches (Drawing for an interior)**, c. 1937 Δ
Sans titre – Lampadaire aux béquilles

662 **Biactric Collars**, c. 1936 Δ
Cols biactriques

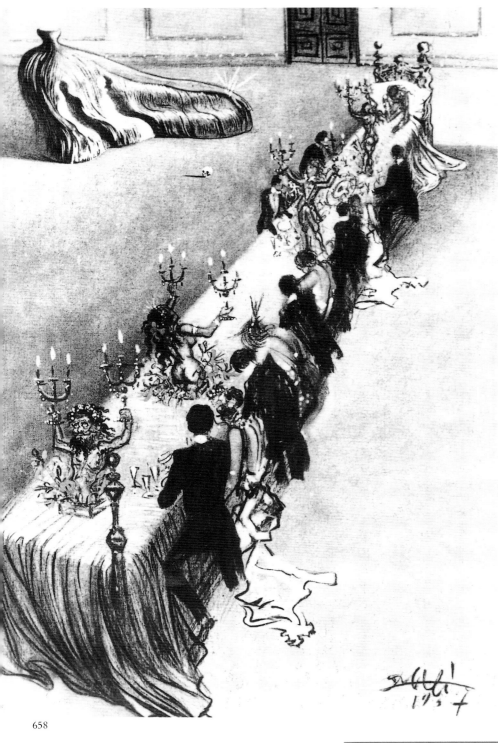

658

662

659

660

661

663

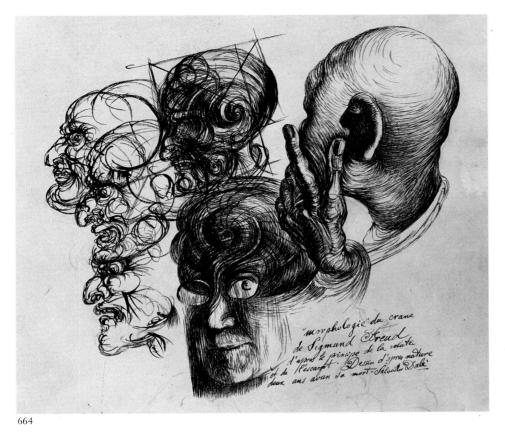

664

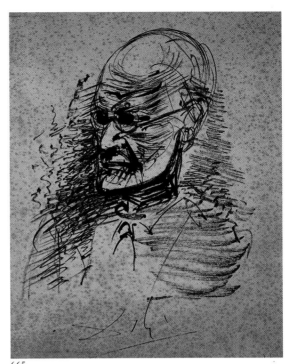

665

sprouted and in flower. To Dalí's way of thinking, the painting represented the first occasion on which a Surrealist work had offered a consistent interpretation of an irrational subject. The paranoiac-critical method was setting out to establish an indestructible assembly of exact details such as Stendhal demanded if an account were to be given of the architecture of St. Peter's in Rome (Dalí's analogy).

The lyrical quality of poetic images is only of philosophical significance if they aspire to the same precision as mathematics, according to Dalí. Poets are as obliged to supply proof as scientists. In the case of Narcissus, a Catalonian saying is apt: if someone is said to have a bulb in the head, it is the equivalent of having a complex in the language of psychoanalysis – and a bulb, of course, can produce a flower. At this point in Dalí's commentary on *The Metamorphosis of Narcissus* he waxed lyrical, addressing Narcissus directly: "Do you understand, Narcissus? Symmetry, that divine hypnosis of the spirit, is already filling your head with the incurable, atavistic, slow sleep of plants, drying out the leathery kernel of your imminent metamorphosis in your brain. The seed that was in your head has fallen into the water. Man becomes plant once more, through the heavy sleep of exhaustion, and the gods through the transparent hypnosis of their passions. Narcissus, you are so motionless one might think you asleep. If you were the rough, dark Hercules, one would say: he is sleeping like a log, like a Herculean oak. But you, Narcissus, who are made of the shy perfumed essences of transparent youth, are sleeping like a waterflower. Now, as the great mystery approaches and the metamorphosis is shortly to be accomplished, Narcissus, motionless, as slow of digestion as carnivorous plants, is becoming invisible. Only the hallcinatory oval of his white head remains, his head grown more tender, his chrysalis head full of biological intent, his head held on fingertips above the water, by the fingertips of a senseless, terrible hand, the shit-eating hand, the deadly hand of his own reflection. When that head splits, when that head is fissured, when that head breaks open, the flower will be there, Narcissus, Gala – my Narcissus."

One day a young psychiatrist phoned Dalí, wanting to discuss an article Dalí had contributed to *Minotaure* on the phenomenon of paranoia. The young man

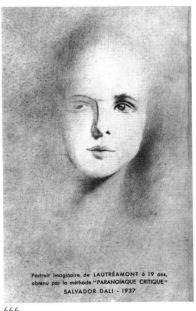

666

663 **Portrait of Sigmund Freud**, 1937 △
Portrait de Sigmund Freud
664 **Portrait of Sigmund Freud – Morphology of the Skull of Sigmund Freud. Illustration for "The Secret Life"**, 1938 △
Portrait de Sigmund Freud – Morphologie du crâne de Sigmund Freud
665 **Portrait of Sigmund Freud**, 1938 △
Portrait de Sigmund Freud
666 **Imaginary Portrait of Lautréamont (Aged 19), Done Using the Paranoiac-Critical Method**, 1937 △
Portrait imaginaire de Lautréamont – à 19 ans obtenu d'après la méthode paranoïaque-critique

667

667 **Study for "The False Inspection" (False Perspective)**, 1937 △

668 **Andrea Palladio: The proscenium of the Teatro Olimpico in Vicenza**, c. 1580 ✫

669 **Palladio's Corridor of Dramatic Surprise**, 1938 ❏
Le corridor de Palladio avec surprise dramatique

670 **Palladio's Thalia Corridor**, 1937 ❏
Le corridor Thalia de Palladio

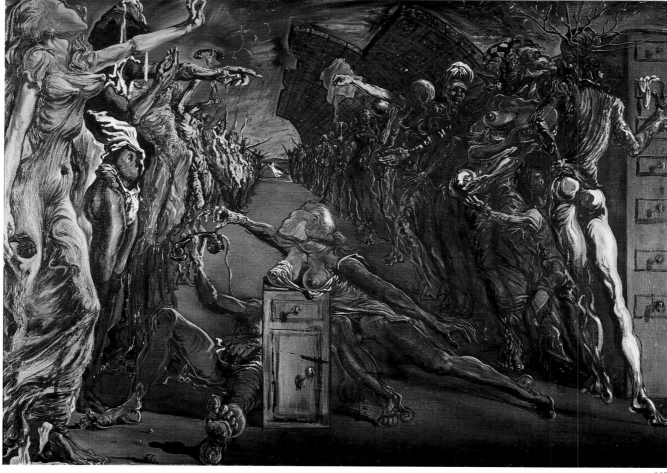

669

670

671 **Study for the self-portrait in "Impressions of Africa", 1938 △**

671

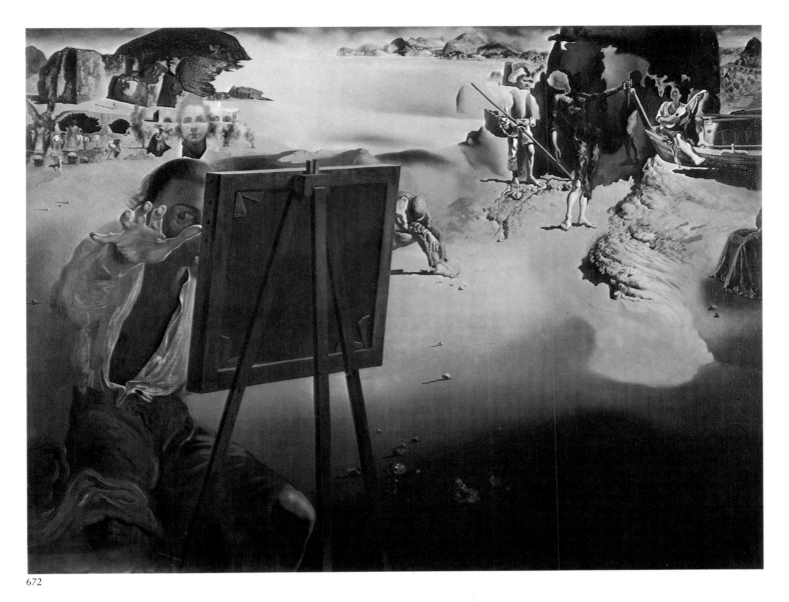

672

was Jacques Lacan. "We were surprised to discover that our views were equally opposed, and for the same reasons, to the constitutionalist theories then almost unanimously accepted." Both names, Lacan's and Dalí's, have become inseparable from the history of enquiry into paranoia: the artist's through his paranoiac-critical method, the psychiatrist's initially through the brilliant doctoral thesis that made him famous in October 1932. As Patrice Schmitt has observed: "Paranoia, in Dalí's understanding, is the very opposite of hallucination. It is an active method. It implies critique. It has exact meanings and a phenomenological dimension. Within the Surrealist movement, it stood opposed to automatism. Automatism was practised in automatic writing and games of consequences (cf. pp.216/217), to which Dalí had introduced the Surrealists […] Lacan, for his part, opposed automatism in his thesis, since it transposed paranoiac interpretation into an organic response; instead, he favoured phenomenological meaning. If we compare the two approaches, we see that for Lacan the interpretative moment is already an act of hallucination, but in fact that equivalence of hallucination and interpretation is the very essence of the phenomenon. For both Dalí and Lacan, paranoia is pseudo-hallucinatory: this is their first link. […] Dalí's dual-image pictures are the clearest demonstration that delirium and interpretation are one and the same. In the dual image, the clear distinctions of classicism come to seem superannuated and incomprehensible, since delirium and interpretation are simultaneous moments of the same type." Be that as it may, when Dalí described his

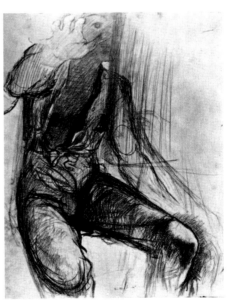

673

672 **Impressions of Africa**, 1938 ❏
Impressions d'Afrique

673 **Study for the self-portrait in "Impressions of Africa"**, 1938 △

676

EXPOSITION

INTERNATIONALE
DU
SURRÉALISME
Janvier-Février 1938

★

ORGANISATEURS | André Breton.
| Paul Eluard.
GÉNÉRATEUR-ARBITRE : Marcel Duchamp.
ASSISTANT : Claude Le Gentil.
CONSEILLERS SPÉCIAUX | Salvador Dali.
| Max Ernst.
MAITRE DES LUMIÈRES : Man Ray.
EAUX ET BROUSSAILLES : W. Paalen.

Mannequins de la Maison P. L. E. M. habillés par Yves Tanguy, André
Masson, Kurt Seligmann, Sonia Mossé, Hans Arp, Oscar Dominguez,
Léo Malet, Max Ernst, Marcel Duchamp, Joan Miro, Marcel Jean,
Man Ray, Espinoza, Matta Echaurren, Maurice Henry, Salvador Dali.

Plafond chargé de 1.200 sacs à charbon
Portes « Revolver »
Lampes Mazda
Échos
Odeurs du Brésil
et le reste à l'avenant.

★

GALERIE BEAUX-ARTS
140, Rue du Faubourg Saint-Honoré — PARIS

674

675

677

674 Title page of the catalogue for the International Surrealist Exhibition at the Galerie des Beaux-Arts, Paris, 1938 ✕

675 Dalí with his dummy. Photo for the International Surrealist Exhibition, 1938 ✕

676-677 The Rainy Taxi (Mannequin Rotting in a Taxi-Cab). For the International Surrealist Exhibition, 1938 ○
Le taxi pluvieux

meeting with the young Lacan in the *Secret Life* what troubled him most was the fact that throughout their interview, as he afterwards realized, he had had a square of white paper sticking to the tip of his nose.

When Picasso sent Dalí a postcard showing a number of blacks, Dalí saw that, considered a certain way, it could be viewed as a face, and promptly took the card as his starting point for the *Paranoiac Visage* (p. 249). It would be false, in this example, to distinguish between two moments: the wrong interpretation of the

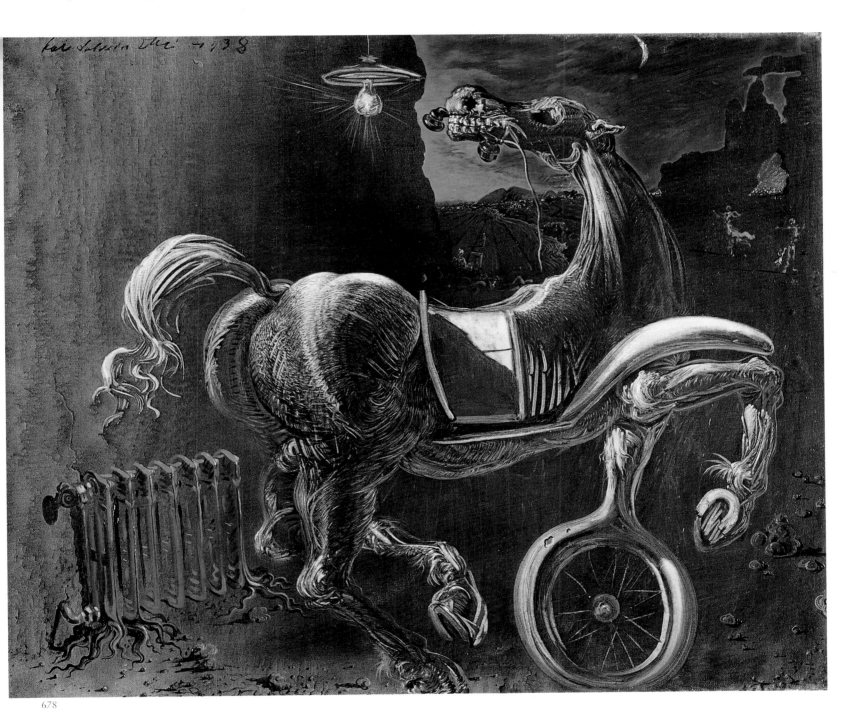

678

678 **Debris of an Automobile
Giving Birth to a Blind Horse
Biting a Telephone**, 1938 ❏
Débris d'une automobile donnant
naissance à un cheval aveugle mordant
un téléphone

679

680

681

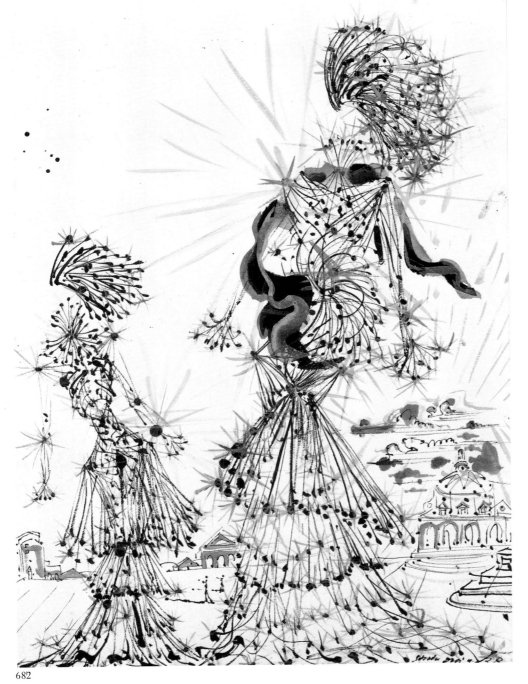

683

679 Gradiva, 1938 △

680 **Coccyx Women**, 1938 △
Femmes-coccyx

681 **Imaginary Figures with a Back-
ground of Spanish Monuments.
Study for the costumes for Coco
Chanel**, 1938 △
Quatre personnages imaginaires sur
fond de monuments espagnols

682 **Composition – Two Women
with a Town in the Background**,
1938 △
Composition – Deux femmes et une
ville dans le fond

683 **Fantastic Beach Scene with
Skeleton and Parrot**, 1938 △
Scène de plage fantastique avec
perroquet et carcasse de bateau

682

684

685

686

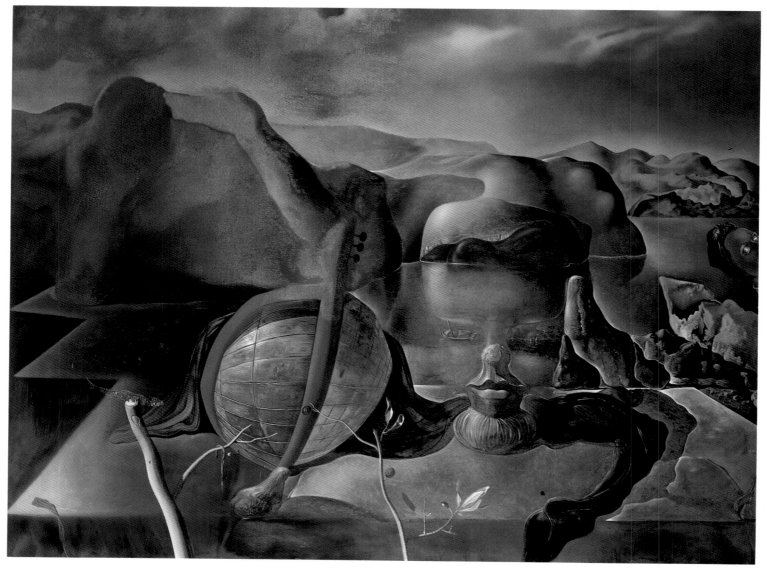

687

688

689

690

card, and then a rational delirium following. Rather, the two aspects of the process are of identical, simultaneous importance. This was the point Dalí and Lacan were in agreement on.

Of *Sleep* (p.291), on one level an almost exact painting of a rock at Cadaqués (p.290), Dalí wrote in the tenth issue of *Minotaure* (winter 1937): "Thanks to the glorious paranoiac-critical method we are obtaining ever more new, exact details. Sleep is a truly monstrous chrysalis, its morphology and nostalgia propped on eleven crutches, each of which is also a chrysalis and should be examined separately." Dalí alluded to Michelangelo's spiral of sleep, and declared that Gaudí had been right on this matter as on so many others. In the *Secret Life* he also reported

684, 685, 686, 688, 689, 690 **Subjects for "The Endless Enigma": Beach at Cape Creus with Seated Woman Seen from the Back Mending a Sail, and Boat. Philosopher Reclining. Face of the Great Cyclopean Cretin. Greyhound. Mandolin, Fruit Dish with Pears, Two Figs on a Table. Mythological Beast,** 1938 △

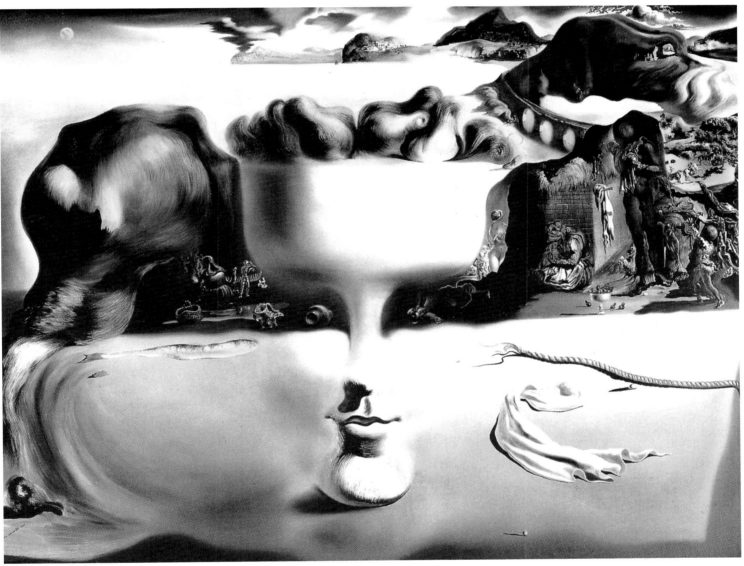

691

that he had often imagined sleep as a huge, heavy head with a long, thin body balanced on the crutches of reality. If ever those crutches break, wrote Dalí, we feel we are falling: it is the familiar sense of tumbling into vast vacancy at that moment when sleep overcomes us. And when we suddenly awaken, he added, we may not necessarily always realize that we are reliving the feeling of expulsion that so traumatized us at birth.

687 **The Endless Enigma,** 1938 ❏
L'énigme sans fin

691 **Apparition of Face and Fruit Dish on a Beach,** 1938 ❏
Apparition d'un visage et d'un compotier sur une plage

1938–1939

693

692

694

695

696

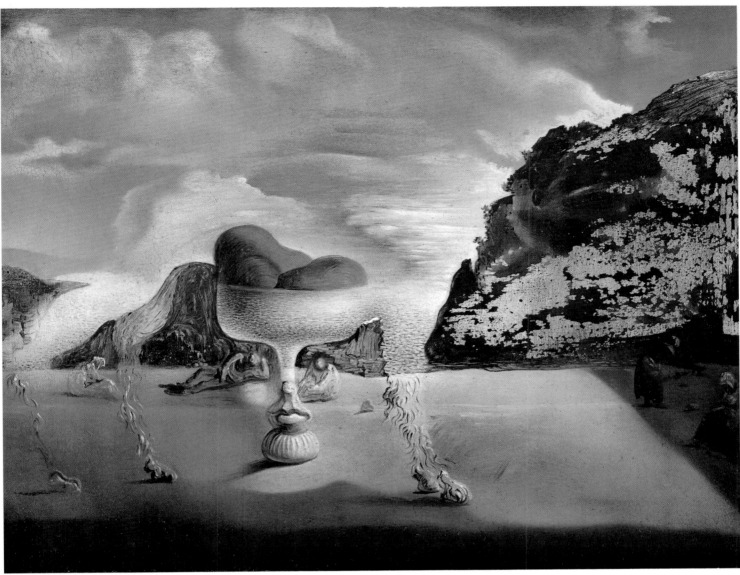

697

The Invisible Object

On 17 January 1938, the International Surrealist Exhibition opened at the Galerie des Beaux-Arts in Paris. It was to mark the pinnacle of the movement's influence and impact. Despite his exclusion from the group, Dalí was exhibited at the show, as was another shortly to be in the same position, Max Ernst. Dalí's *Rainy Taxi* (p.304), the installation referred to by Orwell in his essay as "Mannequin Rotting in a Taxi-cab", occasioned controversy, as we have seen (Orwell was to call it "diseased and disgusting"). The Surrealists were exhibiting everywhere – from May to June at the Guildhall in Gloucester; that spring at Robert's in Amsterdam; that November at Alex Reid's and Lefevre in London; from 13 October till 4 December at the Carnegie Institute in Pittsburgh, and at the Wadsworth Atheneum in Hartford. Dalí was featured in all of these shows, and also worked with André Breton and Paul Eluard on the *Dictionnaire du Surréalisme*, published by the Galerie des Beaux-Arts.

Dalí was now travelling a good deal. On 19 July, accompanied by Edward James and Stefan Zweig to perform the introductions, he met Sigmund Freud in London. Zweig had written to Freud that in his view Dalí was the sole genius among the painters of the age, the one whose work would endure – a fanatic, but also the most loyal of all Freud's disciples among artists. For Dalí, meeting Freud

695 **Metamorphosis of a Man's Bust into a Scene Inspired by Vermeer – The Triple Image**, 1939 △
Métamorphose d'un buste d'homme en scène inspirée par Vermeer – La triple image

696 **Metamorphosis of a Man's Bust into a Scene Inspired by Vermeer – The Triple Image**, 1939 △
Métamorphose d'un buste d'homme en scène inspirée par Vermeer – La triple image

697 **Invisible Afghan with the Apparition on the Beach of the Face of García Lorca in the Form of a Fruit Dish with Three Figs**, 1938 ❏
Afghan invisible avec apparition sur la plage du visage de García Lorca en forme de compotier avec trois figues

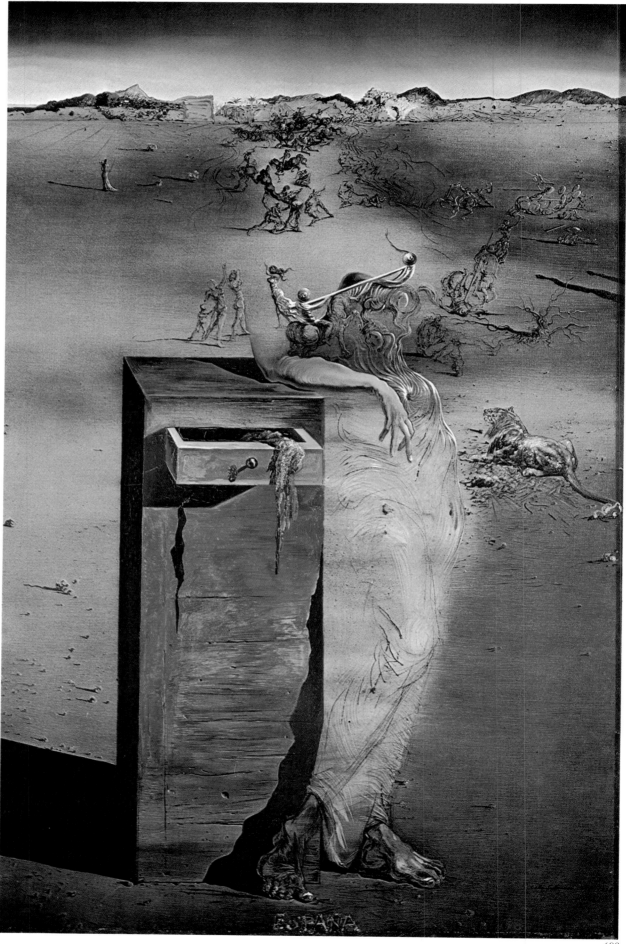

was like meeting God; Julien Green noted in his diary on one occasion that Dalí had spoken of Freud as a Christian would speak of the Gospels. "Contrary to my hopes," recalled Dalí, "we spoke little, but we devoured each other with our eyes. Freud knew nothing about me except my painting, which he admired [...] Before his imperturbable indifference, my voice became involuntarily sharper and more insistent." The day after their meeting, Freud wrote to Zweig that he was glad to have met the young Spaniard because hitherto he had been inclined to suppose the Surrealists (who had taken him as their patron saint) complete fools. But Dalí's technical mastery and fanatical gaze had persuaded him that it might indeed be worth analysing a Surrealist painting. Dalí felt flattered by Freud's comment to Zweig: "I have never seen a more complete example of a Spaniard. What a fanatic!"

At this time, Dalí frequently painted telephones or sardines (or both) on plates, as in *Beach with Telephone* (p. 315), *The Sublime Moment* (p. 315), *Imperial Violets* (p. 315) and *The Enigma of Hitler* (p. 316). The telephone was a symbol of

700

698 **Spain**, 1938 ❑
Espagne

699 **The Warner**, 1938 ❑
L'alerte

700 **Study for "Spain"**, 1936 △

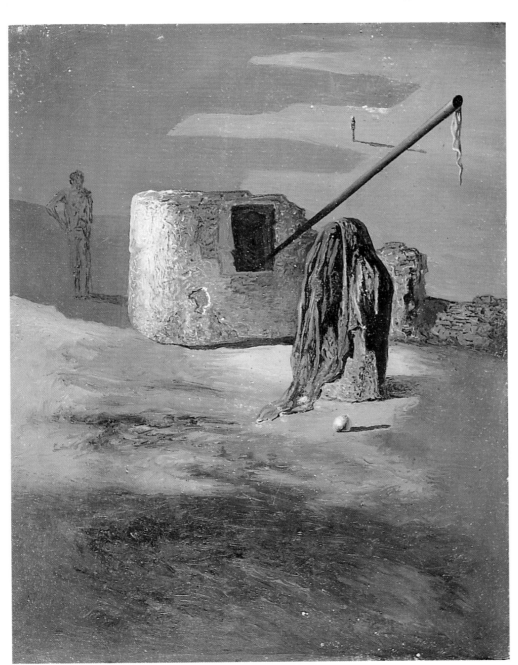

699

1938

701 **Enchanted Beach with Three Fluid Graces**, 1938 ❑
Plage enchantée avec trois grâces fluides

702 **The Transparent Simulacrum of the Feigned Image**, 1938 ❑
Le simulacre transparent de la fausse image

703 **The Sublime Moment**, 1938 ❑
Le moment sublime

704 **Beach with Telephone**, 1938 ❑
Plage avec téléphone

705 **Imperial Violets**, 1938 ❑
Violettes impériales

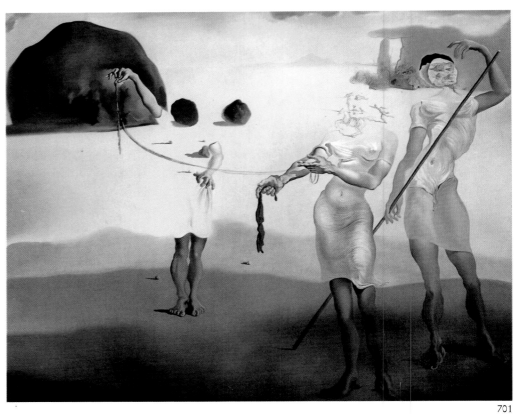

701

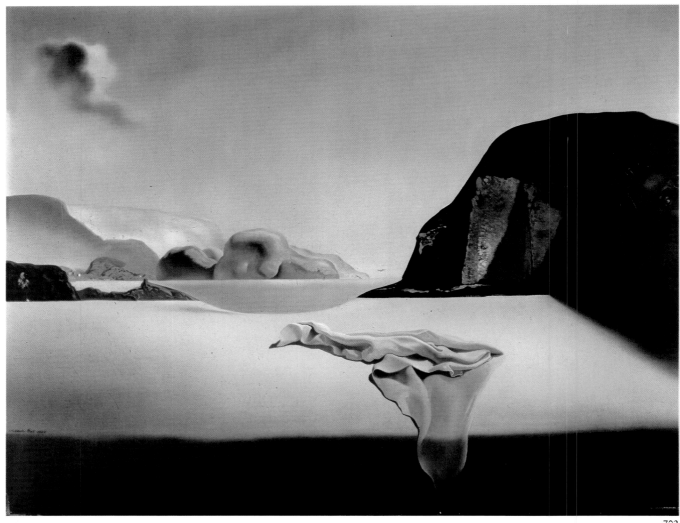

702

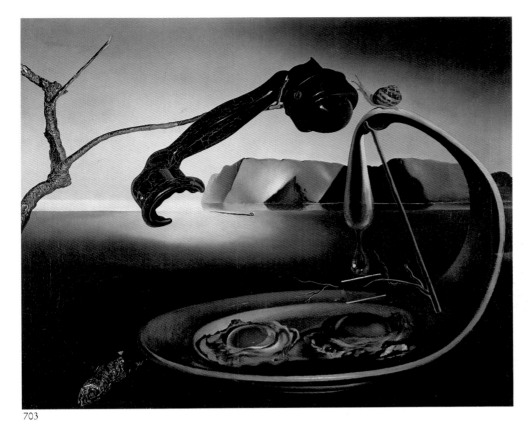

703

705

704

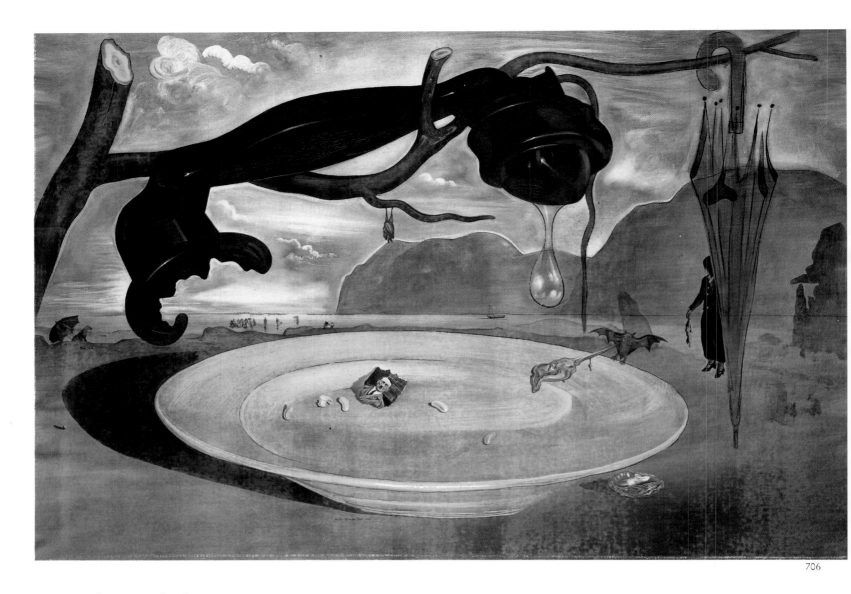

706

706 **The Enigma of Hitler**, c. 1939 ❏
L'énigme d'Hitler

707 **Telephone in a Dish with Three
Grilled Sardines at the End of
September**, 1939 ❏
Téléphone sur le plat avec trois
sardines grillées à la fin de septembre

708 **Philosopher Illumined by the
Light of the Moon and the Setting
Sun**, 1939 ❏
Philosophie éclairée par la lumière de
la lune et du soleil couchant

709 **Landscape with Telephones on
a Plate**, 1939 ❏
Paysage avec téléphones sur un plat

the age, of modernity: "A telephone is talking to a man," as Auden put it. In the era of appeasement and Munich, as the Second World War approached, the telephone must have seemed an emblem of menace. Dalí was forever questing for the secrets of images both visible and invisible, as we clearly see in *The Image Disappears* (p. 310), *Old Age, Adolescence, Infancy (The Three Ages)* (p. 331), and the Voltaire pictures (pp. 331 and 340). Later in life, in 1971, Dalí recalled that for six years he systematically investigated the nature of vision and perception, only to conclude that we have not the smallest grasp of the psychological meaning of vision. We see what we are inclined to see, what we suppose we have occasion to see; and if our preconceptions are clouded, we see something else, in which event visual responses can be manipulated. Dalí used an analogy from the world of radio: impressions can be broadcast in bundles, or subjected to purely psychological interference. Dalí himself had eventually come to the conclusion that the adoption of psychological disguise was a real option in visual perception, and simply a question of research and experience.

707

709

708

4. The Triumph of Avida Dollars

It was 1939, and the clouds of war were gathering over Europe. Dalí, as though intuitively fearing the imminent arrival of German troops, was making ready for a renewed American sojourn. He was designing material, dresses and hats – above all, cutlet hats, inkwell hats, shoe hats, skeleton dresses, dresses with drawers, and so forth – for Elsa Schiaparelli (cf. p.275); a ballet (with costumes by Coco Chanel) for the Monte Carlo Ballet; and an opera, *Tristan Insane*, with music by Wagner (pp.367–372). They were all projects that were to be completed in the U.S.A. – and Dalí was also preparing his next exhibition in New York. Meanwhile, he put the finishing touches to *The Enigma of Hitler* (p.316). He admitted that he did not know what the painting meant and that it was presumably a transcription of dreams he had had after the Munich Agreement. However, he also said that the painting "appeared to me to be charged with a prophetic value, as announcing the medieval period which was going to spread its shadow over Europe. Chamberlain's umbrella appeared in this painting in a sinister aspect, identified with the bat […]"

In New York Dalí was delighted to find that everyone was trying to imitate him. Bonwit-Teller, a department store, asked him to dress one of its windows, and gave him unqualified licence to design and display precisely as he wished. Dalí went rummaging in a store and discovered some wax dummies dating from the turn of the century; they had long human hair taken from deceased persons and were terrible to behold. He planned to have one of the dummies getting into an astrakhan-lined bathtub filled to the brim with water. In its waxen hands it would be holding a mirror to symbolize the myth of Narcissus, and real narcissuses would be growing on the floor and furniture. Above a made bed there would be a buffalo's head with a bloody pig in its jaws; the buffalo's hooves would be the feet of the bed; in the black satin sheets there would be burn-holes at irregular intervals; everywhere there would be (artificial) glowing coals, even on the pillow beside the head of a wax dummy. Beside the bed stood the Phantom of Sleep, in the waxen sleeper's dream. Dalí titled the work *Day and Night*. He was convinced that it would catch the attention of passers-by and would show for all to see what a true Dalí Surrealist vision was like. In this he was not mistaken.

When the display was installed, the crowds that gathered were so large that they impeded the traffic. The management hurriedly decided to remove the main features of the display. When Dalí saw his vandalized exhibit, he calmly climbed into the window and (attracting another crowd) tipped up the bathtub, which smashed the window, soaking the onlookers. Dalí climbed out through the hole in the window and was arrested. Gala and some friends hurried to the police station. "The judge who tried my case betrayed upon his severe features the amusement that my story afforded him. He ruled that my act was 'excessively violent' and that since I had broken a window I would have to pay for it, but he made a point of adding emphatically that every artist has a right to defend his 'work' to the limit."

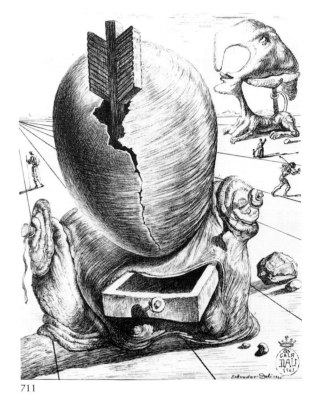

711

710 **Clothed Automobile (Two Cadillacs)**, 1941 ❏
Automobiles habillées (Deux Cadillac)

711 **The Broken Egg**, 1943 △
L'œuf brisé

1939

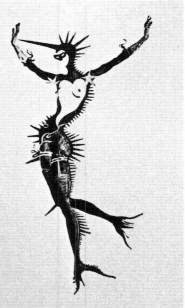

SALVADOR DALI

CORDIALLY INVITES YOU TO ATTEND
THE PRESS RECEPTION OF THE

DALI DREAM OF VENUS

AT THE NEW YORK WORLD'S FAIR ON

WEDNESDAY, MAY 31st, AT 5 O'CLOCK

1939

Please present AMUSEMENT AREA
this card (North of Sun Valley)

712

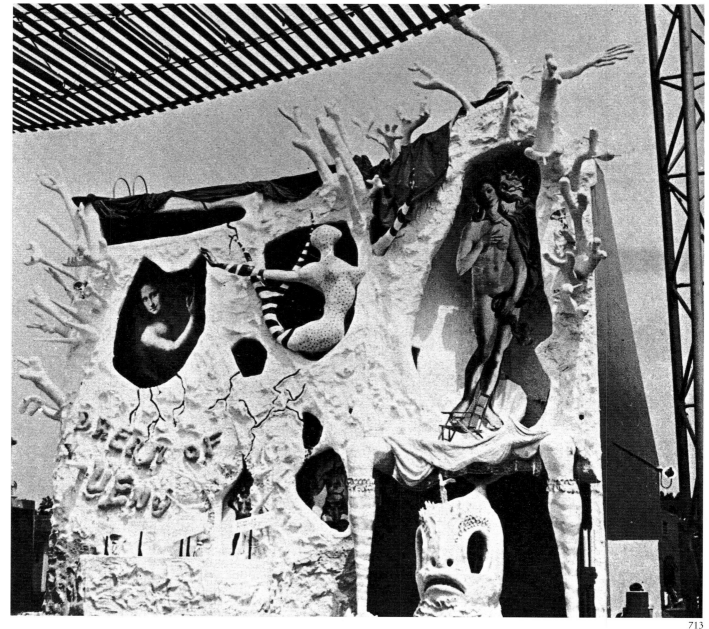

713

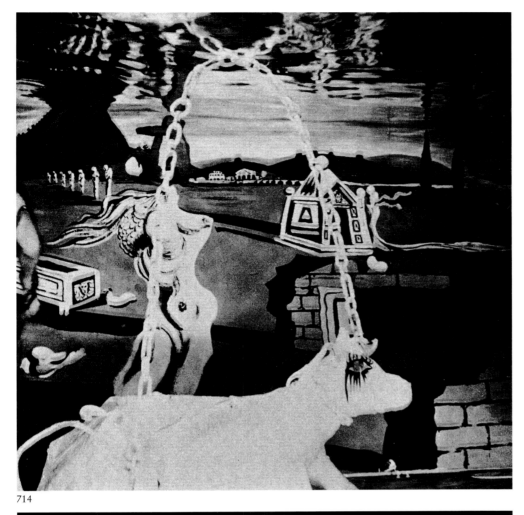

714

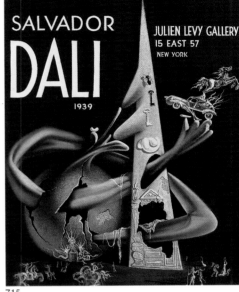

715

716

712 Invitation to the opening of the "Dream of Venus". The opening was in fact postponed to 15 June 1939. ☆

713 The "Dream of Venus" Pavilion, 1939 ☆

714 Interior of the "Dream of Venus" Pavilion, 1939 ☆

715 The Sphere Attacks the Pyramid. Cover of the catalogue of the exhibition at Julien Levy's in New York, 1939 Δ
La sphère attaque la pyramide

716 Woman dressed as a piano, from the "Dream of Venus", 1939 ☆

**Declaration of the Independence of the
Imagination and the Rights of Man
to His Own Madness**

WHEN, IN THE COURSE OF HUMAN CULTURE IT BECOMES NECESSARY FOR A
PEOPLE TO DESTROY THE INTELLECTUAL BONDS THAT UNITE THEM WITH THE
LOGICAL SYSTEMS OF THE PAST, IN ORDER TO CREATE FOR THEMSELVES AN
ORIGINAL MYTHOLOGY WHICH, CORRESPONDING TO THE VERY ESSENCE AND
TOTAL EXPRESSION OF THEIR BIOLOGICAL REALITY, WILL BE RECOGNIZED BY
THE CHOICE SPIRITS OF OTHER PEOPLES — THEN THE RESPECT THAT IS DUE

717

717 **First page of Dalí's "Declaration of the Independence of the Imagination and the Rights of Man to His Own Madness"** ✰

718 **The Sirens from the "Dream of Venus"**, 1939 ✰

718

Once again, Dalí was the talk of the town. The following day, the press took his side, praising the blow he had struck for the "independence of American art". He received a number of offers, among them an offer to design a pavilion for the World Fair on the theme of "The Dream of Venus". Once again, however, his licence to work as he wished was not honoured. His instructions were not followed, and the organizers of the World Fair refused to allow him to put a replica of Botticelli's Venus outside the pavilion, with a fish-head instead of her own; and in revenge Dalí published his *Declaration of the Independence of the Imagination and the Rights of Man to His Own Madness*. Dalí had now grasped that the Americans mainly wanted the use of his name for publicity purposes and were less interested in showing the fiendish fruits of his imagination to the public. Dalí's response was to demand the cheque before he would even talk to potential clients.

The publicity created by the smashed Bonwit-Teller window was well timed and helped launch his own solo exhibition, which opened at the Julien Levy Gallery on 21 March 1939. *Life* magazine reported his latest triumph: "No exhibition had been so popular since Whistler's *Arrangement in Black and Grey No. 1: The Artist's Mother* was shown in 1934. The crowd gaped open-mouthed at pictures with bewildering titles like *Debris of an Automobile Giving Birth to a*

Blind Horse Biting a Telephone or *The One-eyed Idiot*. A fortnight later, Dalí, one of the richest young painters in the world, had sold 21 of his works to private collectors for over $25,000. Two works remained to be sold: *The Enigma of Hitler* ($1,750) and *The Endless Enigma* ($3,000)." And *The Art Digest* reported: "The Dalí exhibition was preceded by the usual publicity campaign, dreamt up in this case by the masters of publicity, Dalí and Levy, for New York's journalists and the broad gullible public [...] after he had smashed the store window, he stepped out through the hole onto the sidewalk and into the front pages of the daily papers…"

Dalí returned to Europe – convinced, in spite of his experiences in New York, that America was now the only country that enjoyed an unusual degree of liberty.

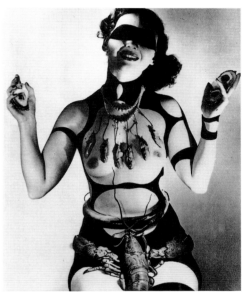

720

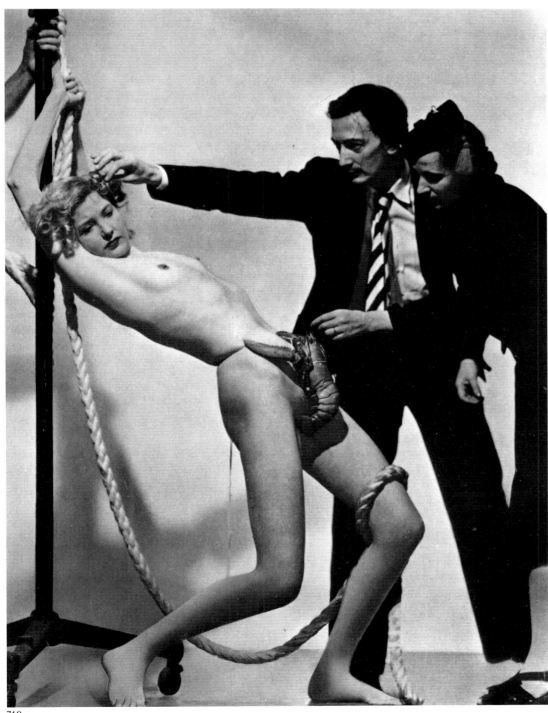

719

719 Dalí and Gala filming the "Dream of Venus" in the Murray Korman Studios in New York, 1939. Photograph: George Platt Lyne ☆

720 Photo by H.P. Horst for "Vogue": Costume for the "Dream of Venus", 1939 ☆

721, 723 Ballet scenes from "Bacchanale" with the Ballets Russes at the Metropolitan Opera House, New York. The design, set and costumes were by Dalí. Photos from the "New York Times", 19 November 1939 ☆

722 Sirens and Graces – Set design for Dalí's "Bacchanale", c. 1939 △
Sirène et ses grâces – Bacchanale

Immediately after I had broken my Bonwit-Teller window," Dalí recalled in the *Secret Life*, looking back on the publicity-getting scandal, "I received an offer to do 'another one', entirely to my taste – a monumental one, that would not have to be broken, in the New York World Fair which was to open in another month

Venus (Nina Theilade), metamorphosed into a fish, plays the lyre for two sea nymphs in the "Bacchanale." Dali did the scenario, decor and costumes for the production.

721

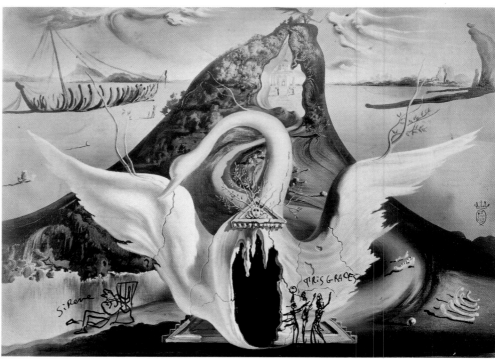

722

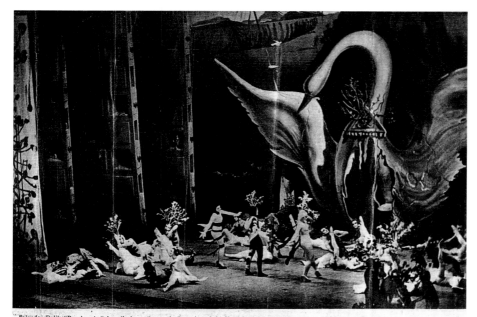

Salvador Dali's "Bacchanale," described as a "paranoiac" version of the Venusberg scene from Wagner's "Tannhaeuser," is in key with the Spanish surrealist's accomplishments in the world of ultra-modern art. Above, the Three Graces are seen joining the rest of the Ballet in the bacchanalia

723

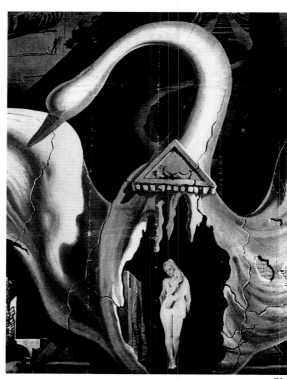

724

and a half, and I signed a contract with a corporation, a contract which appeared to me unequivocally to guarantee my 'complete imaginative freedom'. This pavilion was to be called *The Dream of Venus*, but in reality is was a frightful nightmare, for after some time I realized that the corporation in question intended to

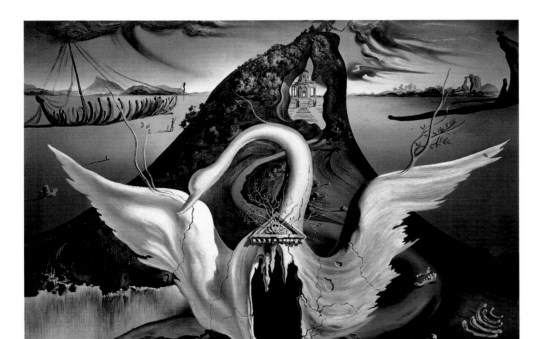

725

726

727

728

729

730

731

732

733

729 **Psychoanalysis and Morphology Meet,**
1939 ❏
Rencontre de la psychanalyse et de la morpho-
logie

730 **Gradiva, She Who Advances,** 1939 △
Gradiva, celle qui avance

731 **Tristan Insane,** c. 1938 ❏
Tristan fou

732 **The Dream of Venus,** 1939 ❏
Le rêve de Vénus

733 **Gradiva Becoming Fruits, Vegetables,**
Pork, Bread, and Grilled Sardine, 1939 △
Gradiva devenant fruits, légumes, charcuterie,
pain et sardine grillée

734 **Metamorphosis of the Five Allegories of**
Giovanni Bellini, 1939 △
Métamorphose des cinq allégories de Giovanni
Bellini

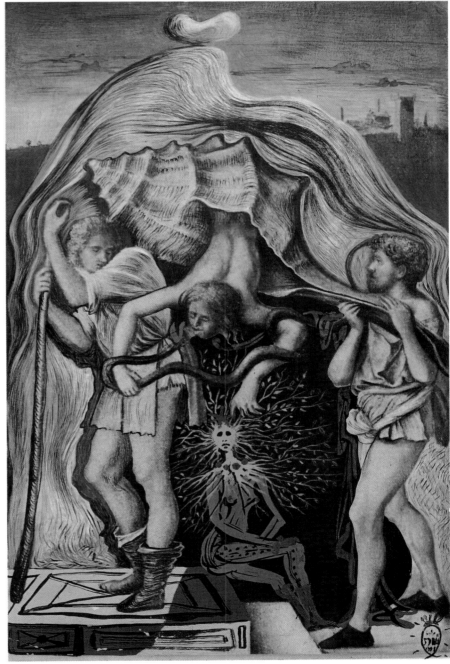

734

735

736

735 **Shirley Temple, the Youngest, Most Sacred Monster of the Cinema in her Time**, 1939 ❏
Shirley Temple, le plus jeune monstre sacré du cinéma de son temps

736 **Baby Map of the World**, 1939 ❏
Bébé-mappemonde

737 **Freud's Perverse Polymorph (Bulgarian Child Eating a Rat)**, 1939 ∆ Le pervers polymorphe de Freud (Enfant bulgare mangeant un rat)

737

738

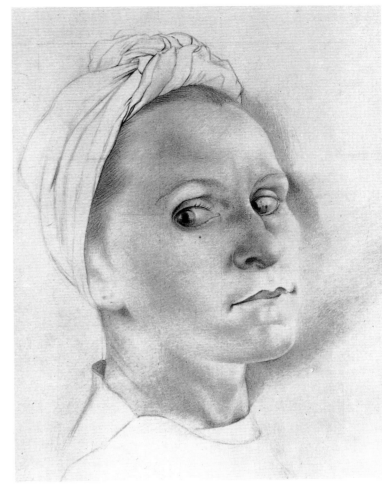

739

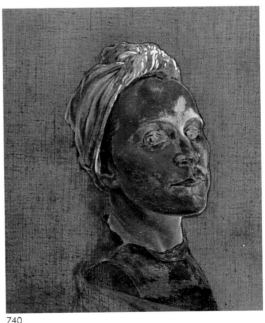

740

make *The Dream of Venus* with its own imagination, and that what it wanted of me was my name, which had become dazzling from the publicity point of view. […] Realizing that the explanations and the letters of protest that my secretary typed every evening to the point of exhaustion were becoming more and more ineffective, I told him to stop all these explanations, and to buy me a large pair of scissors. I appeared the following morning in the workshop where *The Dream of Venus* was being set up. My contract granted me the supreme right of supervision, and I was going to use and abuse this right with the challenging force of my scissors. The first thing I did was to cut open, one after another, the dozen sirens' tails intended for the swimming girls, thus making them totally unusable. […] Resigned, they agreed to do whatever my royal will commanded them. But my struggles were not over, for sabotage was about to begin. They did 'approximately' what I ordered, but so badly and with such bad faith that the pavilion turned out to be a lamentable caricature of my ideas and of my projects. I published on this subject a manifesto: *Declaration of the Independence of the Imagination and of the Rights of Man to His Own Madness.*"

This *Declaration* (cf. p.322) began with the capital letters of Dalí's frustration, in parody of the American Declaration of Independence: "WHEN, IN THE COURSE OF HUMAN CULTURE IT BECOMES NECESSARY FOR A PEOPLE TO DESTROY THE INTELLECTUAL BONDS THAT UNITE THEM WITH THE LOGICAL SYSTEMS OF THE PAST, IN ORDER TO CREATE FOR THEMSELVES AN ORIGINAL MYTHOLOGY […]" – a distinctively Dalinian project, surely.

Dalí went on to give an account of his difficulties with *The Dream of Venus*, invitations to the launch of which (p.320) had already been sent out: "The committee responsible for the Amusement Area of the World's Fair has forbidden me

738 **Apparition of a War Scene on the Face of Lieutenant Deschanel. Cover of "Match"**, 1939 △
Apparition d'une scène de guerre dans le visage du lieutenant Deschanel
739 **Study for "Portrait of Gala"**, 1939 △
740 **Portrait of Gala (unfinished)**, 1939 ❏
Portrait de Gala

329

to erect on the exterior of 'The Dream of Venus' the image of a woman with the head of a fish. These are their exact words: 'A woman with the head of a fish is impossible.' This decision on the part of the committee seems to me an extremely grave one [...] because we are concerned here with the negation of a right that is of an order purely poetic, and imaginative, attacking no moral or political consideration. I have always believed that the first man who had the idea of terminating a woman's body with the tail of a fish must have been a pretty fair poet, but I am equally certain that the second man who repeated the idea was nothing but a bureaucrat. In any case the inventor of the first siren's tail would have had my difficulties with the committee of the Amusement Area. Had there been similar committees in Immortal Greece, fantasy would have been banned and, what is worse, the Greeks would never have created their sensational and truculently Surrealist mythology, in which, if it is true that there exists no woman with the head of a fish (as far as I know) there figures indisputably a Minotaur bearing the terribly realistic head of a bull."

What Dalí objected to was the bureaucratic opposition to originality: "Any authentically original idea, presenting itself without 'known antecedents', is systematically rejected, toned down, mauled, chewed, rechewed, spewed forth, destroyed, yes, and even worse – reduced to the most monstrous of mediocrities. The

741 Untitled – Figure (unfinished),
1938–1939 ❏
Sans titre – Personnage

742 Lady Louis Mountbatten,
1940 ❏
Portrait de Lady Louis Mountbatten

741

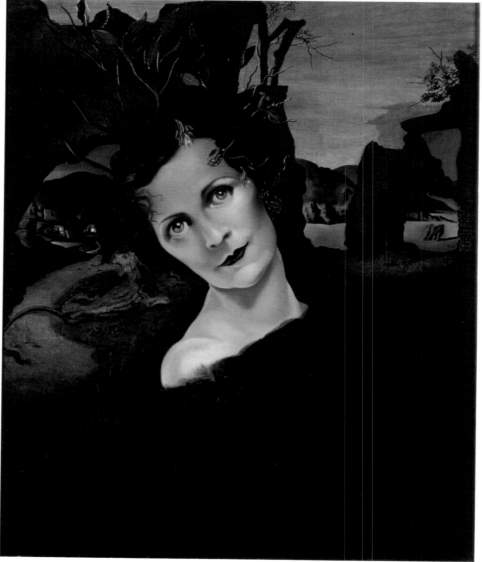

742

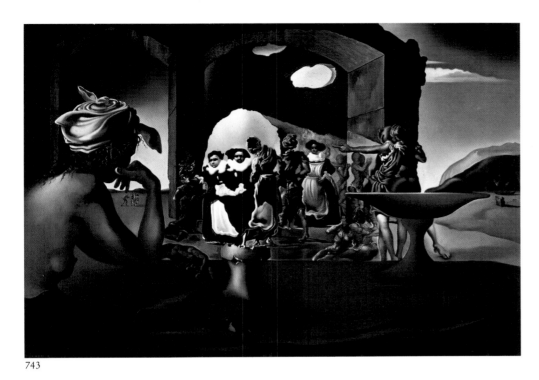

743

743 **Slave Market with the Disap-
pearing Bust of Voltaire**, 1940 ❏
Marché d'esclaves avec apparition du
buste invisible de Voltaire

744 **Old Age, Adolescence, Infancy
(The Three Ages)**, 1940 ❏
Les trois âges (La vieillesse, l'adoles-
cence, l'enfance)

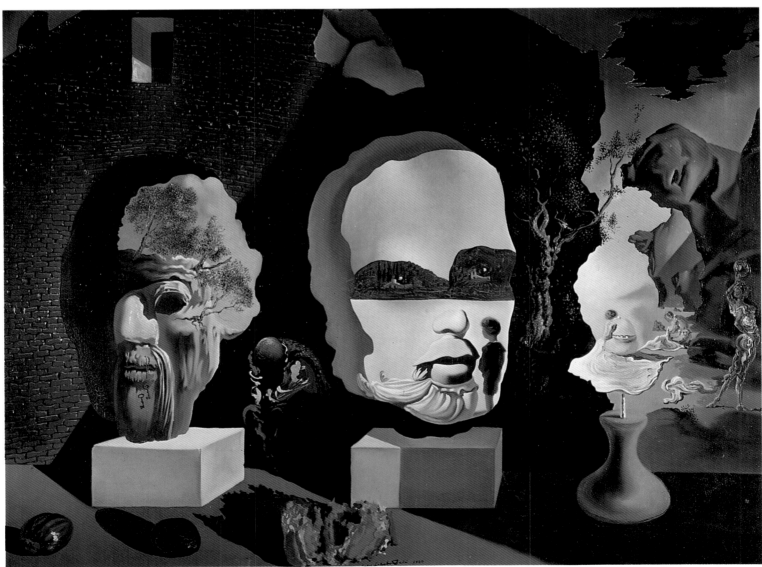

744

745 **Allegory of Sunset Air**
(Allegory of the Evening),
1940–1941 ❏

746 **Spider of the Evening... Hope!,**
1940 ❏
Araignée du soir...espoir

747 **Family of Marsupial Centaurs,**
1940 ❏
Famille de centaures marsupiaux

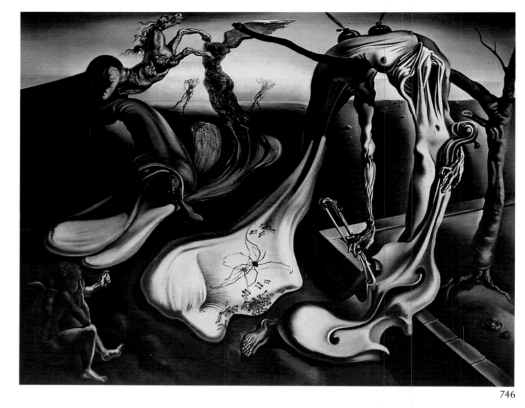

746

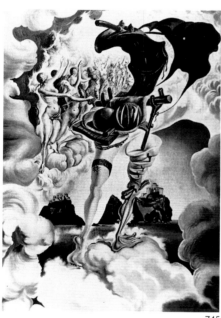

745

747

748

748 **Group of Women Imitating the Gestures of a Schooner**, 1940 ❏
Trois femmes imitant les mouvements d'un voilier

749 **The Golden Age – Family of Marsupial Centaurs**, 1940–1941 ❏
L'âge d'or

750 **Centaur (The Triumph of Nautilus)**, 1940 Δ
Centaure (Le triomphe de Nautilus)

749

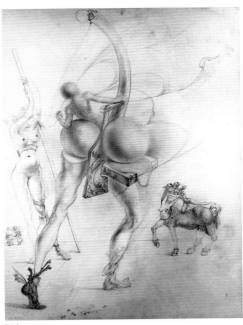

750

751 Untitled (Three Figures and a
Cypress), 1940 △

752 March of Time Committee –
Papillon, c. 1940 ❏

751

753

752

753 Two Pieces of Bread Expressing
the Sentiment of Love, 1940 ❏
Deux morceaux de pain exprimant le
sentiment de l'amour

754 Drawing for the glass hallucina-
tion in Hitchcock's film "Moontide",
1941 △
L'hallucination du verre

excuse offered is always the vulgarity of the vast majority of the public. I insist
that this is absolutely false. The public is infinitely superior to the rubbish that is
fed to it daily. The masses have always known where to find true poetry. The
misunderstanding has come about entirely through those 'middlemen of culture'
who, with their lofty airs and superior quackings, come between the creator and
the public."

Dalí, returning to capitals, launched an impassioned appeal to his American
fellows: "ARTISTS AND POETS OF AMERICA! IF YOU WISH TO RE-
COVER THE SACRED SOURCE OF YOUR OWN MYTHOLOGY AND
YOUR OWN INSPIRATION, THE TIME HAS COME TO REUNITE
YOURSELVES WITHIN THE HISTORIC BOWELS OF YOUR PHIL-
ADELPHIA, TO RING ONCE MORE THE SYMBOLIC BELL OF YOUR
IMAGINATIVE INDEPENDENCE, AND, HOLDING ALOFT IN ONE
HAND FRANKLIN'S LIGHTNING ROD, AND IN THE OTHER LAU-
TREAMONT'S UMBRELLA, TO DEFY THE STORM OF OBSCURANT-
ISM THAT IS THREATENING YOUR COUNTRY! LOOSE THE BLIND-
ING LIGHTNING OF YOUR ANGER AND THE AVENGING
THUNDER OF YOUR PARANOIAC INSPIRATION!"

Dalí went on: "Only the violence and duration of your hardened dream can
resist the hideous mechanical civilization that is your enemy, that is also the

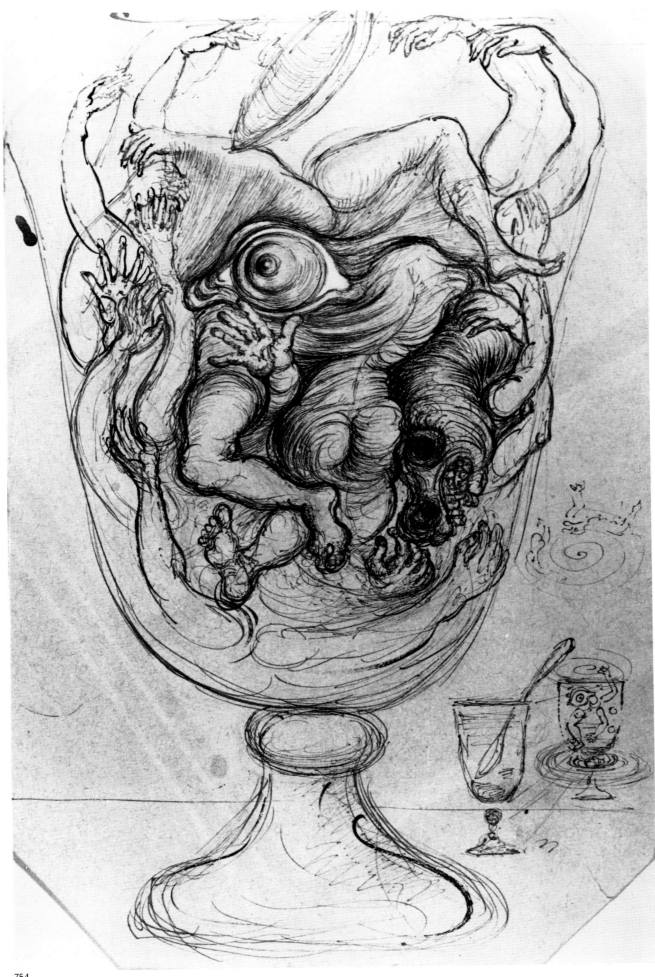

754

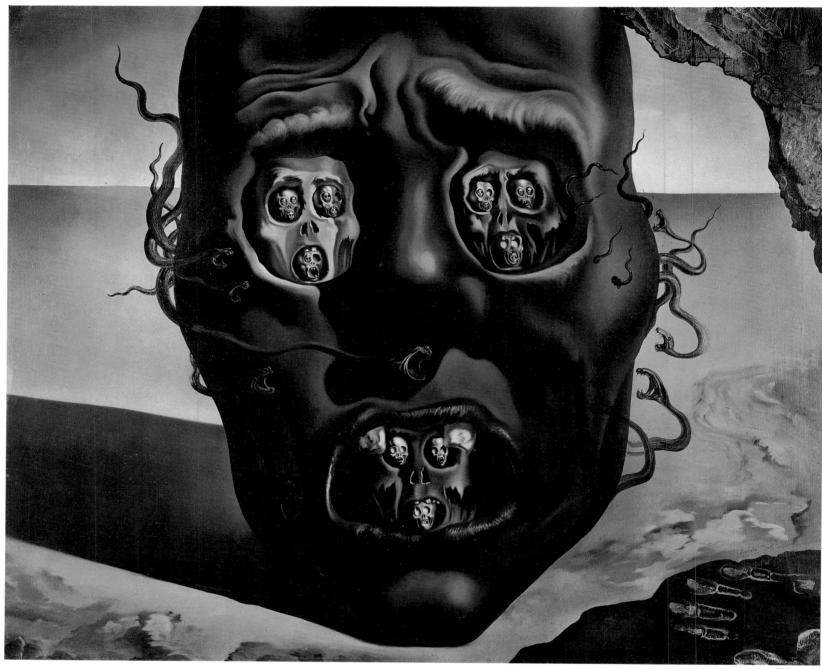

755

755 **The Face of War**, 1940–1941 ❏
Visage de la guerre

756 **Ballerina in a Death's-Head**, 1939 ❏
Ballerine – Tête de mort

757 **Human skull consisting of
seven naked women's bodies.** Photo-
graph: Philippe Halsman, 1951, after
a drawing by Dalí ☆

758 **The Face of War – Drawing for
the nightmare scene in the film
"Moontide"**, 1941 △
Visage de la guerre

759 **Café scene. The figures at the
table make a skull – Drawing for
the nightmare in "Moontide"**,
1941 △

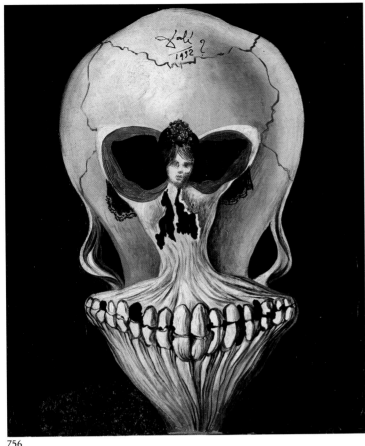

756

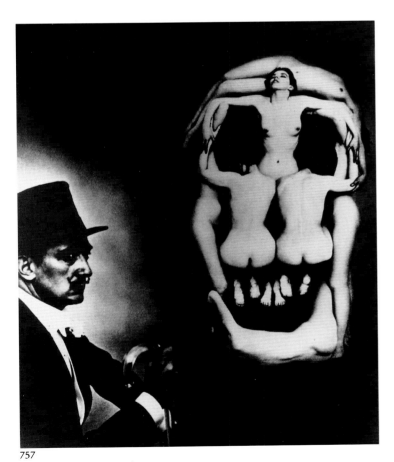

757

758

759

enemy of the 'pleasure-principle' of all men. It is man's right to love women with the ecstatic heads of fish. It is man's right to decide that lukewarm telephones are disgusting, and to demand telephones that are as cold, green and aphrodisiac as the augur-troubled sleep of the canharides. Telephones as barbarous as bottles will free themselves of the lukewarm ornamentation of Louis XV spoons and will slowly cover with glacial shame the hybrid decors of our suavely degraded decadence [...]"

And, finally reverting one more time to capitals: "ONE THING IS CERTAIN, A CATALAN, CHRISTOPHER COLUMBUS, DISCOVERED AMERICA, AND ANOTHER CATALAN, SALVADOR DALI, HAS JUST REDISCOVERED CHRISTOPHER COLUMBUS. NEW YORK: YOU

760 Study for "Original Sin", 1941 △

761 Original Sin, 1941 ❑
Le péché originel

760

761

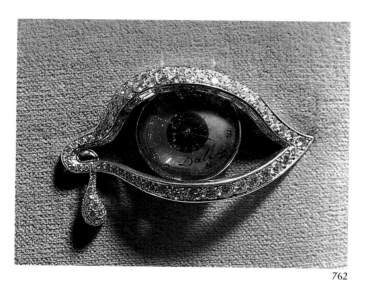

762

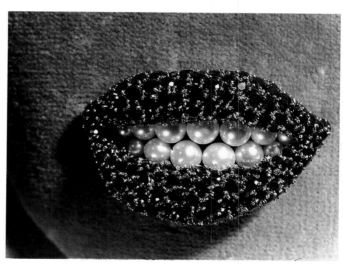

763

762 The Eye of Time, 1949 ○
L'œil du temps

763 Ruby Lips, 1950 ○
Les lèvres de rubis

764 Costume for a Nude with a Codfish Tail, 1941 ❑
Costume de nu avec queue de morue

WHO ARE LIKE THE VERY STALK OF THE AIR, THE HALF CUT FLOWER OF HEAVEN! YOU, MAD AS THE MOON, NEW YORK! [...] YOU MAY WELL BE PROUD. BE PROUD. I GO AND I ARRIVE. I LOVE YOU WITH ALL MY HEART."

764

765

765 **Disappearing Bust of Voltaire,**
1941 ❑
Disparition du buste de Voltaire

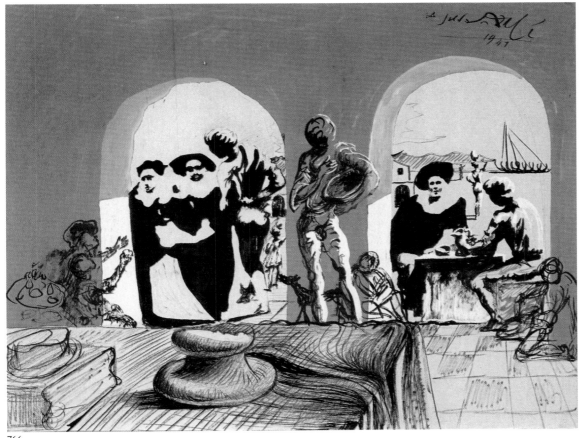

766

767

768

766 Study for "Disappearing Bust
of Voltaire", 1941 Δ

767 Actress Betty Stockfeld is Meta-
morphosed into a Nurse, 1939 Δ

768 Mysterious Mouth Appearing
in the Back of my Nurse, 1941 Δ

769 Dalí with "Soft Self-Portrait with Fried Bacon", 1941 ☆

770 Cover of the exhibition catalogue for the show at Julien Levy's, New York, 1941 ☆

771 Soft Self-Portrait with Fried Bacon, 1941 ❏
Autoportrait mou avec lard grillé

769

770

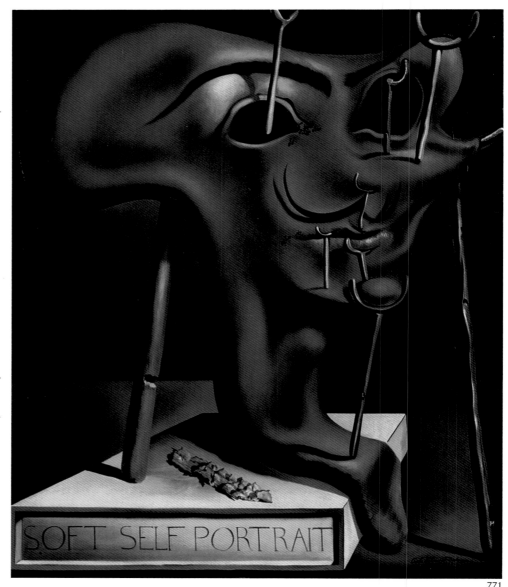

771

Crazy Spaniard Salvador Dalí

The Second World War obliged Dalí to leave Europe. "I needed, in fact, immediately to get away from the blind and tumultuous collective jostlings of history, otherwise the antique and half-divine embryo of my originality would risk suffering injury and dying before birth in the degrading circumstances of a philosophic miscarriage occurring on the very sidewalks of anecdote. No, I am not of those who make children by halves. Ritual first and foremost! Already I am concerning myself with its future, with the sheets and the pillows of its cradle. I had to return to America to make fresh money for Gala, him and myself."

At the border they met a great many friends again – among them Marcel Duchamp, who had established the concept of the ready-made. Dalí claimed: "He was terrorized by those bombardments of Paris that had never yet taken place. Duchamp is an even more anti-historical being than I; he continued to give himself over to his marvelous and hermetic life, the contact with whose inactivity was for me a paroxysmal stimulant for my work."

They left Arcachon together, a few days before the Germans invaded, and travelled via Spain to Portugal. Dalí made the detour to Figueras and Port Lligat

on the way, to see his family and examine the state the house was in after the Civil War.

In Lisbon they met a woman who looked like Elsa Schiaparelli – and *was* Elsa Schiaparelli. They met a man who could have been René Clair – and *was* René Clair. And they happened upon an old man sitting on a bench who looked exactly like Paderewski – and who really *was* Paderewski. They sailed to New York aboard the *Excambión*. Eight years of American exile awaited them.

Once in the U.S.A. they accepted their friend Caresse Crosby's invitation to stay at Hampton Manor near Fredericksburg, Virginia. In her diary for 1934-1944, Anaïs Nin described their arrival and Gala's flair for taking charge from the outset: "They hadn't counted on Mrs. Dalí's talent for organization. Before anyone realized what was happening, the entire household was there for the sole purpose of making the Dalís happy. No one was allowed to set foot in the library because he wanted to work there. – Would Dudley be so kind and drive to Richmond to pick up something or other that Dalí needed for painting? Would I (Nin) mind translating an article for him? Was Caresse going to invite *Life* magazine for a visit? In other words, everyone performed the tasks assigned to them. All the while, Mrs. Dalí never raised her voice, never tried to seduce or flatter them: it was implicitly assumed that all were there to serve Dalí, the great, indisputable artist." Caresse Crosby later reported that she was away for a few weeks, and left the Dalís at Hampton Manor in the company of Henry Miller, the novelist. She was far from surprised when she returned to find the painter going over *The Secret Life of Salvador Dalí*, the autobiography he had written there in July 1941, while Miller was busy painting watercolours.

772 **Design for "Labyrinth"**, 1941 △

772

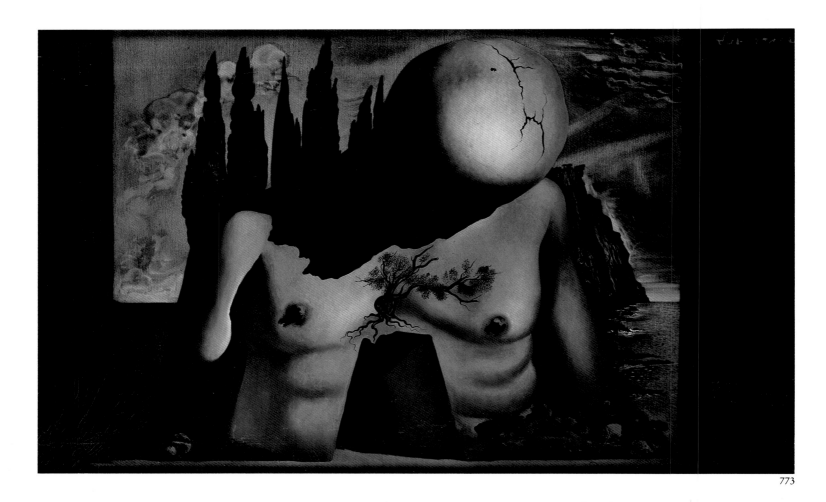

773

773 Design for the set of "Labyrinth", 1941 ❑

774 "Labyrinth", danced by the Ballets Russes at the Metropolitan Opera House, New York, October 1941 ☆

775 Design for the set of "Labyrinth", 1941 ❑

774

775

776

776 **Study for the set of "Laby-
rinth" – Fighting the Minotaur,**
1942 Δ
Combat avec le Minotaure

777 **Saint George and the Dragon,**
1942 ❏
Saint Georges et le dragon

777

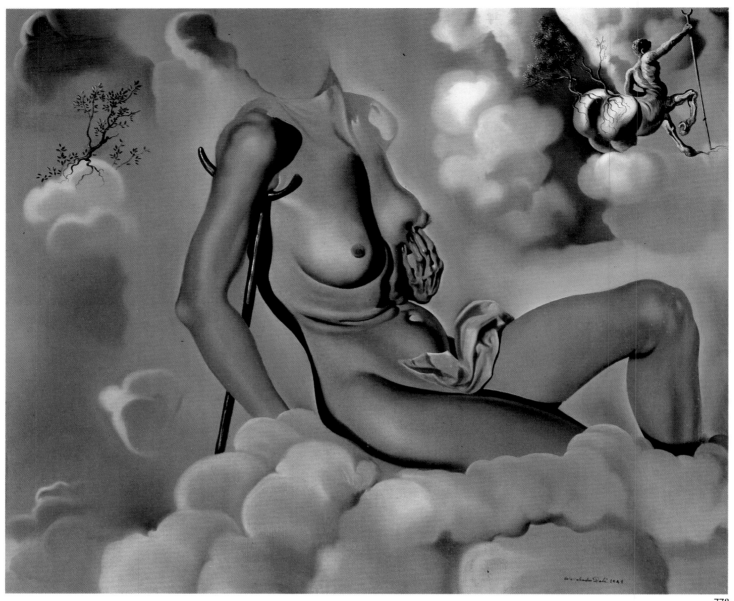

778

779

780

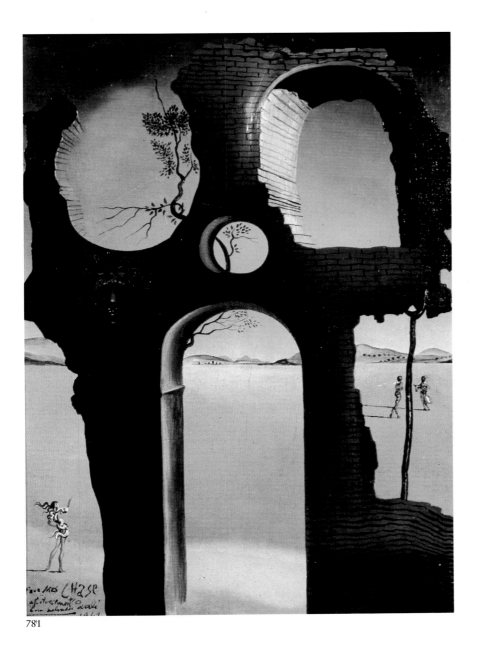

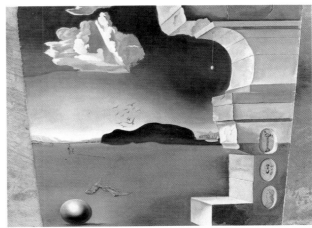

778 **Honey is Sweeter than Blood,** 1941 ❏
Le miel est plus doux que le sang
779 **Mural painting for Helena Rubinstein (panel 1),** 1942 ❏
780 **Untitled – Design for the mural painting for Helena Rubinstein,** 1942 ❏
781 **Ruin with Head of Medusa and Landscape (dedicated to Mrs. Chase),** 1941 ❏
Ruine avec tête de Méduse et paysage (dédicacé à Mrs. Chase)
782 **Mural painting for Helena Rubinstein (panel 2),** 1942 ❏
783 **Mural painting for Helena Rubinstein (panel 3),** 1942 ❏
784 **Nude on the Plain of Rosas,** 1942 ❏ Nu dans la plaine de Rosas

781

782

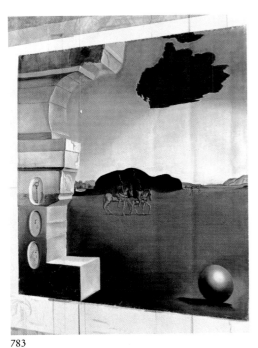

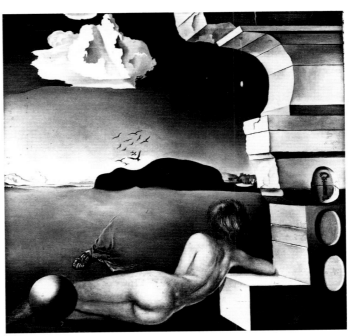

783

784

347

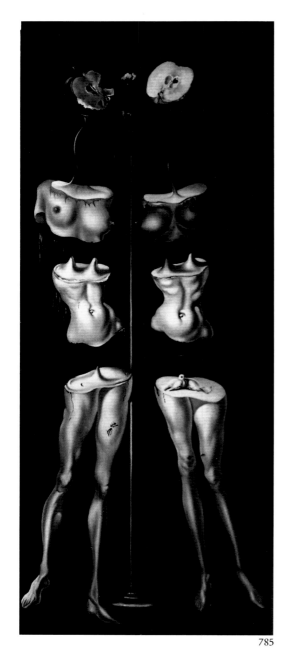

787

785 **Untitled – Set design (Figures cut in three)**, 1942 △
786 **Temple – Sketch for a set design**, c. 1941 ❏
Temple
787 **Composition (Two Harlequins)**, 1942 ❏
Composition (Les deux arlequins)

Dalí's first exhibition, at the Julien Levy Gallery in 1941, produced a heavy crop of reviews. *The Art Digest*, a magazine Dalí did not particularly care for, wrote ironically: "Crazy Spaniard Salvador Dalí is on 57th Street again, arousing the curiosity of sensible people who warily wonder: 'Is Dalí mad, or is he a wily businessman?' In my view the question is not quite right, because to be a wily businessman these days you inevitably have to be practically mad [...] Dalí's secret consists in juxtaposing the most traditional of objects in the most incongruous of ways. A horse and a telephone are not especially exciting per se; but if the horse nonchalantly appropriates the telephone, it starts a reaction in the observer at chromosome level. Without his feverish imagination and unpredictable statements, Dalí would simply be one competent painter among many, with a fine command of draughtsmanship and a first-rate miniaturist's talent. That this artist can draw and paint is undeniable. Countless artists with every bit as much talent are dependent on the Works Progress Administration [...] Is Dalí mad? Statistically the figures are against him: there are more of our kind than there are of his."

To which we might be tempted to add that that is cause for congratulation. The critic was palpably expressing American nationalist resentment at seeing the Surrealist pollen drifting over from Europe and fertilizing the American art scene. Other, less nationalist critics, such as Peyton Boswell, emphasized the overall significance of Dalí's work and did not hesitate to see him as a witness of his age: "Dalí has succeeded better than any other artist in creating an expression of the age." It was an age of transition, in which received values were being questioned; and Dalí was subjecting it to close, intense scrutiny – the findings of which were visible on his canvases as on a radar screen. Dalí closed his autobiography with this statement: "And I want to be heard. I am the most representative incarnation of postwar Europe; I have lived all its adventures, all its experiments, all its dramas. As a protagonist of the Surrealist revolution I have known from day to day the slightest intellectual incidents and repercussions in the practical evolution of dialetical materialism and of the pseudo-philosophical doctrines based on the myths of blood and race of National-Socialism; I have long studied theology. And in each of the ideological short-cuts which my brain had to take so as always to be the first I have had to pay dear, with the black coin of my sweat and passion."

788

789

790

Somewhat more modestly, he added a comment that is extremely revealing: "Heaven is what I have been seeking all along and through the density of the confused and demoniac flesh of my life – heaven! Alas for him who has not yet understood that! The first time I saw a woman's depilated armpit I was seeking heaven. When with my crutch I stirred the putrefied and worm-eaten mass of my dead hedgehog, it was heaven I was seeking. When from the summit of the Muli de la Torre I looked far down into the black emptiness, I was also and still seeking heaven! Gala, you are reality! And what is heaven? Where is it to be found? Heaven is to be found, neither above nor below, neither to the right nor to the left, heaven is to be found exactly in the centre of the bosom of the man who has faith! At this moment I do not yet have faith, and I fear I shall die without heaven."

In October Dalí went to New York to work on *Labyrinth*, a ballet (cf. pp.344/345). His libretto was inspired by the myth of Theseus and Ariadne; he also designed the set and costumes. His choreographer was another exile, Léonide Massine. The ballet was premièred in the Metropolitan Opera. Immediately afterwards, Dalí was accorded the official recognition of a retrospective show mounted by the Museum of Modern Art (together with a homage to his fellow-countryman Miró). The exhibition included over forty drawings and paintings by Dalí, from work done in his youth to the very latest products of his imagination. It afforded a fairly complete overview of his development – from Cubism to Surrealism to drawers and telephones. The exhibition travelled to Los Angeles, Chicago, Cleveland, Palm Beach, San Francisco, Cincinnati, Pittsburgh and Santa Barbara, making Dalí a household name from coast to coast.

Dalí was now making a great deal of money. American vitality was good for him – nourishing, as it were. And he was getting more and more commercial commissions. He did not take up all the offers, but he was well aware that these subsidiary activities represented a good way of getting to know (and taking advantage of) the unlimited opportunities offered by the country of his exile. It was at this time that Breton quite rightly thought up his famous anagram, Avida Dollars. Dalí thought it "auspicious". His break with the Surrealists was now complete. In the New York magazine *View* (June 1941), Nicolas Calas raged: "I

788 **Equestrian Parade**, 1942 ❑
Parade de cavaliers

1941–1943

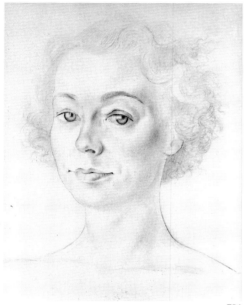

791

accept the challenge and reply without hesitation: 'Yes, Dalí is a renegade!' [...] He claims the age of experiment is over, and tells us the rose is a prison and the prisoner is none other than himself! As for the rose, we admire its perfection without wondering if it is happy to be a palace of perfumed songs or a dagger thrust into a woman's breast. The reason for Dalí's change is quite different: when he was confronted with results (as happens to us all) and found they were the total opposite of what his experience had prepared him for. Dalí was terrified, felt guilty, and hastily withdrew to aesthetic positions intended to please the leaders of the triumphant counter-revolution while he still could [...] The captive of his own errors, no longer capable of distinguishing what is modern in science and aesthetics from what is not. Dalí is like a naïve girl from the country who thinks herself stylish if she puts a new ribbon on her grandmother's hat."

Dalí had indeed said, "Over and done with: the time for experiments is over, a thousand times over. The hour of personal creation has struck." But he paid no attention to the criticism levelled at him. He was far too busy. His years in America were years of hectic activity. He designed jewellery with the Duc de Verdura. He designed Helena Rubinstein's apartment (cf. pp.346/347). He did regular work for leading magazines such as *Vogue*, *Harper's Bazaar*, *Town and Country*. He produced new ballets, designing the sets and costumes himself; among them were Lorca's *El Café de Chinitas*, *Colloque sentimental* (based on Paul Verlaine), and *Tristan Insane*. He illustrated Maurice Sandoz's *Fantastic Memories*. In the space of a few weeks he wrote his first novel, *Hidden Faces*, at the home of the Marquis de Cuevas in New Hampshire. In 1943 he created the advertising for Schiaparelli's perfume 'Shocking', and advertised himself with a photo feature in *Click* magazine. He exhibited portraits of prominent Americans

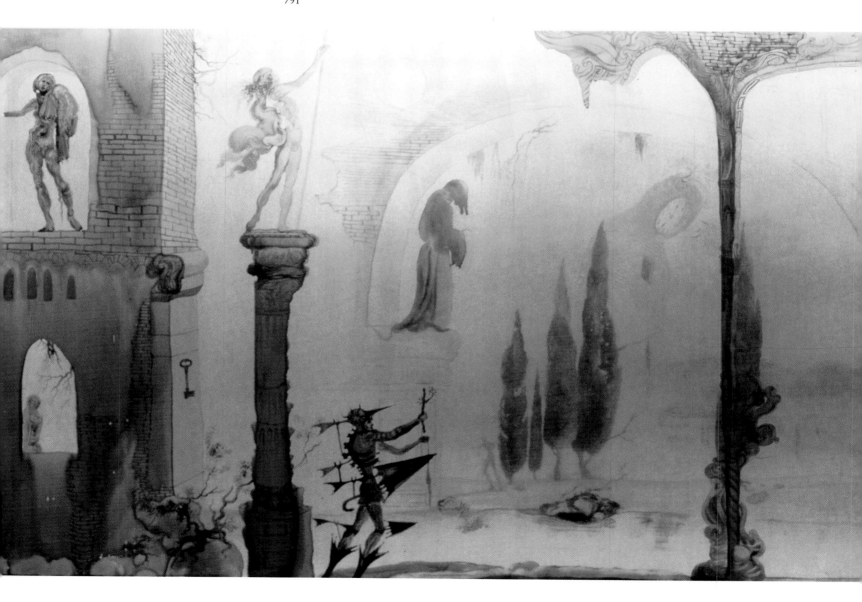

791 **Study for "Portrait of Mrs. George Tait, II", 1941** △

792 **Composition, 1942** ❑
Composition

793 **Portrait of Mrs. George Tait, II, 1941** ❑
Portrait de Mrs. George Tait, II

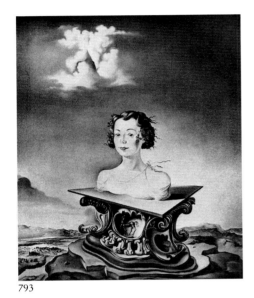

793

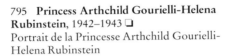
794

794 **Study for the portrait "Princess Arthchild Gourielli-Helena Rubinstein, 1942–1943** △

795 **Princess Arthchild Gourielli-Helena Rubinstein, 1942–1943** ❑
Portrait de la Princesse Arthchild Gourielli-Helena Rubinstein

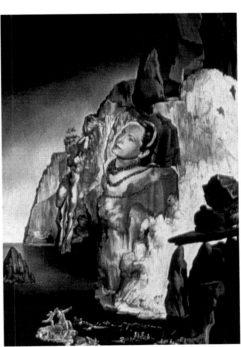

795

792

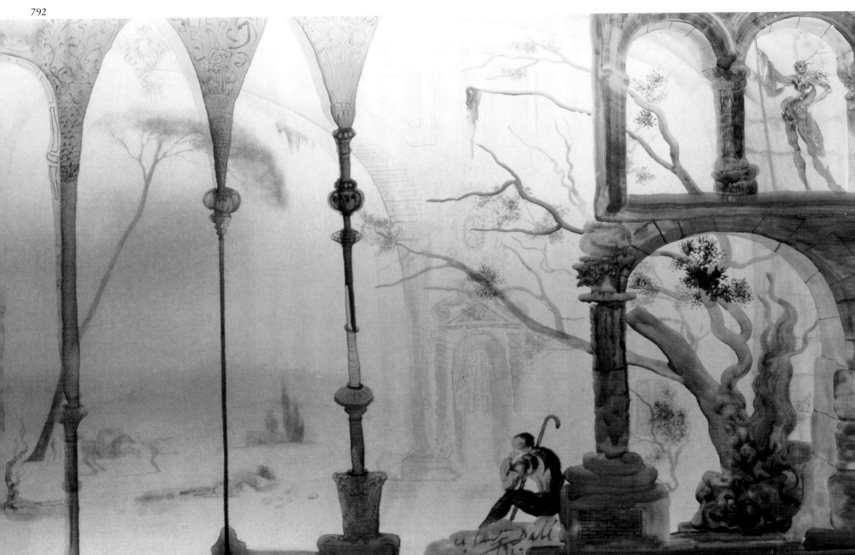

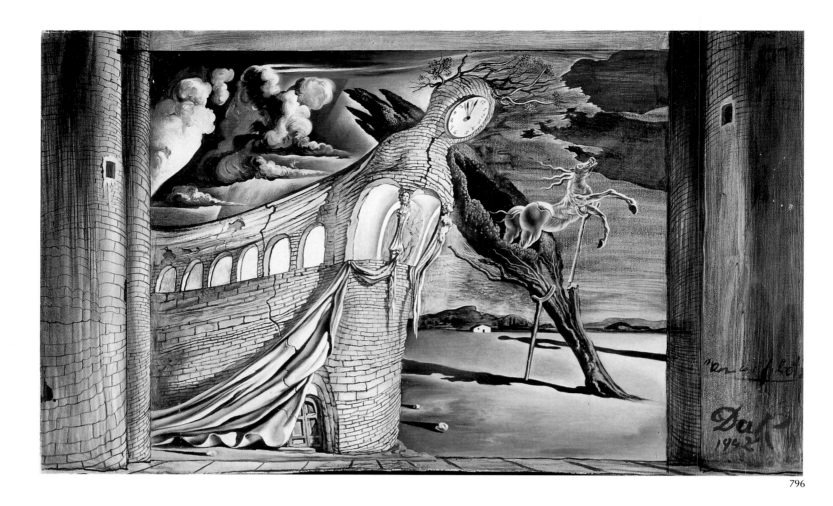

796

796　Design for the set of "Romeo and Juliet", 1942 ❑

797　Design for the set of "Romeo and Juliet" – Backdrops and wing flats, 1942 ❑

798　Design for the set of "Romeo and Juliet", 1942 △

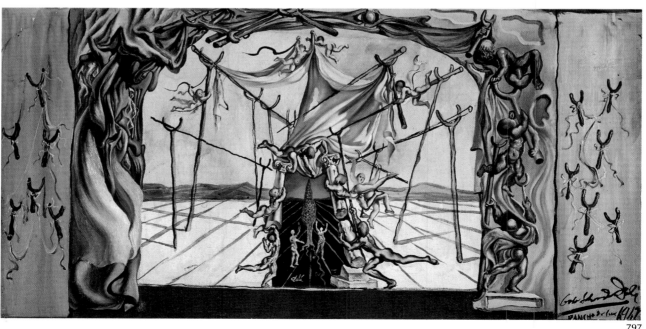

797

1942

798

799

799 **Juliet's Tomb**, 1942 ❑
Le tombeau de Juliette

800 **Study for the set of "Romeo
and Juliet"**, 1942 △

801 **Romeo and Juliet Memorial,**
1942 ❑

800

801

353

1942

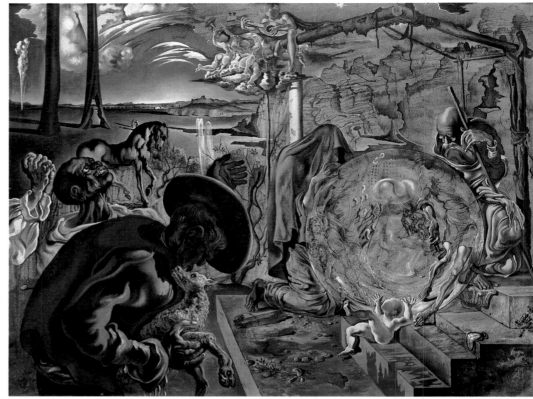

802 **Nativity of a New World,**
1942 ❏
Naissance du Nouveau monde

803 **Divine Couple – Sketch for
"Nativity of a New World"**, 1942 Δ
Couple céleste

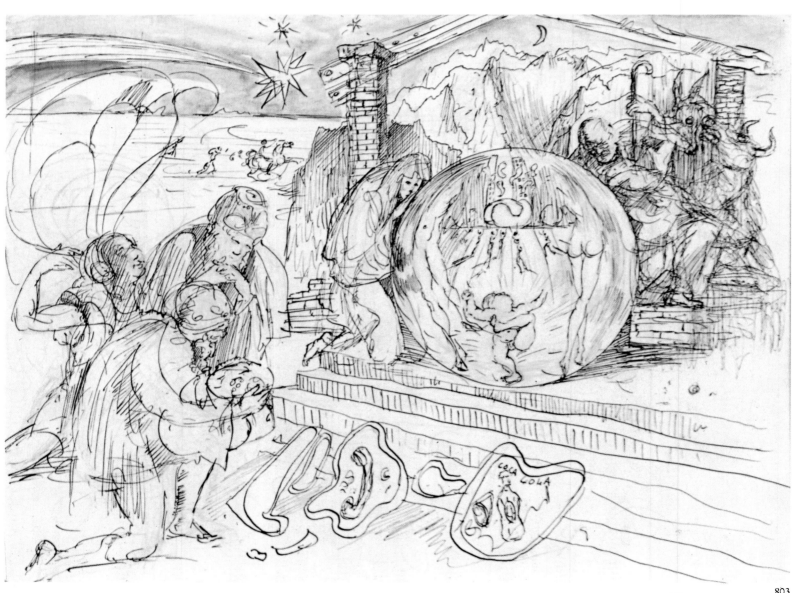

at the Knoedler Gallery, New York, and even gave a dinner in aid of needy émigré artists. These activities (which do not necessarily appear here in chronological order) give some idea of Dalí's feverish activity during the war years.

1946 found Dalí in Hollywood, working with Walt Disney on a film project called *Destino*, which was unfortunately never to be completed. It was intended to use cartoon characters, settings and objects alongside real ones (an idea which has since proved fruitful for other directors), and the story involved a young girl and Chronos, God of Time. It was like a ballet: the young girl and the ancient god brought monsters into the world, monsters that drowned in primeval waters at the end of the film. When Dalí realized that the project was coming to nothing, he accepted another commission and designed the dream sequence in Alfred Hitchcock's *Spellbound*.

About this time, Dalí met the photographer Philippe Halsman; a friendship resulted that was to last until Halsman's death in 1979. At their first meeting, Halsman asked: "Dalí, you wrote that you can remember life inside the womb. I would like to photograph you as an embryo inside an egg." To which Dalí replied: "A good idea. But I should have to be completely naked." Halsman: "Of course. Would you care to undress?" Dalí: "No, not today… next Sunday." Countless photographs resulted from this exchange. Dalí would ask: "Can you make me look like a Gioconda? Can you do a portrait photo that makes half of me look like myself and the other half like Picasso?" And Halsman would always find a way of achieving the desired effect. Halsman gave his own explanation of Dalí's

805

804 **The Flames, They Call**, 1942 ❑
Las Llamas, llaman

805 **Design for a poster for "The Se-cret Life of Salvador Dalí". The auto-biography was published by Dial Press, New York**, 1942 △

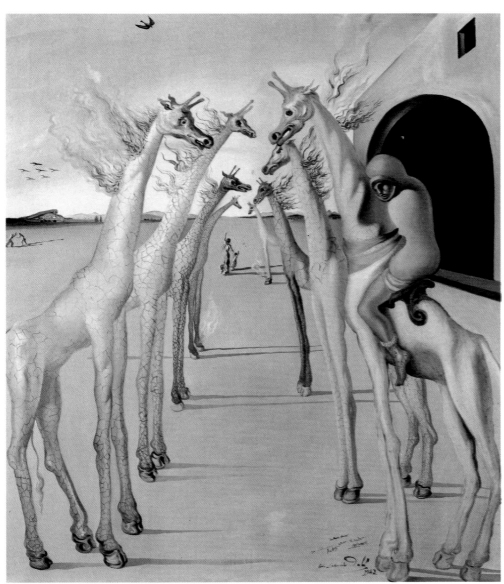

804

1942

fascination with these photographs: "The real reason for Dalí's photographic eccentricity is that it is Surrealism taken to the extreme. He would like the least of his actions to be a surprise, a shock. His Surrealist creativity is only partially expressed in his paintings. His own personality is the most Surreal of his creations – and it extends into his handwriting, which is more Surreal than any of his pictures."

From then on, however, Dalí took to speaking less of the conquest of the irrational and more of the conquest of reality. In *Esquire* (August 1942) he published an article titled "Total Camouflage for Total War", in which he defined the essence of the Dalí method of bewildering the public and creating an absolute magic: "I believe in magic, which ultimately consists quite simply in the ability to render imagination in the concrete terms of reality. Our over-mechanized age underestimates what the irrational imagination – which appears to be impractical, but is nonetheless fundamental to all these discoveries – is capable of [...] In the realm of the real, the struggles of production are now decisive and will be in the foreseeable future. But magic still plays a part in our world."

In the pictures he painted in America, his use of colour, space, and often landscape, too, still harked back to Catalonia, even if the people in them were Amer-

806 **Portrait of Mrs. Luther Greene,** 1942 ❑
Portrait de Mrs. Luther Greene

807 **Study for the campaign against venereal disease: "Soldier Take Warning",** 1942 △

806

808 **Untitled – For the campaign against venereal disease,** 1942 ❑

809 **Melancholy – Portrait of Singer Claire Dux,** 1942 ❑
Mélancolie – Portrait de la cantatrice Claire Dux

810 **Portrait of the Marquis de Cuevas,** 1942 ❑
Portrait du marquis de Cuevas

811 **Portrait of Mrs. Ortiz-Linares,** 1942 ❑
Portrait de Madame Ortiz-Linares

807

808

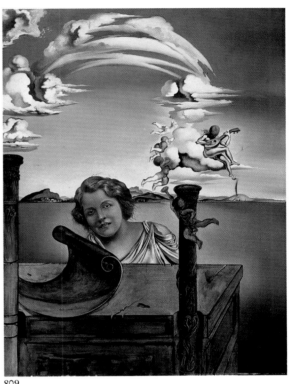

809

810

811

ican. Dalí had the audacity to paint a Coca Cola bottle before anyone else, drew attention to race problems in the U.S.A., and poked fun at the cult of American football. All these subjects appeared in a single painting, *Poetry of America* (p.364) – a title to which he added the words *The Cosmic Athletes* shortly before he died.

His method was now practically the reverse of what it had been. He defined his famous *Soft Self-Portrait with Fried Bacon* (p.342), for instance, as "an anti-psychological self-portrait; instead of painting the soul, that is to say, what is within, I painted the exterior, the shell, the glove of myself. This glove of myself is edible and even tastes a little rank, like hung game; for that reason there are ants and a rasher of fried bacon in the picture. Being the most generous of all artists, I am forever offering myself up to be eaten, and thus afford delicious sustenance to the age."

Sigmund Freud is always present in Dalí's work, even if a religious note is increasingly struck from this time on. Dalí's comment on *Dream Caused by the Flight of a Bee around a Pomegranate, One Second before Awakening* (p.377) was: "For the first time, Freud's discovery that a typical narrative dream is prompted by something that wakes us was illustrated in a picture. If a bar falls on a sleeper's neck, it both wakes him and prompts a long dream that ends with the falling of the guillotine; similarly, the buzzing of the bee in the painting prompts the bayonet prick that wakens Gala. The burst pomegranate gives birth to the entirety of biological creation. Bernini's elephant in the background bears an obelisk with the papal insignia."

1942

812 **Design for the interior decoration of a stable-library**, 1942 Δ
Projet d'interprétation pour une étable-bibliothèque
813 **The Sheep (after conversion)**, 1942 Δ
Les moutons
814 **The Sheep, painting by Karl Schenk, before adaptation by Dalí** (cf. no. 813), 1942 ✰

814

813

359

1943

815

816

815 **Portrait of Mrs. Harrison Williams**, 1943 ❏
Portrait de Madame Harrison Williams

816 **Portrait of Ambassador Cardenas**, 1943 ❏
Portrait de l'ambassadeur Cardenas

817 **The Triumph of Tourbillon**, 1943 ❏
Le triomphe de Tourbillon

818 **Condottiere (Self-Portrait as Condottiere?)**, 1943 Δ
Condottière

817

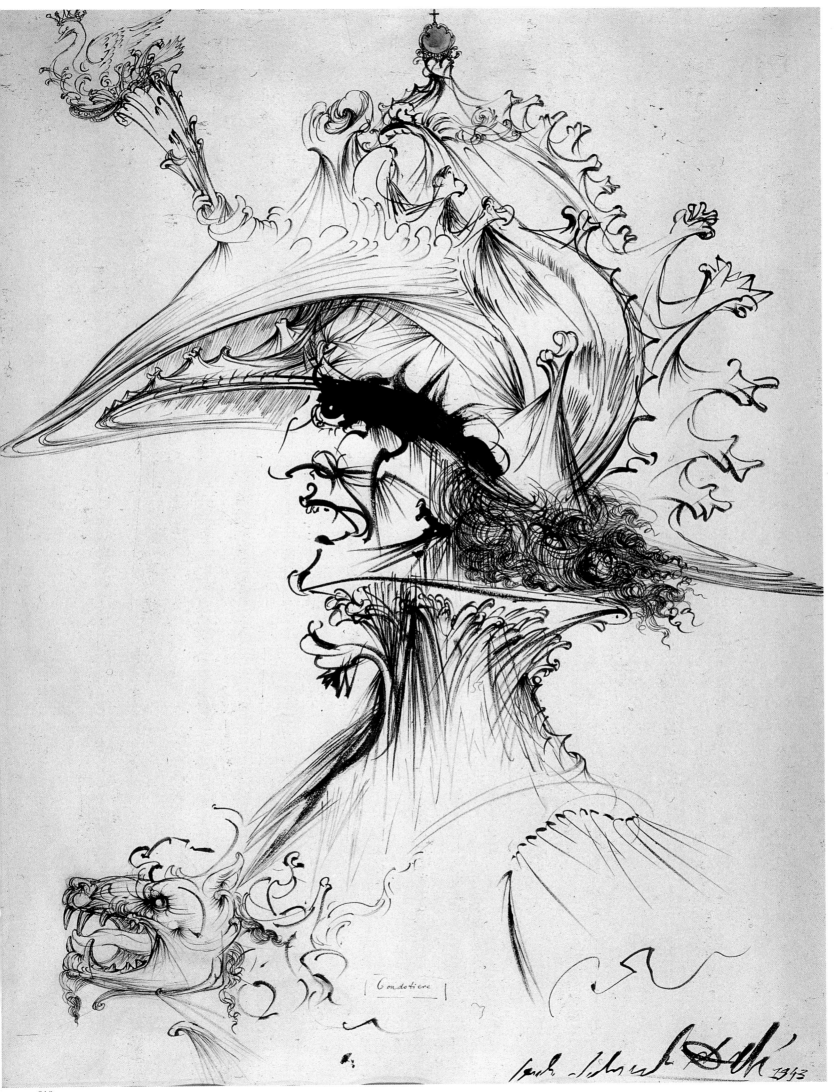

Condotiere

819

821

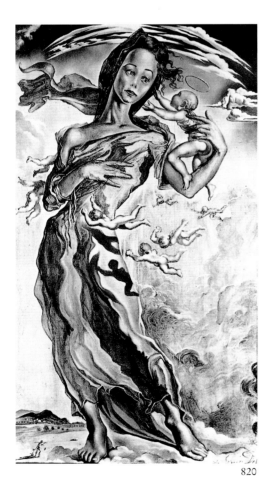

820

A Meissonier of the Unconscious

Though Dalí could refer to the Second World War, in his *Secret Life*, as "an episodic children's fight on a street-corner", he had preferred to sit it out in the U.S.A. America appealed to him. "I travelled in America, but instead of romantically and directly rubbing the snakeskin of my body against the asperities of its terrain, I preferred to peel protected within the armor of the gleaming black crustacean of a Cadillac which I gave Gala as a present. Nevertheless all the men who admire and the women who are in love with my old skin will easily be able to find its remnants in shredded pieces of various sizes scattered to the winds along the road from New York via Pittsburgh to California. I have peeled with every wind; pieces of my skin have remained caught here and there along my way, scattered through that 'promised land' which is America; certain pieces of this skin have remained hanging in the spiny vegetation of the Arizona desert, along the trails where I galloped on horseback, where I got rid of all my former Aristotelian 'planetary notions'. Other pieces of my skin have remained spread out like tablecloths without food on the summits of the rocky masses by which one reaches the Salt Lake, in which the hard passion of the Mormons saluted in me the European phantom of Apollinaire. Still other pieces have remained suspended along the 'antediluvian' bridge of San Francisco, where I saw in passing the ten thousand most beautiful virgins in America, completely naked, standing in line on each side of me as I passed, like two rows of organ-pipes of angelic flesh with cowrie-shell sea vulvas." Such was Dalí's enthusiasm for America, indeed, that at times he was quite carried away by it.

The Americans, meanwhile, were busy trying to make up their minds about

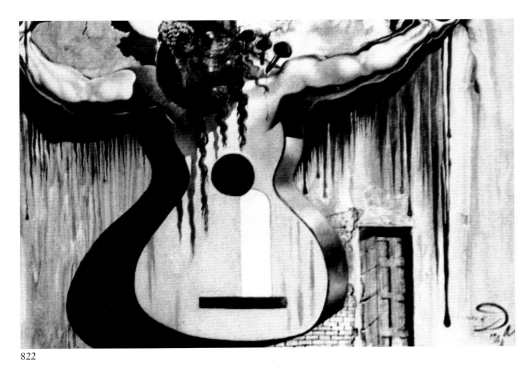

822

823

Dalí, and where he fitted in with Surrealism as a whole. Robert M. Coates, in *The New Yorker* (November 1941), noted that the tendency to view Surrealism as a private product of Dalí's imagination was too widespread, and dictated responses to Surrealism in terms of responses to Dalí. This reaction led, according to Coates, to an under-valuation of Lurcat, Tanguy and Masson, and of artists such as Peter Evergood and James Guy on the American side of the Atlantic. Surrealism, he argued, was the most substantial and promising movement of the times, and must be more than Dalí's dreams and erotic fantasies – though he was careful to concede Dalí's technical mastery, apparent (for example) in the fish scales in *Imperial Violets* (p. 315) or the opalescent, shimmering effects in *Apparition of Face and Fruit Dish on a Beach* (p. 309).

The Avida Dollars machine was working smoothly, and in November 1941 Dalí shared a major retrospective at the Museum of Modern Art in New York with his old fatherly friend Joan Miró, who had given him his entrée to Paris. Critic Peyton Boswell took the opportunity, in *The Art Digest*, to describe Dalí's art as morbid, sado-masochistic and nihilist (in contrast to Miró's) – and to celebrate its hypnotic hold on the public notwithstanding. To Boswell's way of thinking, the merit of Dalí's art lay in its qualities as precision representation, which he likened to those of realistic miniatures. Even Dalí's opponents, Boswell pointed out, had to concede that Dalí's pictures were never boring and always had a manifest thought content. In time of war, when the whole world was going through convulsions of hysteria, it was good, declared Boswell, to consider a canvas that juxtaposed a horse and a telephone. In such juxtaposition there might, after all, be more intuitive wisdom than anyone guessed.

The Dial Press publication of *The Secret Life of Salvador Dalí*, in an admittedly imperfect English version by Haakon Chevalier, prompted cries of protest. Sol

819 **Untitled – New Accessories,** 1943 ❑
Sans titre

820 **Madonna,** 1943 ❑
La madone

821 **Stage curtain for the ballet "Café de Chinitas", performed by the Ballet Theatre,** 1943 ❑
The ballet used Spanish folk music in an arrangement by Lorca, and Dalí, homesick for Spain, designed the set and costumes.

822 **Painting for the backdrop of "Café de Chinitas",** 1943 ❑

823 **The Madonna of the Birds with Two Angels,** 1943 △
Vierge aux oiseaux, avec deux anges

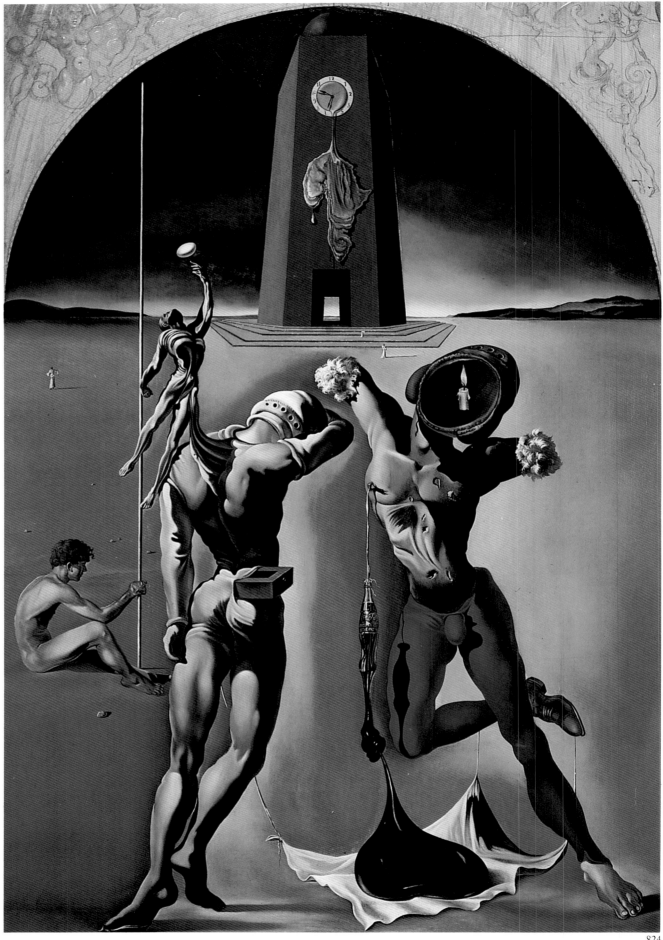

824

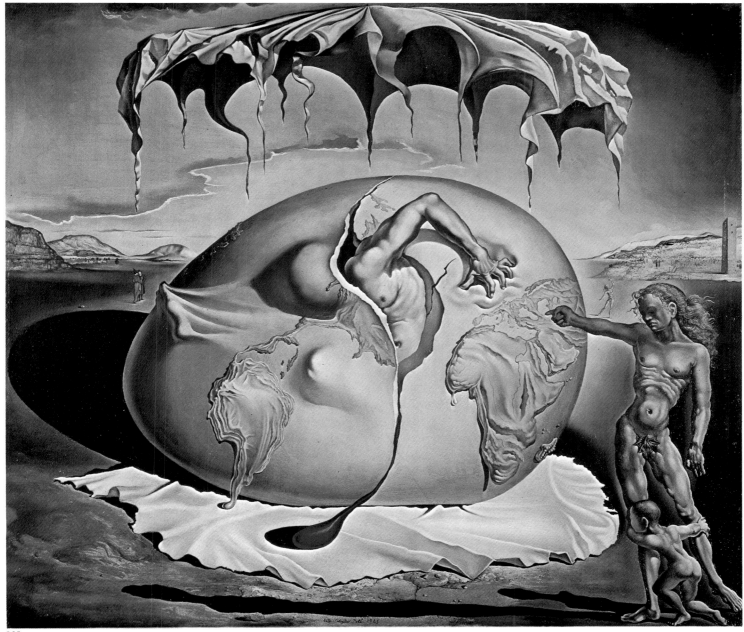

825

826

827

824 **Poetry of America – The Cosmic Athletes**, 1943 ❏
Poésie d'Amérique – Les athlètes cosmiques

825 **Geopolitical Child Watching the Birth of the New Man**, 1943 ❏
Enfant géopolitique observant la naissance de l'homme nouveau

826 **Dalí in the egg. Photograph by Philippe Halsman after an idea of Dalí's**, 1942 ✮
Dalí dans l'œuf

827 **Allegory of an American Christmas**, 1943 ❏

A. Davidson (in *The Art Digest*, February 1943) observed that the public display of so schizophrenic a personality inevitably tempted one to seek the answers to the questions raised by the artist's work in the profile of his psychology; but the temptation was one that was best resisted. Dalí's indulgences, his perversities and crimes, his breached taboos and childhood violence, were to Davidson (as to Orwell and many others) the record of a disturbed candidate for psychoanalysis, and not the transcript of a genius's aesthetic stratagems. No doubt the Freudians would have a field day with the *Secret Life*, concluded Davidson; certainly it offered ample opportunity to grub about in the entrails of Surrealism. Elsewhere, in the *Pacific Art Review*, Stephen S. Kayser quoted a French psychologist, Frois-Wittmann, as seeing the limits of Dalí's art as being similar to those of Brueghel's or Bosch's. The difficulty was not that these artists presented their fantastic obsessions but that, by recording those obsessions in such precise detail, they foregrounded them in the eye of the public. Such painters were "Meissoniers of the unconscious". It is unclear whether this comment was intended as praise or damnation; but Dalí was certainly flattered rather than affronted.

828　Monumental shield for "Hidden Faces". The book was published by Dial Press in New York, 1944 △

829　Frontispiece for "Hidden Faces" – I am the Lady…, 1944 △
Je suis la dame…

830　Tristan Insane (Tristan as Christ), 1944 △
Tristan fou

829

830

831

831 Study for the backdrop of the ballet "Tristan Insane" (Act II), 1944 ❏

832

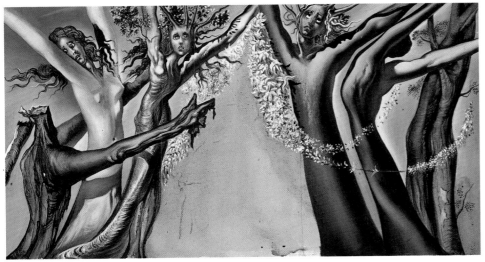

833

832 **"Tristan Insane": "The first paranoiac ballet based on the eternal myth of love unto death"** ☆
It was performed by Ballet International in 1944. Dalí used musical themes from Wagner's "Tristan and Isolde". The choreography was by Léonide Massine, the set and costumes by Dalí.

833 **Study for the set of the ballet "Tristan Insane" (Act I), 1944** ❏

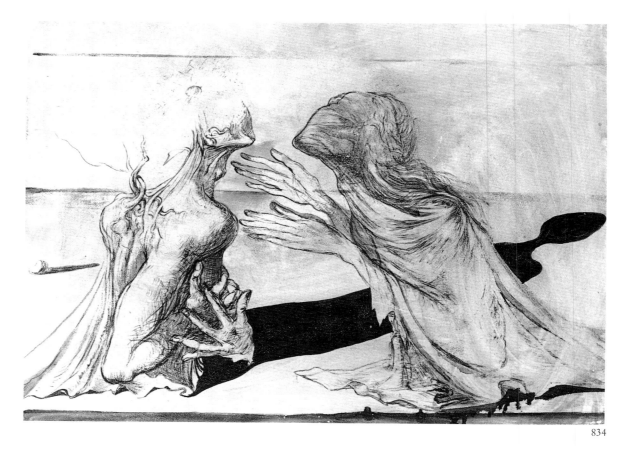

834

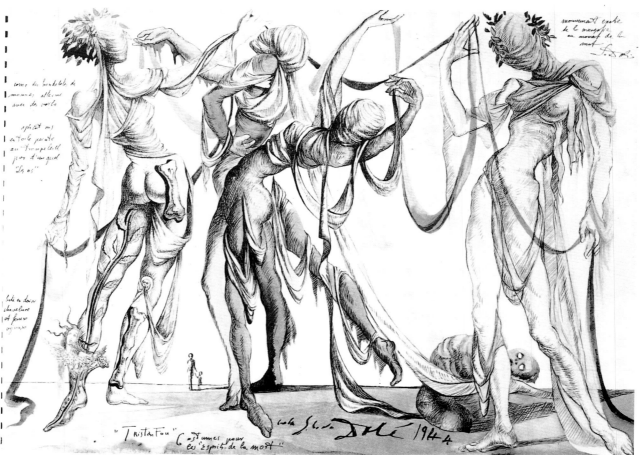

835

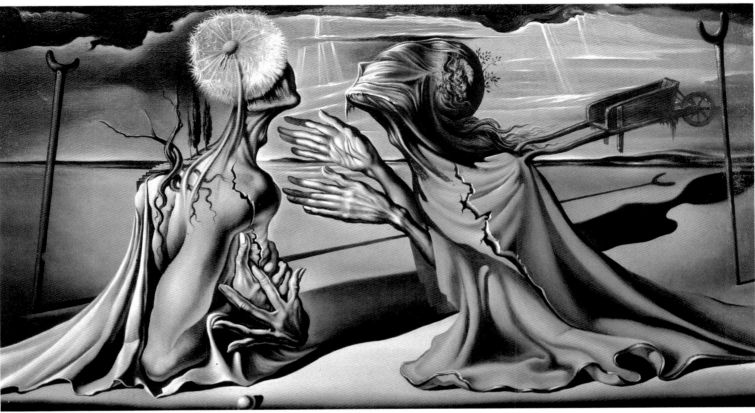

836

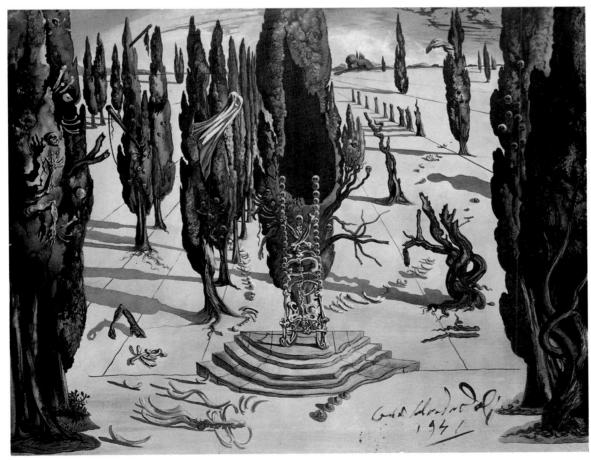

837

834 "Tristan and Isolde" – Study for the set of the ballet "Bacchanale", 1944 ❑

835 "Tristan Insane": Costumes for the Spirits of Death, 1944 △

836 Design for the set of the ballet "Tristan and Isolde", 1944 ❑

837 Set of "Tristan and Isolde", 1941 ❑

Dalí was in fact the "Meissonier of the unconscious" *par excellence*. He painted colour photographs of his dreams. He was an Einstein of phantasmagoric paranoia. From his memories and imagination he created juxtapositions of images real and fictitious; it was as if he merely needed to take up his paranoiac brush, and the images flowed along the conductor. Whenever Dalí provides a commentary on one of his own works (and he did so unstintingly) we feel – as we do when a magician lets us into his secrets – almost disappointed, to realise that what dazzled us initially with its lunatic, inspired brightness draws in fact upon logical, lucid, concrete sources in philosophical reflection of a profoundly intelligent order. The bizarrerie of Dalí comes from the mirror-image distortions that occur when his thinking is transferred to canvas. It is logic through the looking-glass.

Through it all, we do well to bear in mind that Dalí was the very opposite of the petty snobs of Paris salons. He remained in a real sense the boy from Figueras. The 1939 *Philosopher Illumined by the Light of the Moon and the Setting Sun* (p.317), though a weird, dark and unsettling picture, seems sweetness and light once we learn how it came to be painted. The premonitory quality is related to the fears of a German invasion which Dalí and Gala had as they withdrew to the Font-Romeu region on the Atlantic; but the reclining figure comes directly out of Dalí's surfeited weariness of Surrealist circles, a weariness that had him pining after Port Lligat. The man was inspired by the fishermen of Port Lligat, in particular one named Ramón de Hermosa: "He was a man of about fifty, very hale and hearty, with a coquettish moustache *à la* Adolphe Menjou – he even looked

838

839

840

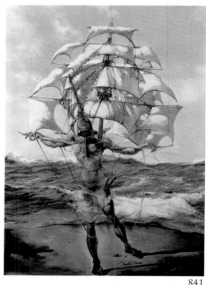

841

838 Dalí and two dancers from Ballet International who took part in the "Colloque sentimental", 1944 ✯

839 Victory – Woman Metamorphosing into a Boat with Angels, 1945 ❏
Victory – Femme se transformant en bateau avec anges musiciens

840 Costume for "Tristan Insane" – The Boat, c. 1944 ❏

841 Costume for "Tristan Insane" – The Ship, 1942–1943 △
Le navire

842 Study for "Colloque sentimental", 1944 ❏

843 Colloque sentimental, 1948 ✯

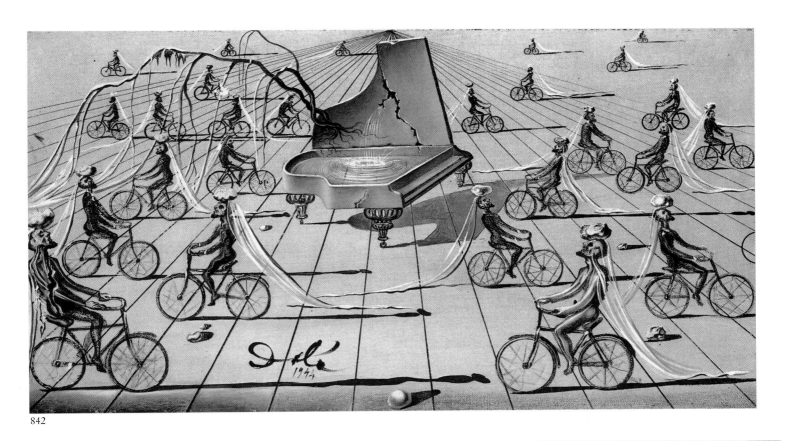

842

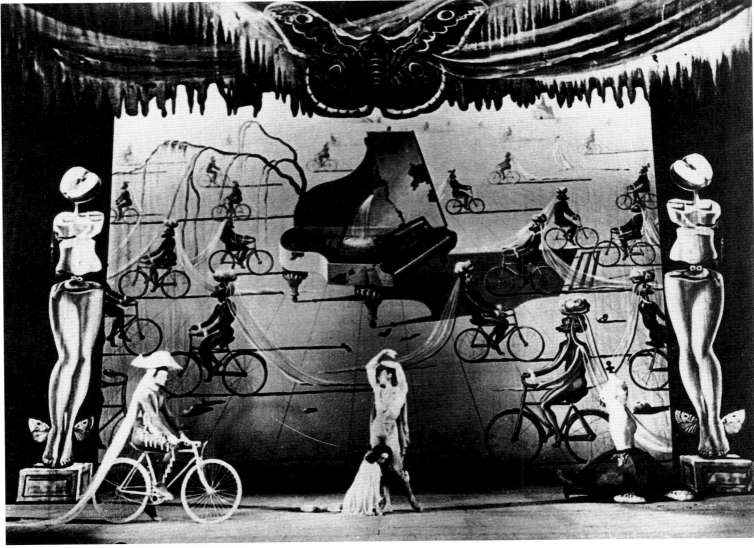

843

1944

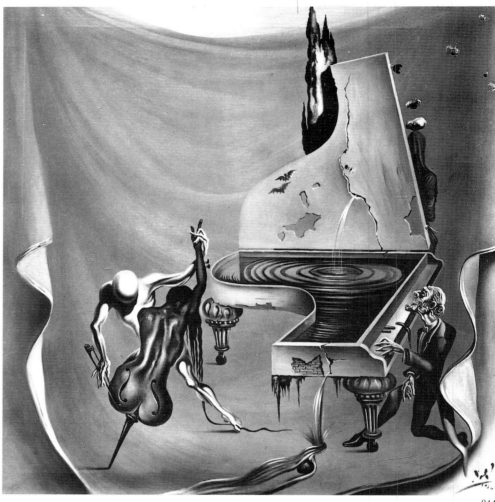

844

a little like him. He was probably the laziest man in the world. He liked to repeat the phrase, 'There are years when you don't feel like doing anything.' […] His case of do-nothingness was so proverbial that it had been accepted, with a touch of pride even, by the fishermen. […] Ramón had the virtue of telling the least interesting things in the world with a minuteness and an epic tone worthy of the *Iliad*. His best story was about a three-day trip he had made in which he had had the duty of carrying a small suitcase for a billiard champion. It was told with all the minute-to-minute details and was a masterpiece of build-up without suspense. After the tense, agitated conversations of Paris, swarming with double meanings, maliciousness and diplomacy, the conversations with Ramón induced a serenity of soul and achieved an elevation of boring anecdotism that were incomparable. And the gossip of the fishermen of Port Lligat, with their completely Homeric spirit, was of a corporeal and solid substance of reality for my brain weary of 'wit' and *chichi*."

In related fashion, *Poetry of America – The Cosmic Athletes* (p. 364) should be seen as a homage to the New World that welcomed Dalí in and gave him a safe refuge during the Second World War. The painting draws upon childhood memories, featuring the plain of Ampurdán rendered in a style that might as well represent the desert Arizona Dalí enthused over. It includes the tower at the Pichot residence, the hills of the Cadaqués hinterland, and the coast at Cape Creus. In short, it is Catalonia Americanized: to provide his account of a new place, Dalí drew on memories of old. Indeed, in the distance of this sandy landscape we see a female figure reminiscent of his cousin Carolinetta. In the foreground, two male figures are posed in American football attitudes. The two players, a white and a black, are wearing kit that recalls Italian Renaissance cos-

contd. on p. 380

845

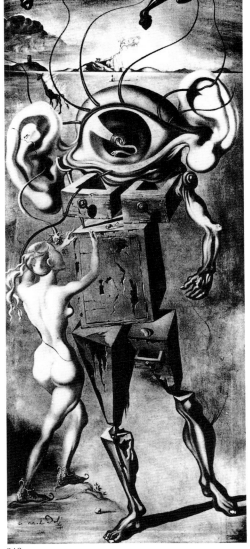

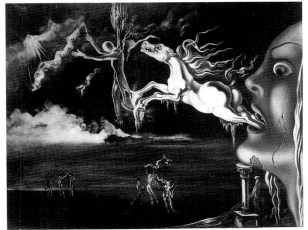

846

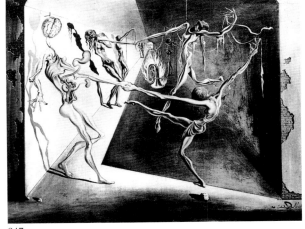

847

848

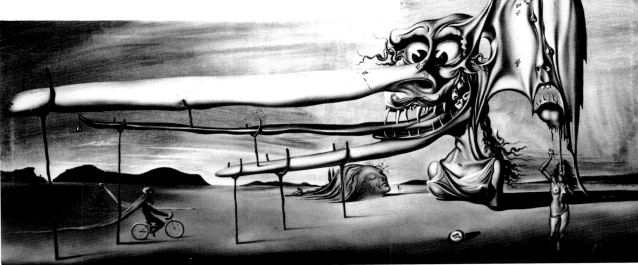

849

1944

850

850 **Leg Composition. Drawing from a series of advertisements for Bryans Hosiery**, c. 1944 △
Composition à la jambe

851 **Paranoia (Surrealist Figures)**, 1944 ❏
Paranoïa (Figures surréalistes)

852 **Dream Caused by the Flight of a Bee around a Pomegranate, One Second before Awakening**, 1944 ❏
Rêve causé par le vol d'une abeille autour d'une pomme-grenade, une seconde avant l'éveil

853 **Gala Naked. Study for "Dream Caused by the Flight of a Bee…"**, 1944 △
Gala nue

851

852

853

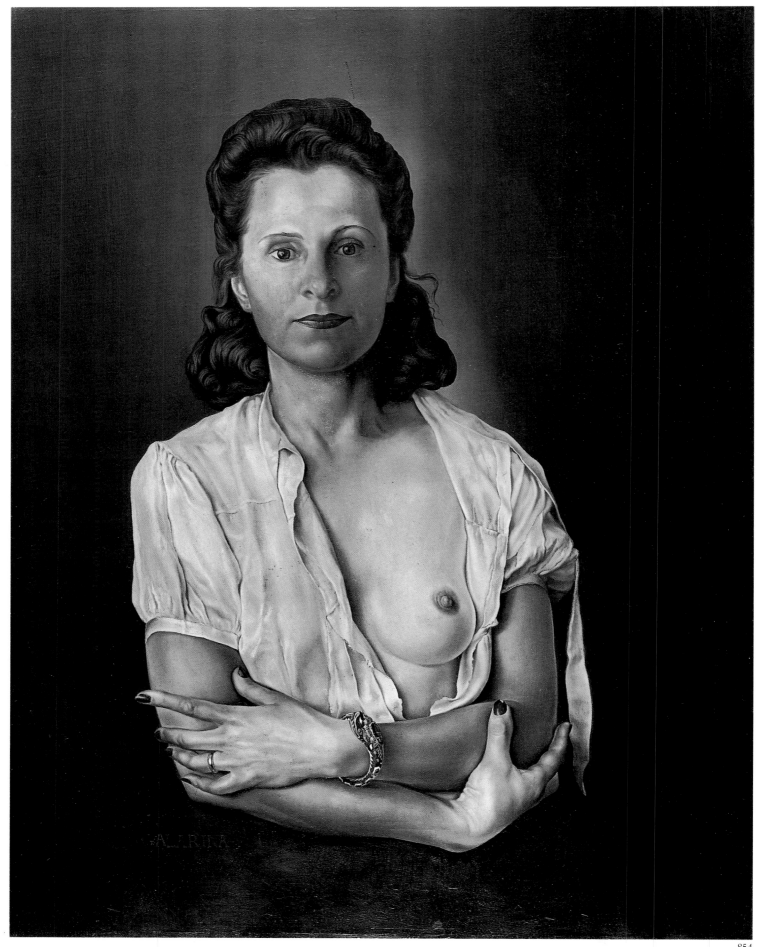

854 Galarina, 1944–1945 ❏

855

855 **Portrait of Gala**, 1941 ∆
Portrait de Gala – «Galarina»

856

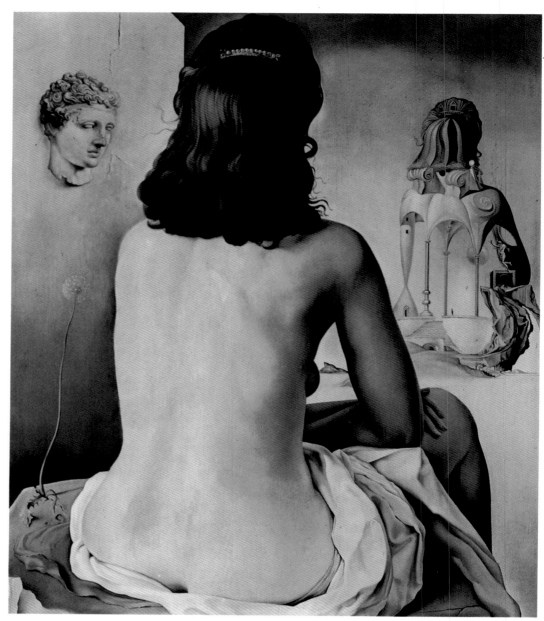

857

856 Untitled – Illustration for "50 Secrets of Magic Craftsmanship", published in 1948 by Dial Press in New York, 1947 △

857 My Wife, Nude, Contemplating her own Flesh Becoming Stairs, Three Vertebrae of a Column, Sky and Architecture, 1945 ❏
Ma femme, nue, regardant son propre corps devenir marches, trois vertèbres d'une colonne, ciel et architecture

tumes. The white brings a Morrone warrior to mind: his head is an empty, puppet's head, and his body is giving birth (as it were) to a Coca Cola bottle. The black is giving birth to a new Adam, who holds the egg of the future world balanced on his forefinger. According to Dalí, this exceedingly moralistic painting was one of his warnings against war. Black America, triumphant yet horrified, is almost refusing to take note of the white man's unstoppable self-destruction – as if Dalí had intuited the racial conflict that was to haunt the U.S.A. in the post-'45 decades. The limp map of Africa hanging from the mausoleum tower similarly seems to point to bad times ahead for the continent.. As for the Coca Cola bottle, it unwittingly anticipates developments in art that we subsequently learnt to associate with the names of Andy Warhol and other Pop artists. Convinced as they might be that they were the first to take an interest in the mass-produced articles of modern consumer society, Dalí had been there before them.

Dalí's acquaintance with America, with the dynamism of a land he felt was symbolized by two football players, led him to the conviction that what Americans loved best was blood first and foremost (his proof being scenes in movies that showed the hero being sadistically beaten). He also insisted that Americans loved soft watches. They were always looking at their own watches, always in a terrible hurry – and when Salvador Dalí offered them a soft, imprecise watch as

858

858 Study for "Galarina", 1943 △

859 Three Apparitions of the Face
of Gala, 1945 ❏
Trois visages de Gala apparaissant sur
des rochers

860 Portrait of Gala. Study for
"Galarina", c. 1941 △
Portrait de Gala

861 Dalí painting "Galarina" at
Caresse Crosby's home, 1944 ☆

860

861

859

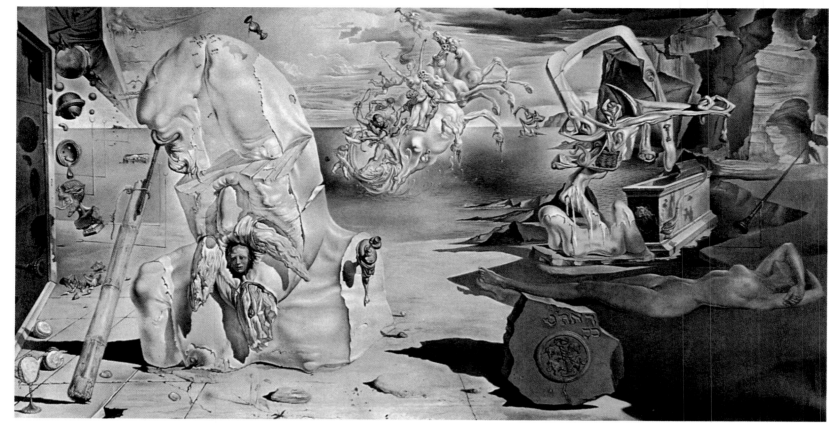

862

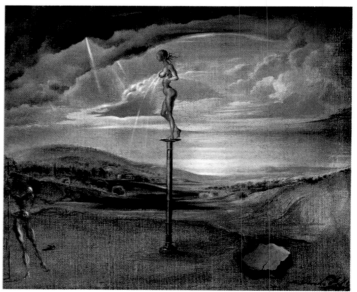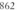

864

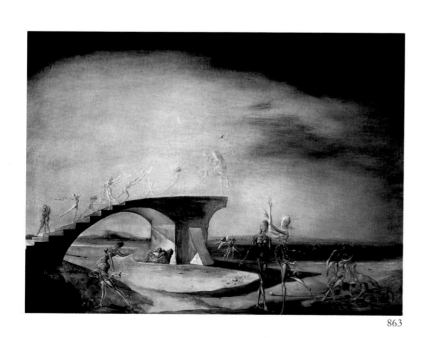

863

862 **The Apotheosis of Homer,**
1944–1945 ❏
L'apothéose d'Homère

863 **The Broken Bridge of the
Dream,** 1945 ❏
Le pont brisé du rêve

864 **Fountain of Milk Flowing
Uselessly on Three Shoes,** 1945 ❏
Fontaine de lait coulant en vain sur
trois souliers

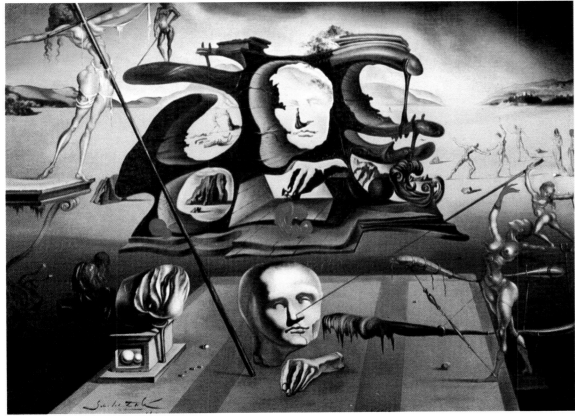

865

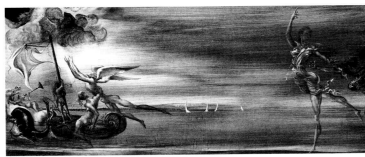

866

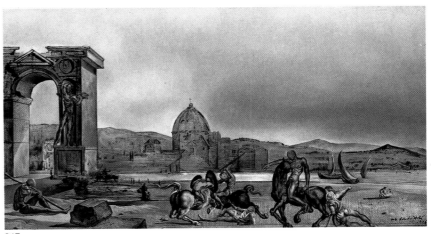

867

865 Napoleon's Nose, Transformed
into a Pregnant Woman, Walking
his Shadow with Melancholia
amongst Original Ruins, 1945 ❏
Nez de Napoléon transformé en
femme enceinte promenant son ombre
avec mélancolie parmi des ruines
originales

866 Untitled – Scene with Marine
Allegory, 1945 ❏
Sans titre – Scène avec allégorie marine

867 Autumn Sonata, 1945 ❏
Sonate d'automne

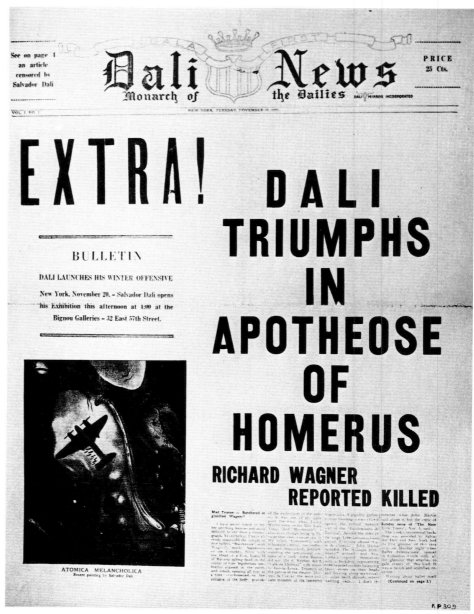

runny as Camembert they were so grateful to be released from their enthrallment to time that he was an instant success. A further American preoccupation, in Dalí's view, was with the murder of children: the massacre of the innocents, he claimed, was the major psychological obsession of the U.S.A.

In evolving these conscious ideas out of unconscious intuitions, and tuning in to the spirit of the age – a process that was Surrealist to the core, since what interested Dalí most was always the intangible – Dalí was arriving at a turning point, doubtless in reaction to his contact with American realities. The critics, inspired in part by the resentful tone taken by Breton, tried to make sense of the shift in emphasis. An article in the January 1942 *Art News* noted that Dalí's technique, from the *Basket of Bread* of 1926 (p.113) to the 1940 *Two Pieces of Bread Expressing the Sentiment of Love* (p.334), was profoundly academic, and established that at the age of thirty-eight (eleven years Miró's junior) Dalí had as accomplished a mastery of his craft as any other living painter, and indeed assigned greater weight to that mastery than he did to complex Surrealist ideas and ideology. The *Art News* critic suggested that Dalí had moved on from smooth

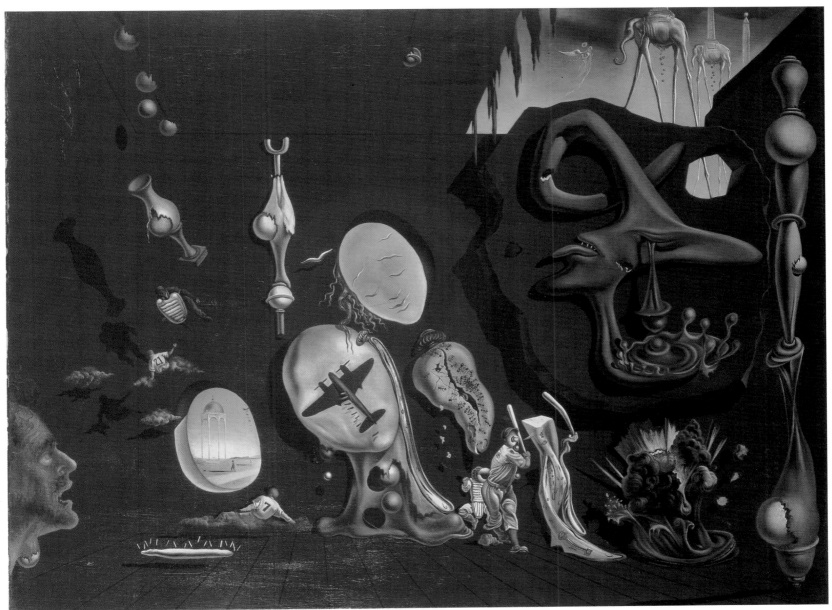

869

surfaces painted in imitation of Renaissance art, via Böcklin, to the Mannerists, from whom he took gentle contours and impasto application, and the title to call himself a classicist. James Thrall Soby had forecast, in a catalogue essay, that Dalí would be turning increasingly from the unconscious to the conscious; and *Art News* added that if that were the case (and, as we have seen, there were signs that it was) nothing need stop Dalí from becoming the greatest academic painter of the twentieth century.

In fact Dalí was remaining truer to his established method of endowing every-day things with an epic dimension than ever. *Two Pieces of Bread Expressing the Sentiment of Love* (p.334), which features only bread, crumbs and a chess pawn, remarkably illustrates Dalí's command of a technique academic painters strove for in vain. The still life was painted in Arcachon in spring 1940, when Marcel Duchamp spent the afternoons playing chess with Gala while Dalí painted the pieces of bread. Dalí, in search of "the exact mixture of amber oil, of gum, of varnish, of imponderable ductility and of super-sensitive materiality" that would express the tactile qualities he wanted, found one day that a pawn had been left

868 Title page of the first number of the "Dalí News", which appeared on 20 November 1945 for the exhibition in the Bignou Gallery. The page shows a detail of "Melancholy, Atomic, Uranic Idyll". ☆

869 Melancholy, Atomic, Uranic Idyll, 1945 ❏
Idylle atomique et uranique mélancolique

1945

by the players beside his bread; and presently Gala and Duchamp found themselves looking for a substitute, Dalí having kept the chess piece for his own purposes. Thus it was (Dalí recalled with characteristic wryness) that Marcel Duchamp played a key part in the making of the picture.

Bread, as we have seen, played an important part in Dalí's art, whether in paintings or in sculptural objects such as the *Retrospective Bust of a Woman* (p.139). Dalí gave an explanation for this striking presence in a catalogue for Bignou's Gallery in New York. Commenting on his 1945 *Basket of Bread – Rather Death than Shame* (p.386), he declared that his aim was to recover the lost technique of the old masters and establish the motionlessness of pre-explosive objects. Bread was one of his oldest obsessional fetishes in his work, and he had remained true to it; he had painted *Basket of Bread* (p.113) a full nineteen years earlier, and, if the two paintings were compared (thus Dalí), they would reveal the entire history of painting, from the linear charm of primitivism to three-dimensional hyper-aestheticism.

We should never forget either, added Dalí, that the two most powerful motors

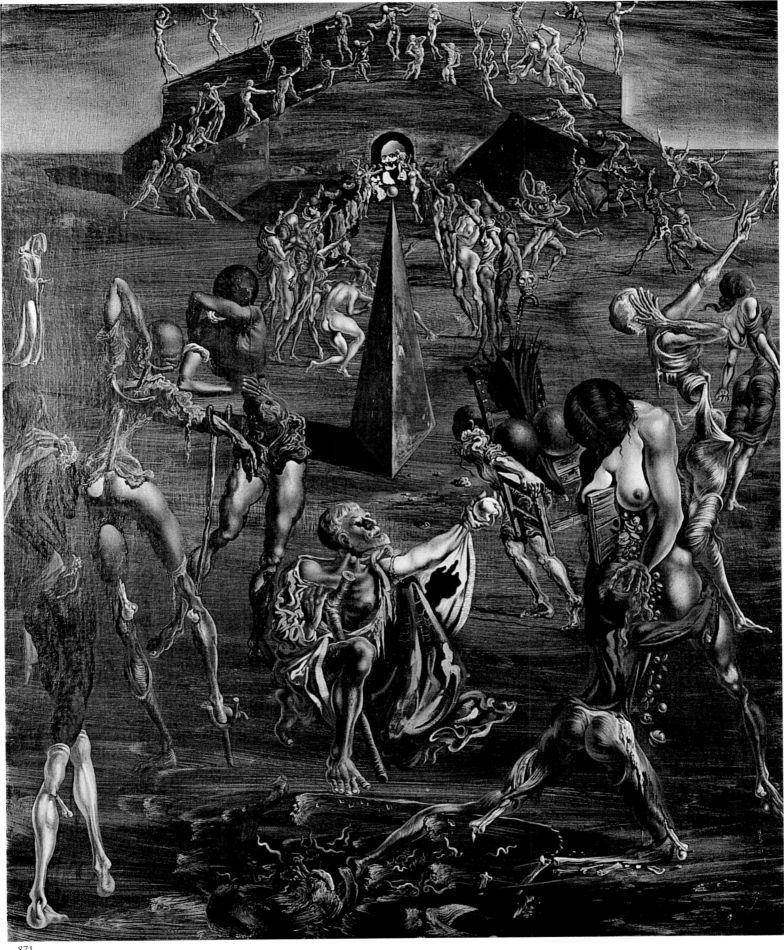

871

1945–1946

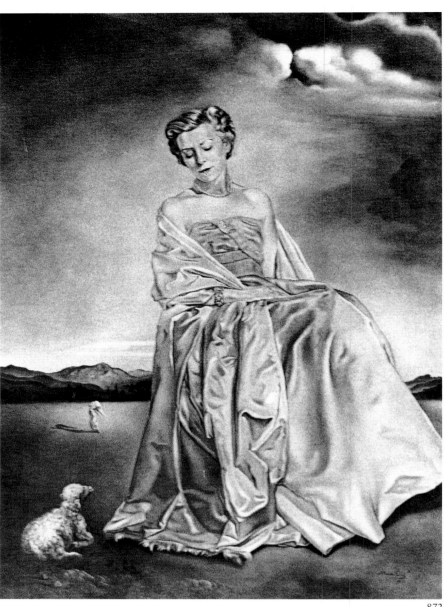

872

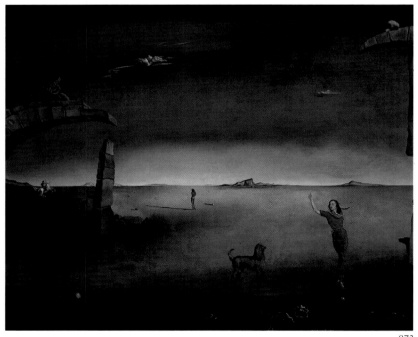

873

872 **Untitled – Portrait of a Woman**, 1945 ❏
Sans titre – Portrait de femme

873 **Composition – Portrait of Mrs. Eva Kolsman**, 1946 ❏
Composition – Portrait de Madame Eva Kolsman

874 **Portrait of Mrs. Isabel Styler-Tas**, 1945 ❏
Portrait de Mrs. Isabel Styler-Tas

875 **Study for "Portrait of Mrs. Isabel Styler-Tas"**, 1945 △

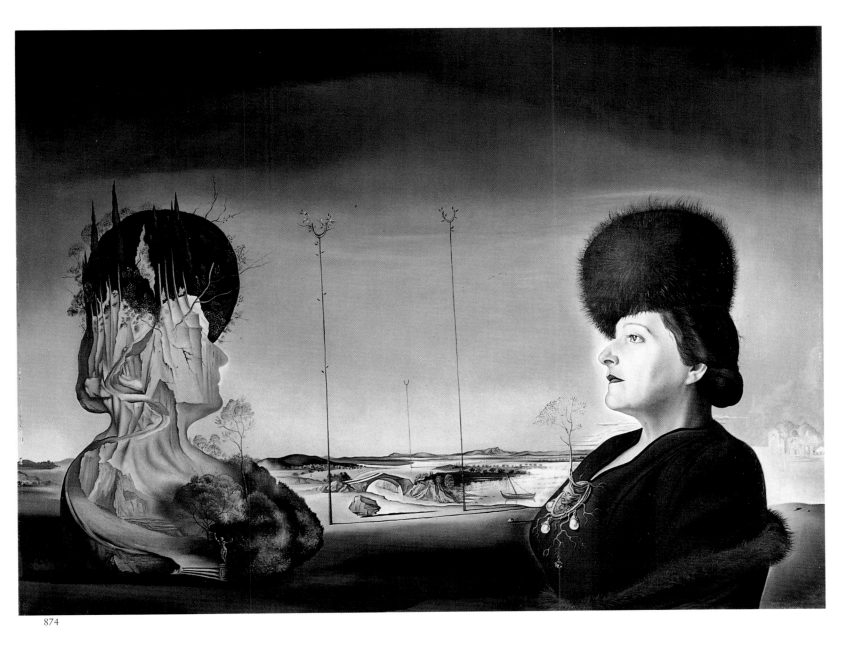

874

driving his super-sensitive artistic brain were the libidinous instinct and fear of death. These were to remain constant till Dalí's death; they were also mirrors of his age, throughout. Not one minute passed, stated Dalí, without the sublime Roman, Catholic and apostolic spectre of Death accompanying him on the most penetrating and idiosyncratic of imaginative journeys.

The Face of War (p. 336) was painted in California at the end of 1940. Anticipating the horrors which were mostly yet to come in the Second World War, this terrible face with eyes of death is primarily a retrospective response to the grim tragedy of the Spanish Civil War. The "crude reality of violence and of blood" in that war had deeply shocked Dalí: "all at once, in the middle of the cadaverous body of Spain half devoured by the vermin and the worms of exotic and materialistic ideologies, one saw the enormous Iberian erection, like an immense cathedral filled with the white dynamite of hatred. To bury and to unbury! To unbury and to bury! To bury in order to unbury anew! Therein lay the whole carnal desire of the civil war of that land of Spain, too long passive and unsated, too long patient in suffering others to play the humiliating game of the vile and anecdotic ping-pong of politics on the aristocratic nobility of its back [...] It was going to be necessary for the jackal claws of the revolution to scratch down to the atavistic

contd. on p. 395

875

1944–1945

876 Alfred Hitchcock was determined to use Dalí's skills to design the Freudian dream sequence in his film "Spellbound". David O. Selznick made it possible. "I could have taken

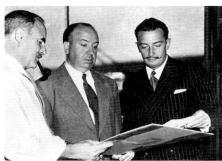

876

877

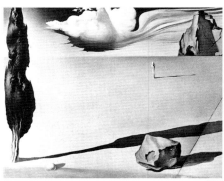

878

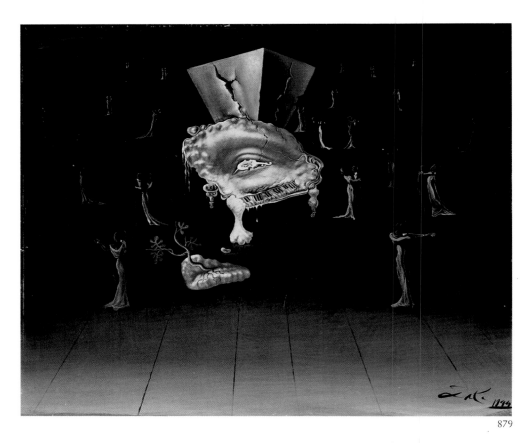

879

880

De Chirico or Max Ernst," Hitchcock said, "but no one is as imaginative and extravagant as Dalí." The photo shows Dalí with Hitchcock, 1945 ✶

877 Photo: Dalí with Gregory Peck and Ingrid Bergmann, 1945 ✶

878 Design for "Spellbound", 1945 ❏

879 Untitled – Design for the ball in the dream sequence in "Spellbound", 1944 ❏

880 The ball as filmed by Hitchcock, 1945 ✶

390

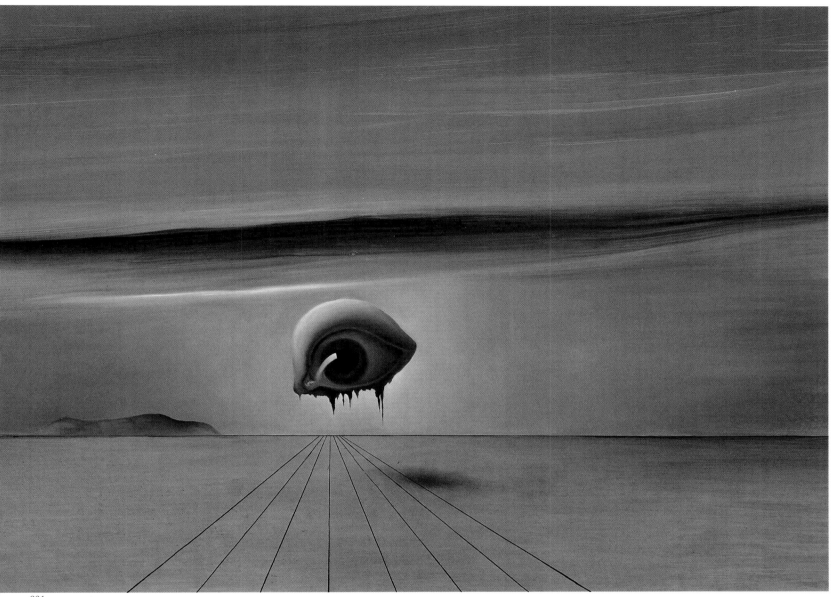

881

882

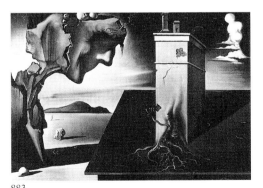

883

884

881 The Eye – Design for
"Spellbound", 1945 ❏

882 Drawing for "Spellbound",
1945 △

883 Spellbound, c. 1945 ❏

884 Study for the dream sequence
in "Spellbound", c. 1945 ❏

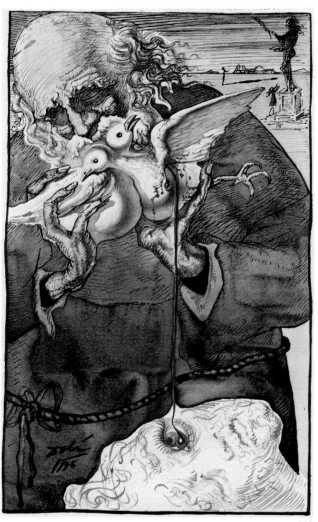

885

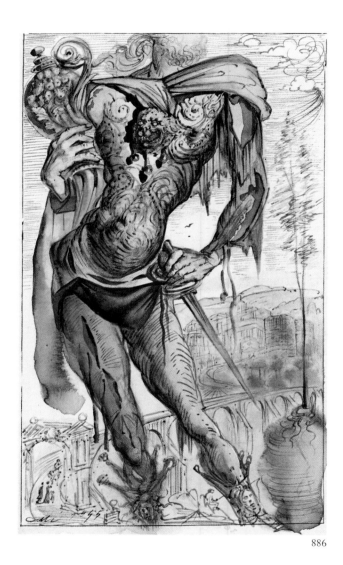

886

885 Illustration for "The Autobiography of Benvenuto Cellini", 1945 △

886 Illustration for "The Autobiography of Benvenuto Cellini", 1945 △

887 Drawing for Disney's "Destino", 1946–1947 △

888 Double Image for "Destino", 1946 ❏

889 Inspired by the success of the dream sequence in "Spellbound", Walt Disney approached Dalí to design a six-minute cartoon sequence: "Destino". It was to have become part of a new film on the lines of "Fantasia" (1941), but in fact the plans came to nothing. The photo shows Dalí and Disney in California in 1947. ✰

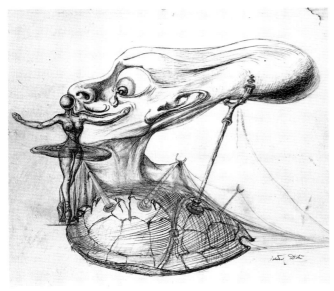

887

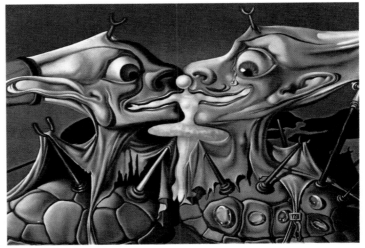

890

888

889

891

890–891 Designs for "Destino",
1947 △

892

893

892 One of 13 illustrations for Shakespeare's "Macbeth". The edition was published by Doubleday, New York, 1946 △

893 Illustration for "The Autobiography of Benvenuto Cellini", 1945 △

894 Don Quixote and the Windmills. Illustrations for the edition published by Random House in New York, 1945 △
Don Quichotte et les moulins à vent

895 Christmas – For the cover of "Vogue" (USA), 1946 ❏
Noël

896 Cover of the Christmas "Vogue" (USA), 1946 ✗

897 Desert Trilogy – Flower in the Desert. Painting by Dalí to launch the perfume "Desert Flower" on the market, 1946 ❏
Trilogie du désert – Fleur dans le désert

894

895

896

897

898 Desert Trilogy – Apparition of a Couple in the Desert – For "Desert Flower" perfume, 1946 ❏
Trilogie du désert – Apparition d'un couple dans le désert

899 Desert Trilogy – Apparition of a Woman and Suspended Architecture in the Desert – For "Desert Flower" perfume, 1946 ❏
Trilogie du désert – Apparition d'une femme et architecture en suspension dans le désert

898

899

layers of tradition in order […] The past was unearthed, lifted to its feet, and the past walked among the living-dead, was armed […] For nothing is closer to an embrace than a death-grapple." As for Bataille, death and eroticism were always closely related in Dalí's eyes. Of this somewhat Gothic response to the civil war, what survives in the 1940 painting is the atmosphere of terror, emphasized by the sombrely earthy browns. (Dalí always pointed out that it was the only painting of his in which a print of his hand could be seen.)

Dalí's avowal of a classicism that served to reinforce his fantasies and leitmotifs became clearer from one work to the next. The masterly pictures he was painting were attempts to create a synthesis out of his craft and his ideas. Dalí's principle of seeing landscapes through architectural or landscape gaps (which might also have dual image functions) was part of this endeavour. In *Disappearing Bust of Voltaire* (p. 340), Houdon's bust of the French writer can equally well be seen as a group of figures. Again Dalí is offering us a part of his imaginative life. The painting was done in the U.S.A., the year after *Slave Market with the Disappearing Bust of Voltaire* (p. 331). In that picture, painted at Arcachon in 1940, the fruit bowl from *The Endless Enigma* (p. 308) reappears, with Gala, whose love (Dalí said) had saved him from a world full of slaves. Dalí, immersed in the life of art,

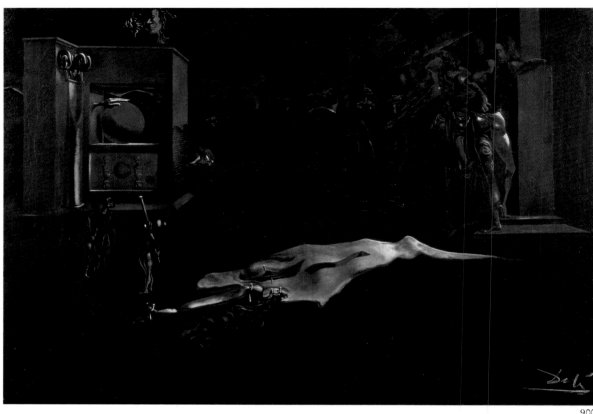

900

901

ascribed to Gala the magical ability to dissolve the image of Voltaire, and thus to protect him from the critical scepticism of the French Enlightenment. He later recalled that as he was painting the picture he continually recited a poem, "The Love of War", by Joan Salvat Papasseit, a Catalonian anarchist he greatly admired. In Barcelona, Papasseit was accused of being a right-wing extremist because he spoke out for war at a time when everyone else was espousing pacifism.

The dropping of the first atom bomb on Hiroshima, on 6 August 1945, deeply shocked Dalí. He expressed his response in works such as *Melancholy, Atomic, Uranic Idyll* (p.385), *The Apotheosis of Homer* (p.382) and *The Three Sphinxes of Bikini* (p.411). These paintings introduced a new technique which he called "nuclear" or "atomic painting". The technique peaked in a masterpiece he completed in 1949, *Leda Atomica* (p.425).

900 **The Stain**, 1946 ❏
Le crachat
901 **Untitled (Spanish Dances in a Landscape)**, 1946 ❏
Sans titre (Scène de danses espagnoles dans un paysage)
902 **Giant Flying Mocca Cup, with an Inexplicable Five-Metre Appendage**, c. 1946 ❏
Demi-tasse géante volante, avec annexe inexplicable de cinq mètres de longueur

·The true painter must be able patiently to copy a pear while surrounded by rapine and upheaval.

903 Drawing for "50 Secrets of Magic Crafts-
manship". The book was published by Dial
Press, New York in 1948. ∆

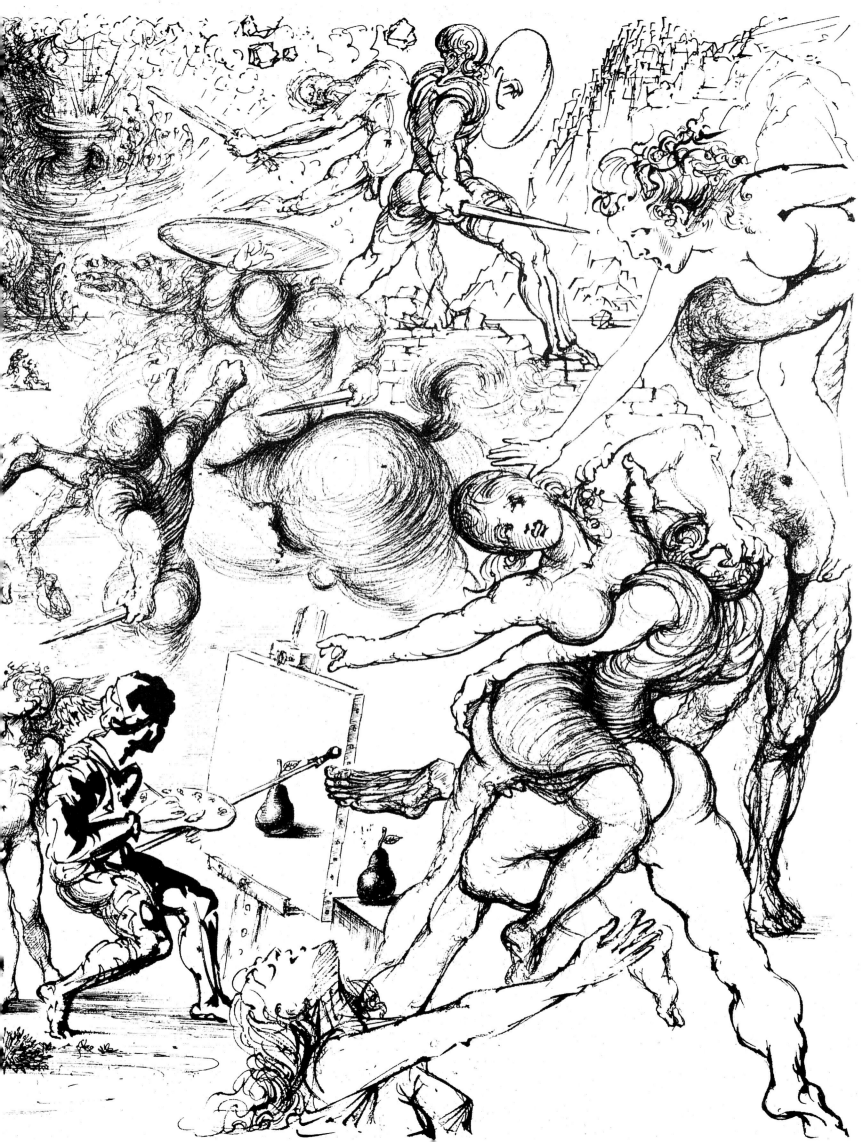

905

904 Dalí with "Tuna Fishing", 1967 ☆

905 Drawing for "50 Secrets of Magic
 Craftsmanship". The book was
 published in 1948 by Dial Press, in
 New York, 1947 △

Pages 404 and 405:
Study of flies for "The Face", 1972 △

Robert Descharnes/Gilles Néret

Salvador
DALÍ
1904–1989

The Paintings
1946–1989

Conception: Gilles Néret

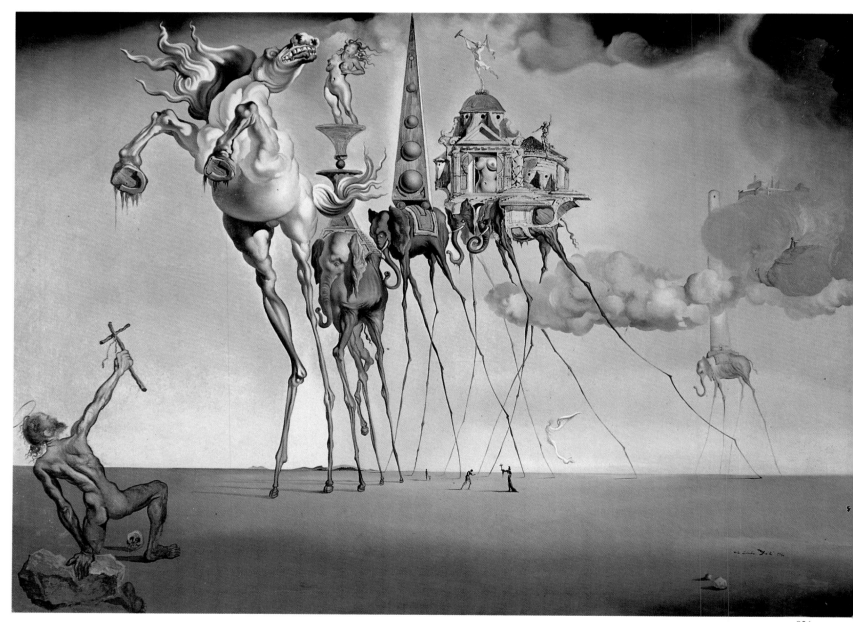

906

For Dalí, the atom bomb was the start of a new era. He succumbed to mysticism – nuclear mysticism, as it were. The Hiroshima explosion coincided with his own classicist explosion. In its characteristically mischievous way, *Art News* commented: "The possibility cannot be ruled out that Dalí will be giving more attention to the conscious realm from now on than to the unconscious. If this does indeed be the case, nothing need prevent him from becoming the greatest academic painter of the twentieth century."

After the Second World War, Dalí did not immediately return to Europe. The change from the psychoanalysis Dalí to the nuclear physics Dalí was making heavy demands on him. In his *Mystical Manifesto*, Dalí described the change that was occurring in him at that time in the following terms: "The explosion of the atom bomb on 6 August 1945 sent a seismic shock through me. Since then, the atom has been central to my thinking. Many of the scenes I have painted in this period express the immense fear that took hold of me when I heard of the explosion of the bomb. I used my paranoiac-critical method to analyse the world. I want to perceive and understand the hidden powers and laws of things, in order to have them in my power. A brilliant inspiration shows me that I have an unusual weapon at my disposal to help me penetrate to the core of reality: mysticism – that is to say, the profound intuitive knowledge of what is, direct communication with the all, absolute vision by the grace of Truth, by the grace of God. More powerful than cyclotrons and cybernetic calculators, I can penetrate to the mysteries of the real in a moment… Mine the ecstasy! I cry. The ecstasy of God and Man. Mine the perfection, the beauty, that I might gaze into its eyes! Death to academicism, to the bureaucratic rules of art, to decorative plagiarism, to the witless incoherence of African art! Mine, St. Teresa of Avila!… In this state of intense prophecy it became clear to me that means of pictorial expression achieved their greatest perfection and effectiveness in the Renaissance, and that the decadence of modern painting was a consequence of scepticism and lack of faith, the result of mechanistic materialism. By reviving Spanish mysticism I, Dalí, shall use my work to demonstrate the unity of the universe, by showing the spirituality of all substance."

This avowal of mysticism was consistent enough as a product of Dalí's experience to date. And he was to be as good as his word; from that time on, until the end of his life, he applied mystical principles to his work. The paintings he would create in the years ahead often met with a mixed response; but among them are numerous masterpieces.

The second subversive force that filled the "ex-Surrealist" (who in fact remained more of a Surrealist than ever) was – by his own account – the ability to draw. Dalí discussed this in *50 Secrets of Magic Craftsmanship*, which was a regular treatise on the art of painting and which he characteristically praised by saying: "Reading it, I really learnt to paint almost as well as Zurbarán." In the treatise he noted that people now knew how to make an atom bomb, but "no one knows what the mysterious juice was made of, the painting medium into which the

907

906 **The Temptation of Saint Anthony**, 1946 ❏
La tentation de Saint Antoine

907 **Drawing for the programme for the ballet "As You Like It"** after Shakespeare's comedy, 1948 △

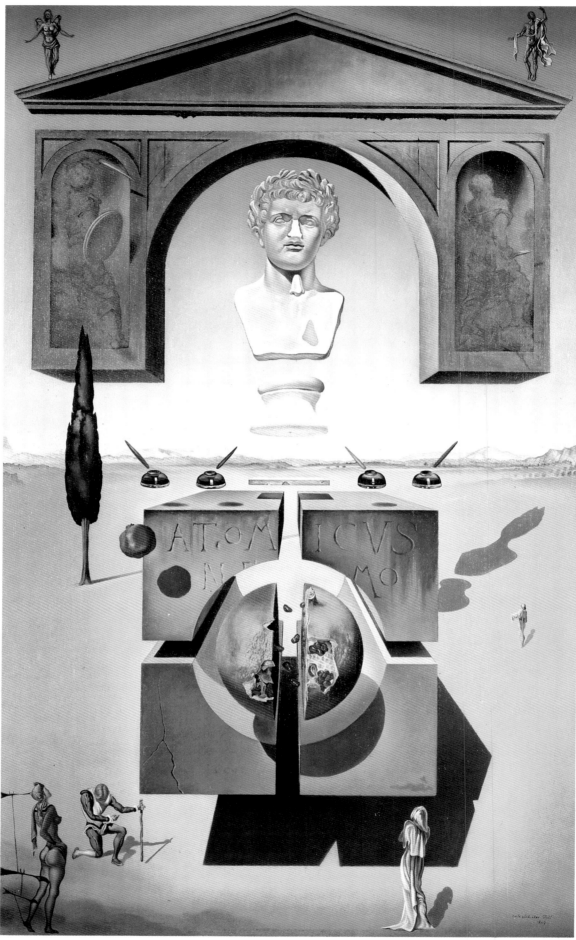

908 **Dematerialization near the Nose of Nero**, 1947 ❏
La séparation de l'atome

908

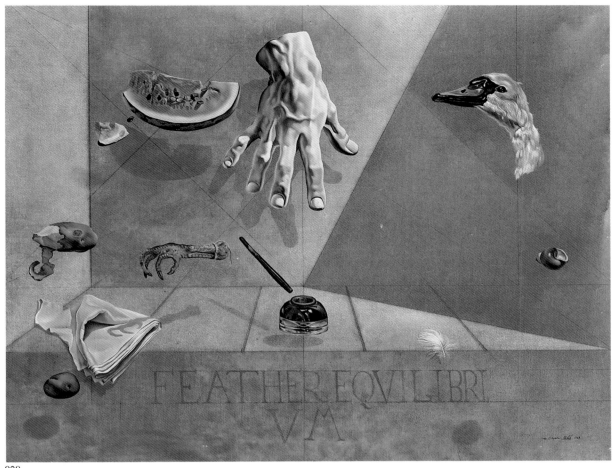

909

brothers van Eyck or Vermeer van Delft dipped their brushes." He went on to provide his own recipes. First he dealt with questions of equipment: five different brushes to suit five different kinds of movement. Then he turned to optics, the binocular vision he was later to use (there was method in his supposed madness), and examined the astounding opportunities open to stereoscopic painting. Thanks to "much-despised sensory perception", he was able fully to adapt this way of seeing to his "system" of steered dreaming. One of his aphorisms declared: "When you are painting, always think of something else."

The advice was both mischievous and (how Dalí loved the hierarchical note!) authoritative. He then turned to the central, unique, dreamlike impulse of art, "to take oneself ad absurdum by hypnotically questioning one's own sense of perception". He wrote of the "three eyes", which were fundamentally nothing but a re-statement of the theory of the third eye which is so common among visionaries everywhere. In his *50 Secrets of Magic Craftsmanship* Dalí advised young artists not merely to see, but "to see metaphysically". He also provided a host of technical hints which he had learnt through years of practice and by patient study of writing on art, among them Cennino Cennini's *Il Libro dell'arte* (which had itself been inspired by the writings of a monk, Theophilus Presbyter). Cennini's work had been *the* treatise on the art of painting since the 14th century. Next came Luca Pacioli and the masters of the Italian Renaissance, whose secrets Dalí had rediscovered.

Having established the direction and preconditions of his current evolution, Dalí felt free to return to Europe at last. On 21 July 1948, he and Gala arrived at Le Havre. They immediately travelled on to Port Lligat. There Dalí promptly set to work on two commissions he had accepted, designing the sets and costumes

910

909 **Feather Equilibrium**, 1947 ❏
Equilibre intra-atomique d'une plume de cygne

910 **Study for "Dematerialization near the Nose of Nero"**, 1947 △

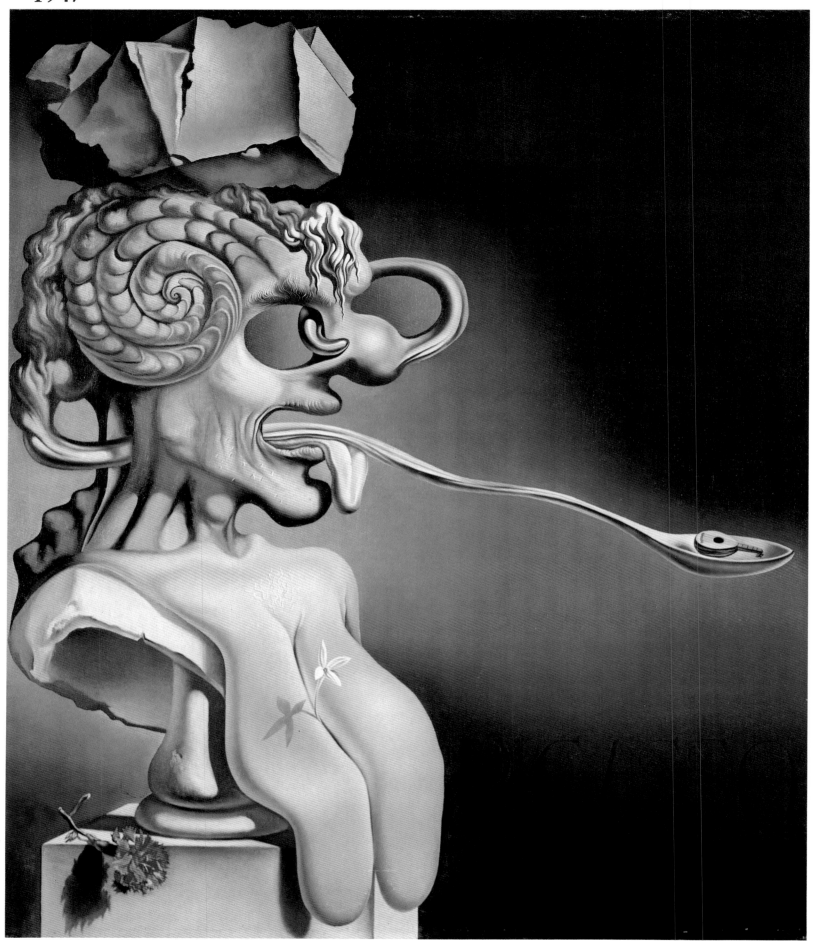

for Peter Brook's production of Richard Strauss's *Salome* and Luchino Visconti's of Shakespeare's *As You Like It*.

Above all, Dalí was itching to retun to painting, and to establish the new Dalí approach as swiftly as possible. It was very important for him now to adopt his new religious themes; this was something that many of his critics who had no special interest in spiritual matters were unable to understand. He was obsessed with the absolute, and the classical iconography of Christianity afforded a means of exploring different artistic territory: the territory of the sacred. Great painters had always wanted to paint a crucifixion. Now the Madonna, Christ, the Last Supper and other central images were to grant him access to that heaven he was already seeking at the close of *The Secret Life of Salvador Dalí.*

While still in New York, Dalí had painted *The Temptation of Saint Anthony* (p. 406). At that time he had extensive contacts in the film and theatre world. After working on Hitchcock's *Spellbound*, he decided to enter Albert Levin's competition for material for a film version of Guy de Maupassant's *Bel Ami*. Max Ernst won the competition, and his picture was the only colour shot in the entire black-and-white film; but even if Dalí's *Temptation of Saint Anthony* did not win, the picture is still of great significance in Dalí's work. It marks the point in his creative life when intermediates between heaven and earth become important

contd. on p. 417

913

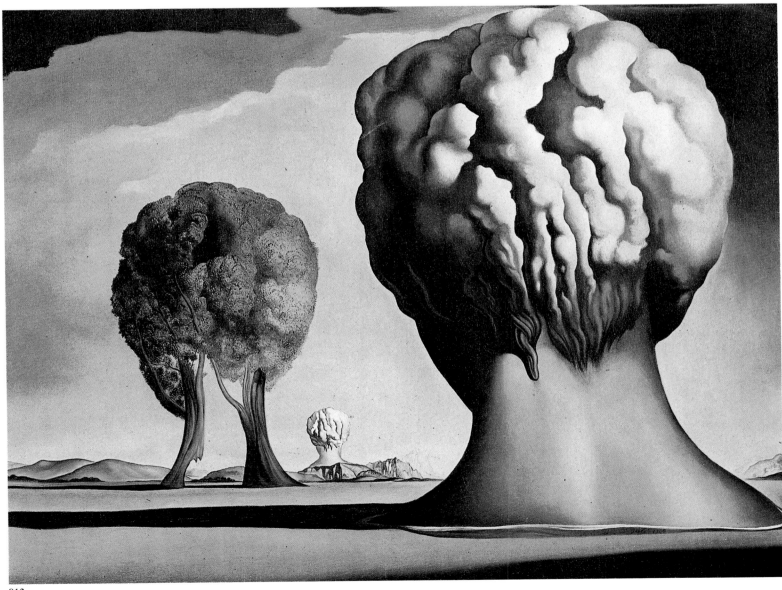

912

The true painter must be able, befor
to limit himself to reproducing

914 Rock and Infuriated Horse
Sleeping under the Sea, 1947 ❑

914

panorama
art

915 **Battle over a Dandelion**, 1947 □
Bataille autour d'un pissenlit
916 **Drawing for "50 Secrets of
Magic Craftsmanship"**, 1947 △

915

916

The true painter must be able, with
to have the most unusual

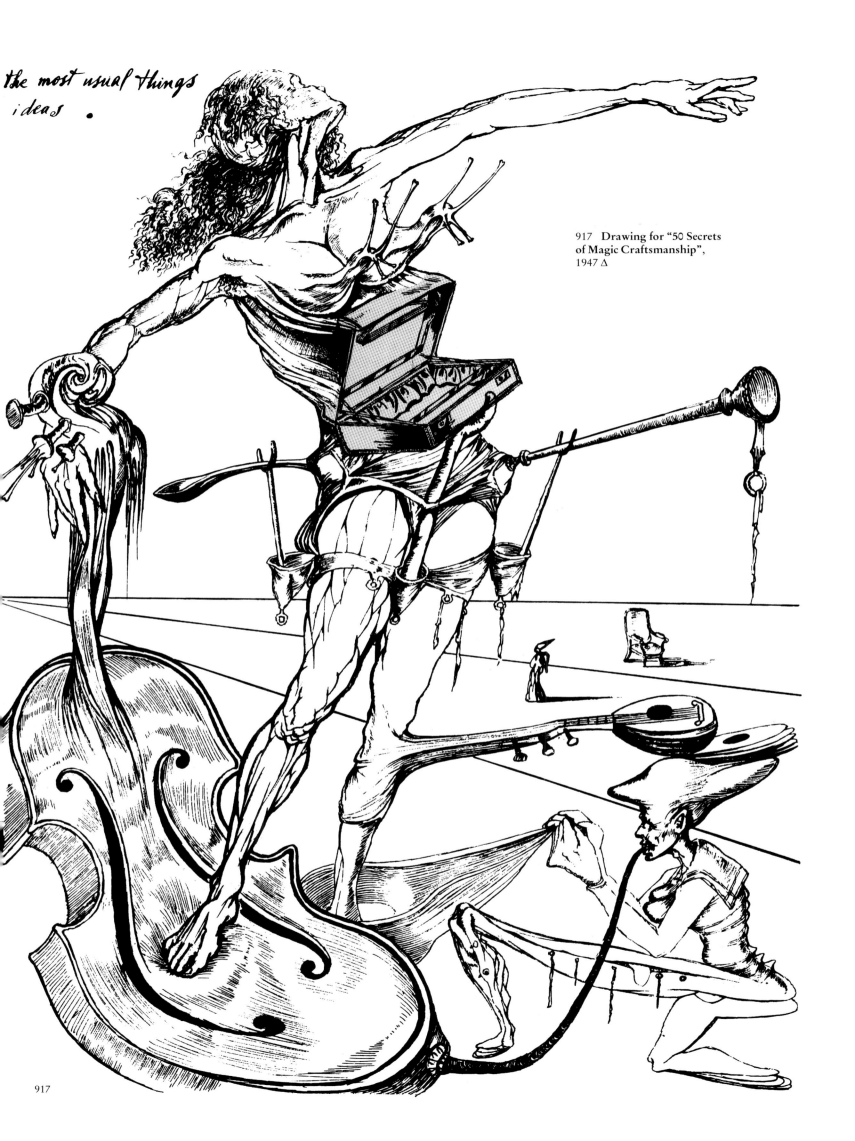

the most usual things
ideas .

917 Drawing for "50 Secrets
of Magic Craftsmanship",
1947 △

917

The imposibel modol

919

920

– in this case, the elephants with their spindly legs. They anticipate the theme of levitation, which was subsequently to be fully developed in his "mystical-corpuscular" paintings. The temptation that confronts the saint takes various forms: a rearing horse, symbolic of power, but also (here) of the Fountain of Desire on its back, topped with a naked woman, another bearing a Roman obelisk inspired by Bernini, the others with a building reminiscent of the Palladium and a phallic tower. In the distant clouds we glimpse parts of El Escorial, representing spiritual and temporal order.

Dalí decided that henceforth he would devote himself to his threefold synthesis of classicism, the spiritual, and concern with the nuclear age. "My ideas were ingenious and abundant. I decided to turn my attention to the pictorial solution of quantum theory, and invented quantum realism in order to master gravity … I painted *Leda Atomica* (p. 425), a celebration of Gala, the goddess of my metaphysics, and succeeded in creating 'floating space'; and then *Dalí at the Age of Six, When He Thought He Was a Girl Lifting with Extreme Precaution the Skin of the Sea to Oberserve a Dog Sleeping in the Shade of the Water* (p. 433) – a picture in which the personae and objects seem like foreign bodies in space. I visually dematerialized matter; then I spiritualized it in order to be able to create energy. The object is a living being, thanks to the energy that it contains and radiates, thanks to the density of the matter it consists of. Every one of my subjects is also a mineral with its place in the pulsebeat of the world, and a living piece of uranium. In my paintings I have succeeded in giving space substance. My

contd. on p. 423

918 **The Impossible Model (Drawing for "50 Secrets of Magic Craftsmanship")**, 1947 △
Le modèle impossible

919 **Portrait of Mrs. Mary Sigall,** 1948 ❏
Portrait de Mrs. Mary Sigall

920 **Portrait of Nada Pachevich,** 1948 ❏
Portrait de Nada Patchevitch

417

1947

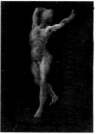

921

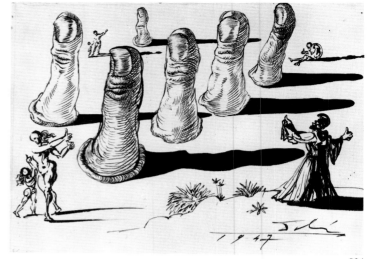

924

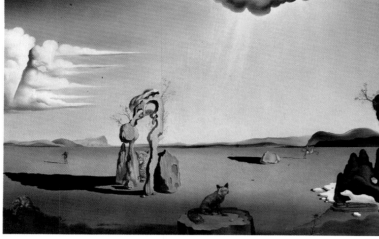

922

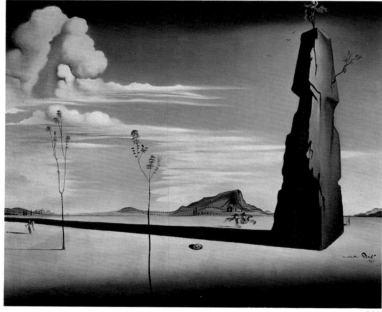

923

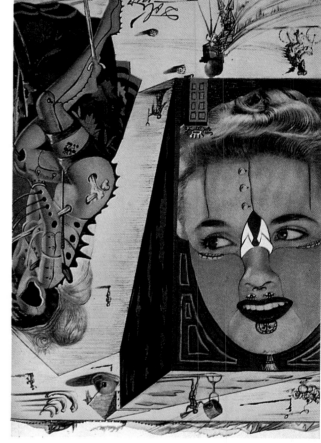

925

921 **Untitled (Male Nude in a Landscape)**, 1948 ❏
Sans titre (Nu masculin dans un paysage)

922 **Nude in the Desert (Wild Animals in the Desert)**, 1948 ❏
Nu dans le désert (Bêtes sauvages dans le désert)

923 **Untitled (Landscape)**, 1947 ❏
Sans titre (Paysage)

924 **Cathedral of Thumbs (The Thumbs). Illustration for the "Essays" of Montaigne, in an edition published by Doubleday, New York, 1947** Δ
Les pouces

927

928

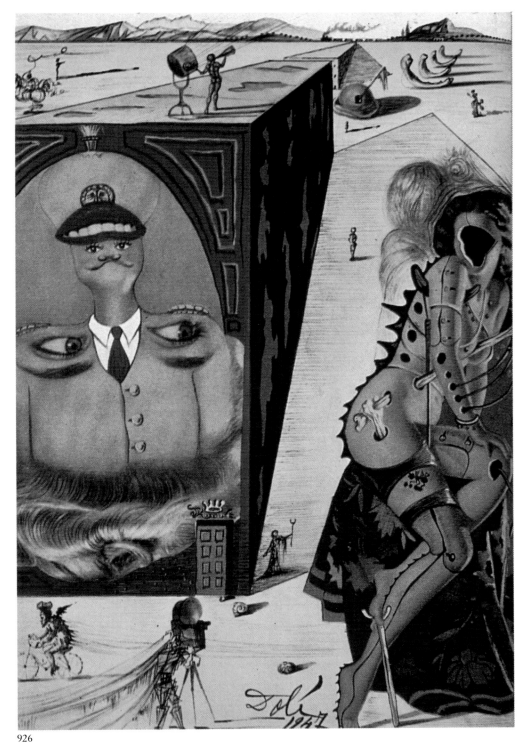

926

929

925, 926 **Hollywood. Cover illustra-**
tion for "Sunset" magazine. Dual
image, to be viewed in two ways,
1947 △

927 **Study for a portrait**
(unfinished), c. 1948 ❑

928 **Untitled (Temple Frontage**
with Atomic Explosions), c. 1947 ❑
Sans titre (Frontispice de temple avec
explosions de bombes atomiques)

929 **Wheat Ear,** 1947 ❑
Epis de blé

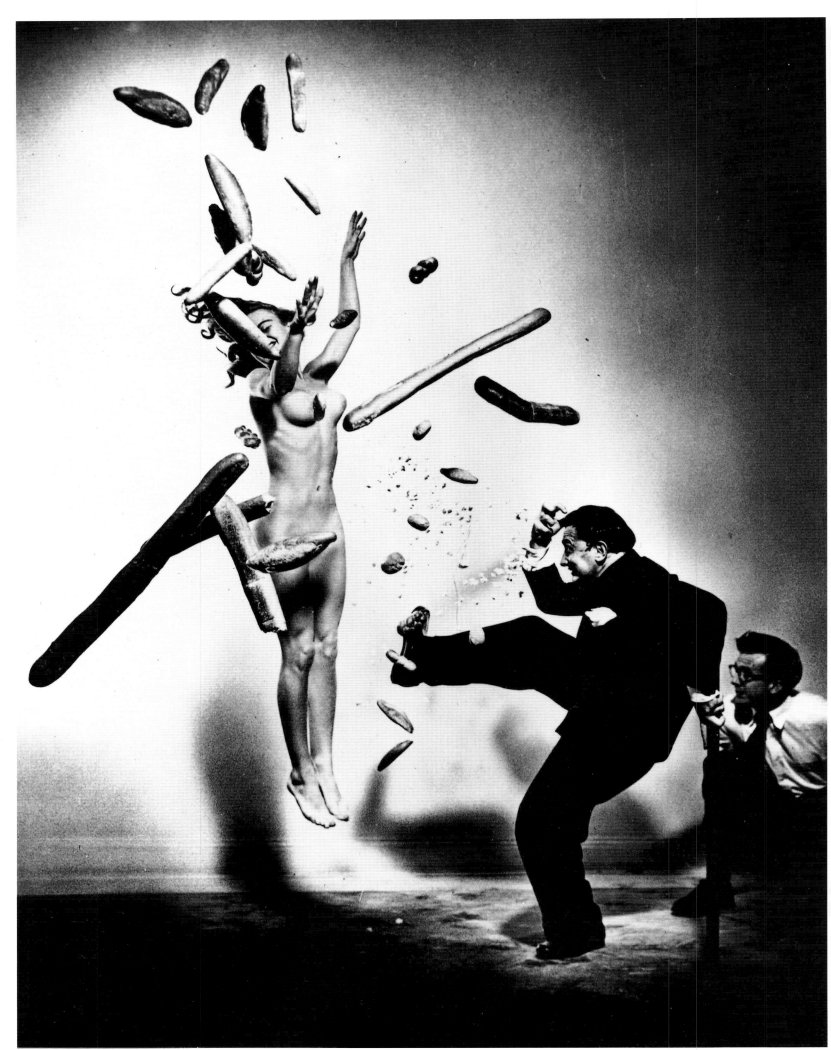

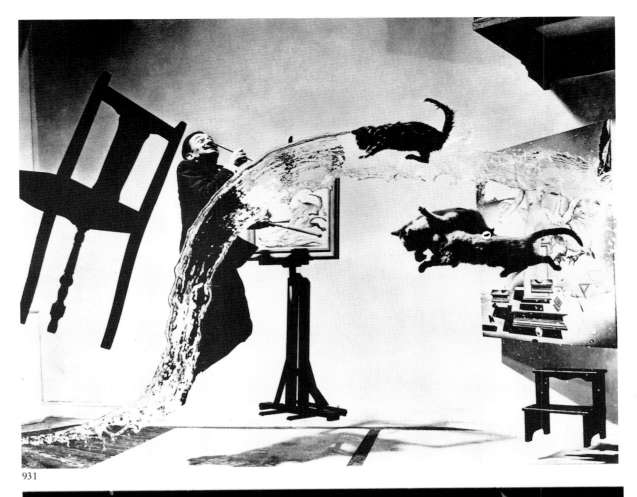

931

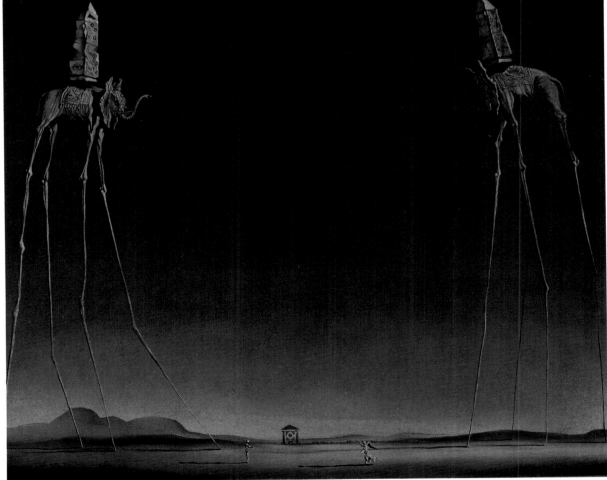

932

930, 931 "The Cosmic Dalí". From a
series of photographs by Philippe
Halsman, designed by Dalí, 1948 ☆

932 The Elephants, 1948 ❏
Les éléphants

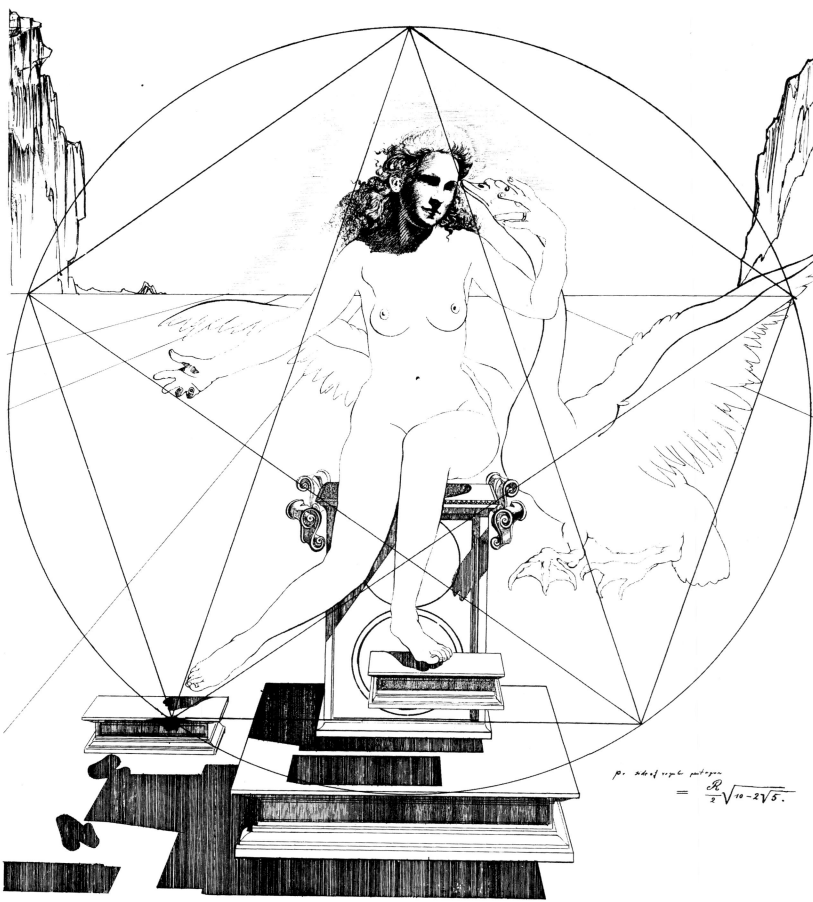

per side of regular pentagon $= \dfrac{R}{2}\sqrt{10-2\sqrt{5}}.$

LEDA ATOMICA 1947.
Dali de Figueras

933

934

935

Cupola Consisting of Twisted Carts (p. 445) is the most magnificent demonstration of my mystical way of seeing. I maintain with full conviction that heaven is located in the breast of the faithful. My mysticism is not only religious, but also nuclear and hallucinogenic. I discovered the selfsame truth in gold, in painting soft watches, and in my visions of the railway station at Perpignan. I believe in magic and in my fate."

933 **Study for "Leda Atomica",** 1947 Δ

934 **Studies for the air centres and soft morphologies of "Leda Atomica",** 1947 Δ
Etude des centres d'air et des morphologies molles de «Léda atomica»

935 **Study for "Leda Atomica",** 1949 Δ

Phallic Swans and Radiant Virgins

The first pictures in the new series were the two versions of *The Madonna of Port Lligat* (pp. 426 and 443); he showed the smaller version to Pope Pius XII on 23 November 1949. Dalí also produced a hundred illustrations for Dante's *Divine Comedy*. A particularly fine product of his mystical, ecstatic approach was the well-known *Christ of St. John of the Cross* (p. 451). The *Royal Heart* (p. 452), made of gold and rubies, is Dalí's arresting response to a remembered question his mother asked: "Dear heart, what do you want?"

The new Dalí was derided – particularly by the Surrealists. In the new edition of his *Anthology of Black Humour*, Breton wrote: "It can be taken for granted that these remarks apply only to the early Dalí, who disappeared around 1935 and has been replaced by the personality who is better known by the name of Avida Dollars, a society portrait painter who recently returned to the bosom of the Catholic church and to the 'artistic ideal of the Renaissance', and who nowadays quotes letters of congratulation and the approval of the Pope." On the other hand, there were others who took the new Dalí very seriously, and they included critics whose opinions carried weight. Father Bruno Froissart wrote: "Salvador

936

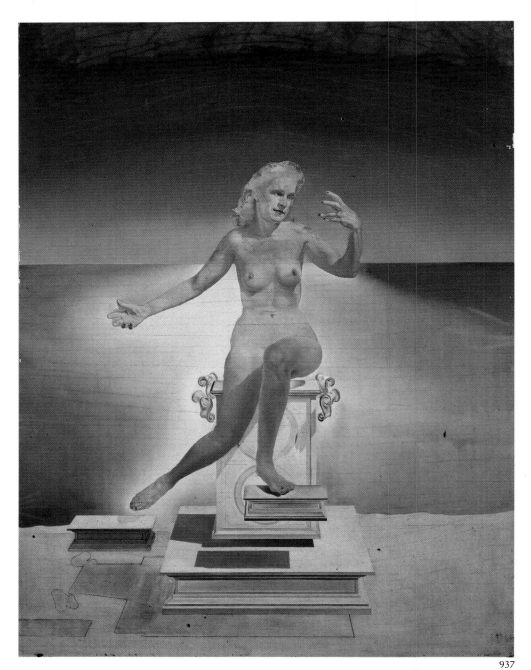

937

936 **The Annunciation**, 1947 △
L'annonciation

937 **Leda Atomica (first unfinished version)**, 1948 ❏

938 **Leda Atomica**, 1949 ❏

Dalí has told me that nothing has as stimulating an effect on him as the idea of the angel. Dalí wanted to paint heaven, to penetrate the heavens in order to communicate with God. For him, God is an intangible idea, impossible to render in concrete terms. Dalí is of the opinion that He is perhaps the substance being sought by nuclear physics. He does not see God as cosmic; as he said to me, that would be limiting. He sees this as a thought process contradictory within itself, one which cannot be summarized in a uniform concept of structure. At heart a Catalonian, Dalí needs tactile forms, and 'that applies to angels, too'… If he has been preoccupied with the Assumption of the Virgin Mary for some time now, it is, as he explains, because she went to heaven 'by the power of the angels'… Dalí conceives protons and neutrons as 'angelic elements'; for, as he puts it, in the heavenly bodies there are 'leftovers of substance, because certain beings strike me as being so close to angels, such as Raphael or St. John of the Cross'."

Jean-Louis Ferrier wrote an entire book, *Leda atomica – Anatomie d'un chef*

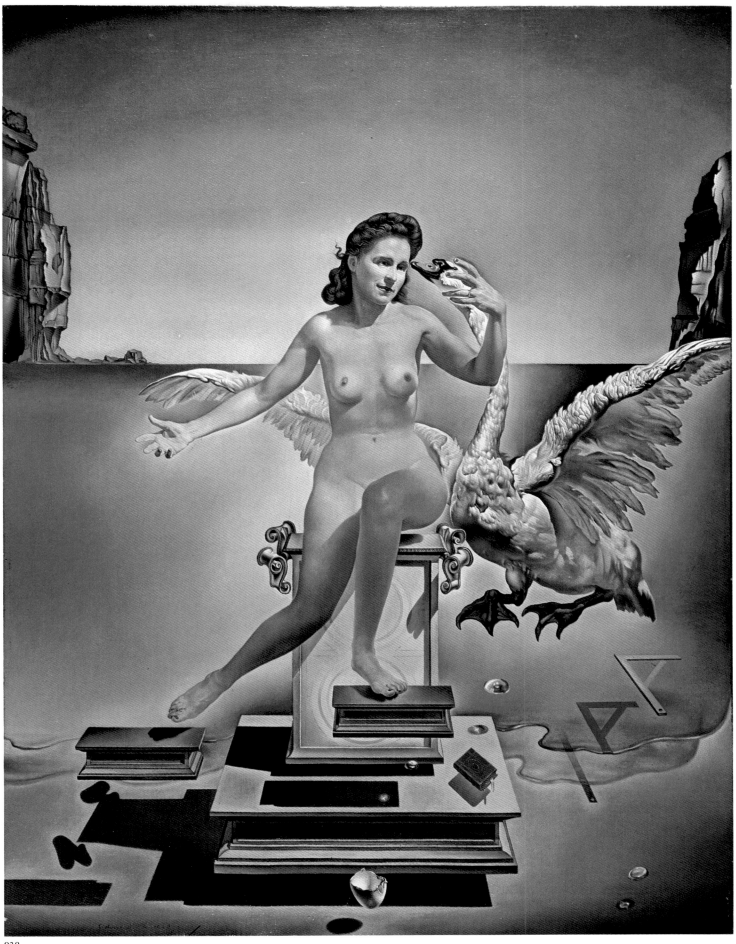

938

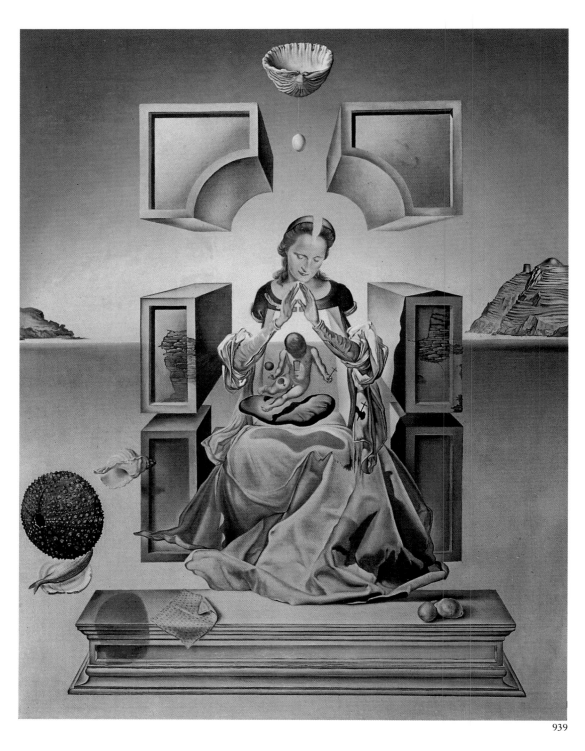

939

939 **The Madonna of Port Lligat
(first version)**, 1949 ❏
La Madone de Port Lligat

d'œuvre, about Dalí's painting *Leda Atomica* (p. 425). Ferrier compares it with
other artists' treatments of the story of Leda: "Erotic 18th century engravings and
graffiti provide a key to the myth of Leda; Zeus is metamorphosed into a phallus
with wings, the better to seduce the wife of Tyndareus. This is the underlying
meaning of the myth, and it is one that remains concealed throughout traditional
art. But Dalí reverses this meaning in *Leda Atomica*. The myth now means the
exact opposite; for the state of levitation in which we see the woman and the swan
stands for purity and sublimation. Seen in this way, *Leda Atomica* introduces
Dalí's religious period… In Western art, down to Poussin and Moreau, the myth
of Leda has always been represented without significant change. But in Moreau
the swan, laying its head upon Leda's, occupies the place normally reserved for
the Holy Ghost. Like Dalí, Moreau was seeing the myth of Leda in terms of

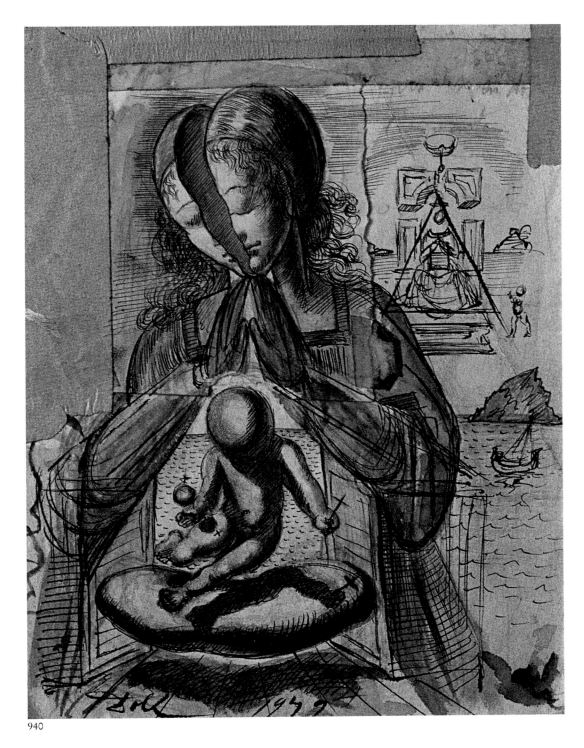

940

940 **Study for "The Madonna of Port Lligat"**, 1949 △

initiation ritual and psychoanalysis." Ferrier hit the nail on the head: "The Dalí delirium will seem less of a delirium if we grasp that basically he is trying to introduce into everyday life the archetypes that constitute the true categories of thought – which Kant, writing a century and a half before psychoanalysis, could not know. Jung was a pioneer when he lamented the terrible lack of symbols in the world at that time." Ferrier ends by saying: "Salvador Dalí differs from most modern painters in his extraordinary virtuosity, which consists in a direct continuation of classical austerity. The artist's painstaking craftsmanship goes hand in hand with a polymorphous grasp of culture which includes traditional disciplines of knowledge as well as contemporary science and the findings of various types of psychoanalysis for nearly a century now. These things together are vital to the meaning of his art."

941

942

943

941, 943 Costumes for the ballet
"El Sombrero de Tres Picos" by
Manuel de Falla, 1949 ☆

942 Set design for "El Sombrero
de Tres Picos", Act 2, 1949 ❏

1949

944

945

946

947

948

430

949

All of Dalí's works are strictly mathematical in conception. The floating state of the figures and objects in his paintings at this time related not only to the Golden Section and contemporary physics, but also to Dalí's spiritual development. Dalí, dualist as ever in his approach, was now claiming to be both an agnostic and a Roman Catholic.

Dalí attributed his twofold habits of perception to the death of his brother (before his own birth). His parents gave Dalí the same name as his dead brother, Salvador: "An unconscious crime, made the more serious by the fact that in my parents' room – a tempting, mysterious, awe-inspiring place to which access was prohibited and which I contemplated with divided feelings – a majestic photo-

944, 945, 946, 947, 948, 949 Set design for the ballet "Los sacos del molinero", 1949 ❏

950 Backdrop for "Don Juan Tenorio", 1950 ❏

951 Four Armchairs in the Sky, 1949 △
Quatre fauteuils dans le ciel

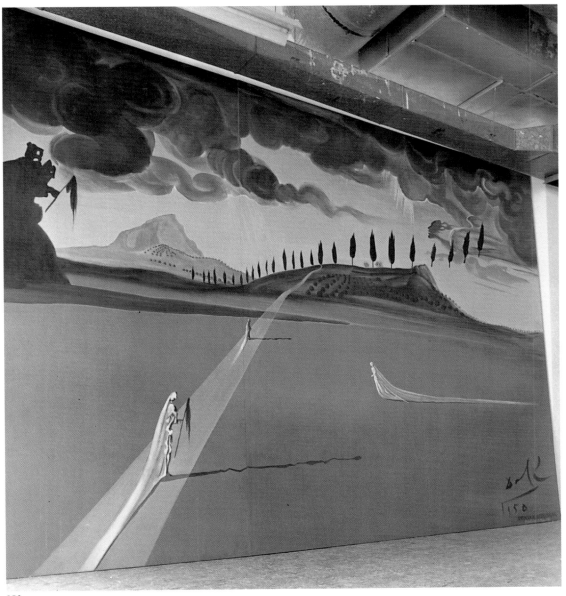

950

graph of my dead brother hung beside a reproduction of Velázquez's *Crucifixon*. And that picture of the Saviour, whom Salvador had doubtless followed on his angelic ascension to heaven, established an archetype within me that arose out of the four Salvadors who made a corpse of me – the more so, since I began to look as much like my dead brother as I looked like my reflection in the mirror. I thought myself dead before I became really aware that I was alive... My preferred psychiatrist, Pierre Roumeguère, assures me that my forced identification with a dead person meant that my true image of my own body was of a decaying, rotting, soft, wormy corpse. And it is quite right that my earliest memories of true and powerful existence are connected with death... My sexual obsessions are all

951

431

linked to soft bulges: I dream of corpse-like shapes, elongated breasts, runny flesh – and crutches, which were soon to play the part of holy objects for me, were indispensable in my dreams and subsequently in my paintings, too. Crutches propped up my weak notion of reality, which was constantly escaping me through holes that I even cut in my nurse's back. The crutch is not only a support: the forked end is an indication of ambivalence."

Thus the dualism or ambivalence that underpins so much of Dalí's life and work began with the death of his brother before his own birth; continued in the merging of Vermeer with the logarithmic, mathematically self-perpetuating spiral; and informed his love for Gala, his "legitimate, scented wife", his new doppelgänger, his muse, his Helen of Troy, his lacemaker, his "Nietzschean rhinoceros forever struggling for power". Dalí stated: "Gala gave me a structure that was lacking in my life, in the truest sense of the word. I existed solely in a sack full of holes, soft and blurred, always looking for a crutch. By squeezing up close to Gala, I acquired a backbone, and by loving her I filled out my own skin. My seed had always been lost in masturbation until then, thrown away into the void, as it were. With Gala I won it back and was given new life through it. At first I thought she was going to devour me, but in fact she taught me to eat reality. In signing my pictures 'Gala-Dalí' I was simply giving a name to an existential truth, for without my twin, Gala, I would not exist any more."

For the creator of the soft watches, Dalí and Gala were the incarnations of the Dioscuri, the heavenly twins born of Leda's divine egg: "Castor and Pollux, the

952 **Dalí's Moustache**, 1950 △
Les moustaches de Dalí

953 **Erotic Beach**, 1950 ❏
Plage érotique

952

953

stereochemical divine twins", was how Dalí referred to the antecedents of himself and his "twin", Gala. And in acquiring a twin, he also "had two memories instead of one, perhaps even three, for the same price, which can only compound the immortality of memory." It is understandable enough that when one of the twins, Gala, died in 1982, the other felt abysmally lonely – the lacemaker without the rhinoceros…

One of Dalí's best known pictures is the *Christ of St. John of the Cross* (p. 451). The figure appears above the bay at Port Lligat. Compositionally, the figure of Christ was inspired by a drawing St. John of the Cross had done while in ecstasy and which is in the keeping of the monastery at Avila. The figures beside the boat were borrowed from a picture by Le Nain and a drawing Velázquez did for his painting *The Surrender of Breda*. Dalí said: "It began in 1950 with a cosmic dream I had, in which I saw the picture in colour. In my dream it represented the nucleus of the atom. The nucleus later acquired a metaphysical meaning: I see the unity of the universe in it – Christ! Secondly, thanks to Father Bruno, a Carmelite monk, I saw the figure of Christ drawn by St. John of the Cross; I devised a geometrical construct comprising a triangle and a circle, the aesthetic sum total of all my previous experience, and put my Christ inside the triangle." When the painting was first exhibited in London, an influential critic damned it as banal. And some years later it was badly damaged by a fanatic in the Glasgow Art Gallery.

954 **Myself at the Age of Six when I Thought I Was a Girl Lifting with Extreme Precaution the Skin of the Sea to Observe a Dog Sleeping in the Shade of the Water**, 1950 ❑
Moi-même à l'âge de six ans, quand je croyais être petite fille, en train de soulever avec une extrême précaution la peau de la mer pour observer un chien dormant à l'ombre de l'eau

955 **Study for "Myself at the Age of Six…"**, 1950 △

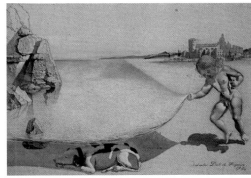

955

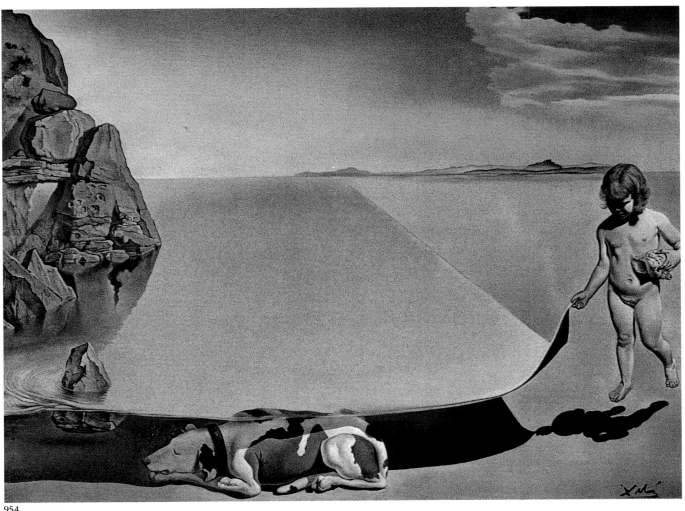

954

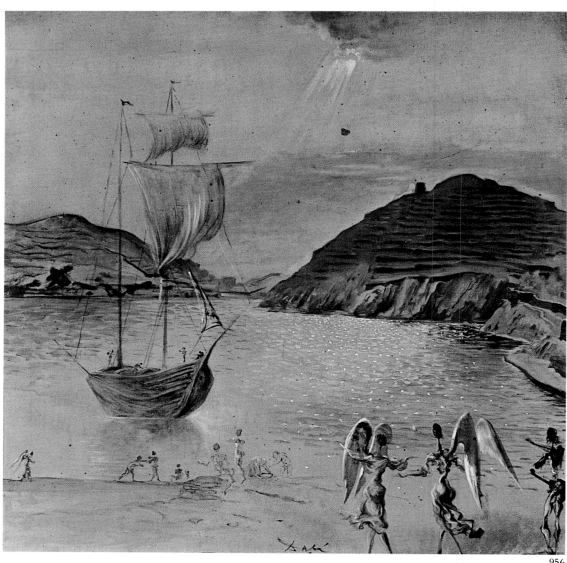

956

Raphael's Atomic Explosion

956 **Landscape at Port Lligat with Homely Angels and Fishermen,** 1950 ❑
Paysage de Port Lligat avec anges familiers et pêcheurs

957 **Landscape at Port Lligat, which was a constant inspiration to Dalí. This photograph was taken in 1955.** ✩

958 **Landscape at Port Lligat,** 1950 ❑
Paysage de Port Lligat

959 **Angel (Study),** 1950 △

In general, Dalí's endeavour was to paint an image of modern times in the manner of the great old masters he so deeply admired, with improvements of his own. It was an attempt expressed in his distinctive synthesis of atomic mysticism and classicism, a synthesis which he described in the *Mystical Manifesto* (1951) and which was to influence all his subsequent work.

It would be wrong, however, to claim that any clear break was made with the earlier work; in fact, neither his technique nor his paranoiac-critical method changed in any real way. If an alteration can be detected, it is in his subject matter. In this connection we do well to bear in mind that Dalí's mysticism was inseparable from erotic deliria. "Eroticism is the royal road of the spirit of God," he declared. If the new man of God relished "the most delicious behinds one can imagine", then he was as likely to paint *Young Virgin Auto-Sodomized by her Own Chastity* (p. 478) as a Madonna, a Christ, or the exploded head of a Raphaelesque saint.

957

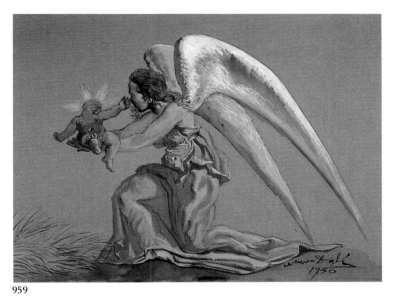

959

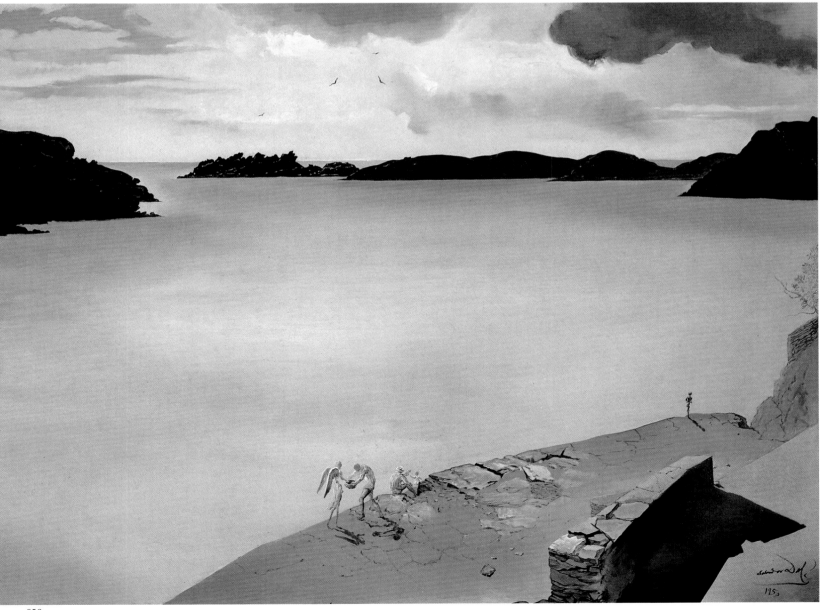

958

1950

960

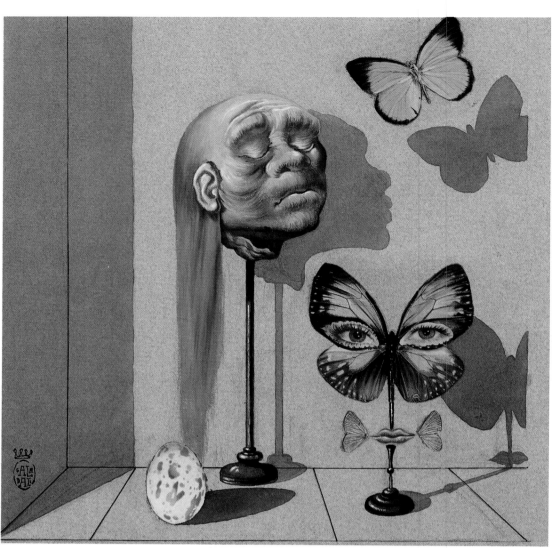

961

960 Death in Person … The Trumpets of the Last Judgement. Drawing for "On the Verge" (La Limite) by Maurice Sandoz, published by Doubleday, New York, 1950 Δ
C'est la mort elle-même…
Les trompettes du jugement dernier

961 Frontispiece for "La Limite" (On the Verge), published by La Table Ronde, Paris, 1950 Δ

962 The Creation of Eve – Gaining Twofold Living Nature from the Sleep of Man, 1950 Δ
La création d'Eve – Rendre du sommeil de l'homme la nature vivante redoublée

963 Kneeling Figure (Microphysical Phosphenes), 1950–1951 Δ
Personnage à genou (Phosphènes microphysiques)

964 The Soft Watch, 1950 Δ
La montre molle

965 Rhinoceros Disintegrating, 1950 Δ
Rhinocéros en désintégration

Dalí's continuity within his own œuvre is very clearly apparent in his Madonnas and Christs. All the geological characteristics of Port Lligat, he declared, referring to *The Madonna of Port Lligat* (p. 443), were present in *The Weaning of Furniture-Nutrition* (p. 226) or *Leda Atomica* (p. 425). But now he had created a tabernacle of living flesh, a thing of sublimation that revealed the heavenly spheres and in which the Christ Child sat at the centre, the bread of the Eucharist suspended at his heart. Similarly, the *Christ of St. John of the Cross* (p. 451) drew upon the technical and artistic resources Dalí had so masterfully demonstrated in *Basket of Bread* (p. 113). When the Museum of Glasgow bought the painting in 1952, Dalí explained in a letter to *Scottish Art Review* (Vol. IV no. 1, 1952): "One of the first objections to this painting came from the position of the Christ, that is, the angle of the vision and the tilting forward of the head. This objection from the religious point of view fails from the fact that my picture was inspired by the drawing made of the Crucifixion by St. John of the Cross himself. In my opinion, it is a drawing made by this saint after an Ecstasy as it is the only drawing ever made by him. This drawing so impressed me the first time I saw it that later in California, in a dream, I saw the Christ in the same position, but in the landscape of Port Lligat, and I heard voices which told me, 'Dalí, you must paint this Christ.' The next day I started the painting. Until the very moment I started the composition, I had the intention of putting in all the attributes of the Crucifixion – the nails, the crown of thorns, etc. – and it was my intention to change the blood into red carnations which would have hung from the hands and feet, along with three jasmine flowers issuing from the wound in the side. These flowers would

962

963

964

965

1950

966

967

**966 The set of the ballet "Don Juan
Tenorio", 1950** ☆

**967 Design for the death scene in
"Don Juan Tenorio", 1950** Δ
Escenografía de la muerte «Don Juan»

**968 Landscape with Horseman and
Gala, 1951** Δ
Paysage avec cavalier et Gala

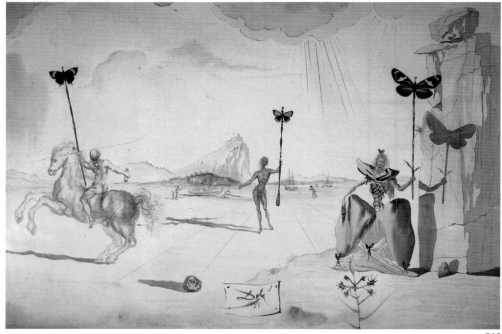

968

969

969 **Untitled (Ants and Wheat Ear),**
c. 1951 Δ
Sans titre (Fourmis et épis de blé)

970 **Exploding Flower,** c. 1951 Δ
Fleur explosive

970

1950

971 **Mystical Carnation,**
1950–1951 ❏
Œillet mystique

972 **Carnation and Cloth of Gold,**
1950 ❏

973 **Study for the head of "The**
Madonna of Port Lligat", 1950 Δ

971

972

974 **Metamorphosis and Dynamic**
Disintegration of a Cuttlefish Bone
Becoming Gala (Study for "The
Madonna of Port Lligat"), 1950 Δ
Métamorphose et désintégration
dynamique d'un os de seiche devenu
Gala

975 **Study for the child in "The**
Madonna of Port Lligat", 1950 Δ

976 **Cork (Study for "The Madonna**
of Port Lligat"), 1950 ❏

977 **Study for the drapery in "The**
Madonna of Port Lligat", 1950 Δ

973

have been executed in the ascetic manner of Zurbarán. But a second dream, just towards the completion of my painting, changed all this, and also perhaps the unconscious influence of a Spanish proverb which says, 'A bad Christ, too much blood'. In this second dream I saw again my picture without the anecdotal attributes but just the metaphysical beauty of Christ-God. I also first had the intention of taking as models for the landscape the fishermen of Port Lligat, but in this dream, in place of the fishermen of Port Lligat, there appeared in a boat a figure of a French peasant painted by Le Nain of which the face alone had been changed to resemble a fisherman of Port Lligat. Nevertheless, the fisherman, seen from the back, had a Velázquezian silhouette.

My aesthetic ambition, in this picture, was completely the opposite of all the Christs painted by most of the modern painters, who have all interpreted Him in the expressionistic and contortionistic sense, thus obtaining emotion through ugliness. My principal preoccupation was that my Christ would be beautiful as

975

976

974

977

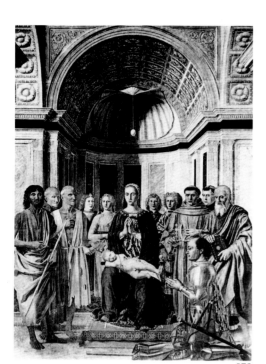

978

980

979

978 **Piero della Francesca: Madonna and Child**, 1470–1475 ✭

979 **A drop of milk: stroboscopic photograph of the impact splash at 1/100,000th of a second exposure** ✭

980 **Study after "Madonna and Child" by Piero della Francesca for "The Madonna of Port Lligat"**, 1950 △

981 **The Madonna of Port Lligat**, 1950 ❑
La Madone de Port Lligat

the God that He is. In artistic texture and technique, I painted the *Christ of St. John of the Cross* in the manner in which I had painted my *Basket of Bread*, which even then, more or less unconsciously, represented the Eucharist for me.

The geometrical construction of the canvas, especially the triangle in which Christ is delineated, was arrived at through the laws of Divine Proporzione by Luca Pacioli."

Though the great difference between Picasso and Dalí (at least according to the latter) was that Picasso's labours were devoted to ugliness and Dalí's to beauty, one thing is clear: both artists pushed back the frontiers of art with dramatic assurance. *Raphaelesque Head, Exploded* (p.444) is a fine example of Dalí's peculiar approach to pushing them back. J. P. Hodin, in "A Madonna Motif in the Work of Munch and Dalí" (*The Art Quarterly*, 16, summer 1953), observed: "In contemporary painting it was Picasso who first demonstrated… broken forms in the period of analytical cubism. This disintegrated form symbolizes the end of an idealistic notion, that of the Virgin Mary. But Dalí does not suffer as Munch did. He is a cold observer of fact. Moreover, the inner volume of the head represents in *Raphaelesque Head, Exploded* a Renaissance cupola. It is evident that what is here burst is not only an individual ideal but a whole cultural edifice.

The Raphaelesque Madonna itself was no longer the Madonna of a profound belief as had been that of the Sienese masters. In the age of Leonardo da Vinci, the other-worldly Christian vision began to crumble under the impact of scientific thought. The constructivist Gabo is conscious of this process when he writes: 'At first sight it seems unlikely that an analogy can be drawn between a scientific work of Copernicus and a picture by Raphael, and yet it is not difficult to discover the tie between them. In fact Copernicus' scientific theory of the world is coincident with Raphael's conception in art. Raphael would never have dared to take the naturalistic image of his famous Florentine pastry cook as a model for the Holy Mary if he had not belonged to the generation which was already prepared to abandon the geocentric theory of the Universe.' In the artistic concept of Raphael there is no longer any trace of the mythological religious mysticism of the previous century as there is no longer any trace of this mysticism in Copernicus' book, *Revolution of the Celestial Orbits*. Dalí uses a vulgarized, de-

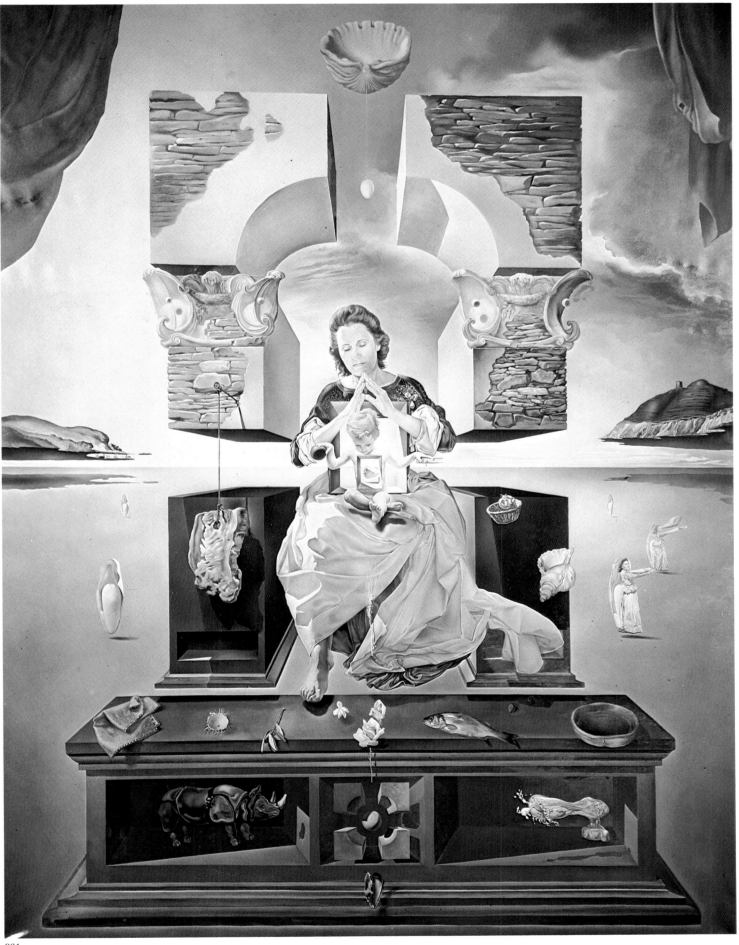

981

982

983

984

982 Giovanni Paolo Pannini: The Interior of the Pantheon (detail), c. 1750. Building of the Pantheon was begun by Agrippa in 27 B.C. and completed by Hadrian between A.D. 118 and 125–128. ☆

983 Celestial Coronation, c. 1951 △
Couronnement céleste

984 Raphaelesque Head, Exploded, 1951 ❏
Tête raphaëlesque éclatée

idealized Raphaelesque type with pretty features. The beautiful head explodes as it were under the bombardment of Sperma, which by way of a magnificent trick of the artist are collected inside the head on the stalk of an ear of corn, the symbol of Demeter, of fertility and growth. Both Munch and Dalí give the metamorphosis of the archetypal idea of immaculate womanhood in its Gothic and Renaissance shape; they demonstrate the transformation of a world conception."

In an afterword to his *Secret Life*, Dalí remarked: "At this moment I do not yet have faith, and I fear I shall die without heaven." In May 1952, in *Liturgical Arts*, he spelt out more clearly the creed that was to underpin his future development as an artist, a conviction that in painting a genius without faith was of greater value than a believer without genius. His old friend the couturier and himself were at one, in an age that was seeing the decline of religious art, in feeling that geniuses without faith were more desirable than believers without genius. They were convinced (averred Dalí) that even atheists or members of the Communist Party (such as Picasso) – geniuses, in a word – could produce important religious works of art if they so desired. And Dalí said that not a day passed but he prayed that

985

986

987

Picasso would renounce Communism and turn to Spanish mysticism, which one really might think was in his blood, after all. Of course there was a daemonic danger for religious art if it availed itself of atheist artists; the best thing would undoubtedly be for religious art to be created, as it was in the Renaissance, by artists whose faith was the equal of their genius, such as Zurbarán, El Greco, Leonardo da Vinci or Raphael. Catholics believed in the freedom of the human soul, said Dalí, which was the reason why Catholicism, in its universality, must accept the exploration of any and every authentic spirituality, regardless of whether it was at one with the Catholic religion. And even if the Catholic Church was in every respect the very opposite of Communism, which was even capable of spurning music for political reasons, that need be no obstacle! One thing was for sure: modern art embodied the worst consequences of materialism, which produced pure decorativeness. The purely decorative was safe from certain dangers, such as failure in broaching great religious themes; but so-called abstract artists (Dalí continued) were at bottom artists who believed in nothing whatsoever. To believe in nothing led inevitably to non-representational, non-fig-

contd. on p. 455

985 **The Wheelbarrows (Cupola Consisting of Twisted Carts)**, 1951 Δ
Les brouettes (Panthéon formé par des brouettes en contorsion)

986 **Raphaelesque Head, Exploding,** c. 1951 Δ
Tête raphaëlesque éclatant

987 **Explosive Madonna,** 1951 Δ
La madone explosive

988

989

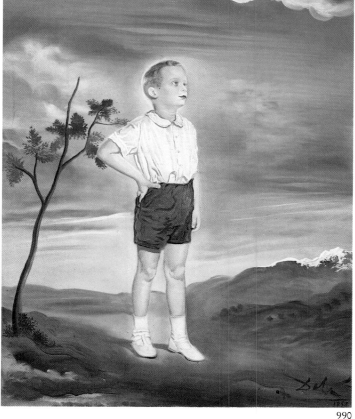

990

988 **"La turbie" – Sir James Dunn Seated**, 1949 ❏
«La turbie» – Sir James Dunn assis

989 **Portrait of Colonel Jack Warner**, 1951 ❏
Portrait du Colonel Jack Warner

990 **Portrait of a Child (unfinished?)**, 1951 ❏
Portrait d'enfant

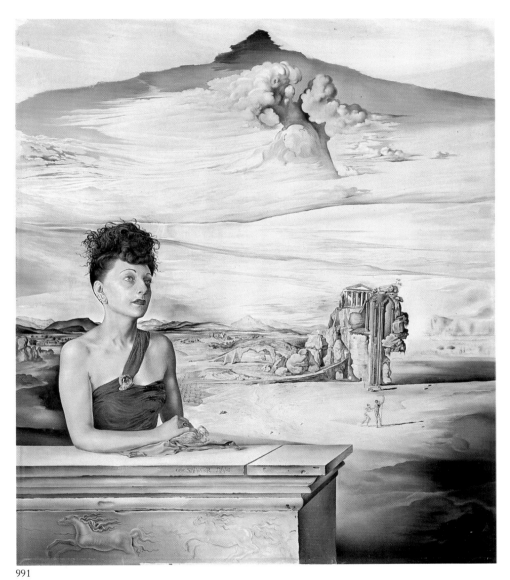

991

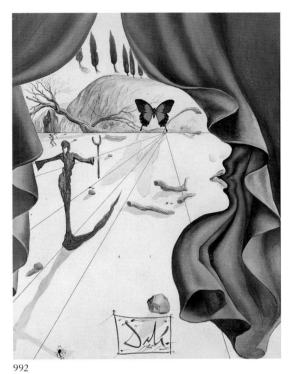

992

991 **Portrait of Mrs. Jack Warner,**
1951 ❑
Portrait de Mrs. Jack Warner

992 **Portrait of Katharina Cornell,**
1951 ❑
Portrait de Katharina Cornell

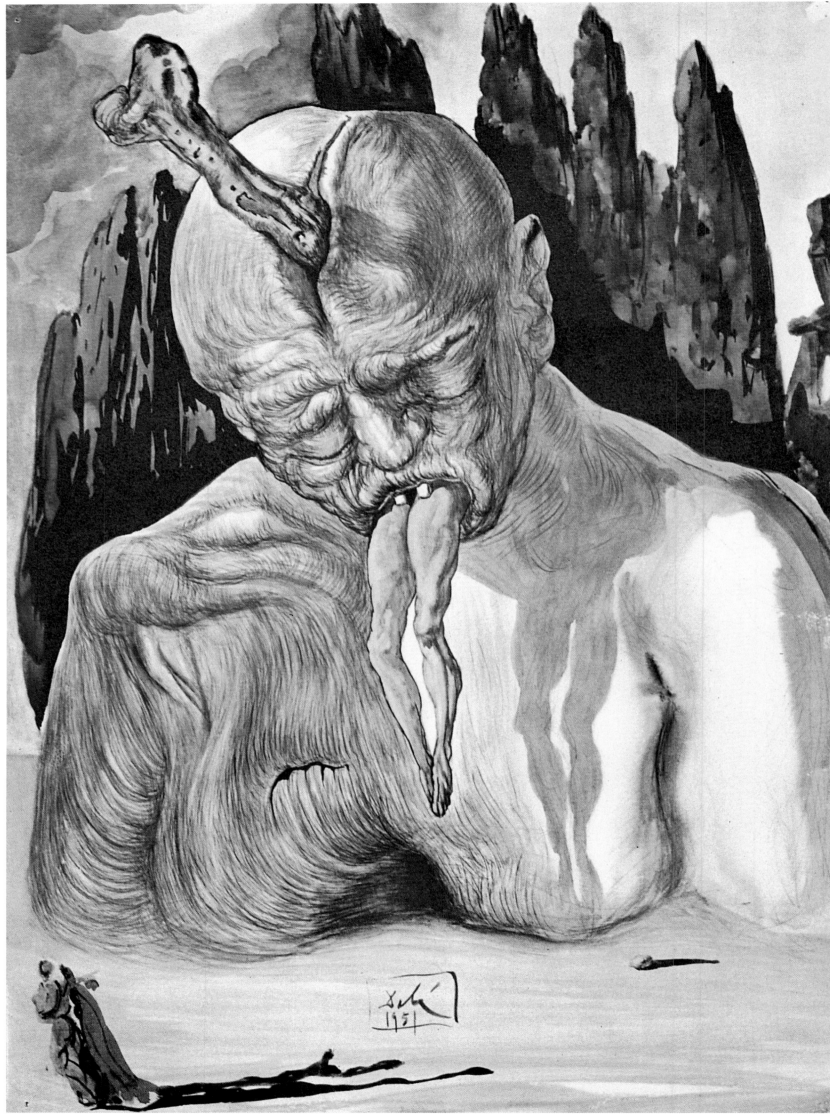

994 Cerberus. Illustration for the "Divine Comedy", 1951 Δ

995 The Fallen Angel. Illustration for the "Divine Comedy", 1951 Δ
L'ange déchu

996 The Followers of Simon. Illustration for the "Divine Comedy", 1951 Δ
Les Simoniaques

1951

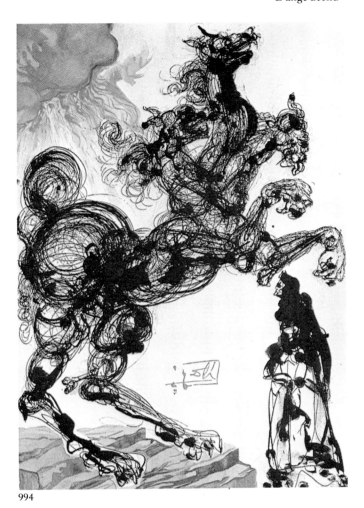

994

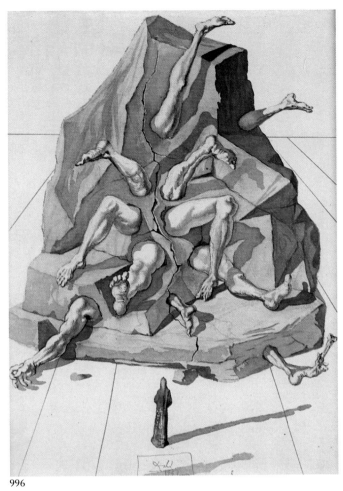

996

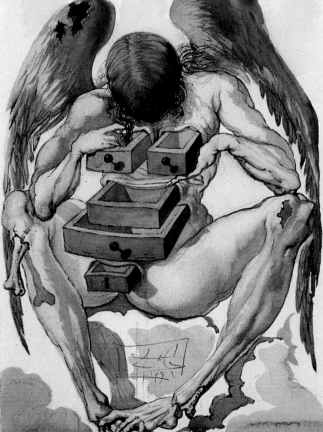

995

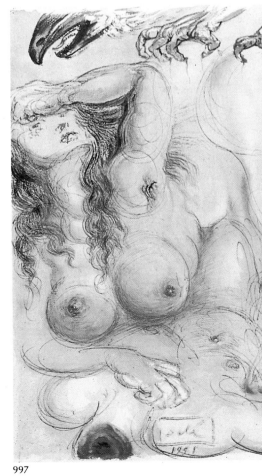

997

449

993 A Logician Devil – Lucifer. Illustration for Dante's "Divine Comedy". Commissioned by the Italian government, 1951 Δ
Un diable logicien – Lucifer

997 Illustration for the "Divine Comedy", 1951 Δ

998

999

1000

998 **"Christ on the Cross", drawn by St. John of the Cross (1542–1591) in a state of ecstasy.** ✩
Dalí's attention was drawn to this drawing by one Father Bruno. It struck him with the force of revelation, and inspired this unforgettable painting. What impressed him most was that St. John of the Cross had not drawn the crucifixion in its customary upright angle but in the position in which a dying person offered a cross to kiss would see it.

999 **Study for "Christ of St. John of the Cross",** 1950 △

1000 **Study for "Christ of St. John of the Cross",** 1951 △

1001 **Velázquez: Study for "The Surrender of Breda",** c. 1635 ✩

1002 **Louis le Nain: Farmers in front of their House (detail),** 1642 ✩

1003 **Christ of St. John of the Cross,** 1951 ❑
Christ de saint Jean de la Croix

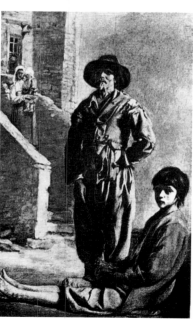

1001 1002

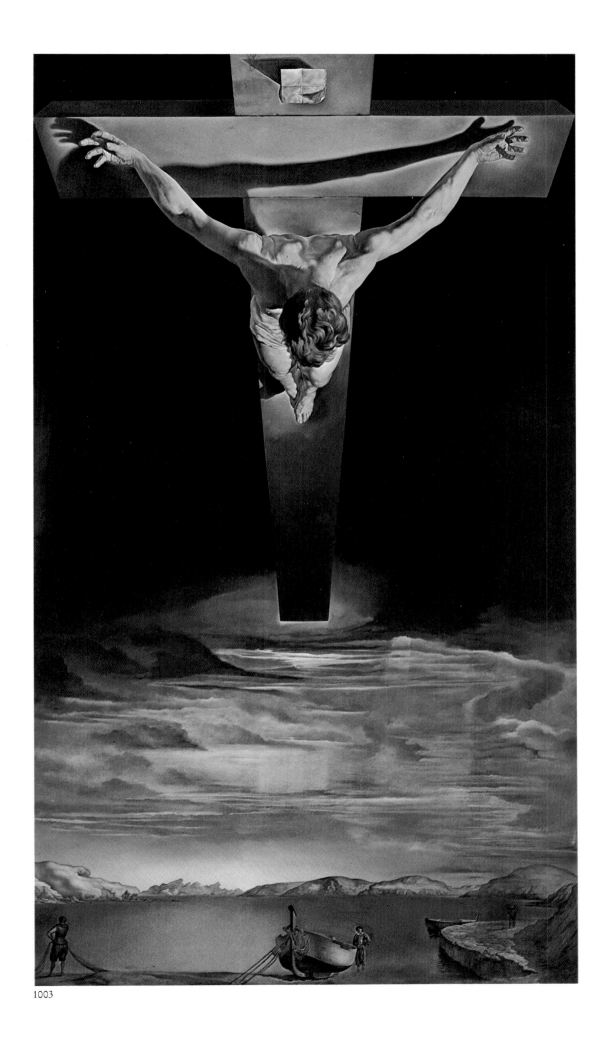

1003

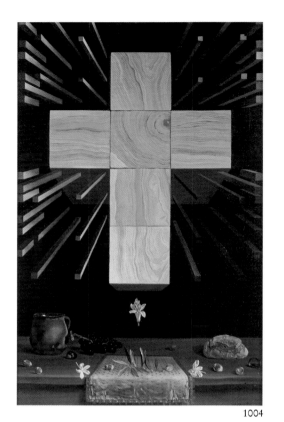

1004

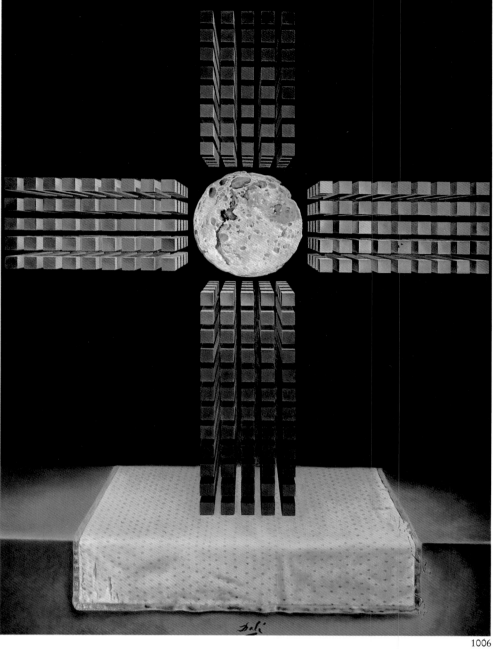

1006

1005

SALVADOR DALI

MANIFESTE MYSTIQUE

1007

452

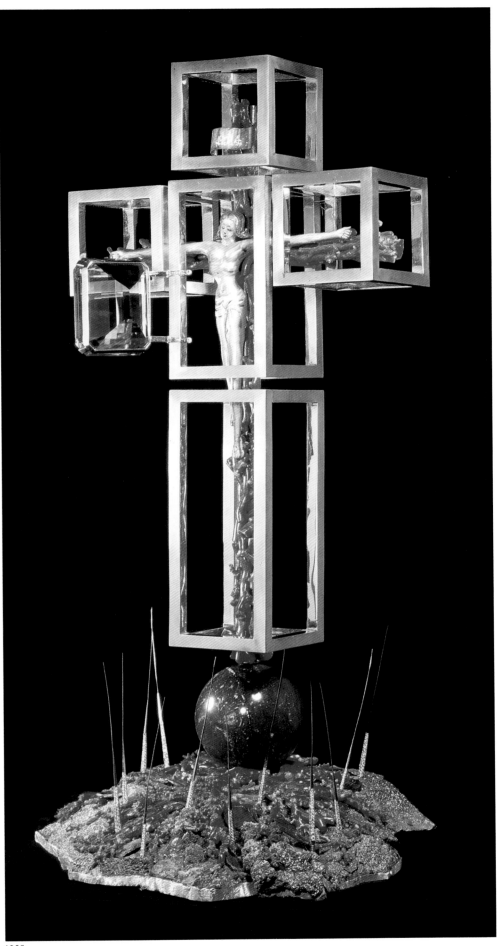

1004 **Arithmosophic Cross**, 1952 ❏
La croix aux iris

1005 **The Royal Heart**, 1953 ○
Le cœur royal

1006 **Nuclear Cross**, 1952 ❏
Croix nucléaire

1007 **Title page of the "Mystical Manifesto"**, 1951 ☆

1008 **The Angel Cross**, 1960 ○
Le croix de l'ange

1008

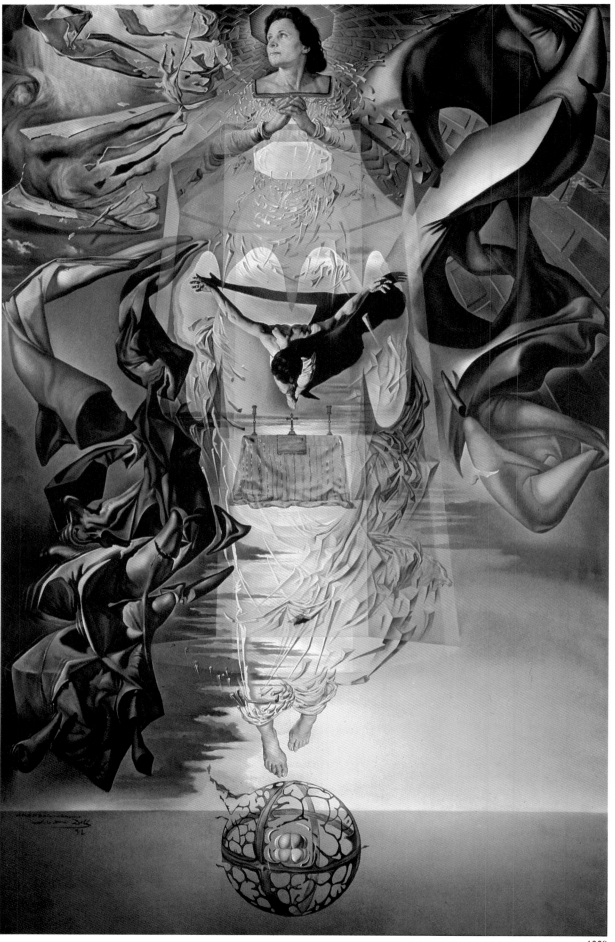

1009

1010

1011

urative painting. Those who believed in nothing would paint nothing too – or very nearly nothing. That very nearly nothing could at times produce happy finds, or attractive associations of form and colour; and therefore it was perfectly legitimate to employ this kind of art in the service of the decorative when it had no meaning whatsoever, as in patterns on drapes or church windows, where the sole function was to establish an atmosphere. Such an atmosphere might (for instance) be amply enjoyed in certain Spanish churches where the geometrical and polychromatic residue of Moorish culture (such as survived the post-reconquest destruction) afforded rich pleasures to the eye. But in general, Dalí for his part asserted that he was firmly convinced that the end of materialism was nigh. The signs were apparent, he declared, in the extraordinary progress made in nuclear physics, a science he felt would lead the younger generation back to religious faith and to mysticism. Dalí sensed an overwhelming force of renewal was about to break upon modern painting, a reaction to present-day materialism that would provide figurative keys to a new religious cosmology.

Henceforth, in works such as *Feather Equilibrium* (p. 409) or *Nuclear Cross* (p. 452), Dalí's point of reference was always the *Mystical Manifesto* – or, as he later referred to it (with greater precision), his *Anti-Matter Manifesto*. His logic, as always, was irrefutable: if physicists were producing anti-matter, why should not painters, who already specialized in depicting angels, be permitted to paint it? In the Surrealist period, said Dalí, he had been out to create the iconography of an inner world, the realm of Father Freud. He had succeeded. Now the outer world of physics had outstripped that of psychology, and Heisenberg was his new father. Ever since he had had to spend a month and a half in hospital recuperating from an appendicitis operation, during which time he had done a lot of reading, Dalí had been enthusiastic about the new physics – not least because he was convinced that he was at least as intelligent as the scientists, since he had arrived at the same conclusions independently (he claimed). Hence his admiration for Heisenberg. Dalí's atomic approach to art covered a multitude of techniques, from molecular structural precision to the gelatinous viscosity of the primaeval soup. His aim was invariably to integrate the discoveries and experiences of modern art into the great classical tradition. The latest microphysical structures – such

1012

1013

1014

1013 **Gala Placida**, 1952 △

1014 **Equestrian Molecular Figure**, 1952 △
Figure équestre moléculaire

1015 **Galatea of the Spheres**, 1952 ❑
Galatée aux sphères

as those of Klein, Matthieu or Tàpies – cried out to be redeployed in painting, since they represented none other than what the brush stroke represented in the age of Velázquez (of whom Quevedo, the incomparable Spanish writer, had said he painted with dabs of sunlight).

Mysticism and good draughtsmanship were the twin roads to salvation by which Salvador, the appointed saviour of modern art, was going to achieve a renewal of aesthetics. Dalí felt that Picasso's crusade had paved the way for the royal arrival of Salvador's new mystic presence. In 1951, he declared, there could be no experiences more subversive for an ex-Surrealist than, first, to become a mystic, and, second, to be able to draw. And both sources of strength were his, Dalí's. Catalonia, he declared, had produced three geniuses: Raymond de Sebond, author of the *Théologie naturelle*; Gaudí, the great architect of Mediterranean Neo-Gothic; and Salvador Dalí, inventor of the new paranoiac-critical mysticism and, as his very name suggested, saviour of art.

Dalinian mysticism was founded upon the metaphysical spirituality of quantum physics in particular, and on morphology in general. Form was a reaction of matter to inquisitorial compulsions from without. Beauty, for Dalí, was always an extreme spasm in a long and unremitting inquisitorial process. Freedom was non-form. Every rose grew to perfection in a prison. The finest architecture of the human soul was the temple of San Pietro, which recalled the divine Bramante in Rome, and El Escorial in Spain – both, according to Dalí, conceived in a spirit of ecstasy. Ecstasy was the polar opposite of academicism, the one incorruptible, the other corruptible.

Dalí's advice to would-be artists was to paint what they saw in nature, as honestly as possible. He advised use of Renaissance technique, since it represented

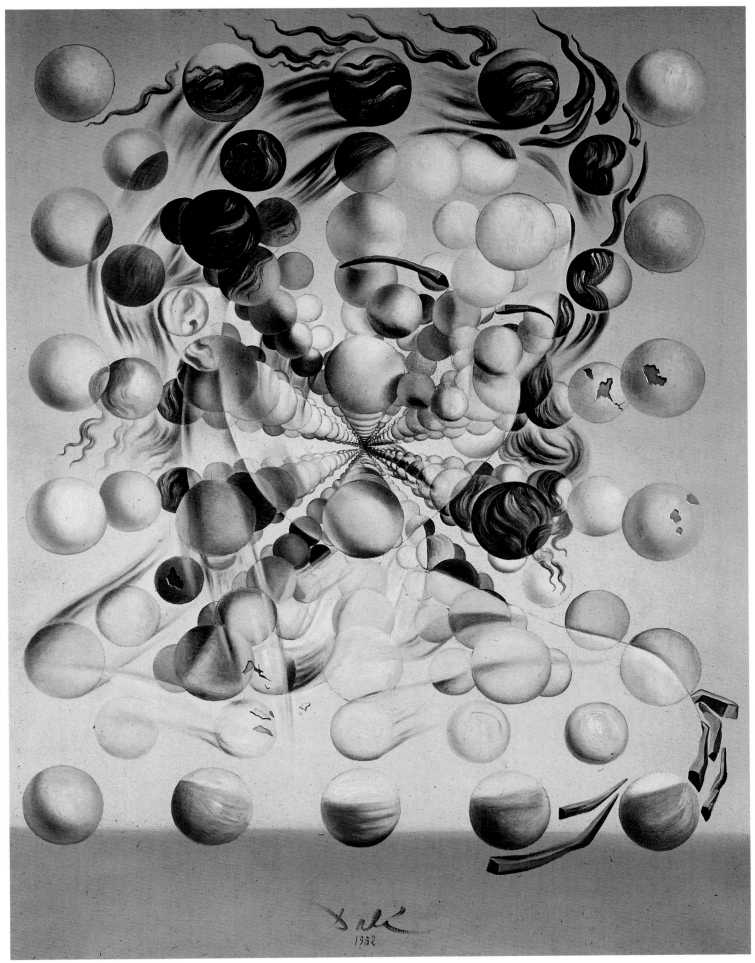

1015

1952

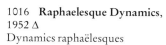

1016 **Raphaelesque Dynamics**,
1952 Δ
Dynamics raphaëlesques

1017 **Madonna in Particles**, 1952 Δ
Madone corpusculaire

the peak of achievement in visual representation. The decadence of modern painting came from scepticism and the lack of faith, and these derived in turn from rationalism, positivism, belief in progress, and mechanistic or dialectical materialism. Dalí urged Pythagoras, Heraclitus, the limpid aesthetics of Luca Pacioli, and St. John of the Cross, upon the attention of artists.

Dalí was fascinated by the modern insight that matter was continually in a state of process, dematerializing and dissolving constantly. This, he felt, proved the spirituality of substance. And the physical light of Dalinian paranoiac-critical activity, he said, was similarly a thing of waves and particles.

Ever since the theory of relativity had banished Time from its throne and relegated it to a relative function (in the spirit of Heraclitus, who said "Time is a child", and of Dalí's famous soft watches), and ever since the other complex insights of twentieth century physics, it had been an open secret that the great problem facing metaphysics was the nature of substance. In aesthetics, it was mystics alone (asserted Dalí) who could establish the new golden sections of the spirit of the age. If a new Renaissance had not yet begun, it was the fault of the

contd. on p. 471

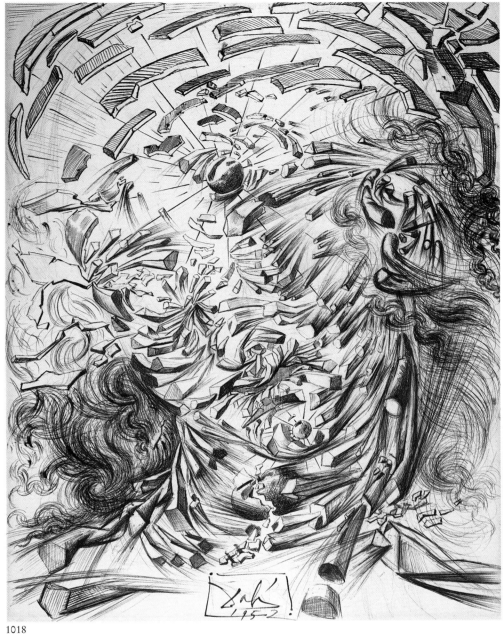

1018

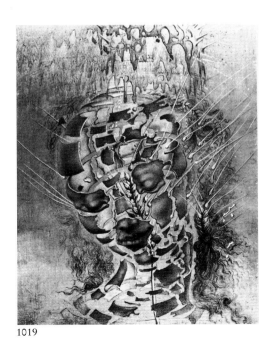

1019

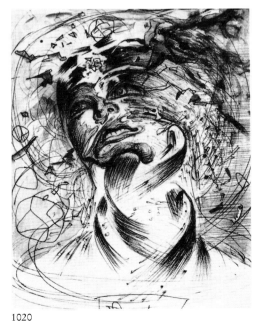

1020

1018 **Nuclear Head of an Angel,**
1952 △
Tête nucléaire d'un ange

1019 **Study for the Head of the
Virgin,** 1952 △

1020 **Exploding Head,** 1952–1954 △
Tête explosive

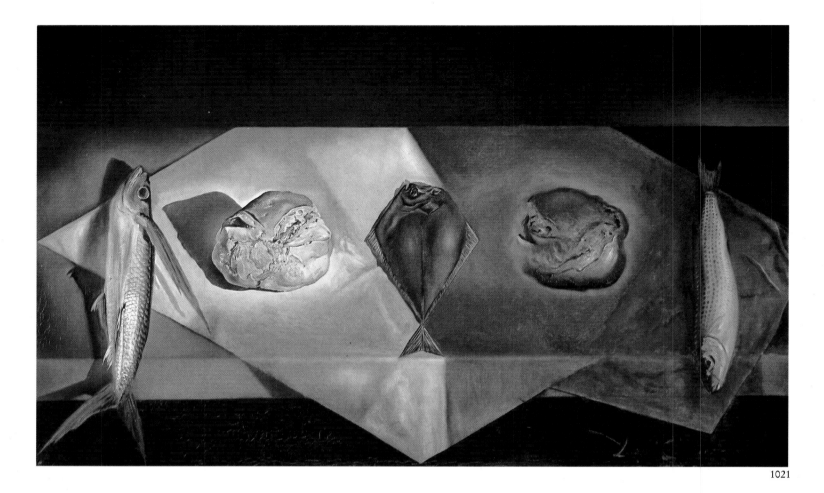

1021

1022

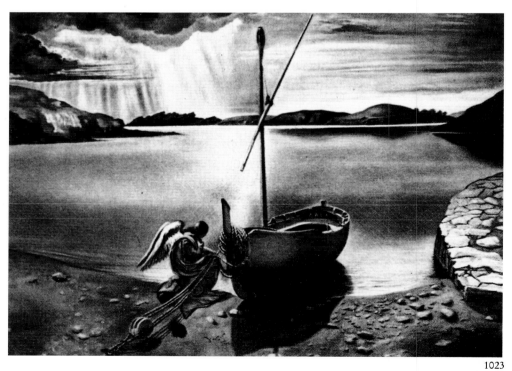

1023

1021 **Eucharistic Still Life**, 1952 ❏
Nature morte évangélique

1022 **The Tree**, 1952 ❏
L'arbre

1023 **The Angel of Port Lligat**,
1952 ❏
L'ange de Port Lligat

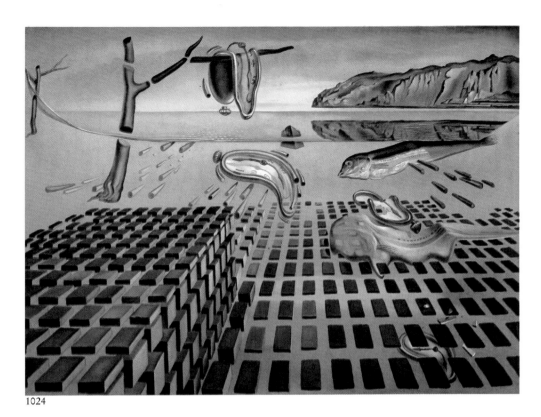

1024

1024 **The Disintegration of the Persistence of Memory**, 1952–1954 ❏
Désintégration de la persistance de la mémoire

1025 **The Angel of Port Lligat**, 1952 ❏
L'ange de Port Lligat

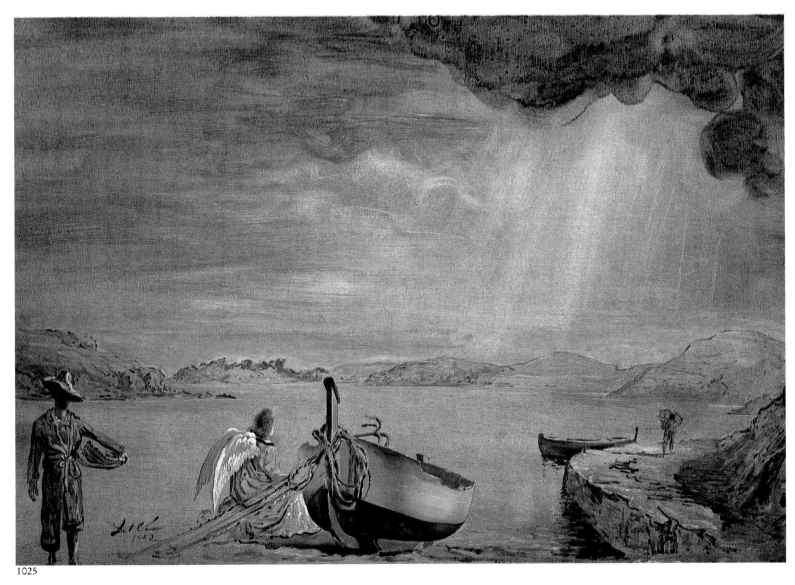

1025

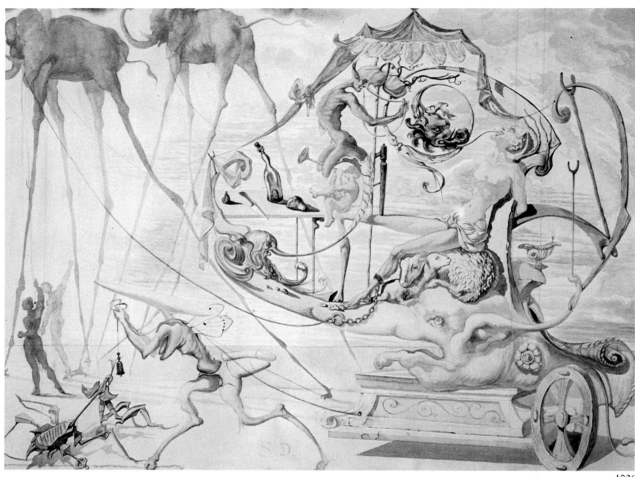

1026

1026 **The Grape Pickers: Bacchus'
Chariot (The Triumph of Dionysus),**
1953 Δ
Les vendangeurs: le char de Bacchus
(Le triomphe de Dionysios)

1027, 1029, 1030 **Costume designs
for "Le Ballet des vendangeurs" (The
Grape Pickers' Ballet),** 1953 Δ

1028 **Tortoise, for "Le Ballet des
vendangeurs",** 1953 Δ

1027

1028

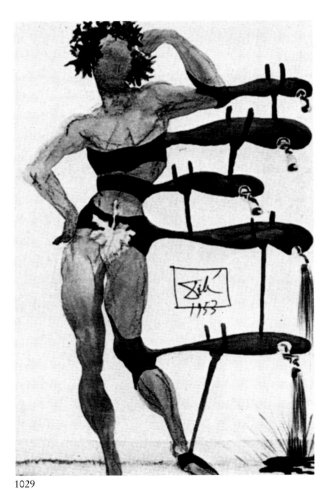

1029

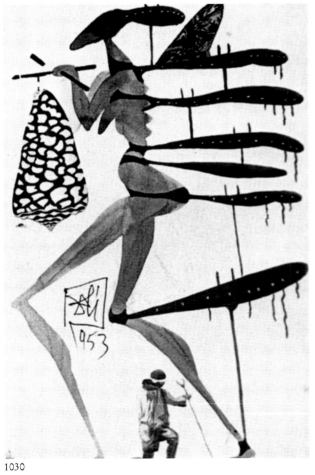

1030

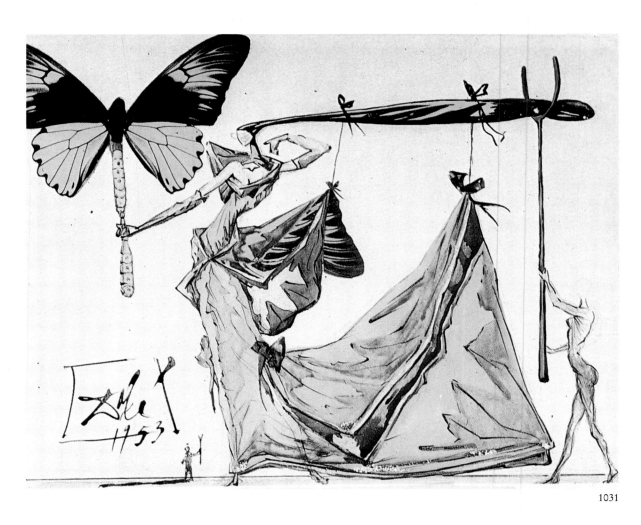

1031

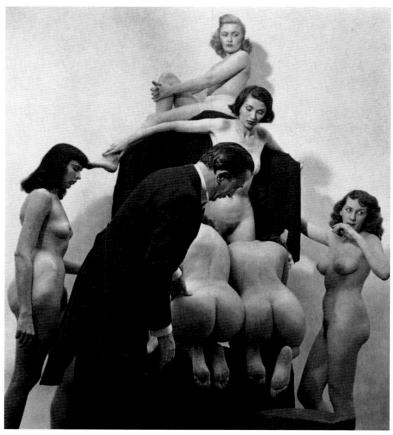

1032

1033

1034

1036

1038

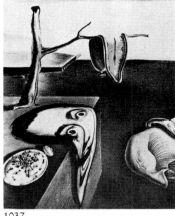

1037

1039

1035

1031, 1034 **In 1953 Dalí entered a New York fashion contest. The theme was "The Woman of the Future". The dress he designed was so huge that Philippe Halsman was unable to photograph it in the streets, and had to take it to the roof of the "Roxy". The photographer's daughter modelled the dress.** ✩

1032, 1033, 1035 **Female Bodies as a Skull.** Photographs by Philippe Halsman, after a gouache by Dalí. The final result of their patient efforts can be seen on p. 337. ✩

1036, 1037, 1038, 1039 **Four photo-portraits by Dalí: Dalí Cyclops, Dalí Mona Lisa, Dalí Soft Watch, Dalí Avida Dollars. Photographs: Philippe Halsman, from "Dalí's Moustache", 1954** ✩

1954

1040 **Crucifixion**, 1954 ❏

1041 **Gala Contemplating "Corpus Hypercubus"**, 1954 ❏
Gala regardant le «Corpus Hypercubus»

1042 **Portrait of Gala with Rhinocerotic Symptoms**, 1954 ❏
Portrait de Gala avec symptômes rhinocérontiques (Galatea)

1040

1041

1042

1043 **Corpus Hypercubus (Crucifixion)**, 1954 ❏
Corpus Hypercubus

1044 **St. James of Compostela.** Detail showing the same folds in Gala's cloak from a different angle. 1957 ✰

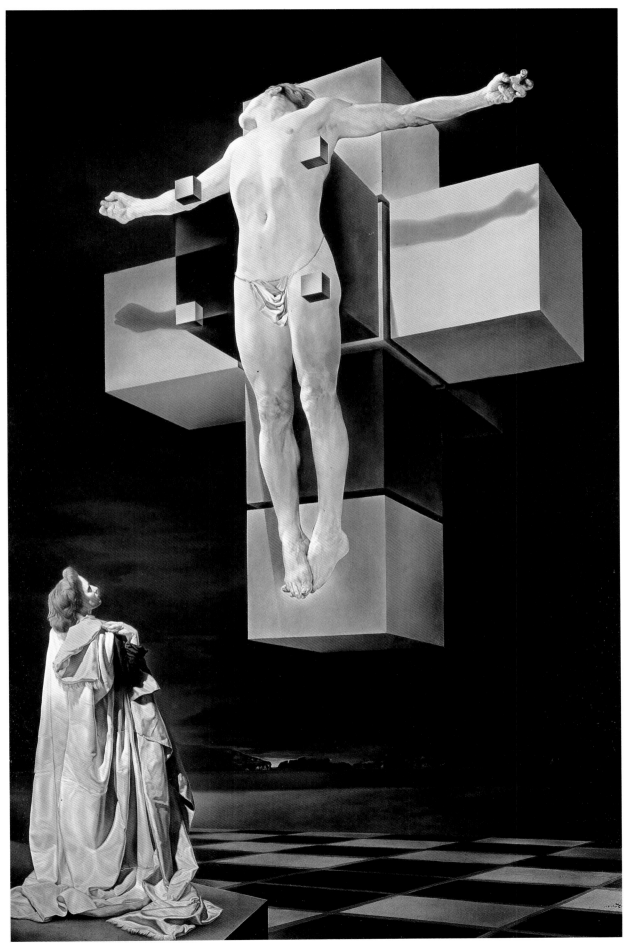

1043

1044

1954

1045 **Anthropomorphic Figure**, 1954 Δ
Figure anthropomorphe
1046 **Grey Head of an Angel**, 1952–1954 Δ
Tête d'ange gris
1047 **Head Bombarded with Grains of Wheat
(Particle Head over the Village of Cadaqués)**,
1954 ❏
Tête bombardée par des grains de blé (Tête corpusculaire sur le village de Cadaqués)

1048 **The Maximum Speed of Raphael's
Madonna**, 1954 ❏
La madone de Raphaël à la vitesse maximum

1049 **Soft Watch at the Moment of First Explosion**, 1954 ❏ Montre molle au moment de sa première explosion
1050 **Microphysical Madonna**, 1954 ❏
Madone microphysique
1051 **Madonna and Particle Child (Nuclear Drawing)**, 1954 Δ Madone et enfant corpusculaires (Dessin nucléaire)
1052 **Sketch for "Soft Watch Exploding into 888 Pieces after Twenty Years of Complete Motionlessness"**, 1954 Δ
«Montre molle explosant en 888 morceaux après vingt ans de complète immobilité»

1045

1047

1048

1050

1051

1046

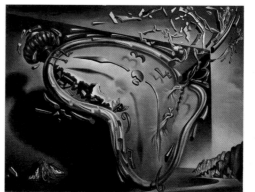

1049

1052

1053 **Rhinocerotic Disintegration
of Illissus of Phidias**, 1954 ❏
Figure rhinocérontique de l'Illisos de
Phidias

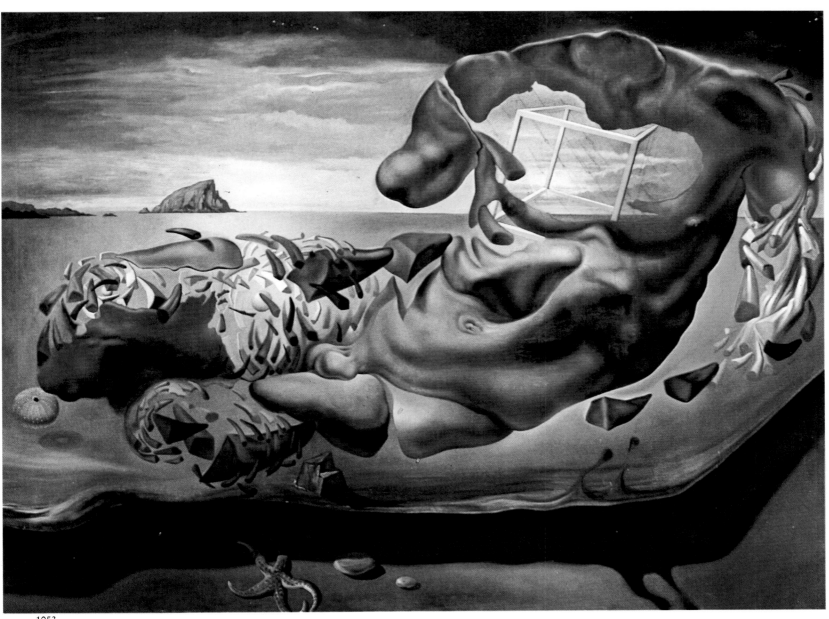

1053

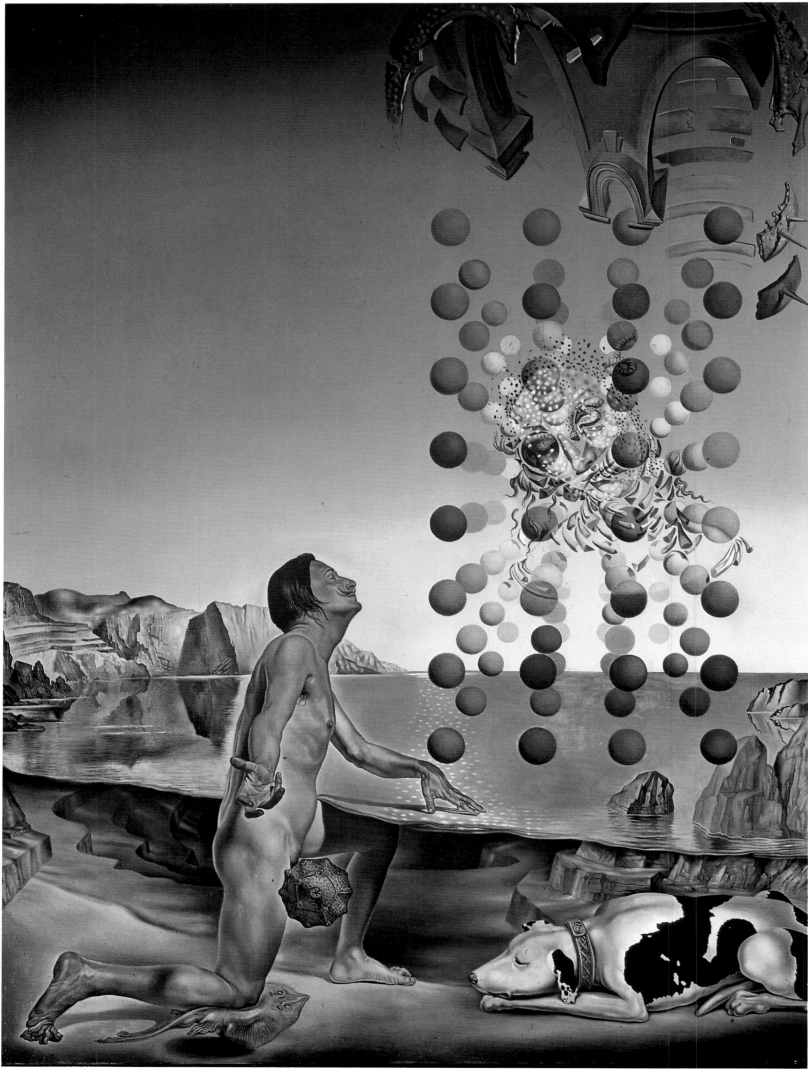

artists, who this time were behind the scientists, limping along behind modern progress or indolently grazing in pathetic Marxist pastures. Contemporary painters, declared Dalí, painted nothing: they were non-figurative, non-objective, non-expressive in approach, and painted nothing whatsoever.

Dalí concluded his *Mystical Manifesto* (which he dated 15 April 1951, at Neuilly):

"NON!

Finished repudiation and retrogression, finished surrealist indisposition, existential anguish, mysticism and the paroxysm of joy in the ultra-individualist affirmation of all man's heterogeneous tendencies toward the absolute unity of ecstasy. I want my next Christ to be the painting containing the most beauty and joy that has ever been painted up to today. I want to paint a Christ who will be absolutely the contrary in everything from the materialist and savagely antimystic Christ of Grünewald!

1054 **Dalí Nude, in Contemplation before the Five Regular Bodies Metamorphized into Corpuscles, in which Suddenly Appear the Leda of Leonardo Chromosomatized by the Visage of Gala**, 1954 ❏
Dalí nu, en contemplation devant cinq corps réguliers métamorphosés en corpuscules, dans lesquels apparaît soudainement la Léda de Léonard chromosomatisée par le visage de Gala

1055 **Galatée**, 1954–1956 ❏

1056 **In this detail from "Myself at the Age of Six…" the same dog appears as in "Dalí Nude, in Contemplation…"**, 1950 ✫

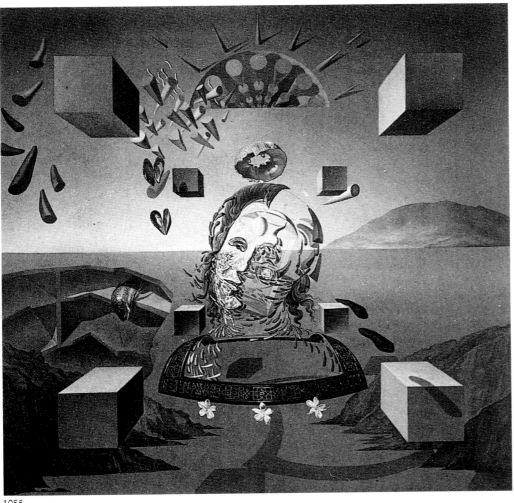

1055

1056

1057

1057 **Ayne Bru (16th century): Martyrdom of St. Cucufa. The ubiquitous Dalí dog originated in this painting.** ✫

471

1954

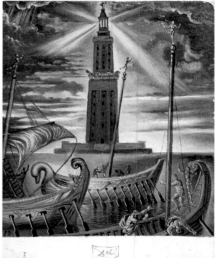

Designs for a film, "The Seven Wonders of the World":

1058 **The Colossus of Rhodes,** 1954 ❑
Le colosse de Rhodes

1059 **The Lighthouse at Alexandria,** 1954 ❑
Le phare d'Alexandrie

1060 **The Lighthouse at Alexandria,** 1954 ❑
Le phare d'Alexandrie

1061 **The Walls of Babylon,** 1954 ❑
Les murs de Babylone

1062 **The Pyramids and the Sphynx of Gizeh,** 1954 ❑
Les pyramides et le sphinx de Guizèh

1063 **Symphony in Red,** 1954 ❑
Symphonie en rouge

1064 **Statue of Olympic Zeus,** 1954 ❑
Statue de Zeus olympien

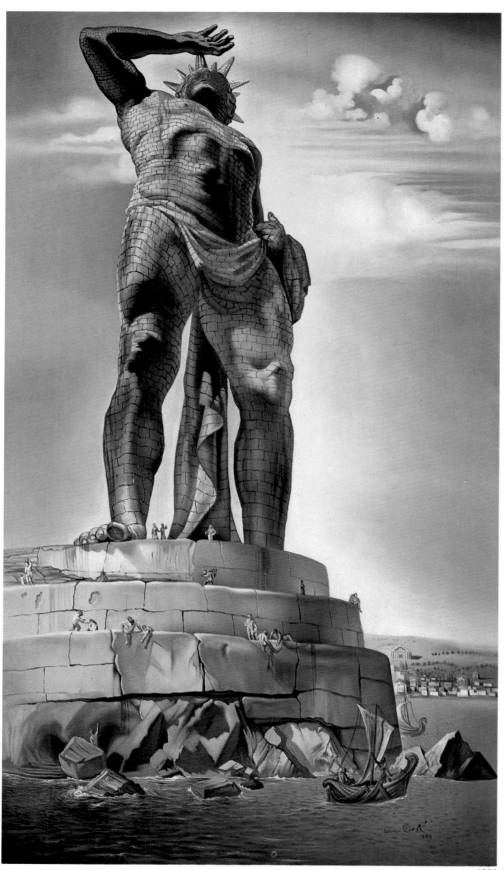

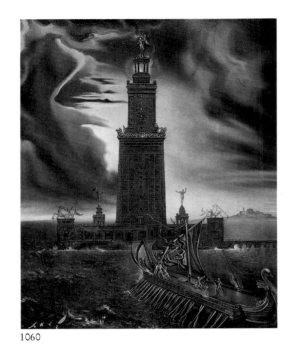

1060

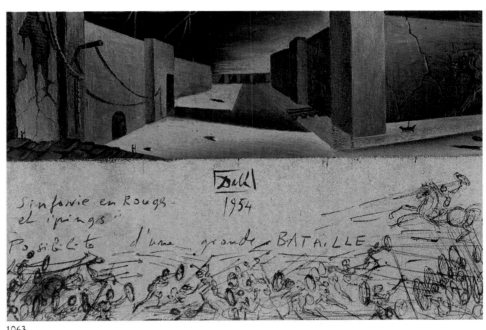

1063

1061

1062

1064

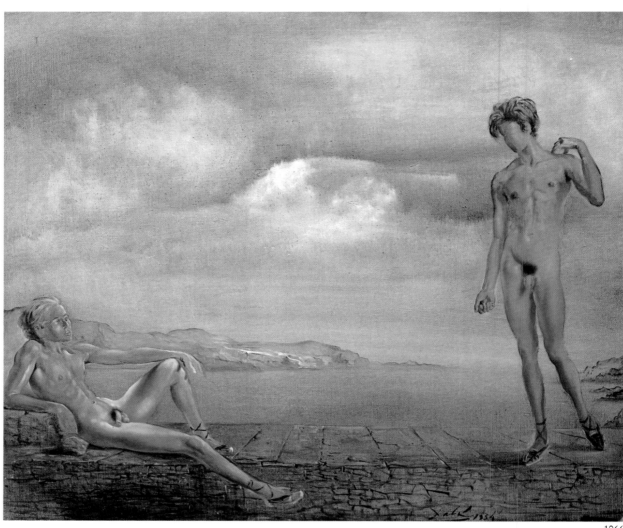

1066

1065

1065 **Noon (Barracks at Port Lligat; detail)**, 1954 ❏
Midi
1066 **Two Adolescents**, 1954 ❏
Deux adolescents
1067 **Equestrian Fantasy (Portrait of Lady Dunn-Beaverbrook)**, 1954 ❏
Fantaisie équestre (Portrait de Lady Dunn-Beaverbrook)
1068 **Portrait of Mrs. Reeves**, 1954 ❏
Portrait de Mrs. Reeves
1069 **Portrait of Mrs. Ann Woodward**, 1954 ❏
Portrait de Mrs. Ann Woodward

Absolute monarchy, perfect esthetic cupola of the soul, homogeneity, unity, and biological, hereditary, supreme continuity. All of the above will be suspended near the cupola of the sky. Below, crawling and supergelatinous anarchy, viscous heterogeneity, ornamental diversity of the ignominious soft structures compressed and rendering the last piece of their ultimate forms of reactions 'Anarchical Monarchy'. This is the '(almost divine) harmony of opposites' proclaimed by Heraclitus, which only the incorruptible mould of ecstasy will one day form using new stones from the Escorial.

Picasso, thank you! With your Iberian anarchical, integral genius you have killed the ugliness of modern painting: without you, without your prudence and moderation that characterize and are the honor of French art, we would risk having 100 years of more and more ugly painting until we progressively arrived at your sublime 'esperantos abatesios' of the Dora Mar series. You, with a single blow of your categorical sword, you have killed the bull of ignominy, also and especially the even blacker one of complete materialism. Now the new epoch of mystic painting begins with me."

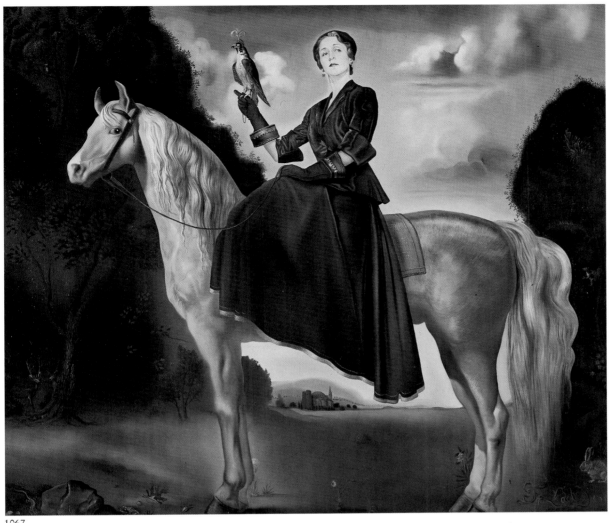

1067

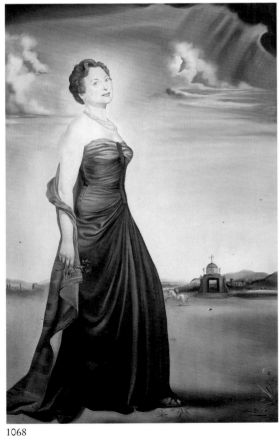

1068

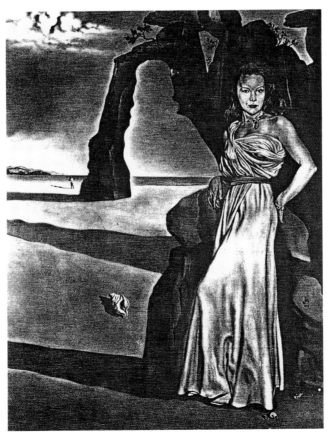

1069

1955

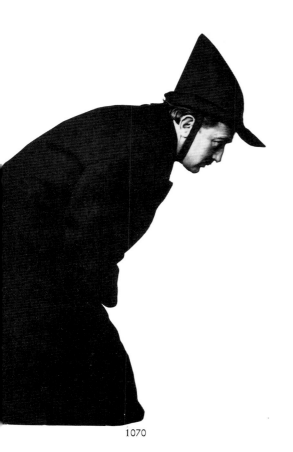

1070

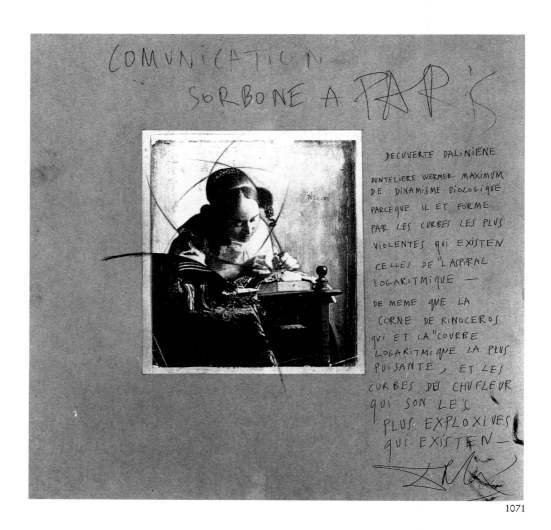

1071

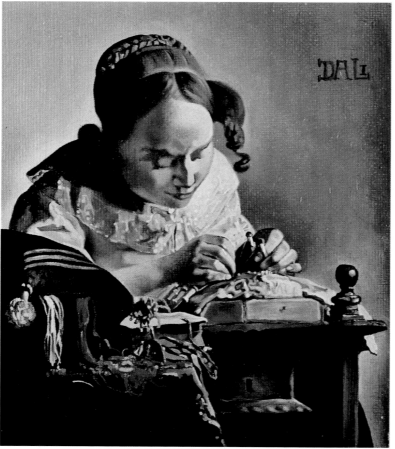

1072

1070 **Dalí and the Rhinoceros. Photograph by Philippe Halsman, New York, 1956.** The photo has been divided down the centre, with Dalí at left (p. 476) and the rhinoceros looking at him from the right (p. 477), 1956 ✰

1071 On 17 December 1955, Dalí went to the Sorbonne in Paris in a white Rolls Royce filled with cauliflowers, there to lecture on "Phenomenological Aspects of the Paranoiac-Critical Method" to an enthusiastic audience. He used the document illustrated here to explain that Vermeer's "Lacemaker" attains the highest degree of biological dynamism thanks to the rhinoceros horns of which (in Dalí's opinion) the painting consists. ✰

1072 The Lacemaker (Copy of the painting by Vermeer van Delft), 1955 ❏
La Dentellière

1073 In May 1955 Dalí painted a paranoiac-critical version of Vermeer's "Lacemaker" in the rhinoceros enclosure at Vincennes zoo. ✰

1074 Rhinocerotic Bust of Vermeer's "Lacemaker", 1955 ○
Buste rhinocérontique de la «Dentillière» de Vermeer

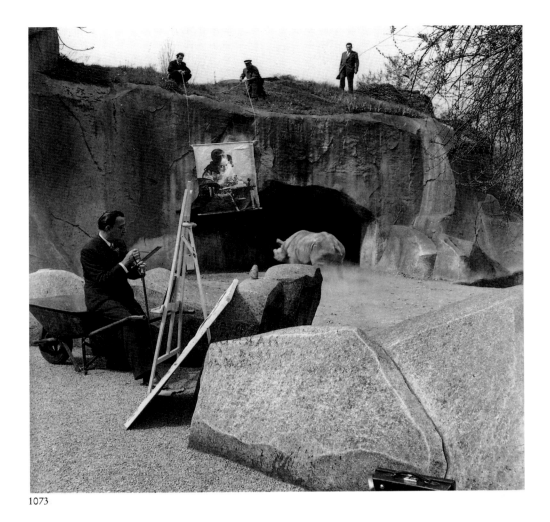

1073

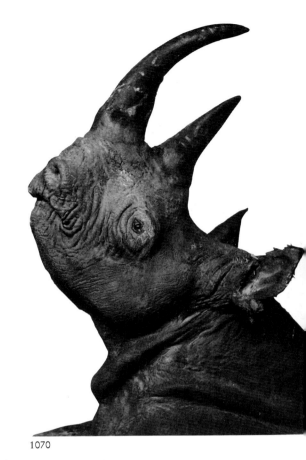

1070

The Amazing Adventure of the Lacemaker and the Rhinoceros

1074

Was it perhaps a spirit of revenge that now impelled him to interpolate between *Christ of St. John of the Cross* (p. 451) and his version of the Last Supper (pp. 488–489), a painting which is arguably his most erotic of all, *Young Virgin Auto-Sodomized by her Own Chastity* (p. 478)? The history of the painting is closely connected to Dalí's sister. In his scatalogical period – which to Dalí's delight scandalized the Surrealists – he had painted a picture of his sister, a rear view which emphasized the girl's behind. To make sure that the point was not lost on anybody, he titled it: *Portrait of my Sister, her Anus Red with Bloody Shit*. It was an image that remained with him and which he expressed in a poem, *Love and Memory*, which he published in the "Editions surréalistes" in 1931. Why did he return to the subject in 1954, this time in a form that went far beyond the obscene poem? Was it revenge? True, twenty years on his memory rather glamourized Ana María, who was a short, plump woman; he reshaped her along the lines of a photograph in a soft-porn magazine. Still, it looks as if he were settling an old score with her. Continuity of this kind is indicative of the development of Dalí's mind: starting with a memory that was still fresh, mental processes in him combined analytic intelligence with powerful erotic fantasy to produce, in the 1954 picture, a veritable lyrical feast. In the painting, Ana María's firm, attractive behind is related to a rhinoceros horn, which in turn is related to fantasy images of an erection that enables him to penetrate his sister's "anus red with bloody shit."

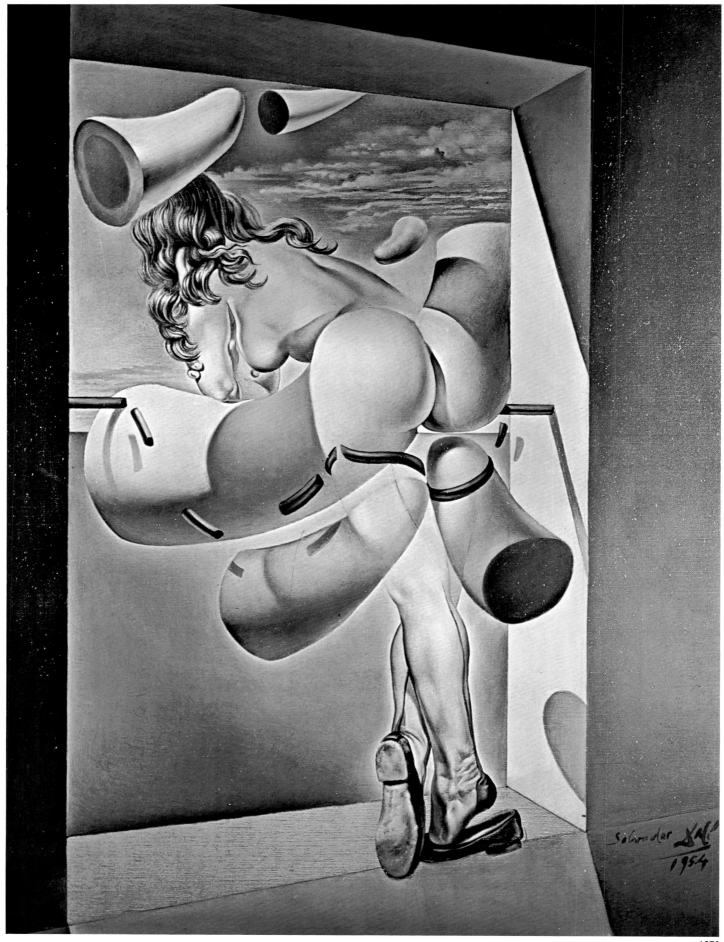

1075 **Young Virgin Auto-Sodomized by her Own Chastity**, 1954 ❑
Jeune vierge autosodimisée par les cornes de sa propre chasteté

1076 **Paranoiac-Critical Painting of Vermeer's "Lacemaker"**, 1955 ❑
Peinture paranoïaque-critique de la «Dentellière» de Vermeer

1076

1077 **Dalí and the rhinoceros at Vincennes zoo**, 1955 ☆

1078 **Rhinocerotic Figures**, 1955 ❏
Figures rhinocérontiques

1079 **Combat (Microphysical Warriors)**, 1955 △
Combat (Guerriers microphysiques)

1080 **Blue Horns. Design for a scarf**, 1955 △ Cornes bleues

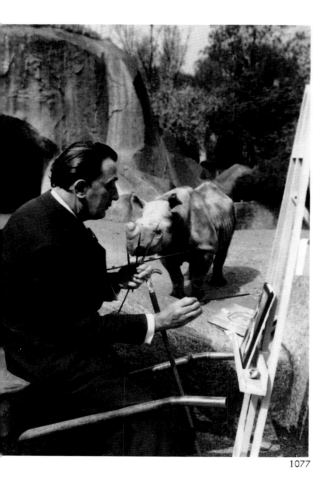

1077

1079

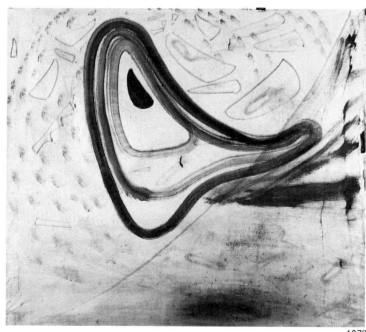

1078

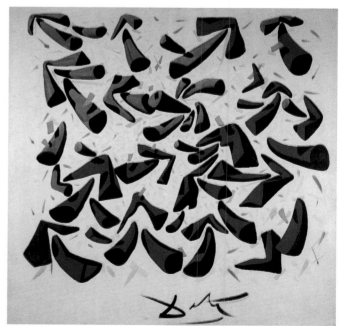

1080

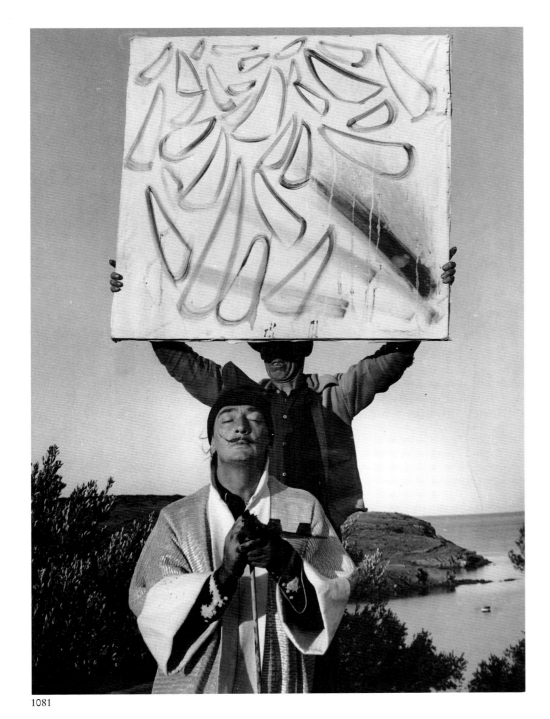

1081

1081 **Untitled (The Amazing Adventure of Vermeer's "Lacemaker")**, 1955 ❑
Sans titre (Histoire prodigieuse de la «Dentellière» de Vermeer)

1082 **The Ascension of St. Cecilia,** 1955 ❑
Sainte Cécile ascensionniste

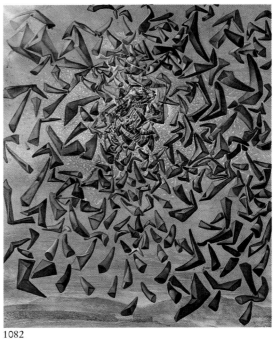

1082

1083 Dalí painting the "Rhino-
cerotic Portrait of Vermeer's Lace-
maker". Still from filming of "L'his-
toire prodigieuse de la dentellière et
du rhinocéros" (The Amazing Ad-
venture of the Lacemaker and the
Rhinoceros), 1955 ✰

1084 Rhinocerotic Portrait of
Vermeer's "Lacemaker", 1955 ❑
Portrait rhinocérontique de la
«Dentellière» de Vermeer

1085 Dalí and Gala bathing with
Vermeer's "Lacemaker" at Port
Lligat. 1959 ✰

1084

1083

Revenge in true Catalonian style – for Ana María's own memoirs, when all was
said and done, contained little of an inflammatory nature. Expressing himself
through the rhinoceros horn permitted Dalí to respect the demands of chastity
which, at that time, had become "an essential requirement of the spiritual life."

From then on, he used the rhinoceros horn in a number of ways – for instance,
in a film he made in 1954 with Robert Descharnes titled *L'histoire prodigieuse de
la dentellière et du rhinocéros*. The title linked Vermeer's *Lacemaker* (cf. p.476)
with a rhinoceros, which may well seem preposterous. Of course, Dalí had been
meticulous in the composition of his paintings since his youth. In the course of
his work with Prince Matila Ghyka he became very interested in the dynamics of
the mathematically self-perpetuating logarithmic spiral. At the same time, he
came across the findings of recent research in nuclear physics, and was fascinated
by the particles newly identified. The distinctive quality of Vermeer's art had
intrigued him from early in his life; and in typical paranoiac style he concentrated
on the one painting, *The Lacemaker*, a reproduction of which he had seen in his
parents' home. The Vermeer made a peaceful impression; it was also striking for
its compositional austerity and for the particle quality of the tiny brush strokes
Vermeer had used. For Dalí it represented the greatest power and the most ar-
resting cosmic synthesis. Subsequently, in Paris, he delivered a remarkable lecture
– "Aspects phénoménologiques de la méthode paranoïaque-critique" – in which
he examined the connections between the lacemaker and a rhinoceros. It is fa-
miliar enough nowadays to anyone who takes an interest in Dalí's thinking; here,
it will be worthwhile quoting Dalí's own words in the *Diary of a Genius* for 18
December 1955: "Yesterday evening, Daliesque apotheosis in the temple of
knowledge, before a fascinated crowd. Immediately after my arrival in the cauli-
flower-covered Rolls, after being greeted by thousands of flashing cameras, I

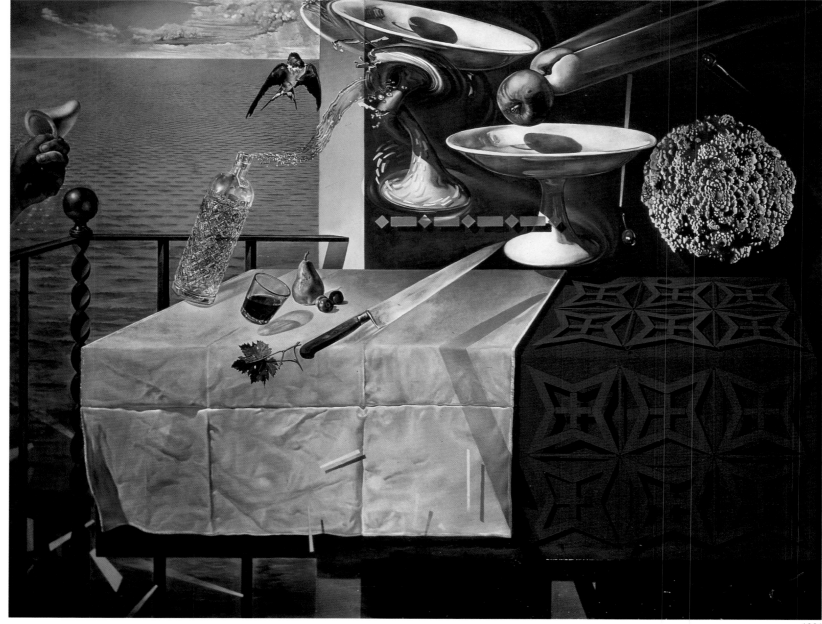

1086

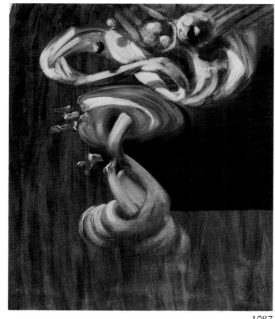

1087

1088

1089

1086 **Still Life – Fast Moving**, 1956 ❏
Nature morte vivante

1087 **Study for a fruit bowl in "Still Life – Fast Moving"**, 1956 ❏

1088 **Vase of Flowers**, 1956 △
Vase de fleurs

1089 **The Motionless Swallow. Study for "Still Life – Fast Moving"**, 1956 ❏
L'hirondelle immobile

1090 **Wine Glass and Boat**, 1956 ❏
Verre de vin et bateau

1091 **Portrait of Laurence Olivier in the Role of Richard III**, 1955 ❏
Portrait de Laurence Olivier dans le rôle de Richard III

1092 **The Skull of Zurbarán**, 1956 ❏
Le crâne de Zurbarán

1093 **Untitled (Landscape with Butterflies)**, c. 1956 ❏
Sans titre (Paysage aux papillons)

1090

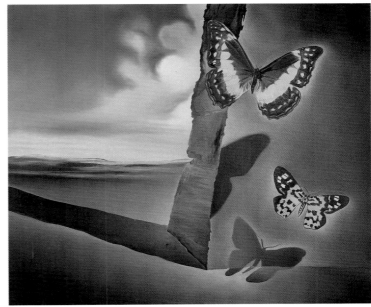

1093

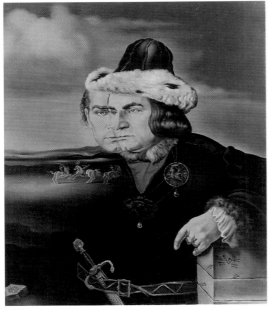

1091

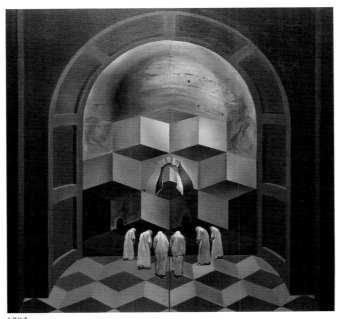

1092

1956

began to speak in the great amphitheatre of the Sorbonne. The trembling listeners were expecting decisive words. They got them. I have decided (I say) to inform you of the most hallucinatory experience of my entire life in Paris, because France is the most intelligent country in the world. While I, Dalí, come from Spain, the most irrational country in the world… Frenetic applause greeted these opening words, because no one is more receptive to compliments than the French. The intelligence (I said) only leads us into the coefficients of a gastronomic, super-gelatinous, Proustian, stale uncertainty. For that reason it is both good and necessary if a Spaniard such as Picasso or I comes to Paris from time to time, to thrust a piece of raw meat bleeding truth under the noses of the French. At this point

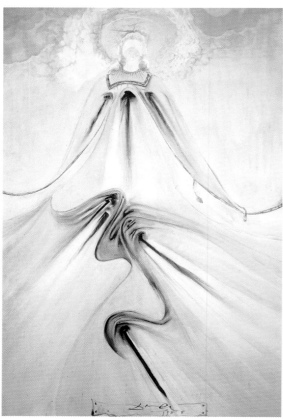

1094

1094 **Assumpta Canaveral**, 1956 △
Assumpta Canaveral

1095 **Saint Surrounded by Three Pi-Mesons**, 1956 ❑
Saint entouré de trois pi-mésons

1096 **St. Helen of Port Lligat**, 1956 ❑
Sainte Hélène à Port Lligat

1097 **Anti-Protonic Assumption**, 1956 ❑
L'Assomption anti-protonique

1095

1096

there was a commotion, as I had anticipated. I had won! I went on rapidly: One of the most important modern painters is doubtless Henri Matisse, but Matisse represents the after-effects of the French Revolution, that is to say, the triumph of the bourgeoisie and of philistine taste. Thunderous applause!!! I continued: Modern art has produced a new maximum of rationality and a maximum of scepticism. Today's young painters believe in nothing. It is only normal for someone who believes in nothing to end up painting practically nothing, which is the case in the whole of modern art, including the abstract, aesthetic and academic varieties." To the accompaniment of enthusiastic cheers, Dalí began to demonstrate that the curve of a rhinoceros horn is the only one that is perfectly logarithmic. He then explained his paranoiac-critical copy of Vermeer's painting, which shows the lacemaker with an infinite number of rhinoceros horns (p.479). What he had to say about the rear end of the beast prompted mirth: "On the screen there appeared the rear end of a rhinoceros which I had recently dissected only

1097

1955

1098 **The Last Supper,**
1955 ❑
La cène

488

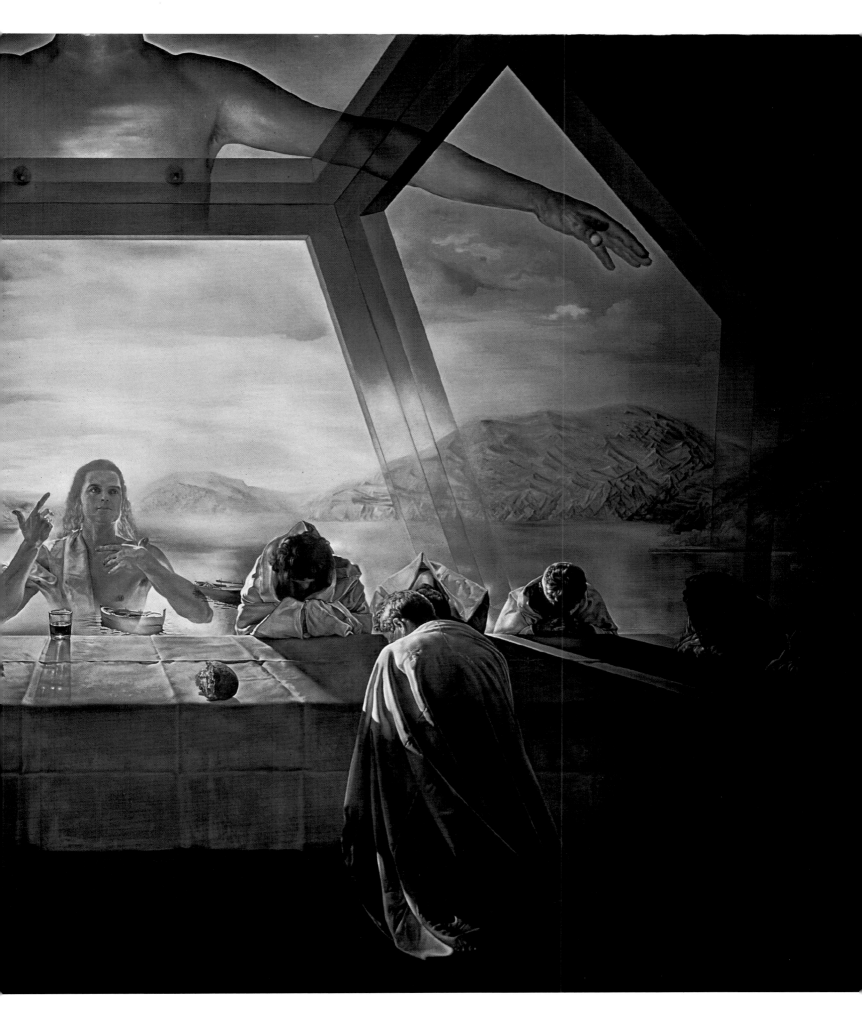

1099

1101

1100

to find that it was nothing but a folded-up sunflower. The rhinoceros is not content whith having one of the most beautiful logarithmic curves on its nose, no, even in its behind it has myriad sunflower-shaped logarithmic curves." Then Dalí proposed a progression: Mist = lacemaker = rhinoceros horn = particle and logarithmic granularity of the sunflower, then of cauliflower = the granularity of the sea urchin, which accoring to Dalí is nothing but a drop of water that gets goose pimples at the very moment it comes into existence, for fear of losing its original purity of form.

Silencing the tremendous applause with a gesture, Dalí concluded: "After this evening's exposition I believe that in order to get from the lacemaker to the sunflower, from the sunflower to the rhinoceros, and from the rhinoceros to the cauliflower, one really needs a certain amount of brain."

Performances of this kind were generally preceded by "practical work" – in this case, a paranoiac-critical interpretation of Vermeer's *Lacemaker* in the rhi-

contd. on p.498

1102

1103 **The Space Elephant**, 1961 ○
L'éléphant spatial

1104 **Untitled (Surrealist Landscape)**, 1957–1958 △
Sans titre (Paysage surréaliste)

1105 **Metamorphosed Women – The Seven Arts**, 1957 ❏
Femmes métamorphosées – Les sept arts

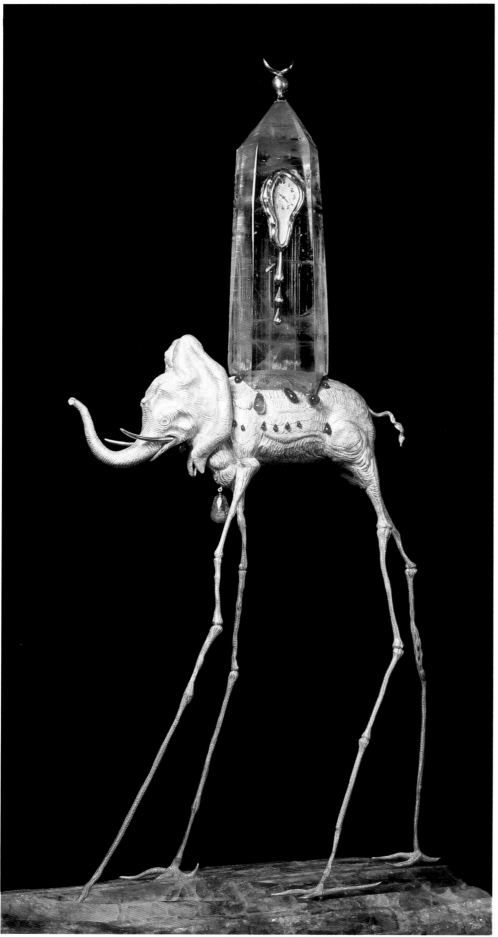

1103

1104

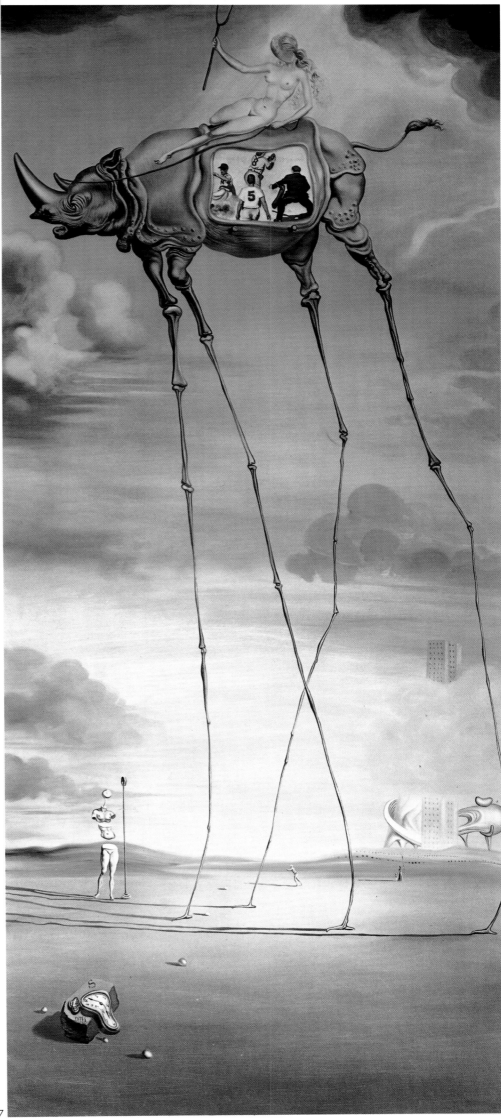

1106 Butterfly Landscape (The Great Masturbator in a Surrealist Landscape with D.N.A.), 1957–1958 Δ
Paysage aux papillons (Grand masturbateur dans un paysage surréaliste avec A.D.N)

1107 Celestial Ride, 1957 ❏
Chevauchée céleste

1105

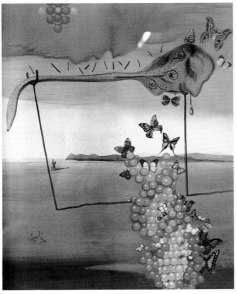

1106

1957

1108 **The Grand Opera**, 1957 ❏
Grand opéra

1109 **Sorcery – The Seven Arts**,
1957 ❏
Ensorcellement – Les sept arts

1110 **Modern Rhapsody – The
Seven Arts**, 1957 ❏
Rhapsodie moderne – Les sept arts

1111 **Dance – The Seven Arts**,
1957 ❏
La danse – Les sept arts

1112 **Music – The Red Orchestra –
The Seven Arts**, 1957 ❏
La musique – L'orchestre rouge – Les
sept arts

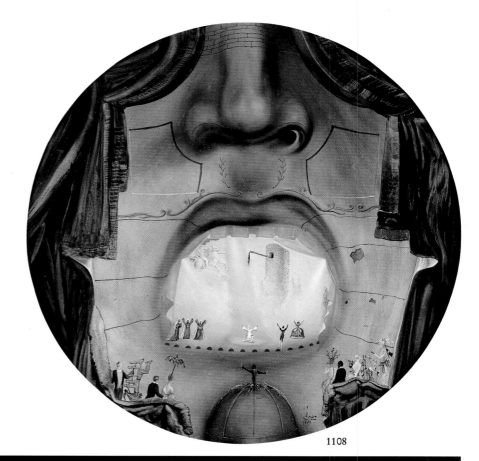

1108

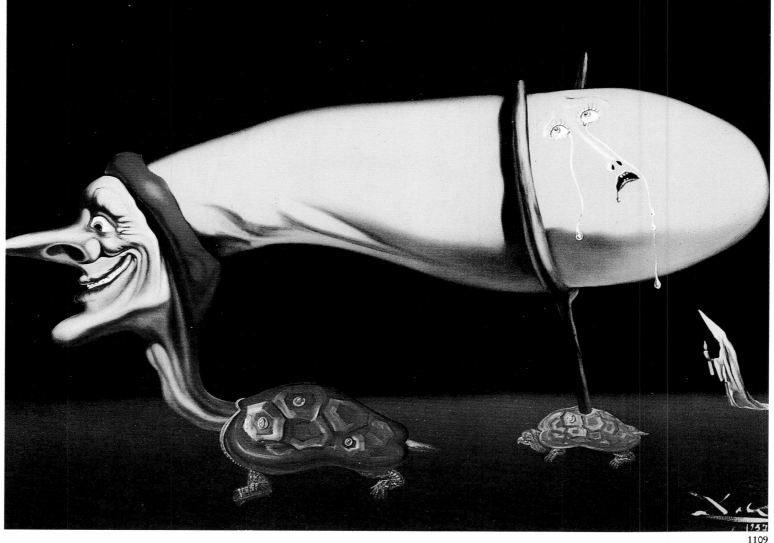

1109

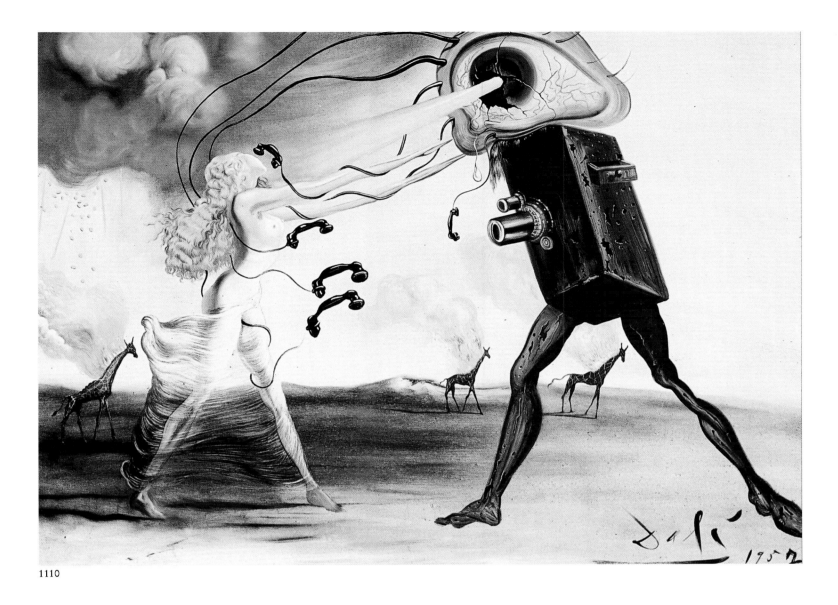

1110

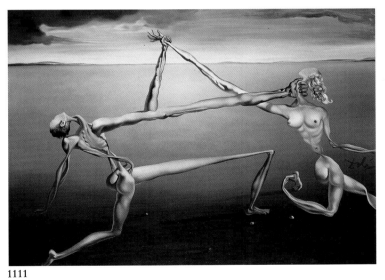

1111

1112

p.496

1113 St. James of Compostela,
1957 ❑
Saint Jacques le Grand (Santiago el
Grande)

p.497

1114 "St. James of Compostela"
seen from Dalí's studio window
at Port Lligat at night,
1957 ☆

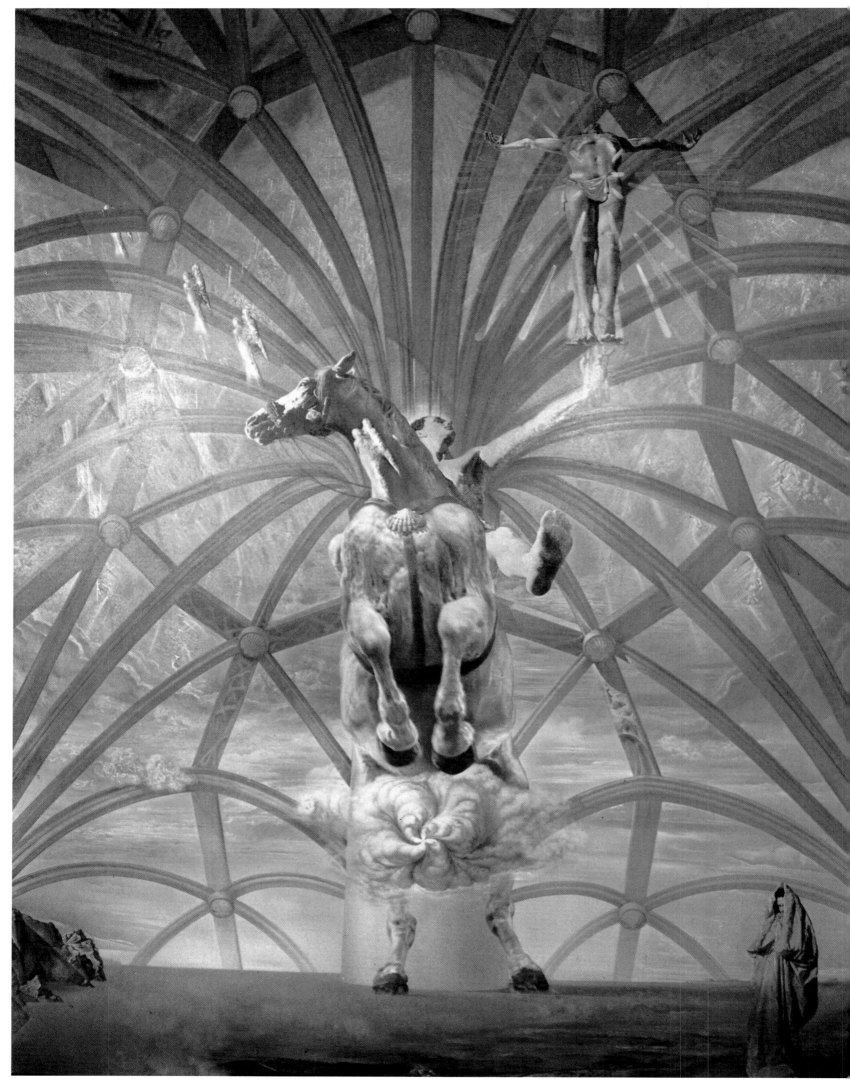

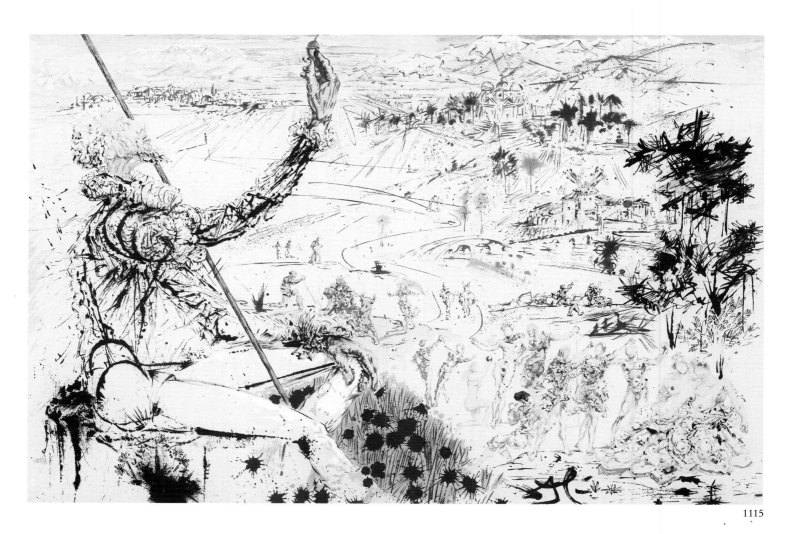

1115

1115, 1116, 1117, 1118, 1119 **Illustra-tions for "Pages choisies de Don Quichotte de la manche", by Joseph Forêt, published in 1957.** △
Though this was Dalí's first ever venture into lithography, he contrived to develop new methods for the work on this book. The stones he used were limestone slate over 135 million years old.

noceros enclosure at the Vincennes zoo. These events tended to rouse the critics from their lethargic slumbers and unsettle them. One of them, in an article headed 'Will Dalí kill modern art?' wrote: "Everything Salvador Dalí says, everything he does, and almost everything he paints, at least has the merit of embarrassing, bewildering, even annoying all those for whom modern art has its rules and frontiers and who would never dream of questioning their own certainty on the matter. Dalí sets various movements going in a field where both critics and artists all too often tend to be cosily snoozing. Scandal, provocation and crazy eccentricity – all hallmarks of the dandy – serve him in the pursuit of critical ends which use sacrilege to help 'a truth' see justice done. For twenty-five years, Dalí's work has been taking its bearings from the opposite of everything that is known as 'painting', and has been aiming to diminish the value of whatever passes for current 'taste' – Cubism, abstract art, Expressionism and so forth. He makes no secret of it; quite the contrary, he loudly proclaims his wish 'to kill modern art'. It would be wrong to be deceived by the humorous or delirious nature of his statements. Dalí is serious, very serious, and the 'first-class-intelligence' which André Breton conceded in 1936 that Dalí possessed is in the service of destructive activities which may cost 'modern art' the whole of its prestige."

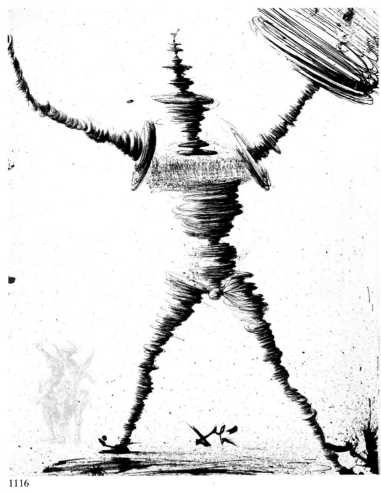

1116

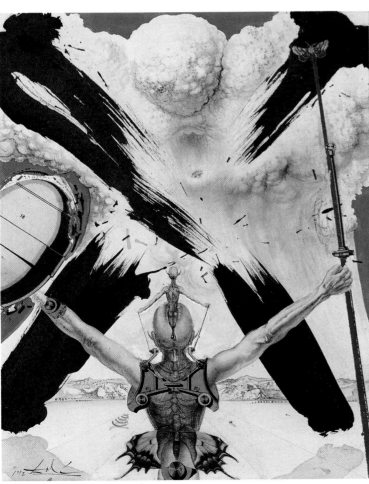

1117

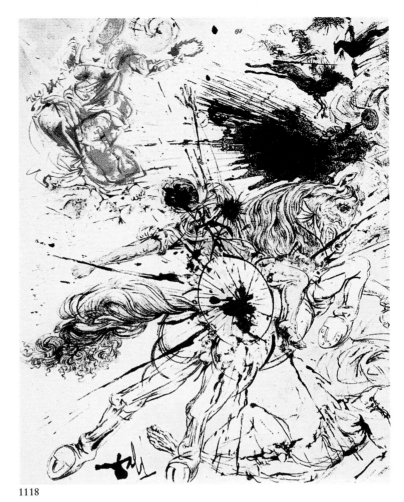

1118

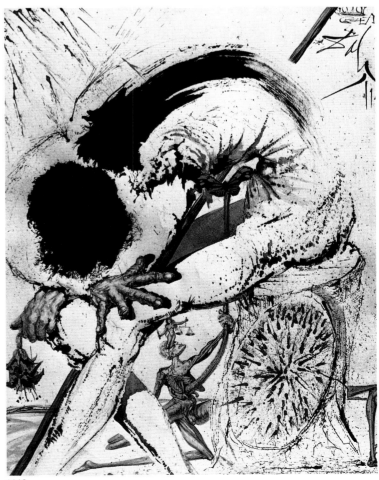

1119

1120

1121

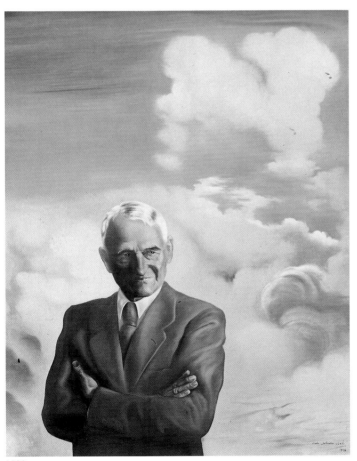

1122

1123

1120 **Portrait of Chester Dale and his Dog Coco,** 1958 ❑
Portrait de Chester Dale et de son chien Coco

1121 **Portrait of Reinaldo Herrera, Marquis de Torre Casa,** 1959 ❑
Portrait de Reinaldo Herrera, Marquis de Torre Casa

1122 **Portrait of Sir James Dunn,** 1958 ❑
Portrait de Sir James Dunn

1123 **The Duke of Urbino (Portrait of Count Theo Rossi di Montelera),** 1957 ❑
Le Duc d'Urbino (Portrait du Comte Theo Rossi di Montelera)

1124

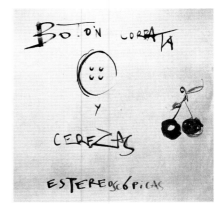

1125

1126

1127

1128

1129

Matisse's Fly

In *Mentira y verdad de Salvador Dalí* (Lying and Truth in Salvador Dalí), the critic A. Oriol Anguera claims that Dalí's art is given an appearance of thought by its constant use of "Freudian machinery", just as a short-sighted person appears to be able to see perfectly if he wears glasses all the time. And since Freud's fanciful theories (thus Anguera) are based on the unconscious and on the erotic, it was not difficult for Dalí to locate libidinous or unconscious roots for whatever he chose to paint. Anguera's view cannot be discounted. Since the *Mystical Manifesto* – which for Dalí was inseparable from the dropping of the atom bomb and developments in nuclear physics – the artist had been more concerned with outer than with inner phenomena, more with the conscious than with the unconscious, more with the surface than with the content, as his *Soft Self-Portrait with Fried Bacon* (p. 342) shows; nonetheless, it is clear that Dalí did have constant recourse to Anguera's "Freudian machinery". It served as a means of transposing his own private mythology into an available scheme, just as the crystal stopper had helped him in his early days to see the world as an Impressionist.

503

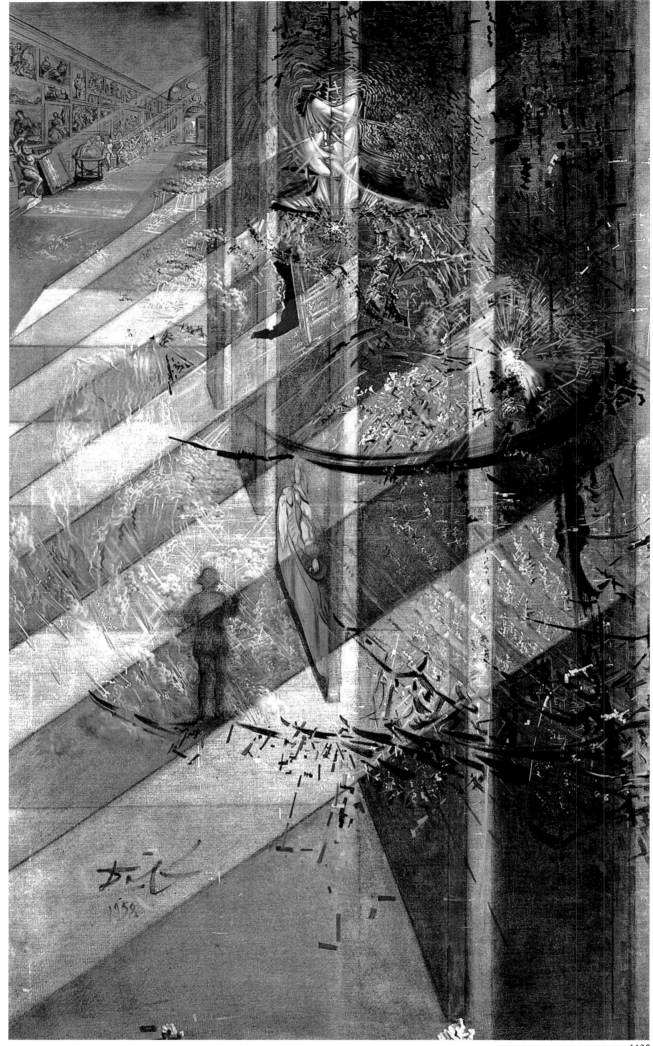

504

In much this way, Dalí's gaze lighted upon Matisse's fly (cf. the photograph on p. 503). It was not quite done up, and a button was still visible. In *Tout Dalí en un visage* (All of Dalí in one Face) Dalí explains that the collar button in *The Hallucinogenic Toreador* (p. 578) was directly inspired by Matisse's fly. It was (says Dalí) the button on the French bourgeoisie's fly – always forgotten, forever unfastened. And Dalí published the photograph as Dalinian proof. Dalí, of course, as a self-proclaimed anarchist and monarchist, had little time for the middle classes, particularly the French. He despised them always, attacked them, could not take them seriously; and, in his view, the French middle classes stood

1132

1131

1134

1130 **Velázquez Painting the Infanta Margarita with the Lights and Shadows of his Own Glory,** 1958 ❏
Vélasquez peignant l'infante Marguerite avec les lumières et les ombres de sa propre gloire

1131 **Pi-Mesonic Angel,** 1958 △
Ange pi-mésonique
1132, 1133, 1134 **From Velázquez to Hippy-Dalí: Velázquez' self-portrait superimposed on a photograph of Dalí.** Dalí as a modern reincarnation of Velázquez? ✩

1958

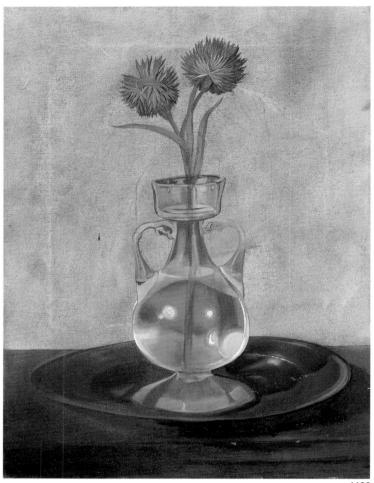

1135

1136

1135　**Vase of Cornflowers**, 1959 ❏
Le vase de bleuets

1136　**Dionysus Spitting the Complete Image of Cadaqués on the Tip of the Tongue of a Three-Storied Gaudinian Woman**, 1958 ❏
Dionysios crachant l'image complète de Cadaqués sur le bout de la langue d'une femme à trois étagères

1137　**Meditative Rose**, 1958 ❏
Rose méditative

for the middle classes everywhere, with their pompous and vulgar taste in art. He saw Matisse, "the illustrious painter of algae", as archetypical of middle class art, with his showy Chinese vases in the homes of the *nouveaux riches* and his figures whose money would not even gain them entry to the Ministry of Snobbery. At the same time, Dalí loved the aristocracy. The button on Matisse's fly would never have been associated with the toreador's button in the painting, needless to say, if Dalí himself had not pointed out the connection. Nor would any connection have been seen between Matisse's fly and the philosophical theories of Francesco Pujols, the Catalonian writer and friend of Dalí; or with the cybernetic machine with a button keyboard that Dalí had made from an etching he discovered in an old book on the theories of Raimundus Lullus. The secret life of buttons – and, as we shall see, of flies – is a mysterious one.

For other historic buttons in Dalí's art (according to Dalí himself) we might look to *The Chemist of Ampurdán in Search of Absolutely Nothing* (p. 258). The man would be worthy of a Zola or Flaubert. We see him in a bare, desolate landscape with certain features dear to the artist, as we know. And Dalí has no mercy on this pillar of the middle class. Rather than have us think the apothecary of Figueras might be looking for a lost button, say, or perhaps a needle in a haystack, Dalí insists that this philistine representative of the complacent, unreflective silent majority, is looking for absolutely nothing.

If we bear Dalí's paranoiac sense of humour in mind, it is only logical that a fly button should lead on to a cherry he defines as stereoscopic. Late in life he was to be obsessed with reliefs; and from this obsession it was but a brief step to

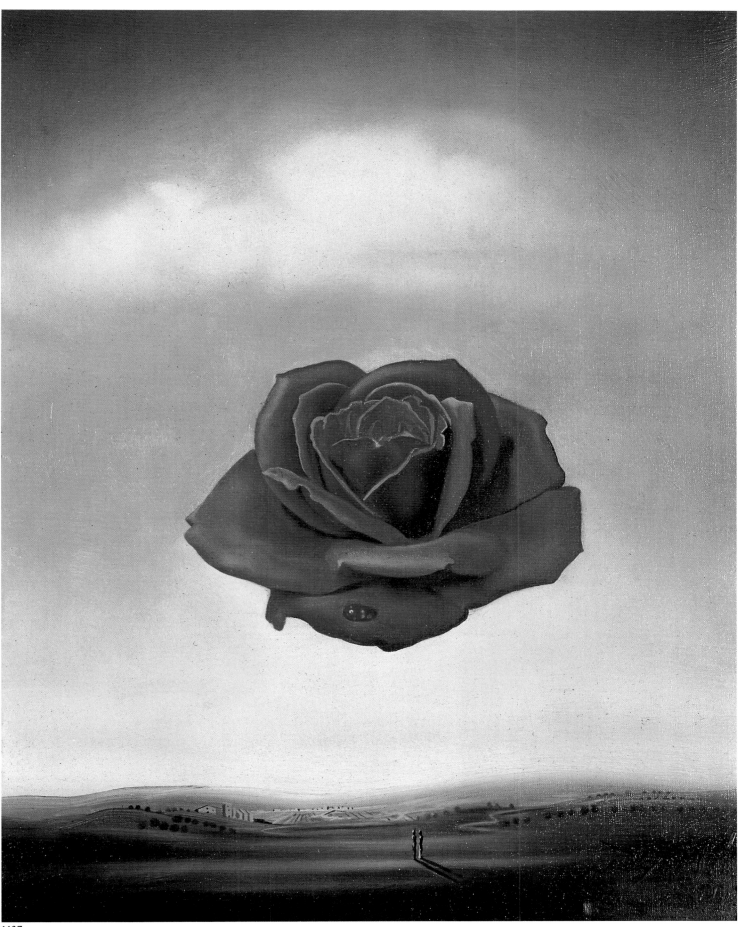

1137

1138 Clown, for "The Amazing Adventure of the Lacemaker and the Rhinoceros", 1958 △
Paillasse pour «L'histoire prodigieuse de la dentellière et du rhinocéros»

1139 Photograph of Hitler, used for the painting "Moonlit Landscape with Accompaniment" (no. 1141) ☆

1138

1139

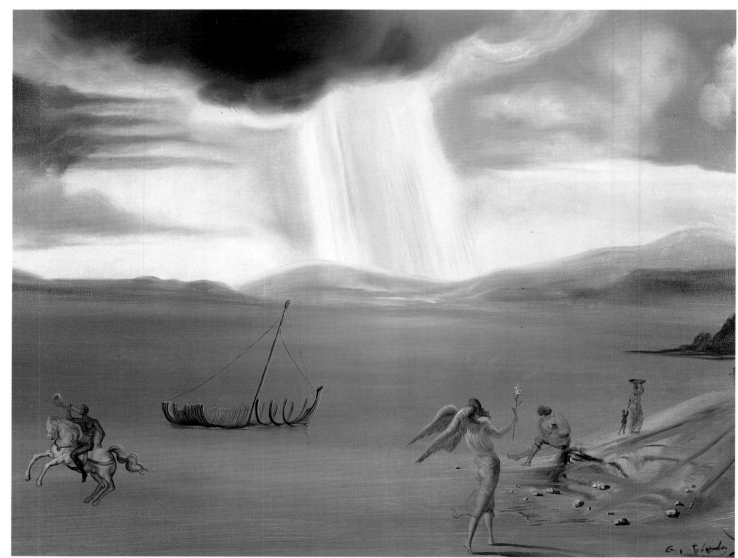

1142

1142 Landscape near Port Lligat, 1958 ❏
Paysage de Port Lligat

1140

1141

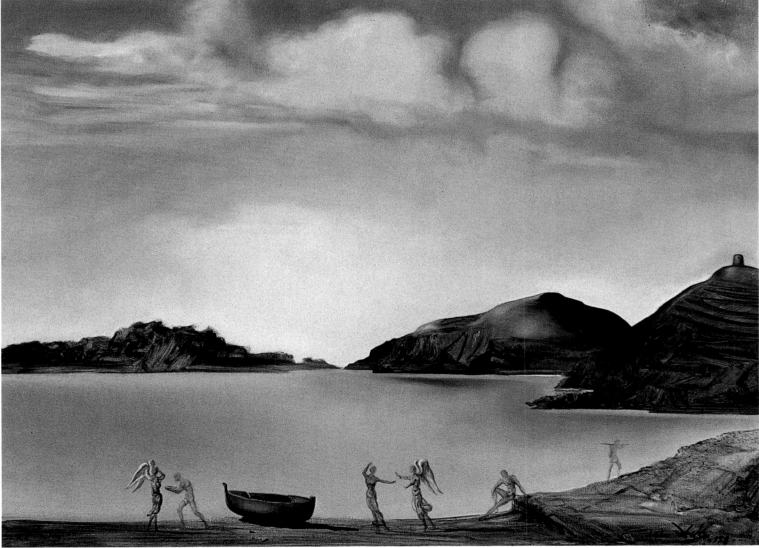

1143

1143 **Port Lligat at Sunset**, 1959 ❑
Port Lligat au coucher du soleil

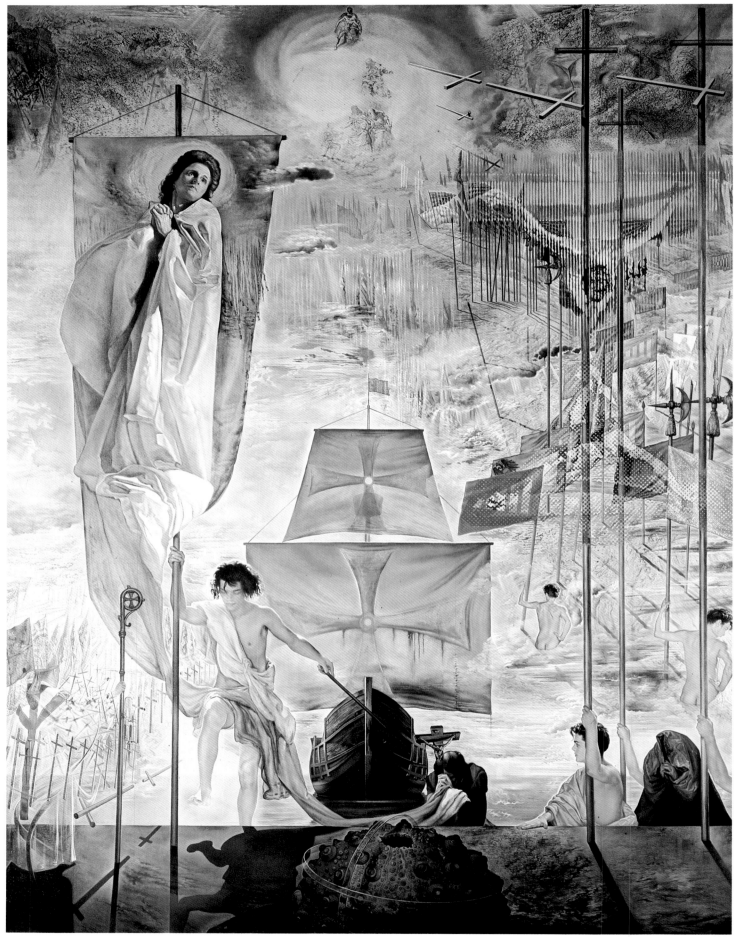

stereoscopic works consisting of two seemingly identical paintings (cf. p.662 for an example) that can be seen together as one. The effect thus created was a unique one of three-dimensional relief. This quest for a dimension beyond the two dimensions of canvas, expressed in twinned pictures and by other strategies, became the late common denominator in Dalí's art, which was a constant search for greater perfection.

Dalí often asserted that when he saw paintings by the Dutch artist Gerard Dou in the art magazine *Gowans*, which his father gave him as a boy, he came to the conclusion that Dou was the first stereoscopic painter. Many of Dalí's works were versions of others he had already painted, or reduplicated the same subjects; and by looking at them through a set of a lenses, or in a mirror, he perceived them as a relief. After all (Dalí liked to point out), was it not the Dutch who invented the microscope? And did they not do so during Dou's lifetime? For Dalí, Gerard Dou was the painter *par excellence* of the third dimension.

The Pope's Ear (p.503), a painting almost wholly grey, seems an abstraction of dots when viewed from up close. From a distance of six feet it becomes Raphael's

1146

1145

1144 The Discovery of America by Christopher Columbus (The Dream of Christopher Columbus), 1958–1959 ❏
La découverte de l'Amérique par Christophe Colomb (Le rêve de Christophe Colomb)

1145 Of the Very Monarchical Education of the Young, 1959 ❏
De la très Monarchique Education de la Jeunesse

1146 Study for "The Discovery of America by Christopher Columbus", 1958 △

1958–1959

1147 **Christ on a Pebble**, 1959 ○
Christ au galet

1148 **Cosmic Madonna**, 1958 ❏

1149

1148

1149 **Ascension**, 1958 ❏
L'Ascension

1150 **The Virgin of Guadalupe,**
1959 ❏ La Vierge de Guadalupe

Sistine Madonna. And from fifty feet it is a huge angelic ear, painted in anti-matter (thus Dalí) and embodying pure energy. We might call it an alchemical *idea* of an ear. The Rabelaisian conceit of birth via the ear enters into the picture too.

Even when Dalí was painting the society portraits of American millionaires which he trusted would make him in turn a wealthy man, he kept the practical application of his theories firmly in mind. Like many a major artist, he liked to play games (albeit serious ones) with his patrons. Thus the *Portrait of Chester Dale and his Dog Coco* (p. 500), for Dalí, was an exercise in "physiognomic synchronism", with the aim of painting one face to look like another – the other being in this case that of Pope Innocent X. In this sense, nothing in Dalí is innocent. Hitler's nose and moustache become a moonlit landscape (p. 509). And no one has the slightest idea where the "pi-mesons" in *Saint Surrounded by Three Pi-Mesons* (p. 486) are supposed to be.

Even Christ became a *Corpus Hypercubus* (p. 467): explosive, atomic, hyper-Cubist. The painting was a Dalinian synthesis intended, among other things, to expose Cézanne's art to ridicule once and for all – for this was an art which took the geometrical principles on which Cézanne based his perceptions and rendered them in classical technique and academic formulae. Dalí saw the painting as transcendental, metaphysical Cubism, and declared that it derived wholly from Juan de Herrera's discourse on the cube. Herrera was Philip II's architect and the designer of El Escorial. Dalí's cross was an octahedric hypercube (his term) involving the number nine, which merged with the body of Christ. On the human side, Gala entered into perfect unity with the hypercubic nature of the octahedron. Dalí commented that he could only approach the sublimity of Velázquez or Zurbarán when he painted Gala. He used a Port Lligat setting for the painting, as so often before.

There was no doubt about it: from that time on, Dalí considered himself the

1150

1151 **The Maid of the Disciples of Emmaus,** 1960 ❏
La servante des disciples d'Emmaüs

1152 **The Trinity (Study for "The Ecumenical Council"),** 1960 ❏
La Trinité

1151

1152

only artist who could save the art of painting and continue the work of Velázquez by integrating the scientific discoveries and technniques evolved since the old master's day into his manner. In this view of himself, Dalí was surely not so wrong. The photomontage (p. 505), at any rate, confirms that there was at least a physiognomic likeness between the two artists – and that their moustaches functioned in like manner as antennae!

Ever since he first set foot on the pavements of Paris, Dalí the Surrealist had never tired of proclaiming that the ultra-academic Salon *Pompiers* – and particularly Meissonier and the Spanish artist Mariano Fortuny – were a thousand times more interesting than the contemporary representatives of this ism or that, or the objects of African, Polynesian, Indian or Chinese art and craft. Small wonder, then, that at one period (especially the late Fifties and early Sixties) he turned to that genre so beloved of 19th century academic painters, the history painting. *The Discovery of America by Christopher Columbus* (p. 510), painted in 1958/59, is a case in point; while another based on historical motifs in art was the 1957 *St. James of Compostela* (p. 496). St. James Major, honoured at the great old pilgrim city of Santiago de Compostela, is the patron saint of Spain, and Dalí averred that the saint brought home to him, with an existential thrill, the unity of his fatherland. In the painting, everything derives from the four petals of a jasmine flower, which in turn emerges from a (creative) atomic cloud. Three years after the Columbus picture, Dalí – prompted by a Fortuny painting in the Barcelona Museo d'Arte Moderno – produced a third major historical work, *The Battle of Tetuán* (pp. 540–541).

The Discovery of America by Christopher Columbus represented a significant step in Dalí's art. For the first time, while adhering minutely to his earlier techniques, he ventured into the approach characteristic of what he himself termed his particle period. Dalí and Gala are present in the painting: the large figure on

the banner on the left is Gala, while the artist himself, clad in missionary brown, is kneeling with a crucifix. The picture is a homage to Velázquez incorporating signally modern methods: what was most important to Dalí himself in this painting, technically speaking, was the use of a photomechanical replication technique which associated the picture – in many respects another *Christ of St. John of the Cross* (p.451) – with Velázquez's image of glorious Spanish halberds in his *Surrender of Breda* in the Prado.

Henceforth, both in works of central importance and in others of marginal slightness, Dalí had this synthesis of great past techniques with the scientific progress of his own century firmly in mind. He declared that *tachisme*, invented by Protagoras as long ago as the Golden Age of Greece, was merely refined by Mariano Fortuny. The principle at issue was that the subtler the work, the greater the impact of each and every mark. A direct line thus led both to the wonderful particle drawing *St. Anne and St. John* (p.516), and the watercolour, part of a

1153

1154

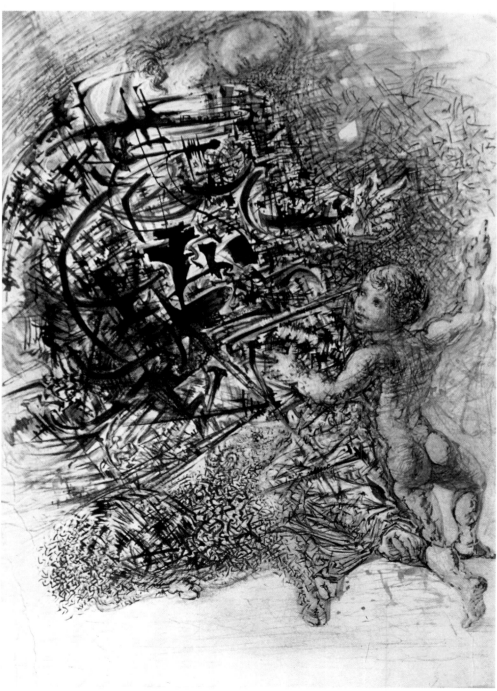

1155

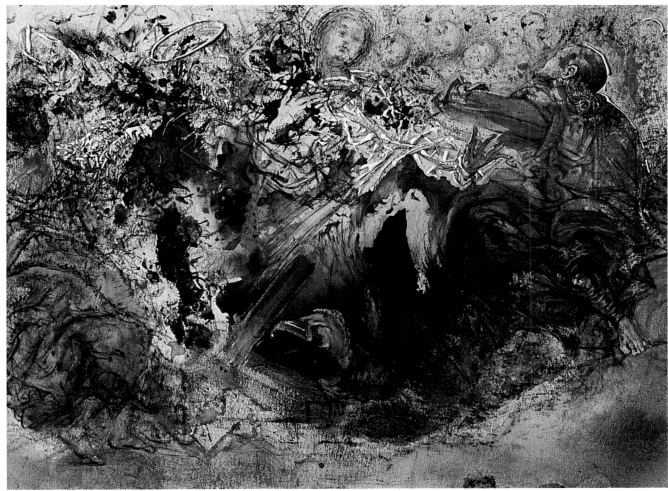

1156

series, and to *The Ecumenical Council* (p. 530), which Dalí painted at the same time. To highlight his figures he used unmixed colours, in the main; but it is primarily the draughtsmanship that gives life to St. Anne and St. John, since they are conceived as a kind of higgledy-piggledy calligraphic inspiration. The voluptuous and surely heathen body of the Magdalene in *The Life of Mary Magdalene* (p. 525) seems to have materialized from the clouds; and the fact that this was painted in 1960 at Port Lligat, at the same time as *St. Anne and St. John* and *The Ecumenical Council*, is eloquent of Dalí's stylistic versatility. What we see in the places where the darkest clouds are gathering recalls *The Discovery of America by Christopher Columbus* (p. 510).

1153 **St. Anne and the Infant,** 1960 △
Sainte Anne et l'enfant

1154 **Religious Scene in Particles,**
c. 1958 ❏
Scène religieuse corpusculaire

1155 **St. Anne and St. John,** 1960 △
Sainte Anne et Saint Jean

1156 **San Salvador and Antoni Gaudí Arguing over the Crown of the Virgin,** 1960 △
San Salvador et Antoni Gaudí se disputant la couronne de la vierge

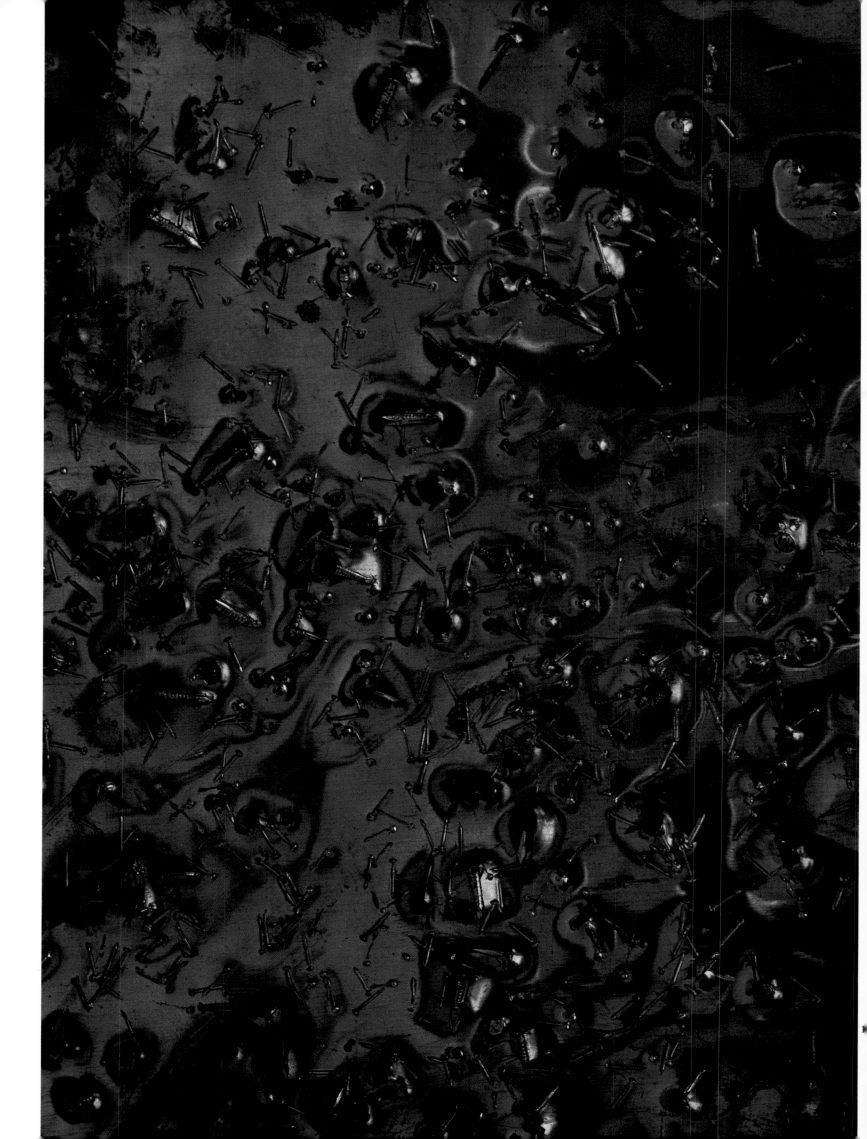

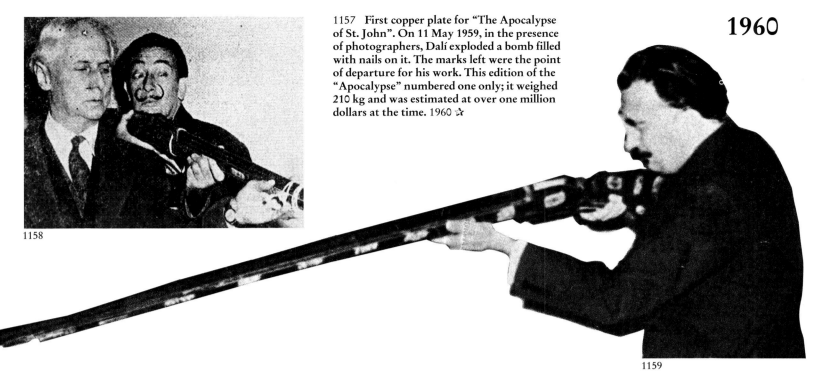

1157 First copper plate for "The Apocalypse of St. John". On 11 May 1959, in the presence of photographers, Dalí exploded a bomb filled with nails on it. The marks left were the point of departure for his work. This edition of the "Apocalypse" numbered one only; it weighed 210 kg and was estimated at over one million dollars at the time. 1960 ☆

1158

1159

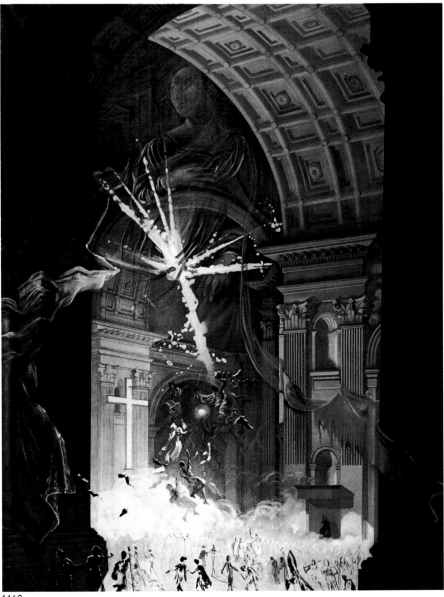

1160

1161

1158 **Dalí demonstrating to Max Ernst a new method of painting, using a gun.** 1957 ☆
1159 **Dalí with a gun,** 1957 ☆
1160 **St. Peter's in Rome (Explosion of Mystical Faith in the Midst of a Cathedral),** 1960–1974 ❏
Basilique de Saint Pierre de Rome (Explosión de fe mistica en el centro de une catedral)
1161 **Portrait of St. Jerome,** 1960 ❏
Portrait de Saint Jérôme

1959–1960

1162

1162 **The Bomb of the Apocalypse,** 1959 ○
Bombe de l'Apocalypse

1163 **Dalí about to throw the bomb of the Apocalypse,** 1959 ☆

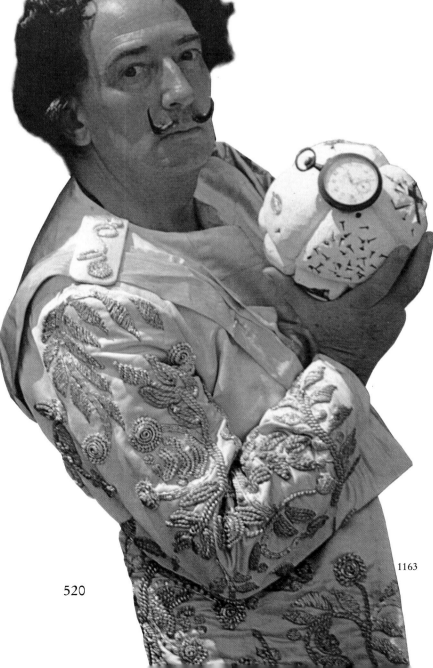

1163

1164 **Cover of "The Apocalypse of St. John"** in repoussé bronze, studded with gems and forks, in a perspex globe, 1958–1961 ○

1165 **Christ. From "The Apocalypse of St. John",** 1958–1960 △

1164

1165

1166 **Pietà. From "The Apocalypse of St. John",** 1960 △

1166

1960

1167

1169 **A Fate of the Parthenon,**
1960 ❏
Une Parque du Parthenon

1170 **Madonna,** 1960 ❏
Madone

1960

1168

1169

Painting with Arquebus and Nailbombs

1170

At the same time as he produced the voluptuous nude of Mary Magdalene
(p.525), Dalí was working on a number of comparable pictures, and still questing
for new techniques within a classical aesthetic repertoire. Among other things, he
stuck real teeth and nails to his canvases. His most important works at this period
included *Hyperxiological Sky* (p.524) and the lost wax mould for a book binding
using knives and forks, precious stones and choice pearls on a bronze ground,
painted in leaf gold, intended for a single huge copy of *The Apocalypse of St. John*
(cf. p.520), done in 1960 by Joseph Forêt. The cover was a bronze door weighing
over two hundred kilograms and valued, at the time, at a million dollars. Dalí saw
the work as an apocalyptic upheaval, a blitz of lightning and fury, a creation – to
accomplish which he first belaboured the wax plate supplied from Paris by Joseph
Forêt with an axe. Into the wax he introduced many and various objects, from
honey cake (honey being meant as a spiritual image of the Old Testament) to
golden needles in a blaze of rays about Christ. Above Christ Dalí placed an agate
as a symbol of purity, and at the very top, as if a kind of sun were crowning the
ensemble, a shell with a small golden figurine at the tip, in a style reminiscent of
17th century French work. The knives and forks were a product of Dalinian logic:
to Gala he explained that the Apocalypse could be eaten only when it had had

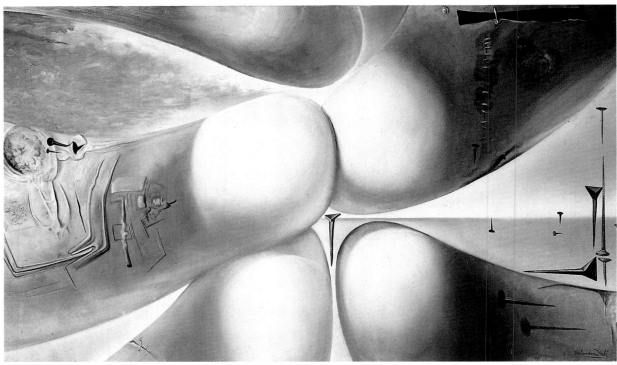

1171

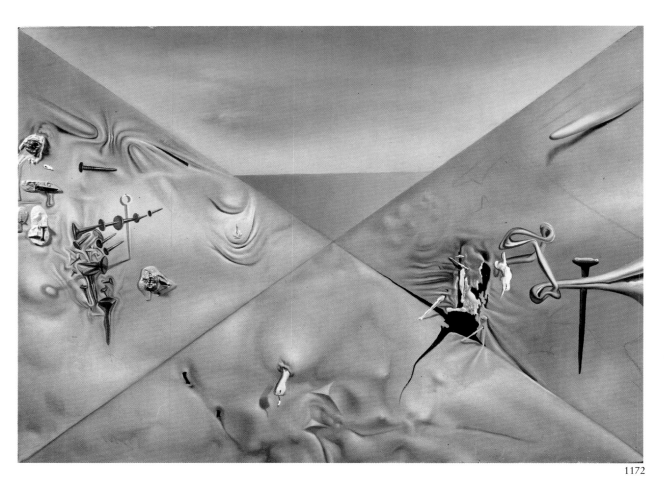

1172

1171 **Continuum of the Four Buttocks –... Five Rhinoceros Horns Making a Virgin – Birth of a Deity**, 1960 ❏

Continuum à quatre fesses – Déesse s'appuyant sur son coude ou Cinq cornes de rhinocéros formant une vierge – Naissance d'une divinité

1172 **Hyperxiological Sky**, 1960 ❏
Ciel hyparxiologique

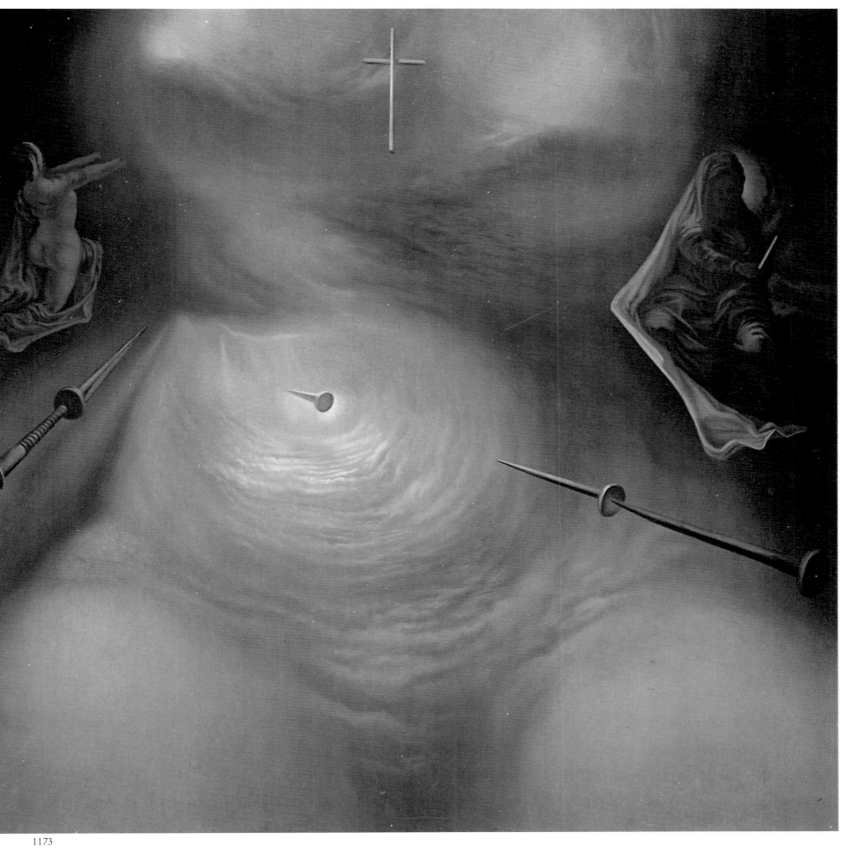

1173

1173 **The Life of Mary Magdalene,**
1960 ❏
Vie de Marie-Madeleine

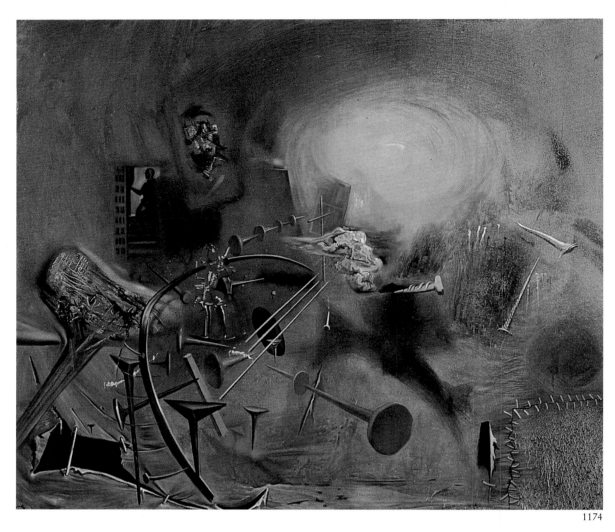

1174

1175

1176

1177

**1174 Portrait of Juan de Pareja
Repairing a String of his Mandolin,**
1960 ❑
Portrait de Juan de Pareja réparant une
corde à sa mandoline

**1175 The Maids-in-Waiting
(Las Meninas; B),** 1960 ❑

1176 The Maids-in-Waiting
(Las Meninas; A), 1960 ❑

1177 Numerical Composition
(unfinished), c. 1960 ❑
Composition numérique

time to mature, like a well-ripened cheese. The idea of eating, here as elsewhere in Dalí, should doubtless be associated with the central importance of Communion in Christianity; we may also legitimately think of Revelation 10, 9: "And I went unto the angel, and said unto him, Give me the little book. And he said unto me, Take it, and eat it up; and it shall make thy belly bitter, but it shall be in thy mouth sweet as honey." Last but not least, Dalí used nails – five hundred and eighty-five, corresponding (he announced) to Raimundus Lullus's five hundred

1178 **Figure in the Shape of a Cloud**, c. 1960 ❑
Personnage en forme de nuage
(Cuerpo de nubes)

1179 **At a press conference on 1 June 1954 at the Palazzo Pallavicini in Rome, Dalí appeared from a "metaphysical" cube to demonstrate his rebirth.** ✩

1178

1179

and eighty-five categories of the soul. He shot nails into his etchings with an arquebus.

In all his studies and apocalyptic explosions, Dalí was concerned to use materials that seemed incompatibly opposed – nails, say, in a sky – and his experiments with polarities were invariably striking. He said that the *Hyperxiological Sky* (p.524) was the first sky in history to be painted after a definition by his genius friend and fellow Catalonian, the least known of all philosophers, Francesco Pujols, according to whom the sky was a substance of colloidal origin. And the body of Mary Magdalene, too, was not a product of the artist's imagination but done from life models (cf. p.528).

New publicity-getting techniques such as the use of an arquebus (cf. p.519) or of bombs (p.520) were not necessarily all that new, but Dalí perfected them and then left them to his successors, such as Niki de Saint-Phalle. In the *Diary of a Genius*, in the entry for 6 November 1957, Dalí relates how he used his technique of immaculate maculature (*éclaboussure immaculée*) in the making of his *Don Quixote* illustrations. "Joseph Forêt has just brought the first copy of the *Quixote* illustrated by me in a technique that, since I inaugurated it, has triumphed the world over, even though it is really inimitable. Once again, Salvador Dalí has gained an imperial victory. It is not the first time. At the age of twenty, I made a bet that I would win the Royal Academy of Madrid's Grand Prix by painting a picture that I would execute without at any time touching the canvas with a brush. Of course I won the prize. The painting depicted a naked and virginal young woman. Standing at a distance of more than three feet from my easel, I projected the colours which splattered on to the canvas. The extraordinary thing was that not a spot was out of place. Each splatter was immaculate.

1180

1180 **A Propos of the "Treatise on Cubic Form" by Juan de Herrera**, 1960 ❑

A propos du «Discours sur la forme cubique» de Juan de Herrera

1181

1182

1183

1181 Woman Undressing, 1959 ❑
Femme se déshabillant (Muchacha desvistiendose)

1182 Female Seated Nude, c. 1960 ❑
Nu féminin assis

1183 Study for "Woman Undressing", 1959 ❑

It was a year ago to the day that I won the same bet in Paris. During the summer, Joseph Forêt landed at Port Lligat with a cargo of heavy lithographic stones. He insisted that I illustrate a *Don Quixote* on those stones. As it happened, at that time I was against the art of lithography for aesthetic, moral and philosophical reasons. I considered the process was without strength, without monarchy, without inquisition. In my view, it was nothing but a liberal, bureaucratic and soft process. All the same, the perseverance of Forêt, who kept bringing me stones, exasperated my anti-lithographic will to power to the point of aggressive hyper-aestheticism. While in this state, an angelic idea made the jaws of my brain gape. Had not Gandhi already said: 'The angels dominate situations without needing a plan?' Thus, instantly, like an angel, I dominated the situation of my *Quixote*.

I might not be able to shoot a bullet from an arquebus against paper, without tearing it, but I could shoot against a stone without breaking it. Persuaded by Forêt, I wired to Paris to have an arquebus ready as soon as I arrived. My friend the painter Georges Mathieu presented me with a very precious fifteenth-century arquebus whose breech was inlaid with ivory. And on the 6th of November, 1956, surrounded by a hundred sheep sacrificed in a holocaust to the very first parchment copy, I fired, on board a barge on the Seine, the world's first lead bullet filled with lithographic ink. The shattered bullet opened the age of 'bulletism'. On the stone, a divine blotch appeared, a sort of angelic wing whose aerial details and dynamic strength surpassed all techniques ever employed before. In the week that followed I gave myself up to new and fantastic experiments. In Montmartre, before a delirious crowd, surrounded by eighty girls on the verge of ecstasy, I filled two hollowed-out rhinoceros horns with bread crumbs soaked in ink, and then calling upon the memory of my William Tell, I smashed them on the stone. The result was a miracle for which God should be thanked: the rhinoceros horns had drawn the two open arms of a windmill. Then a double miracle: when I

1184

received the first proofs a bad 'take' had left spots on them. I believed it my duty to incorporate and accentuate those spots in order to illustrate paranoiacally the whole electric mystery of the liturgy of this scene. Don Quixote encountered in the outside world the paranoiac giants he carried within himself. In the scene of the wine-skins, Dalí recognised the hero's chimerical blood and the logarithmic curve that swells Minerva's forehead. Better still, Don Quixote, being a Spaniard

1184 **Gala Nude, Seen from behind,** 1960 ❑
Gala nue de dos

1185

1186

1187

and a realist, does not need an Aladdin's lamp. It is enough for him to take an acorn between his fingers, and the Golden Age is reborn.

As soon as I returned to New York, the television producers were fighting over my efforts at 'bulletism'. As for me, I slept all the time in order to find in my dreams the most effective and accurate way of firing my ink-filled bullets so as to arrange the holes mathematically. With armoury specialists from the New York Military Academy, I woke every morning to the sound of arquebus shots. Each explosion gave birth to a complete lithograph which I only had to sign for collectors to tear it from my hands at fabulous prices. Once again I perceived that I had been in advance of the ultimate scientific discoveries when I learned, three months after my first arquebus shot, that learned men used a gun and bullets like mine to try and discover the mysteries of creation.

In May of this year I was again in Port Lligat. Joseph Forêt was waiting for me with the trunk of his car full of new stones. New blasts of the arquebus once more gave birth to *Don Quixote*. Overwhelmed by suffering, he was transfigured into an adolescent whose plaintive sadness did justice to his blood-crowned head. In a light worthy of Vermeer filtering through Hispano-Mauresque window niches, he read his tales of courtly love. With a tube of 'silly putty' like those that American children play with, I created spirals along which the lithographic ink ran: it was an angelic shape with a gilt fuzziness, the break of day. Don Quixote, paranoid microcosmos, merged into and then emerged from the Milky Way, which is nothing other than the path of Saint James.

Saint James was watching over my work. He manifested himself on July the 25th, his name day, when, in the course of my experiments, I achieved an explosion that will remain forever glorious in the history of morphological science. It has been etched for eternity in one of the stones that Joseph Forêt, with his saintly insistence, kept offering assiduously to the lightning strokes of my imagination. I took an empty Burgundy snail and filled it right up with lithographic ink. Next

1185 **The Ecumenical Council,** 1960 ❑
Le concile œcuménique

1186 **The Ecumenical Council,** 1960 ❑
Le concile œcuménique

1187 **Cathedral (unfinished),** c. 1960 ❑
Cathédrale

531

1960–1961

1188 **Portrait of a Man (They Were Three)**, 1960 ❏
Portrait d'homme

1189 **Portrait of a Woman – Grey Jacket, Wearing a Pearl Necklace**, c. 1961 ❏
Portrait de femme – Veste grise, porte un collier de perles

1190 **Portrait of "Bobo" Rockefeller (unfinished)**, 1960 ❏
Portrait de «Bobo» Rockefeller

1191 **Birth of a Deity**, 1960 ❏
Naissance d'une divinité

1192 **Portrait of Countess Ghislaine d'Oultremont**, 1960 ❏
Portrait de la Comtesse Ghislaine d'Oultremont

1193 **Portrait of Mrs. Fagen**, 1960 ❏
Portrait de Mrs. Fagen

1194 **Untitled (The Lady of Avignon)**, c. 1960 ❏
Sans titre (La dama d'Avinyo)

1188

1189

1190

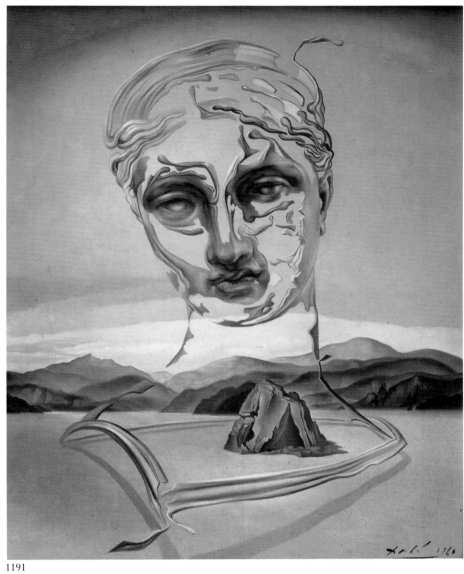

1191

1194

1192

1193

533

1195

1195 **The eye in the "Ballet of Gala".** Costumes and set design by Dalí, danced by Ludmilla Tcherina at the Teatro della Fenice in Venice in choreography by Maurice Béjart, on 22 August 1961. ✰

1196 **Leda's Swan (Leda and the Swan),** 1961 △
Le cygne de Léda (Léda et le cygne)

1197 **Dalí painting "The Medusa of Sleep" on Gala's forehead,** c. 1945 ✰
Dalí peignant une pieuvre sur le front de Gala

1198 **The Head of the Medusa,** 1962 △
Tête de méduse

I slid it into the barrel of the arquebus and aimed at the stone at very close range. When I fired, a volume of liquid perfectly espousing the curve of the snail's spirals produced a splatter which after a long analysis I found to be increasingly divine, as if in fact there was nothing less than a state of 'pre-snailian galaxy' at the supreme moment of its creation. Saint James's Day will therefore go down in history as the day that witnessed the most categorical Dalinian victory over anthropomorphism.

The day following that blessed day, there was a storm and it rained tiny toads which were at once plunged into the ink and formed the pattern of Don Quixote's embroidered costume. These toads created the batrachian humidity opposed to the dazzling dryness of the high plains of Castile which reigned in the hero's head. Chimera of chimeras. Nothing was chimera any longer. Sancho appeared, while Don Quixote touched with his finger the dragons of Doctor Jung.

Today, when Joseph Forêt has just laid on my table the very first copy, I can exclaim: 'Bravo Dalí! You have illustrated Cervantes. Each of your explosions contains in truth a windmill and a giant. Your work is a bibliophilic giant, and it is the pinnacle of all the most fertile lithographic contradictions.'"

1196

1197

1198

I'm not the clown!" cried Dalí in his own defence. "But in its naïvety this monstrously cynical society does not see who is simply putting on a serious act the better to hide his madness. I cannot say it often enough: I am not mad. My clear-sightedness has acquired such sharpness and concentration that, in the whole of the century, there has been no more heroic or more astounding personality than me, and apart from Nietzsche (who finished by going mad, though) my equal will not be found in other centuries either. My painting proves it."

In point of fact, Dalí observed the gradual decline of modern art with contempt. As it slid into nothingness, he laughed to see what Duchamp's ready-mades in Dada and Surrealist days had led to. He was amused to see the urinal Duchamp had exhibited in New York in 1911 as a sculpture titled *Fontaine*. "The first person to compare the cheeks of a young woman with a rose was plainly a poet. The second, who repeated the comparison, was probably an idiot. All the theories of Dadaism and Surrealism are being monotonously repeated: their soft contours have prompted countless soft objects. The globe is being smothered in ready-mades. The fifteen-metre loaf of bread is now fifteen kilometres long… People have already forgotten that the founder of Dadaism, Tristan Tzara, stated in his manifesto in the very infancy of the movements: 'Dada is this. Dada is that… Either way, it's crap.' This kind of more or less black humour is foreign to the new generation. They are genuinely convinced that their neo-Dadaism is subtler than the art of Praxiteles."

Dalí recalled: "During the last war, between Arcachon and Bordeaux, Marcel Duchamp and I talked about the newly awoken interest in preparations using excrement; tiny secretions taken from the navel were considered 'luxury editions'. I replied that I would have liked to have a navel secretion of Raphael. Now a well-known Pop artist is selling artists' excrement in Verona, in extremely stylish flacons, as a luxury item. When Duchamp realised that he had scattered the ideas of his youth to the winds, until he himself was left with none, he most aristocratically declined to play the game, and prophetically announced that other young men were specializing in the chess match of contemporary art; and then he began to play chess…"

And Dalí observed: "At the time there were just seventeen people in Paris who understood the ready-mades – the very few ready-mades by Marcel Duchamp. Nowadays there are seventeen million who understand them. When the day comes that every object that exists is a ready-made, there will no longer be any ready-mades at all. When that day comes, originality will consist in creating a work of art out of sheer urgent compulsion. The moral attitude of the ready-made consists in avoiding contact with reality. Ready-mades have subconsciously influenced the photo-realists, leading them to paint ready-mades by hand. There can be no doubt that if Vermeer van Delft or Gerard Dou had been alive in 1973, they would have had no objection to painting the interior of a car or the outside of a telephone box…"

1200

1199 **Macrophotographic Self-Portrait with Gala Appearing as a Spanish Nun**, 1962 △
Autoportrait macrophotographique avec apparition de Gala en religieuse espagnole

1200 **Detail from "Macrophotographic Self-Portrait…"**, 1962 ✗

1201

1202

1203

Dalí declared: "It is quite correct that I have made use of photography throughout my life. I stated years ago that painting is merely photography done by hand, consisting of super-fine images the sole significance of which resides in the fact that they were seen by a human eye and recorded by a human hand. Every great work of art that I admire was copied from a photograph. The inventor of the magnifying glass was born in the same year as Vermeer. Not enough attention has yet been paid to this fact. And I am convinced that Vermeer von Delft used a mirror to view his subjects and make tracings of them. Praxiteles, most divine of all sculptors, copied his bodies faithfully, without the slightest departure. Velázquez had a similar respect for reality, with complete chastity…" And: "The hand of a painter must be so faithful that it is capable of automatically correcting constituents of Nature that have been distorted by a photograph. Every painter must have an ultra-academic training. It is only through virtuosity of such an order that the possibility of something else becomes available: Art."

Dalí prophetically added: "I foresee that the new art will be what I term 'quantum realism'. It will take into account what the physicists call quantum energy, what mathematics calls chance, and what the artists call the imponderable: Beauty. The picture of tomorrow will be a faithful image of reality, but one will sense that it is a reality pervaded with extraordinary life, corresponding to what is known as the discontinuity of matter. Velázquez and Vermeer were divisionists. They already intuited the fears of modern Man. Nowadays, the most talented and sensitive painters merely express the fear of indeterminism. Modern science says that nothing really exists, and one sees scientists passionately debating photographic plates on which there is demonstrably nothing of a material nature. So artists who paint their pictures out of nothing are not so far wrong. Still, it is only a transitional phase. The great artist must be capable of assimilating nothingness into his painting. And that nothingness will breathe life into the art of tomorrow."

On 15 October 1962, Dalí exhibited *The Battle of Tetuán* in the Palacio del Tinell in Barcelona, alongside the picture by Mariano Fortuny that had inspired it. To Dalí's way of thinking, it was the start of a war of pictures. In his own work, as in Fortuny's, virtuosity was a function of carefully quantified patchwork and dabs, from which substance the images emerged suddenly. Dalí illuminatingly commented that when he considered the patterning of print on a newspaper, what he saw was *The Battle of Tetuán*. Or soccer games. In the *Diary of a Genius* he wrote (3 September 1963):

"I have always been in the habit of looking at papers upside down. Instead of reading the news, I look at it and I see it. Even as an adolescent, I saw, among the typographical spirals, and just by squinting, soccer games as they would look on television. It even happened that before half time, I had to go and rest, so exhausted was I by the ups and downs of the game. Today, holding the papers upside down, I see divine things moving at such a pace that I decide, in a sublime inspiration of Dalinian pop art, to have pieces of newspapers repainted which contain aesthetic treasures that are often worthy of Phidias.

I shall have these newspapers, in outsize enlargements, quantified by fly droppings… This idea occurs to me when I notice the beauty of certain newspaper collages, yellowed and a bit flyspecked, by Pablo Picasso and Georges Braque.

1204

1205

1201 **Study for "The Battle of Tetuán"**, 1961 △

1202 **Arabs. Study for "The Battle of Tetuán"**, 1961 ❏

1203 **Study for "The Battle of Tetuán"**, 1961 △

1204 **Arab**, 1962 △
Arabe

1205 **Arabs. Study for "The Battle of Tetuán"**, 1960 △
Arabes

1962

1206

1206 **Study for "The Battle of Tetuán"**, 1962 ❏

1207 **The Battle of Tetuán,** 1962 ❏
La bataille de Tétouan

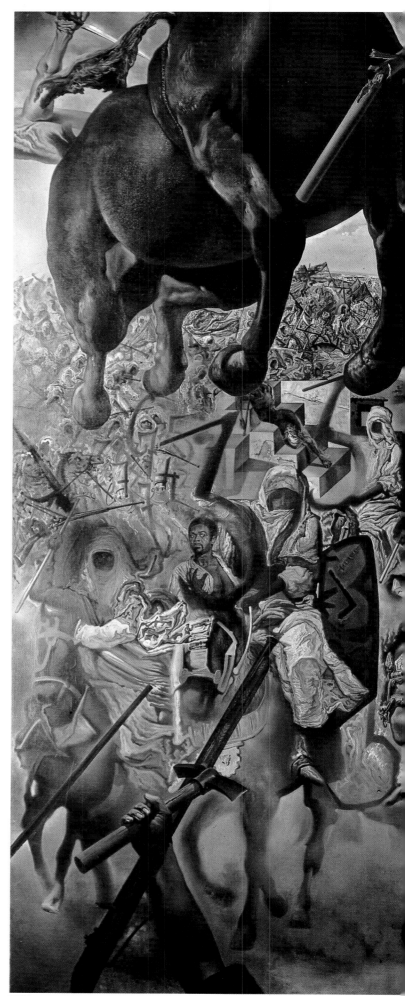

1207

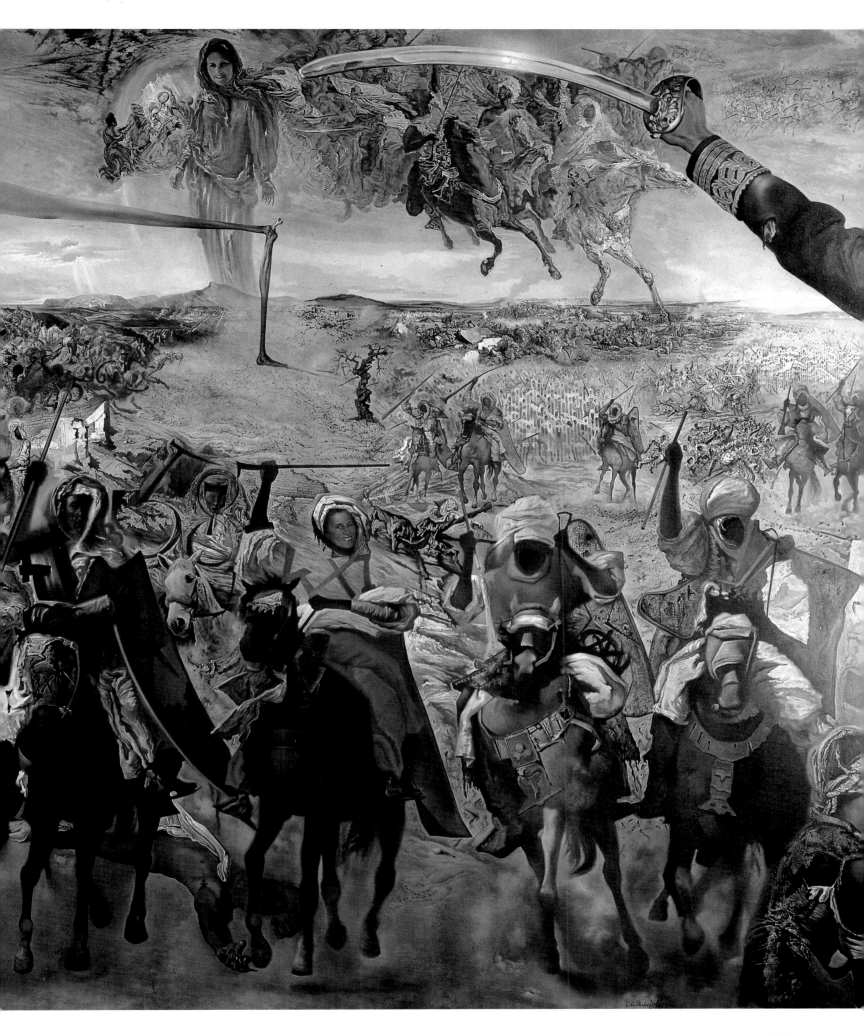

1208

1209

1210

1208 **Mohammed's Dream (Homage to Fortuny)**, 1961 ❏
Rêve de Mahomet (Hommage à Fortuny)

1209 **Arab**, 1962 Δ
Arabe

1210 **Arabs – The Death of Raimundus Lullus**, 1963 ❏
Arabes – Mort de Raymond Lulle

1211

This evening, while I am writing, I am listening to the radio, which is resounding with the boom of guns that are deservedly being fired for Braque's funeral. Braque – who is famous among other things for his aesthetic discovery of newspaper collages. And I dedicate in homage to him my most transcendent and much more instantaneously famous bust of Socrates quantified by flies."

1212

1211 **Desoxyribonucleic Acid Arabs**, c. 1963 ❑
Arabes acidodésoxyribonucléiques

1212 **Mohammed's Dream**, 1963 ❑
Le songe de Mahomet

1214

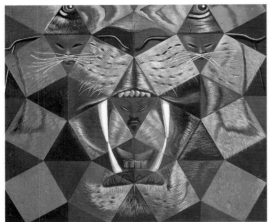

1213

1213 Study for "Fifty Abstract Paintings…", 1963 Δ

1214 The Infanta (Standing Woman), 1961 ❏
Infante

1215 Twist in the Studio of Veláz-quez (first version), 1962 ❏
Twist dans l'atelier de Vélasquez

1216 Fifty Abstract Paintings which as Seen from Two Yards Change into Three Lenins Masquerading as Chinese and as Seen from Six Yards Appear as the Head of a Royal Bengal Tiger, 1963 ❏

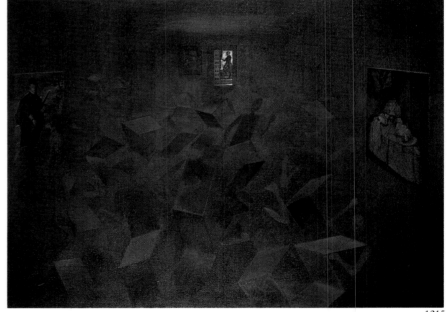

1215

The Electrocular Monocle and the Paranoiac-Critical Method

Dalí took a lively interest in every kind of scientific development, and in spring 1962 he returned from America with an "electrocular monocle". This astounding gadget had been developed by the electronics section of a major aeronautics company. A recorder registered images and transferred them televisually to a telescopic tube that substituted for a screen, a telescope so constructed that the eye could distinguish the televised image yet at the same time see everything in its

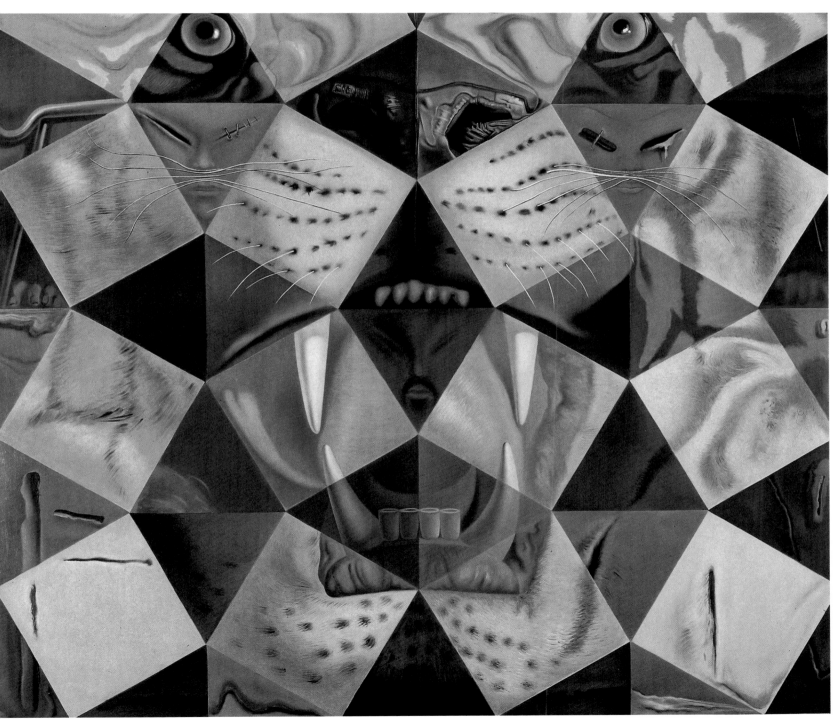

1216

1962

1217

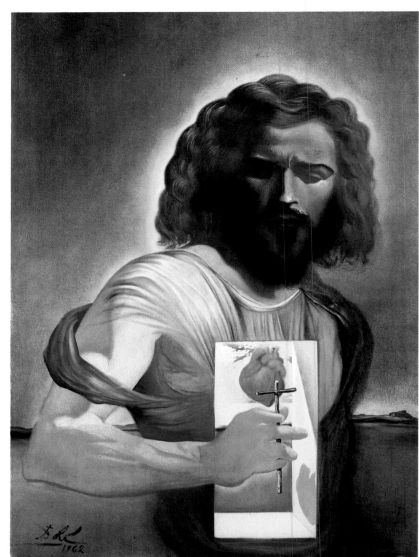

1218

1219

1217 **Madonna with a Rose**, 1964 ∆
Madone à la rose

1218 **The Sacred Heart of Jesus**,
1962 ❏
Cœur Sacré de Jésus

1219 **St. George and the Dragon**,
1962 ❏
Saint Georges et le dragon

1220 **Madonna with a Mystical
Rose**, 1963 ❏
Madone à la rose mystique

1221 **The Alchemist**, 1962 ❏
L'alchimiste

1222 **Portrait of Mr. Fagen**, 1962 ❏
Portrait de Mr. Fagen

1220

1221

field of vision in a perfectly normal way. For Dalí, the painter needed a second type of vision, occasioned by irritation of the retina. This double vision, which others were prompting with the help of mescalin, hallucinogenic mushrooms or LSD, could be caused by the "electrocular monocle" instead. In conversations with a professor named Jayle, a leading optics specialist, over the course of several years, Dalí had been expressing the wish to have a kind of contact lens filled with fluid introduced into the eye – so that images controlled from outside could even be registered during sleep.

Dalí was so excited by the "electrocular monocle" that he immediately had one installed in the Catalan beret he frequently wore. Dalí – it is worth mentioning – never wore a hat proper, but nonetheless liked to cover his head with the most curious of headgear: for him, anything that touched his hair possessed symbolic meaning. In his youth he had shaved his head for the sake of doing so – to balance a sea urchin. He was once even observed scooping out the soft inside of a *crouston* loaf, which resembles a tricorn hat in shape, and entering the most exclusive club in Figueras, the "Sport Figuerenc", wearing his impromptu hat – causing a scandal amongst the members. Later in London he made a public appearance wearing a diving suit, and posed for photographer Cecil Beaton in a fencer's mask.

If we are to grasp Dalí's art correctly, we need to see how capable he was of reigning in his imagination and his dreams, in order to suit them to the subjects of his paintings. His "paranoiac-critical" activity could be visited on random

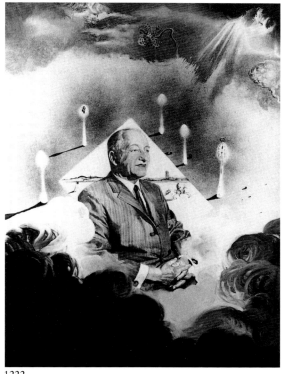

1222

1223

1223 **Galacidalacidesoxyribonuc-leicacid**, 1963 ❏

1224 **Female Nude (after restoration)**, 1964 ❏
Nu féminin

1225 **Hercules Lifts the Skin of the Sea and Stops Venus for an Instant from Waking Love**, 1963 ❏
Hercule soulevant la peau de la mer demande à Vénus d'attendre un instant avant d'éveiller l'Amour

1226 **Untitled (Still Life with Lilies)**, 1963 ❏
Sans titre (Nature morte aux lys)

1224

541

1208

1209

1210

1208 **Mohammed's Dream (Homage to Fortuny)**, 1961 ❏
Rêve de Mahomet (Hommage à Fortuny)

1209 **Arab**, 1962 ∆
Arabe

1210 **Arabs – The Death of Raimundus Lullus**, 1963 ❏
Arabes – Mort de Raymond Lulle

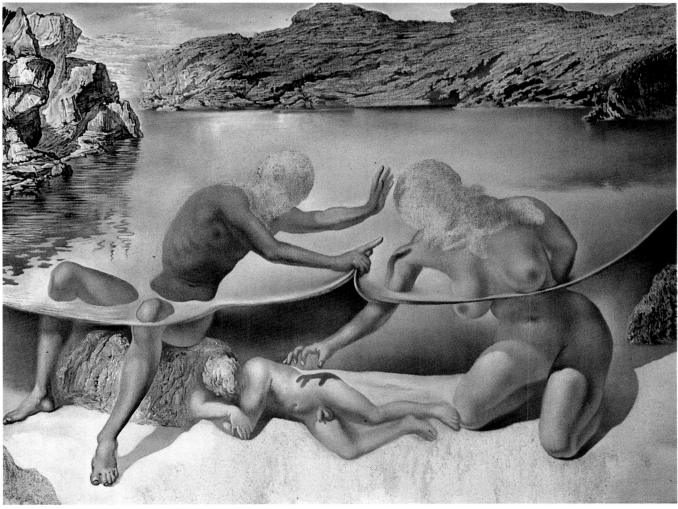

1225

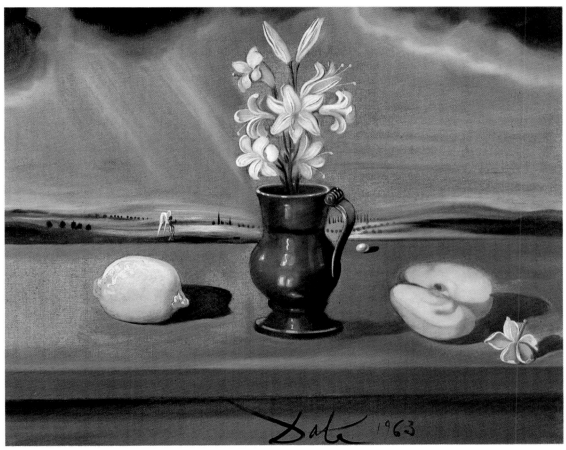

1226

1228

materials suddenly and unexpectedly. For example, at a time when Fortuny's *The Battle of Tetuán* had become an obsession with Dalí, he happened upon a major component of the picture he himself planned to paint on the same subject – in the American news magazine *Time*. One winter evening in New York he discovered, in a trodden and crumpled copy he found in the snow, a photograph of a fantastic Arabian scene, and, quickly picking it up, declared: "I have found my battle of Tetuán." His imagination was always rapid, as this anecdote concerning a newspaper photograph reminds us.

As a whole, Dalí's work as a painter was governed by a quest ruled by the need to discipline his inspiration and technique. In 1948, at a time when he was working on *Leda Atomica* (pp.424–425), he began to take an active interest in the *Divine Proportions* laid down in the 15th century by Fra Luca Pacioli. With the assistance of Prince Matila Ghyka, a Romanian mathematician, Dalí spent almost three months calculating the mathematical disposition of *Leda Atomica*. In all his works to follow, his procedure was the same; he used the golden section, the canon, and the principles of divine proportion. Not long after, in the *Nova Geometria* of Raimundus Lullus, he discovered arguably the most perfect square in

1227 **The Judgement of Paris**, 1963 △
Le jugement de Pâris

1228 **Untitled. Female Nude on a Palette**, 1964 △
Sans titre

aesthetics, known as the *Figura Magistralis*. Lullus's treatise was taken by the architect of El Escorial, Juan de Herrera, as his guide when he composed his discourse on cubic form; and Dalí drew upon this work in the composition of paintings such as *Corpus Hypercubus* (p.467), now in New York's Metropolitan Museum. As with most great artists, it was in fact an innate sixth sense for proportion that enabled Dalí to run the gamut of the aesthetic range. He was able to endow the rules with life as he desired, whether they derived from antiquity, the Middle Ages or the Renaissance. Every good painter, Dalí said, should proceed as Velázquez did: using his sense of proportion and obeying every rule in the book to the letter in the first version of a painting – and then smashing up the lot, and indeed standing several of the rules on their heads.

1229

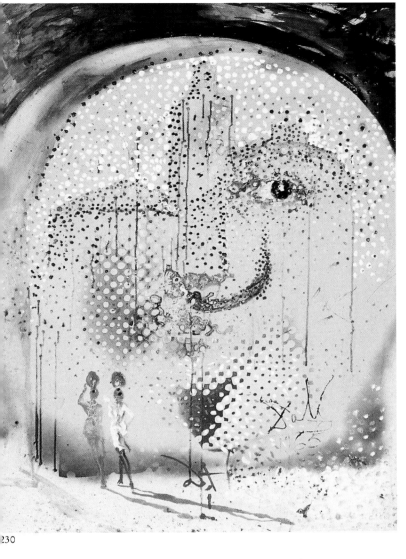

230

1232

231

1229 **Portrait of my Dead Brother,**
1963 ❏
Portrait de mon frère mort

1230 **The Sun of Dalí,** 1965 ❏

1231 **Landscape with Flies,** 1964 ❏
Paysage avec mouches

1232 **Untitled (St. John),** 1964 ❏
Sans titre (Saint Jean)

1965

1233 **Odalisque by a Bath
(Harem Scene)**, 1965 △
Odalísque devant un bassin
(Scène dans un patio de harem)

1234 **Religious Scene**, 1963 △
Scène religieuse

1235 **The Duke d'Olivares**, 1965 △
Le Comte-duc de Olivares (El Conde
Duque d'Olivares)

1233

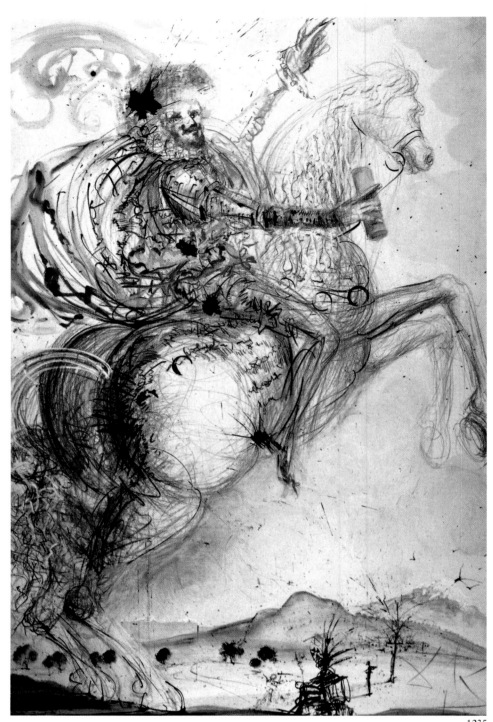

1235

1234

1236 **Philip II Taking Communion**,
1965 △
La communion de Philippe II

1237 **The Apotheosis of the Dollar**,
1965 ❏
L'apothéose du dollar

1236

A custom in Spain is for a woman to place her maiden name before her married name and to associate the former with the latter through a possessive "of", to emphasize that the woman belongs to that particular man. The title of a book by Robert Descharnes, *Dalí de Gala*, thus inevitably suggests that Dalí belonged to Gala – and is quite correct to do so. It was Gala who inspired Dalí, Gala who kept him under control, Gala who saw to the practicalities of their life together. In the *Secret Life*, Dalí confirmed that he would have been nothing without Gala. It is useful to read Descharnes' book if we are to understand his work, and to see that Gala was not only his wife but also adopted the roles of his mother and sister. Psychiatrist Pierre Roumeguère wrote a study of Dalí's personality which nicely complements Dalí's own mythology of Gala. In it, Dalí is cast as Pollux, while his dead brother is Castor and Gala Helen. That is to say, after having been Leda's mother, Gala became the immortal sister of Pollux, and Leda's daughter. Roumeguère's theory changes the contours of the Port Lligat house: suddenly we have to accommodate an extra oval, the egg in which Gala and Dalí were united, in our ideas.

1237

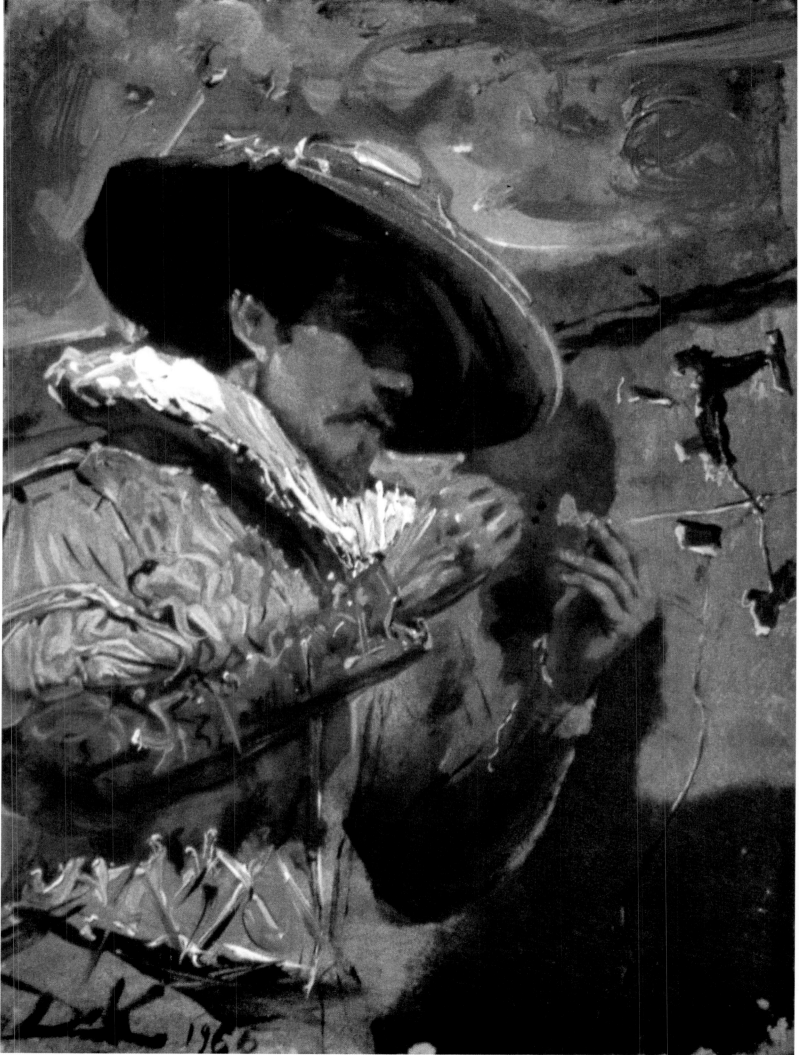

1238

From now on, Dalí lived with two *idées fixes*: that of the Dioscuri, and that of cybernetic science. His mind was busy looking for correlations between the two areas. One of the preliminary sketches for *The Battle of Tetuán* bears the dedication, "For Helen from her Dioscuri". Dalí was excited to discover that the word "cybernetic" was etymologically derived from the Greek "kybernetes", a steersman or pilot. For Plato, the pilot's task was clear. The captain chose a harbour

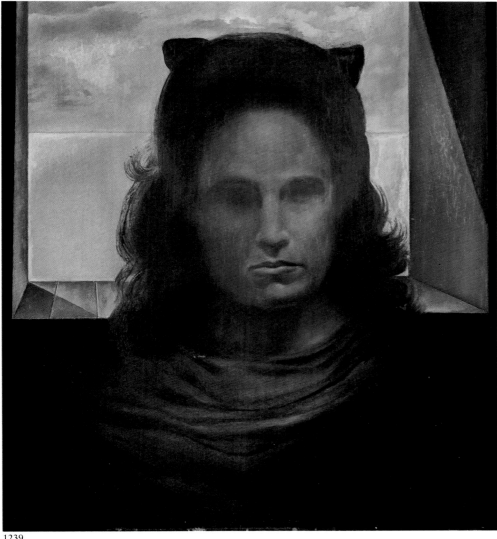

1239

into which the craft was to be sailed. The helmsman adjusted the rudder in order to steer the vessel in the required direction. And the pilot ensured that the helmsman was continually aware how to use his rudder in order to reach the harbour. In this joint effort, the captain took the decision on a goal, the helmsman steered, and the pilot gave guidance. The pilot, in other words, is cybernetic in terms of his activity; and this derivation and meaning of the word struck Dalí powerfully, since he saw himself as the pilot of his own life. But he went a step further and found a way of associating this with his other current obsession, with the Dioscuri. Was it not the task of Castor and Pollux, in antiquity, to guide ships? Having made this connection, Dalí averred that, with the remote guidance of the Dioscuri, he was piloting the boat of their life, with Gala's hand firmly on the rudder.

1238 **Disguised Personage Pinning a Butterfly**, 1965 ❏
Personnage déguisé en train de clouer un papillon

1239 **Portrait of Gala (Gala against the Light)**, 1965 ❏
Portrait de Gala (Gala à contre-jour)

1240

1241

1965

1240 Detail from the cover of
"Diary of a Genius", 1964 ☆

1241 Cover of "Diary of a Genius",
published by Doubleday, New York,
1965 ☆

1242 The Railway Station at
Perpignan, 1965 ❏
La gare de Perpignan

558

1242

1965

The Mystical Railway Station of Perpignan

I t is always at Perpignan station," announced Dalí in the *Diary of a Genius* (19 September 1963), "when Gala is making arrangements for the paintings to follow us by train, that I have my most unique ideas. Even a few miles before this, at Boulou, my brain starts moving; but it is the arrival at Perpignan station that marks an absolute mental ejaculation which then reaches its greatest and most sublime speculative height. I remain for a long time at this altitude, and you will note that during this ejaculation my eyes are always blank. Towards Lyon, however, the tension begins to slacken, and I arrive in Paris appeased by the gastronomic phantasies of the journey – Pic at Valence and M. Dumaine at Saulieu. My brain becomes normal again though I am still a genius, as my readers should be so kind as to remember. Well, on this 19th of September, at Perpignan station, I had a kind of ecstasy that was cosmogonic and even stronger than preceding ones. I had an exact vision of the consitution of the universe. The universe, which is one

1243

1244

1245

1246

1247

1248

1249

1250

1251

of the most limited things that exist, is, all proportions being equal, similar in its structure to Perpignan railway station…" (Elsewhere, Dalí put it differently, declaring that the most reassuring moment in the entire history of art took place on 17 November 1964 at Perpignan railway station, where he discovered the means of painting the third stereoscopic dimension in oil.)

Gala considered Dalí as Leda considered the swan. The swan was spermatozoic. The divine egg of Pollux and Helen, twins from a single egg, is already present in the belly of the swan (*Leda and the Swan*, p. 535). In *The Railway Station at Perpignan* (pp. 558–559), we have a transposed image of Gala and Dalí, in which figures from Millet's *Angelus* (again) are arrested in atavistic attitudes, in front of a sky that is suddenly transformed into a gigantic Maltese cross. At the railway station at Perpignan, which is similar in structure to the universe, again, Dalí was painting the saga of Gala and Dalí, a thing of light and ecstasy and ejaculation.

1965–1966

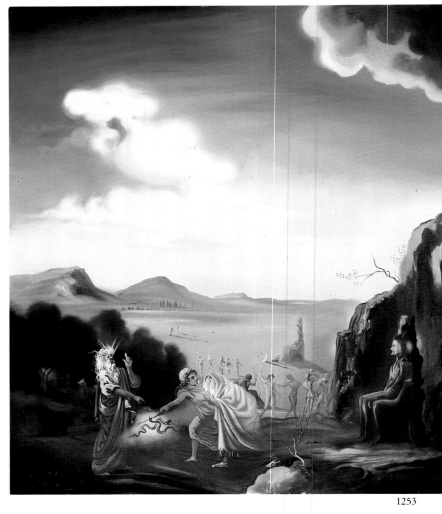

1253

1252

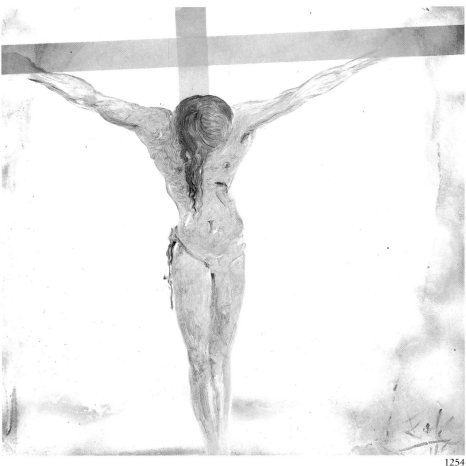

1254

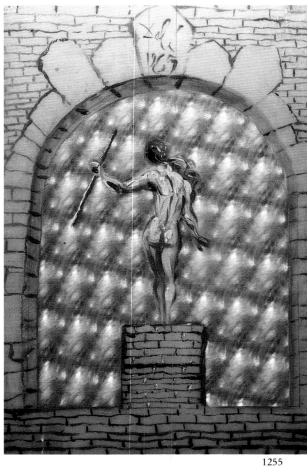

1255

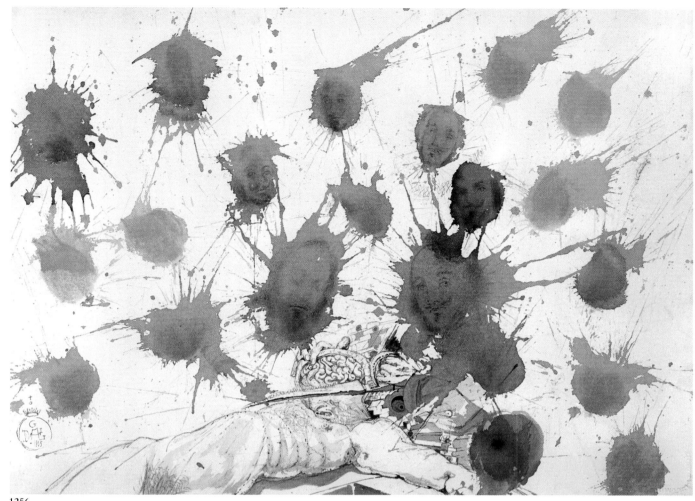

1256

1257

1258

1259

1260

The Art of the Pompiers Quantified: Homage to Meissonier

1259 Poster for "Homage to Meissonier", 1967 ✭

1260 Dalí with "Tuna Fishing", 1967 ✭

1261 Ernest Meissonier: The Battle of Friedland, 1807 (detail), 1888 ✭

1262 Homage to Meissonier, 1965 ❑
Hommage à Meissonier

564

Among the masterpieces Dalí painted, among the myths that obsessed him in his later period as he approached the time when the glorious twins of the Dioscuri must part, *Tuna Fishing* (pp. 568–569) and the *Hallucinogenic Toreador* (p. 578) – his great legacy to the art – occupy the most significant place.

The former painting, measuring an immense 304 by 404 centimetres, was presented publicly at the Hotel Meurice in Paris (Dalí's routine base on visits to the French capital) at an exhibition in homage to Meissonier. Drawing on the artist's own words, Jacques Michel wrote in *Le Monde* that it was Dalí's most ambitious picture yet. The motif came from Dalí's father, a gifted story-teller; but the alarming energy in the painting was in no wise related to the photographic mannerisms of certain *Pompiers* on display at the same show, such as Detaille, A. de Neuville, Suraud and Boldini. Dalí's homage was to Meissonier and also to Gustave Moreau, whom he reconciled in his own artistic person via Surrealism.

After Pop art and Op art, Dalí was doing his personal version of the *Pompiers*. His invitation to the show announced that Dalí would be offering tuition in

1261

1262

1263 **Study for "Tuna Fishing"**, 1966–1967 Δ

1264,1265,1266,1267 **The progress of "Tuna Fishing" from 1966 to 1967** ☆

1268,1269 **Studies for "Tuna Fishing"**, 1966–1967 Δ
Exhibited when the immense painting was unveiled at the "Homage to Meissonier" show in the Hotel Meurice, Paris. Dalí explained that there could be no question of a backlash, since any

1263

1264

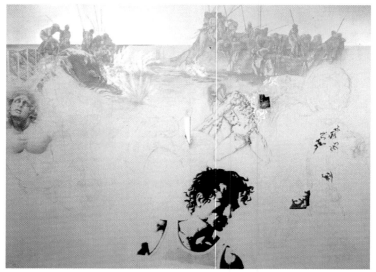

1265

avant-garde could naturally and inevitably only be successful in proportion to the murderously multiplying debris of the explosion of 1900. In the wake of microphysics, op-art and their unimportant followers, said Dalí, it was time to return to academic art, which suddenly bloomed with all the freshness and life of a rose quantized by everything that had succeeded in securing a niche in contemporary aesthetics – one of the mightiest tragedies in all history.

drawing and composition, from models, and demonstrating the truth of the great master Ingres' maxim that draughtsmanship was the most honest aspect of art. Dalí needed two whole summers (1966 and 1967) to paint *Tuna Fishing*, a work full of dionysian figures. The picture was a kind of testament, the fruit of forty years of devoted searching for means of visual expression. In it, Dalí combined all the styles he had worked in: Surrealism, "refined Pompierism", pointillism, action painting, tachism, geometrical abstraction, Pop art, Op art and psychedelic art. The painting has proved as significant as his 1931 soft watch masterpiece, *The Persistence of Memory*. Dalí himself offered this account of it: "It is the most ambitious picture I have ever painted, because its subtitle is *Hommage à Meissonier*. It is a revival of representational art, which was underestimated by everyone except the Surrealists throughout the period of so-called 'avant-garde' art. It was my father who told me of the epic subject. Though he was a notary in Figueras, Catalonia, he had a talent for story-telling that would have been worthy of a Homer. He also showed me a print he had in his office by a Swiss artist – one of the Pompiers – showing a tuna catch; that picture also helped me create this painting. What finally made me decide to take the subject, which had been tempting me my whole life long, was my reading of Teilhard de Chardin, who believed that the universe and cosmos are finite – which the latest scientific discoveries have confirmed. It then became clear to me that it was that finite quality, the contractions and frontiers of the cosmos and universe, that made energy possible in the first place. The protons, antiprotons, photons, pi-mesons, neutrons, all the elementary particles have their miraculous, hyper-aesthetic energy solely because of the frontiers and contraction of the universe. In a way, this liberates us from the terrible Pascalian fear that living beings are of no importance compared with the cosmos; and it leads us to the idea that the entire cosmos and universe meet at a certain point – which, in this case, is the tuna catch. Hence the alarming energy in the painting! Because all those fish, all those tuna, and all the people busy killing them, are personifications of the finite universe – that is to say, all the components of the picture (since the Dalí cosmos is restricted to the circum-

contd. on p.577

1268

1269

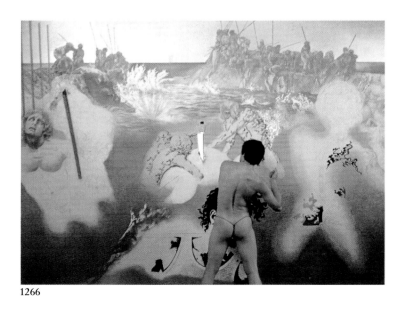

1266

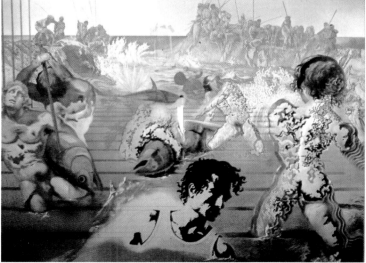

1267

1967

1270, 1271 **Large Figure for "Tuna Fishing"**, 1966–1967 Δ Grande figure pour «La pêche aux thons»
1272 **Tuna Fishing**, 1966–1967 ❏ La pêche aux thons

1270

1271

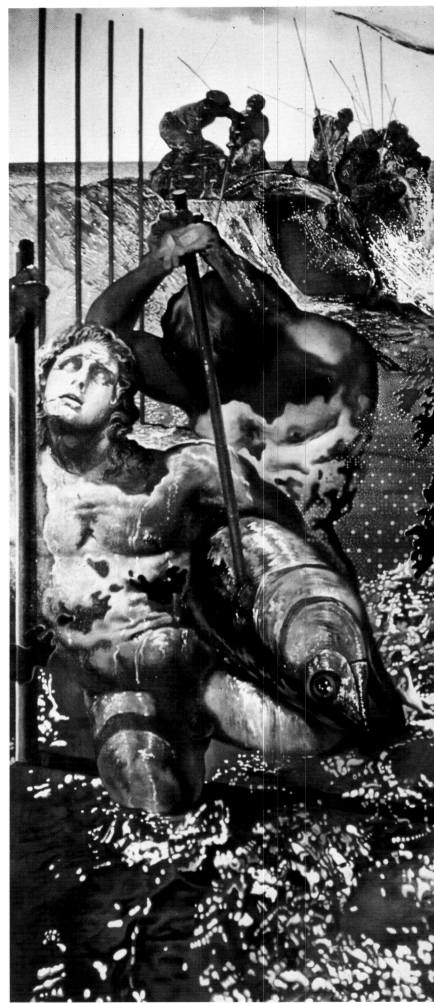

1272

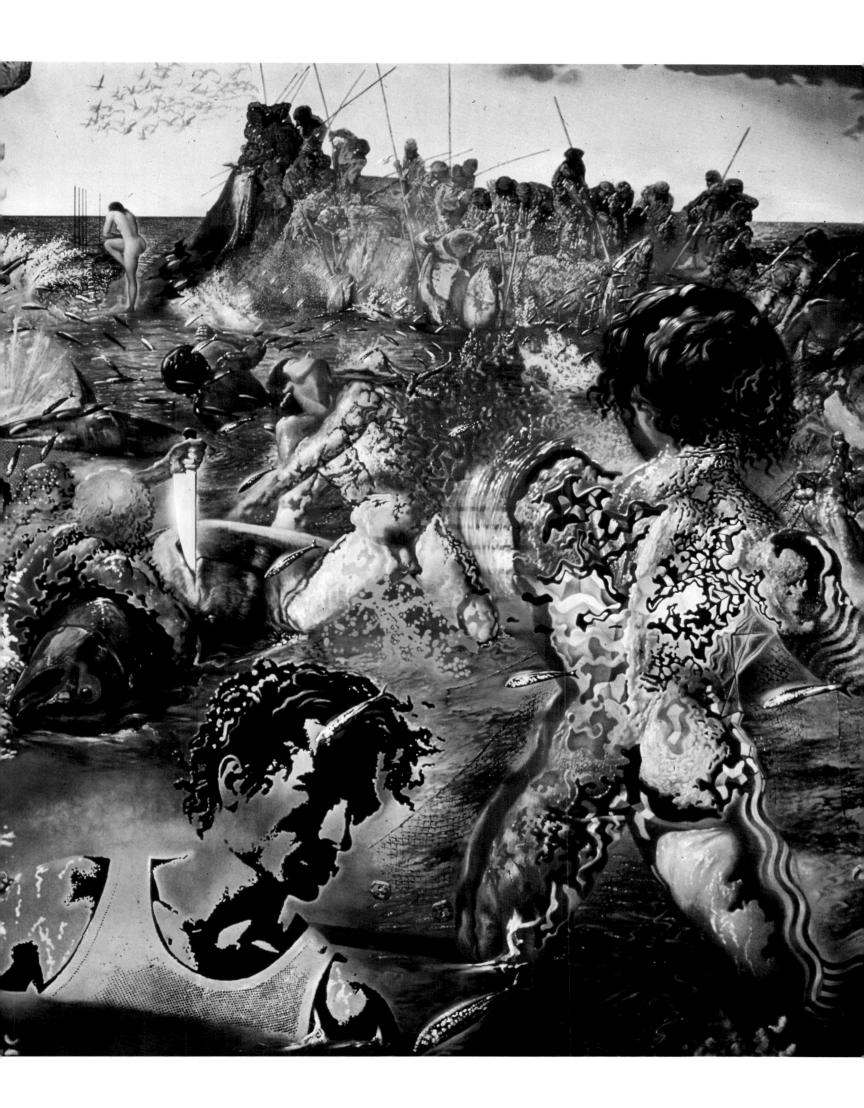

1967

Illustration for Dalí's book "Les Méta-morphoses Erotiques" (The Erotic Metamorphoses), published in 1969. This was one of the great achievements of Dalinian phantasmagoria and of his application of the paranoiac-critical method to erotica.

1273 Pimp, undated △
Le maquerau

1274 Tap (Grill), undated △
Le robinet (La grille)

1275 **Emblem of Wounded Pride**, undated △
Emblème de l'orgueil meurtri

1276 **The Mountains of Cape Creus on the March (LSD Trip)**, 1967 △
Les montagnes du Cap Creus en marche (L.S.D. Trip)

1277 **The Flower Show – Carnations**, 1967 △
Les floralies – Les œillets aux clés

1278 **One of 21 graphics for "Dalí illustre Casanova" (Dalí illustrates Casanova), published in Paris**, 1967 △

1273

1276

1274

1275

1277

1278

1966–1973

1279 **Behind,** 1973 Δ
Culo – Cul

1280 **Untitled (Erotic Drawing),**
1932 Δ
Sans titre (Dessin érotique)

1281 **Untitled (Erotic Scene with
Seven Figures),** c. 1966 Δ
Sans titre (Scène érotique à sept
personnages)

1282 **Figure Climbing a Stair,** 1967 Δ
Personnage montant un escalier

1279

1280

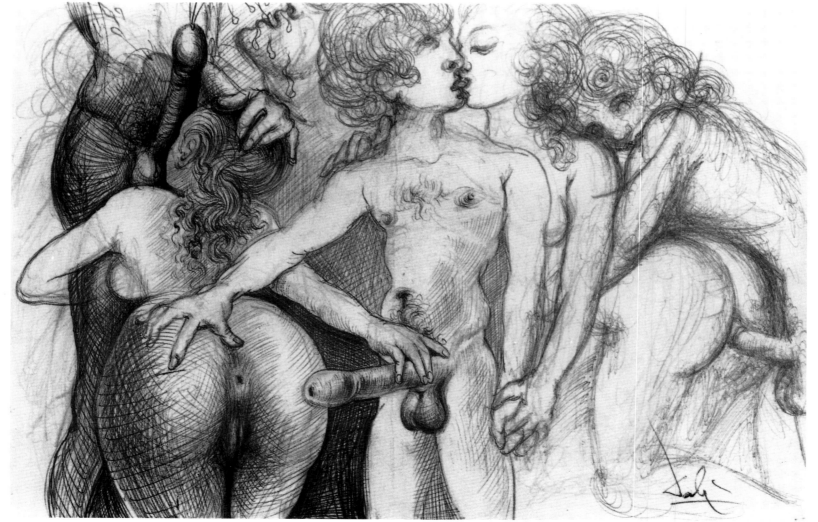

1281

1282

573

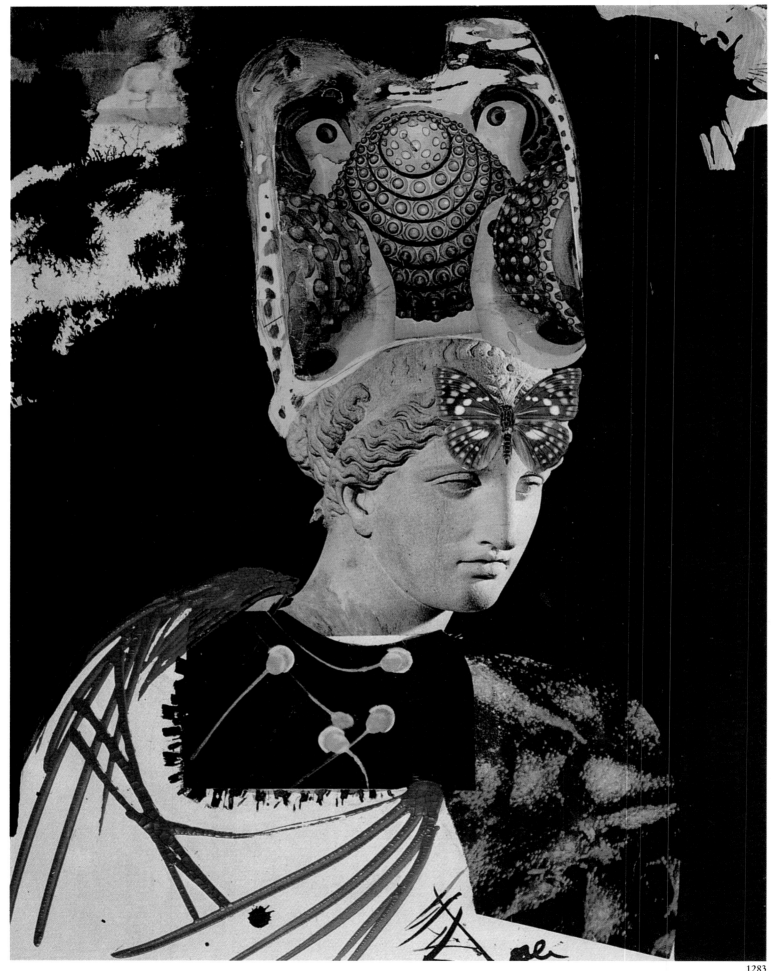

1283

1283 Mad Mad Mad Minerva –
Illustration for "Memories of
Surrealism", c. 1968 ❏
Folle folle folle Minerva

1284 The Patio of Port Lligat,
1968 ❏ Le patio de Port Lligat
1285 Fisherman of Port Lligat,
Mending his Net, 1968 ❏ Pêcheur de
Port Lligat réparant ses filets

1284

1285

576

1287

1288

scribed area of the tuna catch) achieve a maximum of hyper-aesthetic energy in it. Thus *Tuna Fishing* is a biological spectacle *par excellence*, since (following my father's description) the sea, which is initially cobalt blue and by the end is totally red with blood, represents the super-aesthetic power of modern biology. Every birth is preceded by the miraculous spurting of blood, 'honey is sweeter than blood', blood is sweeter than blood. Currently America has the privilege of blood, because America has the honour of having the Nobel Prize winner Watson who was the first to discover the molecular structure of desoxyribo-nucleic acid which, together with the atom bomb, constitutes the essential guarantee of future survival and hibernation for Dalí."

The Hallucinogenic Toreador

It is a cliché that those who are about to die, in the instant of death, see their whole lives before them, as if in a film. Dalí's *The Hallucinogenic Toreador* (p.578) is like one of those films, projected by Dalí before setting out on the dusty road to death himself. The film (so to speak) bears the same relation to *Un Chien Andalou* as a full length feature film does to a commercial. The April 1970 issue of *Art Magazine* found that "In Dalí's *The Hallucinogenic Toreador*, a major work, he has chosen diverse elements – the duality of the image, the illusion of space reminiscent of his *Spectre of Sex Appeal* (p.215). He uses the *Venus de Milo*, as in his *Venus de Milo with Drawers* (p.279). In this painting he exhibits the whole dictionary of metaphors which he has compiled in his 'paranoiac-critical' system: the

1289

1286 **Cosmic Athlete**, 1968 ❏
Athlète cosmique

1287 **Tauromachia I – The Torero, the Kill (third and final round of the bullfight)**, 1968 △
Tauromachie I – El Torrero, Suerte de Matar
1288 **Light and Shadow**, 1968 △
Soli i sombra
1289 **Study for "Cosmic Athlete"**, 1968 △

577

TORERO ALUCINOGEN

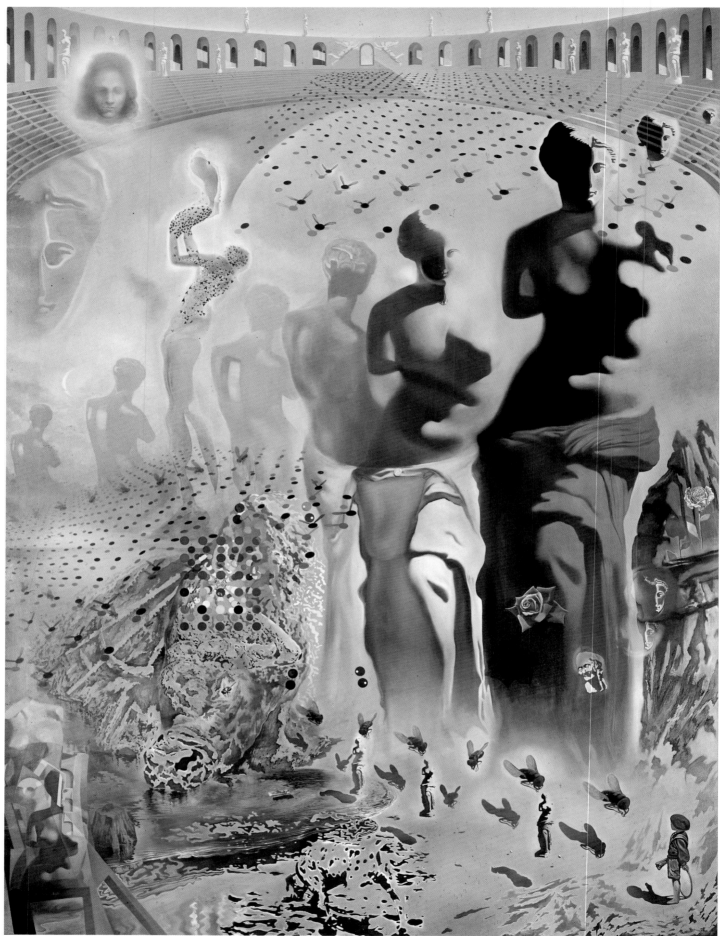

1291

1292

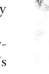

1293

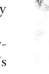

1290 **The Hallucinogenic Toreador,**
1968–1970 ❑ Le torero hallucinogène
1291 **Sketch for "The Hallucin-
ogenic Toreador", 1968** ✰
1292 **Dalí posing for photographer
Meli in front of the half-finished
"Hallucinogenic Toreador", 1968** ✰
1293 **Study for the toreador's face
in "The Hallucinogenic Toreador",**
1968 Δ The likeness suggests that it
could well have become Gala's face.

bee, the bull, his wife Gala, Dalí as a small child, space, its creative and destructive powers; the imagery is as complicated and clear as Dalí's technique affords; it is lucid illusion, the breathtaking swirl juxtaposed on the hidden image in his all-encompassing fantasy of time. This is perhaps one of Dalí's most remarkable works in years. In it he has freed himself of painting his heraldic image of God."

Dalí himself must have felt *The Hallucinogenic Toreador* to be of great importance, since he urged Luis Romero, author of *Tout Dalí en un visage* (Barcelona, 1975) to take the painting as both his point of departure and his set of coordinates. And the book did indeed prove a resumé of the subjects that obsessed and disquieted Dalí, in that one painting and in general: Gala, angels, rocky cliffs, flies, Venus, petrifaction, landscape, tears, the moon. Bullfight subject matter was rare in Dalí, in contrast to Picasso – curiously, since Dalí was so much the typical Spaniard, and saw himself as such. He had once toyed with the idea of organizing a bullfight together with Miguel Dominguin, it is true, at which the major novelty was to have been that the dead bull, instead of being dragged from the arena by mules, would be lifted out by helicopter.

The Hallucinogenic Toreador is once again a Dalinian picture *à clef*. The toreador himself – "who is to die, indeed is already dead" – represents the painter's dead elder brother, the Salvador Dalí Domenech who was born, and died, before Dalí himself was born. Dalí's parents had wanted the second son to be an exact

1294 Venus brand pencil box, on
which Dalí discovered the face of the
toreador ☆

1294

1295

1295 A picture in the painting:
Meli's photograph shows Dalí's new
ballpoint sketchwork, 1968 ☆

1296 "The Hallucinogenic
Toreador", divided into squares
by Dalí, 1968–1970 ☆

copy of the first, lost boy. Dalí had already painted *Portrait of my Dead Brother*
(p.552) – a venture into the Benday dot technique that was so frequently used by
American Pop artists. The toreador, however, also represents a large number of
dead friends, from García Lorca to René Crevel, and including Prince Alexis
Mdivani (who died when he crashed in his Rolls-Royce), Pierre Batcheff (who
acted in *Un Chien Andalou*), and even the Kennedy brothers. The toreador (as
Luis Romero wrote, recording Dalí's own view) makes a calm and sovereign
impression. His stoicism is apparent in a single tear of resignation. He is the sum
and paradigm of all the young friends Dalí had left behind, all who had gone on
to the realm of the dead, and so the toreador becomes a kind of funerary figure
in the pantheon of friendship – and perhaps (Romero suggested) Dalí's way of
warding off the fear of death. The death of a toreador in the arena is of course one
of the standard subjects in Spanish art and life. Dalí's toreador came from the
picture on a packet of British Venus brand pencils (cf. p.580), where his eye
discovered the hidden dual image. He showed the picture to Gala; and she
showed it to others; no one but Dalí, though, could see the image that was so clear
to him. There is a link across the years, surely, between *The Hallucinogenic Tor-
eador* and *The Invisible Man* (unfinished, p.180): we might even see the later

contd. on p.587

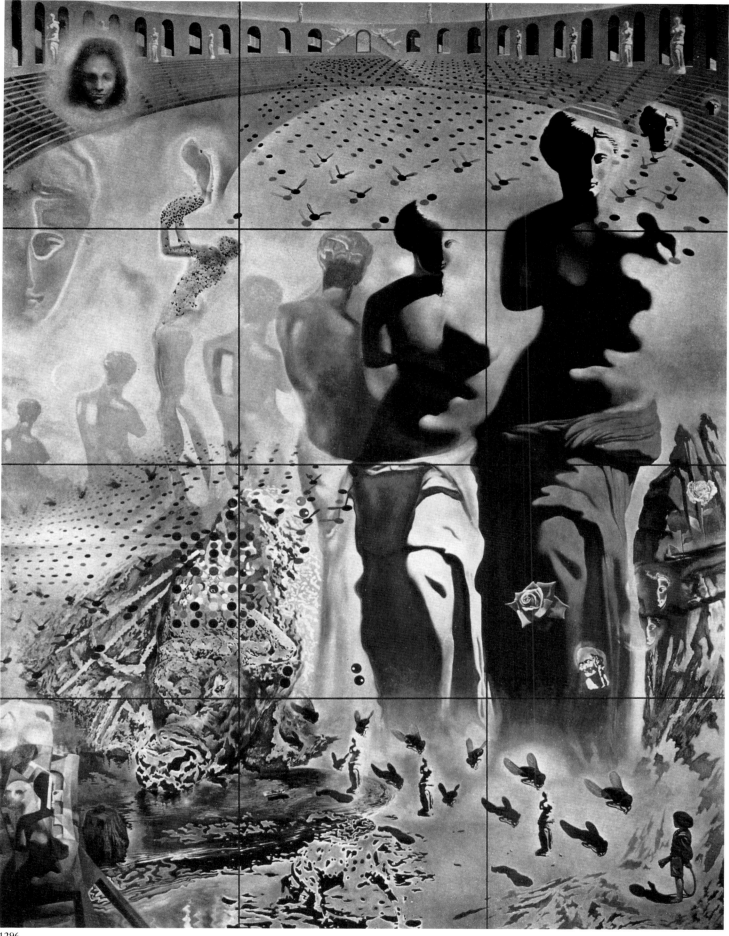

1296

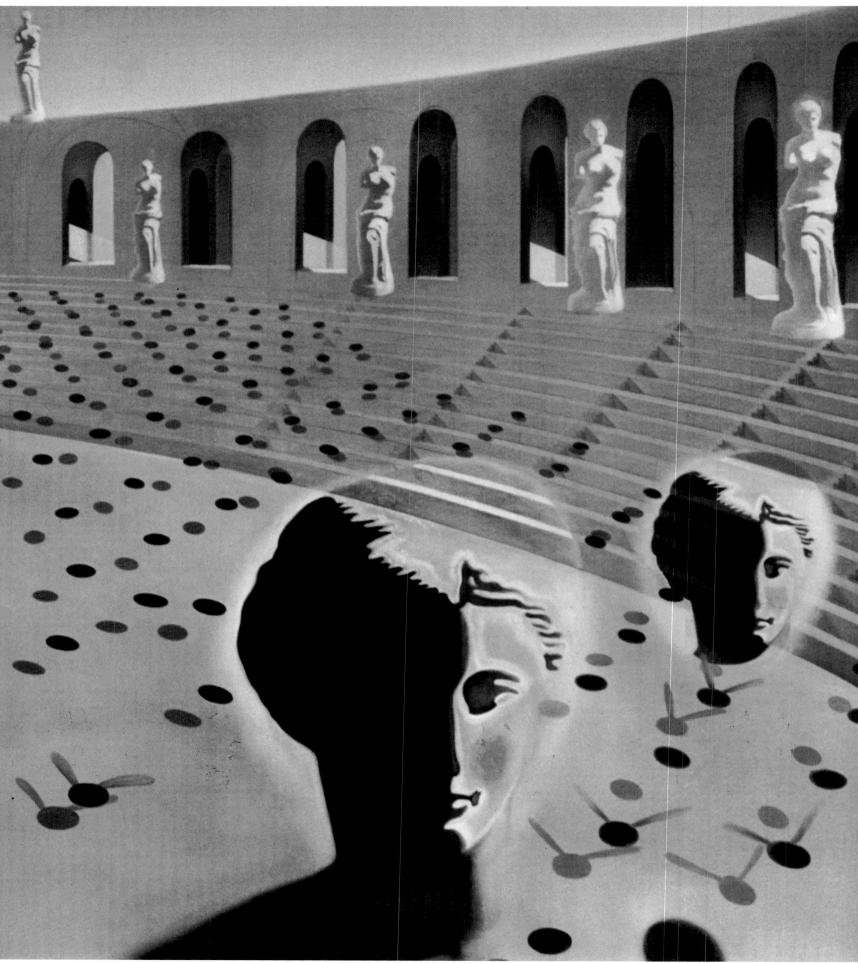

1297

1297 **One square metre of "The Hallucinogenic Toreador" in Dalí's division,** 1968–1970 ☆

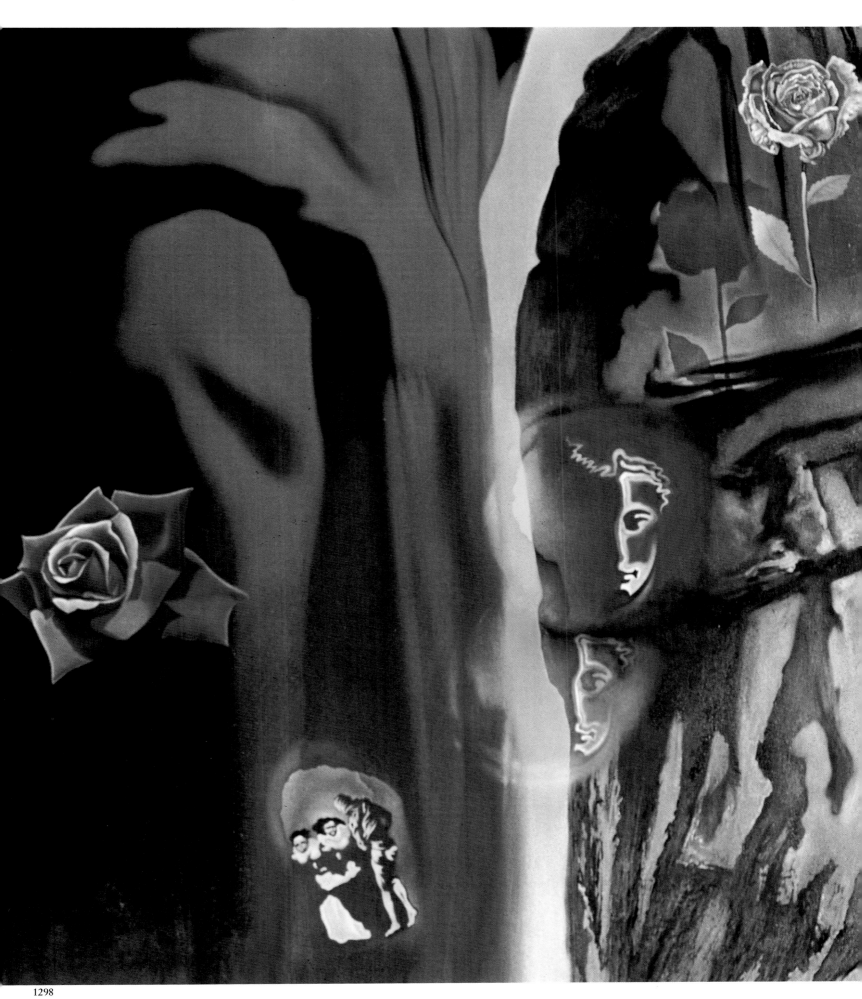

1298

1298 **A further square metre of
"The Hallucinogenic Toreador",**
1968–1970 ✫ Every square might be a
picture in its own right.

1299

1300

1299 Study of flies for "The Hallu-
cinogenic Toreador", 1968 △
1300 Dalí found inspiration in clas-
sical still life painting as practised by
a Velázquez or Zurbarán. This
painting by Balthasar van der Ast
includes flies on the fruit,
c. 1632 ☆
1301 Seven Flies and a Model,
1954 △
Sept mouches et un modèle
1302 A square metre of "The Hallu-
cinogenic Toreador", 1968–1970 ☆

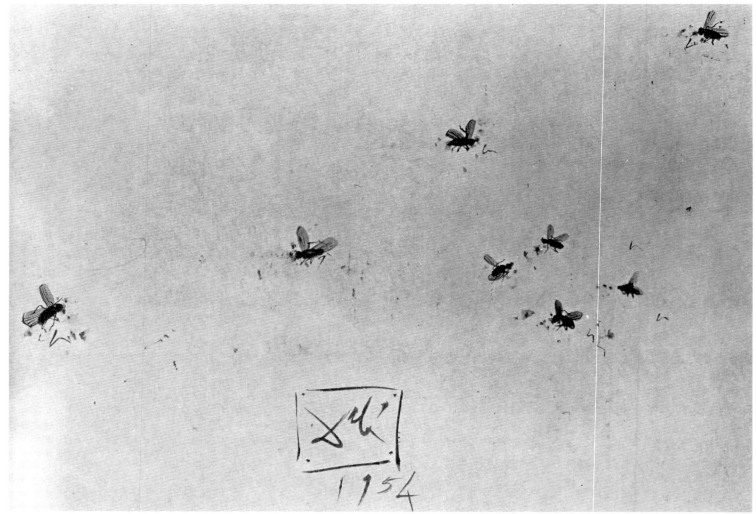

1301

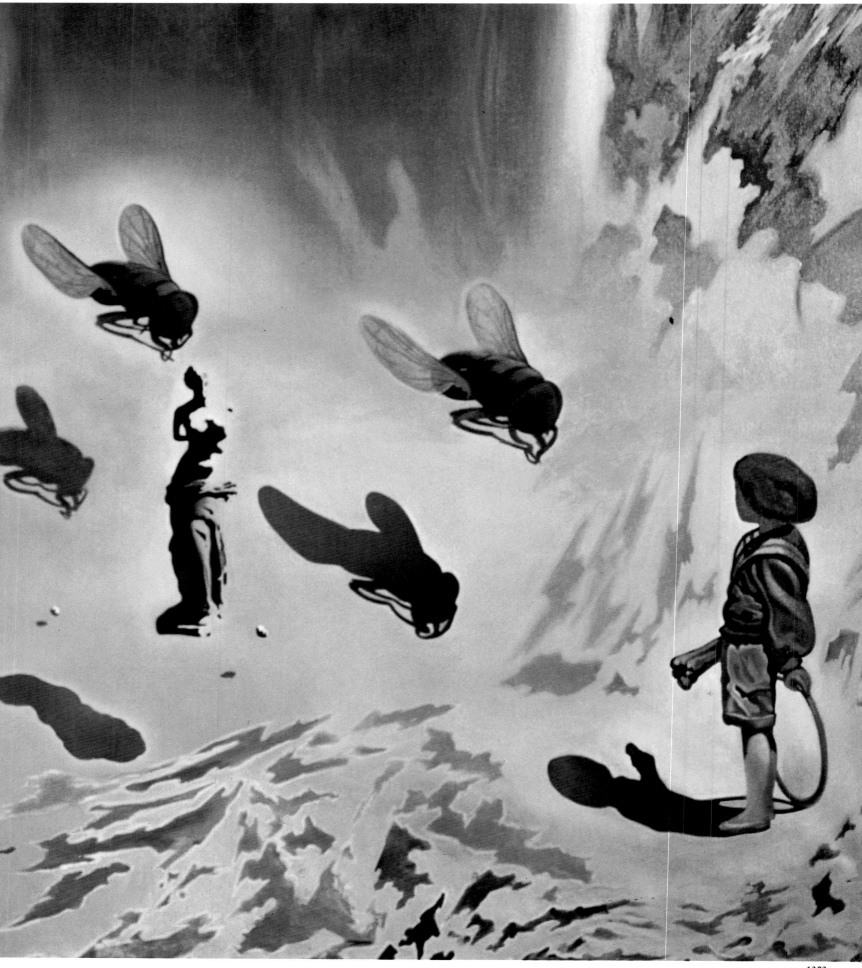

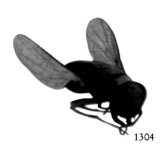

1303 A further square metre of "The Hallucinogenic Toreador", 1968–1970 ☆

1304 The flies from "The Hallucinogenic Toreador" (detail) ☆

painting as the successful, completed version of the earlier picture, which Dalí had abandoned at the time because he was dissatisfied with his work (though he nonetheless ascribed magical powers to it, powers that would protect Gala and himself). The new, patchwork picture brought together components from earlier works, from grandmother Ana sewing to the boy we have already seen in *The Spectre of Sex Appeal* (p. 215).

What was it that that boy, almost as old as the century, saw? From his vantage point at bottom right, he cannot view the entire picture, yet still he seems entranced by it all – by the fliés, huge autogiros of flies; by the diminutive figures of Venus; by the roses; the face of Gala, aureoled like Christ's and even resembling His, and positioned diagonally opposite the boy. It is a whole brave new world he sees, a world where the senses are deceived, where illusion is a shape-shifting chaos, a realm that seems substantial one moment and hallucinatory the next. Are these statues living flesh, or marble? Some have windows in their backs,

contd. on p. 596

1305

1306

1307

1305 The little boy – none other than Salvador himself. Detail from "The Spectre of Sex Appeal". It is the same boy as in "The Hallucinogenic Toreador". ☆

1306 Another fly from "The Hallucinogenic Toreador" ☆

1307 Dalí as a Child with his Father, 1971 △
Dalí enfant avec son père

1969

1308 **The Hour of Monarchy**, 1969 ❏
L'heure de la monarchie
Ceiling of the Palacio Albéniz de
Montjuïc, Barcelona

1309 **The Pool of Tears. Illustration
for "Alice in Wonderland" by Lewis
Carroll, in an edition published by
Maecenas Press, New York,
1968,1969** Δ
La mare aux larmes

1310 **Untitled (Surrealist Angel)**,
c. 1969 ❏
Sans titre (L'ange surréaliste)

1308

1309

1310

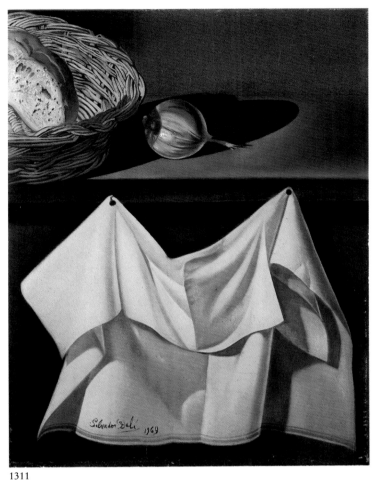

1311

1311 **Untitled (Still Life with White Cloth),** 1969 ❑
Sans titre (Nature morte au drapé blanc)

1312 **Study of a Female Nude,** 1969 ❑
Etude de nu féminin

1313 **Study of a Male Nude – Saint Sebastian,** 1969 ❑
Saint Sébastien

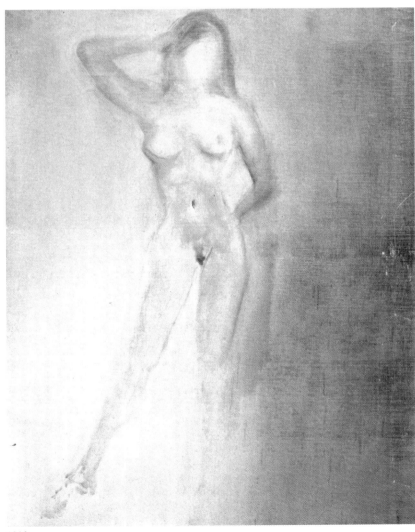

1312

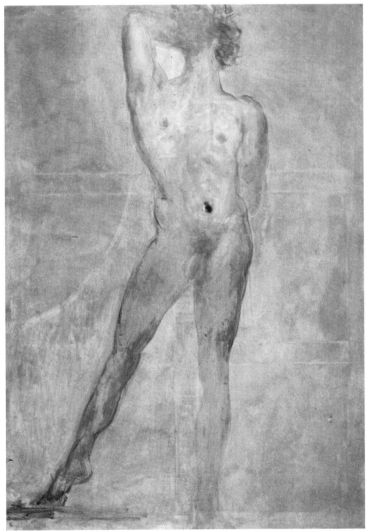

1313

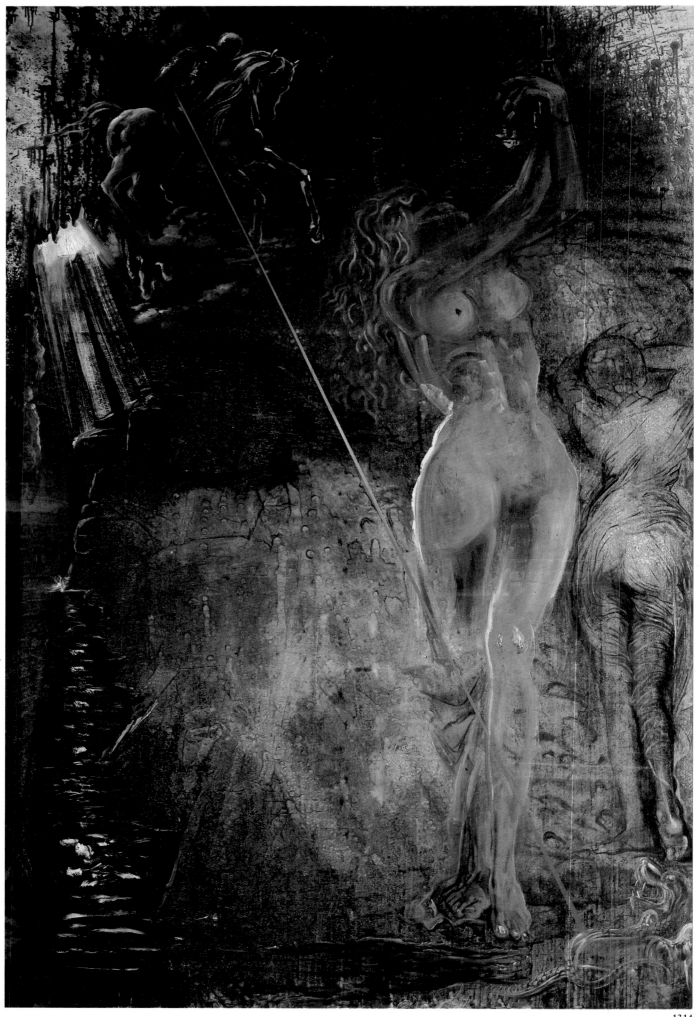

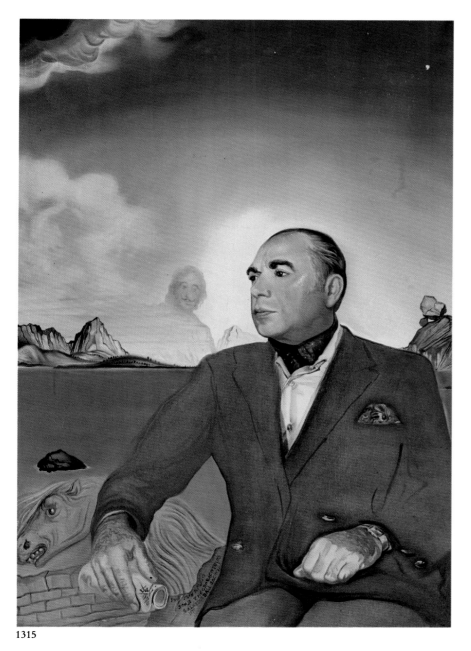

1315

1314 **Roger Freeing Angelica (St. George and the Damsel)**, 1970–1974 ❑
Roger délivrant Angélique (Saint Georges et la demoiselle)

1315 **Portrait of John Theodoraco-poulos**, 1970 ❑
Portrait de John Theodoracopoulos

1316 **Untitled (Michelangelo Head with Drawer)**, c. 1970 ❑
Sans titre (Tête de Michel-Ange au tiroir)

1317 **Patient Lovers (Apparition of a Stereoscopic Face in the Ampurdán Landscape)**, 1970 △
Patient Lovers (Apparition d'un visage à tendance stéréoscopique dans un paysage de l'Ampurdán)

1316

1317

1318

1318 **Nude Figures at Cape Creus,** 1970 ❑
Cap Creus con desnudos

1319 **Winged Victory,** 1970 △
Les ailes de la victoire

1320 **Apparition of Venus,** 1970 ❑
Apparition de Vénus

1321 **Silhouette of a Tightrope Walker and Clown,** c. 1970 ❑
Silhouette d'équilibriste et bouffon

1322 **Christ,** 1970 △
Christ

1323 **Les demoiselles d'Avignon (The Girls of Avignon),** 1970 △

1319

1320

1322

1321

1323

1970

1324 **View of Púbol,** 1971 Δ
Vue de Púbol

1325 **Hannibal Crossing the Alps,**
1970 Δ
Hannibal traversant les Alpes

1324

1325

1326 **View of Púbol**, 1971 ❑
Vue de Púbol

1327 **Rhinoceros**, 1970 △
Rhinocéros
Special synthetic material developed
by Dalí on the principle of flies' eyes.

1328 **The Dalinian Senyera
(Catalonian National Flag)**, 1970 ❑
La senyera Dalíniana

1326

1328

1327

like the nurse in *The Weaning of Furniture-Nutrition* (p.226). The figures of Venus are of various sizes, some of them glowing, and recall the starry patterns we see when we rub our eyes – such as Dalí described in connection with the heads of Lenin in *Partial Hallucination. Six Apparitions of Lenin on a Grand Piano* (p.164). Dalí generally referred to these phosphenes as recollections of his intra-uterine paradise, which he lost on the day he was born. The matronly Venus de Milo, replicated numerous times in this painting around a bombastic architectural arena that recalls a Roman circus rather than a bullfight, had long been an element in Dalí's personal mythology. Hers was the first female figure he had ever modelled in clay, from a reproduction in his parental dining room, and she was the Venus he had discovered on a box of British pencils bought in New York.

1329

1330

1331

Dalí found her facial expression stupid but opined that stupidity, after all, was inseparable from feminine beauty – though it was not suitable for a woman of style, whose gaze should be or at least seem intelligent. For a young lad, the Venus was the peak of erotic attraction; and Dalí, as we have seen, was partial to the female anatomy. He was also obsessed with the quest for God; and *The Hallucinogenic Toreador*, replicating the Venus to infinity, might plausibly be read as an attempt to marry his two obsessions. Enthroned at top left amid the architectural pomp, at the opposite end from the boy Dalí, is Gala: her head dominates the picture, while at the same time appearing outside and independent of it. Toreador-Dalí is offering up the death of the bull in her honour. She is Gala the omnipresent, Gala, with whom Dalí galloped at the head of the Moorish horse-

Dalí was always a lover of horses. Many of his paintings feature horses, among them "The Temptation of St. Anthony", "Debris of an Automobile Giving Birth to a Blind Horse Biting a Telephone" and "St. James of Compostela". In the 1970s he painted a number of pictures including horses and a series of superb lithographs titled "Les chevaux de Dalí" (Dalí's Horses):

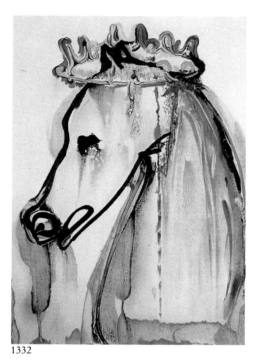
1332

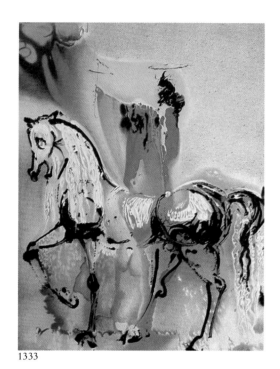
1333

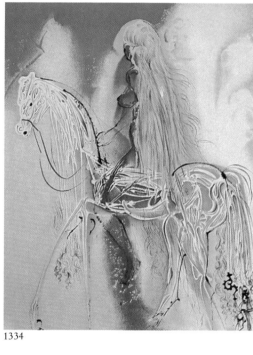
1334

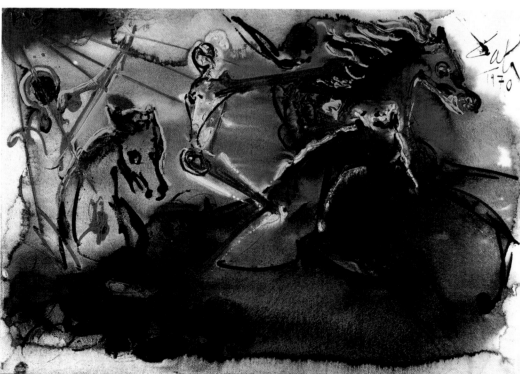
1335

1329 **Clauilegnio – The Flaming Horse (Dalí's Horses)**, c. 1971 △
Clauilegnio (Les chevaux de Dalí)

1330 **Trajan on Horseback**, 1972 ❏
Trajan à cheval

1331 **The Second Coming of Christ**, 1971 ❏

1332 **Caligula's Horse (Dalí's Horses)**, c. 1971 △
Le cheval de Caligula (Les chevaux de Dalí)

1333 **The Christian Knight (Dalí's Horses)**, 1971 △
Le chevalier chrétien (Les chevaux de Dalí)

1334 **Lady Godiva (Dalí's Horses)**, 1971 △
Lady Godiva (Les chevaux de Dalí)

1335 **The Horsemen of the Apocalypse**, 1970 △
Cavaliers de l'apocalypse

1971

1338

1336

1337

men in *The Battle of Tetuán* (pp. 540–541), Gala who appeared as St. Helen in *The Ecumenical Council* (p. 530), Gala who was given features à la Leonardo da Vinci in *Anti-Protonic Assumption* (p. 487), in *The Apotheosis of the Dollar* (p. 555), in *Impressions of Africa* (p. 303), Gala who became ever more obsessively present in Dalí's work as he neared the end. She was a face, a profile, a back, or architecture. She was a waterfall or a cliff or crag, a Muse and a saint, a stone wall and a shower of gold.

Dalí squared up the picture (p. 581), and every square metre is a picture in its own right. It is an exhibition of Dalí, a kind of retrospective in a single painting. And of course there were inevitably those who – when confronted with the Venus de Milo, with cliffs and crags, with a bull stuck full of banderillas and thrusting its jaw into the sand of the arena and (at once) the clear waters of the bay at Cadaqués – said that Dalí was repeating, copying, self-parodying himself. Solitary bathers, busts of Voltaire, Venuses, the shadows of the woman peasant from *The Angelus* – all of it struck some observers as too familiar for comfort. Luis Romero's book may be taken as conveying the gist of Dalí's riposte. Dalí was not so much indulging in self-plagiarization as using materials from his own psycho-

1339

1339, 1340 **Dalí's covers for the December issues of French and American "Vogue", 1971** ☆
These issues have become collectors' items. They were not about fashion; even the advertisements, touched up by Dalí, showed Yves Saint-Laurent ties exploding or Porthaut kerchiefs metamorphosing into grand pianos.

1341 **Marilyn Monroe, 1972** ❏

1340

1341

1342

1343

1344

1342 **Hall of Gala's castle at Púbol with ceiling painting by Dalí,** c. 1972 ☆

1343 **Radiators, Radiator Covers,** c. 1972 ❏
Radiateurs cache-radiateurs

1344 **Open doorway in** *trompe l'œil*, c. 1972 ❏
Porte en trompe-l'œil

1345 **Ceiling of the hall of Gala's castle at Púbol,** 1971 ❏
Plafond du hall du château de Gala à Púbol

1346 **Dalí by the pool at Port Lligat, inspired by the packaging of a transistor radio,** 1972 ☆

1347 **Armchair with Landscape painted for Gala's castle at Púbol,** 1972–1974 ○
Fauteuil à paysage

1345

1346

logical and visual world, parts of his personal cosmogony. In this one might compare him with Balzac, the French novelist, who re-used characters in several novels and thus established unity and consistency in the fictional world he was creating. Dalí's work, like Balzac's, might be seen as adding up to a *Comédie humaine* – a painted human comedy in which the imaginative powers of the unconscious invaded the turbulent scene of given actuality. *The Hallucinogenic Toreador* might to some extent be seen as an architectural work built with costly materials from torn-down architectural wonders designed by one and the same architect, built by the same craftsmen, or sculpted by the same sculptor – though with the difference that, in the making of Dalí's painting, nothing needed tearing down.

We have yet to consider the appalling flies, an entire squadron of which are bearing down upon the boy Dalí – though he seems too self-possessed to flinch. It is apt to recall not only Beelzebub but also the mystical *bodegóns* (a genre Velázquez and Zurbarán practised), which are votive offerings placed by the faithful at the foot of statuettes in niches, and in which flies (according to van der Ast, p.584) symbolize death. Spain, of course, has always been a country of flies. Dalí paid tribute to flies in his *Diary of a Genius*, calling them the Muses of the Mediterranean. From flies, he claimed, Greek philosophers lying in the sun derived their inspiration. Elsewhere he said that he imagined Velázquez surrounded by flies as he painted. And when Dalí grew his moustache beyond normal size, he insisted it had the virtue of attracting and trapping flies, like flypaper, so that he could paint in peace. There was also a scientific reason for Dalí's interest in flies, though. He was fascinated by the structure of their eyes, and the parabolic curves involved; and for Dalí the vision of flies was connected with his own vision of the railway station at Perpignan as the charismatic centre of the world where he

1347

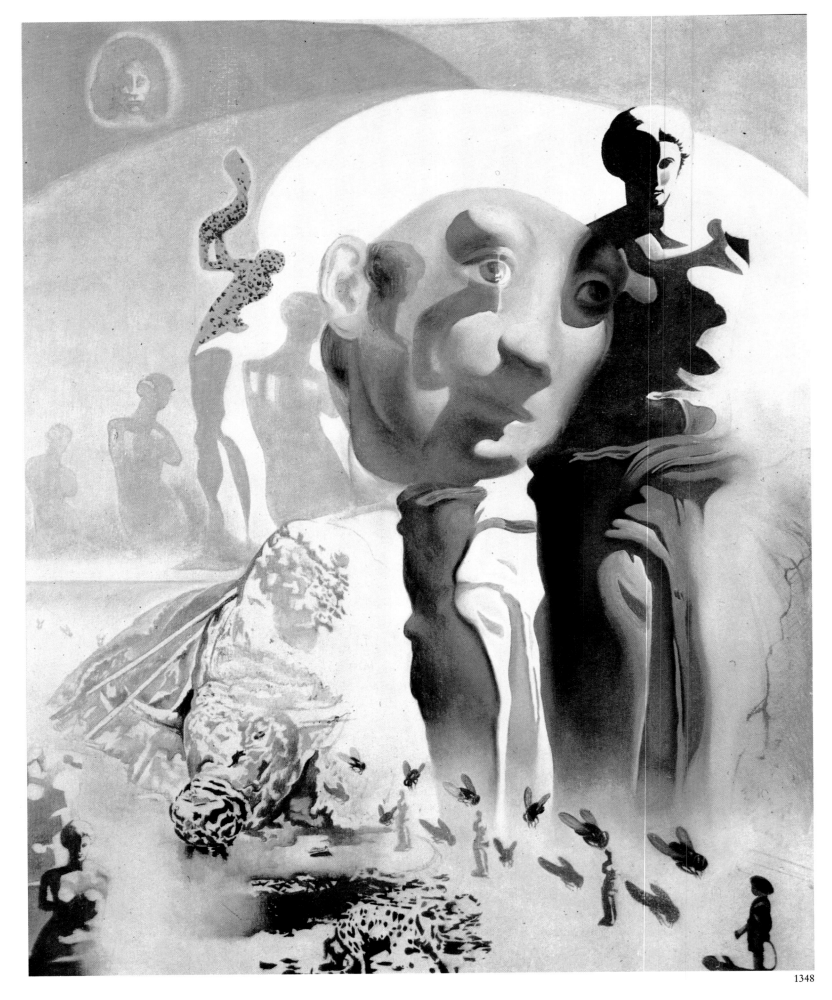

1348 **The Face**, 1972 ❑
Le visage

1349 **Space Eve**, 1972 ❑
Eva espacial

1350 **Now it is evening (Amazon)**,
1971 △
Maintenant c'est le soir (Amazone)

1351 **Quantification of Leonardo da
Vinci's "Last Supper"**, c. 1972 ❑
Quantification de «La Cène» de
Léonard de Vinci

1352 **Figure with Flag. Illustration
for "Memories of Surrealism"**,
c. 1971 ❑
Personnage au drapeau

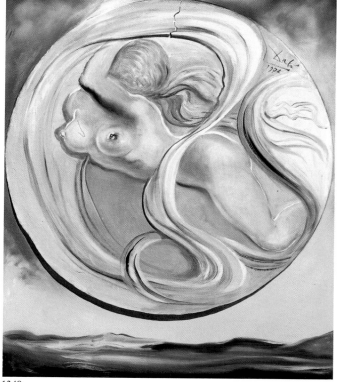

1349

1351

1350

1352

603

1353 "Dalí" palette. Frontispiece for the outline of "The Key Dalí Paintings", 1972 ❏
Palette «Dalí»

1354 The Banker (series of eleven gouaches on different professions), 1971 Δ
Le banquier

1355 Design for the pool at Port Lligat , 1971 ❏
Projet pour la piscine de Port Lligat

1357 Gala's Dream (Dream of Paradise), c. 1972 ❏
Le rêve de Gala (Rêve de paradis)

1353

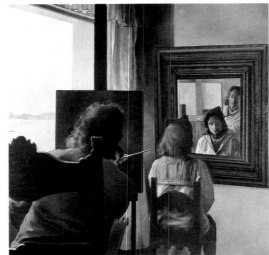

1356

1354

1355

1357

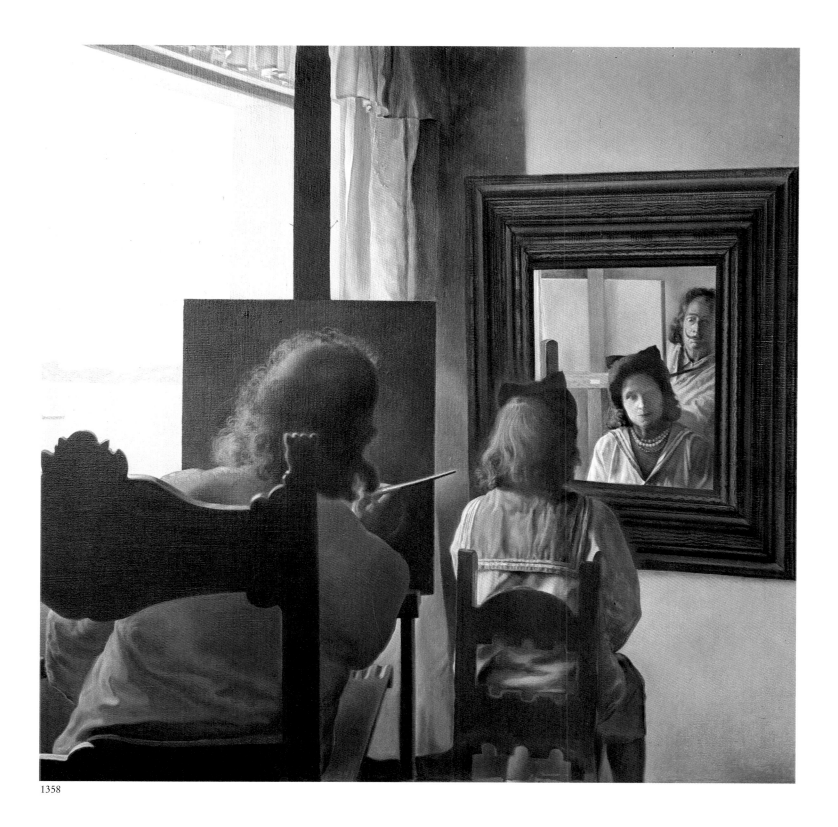

1358

made prophesies and important discoveries. In *The Hallucinogenic Toreador*, Dalí's flies also bear a strong resemblance to helicopters – or rather, to vertical take-off and vertical landing autogiros of the kind developed by the Spanish inventor La Cierva in 1923. Another Spanish scientist Dalí admired and who gave his name to the street where Dalí (and the scientist himself) were born was Narciso Monturiol, who invented a kind of submarine inspired by watching coral divers off the coast of Cape Creus. Monturiol's craft, the "Ictineo", dived for several hours to a depth of thirty metres, years before Jules Verne dreamt up the "Nautilus". The autogiro and the submarine were two Spanish inventions Salvador Dalí was particularly proud of. In a welter of symbols and interpretations, he defined

1356, 1358 **Dalí from the Back Painting Gala from the Back Eternalized by Six Virtual Corneas Provisionally Reflected in Six Real Mirrors (unfinished), 1972–1973** ❏
Dalí de dos peignant Gala de dos éternisée par six cornes virtuelles provisoirement réfléchies par six vrais miroirs
Stereoscopic work in two elements, left and right component

1359 **Sfumato**, 1972 Δ
Dalí developed a new technique using
paper scorched and smoked with a candle.

1359

1360 **Debris Christ**, c. 1969 ○
Christ aux déchets
Dalí's immense sculpture in an olive grove at
Port Lligat consisted of an old boat, branches,
stones, roof tiles and other found items.

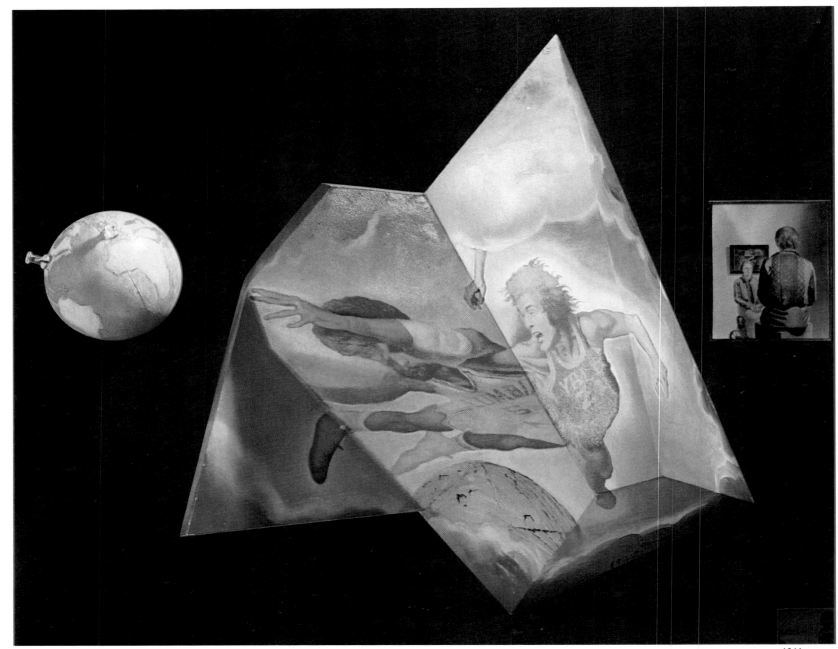

1361

1362

1363

the autogiro as the mystical flying body *par excellence* which represented the most exalted and angelic property of human kind: sublimation. The submarine, on the other hand, stood for the unconscious and its impenetrable vagaries. For Dalí, Spanish mysticism led directly and vertically from the depths of the submarine to the lofty heights of the autogiro: his whole life, he declared, had been led between the diametrically opposed ideas of exalted height and bottomless depth.

1364

1361 Polyeder. Basketball Players Metamorphosing into Angels (Montage for a hologram – central portion), 1972 ❏
Polyèdre. Joueurs de basket-ball se transformant en anges

1362, 1363 The Sleeping Smoker (Stereoscopic painting), 1972–1973 ❏
Le fumeur endormi

1364 Holos! Holos! Velázquez! Gábor!, 1972–1973 ☆
Holos! Holos! Vélasquez! Gábor!
Hologram: the first three-dimensional collage

1365 Untitled (Stereoscopic painting), 1972 ❏
Sans titre (Peinture stéréoscopique)

1366 On 21 May 1973 Dalí presented his first chronohologram at a press conference at the Hotel Meurice. ☆

1365

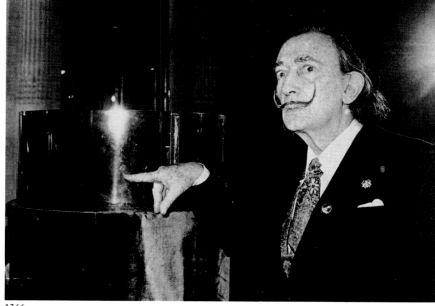

1366

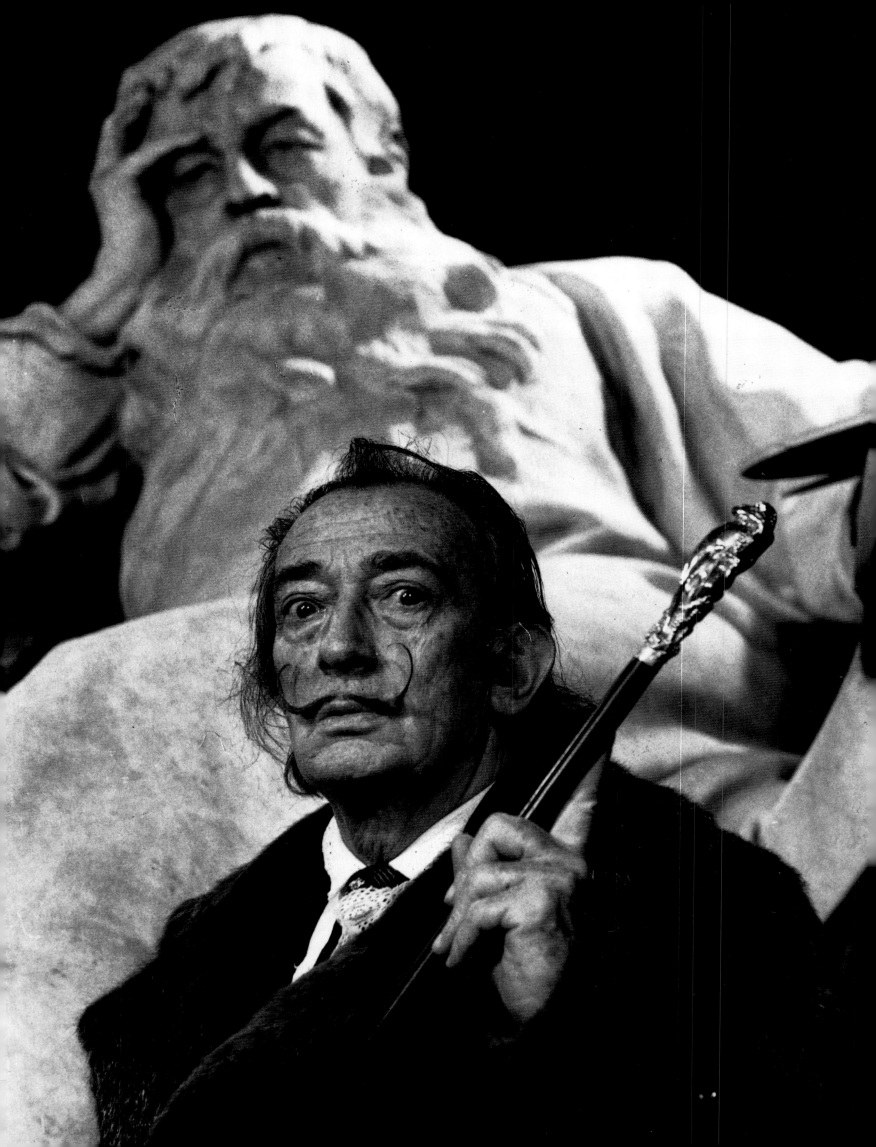

The Dalí Memorial Theatre

What greater pleasure could there be for a patriotic Spanish painter who liked chocolate than to have his pictures (together with Fragonard's) reproduced on Marquise de Sévigné chocolate boxes and, during his lifetime, to have a Dalí museum in his home town? When he walked through Figueras, Dalí could admire the mesh-like byzantine cupola atop the town theatre, designed by Pérez Piñero. Dalí designed the museum that was installed in the building himself, working upwards from the ruins that remained after shelling in the Civil War. He designed even the tiniest details himself, from the loaves on the heads of fully-equipped divers outside to the toilets and the poster for the national lottery inside. It is a kind of "Cave of Dalí Baba". His works are displayed in haphazard fashion,

1367 Dalí in front of the statue of Ernest Meissonier by Antonin Mercié (1895), 1971 ☆

1368 The patio of the Teatro Museo Dalí in Figueras during rebuilding work, 1973 ☆

1368

611

without their titles (at his request). There are paintings, stereoscopic photographs, a bendy metal crucifix that stylistically matches Piñero's architecture, the famous rainy taxi, and much more beside. But the most arresting aspect of the museum is its success in affording an insight into Dalí's mind. Thus there is a room that copies the face of Mae West, there are extremely classical studies, a nude by Bougereau, a picture by Fortuny, ceiling paintings by Dalí, tiny and immense *trompe l'œil* paintings in which Dalí (as early as 1939) seems to have been poking fun in advance at his later photorealist disciples in America – all amidst stage sets and books he illustrated. It is a veritable Dalí universe.

The Teatro Museo Dalí in Figueras was opened on 28 September 1974. Along with Dalí's own works, it exhibits paintings and sculptures by friends such as Ernst Fuchs, the Austrian artist, who donated a voluptuous figure of a woman (cf. pp.614–615). There is a bust of Dalí (p.734) by Arno Breker, the German artist who made his career during the Third Reich. There is work by Pichot, nephew of the painter and family friend who was a neighbour in Dalí's boyhood and helped get the young Dalí started in Paris. *Le Nouveau Journal* reported that Dalí had opened his own museum in his home town of Figueras, where he had exhibited his very first pictures as a fifteen-year-old. The paper pointed out that only four letters had had to be changed to make the Teatro Municipal into the Teatro Museo Dalí. (Dalí observed that everything he did was theatrical, and that he could not have made a better choice.) Now aged seventy, Dalí was fulfilling a lifelong wish. The reason he was able to convert the theatre into a Dalinian ready-

1370 **Photomontage of the Shell of the Theatre in Figueras**, 1961 ☆
In the doorway is Don José Nieto Velázquez, probably related to the artist

and head of the royal tapestry works. He is pulling a curtain aside to reveal the dazzling light outside.

1369

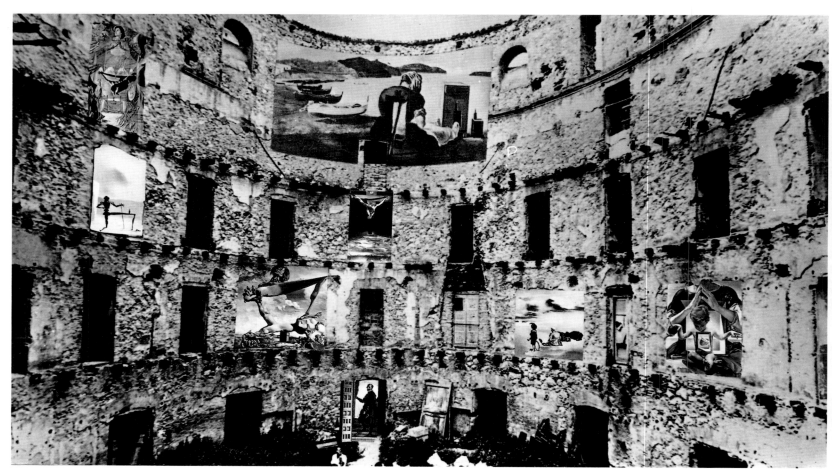

1370

1372

Gala
y
Salvador
Dalí

1373 Dalí outside the museum, in front of his memorial to the Catalonian philosopher Francesco Pujols, whom he greatly admired. ☆

1371 Pérez Piñero's cupola for the Teatro Museo Dalí, with the lit Santa Maria tower behind it ☆

1372 Invitation to the opening of the Teatro Museo Dalí on 28 September 1974 ☆

1373

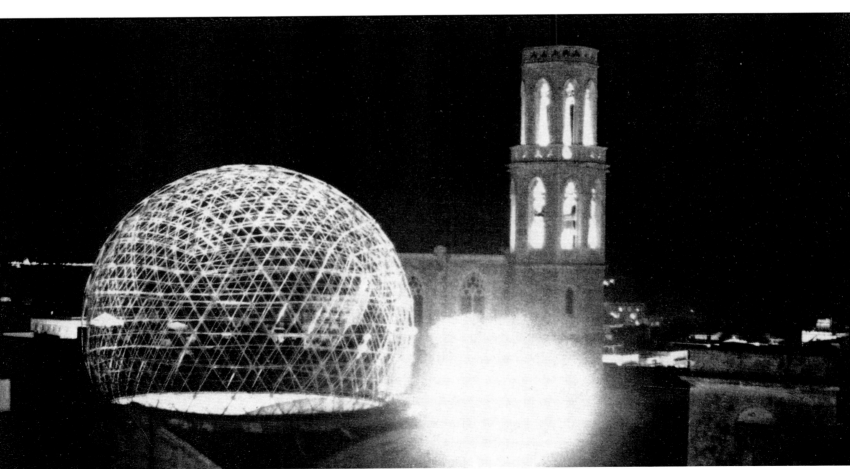

1371

1374

614

1375

1376

1374, 1375, 1376, 1377 **Views of the patio and cupola** ✫
Dalí is pointing his cane at the "Venus de Fuego", a well-known Barcelona music hall dancer, seen here in a bikini in the same pose as the bronze statue of "Queen Esther". The statue was a gift to Dalí from the Austrian artist Ernst Fuchs. Dalí placed it on the Cadillac in parody of bonnet figurines.

1377

made was that it had been seriously damaged by a bomb in the Spanish Civil War. Architects Ros de Ramis and Bonaterra Matra, who had already designed the Picasso museum in Barcelona, took care to strip the immense semi-circle of the theatre of all that was unnecessary. The entire space was to become a Dalinian work of art, an exercise in dynamic idiosyncrasy. Pérez Piñero devised the light-weight geodesic bubble above the building. Dalí, who painted a composition of his own on the ceiling of the one-time foyer, said: "When I build, I always begin at the top." The ceiling painting showed Dalí and Gala showering gold on Figueras. Dalí added a semi-circular myrtle maze consisting of Gs (for Gala) intertwined. A sculptor named Damian designed the octagonal entrance doors adorned with 200,000 midnight blue glass balls. To this day the museum continues to evolve; but it is already a genuinely Dalinian building.

On 23 May 1973, Dalí exhibited his first "chrono-hologram" at the Hotel Meurice in Paris. (Cf. *Holos! Holos! Velázquez! Gábor!*, p. 609 and *Polyeder. Basketball Players Metamorphosing into Angels (Montage for a hologram – central portion)*, p. 608.) To Dalí, it was the archetype of menace in painting, of meta-physical hyper-realism. It was with such concepts in mind that he created the

1378

1379

1378 The gigantic eggs that top the façade, and the Gorgot Tower, later renamed the Galatea Tower. The tower was intended to house the administration, library, and photographic and video archives. ✮

1379 Dalí saw the theatre of his home town, built in the mid-19th century, as a neo-Palladian piece of pomp. Hence his notion of topping the façade with a row of synthetic Art Deco dummies. ✮

1380 A stairway in the museum, with a plywood work made specially for this position in 1977 ✮

1380

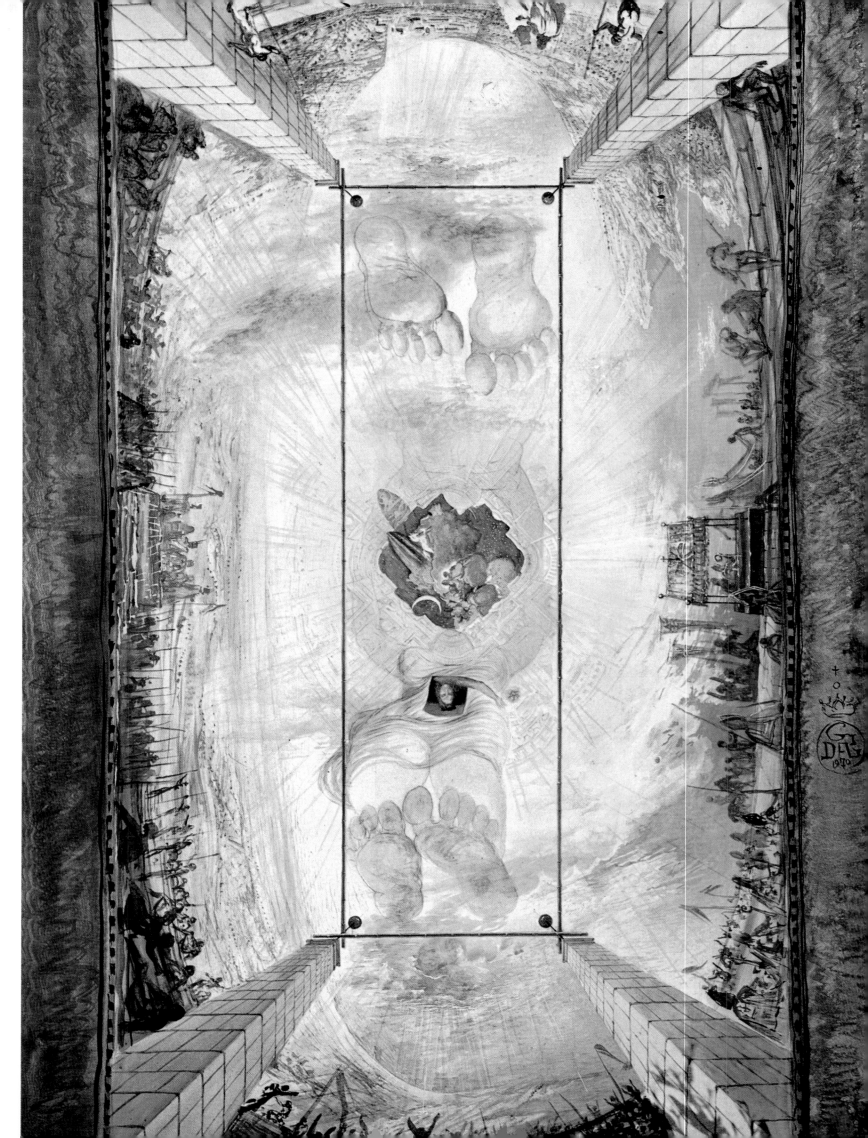

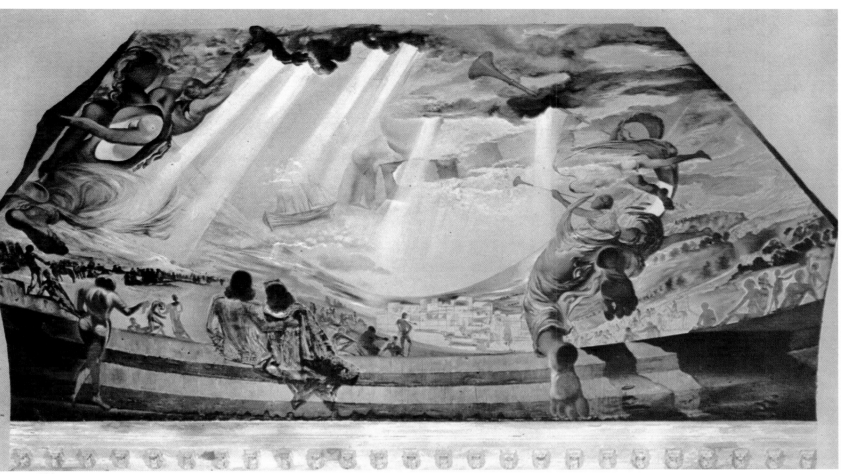

1382

museum in Figueras. It is worth adding that Dennis Gábor was an English physicist who was awarded the Nobel Prize in 1971 for his invention of holography. A hologram is an image created by using a laser to simulate the appearance of three-dimensionality. Dalí himself described *Polyeder*, one of the very first holograms he made, as a holographic view of a room in the Teatro Museo Dalí in Figueras. It shows a double portrait of Gala – the Angelus Gala; basketball players metamorphosing into angels, painted on a huge polyeder; and a globe on which Figueras in Spain and Cleveland in the U.S.A. are highlighted – the two towns which had museums devoted to the work of Dalí at that date (before the establishment of the Dalí museum at St. Petersburg, Florida).

With the help of architect Emilio Pérez Piñero, Dalí transformed what had once been the Figueras theatre into a "kinetic Sainte Chapelle". There is a sense of movement about the museum. Those who visit it are continuously aware of the dynamics inherent in the architecture. The pictures, sculptures and *objets d'art* mark out the progress of the artist's career with an unmistakable climactic momentum. The museum presents a concise overview of Dalí's work, and every exhibit highlights a fascinating facet. The exhibits emphasize *topoi* – "or rather, the beginning of all things: *polytopoi*, no longer conceivable since they are already in the fourth dimension." In Dalí's theatrical museum, we are both recipients and actors (a modern concept of the museum), and enter into the psychological dynamics of the artist – dynamics that even outdistance the staggering accelerations of Einstein's new physics.

1381 **Sketch for a ceiling of the Teatro Museo Dalí**, 1970 △

1382 **Ceiling painting in the Teatro Museo Dalí (detail)**, 1972 ❏

619

1383

1386 ▷

1384

1970–1972

1383, 1384, 1386 **This ceiling paint-
ing was in the foyer of the former
theatre, then known as the great
salon, and is titled: "Palace of the
Winds", 1972** ❑ Palais des Vents
The fresco alludes to a Catalonian
poem addressed to the rain that falls
when the west wind turns about to
become the east wind. In the poem,
the east wind has a married lady love
in the west, and whenever he beholds
her he turns about again and returns
weeping.

1385 **Dalí painting the ceiling of the
great salon. At the left we can make
out part of "The Hallucinogenic Tor-
eador", 1970** ☆

1385

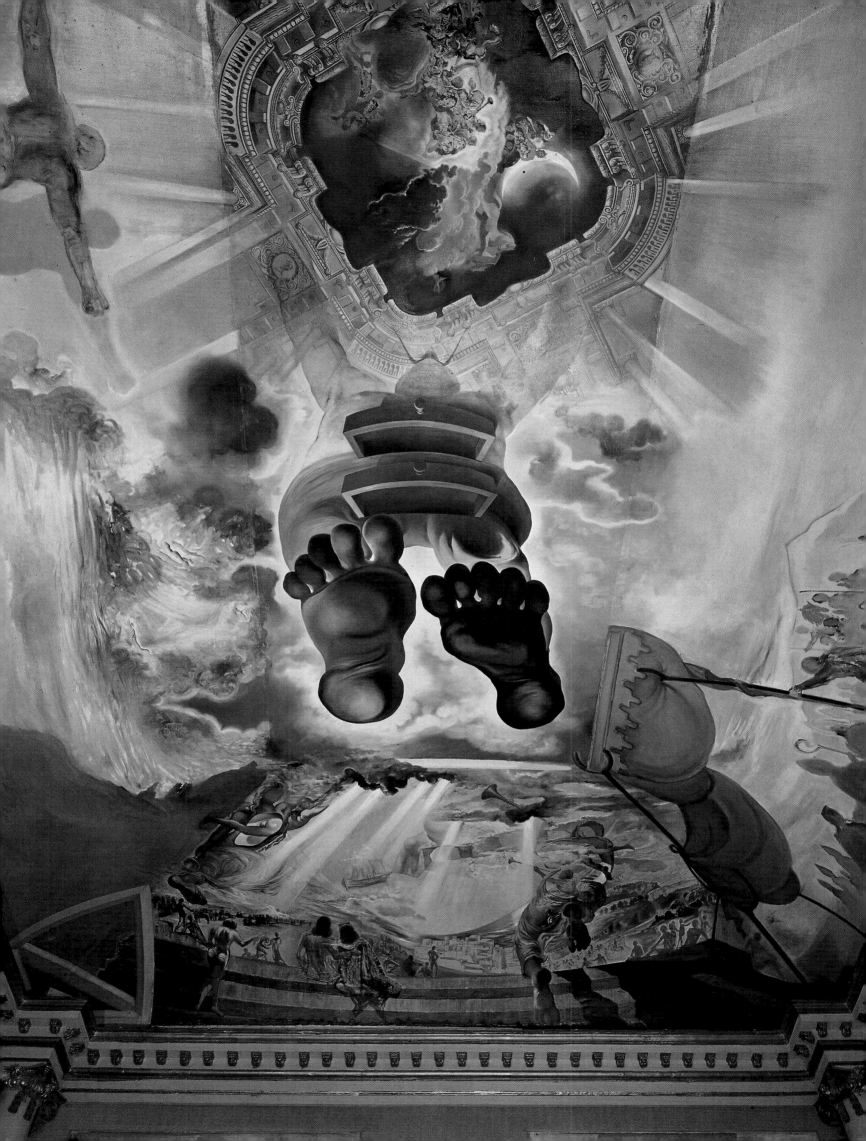

1387

1388

1387, 1389 **Partial views of the great salon, 1972** ❑

1388 **Dalí painting the great salon, 1972** ✩

The Temple of Eroticism

In this temple of eroticism and mysticism, the divine has entered into an alliance with lust, taken with a pinch... not of salt, ironic though it is, but of the choice painterly technique of a Velázquez. Dalí asserted that he gave depth to his own mysticism by compounding it with erotic delirium. Eroticism, he had said, is the royal road to the soul of God, and his museum proved that his principle was truer than ever. In his book *The Erotic Metamorphoses*, a selection of drawings done between 1940 and 1968 (cf. pp.570–571), Dalí said that the greatest difference between eroticism and pornography was arguably, or indeed certainly, that eroticism was divine by nature and brought happiness, whereas pornography proceeded from the abasement of humanity and brought only misfortune. The Romans, he noted, were well aware of this distinction, and in Latin one meaning of *obscenus* was "ominous". Eroticism was on the side of the wealthy. It was on the side of the gods and the eagles! The pornographer, by contrast, was a poor creature much like the tortoise, destined to be crushed sooner or later. The pornographer (in Dalí's account) had a prematurely aged reptilian face; he was an obscene, shameless, bald, heated cripple who stood at street corners offering dirty pictures held in a tortoise claw which barely reached out from the filthy armour of his jacket. Eros, however, the God of Love, stood up straight, his arm raised to Heaven, his proud phallic quiver slung from his immaculate alabaster-white neck. That quiver, full of the arrows of semen, Dalí went on, was one of the most sublime, majestic attributes of angels and eagles in all religions, of those destined to crush the armour of filthy tortoises. They were the Ganymedes, and despised dildos.

According to Roger Peyrefitte, Dalí's invariably well-informed housekeeper, Dalí had a large collection of dildos which he would offer to his models of either

622

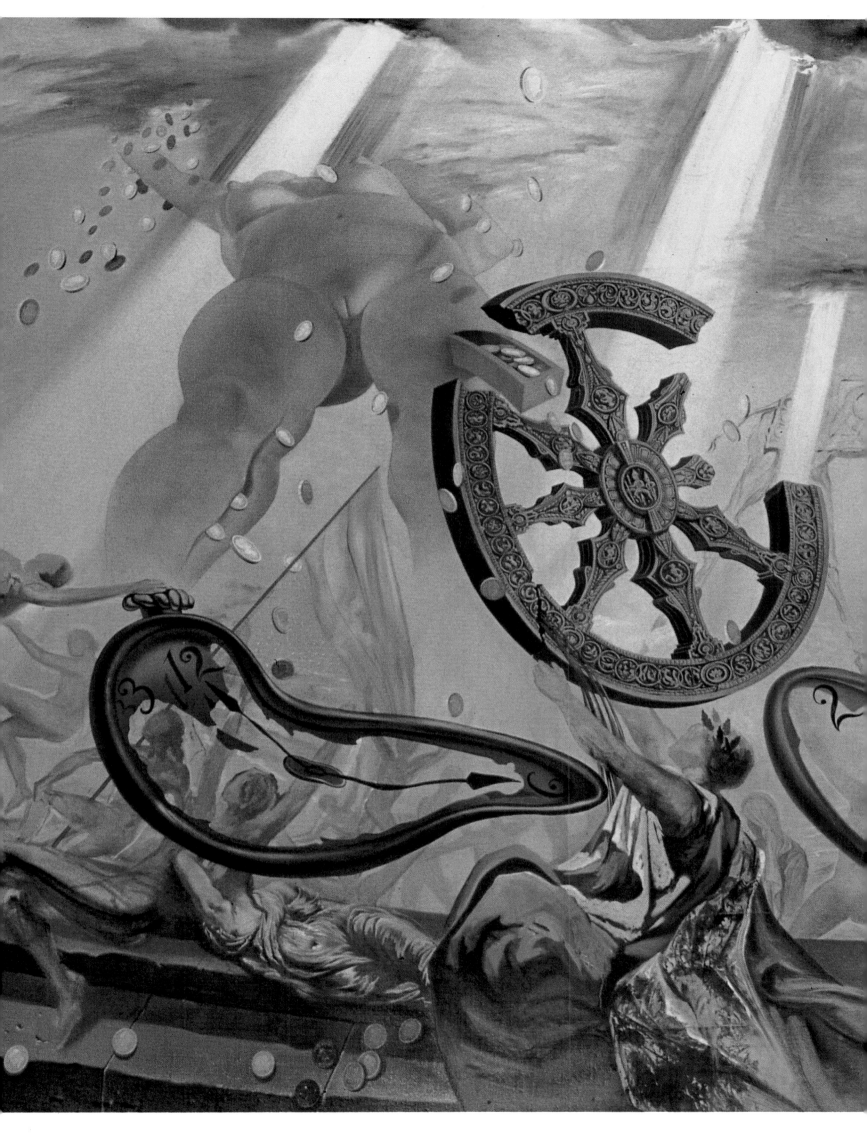

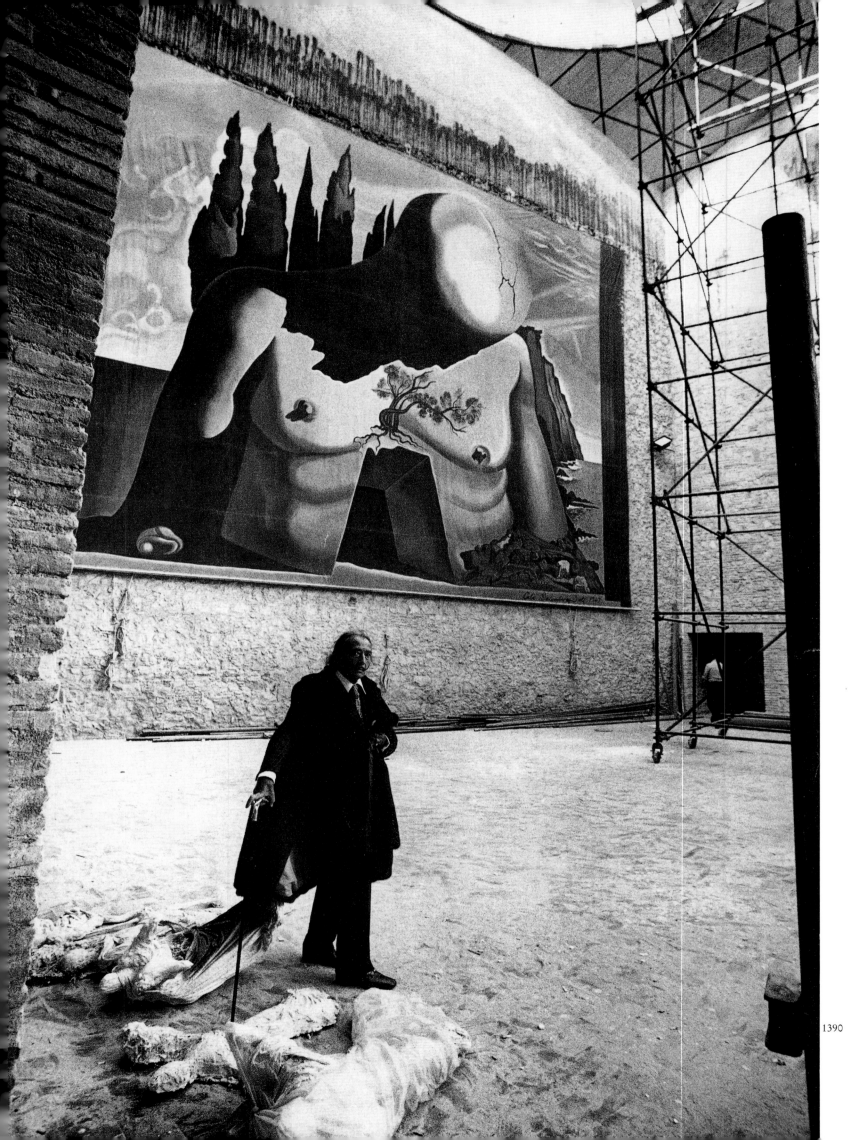

1391

1392

pp. 624, 625

1390, 1391 Puzzle including parts of the original set for the ballet "Labyrinth" and reproductions of "The Hallucinogenic Toreador" ☆
The museum is both a biographical experiment and a summation of Dalí's adventures as artist and man.

1392, 1393, 1394, 1395 Every Tuesday the master gave some fifty students free tuition and corrected their sketches. ☆
Dalí did not hesitate to put the works of illustrious 19th century artists such as Bouguereau or Fortuny on display alongside his own. Similarly, he included their modern descendants, the American hyper-realists such as George Segal or John de Andrea, whose "Musée Grévin" style Dalí admired.

sex when he had a little indulgence in mind. Some of these dildos irreverently had the heads of unexpected people on their shafts: the Pope, Hitler, St. Teresa of Avila, de Gaulle, and others. Dalí also liked to refer to the male member as "the limousine". Dining with pop singer Amanda Lear at Maxim's, he observed that, to judge by his nose, the gentleman at the next table must have a big limousine. In Cadaqués, Dalí liked visiting a young man whose erect member was reputed to be so hard that one could crack nuts open on it. Things of this kind aroused Dalí's admiration. He compared the vagina to a cauliflower and commented that it was Nature's ruse to ensure reproduction, but that the true organ of love was the anus. In the vagina one might poke about without really knowing what one was up to, but in the arsehole there was no room for any such uncertainty. Dalí made these observations in a conversation recorded for French television (though of course it was never broadcast), and declared roundly: "The most important thing in the world is the arsehole." For Dalí, the body no longer had any secrets. He had devised a special procedure (which interested Roger Peyrefitte greatly) to ensure that a woman on all fours would present her anus to greatest advantage: he would place a spirit level on her back, and when the air bubble was precisely in the middle, he claimed, her anus would flower in its full glory. On occasions, he would ask female visitors to sit on a bed of moist clay with their buttocks parted, in order to take an impression of their orifices. He would subsequently frame the impressions, adding the names of the ladies in question. Supposedly – and this again demonstrates Dalí's tirelessly investigative cast of mind – the anus has thirty-five or thirty-seven little creases which are as unique as fingerprints. He regretted that he could not account for the variation in number, but noted that

626

1393

1394

1395

1971

1396 The walls of the old theatre were restored, and Dalí placed specially designed sculptures in the niches. Dalí was inspired by the blue paint that ran down the walls during the vault painting to design a figure wringing out a sheet after a blue rinse. ☆

1396

1397

1398

1397 The museum also has a fairground or flea market atmosphere, with art nouveau furniture, costume jewellery, gilded thrones, old bathtubs, and more of a like kind. This is a reconstruction of his famous Mae West image, as a genuine apartment. ○

1398, 1399 The big net-like transparent cupola over-arches this surprising ensemble, where paintings such as "Galarina", "Basket of Bread", "Gala Nude, Seen from behind" or "Purist Still Life" can be seen along with a bust of Beethoven or a nude store-window dummy. The museum is non-categorizable, for non-categorizable artworks. ☆

1399

1400 **Christ Twisted**, 1976 ○
Christ twisté
This sculpture is made of plastic. It is a homage to Antoni Gaudí, and is positioned before a mirror arrangement such as the great Catalonian architect used in the Sagrada Familia.

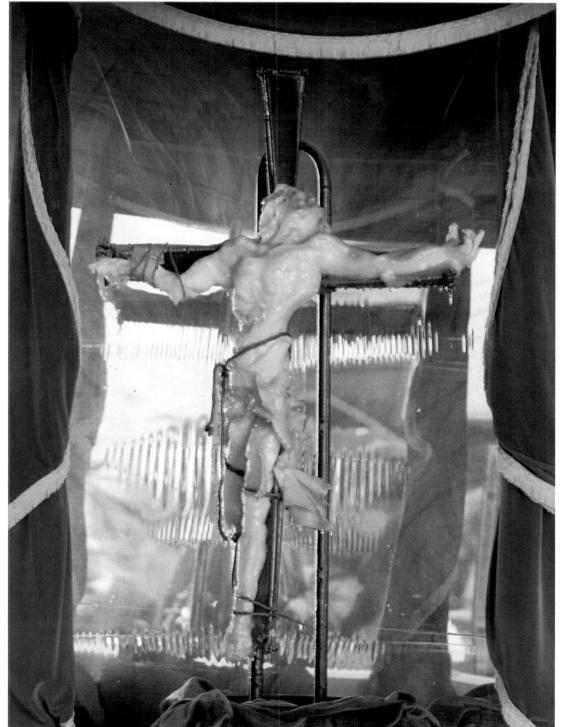

1400

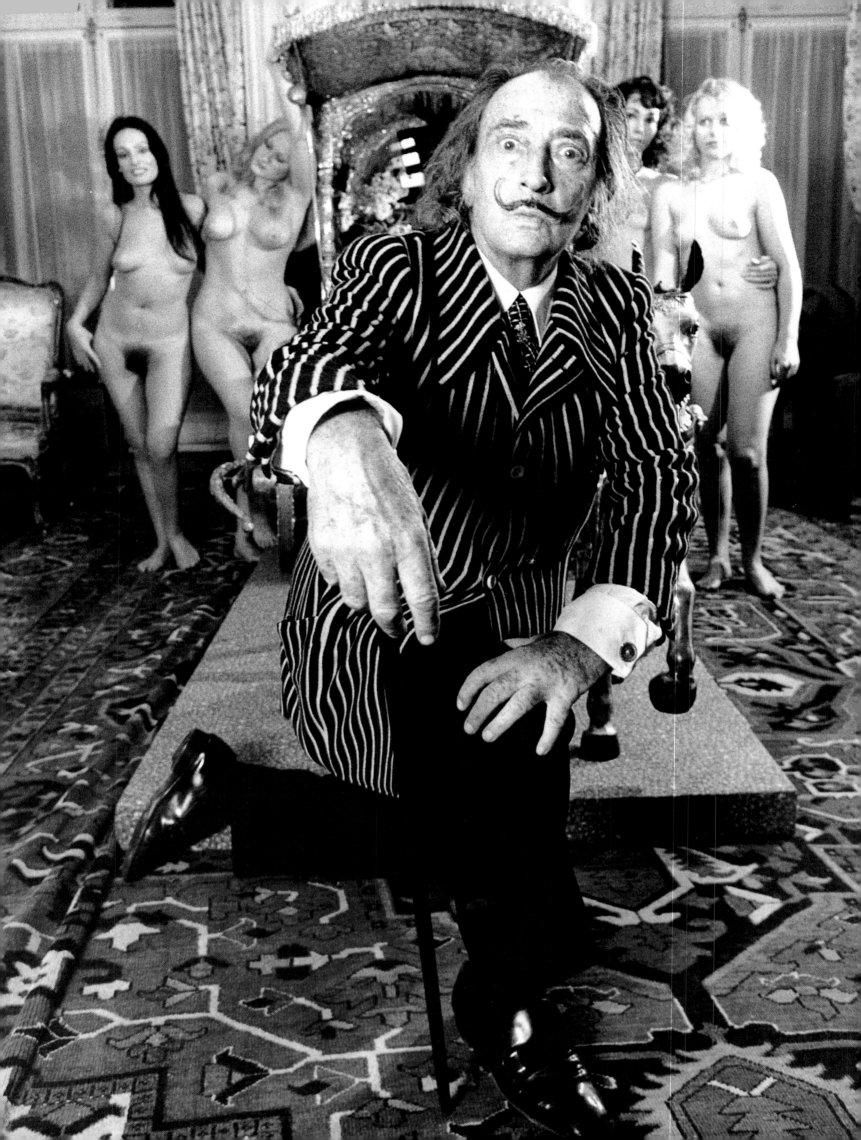

1403

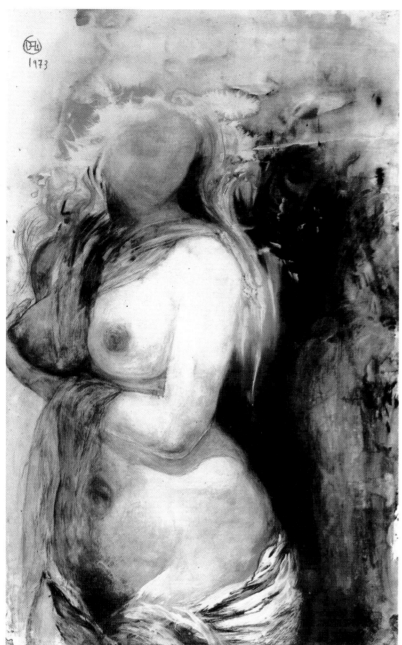

1402

1401 With Dalí we can never be certain if the women are plastic, as in the Teatro Museo Dalí, or flesh and blood, as here in the Hotel Meurice, 1973 ☆

1402 **Pomona, Autumn**, 1973 △
Pomone, automne

1403 **Dalí drawing "Pomona, Autumn"**, 1973 ☆

it had nothing to do with social class, and that thirty-fives were as likely to be found among the aristocracy as among the working classes. Only the backsides of identical twins had exactly the same pattern and number of creases. He conducted experiments to substantiate his claim, and made the impressions of twins' behinds into candelabra.

The fact is that Dalí scarcely made a single sculpture or *objet d'art* that did not have a hidden erotic meaning – as the Surrealists, whom he tricked on more than one occasion, learned to their cost. *Lilith* (pp. 638–639), a painted plaster sculpture done in homage to Raymond Roussel, with hairpins and two bronze equestrian figures by Meissonier, has female genitals made of hairpins at the centre. The

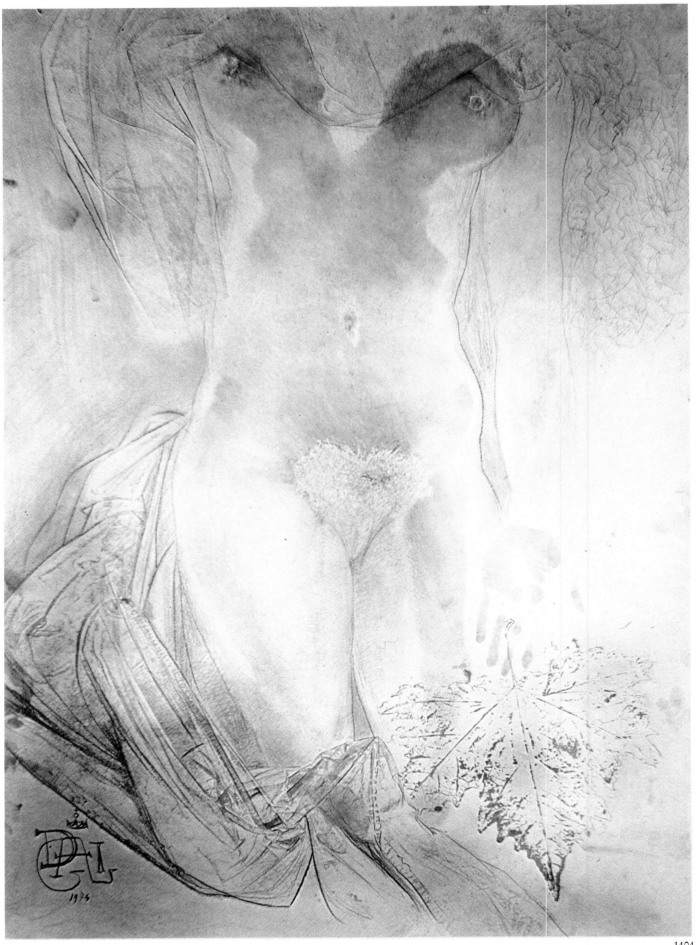

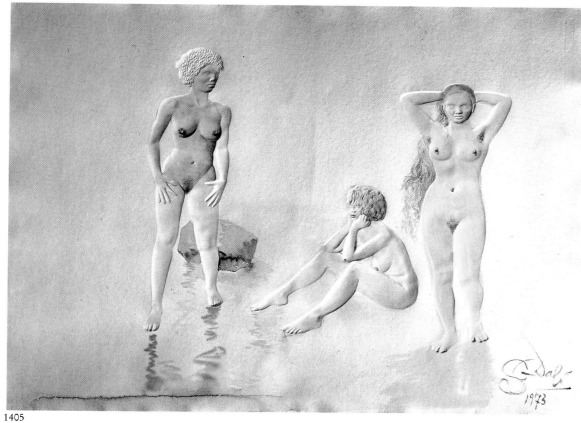

1405

1404 **Nude (transfer technique),**
1974 △
Desnudo de Calcomania

1405 **Three Hyper-Realist
Graces (Anti-Racism),** 1973 △
Trois grâces hyperréalistes
(L'antiracisme)

1406 **Standing Female Nude,**
1974 △
Nu féminin debout

1406

1973

untitled object for Gala (p.639), a spider crab's shell with inlaid cut agate, and Gala's face painted on it, is surely reminiscent of the female genitals. The *Chair with the Wings of a Vulture* (pp.640–641) is a whole erotic ballet of a sculpture. And *Otorhinological Head of Venus* (p.641), a monstrosity dear to Dalí with an ear at the tip of its nose and a nose where its ear should be, is evidently making available, in a novel manner, all of its orifices to the penetrating rhinoceros horn covered by the *Death Mask of Napoleon* (pp.640–641). Incidentally, the base of Napoleon's sarcophagus, in Dalí's view, was eloquent of imperialist power, to the highest degree. (The one reproduced here is inscribed on the base: "For Monsieur

contd. on p.645

1407

1408

1407, 1408 **Gala's Foot**, 1973 ❑
Le pied de Gala
Stereoscopic work, left and right
component

1409 **Portrait of Dr. Brian
Mercer**, 1973 ❑
Portrait du Docteur Brian
Mercer

1410 **Gala's Castle at Púbol**,
1973 ❑
Le château de Gala à Púbol

1411 **Las Galas of Port Lligat**,
1973 ❑
Las Galas de Port Lligat

1409

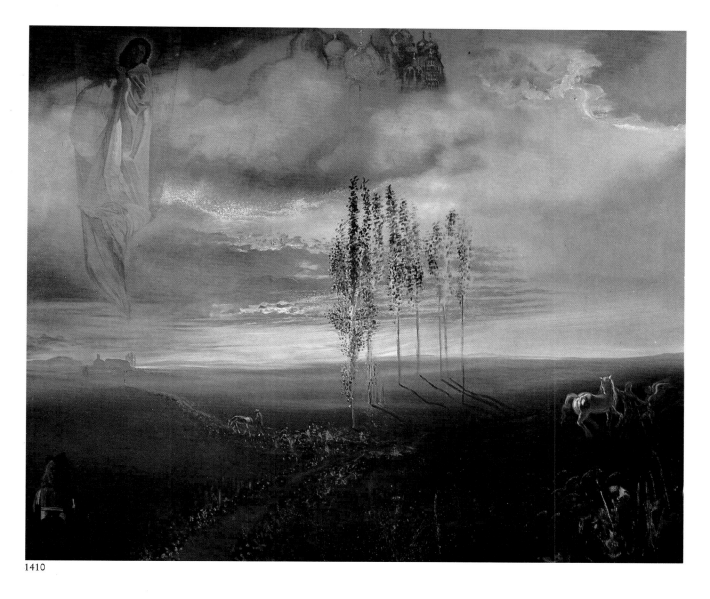

1410

1411

1974

1412 **Cranach Metamorphosis (Woman in a Mirror)**, 1974 ❑
Transformation Cranach (Femme au miroir)

1413 **Figure with Swan**, 1974 ❑
Paraje con Cisne

1414 **Wounded Soft Watch**, 1974 ❑
Montre molle blessée

1415 **The Black Mass**, 1974 ❑
La messe noire (La misa negra)

1416 **Equestrian Portrait of Carmen Bordiu-Franco**, 1974 ❑
Portrait équestre de Carmen Bordiu-Franco

1413

1412

1414

1415

1416

1417 **Lilith (Homage to Raymond Roussel)**, 1966 ○
Lilith (Hommage à Raymond Roussel)
The writer Raymond Roussel had a powerful influence on the Surrealists, and particularly on Dalí. Dalí even titled his painting "Impressions of Africa" after a novel by Roussel.

1418 **Lilith, detail: genitals made of hairpins** ☆

1419 **Untitled (Object for Gala)**, c. 1972 ○
Sans titre (Objet pour Gala)

1418

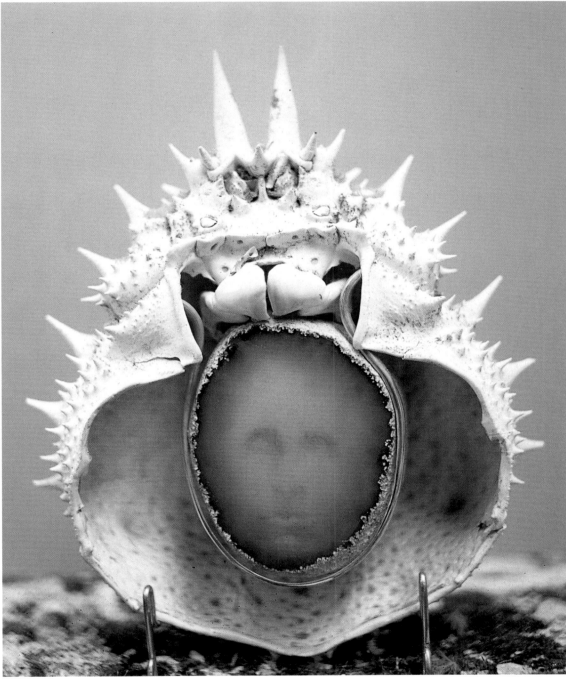

1419

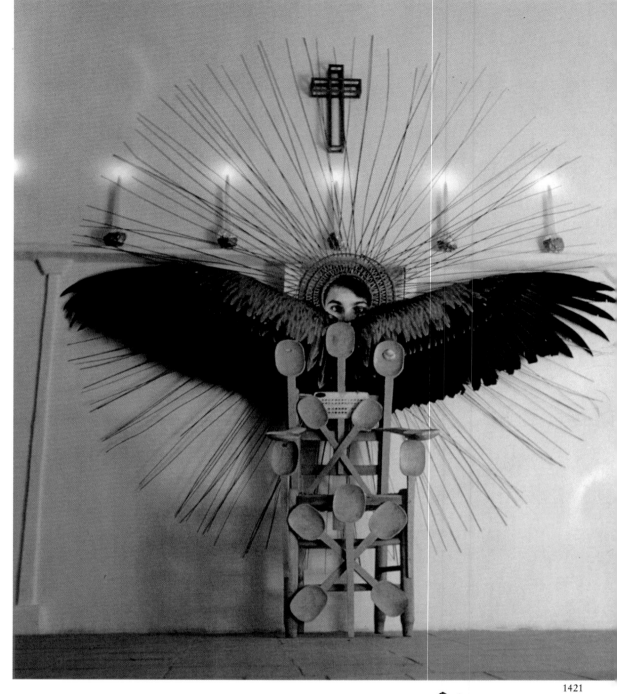

1421

1420 **Bust of Dante**, 1964 ○
Buste de Dante
Adorned with golden spoons.

1421, 1422 **Chair with the Wings of
a Vulture**, 1960 ○
Chaise aux ailes de vautours
A playful object that might be used for
cultic or erotic purposes.

1420

1423

1422

1426

1424

1425

1423, 1424, 1425 **Death Mask of Napoleon – Can Be Used as a Cover for a Rhinoceros,** 1970 ○
Masque funèbre de Napoléon – Pouvant servir de couvercle à un rhinocéros

1426 **Otorhinological Head of Venus,** 1965 ○
Tête otorhinologique de Vénus

1427

1428

1427, 1428 **Michelin's Slave – Can Be Used as a Car**, 1965 ○
L'esclave de Michelin – Pouvant servir d'automobile

1429 **Christ Twisted**, 1976 ○
Christ twisté
This original is made of white wax.

1430 **Swan-Elephant and Serpent. Can Be Used as an Ashtray**, 1967 ○
Cygnes-éléphants et serpent – Pouvant servir de cendrier

1431 **Figurine Nike**, 1973 ○
Figurine Niké
This was another new Dalinian technique: metal-plated paper circuitry plans were electrolysed in gold.

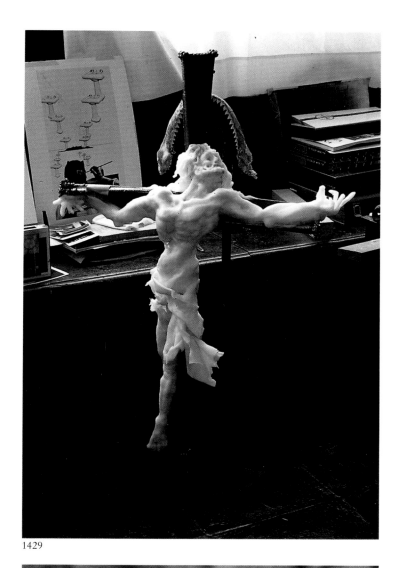

1429

1430

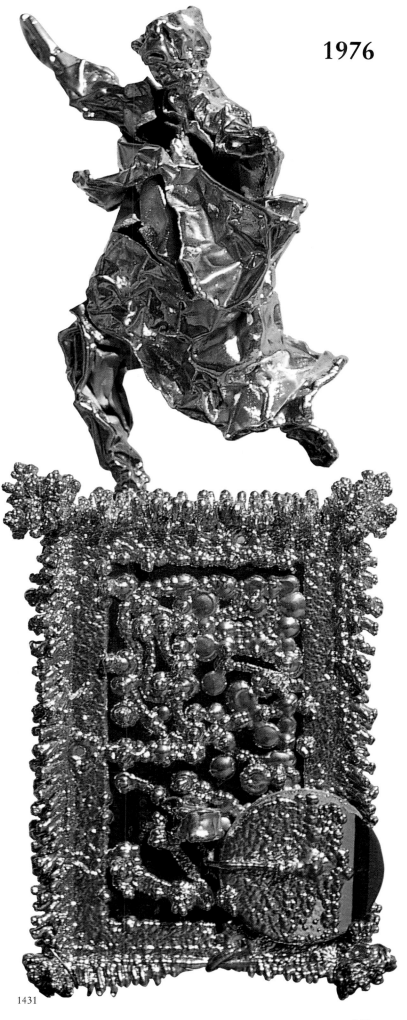

1431

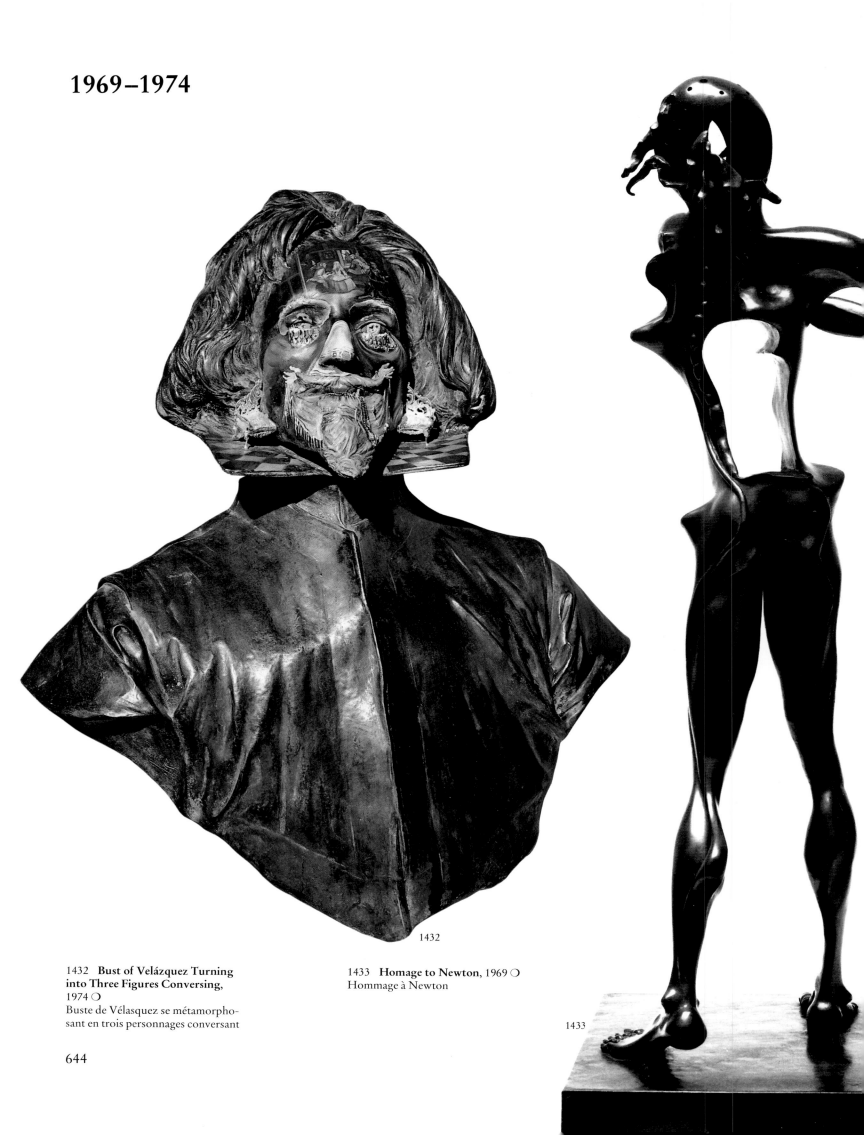

1432 **Bust of Velázquez Turning
into Three Figures Conversing,**
1974 ○
Buste de Vélasquez se métamorpho-
sant en trois personnages conversant

1432

1433 **Homage to Newton,** 1969 ○
Hommage à Newton

1433

Georges Pompidou, President of the Republic of France, with the respect of Salvador Dalí.") The otorhinological head of Venus went back to Dalí's conviction that birth was possible by non-vaginal budding, as in "Pantagruel" or in certain rites of the Cathari.

For another sculpture, in the shape of an immense ear, Dalí placed an entire litter of tiny babies in the hollow. Even the most bizarre of Dalí's ideas could turn out to have been meant seriously; and those that appeared to have been in deadly earnest might be no more than silly, childish jokes. Whenever Dalí reached orgasm, he said, he cried out aloud: "I have lost my seed!" And indeed, the sexual act represented to Dalí not delight so much as a waste of his talent. And he would

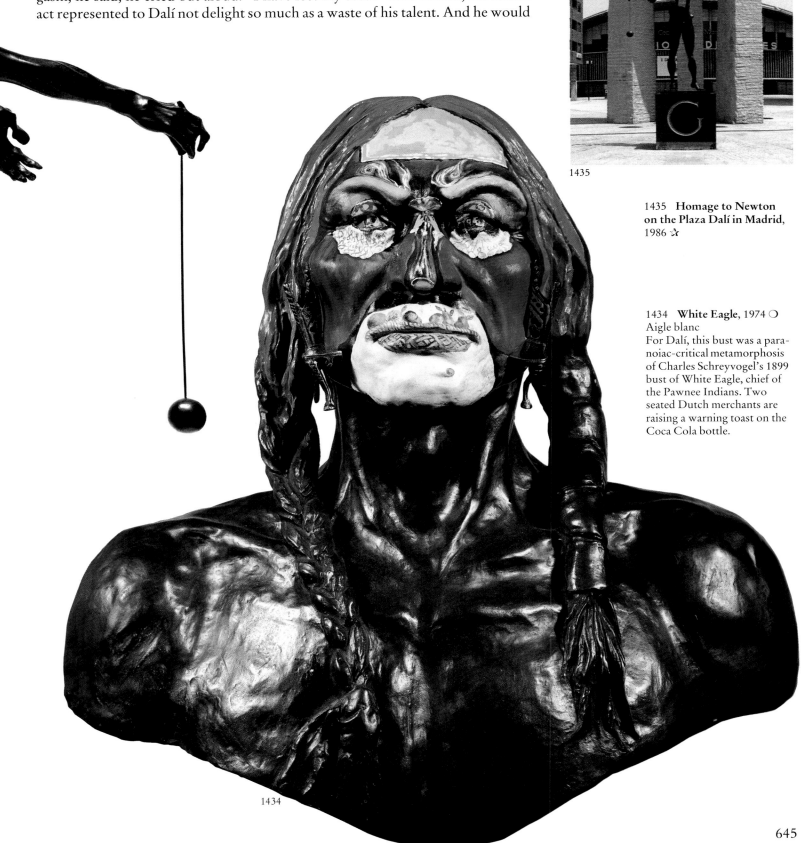

1435

1435 Homage to Newton on the Plaza Dalí in Madrid, 1986 ☆

1434 White Eagle, 1974 ○
Aigle blanc
For Dalí, this bust was a para-noiac-critical metamorphosis of Charles Schreyvogel's 1899 bust of White Eagle, chief of the Pawnee Indians. Two seated Dutch merchants are raising a warning toast on the Coca Cola bottle.

1434

645

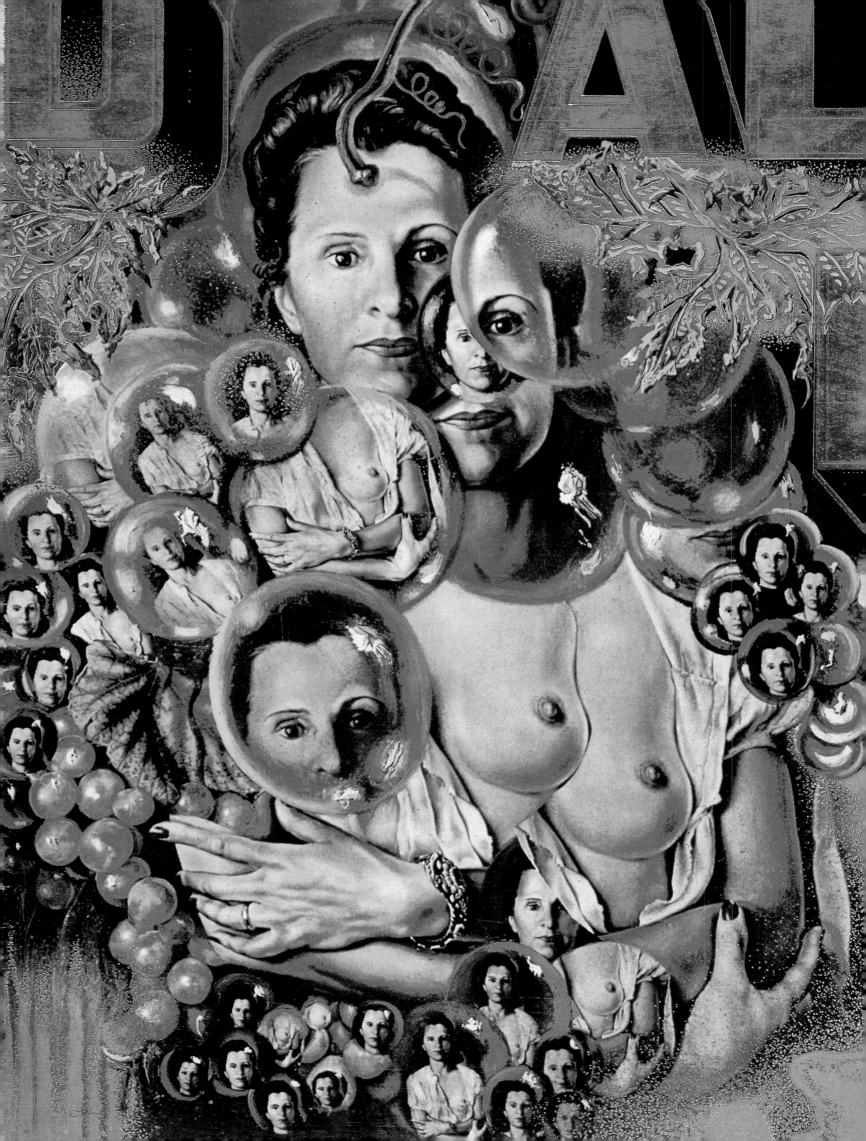

always announce that he was impatiently waiting for a large cheque so that he could load up again.

"Painting," he declared, "like love, goes in at the eyes and flows out by the hairs of the brush. My erotic delirium compels me to take my sodomitic tendencies to the heights of paroxysm." There was no stopping this Dalí. The man of God saw to it that he was surrounded by "the most delicious behinds one can imagine. I persuade the most beautiful of women to undress. I always say the greatest mysteries can be penetrated via the behind, and I have even discovered a profound correspondence between the buttocks of one of the women who visited me at Port Lligat and undressed for me and the space-time continuum, which I have named the continuum of the four buttocks (incidentally, this continuum is simply the representation of an atom). I think up the most delectable and insane of positions in order to maintain a paroxysmal erection, and I am totally happy if I can be present at a successful act of sodomy. For me, everything that matters happens via the eye. I managed to talk a young Spanish woman into allowing a neighbour-

1436, 1437, 1438 Having paid homage to Coca Cola in "The Cosmic Athletes", Dalí returned to rather better taste in a tribute to "The Wines of Gala and of God" ("Les Vins de Gala et du Divin", Draeger, 1977). In this book, Gala's breasts cluster like grapes, and the Bordeaux bottle replaces the Coca Cola bottle. △

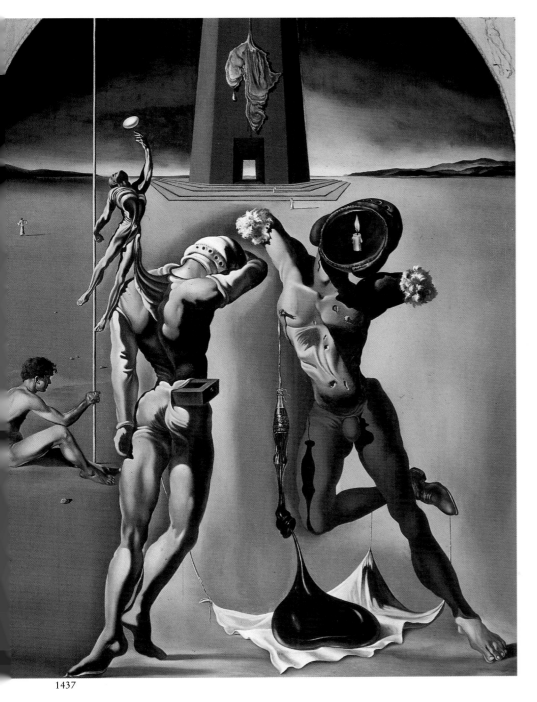

1437

1438

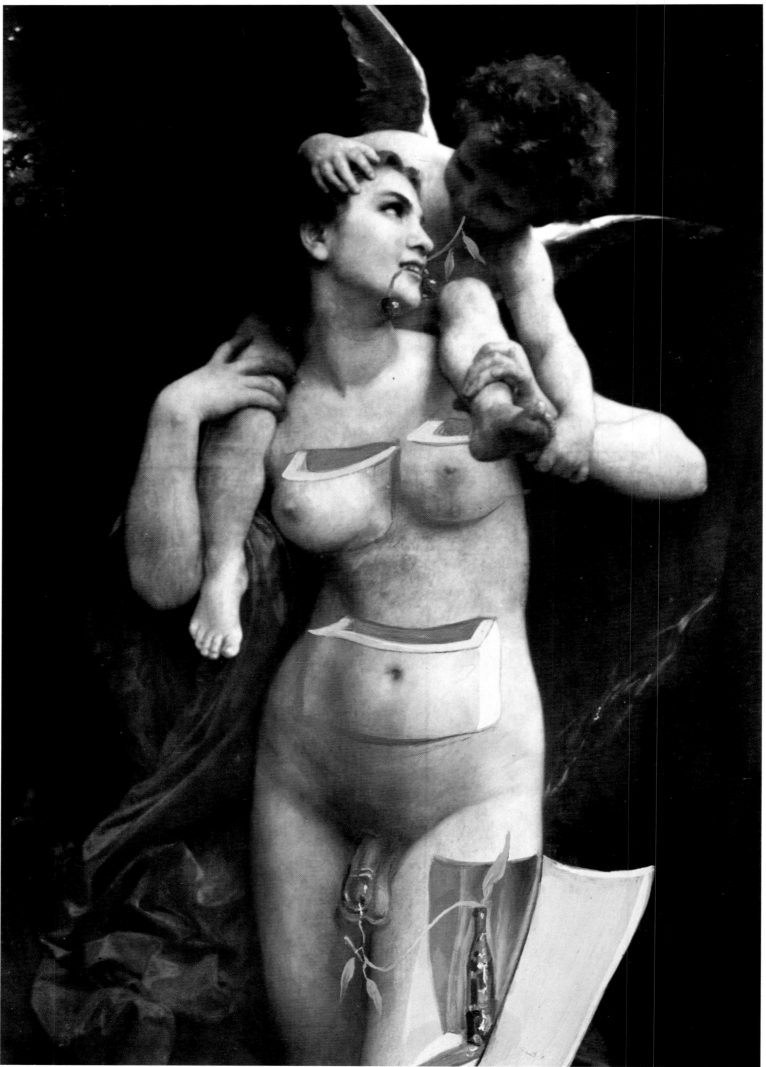

1440

1439, 1440 In "Les Vins de Gala et du Divin" Dalí indulged himself royally, opening drawers out of academic art, juxtaposing a crowd of Bouguereau nudes with a photo of a cat and a motif from his "Imperial Monument of the Child-Woman", 1977 Δ

649

1441

hood youth who was courting her to sodomize her. Together with a girlfriend (the audience are important in my theatre, and play the role of accountants, so to speak), I sit on a divan. The woman and the youth enter by different doors: she is naked beneath a dressing gown, he is unclothed and his member erect. He immediately turns her round and sets about entering her. He does it so rapidly that I get up to check that he is not just pretending, since I don't want to be made a fool of. Then she shouts out ecstatically: 'This is for Dalí, for the divine Dalí!' I don't care for the expression, because I can see how ill-founded it is – particularly since this strong youth is passionately working away in the Spanish girl's

1441 **Architectural Design (Eye Catching Economy)**, 1976 Δ
Projet d'architecture

1442 **The Giraffe (The Giraffe of Avignon)**, 1975 Δ
La girafe (La girafe d'Avignon)

1442

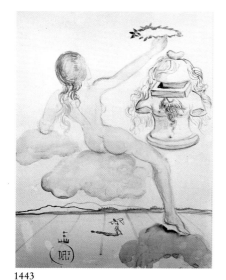

1443

1444

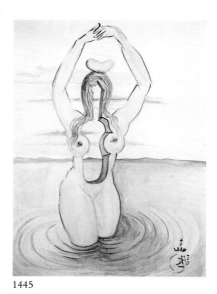

1445

1974–1976

1446

p. 651

1443 **Homage to Philosophy**, 1976 ❑
Hommage à la philosophie

1444 **Lullus – Homage to Raimundus Lullus (design for a ceiling painting)**, 1975 △
Lulle – Hommage à Raymond Lulle

1445 **Musical Harmony**, 1976 △
Harmonie musicale

1446 **Gala Contemplating the Mediterranean Sea which at Twenty Metres Becomes the Portrait of Abraham Lincoln – Homage to Rothko (first version)**, 1974–1975 ❑ Gala regardant la mer Méditerranée qui à vingt mètres se transforme en portrait d'Abraham Lincoln – Hommage à Rothko

1447 **Gala Contemplating the Mediterranean Sea which at Twenty Metres Becomes the Portrait of Abraham Lincoln – Homage to Rothko (second version)**, 1976 ❑ Gala regardant la mer Méditerranée qui à vingt mètres se transforme en portrait d'Abraham Lincoln – Hommage à Rothko

652

behind and she is groaning with pleasure. I say: 'Do you admit that you love the man who's inside your arse?' She instantly stops play-acting and cries out: 'Yes, I worship him!' And then I saw the most astounding thing one can imagine as an expression of phenomenal beauty: the young woman held firmly by the hips and impaled on the man raised her arms and reached behind her, which also lifted her magnificent breasts. At the same time she turned her head back and her lips touched those of the man who was putting her through this exquisite torment. It was a perfect gesture in its way, and transformed the animal couple into a liana, conveying an angelic vision. I have never been able to tell this story without the wonderful feeling that I had revealed the secret of perfect beauty."

Dalí confessed: "I spend considerable amounts on dinners, presents, dresses and entertainment to achieve my ends, to fascinate my protagonists and make them submissive to me. Sometimes the preliminaries take months, and I put together the pieces of my jigsaw with great care. I devise the most artful of per-

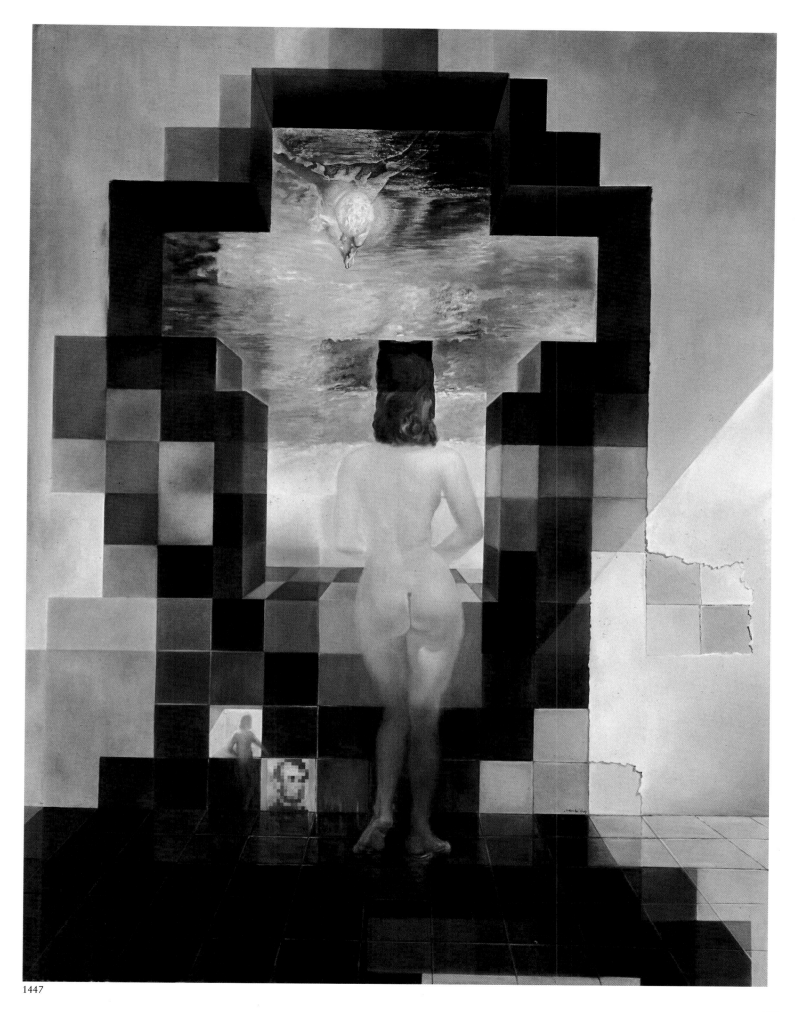

1976

1448 **Soft Monster**, 1976 ❑
Monstre mou

1449 **White Monster in an Angelic
Landscape**, 1977 ❑
Monstre blanc dans un paysage
angélique

1450 **The Happy Unicorn**, 1977 ❑
L'unicorne allègre

1451 **The Unicorn (unfinished)**,
1976 ❑
L'unicorne

1452 **Soft Skulls with Fried Egg
Without the Plate, Angels and Soft
Watch in an Angelic Landscape**,
1977 ❑
Têtes molles avec œuf sur le plat sans
plat, anges et montres molles dans un
paysage angélique

1448

1449

1450

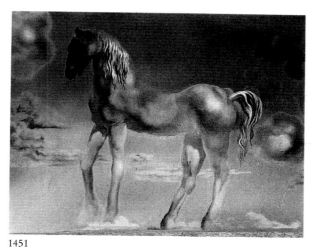

1451

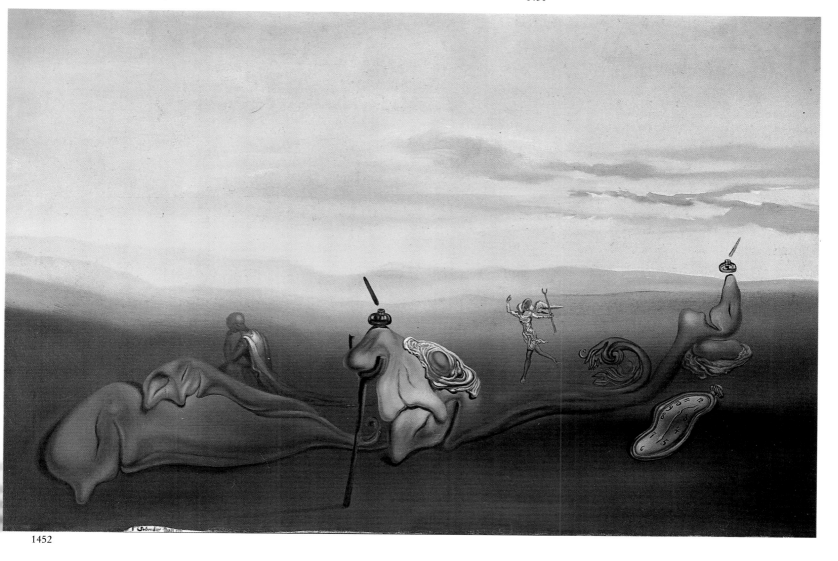

1452

1977

1453

1455

1454

1456

versions, I foist my weird notions on others, I talk people into doing the craziest things and they agree unconditionally." And: "... my only problem is choice. I fish a vast pond in New York or Paris where a hundred women of the world [...] are forever at the ready to obey my whims – not to mention the high-class professionals, whom I call the *danièles* and whom I occasionally use as a stopgap." And finally: "Eroticism, hallucinogenic drugs, nuclear science, Gaudí's Gothic architecture, my love of gold – there is a common denominator in all of it: God is present in everything. The same magic is at the heart of all things, and all roads lead to the same revelation: we are children of God, and the entire universe tends towards the perfection of mankind."

1458

1457

1453 Nike, Victory Goddess of Samothrace, Appears in a Tree Bathed in Light, c. 1977 ❏
Niké, Victoire de Samothrace, apparaissant dans un arbre baigné de rayons lumineux

1454 Aurora's Head, after Michelangelo (detail of a figure on the grave of Lorenzo di Medici), 1977 ❏
Tête de l'Aurore d'après Michel-Ange

1455 Surrealist Angel, c. 1977 ❏
L'ange surréaliste

1456 Untitled, 1977 Δ
Sans titre

1457 Fertility, 1977 ❏
Fecondidad (Fertilité)

1458 Woman with Egg and Arrows, c. 1977 ❏
Femme avec œuf et flèches

1977

1459

1460

1461

1459 **Spanish Knight**, 1977 Δ
Chevalier espagnol

1460 **Daphne: the Tree Woman,**
1977 Δ
Daphne: la femme arbre

1461 **Virgin with Swallows**, 1977 Δ
La vierge aux hirondelles

1462 **Eight Pieces of the Angelus –
Man in Pieces**, 1977 Δ
Ocho trozos de Angelus – Homme en
morceaux

1462

1463

In Quest of the Third and Fourth Dimensions

Among Dalí's numerous recipes for immortality, tested as he faced the approach of death, was the following account of immortality by holography: "When I discovered that a single atom of holographic emulsion contains the complete three-dimensional image, I exclaimed: 'I want to eat it!' This astounded everyone else more than usual, especially my friend Professor Dennis Gábor, who received the 1971 Nobel Prize for physics. In this way, though, I was at least able visually to realize one of my dearest wishes: to eat my worshipped Gala, to take atoms into me, into my organism, that contained a holographic smiling Gala or Gala swimming off Cape Creus. Gala, Belka, the squirrel, the hibernation specialist." ("Belka" is the Russian word for squirrel.) "The recipe for holographic immortality: to be taken with a glass of Solarés water – holographic in-

1463 Dalí as illustrator. The heftier the tome, the happier was Dalí. Here he is launching "Alchimie des philosophes" (The Alchemy of the Philosophers) in 1976. ☆

1976

1464

1465

1466

1467

1468

1469

1470

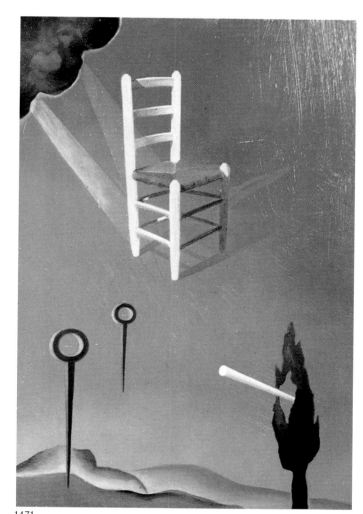

1471

formation that can produce images containing a maximum of happy resurrection instantaneousness. The 'persistence of memory' (as I titled my famous 1930 painting of soft watches) will be complemented by the voluntary programming of desire: the image of a waking, sensual squirrel can make a person immortal."

Dalí, "a true athlete of the psyche" (as Dr. Pierre Roumeguère once called him), took an early interest in abnormalities of visual perception, planning to subject them to his own expressive intentions. In this endeavour, he moved on from initial work with anamorphoses (the first artist of which was Arcimboldo) to what he himself termed "hologramorphoses". These, he believed, would assure him immortality – the immortality of holographically-stored laser-generated images. Surely no one can give as arresting an account of the ageing painter's last dreams as Robert Descharnes, the photographer and Dalí's companion towards the end. For a good twenty years, Dalí was possessed of a passion for the third dimension, and was forever searching for methods of creating in the eye of the beholder the illusion of spatial plasticity. He hoped that, once he had secured these, he would be able to move on into the fourth dimension and thus into immortality. In his contribution to the catalogue for the Dalí retrospective at the Centre Georges Pompidou in 1979, Robert Descharnes quoted Dalí as saying that it was almost twenty years since he happened to drop turpentine and liquid ambergris onto a piece of slate and had noticed, to his surprise, an intricate mesh pattern emerging on the stone. Dalí told Descharnes that he had just invented

1464 **Preparatory drawing for "The Chair" (Thousand and One Visions of Dalí)**, 1976 △
Installation stéréoscopique pour «La chaise» (Les milles et une visions de Dalí)

1465, 1466 **The Chair (Stereoscopic work, left and right component)**, 1976 ❏
La chaise

1467 **Study for "The Chair"**, 1975 △

1468, 1469 **The Wash Basin (Stereoscopic work, left and right component)**, 1976 ❏
Les lavabos

1470, 1471 **The Chair (Stereoscopic work, left and right component)**, 1976 ❏
La chaise

1472

1473

1474

1976–1977

1472, 1473 **Study for "Las Meninas"** (Stereoscopic work, left and right component), 1976 △

1474 **Las Meninas (The Maids-in-Waiting) – First metaphysical hyper-realist painting (unfinished)**, 1977 ❏
Les Ménines – Première peinture hyperréaliste métaphysique

1475 **Portrait of Gala**, 1976–1977 ❏
Portrait de Gala

1476, 1477 **Las Meninas (The Maids-in-Waiting; Stereoscopic work, left and right component)**, 1976–1977 ❏
Les Ménines

1475

1476

1477

liquid television! That is to say: liquid applied to the surface made the immediate "broadcasting" of material possible. Dalí told Descharnes that in New York he had later done intensive work on the patterns of metal lustre with a Dr. Oster of *Scientific American*. Dalí had investigated all the possible results of superimposing various structures of flies' eyes on top of each other. These experiments produced extraordinary three-dimensional images. Dalí later met Dr. Dennis Gábor, the Nobel Prize winning inventor of holography. At the time that he spoke to Descharnes, Dalí had already made six holograms, one of them cylindrical. In parallel he was hoping to extend American photorealism through the use of a system of mirrors devised by Roger de Montebello, adding a third dimension to the perfection of pictures copied from photographs.

Dalí's first holograms were exhibited in New York in April/May 1972 at the Knoedler Gallery. Dennis Gábor contributed the following statement to the catalogue: "Holography is opening the third dimension for the artist. The first stage, already achieved, is the photography of three-dimensional objects and scenes, which, viewed through the resulting holographic plate of film, which itself is invisible, appear in natural size, in three dimensions, and can be viewed from any side, but only in one color. The color can be freely chosen. For instance, yellow for a bronze statue.

The next stage is holography in natural color, already realized in small formats, soon to be available in all sizes. Such holograms can be hung on the wall like pictures, illuminated by a small light source from above.

The third stage, under development, will combine natural color with unlimited depth. The artist can create in the studio landscapes which extend to the horizon and they can be landscapes which have never existed.

It needs only a genius like Salvador Dalí, creating a new art of which old, great painters may have dreamed, but which could only be realized by combining art with the most modern technology."

contd. on p.673

1478

1479

1478, 1479 **Randomdot correlogram – The Golden Fleece (Stereoscopic work, left and right component, unfinished)**, c. 1977 ❏ La Toison d'Or

663

1482

1483

1480

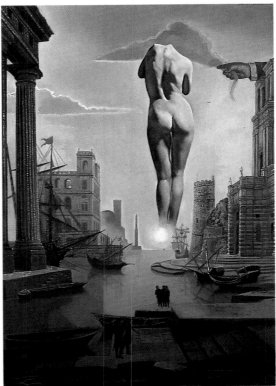

1481

1480, 1481 **Dalí's Hand Drawing Back the Golden Fleece in the Form of a Cloud to Show Gala the Dawn, Completely Nude, Very, Very Far Away Behind the Sun (Stereoscopic work, left and right component),** 1977 ❏
La main de Dalí retirant une Toison d'Or en forme de nuage pour montrer à Gala l'aurore toute nue très, très loin derrière le soleil

For his quantification of a painting by Claude Lorrain, Dalí used classic stereoscopic procedure, a picture for each eye, inventing what he termed "metaphysical hyperrealism" and thus registering the third dimension.

1482 **Study for "Dalí Lifting the Skin of the Mediterranean Sea to Show Gala the Birth of Venus",** 1977 Δ

1483, 1484 **Dalí Lifting the Skin of the Mediterranean Sea to Show Gala the Birth of Venus (Stereoscopic work, left and right component),** 1977 ❏
Dalí soulevant la peau de la mer Méditerranée pour montrer à Gala la naissance de Vénus

1484

665

1486

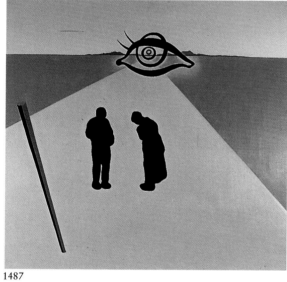

1487

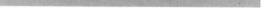

1488

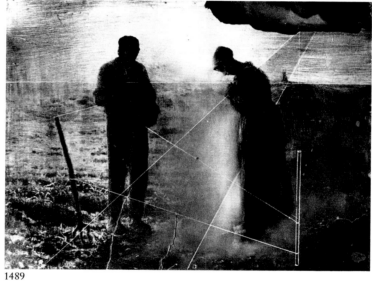

1489

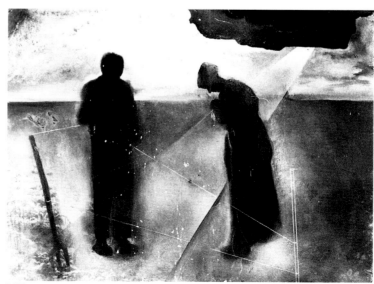

1490

1485, 1486 Gala's Christ (Stereo-scopic work, left and right com-ponent), 1978 ❏
Le Christ de Gala

1487, 1488 The Eye of the Angelus (Stereoscopic work, left and right component, unfinished), 1978 ❏
L'œil de l'Angélus

1489, 1490 Stereoscopic Composi-tion Based on Millet's "Angelus" (unfinished), c. 1978 ❏
Composition stéréoscopique sur l'«Angélus» de Millet

1979

1491, 1492 **Battle in the Clouds**
(Stereoscopic work, left and right
component), 1979 ❑
Bataille dans les nuages

1493, 1494 **Athens Is Burning! –**
The School of Athens (left) and **The**
Fire in the Borgo (right) **– Stereo-**
scopic work using two different pic-
tures, 1979–1980 ❑
Athènes brûle ! – L'école d'Athènes et
L'incendie du Borgo
In "Athens Is Burning!" Dalí con-
tinued his exploration of classic stereo-
scopic art. He used two works by

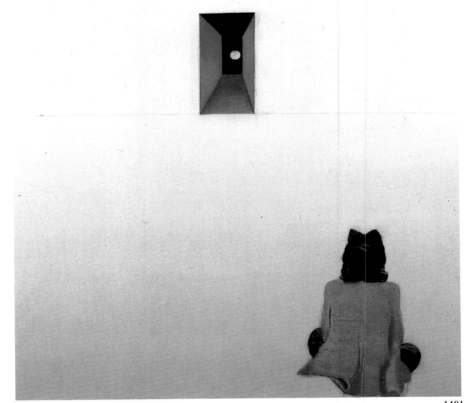

1491

1493

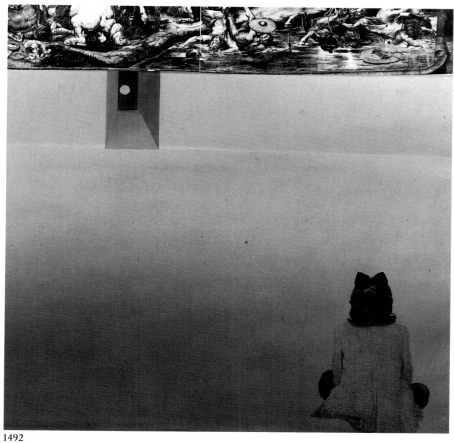

1492

Raphael, adding different visual stimuli to each. The squares of colour were developed by Roger Lanne de Montebello and approach us visually, as we look, along a spiral axis. Dalí also used a vibrant version of pointillism, placing his colours at random in a manner based on research done by Professor Bela Julesz, in order to communicate information on the narrative content of Raphael's works in a form subject to interference. Once we have looked at the paintings for a while, we are surprised to find that we register portions of each narrative simultaneously.

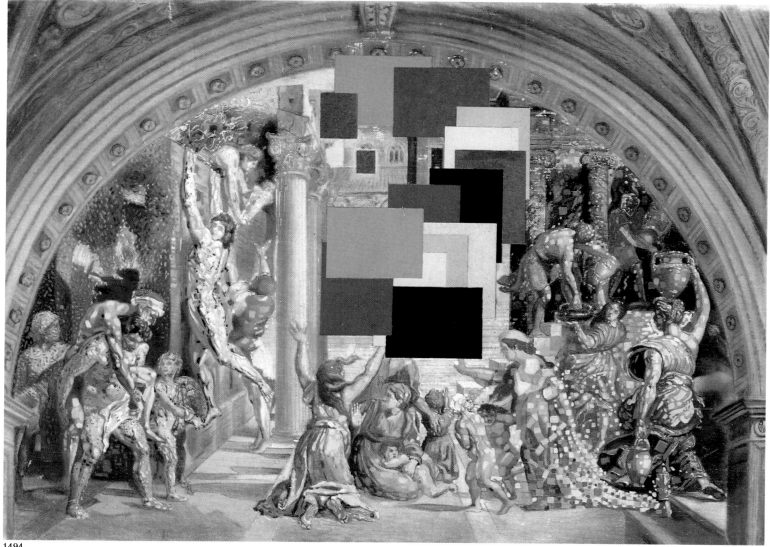

1494

1495 The Harmony of the Spheres, 1978 ❏
L'harmonie des sphères
The picture shows Jason trying to take hold of the Golden Fleece. It is Dalí's first stereoscopic work to unite the left and right components in a single canvas. In this case the spatial impression is only created if we squint a little. The image that results is not three-dimensional on any longer-lasting basis. The balls that represent the Golden Fleece seem to be forever slipping out of Jason's grasp.

1496, 1497 Pentagonal Sardana (Five-cornered Ronde; Stereoscopic work, left and right component), 1979 ❏
Sardane pentagonale

1498 Pierrot lunaire (Unfinished stereoscopic work with left and right components on the same panel), 1978 ❏

1499 Cybernetic Odalisque – Homage to Bela Julesz, 1978 ❏
Odalisque cybernétique – Hommage à Bela Julesz

1495

1496

1497

1498

1499

1500

1501

1500 **Long Live the Station at Perpignan, Long Live Figueras,** 1979 ❑
Vive la gare de Perpignan – Viva Figueras

1501 **Landscape near Ampurdán,** 1978 ❑
Paysage de l'Ampurdán

1502 **Landscape near Ampurdán (Dedicated to Sabater)** , 1978 ❑
Paisantje Empordanes

Of all Dalí's experiments in holography, *Holos! Holos! Velázquez! Gábor!* (p.609), now exhibited at the Figueras museum, was the most ambitious. Dalí was clearly trying to create the first holographic dual image of an imaginary nature; most holographic artists at that date (1972) were still trying to reproduce the visible world exactly. Dalí's hologram was the produce of a collaboration with the New York artist Selwyn Lissac. It crosses fragments of *Las Meninas* by Velázquez with a photograph of cardplayers used as an advertisement for a leading brand of beer. To create the hologram, Dalí and Lissac mounted the various elements of the two pictures on glass plates arranged on as many levels as there were thematic areas. *Holos! Holos! Velázquez! Gábor!* was the first holographic collage.

Dalí also made a number of other three-dimensional works with the aid of the cylindrical hologram, which enables the image to be seen from any side around 360°. One of the best achieved, *Dalí from the Back Painting Gala from the Back*

contd. on p.684

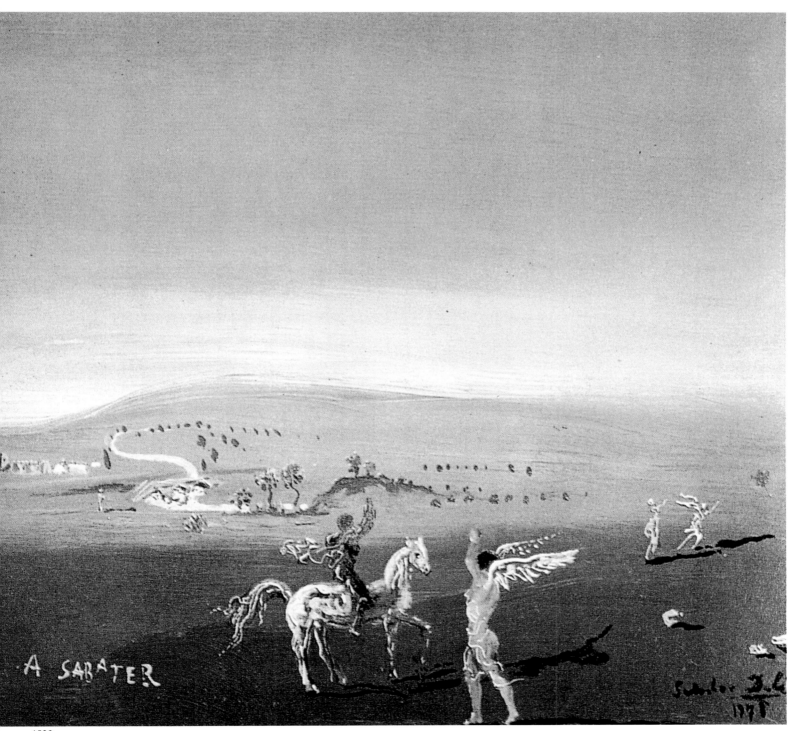

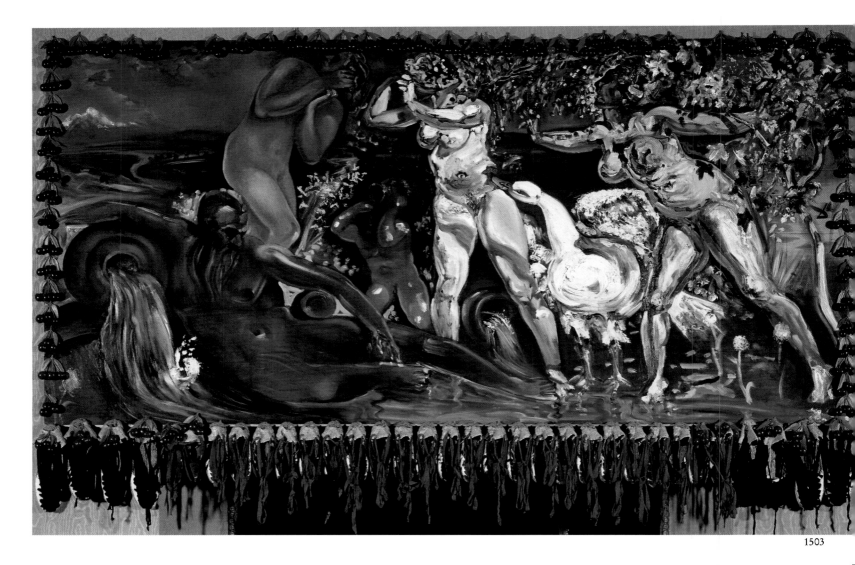

1503

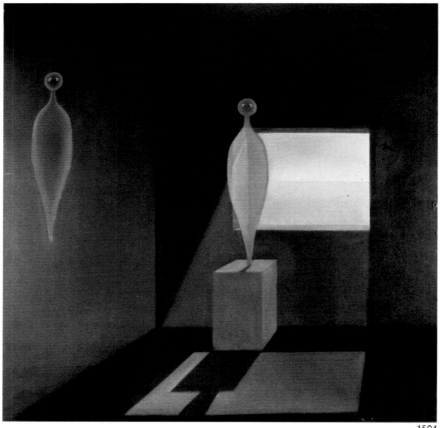

1504

1505

1506

1507

1503 **Allegory of Spring**, 1978 ❑
Allégorie du printemps

1504 **Dark Tapeworms**, c. 1978 ❑
Planaires lugubres

1505 **Phosphene**, 1979 ❑
Phosphène

1506 **Copy of a Rubens Copy of a Leonardo**, 1979 ❑
Copie d'un Rubens copié d'un Léonard

1507 **Proof of a postage stamp designed by Dalí for the French mail**, 1978 △
Effigie de Marianne

1978–1979

1979

1508 **Searching for the Fourth Dimension**, 1979 ❏ A la recherche de la quatrième dimension

1509 **A Soft Watch Put in the Appropriate Place to Cause a Young**

Ephebe to Die and Be Resuscitated by Excess of Satisfaction (unfinished), 1979 ❏ Une montre molle posée à l'endroit adéquat faisant mourir et ressusciter un jeune éphèbe par excès de satisfaction

1508

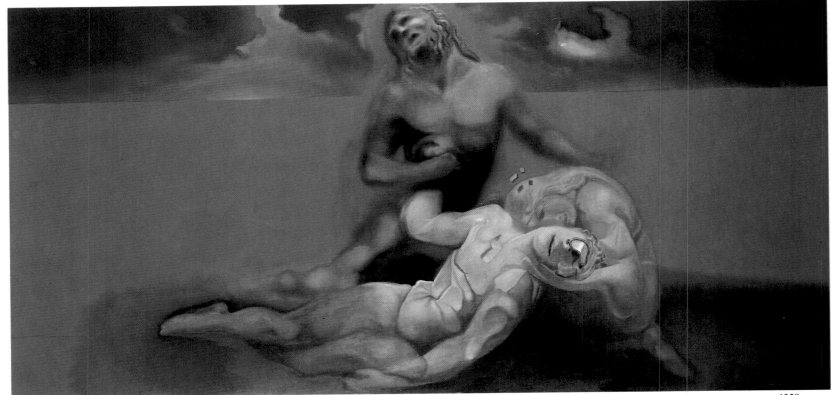

1509

1510 **Dawn, Noon, Sunset, and Twilight**, 1979 ❑
Aurore, midi, couchant et crépuscule
Dalí wanted dialogue to accompany his paintings. For this one there is a tape that goes: "What time is it?" "The hour of the Angelus." "Waiter, bring me a harlequin!"

1511 **Raphaelesque Hallucination**, 1979 ❑
Hallucination raphaëlesque

1510

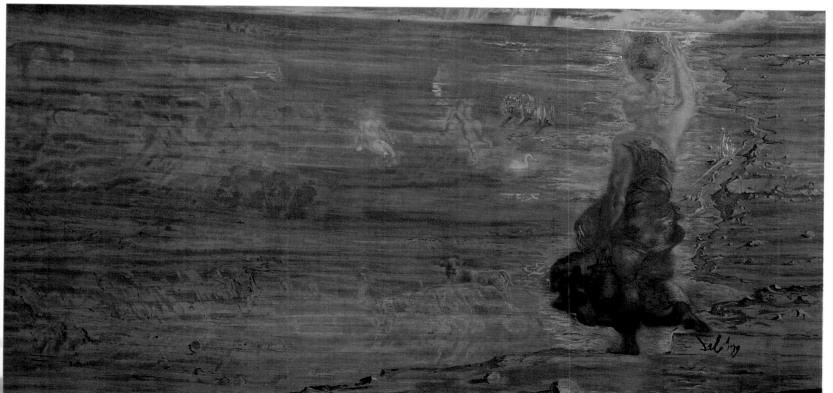

1511

1979

1512　Untitled (Landscape with
Celestial Beings), 1980 ❏
Sans titre (Paysage avec personnages
célestes)

1513　Nude and Horse with Meta-
morphosis (unfinished), c. 1979 ❏
Nu et cheval avec métamorphose

1514　Three Graces of Canova
(unfinished), 1979 ❏
Trois grâces de Canova

1515　Study for "Compianto
Diabele" by Canova (unfinished),
c. 1979 ❏

1514

1512

1513

1515

1516

1518

1519

1517

1516 More Beautiful than Canova, 1979 ❏
Plus beau que Canova

1517 The Cheerful Horse, 1980 ❏
Le cheval gai

1518 Sleeping Young Narcissus, 1980 ❏
Narcisse jeune endormi

1519 Untitled (Bridge with Reflections; sketch for a dual image picture, unfinished), 1980 ❏
Sans titre (Pont avec reflets; projet pour double-image)

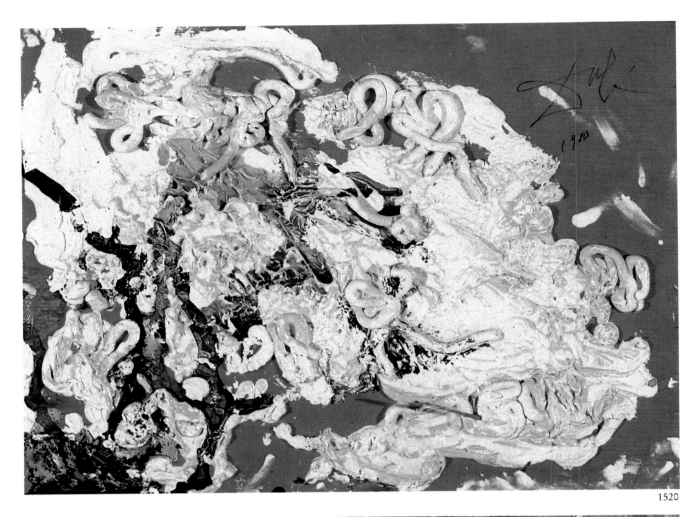

1520

1521

1520　**Arabs**, 1980 ❏
Arabes
1521　**Group Surrounding a Reclining Nude – Velázquez**, 1980–1981 ❏
Groupe de personnages entourant un nu allongé – Vélasquez
1522　**Arabs**, 1980 ❏
Arabes
1523　**Hermes**, 1981 ❏
Hermès

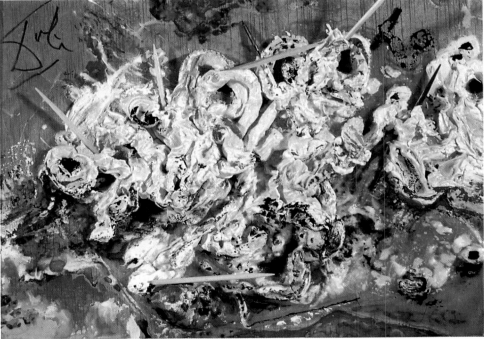

1522

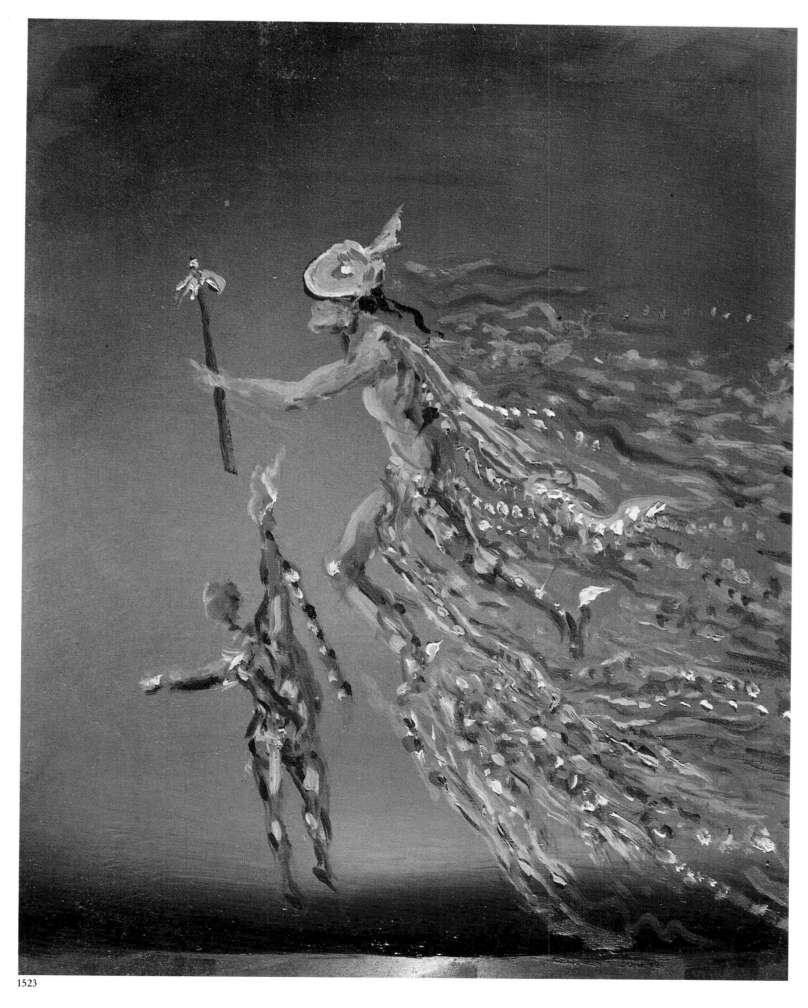

1523

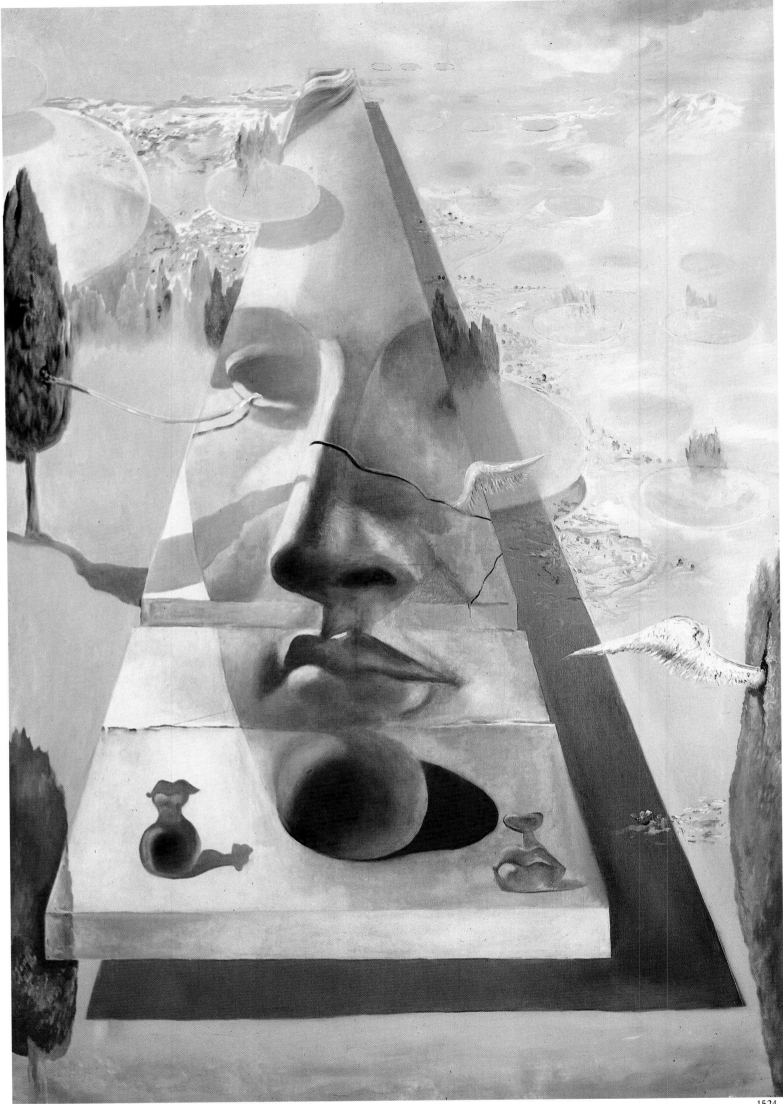

1524

1525

1527

1524　**Apparition of the Visage of Aphrodite of Cnidos in a Landscape,** 1981 ❑
Apparition du visage de l'Aphrodite de Cnide dans un paysage

1525　**The Garden of Hours,** 1981 ❑
Le jardin des heures

These are the flasks for a Spanish perfume, "Salvador Dalí" – inspired in shape by the nose, mouth and chin of the "Apparition of the Visage of Aphrodite":

1526　**For the "Man" perfume the mouth is above the chin** ☆

1527　**For the "Woman" perfume the nose is above the mouth** ☆

1526

1981

1528 **Tower, Grand Piano and Fountain**, 1981 ❑
Tour, piano à queue et fontaine
The tower is the Gorgot Tower, which Dalí later made into the Galatea Tower of his Teatro Museo Dalí.

1529 **The Towers**, 1981 ❑
Les tours
The same tower, doubled up, larger and obviously phallic.

1529

1528

1530 **Great Tapeworm Masturbator Appears behind Arcades**, 1981 ❑
Grand masturbateur-planaire apparaissant derrière des arcades

1530

(pp. 604–605), shows Dalí at work with Gala as his model. The hologram can be considered from any position and the two people portrayed seen from every angle. Dalí abandoned his holographic experiments in 1975, partly because the technology had not evolved as far as could be hoped. Nevertheless, holography remained the source of his hope for three-dimensional total vision. In Dalí's eyes, Cubism came to seem no more than an experiment in holography.

"Stereoscopy," Dalí wrote in *Ten Recipes for Immortality*, "immortalizes and legitimizes geometry, for thanks to it we have the third dimension of the sphere which is capable of containing and limiting the universe in an august, immortal,

incorruptible and royal fashion." Methods of conveying depth relief are all stereoscopic in character and derive from binocular vision, the *sine qua non* of the artist's spatial illusions. "Binocular vision," wrote Dalí in the same publication, "is the Trinity of transcendent physical perception. The Father, the right eye, the Son, the left eye, and the Holy Ghost, the brain, the miracle of the tongue of fire, the luminous, virtual image having become incorruptible, pure spirit, Holy Ghost."

Shortly after 1960, stereoscopic work had already appeared in Dalí's art in experiments with relief postcards using the reticular system (Fresnel). Unfortunately, today's technology only permits reproduction of this relief work on small surfaces. At that time, Dalí also made his experiments in classic stereo painting – two pictures, one for each eye – created by means of geometrical constructions or with photographs taken using stereoscopic equipment (two lenses). Dalí composed the pictures and transferred them to canvas using the technique of the photorealists. *Dalí from the Back Painting Gala from the Back* (pp. 604–605) is

1531 **The Tower of Enigmas,**
1971–1981 ❏
La tour des énigmes

1532 **Seated Figure Contemplating a "Great Tapeworm Masturbator",**
1981 ❏
Personnage assis contemplant un «Grand masturbateur-planaire»

1533 **Tower,** 1981 ❏
Tour

1531

1532

1533

1981

1534 Ready-to-wear Fashion for
Next Spring: "Garlands, Nests and
Flowers", 1981 ❑
Le prêt-à-porter du prochain prin-
temps: «des guirlandes, des nids et des
fleurs»

1534

1537

1535

1536

1535 The Gaseous Swan, 1981 ❑
Le cygne gazeux
1536 Amphitrite, 1981 ❑

1537 The Path of Enigmas
(first version), 1981 ❑
Le chemin de l'énigme

1538 The Path of Enigmas
(second version), 1981 ❑
Le chemin de l'énigme

1538

the pre-eminent work of this kind. Subsequently, after preliminary design work, Dalí would have two independent and often irreconcilable images photographed, would draw them and divide them up spatially, and would then reunite them on the canvases, thus creating the first stereoscopic collage. Roger de Montebello's adaptation of the mirror stereoscope enabled Dalí to paint large format pictures such as *The Chair* (p.660), which measures four metres by two. On this scale, stereoscopic art, for the first time, abandoned the tone of intimacy and became monumental.

Dalí went even further. In *Las Meninas (The Maids-in-Waiting)* (p.663) and in *Dalí's Hand Drawing Back the Golden Fleece in the Form of a Cloud to Show*

1539

1539 **Argus**, c. 1981 ❏

1540 **Medea or Jason Taking Possession of the Golden Fleece**, 1981 ❏
Médée ou Jason se saisissant de la Toison d'Or

1541 **Landscape**, 1981 ❏
Paysage

1542 **Mercury and Argos (after "Mercury and Argos" by Velázquez, Museo del Prado)**, 1981 ❏
Mercure et Argos

1543 **Landscape with Rock in the Shape of a Triumphal Arch**, 1981 ❏
Paysage avec un rocher en forme d'arc de triomphe

1544 **Jason Carrying the Golden Fleece (unfinished)**, c. 1981 ❏
Jason portant la Toison d'Or

1540

Gala the Dawn, Completely Nude, Very Very Far Away Behind the Sun (p.664)
he even attempted to break through the physical horizon.

In *Euréka*, written in 1976, Dalí described the meaning of his quest. Ever since
Impressionism, the entire history of modern art had been focussed on one single
objective: reality. If contemporaries, he felt, were wondering whether there were
anything new left to discover, the answer, he said, was clear. Velázquez.

1541

1543

1542

1544

1545 **The Exterminating Angels**, 1981 ❏
Les Anges exterminateurs

1546 **Untitled (Female Bust with Draped Cloth)**, 1981 ❏
Sans titre (Buste de femme drapé)

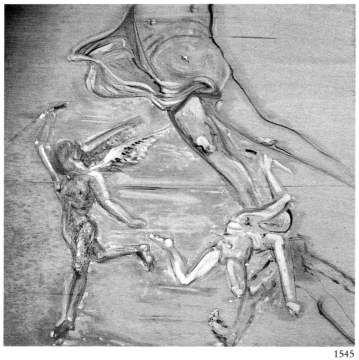

1545

1546

1547

1547 **Figures (Scene after Goya)**, 1981 ❏
Personnages (Scène goyesque)

1548 **Woman on a Ram**, 1981 ❏
Femme sur un bélier

1548

1549

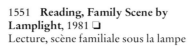

1551 Reading, Family Scene by Lamplight, 1981 ❑
Lecture, scène familiale sous la lampe

1552 Untitled (Imaginary Land-scape at Púbol), 1981 ❑
Sans titre (Paysage imaginaire de Púbol)

1551

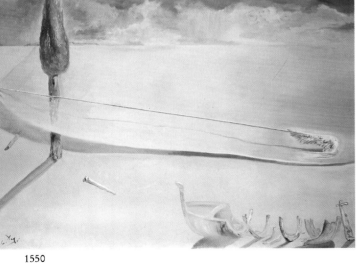

1550

1549 Untitled (Head of a Woman; unfinished), 1981 ❑
Sans titre (Tête de femme)

1550 Untitled (Skin of a Beach), 1981 ❑
Sans titre (Peau d'une plage)

1552

1981

1554

1553

**1553 Spanish Nobleman with a
Cross of Brabant on his Jerkin,**
1981 ❏
Noble espagnol portant la croix-tréflée
sur son pourpoint

1554 The Pearl, 1981 ❏
La perle
Inspired by the figure of the Infanta
Margarita in Velázquez's "Las
Meninas"

Waiting for Immortality

While Dalí was waiting for immortality, he had honours heaped upon him. He was awarded the Grand Cross of Isabella the Catholic, the highest Spanish decoration. On 26 May 1978, he was elected an associate foreign member of the Académie des Beaux-Arts de l'Institut de France. At the presentation ceremony he used the opportunity to speak of Perpignan railway station, "the gravitational centre of our universe. That was the very point Spain revolved about when the continents were torn apart and the Bay of Biscay came into existence. If it had not been for this phenomenon, we should have drifted to Australia and would now be living amongst the kangaroos – the most dreadful thought conceivable... Finally, so as not to become long-winded, I should like to second what my friend Michel de Montaigne said: One must always see the ultra-local in universal terms.

1555

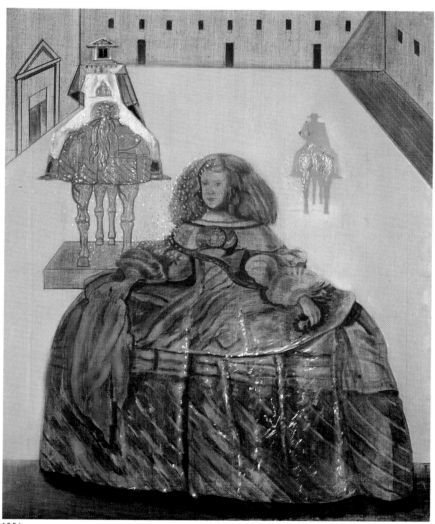

1556

1557

1555 **Velázquez and a Figure**, 1982 ❏
Vélasquez et personnage
After Velázquez's "Christ at the
Pillar", c. 1628–1629, National
Gallery, London

1556 **The Infanta Margarita of Velázquez Appearing in the Silhouette of Horsemen in the Courtyard of the Escorial**, 1982 ❏
L'infante Marguerite de Vélasquez
apparaissant dans la silhouette des
chevaliers dans la cour d'un Escurial

1557 **Three Female Figures in Festive Gowns**, 1981 ❏
Trois figures féminines en vêtements
d'apparat

1558

1558 **Untitled – Equestrian Figure of Prince Baltasar Carlos, after Velázquez, with Figures in the Courtyard of the Escorial**, 1982 ❏
Sans titre – Figure équestre du Prince Baltasar Carlos, de Vélasquez, et personnages dans la cour d'un Escurial

And so I always conclude my writing with the words: 'Long live Perpignan railway station! Long live Figueras!'" *The Railway Station at Perpignan* (pp. 558–559) was painted after a vision: "On 19 September 1963, at Perpignan railway station, I experienced a moment of cosmogonic ecstasy: an exact vision of the constitution of the universe." The painting also includes a variation on the Angelus theme, and on phallic symbols and symbols of mortality.

Writing in *L'Aurore*, Michel Déon, a fellow member of the Académie Française, said: "This Renaissance man may hide as much as he likes behind his exhibitionist façade: what we like is his work, and it is on his work that he will be judged and not on his moist derrières, his prickly sea urchins, his waxed moustache, his mink-lined capes, his Rolls-Royce, his inscrutable friendships with transvestites and his obsessive exploitation of his love for his wife, Gala. He will have introduced an awareness and austerity into painting that we supposed lost, thanks to the fragmentation Picasso initiated. A painter is always a craftsman too, and in this respect Dalí is one of the greatest. Very few realize that this artist is a technical expert, that he has rediscovered many a lost recipe, and that his finest,

1559

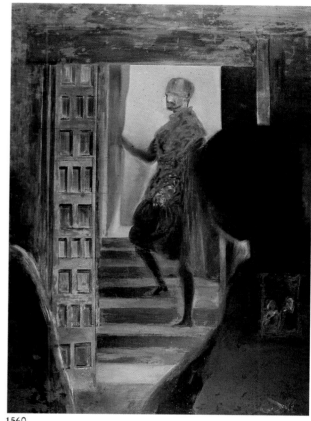

1560

most famous paintings will one day bear comparison with the best of Velázquez or Raphael. [...] People easily assume he is a fool because he says monstrous things in an astonishingly commonsense manner. Everyone who likes him and who considers him a genius, or at least a great talent, would welcome it if this tireless man – who has now been made a member of the Institut de France – would put a stop to some of his clowning. I should be delighted if he would shave off his twirly moustache and stop rolling his bulging eyes and if he would stop riding the prestigious and changing waves of Chance. He has had everything an artist can want. If he could bring himself to stop being a media spectacle, his art would get the full attention it merits and would doubtless increase in significance. Then we would clearly see that his work is among the greatest of the age. But that may be too much to expect of a man who has made mystification a dogma."

In the *50 Secrets of Magic Craftsmanship*, Dalí conceded what it was that tormented him: "Van Gogh was mad, and unconditionally, generously and gratuitously cut off his left ear with the blade of a razor. I am not mad either, yet I would be perfectly capable of allowing my left hand to be cut off, but this under

1559 **Gala in a Patio Watching the Sky, where the Equestrian Figure of Prince Baltasar Carlos and Several Constellations (All) Appear, after Velázquez**, 1981 ❏
Gala dans un patio observant le spectacle du ciel où surgit le portrait équestre du Prince Baltasar Carlos et apparaissent plusieurs Argo (tous) de Vélasquez

1560 **Don José Nieto Velázquez, from "Las Meninas" by Velázquez, Museo del Prado, Madrid**, 1982 ❏
D'après l'«Aposentador» Don José Nieto Vélasquez des «Ménines» de Vélasquez

1982

1561 Untitled (Composition – The Courtyard of the Escorial with Figure and Sebastián de Morra, Velázquez's Dwarf), 1982 ❏
Sans titre (Composition – La cour d'un Escurial avec personnage et Sebastián de Morra, le nain de Vélasquez)
1562 In the Courtyard of the Escorial, the Silhouette of Sebastián de Morra, in which the Face of Gala Surrounded by Catastrophic Signs Appears (unfinished), 1982 ❏
Dans la cour d'un Escurial, la silhouette de Sebastián de Morra dans laquelle apparaît le visage de Gala entouré de signes catastrophéïformes
1563 Sebastián de Morra with Catastrophic Signs (unfinished), 1982 ❏
Sebastián de Morra avec des signes catastrophéïformes
1564 Velázquez Dying behind the Window on the Left Side out of which a Spoon Projects, 1982 ❏
Derrière la fenêtre, à main gauche, d'où sort une cuillère, Vélasquez agonisant

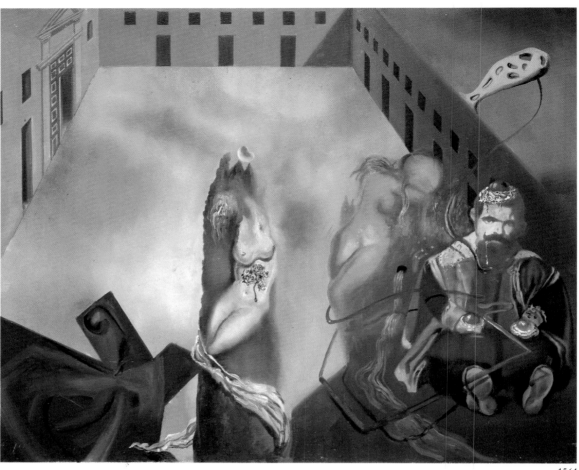

1561

1562

1563

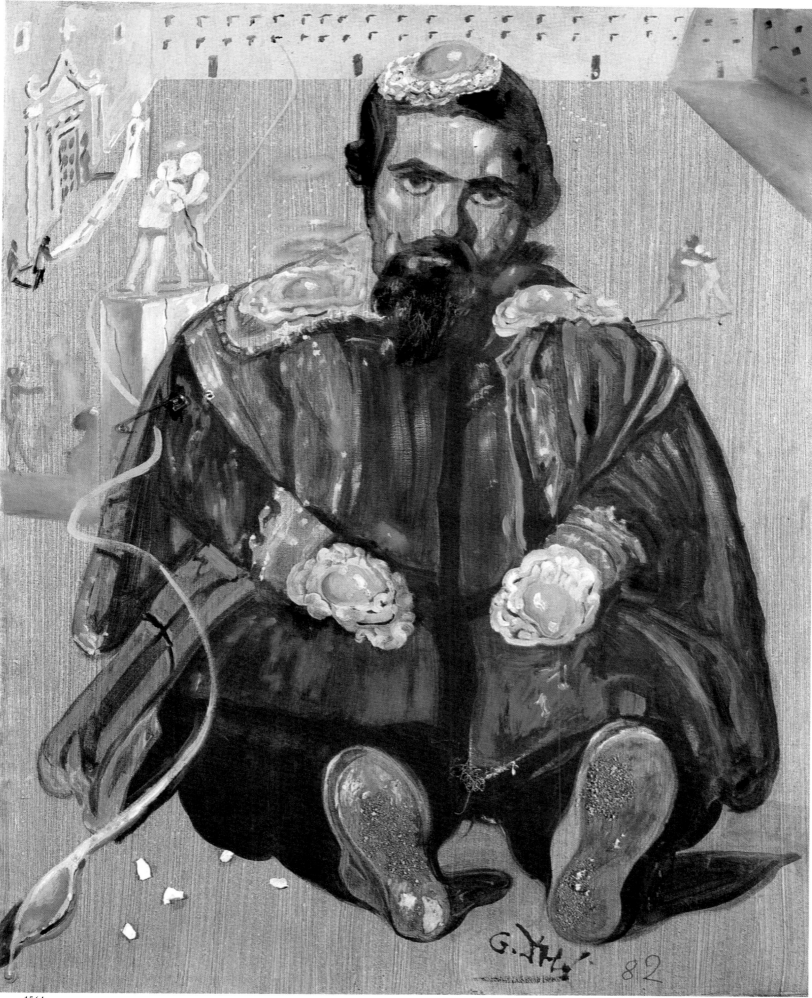

1564

1565

1565 Pietà, 1982 ☐
This group, prompted by the "Pietà" of Michelangelo, is one of several that herald Dalí's end, and in which death is a constant presence.

the most interesting circumstances: on condition, namely, that I might, for ten minutes, be able to observe Vermeer of Delft seated before his easel as he was painting. I should even be capable of much more than that, for I should likewise be prepared to let my right ear, and even both ears, be removed, provided I might learn the exact formula of the mixture which composes the 'precious juice' in which this same Vermeer, unique among the unique (and whom I do not call divine because he is the most human of all painters), dips his exquisitely rare brush [...] This might seem merely another typical Dalinian exaggeration, yet it is a rigorously objective fact: in 1948 a few persons in the world know how to manufacture an atomic bomb, but there does not exist a single person on the globe who knows today what was the composition of the mysterious juice, the 'medium' in which the brothers Van Eyck or Vermeer of Delft dipped their brushes to paint.

No one knows – not even I! […] Thus there is not the faintest shadow of madness in claiming, as I do, that if one places on one of the scales of a balance of pictorial justice a single drop of the medium with which Vermeer of Delft painted, one should not hesitate one second in throwing on the other scale of the same balance the left ear of Van Gogh, the left hand of Salvador Dalí and an impressive quantity besides of viscera of all sorts, even the most intimate, snatched somewhat at random from the most disorganized anatomies of our modern painters. And if all this freshly cut raw flesh does not – as I strongly suspect – suffice to 'make up the weight', one should not then hesitate to add for good measure the two ponderous hands of the touching Paul Cézanne. For the poor man, in spite of his wonderful and ultra-respectable ambition to 'paint like Poussin from nature' and thereby to become the master and the greatest architect of Nature, succeeded merely in becoming a kind of neo-Platonic master mason."

Is this Dalí's megalomania speaking? Doubtless it shares the hubris of genius; but it also has the humility of genius. In the final years of his active life as an artist,

1566

1567

Dalí was still trying to penetrate the secrets of the old masters. In his last works, he was inspired by the masterpieces of Velázquez and by the master of the Sistine Chapel. He cracked their codes, insofar as is possible even for such a genius as Dalí to do so, and adapted and assimilated them into his own visual world. Thus, in *The Pearl* (p.692), he uses the Infanta Margarita from Velázquez' famous painting *Las Meninas* as his source. The pearl has not merely been placed where the Infanta's head should be; rather, a visual displacement is occurring that creates a rich ambiguity. The same tremor of ambiguity is present throughout Dalí's last works, including the *Head Inspired by Michelangelo* (p.712). The head of the *Warrior* (p.705) is also derived from a Michelangelo, this time his head of Lorenzo di Medici. It took Dalí a long time to hit upon the idea of transforming the warrior's eyes into *embozados*. The *embozados*, a veritable institution in Cas-

1566 **Othello Dreaming of Venice**, 1982 ❑
Othello rêvant de Venise
Othello's head is that of Christ in the "Pietà" of Michelangelo. The window in his chest gives upon a magical landscape with Cape Creus. This picture too is a premonition of death.

1567 **Classic Figure and Head (unfinished)**, 1981–1982 ❑
Figure et tête classique

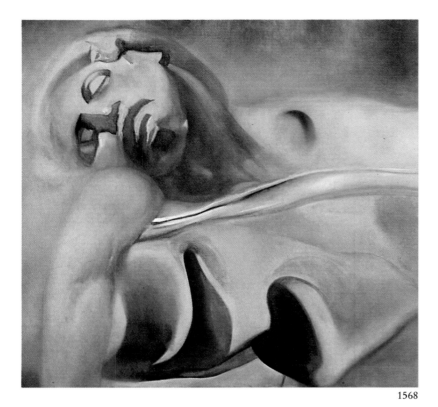

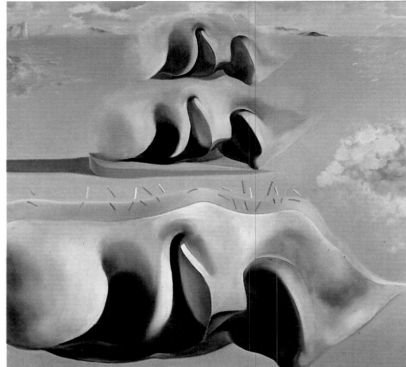

1568

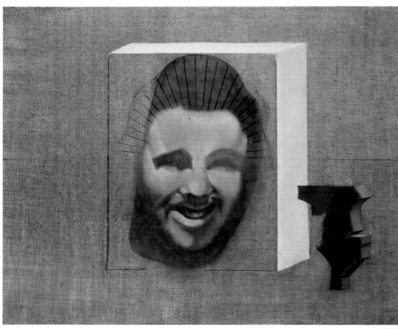

1569

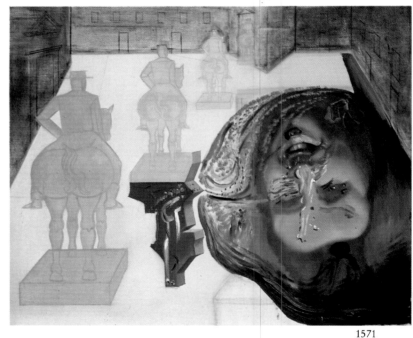
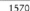

1571

1570

1568 Untitled (first study for "The Three Glorious Enigmas of Gala"), 1982 ❏

1569 Study for "Olé" (unfinished), 1982 ❏

1570 The Three Glorious Enigmas of Gala (first version), 1982 ❏
Les trois énigmes glorieuses de Gala

1571 Olé, 1982 ❏
Last painting in the "Escorial" series

tile, wore masks or hid their faces from the curious with their cloaks. During the Peninsular War, a Napoleonic minister of Italian extraction sparked off a riot when he attempted to ban this custom. Even the head of *Othello Dreaming of Venice* (p. 699) recalls the figure of Christ in Michelangelo's *Pietà* in St. Peter's. We see him in front of a landscape where sea and sky merge. A geological hole in his chest reveals Cape Creus in a magical landscape. This pitiable figure, with its portent of death, makes an impression of profound melancholy.

Dalí was deeply afraid of death. Any and every recipe for immortality was welcome, and he collected them as others collect cooking recipes, hoping that one would work. In the *50 Secrets* he affirmed: "In contrast to the modern works which barely last a season, leaving a more imperceptible spiritual trace even than the collections of dressmakers, the works of the ancient masters are even now giving life to the painting of the near future, for it is they and only they who

1572

1573

1572 The Three Glorious Enigmas of Gala (second version), 1982 ❑
Les trois énigmes glorieuses de Gala
For Dalí, the "Three Enigmas" were the three phases of his life by the side of his beloved companion. This painting was a moving homage to Gala – who died only weeks after it was painted.

1573 Enigma (unfinished version of "The Three Glorious Enigmas of Gala"), 1982 ❑ Enigme

1982

1574

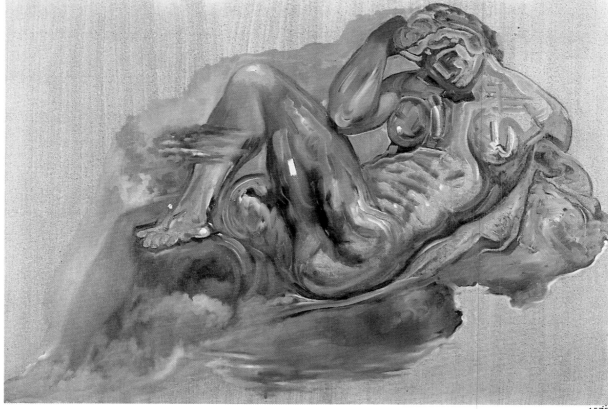

1575

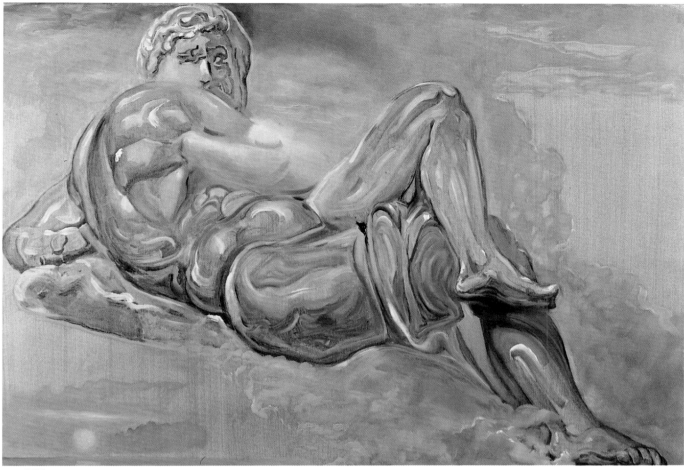

1576

possess all the arts and all the prescience of magic […] Raphael: *there* is a futurist painter, if by this one means that he will continue more and more to exert an active influence on the future!" His whole life long, Dalí spent many a sleepless night questing for the philosopher's stone. He sought constantly after the lost secrets of true technique in painting. He never ceased to wonder whether more or less ambergris, more concentrated or less, needed adding to the mixture, and whether his oil should not be more viscous. And he asserted that when at last he began to paint in accordance with rules he had rediscovered, people who understood nothing about technique continued to insist that his best pictures were painted at a time when he did not yet (so he said) understand how to paint. This period, in his own view, included the Surrealist years. *Galarina* and *The Basket of Bread*, both painted in 1945, he conceded to be well-done whereas he dismissed the 1926 *Basket of Bread* as apprentice work. He came to feel that only his stereoscopic dual images were truly persuasive, indeed perfect – and even those, he claimed, he could return to and improve.

In this connection, he liked to quote his friend Manolo, a Catalonian sculptor who responded to excessive praise bestowed on one of his statues by contemporary art critics by philosophically remarking that they only liked his failures, and that what he had hoped would be a Venus had turned out a toad. Dalí was determined not to paint a Venus that looked like a toad. He wanted no praise for imperfection, and certainly not for ugliness, from the pseudo-aesthetes of the day who might praise his art's expressiveness or human dimensions. What he wanted at the end of his creative life was to be able to paint like Velázquez or Michel-

1574 **Figure Inspired by Michelangelo's Adam on the Ceiling of the Sistine Chapel, Rome,** 1982 ❏
Personnage inspiré par la figure d'Adam, plafond de la Chapelle Sixtine de Michel-Ange à Rome

1575 **After Michelangelo's "Night" on the Medici Tomb, Florence,** 1982 ❏
D'après «La nuit» de Michel-Ange pour le «Tombeau de Julien de Médicis» à Florence

1576 **After Michelangelo's "Day" on the Medici Tomb, Florence,** 1982 ❏
D'après «Le jour» de Michel-Ange pour le «Tombeau de Julien de Médicis» à Florence

1577

1578

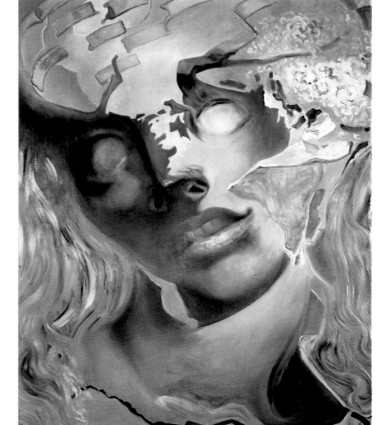

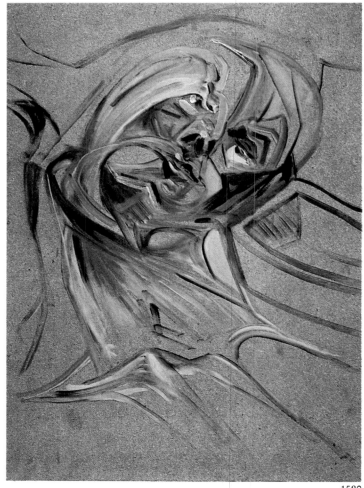

1579

1580

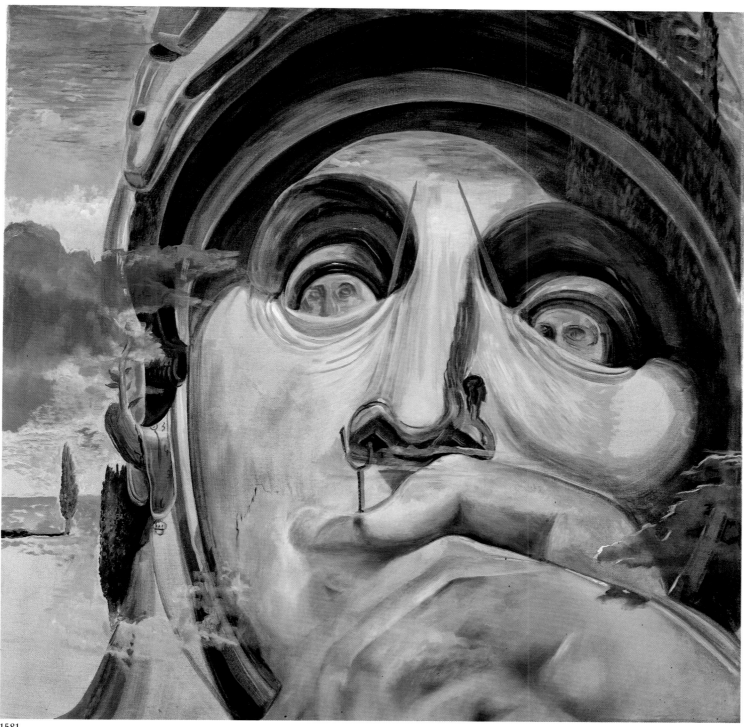

1581

1577 **After the Head of "Giuliano di Medici", Florence**, 1982 ❑
D'après la tête de «Julien de Médicis», Florence

1578 **Head, after Michelangelo's "Giuliano di Medici"**, 1982 ❑
Tête inspirée par le «Julien de Médicis» de Michel-Ange

1579 **Exploded Head**, 1982 ❑
Tête éclatée

1580 **Topological Study for "Exploded Head"**, 1982 ❑

1581 **Warrior**, 1982 ❑
Le guerrier
Inspired by Michelangelo's head of Lorenzo di Medici. The eyes are veiled in accordance with Castilian custom, which called for a mask or cloak to be placed before the face.

1582

1583

1582 After Michelangelo's "Squatting Child", 1982 ❏
D'après «L'enfant accroupi» de Michel-Ange

1583 "Giuliano di Medici" by Michelangelo, Seen from behind, 1982 ❏
«Julien de Médicis» de Michel-Ange vu de dos

1584 After Michelangelo's "Moses", on the Tomb of Julius II in Rome, 1982 ❏
D'après «Moïse» de Michel-Ange, Tombeau de Jules II

1585 Rock Figure after the Head of Christ in the "Pietà" of Palestrina by Michelangelo, 1982 ❏
Figure rocheuse – D'après la tête du Christ de la «Pietà» de Palestrina de Michel-Ange

angelo. And he was painting like Dalí! Was that enough to be immortal? "Ingres," he wrote in the *50 Secrets*, "yearned to paint like Raphael and only painted like Ingres; Raphael yearned to paint like the Ancients and exceeded them. There have been times when I silently admitted to myself, 'I want to paint like Ingres', and it turned out to be like Bouguereau. Nevertheless, I irresistibly paint like Dalí, which is already enormous, for of all contemporary painters I am the one who is most able to do what he wants – and who knows if some day I shall not without intending it be considered the Raphael of my period?"

Dalí was enthusiastic about a theory advanced by a leading teratologist Dr. Hubert Larcher, in a publication entitled *Will Blood Conquer Death?*, which speculated: "What if the body does not die? If our corpse becomes a kind of life factory? There are people who are sheer filth when they are still alive and smell terrible (in our consumer society this applies particularly to bureaucrats, who smell worse than anyone else), but saints, when they die, are metamorphosed into perfume factories. Not only saints, but also great courtesans." According to Dr. Larcher, blood is naturally related to the cosmos, and may well be the substance the alchemists of old were looking for – in their retorts instead of within themselves. Dalí pondered the point: "We know of over fifty saints who died 'in an odor of sanctity', which is not merely a figure of speech, but objective fact. That corpses of certain saints have the property of secreting balms and fragrant oils. They have numerous excellent properties and are known as myrofacts. The most famous case is that of St. Teresa of Avila."

Dalí pondered every conceivable path to immortality. He published his thoughts on the matter in his remarkable *Ten Recipes for Immortality*. In it, he

contd. on p.712

706

1584

1585

1586

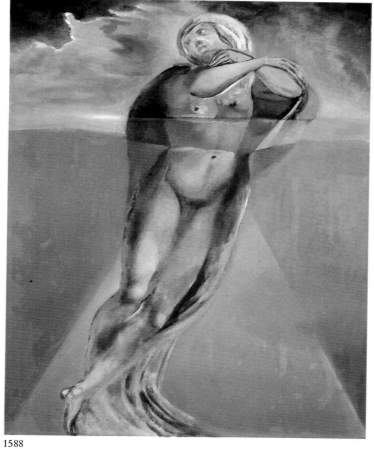

1588

1586 **Pietà. Inspired by the "Pietà" of Palestrina by Michelangelo**, 1982 ❏
Pietà

1587 **Untitled – Nude Figures after Michelangelo**, 1982 ❏
Sans titre – Figures nues d'après Michel-Ange

1588 **Figure in the Water – After a drawing by Michelangelo for the "Resurrection of Christ"**, 1982 ❏
Personnage aquatique inspiré par un dessin de Michel-Ange pour «La Résurrection du Christ»

1589 **Saint Sebastian**, 1982 ❏
Saint Sébastien

1587

1589

1590 **Untitled (Figures, Pietà, Catastrophic Signs)**, 1983 ❏ Sans titre
1591 **Figure after Michelangelo's "Dawn" on the Tomb of Lorenzo di Medici**, 1982 ❏
Personnage inspiré par «L'aurore» de Michel-Ange du tombeau de Laurent de Médicis
1592 **Scene in the Courtyard of the Escorial with a Figure in the Foreground Inspired by Michelangelo's "Evening"**, 1982 ❏
Scène dans la cour d'un Escurial avec, en avant-plan, un personnage inspiré par «Le crépuscule» statue de Michel-Ange du tombeau de Laurent de Médicis

1591

1590

1592

1593

1593 **The Escorial Contorted in Disorderly Fashion and Metamorphosing into a Woman**, 1982 ❏

Un Escurial se contorsionnant de façon désordonnée pour parvenir à se transformer en femme

1594

1594 **Twofold Victory of Gaudí**, 1982 ❑
Double victoire de Gaudí

1595 **Landscape with Hidden Image of Michel-angelo's "David"**, 1982 ❑ Paysage avec l'image cachée du «David» de Michel-Ange

1595

1596

1597

1596 **Catastrophic Architecture and Calligraphy**,
1982 ❑ Architecture et calligraphie catastrophéïforme

1597 **Atmospherocephalic Figures**, 1982 ❑
Personnages atmosphéricocéphales

1598

1598 **Head Inspired by Michel-angelo**, 1983 ❑
Tête inspiré par Michel-Ange

1599 **Mirror Women – Mirror Heads**, 1982 ❑
Femmes-miroirs – Les têtes à miroirs

1600 **Martyr – Inspired by the Suf-ferings of Dalí in his Illness**, 1982 ❑
Martyr

1599

states: "I declare that the body's most important hibernation zone is the arsehole, because the first thing that animals do when they begin their hibernation is to stop up the anus with a paste made of dirt and excrement in order to maintain their metabolism. And this is also a guarantee of intimacy!" In this publication, Dalí also evolved his *sistema caga y menja* – the system of shitting and eating. "Along the lines of Brueghel's *Tower of Babel*, I imagined a 'tower of immortality', one in every town. Every inhabitant who wanted to move his bowels did so immediately, in accordance with a strict procedure, by crapping on the inhabitants of the storey below who were waiting for food. Thanks to certain methods of mental and nutritional perfection, people produced semi-fluid excrement that was comparable, on the whole, to honey. Thus some of them caught the excrement of others in their mouths, and shat in turn on those below them [...] which made for perfect equilibrium in social terms; everyone had something to eat, without needing to work." Dalí's *sistema caga y menja* aimed to eliminate the danger of virtual death, which was a matter of the digestive processes, according to Paracelsus. Dalí noted that contemporary developments illustrated his theory: "Nowadays, towers are again built to shoot machines into space, and we are seeing how human urine and excrement can be recycled, because astronauts drink their pee and shit into small containers in which algae and mushrooms grow to staggering sizes; they can then eat these and shit them, in a cycle. This is not a vicious circle…"

1601

The Bedside Table

Dalí, half in jest and half in earnest, decided to have himself frozen. "Let us assume I die. I should not like people simply to say, 'Dalí is dead.' I want them to add, 'Dalí has done it differently yet again. He's had himself frozen.'" Dalí wanted to be put into preservation the moment he ceased to live, to await the discovery that would one day make it possible for Dalí the genius to be restored to life. "I am convinced that cancer will be curable and the most amazing transplants will be performed, and cellular rejuvenation will be with us in the near future. To restore someone to life will merely involve an everyday operation. I shall wait in my liquid helium without a trace of impatience."

Dalí's wish to return to prehistoric times brings us to his final period, in which he studied the phenomenon of the catastrophe. "Everything I have been doing since then is centred on the phenomenon of catastrophes," Dalí told one of the rare visitors he received at that time. Thanks to the mathematician René Thom, who had evolved a theory of catastrophes, Dalí developed a rigorously qualitative way of thinking derived from recent research in topology and differential ana-

1602

1603

1983

1604

1604 **Bed and Two Bedside Tables Ferociously Attacking a Cello,** 1983 ❏
Lit et deux tables de nuit attaquant férocement un violoncelle

1605 **St. George Overpowering a Cello,** 1983 ❏
Saint Georges terrassant un violoncelle

1606 **Bed, Chair and Bedside Table Ferociously Attacking a Cello,** 1983 ❏
Lit, chaise et table de nuit attaquant férocement un violoncelle

1607 **Warrior Mounted on an Elephant Overpowering a Cello,** 1983 ❏
Guerrier sur un éléphant terrassant un violoncelle

1605

1606

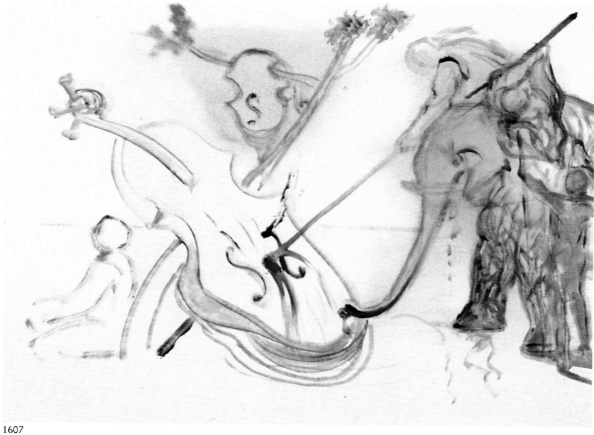

1607

1608

1609

1608 **Pietà**, 1983 ❏

1609 **The Truck (We'll be arriving later, about five o'clock),** 1983 ❏
El camión (Llegaremos mas tarde, hacia las cinco)

1610 **Topological Contortion – Bed and Two Bedside Tables Ferociously Attacking a Cello,** 1983 ❏
Contorsion topologique – Lit et deux tables de nuit attaquant férocement un violoncelle

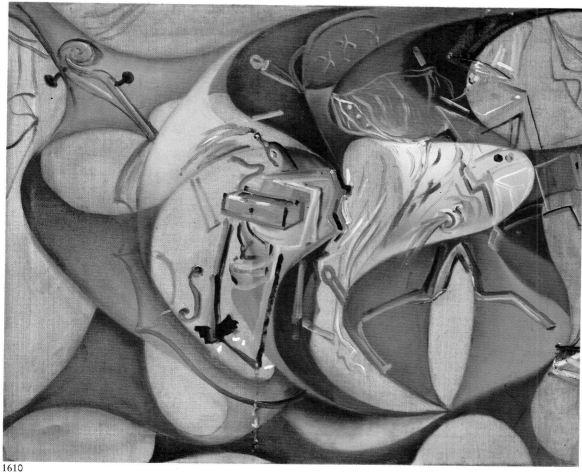

1610

lysis. Dalí found himself in a four-dimensional space-time continuum – for, as René Thom put it, it is possible on an abstract level, purely geometrically, to evolve a theory of morphogenesis. The examples proposed for the study of everyday phenomena in mathematical terms (a lizard on an old wall, the shape of cloud, the fall of a dead leaf, the froth on beer) were sure to appeal to Dalí, who had long been considering flies, grasshoppers and cherries in the same light. One of his last paintings, done only a few weeks before Gala died, is stunning: *The Three Glorious Enigmas of Gala* (p.701). Three periods in Dalí's creative life are seen united in this picture. It was a final act of triple homage to the woman who had become his *Leda Atomica* (pp.424,425) and *The Madonna of Port Lligat* (p.443).

The great catastrophe that was impending in Dalí's own life happened on 10 June 1982, when Gala died, leaving him alone. Dalí tried to commit suicide by dehydrating. How serious was the attempt? He was convinced that dehydration and return to a pupal state would assure him of immortality. He had once read that the inventor of the microscope had seen minute, seemingly dead creatures through the lens of his invention – creatures that were in a state of extreme dehydration and which could be restored to life with a drop of water.

Dalí concluded (or at least liked the idea) that it was possible to live on beyond the point of dehydration. What he had not foreseen, though, was that, having consumed nothing for so long, it became impossible for him to swallow anything at all. From then till his dying day, he was fed liquid nutriments through a tube up his nose. In his *Ten Recipes for Immortality*, Dalí had written of "immortality vouchsafed by dehydration and temporary return to a pupal stage", as the discovery of collemboles, a species of micro-organisms, showed in 1967. These are a living fossil group that have been in existence since the Devonian (a geological system dating back approximately four hundred million years). The truth is that Dalí was not concerned about his body. All that mattered was the immortality of

1611

1611 Topological Contortion of a Female Figure, 1983 ❏
Contorsion topologique de figure féminine

1612 Topological Contortion of a Female Figure Becoming a Cello, 1983 ❏
Contorsion topologique d'une figure féminine devenant violoncelle

1613 Topological Detachment of Europe – Homage to René Thom, 1983 ❏
Enlèvement topologique d'Europe – Hommage à René Thom
René Thom is a French mathematician whom Dalí admired for his disaster theory, which is attracting growing attention in our own day.

the "garden of his mind". Dalí also attempted an auto-da-fé, ringing and ringing the push-button bell that summoned his nurses to his bedside, until eventually the wiring short-circuited and set fire to his bed and nightshirt. Luckily Robert Descharnes was close to hand and saved Dalí's life.

Another side effect was that Dalí lost his voice. He would become impatient and fly into a temper if nobody could understand what he was saying. His retinue, including his confidant Descharnes, needed great patience to decode the scarcely audible murmurs that passed his lips.

Their patience was particularly important when it came to business, since Dalí still ran the multi-national concern that was Salvador Dalí himself. He had established a company, Demart Pro Arte, with Robert Descharnes as president, to protect his work and personal rights, to combat fakes worldwide, and to make new deals. Thus he presided over the creation of a perfume that bore his name; from New York to Tokyo, it was marketed in flacons in Surrealist shapes – a nose, a mouth, or (in the case of the men's product) a testicle. Business was brisk. After all, are not testicles the receptacle of the angels? Until the end he gave whatever instructions were necessary for the realization of projects that mattered to him. One of them was the casting of statues, such as a monumental *Newton* for a Plaza Dalí in Madrid; a big Venus with drawers (originally for the retrospective which Robert Descharnes and Gilles Néret organized for the Seibu Museum in Tokyo in 1964); and a "rhinocerotic lace-maker" and a "rhinocerotic sunflower" dating back to the filming of *L'histoire prodigieuse de la dentellière et du rhinocéros* in the 1950s. He met representatives of the Minami Group (Japan) to discuss the architectural details of his third museum, the Gala-Dalí Museum in Tokyo.

Was Dalí mad? Or senile? A number of Catalonian intellectuals tried hard to claim as much, and wrote an open letter to the Catalonian prime minister, Jordi Pujol, accusing those who were close to Dalí of exerting a bad influence on the

1612

Queue d'aronde $V = x^5/5$ $V = x^5/5 + ux^3/3 + vx^2/2 + wx$

1613

1983

1614

1615

1614 Cutlet and Match – The Chinese Crab, 1983 ❏ Côtelette et allumette – Le crabe chinois

1615 Untitled – Head of a Spanish Nobleman, Fashioned by the Catastrophe Model from a Swallow's Tail and Two Halves of a Cello, 1983 ❏ Sans titre – Tête de noble espagnol formée par le modèle de catastrophe de la queue d'aronde et deux demi-violoncelles

1616 Untitled – Series on Catastrophes, 1983 ❏ Sans titre – Série des catastrophes

1617 The Swallow's Tail – Series on Catastrophes, 1983 ❏ La queue d'aronde – Série des catastrophes
Dalí's last painting, done in May 1983. "Everything I do from now on will be devoted to the phenomenon of catastrophes", Dalí told the few visitors he was still receiving, and added: "Now it is no longer a matter of pure imagination, of my moods and dreams, of automatism. Now I am painting the meaning that derives directly from my existence, my illness or my vital memories."

1616

1617

1618

1618 **The Tomb of Francesco Pujols,**
1982 Δ
Le tombeau de Francesc Pujols

master. They also criticized the management of his business concerns and of the Gala-Dalí theatre museum, and suggested that Dalí was no longer capable of making his own decisions. Dalí was incensed. He summoned Pujol to the Torre Galatea and told him with a smile: "I should like to give one of my most beautiful paintings, *Continuum of the Four Buttocks, or, Birth of a Goddess*, to the province of Catalonia." Who would question the sanity of a man who had just made a gift of a painting estimated at half a million dollars? The Catalonian intellectuals had been wasting their time.

In fact, Dalí was still delighting in life, and constantly quoted Ovid's *Morte carent animae* (Souls forgo death). So much still remained to be done if he was to perfect his work and be assured of immortality. In addition to his rescuer Robert Descharnes, the only one who did not grow rich at Dalí's expense and who conscientiously protected his work and person, the immediate retinue included the painter Antonio Pichot, his pupil from the artistic family that had helped him become a painter; his secretary María Teresa, who read the newspapers to him; and Arturo, who had been in his service since 1948 and acted as Dalí's valet, chauffeur, male nurse, and looked after the master's properties – a car workshop in Cadaqués, a sheep ranch converted into a hotel, the Coral de Gala, the famous house in Port Lligat with its outbuildings, and Púbol castle, which housed his collection.

Dalí followed scientific research more attentively than ever. He was fascinated by desoxyribonucleic acid (DNA), which contains the coded genetic secrets of the species. Was not a DNA molecule a guarantee of immortality? Dalí told Descharnes that it was the most royal of cells: "Every half of a shoot is exactly linked to its matching half, just as Gala was linked to me […] It all opens and closes and interlinks with amazing precision. Heredity depends on a sovereign mechanism, and life is the product of the absolute rule of desoxyribonucleic acid."

Dalí attended to his funeral arrangements himself, and in his will he passed over Catalonia, which he felt had not paid him the respect that was his due, in favour of King Juan Carlos and the Spanish state. He observed: "Crowds go to see my pictures and will go on doing so in future because their vague, inchoate instincts tell them that obvious treasures of authenticity lie hidden in my work and have never yet been seen. Non-artistic treasures that will increasingly tend to become artistic ones." He had *Les Millions d'Arlequins* and the *Serenade* by Enrico Toselli played to him; they had been taped for him at Maxim's in Paris as a reminder of the good old days. He wondered if he still had the time to write a tragedy. So as not to be surprised by death he began with the word, "Curtain".

His moustache waxed by his majordomo and his body embalmed to last at least three hundred years, clad in a tunic adorned with the crown of a marqués and an embroidered border representing the double helix of DNA, the Marqués de Dalí de Púbol (the title conferred on him by King Juan Carlos I on 26 July 1982) lies at rest in a crypt beneath the glass dome of his museum at Figueras, amidst his pictures and objects – among them a Cadillac.

1619 "Bracceli" the Warrior with a Corpse – Torero Series, 1985 △
Guerrier «Bracceli» près d'un cadavre – Série Torero

1620 Two Phoenixes in Combat – Torero Series, 1985 △
Combat de deux phénix – Série Torero

1619

1620

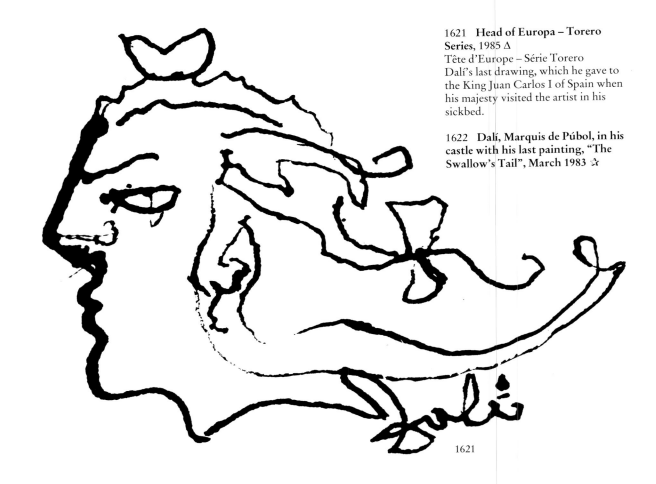

1621 **Head of Europa – Torero Series**, 1985 Δ
Tête d'Europe – Série Torero
Dalí's last drawing, which he gave to the King Juan Carlos I of Spain when his majesty visited the artist in his sickbed.

1622 **Dalí, Marquis de Púbol, in his castle with his last painting, "The Swallow's Tail"**, March 1983 ☆

1621

Elegy to Gala

Source of life,
Nights that never dawn;
I go to the fountain,
And suddenly before me
The beloved image appears,
Preserved deep
In my heart.
I know
That the bread of life is there;
Even with my eyes closed
I can still see –
Radiantly white
And utterly clear –
The bread of life.
I know
That there is the oven
In the flames of which
The beloved image

Of my worshipped Gala is reflected,
Above, adorned
With garlands of death.
I know
That in the womb of the Earth
The block of marble lies
In which the image
Of my beloved Gala slumbers.
Four elements
Of my Gala are interwoven;
Fire, water, earth and air
Tell of her,
Whom I already knew
Before I was born.
Air, air! I breathe
Day and night
With the image of my Gala before my eyes;
In loving memory
Day and night
I breathe the air
Of my beloved Gala.
In the garden fountain
Water falls endlessly
Into depths that never dawn;
There I beheld every detail
Of the portrait of my Gala,
Whom I never loved enough.

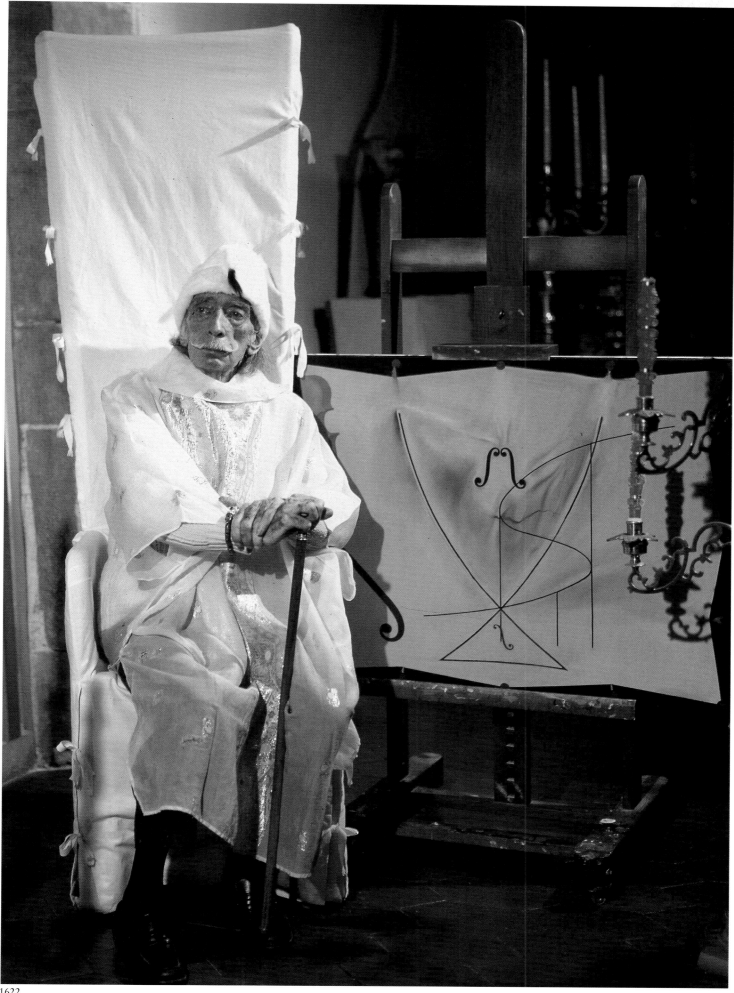

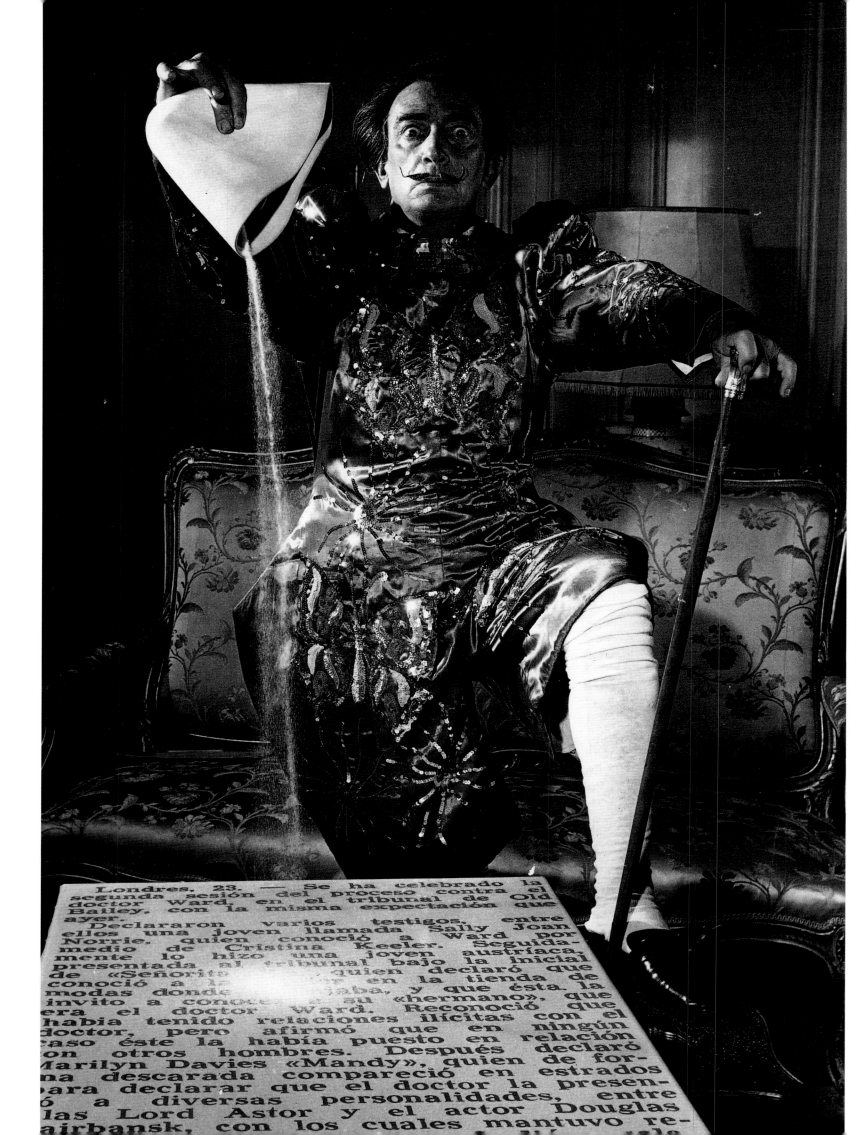

Londres, 23. — Se ha celebrado la
segunda sesión del proceso contra el
doctor Ward, en el tribunal de Old
Bailey, con la misma expectación que
ayer.
Declararon varios testigos, entre
ellos una joven llamada Sally Joan
Norrie, quien conoció a Ward por
medio de Cristina Keeler. Seguida-
mente lo hizo una joven austríaca,
presentada al tribunal bajo la inicial
de «Señorita ...», quien declaró que
conoció a ... en la tienda de
modas donde ... , y que ésta la
invitó a conocer a su «hermano», que
era el doctor Ward. Reconoció que
había tenido relaciones ilícitas con el
doctor, pero afirmó que en ningún
caso éste la había puesto en relación
con otros hombres. Después declaró
Marilyn Davies «Mandy», quien de for-
ma descarada compareció en estrados
para declarar que el doctor la presen-
... a diversas personalidades, entre
... las Lord Astor y el actor Douglas
... airbansk, con los cuales mantuvo re-

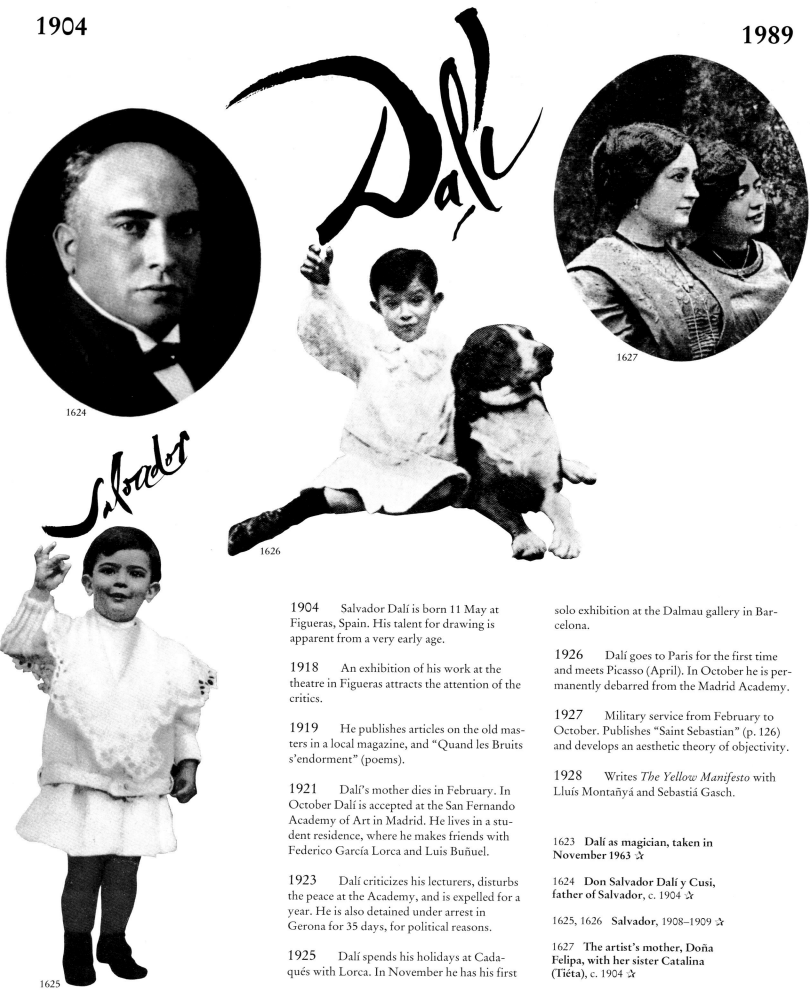

1904

1989

1624

1627

1626

1625

1904 Salvador Dalí is born 11 May at Figueras, Spain. His talent for drawing is apparent from a very early age.

1918 An exhibition of his work at the theatre in Figueras attracts the attention of the critics.

1919 He publishes articles on the old masters in a local magazine, and "Quand les Bruits s'endorment" (poems).

1921 Dalí's mother dies in February. In October Dalí is accepted at the San Fernando Academy of Art in Madrid. He lives in a student residence, where he makes friends with Federico García Lorca and Luis Buñuel.

1923 Dalí criticizes his lecturers, disturbs the peace at the Academy, and is expelled for a year. He is also detained under arrest in Gerona for 35 days, for political reasons.

1925 Dalí spends his holidays at Cadaqués with Lorca. In November he has his first solo exhibition at the Dalmau gallery in Barcelona.

1926 Dalí goes to Paris for the first time and meets Picasso (April). In October he is permanently debarred from the Madrid Academy.

1927 Military service from February to October. Publishes "Saint Sebastian" (p. 126) and develops an aesthetic theory of objectivity.

1928 Writes *The Yellow Manifesto* with Lluís Montañyá and Sebastiá Gasch.

1623 **Dalí as magician, taken in November 1963** ☆

1624 **Don Salvador Dalí y Cusí, father of Salvador,** c. 1904 ☆

1625, 1626 **Salvador,** 1908–1909 ☆

1627 **The artist's mother, Doña Felipa, with her sister Catalina (Tiéta),** c. 1904 ☆

1929 Buñuel and Dalí make *Un Chien Andalou* (p. 154, 155). The film marks their official acceptance into the ranks of the Paris Surrealists. In the spring Dalí is in Paris for filming and, through Miró, meets Tristan Tzara, the Surrealists and Paul Eluard. In the summer, in Cadaqués, he seduces Eluard's wife Gala. This leads to a break with his father.

1930 He begins to evolve his paranoiac-critical method. In *Le Surréalisme au service de la révolution* he publishes "L'Ane pourri", and his *La Femme visible* (p. 158, 167) at the "Editions surréalistes". Dalí buys a fisherman's cottage at Port Lligat near Cadaqués, and henceforth spends a good deal of each year there with Gala. Right-wing extremists wreck the cinema where the Buñuel/Dalí film *L'Age d'Or* (p. 157) is showing.

1931 *Love and Memory* is published in the "Editions surréalistes" series.

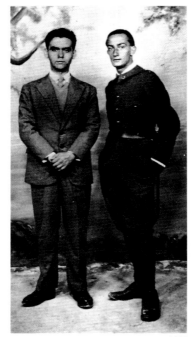

1932 Dalí exhibits in the first Surrealist show in the USA. He writes *Babaouo*, a screenplay – though the film, like all his subsequent film projects, remains unmade. The "Zodiaque" group of collectors is established, and regularly buys his work.

1933 In *Minotaure* magazine he publishes his article on edible beauty and art nouveau architecture, which revives interest in the aesthetics of the turn of the century.

1934 He exhibits *The Enigma of William Tell* (p. 201). This leads to arguments with the Surrealists and André Breton. Dalí's New York exhibition is a triumphant success.

1936 The Spanish Civil War begins. Lecturing at a Surrealist exhibition in London, Dalí narrowly escapes suffocating in a diving suit. In December he makes the cover of *Time* magazine (p. 274).

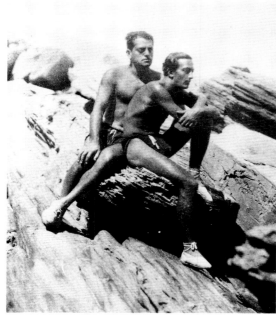

1628 Dalí and Buñuel on the rocks at Cadaqués in summer 1929, when they were working on the screenplay for "L'Age d'Or". ✰

1629 Federico García Lorca and Dalí in uniform in Figueras, 1927 ✰

1630 Dalí and Gala as newly-weds in their Paris flat, 1929 ✰

1631 Lidia (who sold them the fisherman's cottage), Lorca and Gala watching over Port Lligat. Illustration for "Dalí from Gala", published 1926 △

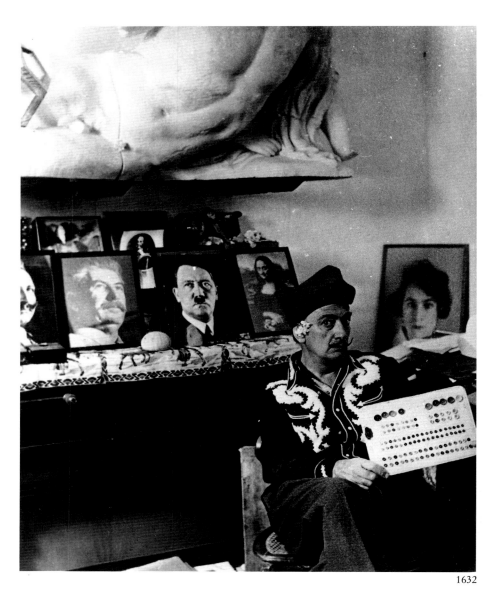

1937 Dalí writes a screenplay for the Marx Brothers and meets Harpo Marx in Hollywood. In July he both paints and writes *The Metamorphosis of Narcissus* (p. 289), a wholesale exercise in the paranoiac-critical method. He designs for Elsa Schiaparelli. Breton and the Surrealists condemn his comments on Hitler.

1938 Dalí exhibits in the Surrealist exhibition in Paris (January). He visits Freud in London (July) and draws a number of portraits of him (p. 298, 299).

1939 The breach with the Surrealists is now final. André Breton anagramatically dubs

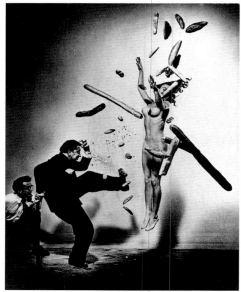

1632

1633

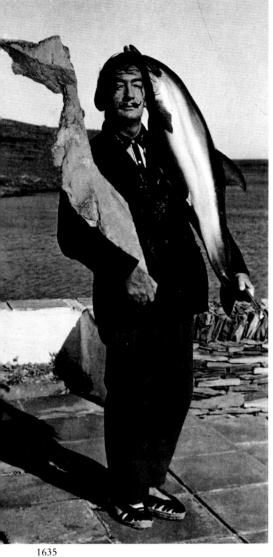

1635

1634

1636

Dalí "Avida Dollars". In the United States Dalí publishes his pamphlet *Declaration of the Independence of the Imagination and the Rights of Man to His Own Madness* (p. 322). In November *Bacchanale* (p. 324, 325), a ballet, is premièred at the Metropolitan Opera in New York, with libretto and set design by Dalí and choreography by Léonide Massine.

1940 After a brief visit to Paris, Dalí and Gala return to New York, where they remain in exile until 1948.

1941 Dalí-Miró exhibition in The Museum of Modern Art, New York.

1942 *The Secret Life of Salvador Dalí* is published in America.

1946 Dalí sketches cartoons for Walt Disney (*Destino*, p. 393), and designs sequences for Alfred Hitchcock's film *Spellbound* (p. 391).

1948 *50 Secrets of Magic Craftsmanship* is published in America.

1949 Dalí and Gala return to Europe. Dalí designs productions by Peter Brook (*Salomé*) and Luchino Visconti (*As You Like It*). He paints *The Madonna of Port Lligat* (p. 426, 443).

1951 Dalí publishes *The Mystical Manifesto* (p. 452). Beginning of his particle period.

1952 Exhibits in Rome and Venice. Nuclear mysticism.

1632 **Dalí in his studio at Port Lligat, with portraits he valued: Stalin, Hitler, the Mona Lisa, Gala.** ✰
1633 **"The Cosmic Dalí", at the time of "Leda Atomica", a photograph by Philippe Halsman, 1950** ✰
1634 **Hypnagogic Bread. Reconstructed in 1964** ○
Pain hypnagogique
1635 **Dalí illustrates his theory of hard and soft, 1958** ✰
1636 **Dalí at the time of the "Mystical Manifesto" with the hypercubic cross, 1953** ✰

1637 The "Diary of a Genius" with a dedication for Gilles Néret Δ

1638 Arno Breker: Bust of Salvador Dalí, 1974 ☆

1637

1638

1639

1953 Triumphant lecture on the phenomenological aspects of the paranoiac-critical method at the Sorbonne (December).

1954 Filming begins on *L'Histoire prodigieuse de la Dentellière et du Rhinocéros*, directed by Robert Descharnes.

1956 Exhibits at the National Gallery, Washington (DC).

1958 12 May: Dalí presents a fifteen-

1641

1640

metre loaf of bread at a happening at the Théâtre de l'Etoile, Paris.

1959 Dalí presents the "ovocipède" he has invented in Paris.

1960 Dalí paints large-format mystical works such as *The Ecumenical Council* (p. 530, 531).

1961 The *Ballet of Gala* (p. 534) is premièred in Venice, with libretto and set design by Dalí and choreography by Maurice Béjart. Dalí gives a lecture on the myth of Castor and Pollux at the Paris Polytechnic.

1962 Publication of *Dalí de Gala* by Robert Descharnes.

1963 Dalí publishes *The Tragic Myth of Millet's Angelus*. He begins to ascribe a decisive role in the constitution of the universe to Perpignan railway station.

1964 First major Dalí retrospective in the Seibu Museum, Tokyo. Dalí publishes the *Diary of a Genius*.

1971 The Salvador Dalí Museum is opened in Cleveland, Ohio, with the E. and A. Reynolds Morse Collection, which is transferred to Saint Petersburg, Florida, in 1982.

1978 Dalí discovers René Thom's work on mathematical catastrophe theory. April:

Exhibits his hyperstereoscopic paintings at the Guggenheim Museum. May: Becomes a member of the Académie des Beaux-Arts, Paris.

1979 The Centre Georges Pompidou (Paris) shows a large Dalí retrospective which travels to the Tate Gallery in London.

1982 10 June: Death of Gala. July: Dalí is created Marquis de Púbol. From now on he lives in the castle at Púbol which he had given to Gala.

1983 Creation of the perfume "Dalí". An important retrospective is seen in Madrid and Barcelona. May: Dalí paints his last picture, *The Swallow's Tail* (p. 723).

1984 Dalí is severely burnt in a fire in his room at Púbol. Robert Descharnes publishes

1639 **Dalí with his wax figure in the Musée Grévin, Paris,** 1968 ✫

1640 **Dalí contemplating his first "hyper-realist, metaphysical, stereoscopic" painting "Las Meninas" in the A.F. Petit Gallery,** 1977 ✫

1641 **A dedication from Dalí to Robert Descharnes** △

1642 **Dalí and Robert Kennedy with "Christ of St. John of the Cross", which was exhibited in New York in 1952** ✫

1642

1643

1644

Salvador Dalí. The Work, The Man (New York, 1984). Retrospective in the Pallazo dei Diamanti, Ferrara (Italy).

1989 23 January: Dalí dies of heart failure in the Torre Galatea, where he has been living since the fire in Púbol castle. He is interred in the crypt of his Teatro-Museo in Figueras as he himself wished. In his will he leaves his entire fortune and works to the Spanish state. In May a large retrospective is seen in Stuttgart, subsequently in Zurich.

1990 The Montreal Museum of Fine Arts shows an exhibition of over one hundred Dalí works. The Dalí estate ($ 130 million) is willed to the state of Spain, with the works to be divided between Madrid and Figueras. Fifty-six paintings will be housed in the Teatro-Museo Dalí, Figueras, Spain, and possibly also in Barcelona, and 130 paintings will be exhibited in Catalonia.

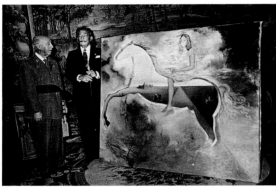

1645

1646

1644 Dalí's last signature, with the crown of the Marquis de Púbol △
1645 Dalí gives Franco the equestrian portrait of the latter's granddaughter ☆
1646 King Juan Carlos I and the Queen visiting Dalí unexpectedly in August 1981 at his home in Port Lligat. ☆
1647 Gala and Dalí by the street sign "Rue Salvador Dalí" on the occasion of his lecture at the Ecole Polytechnique, 1961 ☆
1648 "The Prince of Sleep" (The Principle of Sleep) after an official portrait of King Juan Carlos I, 1973–1974 △
«Le prince du sommeil» (El principe de ensueño)

1647

Bibliography

Selected monographs and publications used by the author:

Ades, Dawn, *Dalí*, London, 1982

Alexandrian, Sarane, *Dalí: peintures*, Paris, 1969

— *Dalí et les poètes*, Paris, 1976

Arco, Manuel del, *Salvador Dalí, ich und die Malerei*, Zurich, 1959

Bataille, Georges, 'Le jeu lugubre', *Documents*, 7, 1929

Bosquet, Alain, *Conversations with Dalí*, New York, 1969

Brans, Jan, *Salvador Dalí und seine religiöse Malerei*, Munich, 1955

Breton, André, *Anthologie de l'humour noir*, Paris, 1953

Cowles, Fleur, *The Case of Salvador Dalí*, London, 1959

— *Salvador Dalí* (biography), Munich, 1981

Dalí, Ana María, *Salvador Dalí, vist per la seva germana*, Barcelona, 1949; French: *Salvador Dalí vue par sa sœur*, Paris, 1960

Descharnes, Robert and Salvador Dalí, *Dalí de Gala*, Lausanne, 1962 (2nd ed. 1979)

— and Ogura Tadao, *Salvador Dalí* (preface by Salvador Dalí), Sheisha, Collection l'Art Moderne du Monde, Tokyo, 1974

— *Salvador Dalí*, New York, 1976

— *Salvador Dalí, The Work, The Man*, New York, 1984

Dopagne, Jacques, *Dalí*, Paris, 1985

Freud, Sigmund, *Letters* (selected by Ernst L. Freud), New York, 1992

Gallwitz, Klaus, *Metamorphose des Narziß. Die Jugend entdeckt Dalí*, Hamburg, 1971

Gérard, Max (ed.), *Dalí de Draeger*, New York, 1968

— *Dalí... Dalí... Dalí...* (preface by Dr. Roumeguère), New York, 1974

Gómez de Liaño, Ignacio, *Dalí*, Barcelona, 1982

Gómez de la Serna, Rámon, *Dalí*, New York, 1979

Jean, Marcel, *Histoire de la peinture surréaliste*, Paris, 1959

Lake, Carlton, *In Quest of Dalí*, New York, 1969

Longstreet, Stephen, *The Drawings of Dalí*, Alhambra, California, 1964

Maddox, Conroy, *Dalí*, New York, 1979

McGirk, Tim, *Gala – Dalís skandalöse Muse*, Munich, 1989

Morse, A. Reynolds, *Salvador Dalí. A guide to his works in public museums*, Cleveland, Ohio, The Salvador Dalí Museum, 1974

— *Salvador Dalí – A panorama of his art. Ninety-three oils 1917–1970*, Cleveland, Ohio, The Salvador Dalí Museum, 1974

Nin, Anaïs, *The Journals of Anaïs Nin*, 3, 1939–1944, New York, 1966

Passeron, René, *Salvador Dalí*, Paris, 1978

Rodriguez, Aquilera, Cesáreo, *Salvador Dalí* (Fundación Gala-Salvador Dalí), Barcelona, 1980

Sánchez Vidal, Agostin, *Buñuel, Lorca, Dalí: El enigma sin fin*, Barcelona, 1988

Santos Torrella, Rafael, *Salvador Dalí*, Madrid, 1952

Soby, James Thrall, *Salvador Dalí*, New York, The Museum of Modern Art, 1941 (3rd ed., 1946)

Tapié, Michel, *Dalí*, Paris, 1957

Thirion, André, *Révolutionnaires sans révolution*, Paris, 1972

Zweig, Stefan, *Briefwechsel*, Frankfurt/M., 1987

Selected exhibition catalogues of recent date (in chronological order):

Dalí. Museum Boymans-van Beuningen, 1971; Baden-Baden, 1971 (Renilde Hammacher-van den Brande, with articles by Patrick Waldberg, Robert Descharnes, Marc Audouin, Gerrit Komrij)

Salvador Dalí. Retrospectiva. Humlebæk, Louisiana Museum, 1973; Stockholm, Moderna Museet, 1973–1974 (Knud Jensen, Steingrim Laursen, Uli Linder, et al.)

Salvador Dalí. Frankfurt/M., Städtische Galerie und Städelsches Kunstinstitut, 1974 (Klaus Gallwitz)

Salvador Dalí, Retrospective 1920–1980, and *La vie publique de Salvador Dalí*. Paris, Musée National d'Art Moderne, Centre Georges Pompidou, 1979–1980 (Daniel Abadie, et al.)

Salvador Dalí. London, The Tate Gallery, 1980 (Simon Wilson)

Salvador Dalí – Gemälde, Zeichnungen, Objekte, Skulpturen (Collection of John Peter Moore). Heidelberg, Castle, 1981 (Klaus Manger, Gómez de la Serna)

Salvador Dalí, Retrospective. Japanese touring exhibition: Tokyo, Isetan Museum of Art; Osaka, Daiman Art Museum; Kitaskyushu, Municipal Museum of Art; Hiroshima, Prefectural Art Museum, 1982 (articles by Michael Stout, A. Reynolds Morse, Albert Field, Selma Holo, Robert Descharnes)

400 Obres de Salvador Dalí del 1914 al 1983. Generalitat de Catalunya/ Ministerio de Cultura, Palau Reial de Pedralbes Barcelona – Museo Español de Arte Contemporáneo Madrid, 1983–1984 (Ana Beristain, Paloma Esteban Leal, et al.)

Dalí di Salvador Dalí. Ferrara, Galleria Civica d'Arte Moderna, Palazzo dei Diamanti, 1984 (Robert Descharnes, et al.)

Salvador Dalí 1904–1989. Staatsgalerie Stuttgart, 1989 (ed. by Karin v. Maur, articles by Rafael Santos Torrella, Marc Lacroix, Lutz W. Löpsinger; with selected bibliography)

Selected works by Salvador Dalí (in chronological order):

'Textes sur Vélasquez, Goya, Le Greco, Michel-Ange, Dürer, Leonardo de Vinci', *Studium*, 6, Figueras, 1919

'Sant Sebastiá', *L'Amic de les Arts*, 16, Sitgès, July 1927

Salvador Dalí and Luis Buñuel, 'Un Chien Andalou', *La Révolution surréaliste*, 12, Paris, 15 December 1929, pp. 34–37

La Femme visible, Paris, 1930.

'L'Ane pourri', *Le Surréalisme au Service de la Révolution*, 1, Paris, July 1930

L'Amour et la mémoire, Paris, 1931

Babaouo: scénario inédit précédé d'un abrégé d'une histoire critique du cinéma et suivi de Guillaume Tell, ballet portugais, Paris, 1932

'De la beauté terrifiante et comestible de l'architecture "Modern Style"', *Minotaure*, 3–4, Paris, 1933

'Interprétation paranoïaque-critique de l'image obsédante "L'Angélus" de Millet', *Minotaure*, 1, Paris, 1933, pp. 65–67

New York Salutes Me, New York, 1934

La Conquête de l'Irrationnel, Paris, 1935. Engl. ed.: *The Conquest of the Irrational*, New York, 1935

Métamorphose de Narcisse, Paris, 1937; Engl. ed.: *Metamorphosis of Narcissus*, New York, 1937

Declaration of the Independence of the Imagination and the Rights of Man to His Own Madness, New York, 1939

'Total Camouflage for Total War', *Esquire*, New York, August, 1942

The Secret Life of Salvador Dalí, New York, 1942

Hidden Faces, New York, 1944

Fifty Secrets of Magic Craftsmanship, New York, 1948

Manifeste mystique, Paris, 1951

Le Mythe de Guillaume Tell. Toute la vérité sur mon expulsion du groupe surréaliste, 1952 (unpublished)

'Je suis un pervers polymorphe', *Arts*, 361, Paris, 29 May 1952

Salvador Dalí and Philippe Halsman, *Dalí's Moustache*, New York, 1954

'Aspects phénoménologiques de la méthode paranoïaque-critique', *La*

Vie médicale, special number *Art et psychopathologie*, Paris, December 1956

Le Mythe tragique de l'Angélus de Millet, interprétation "paranoïaque-critique", Paris, 1963

Journal d'un génie, Paris, 1964; Engl. ed.: *Diary of a Genius*, New York, 1965

Salvador Dalí and Louis Pauwels, *Les passions selon Dalí*, Paris, 1968

Dalí by Dalí. New York, 1970

Salvador Dalí and André Parinaud, *Comment on devient Dalí*. Paris, 1973; Engl. ed.: *The Unspeakable Confessions of Salvador Dalí*, London, 1976

Dix recettes d'immortalité, Paris, 1973

Les Dîners de Gala, Paris, 1973; Engl. ed.: *The Dinners of Gala*, New York, 1973

Les vins de Gala, Paris, 1977; Engl. ed.: *The wines of Gala*, New York, 1978

Quotations from "The Secret Life of Salvador Dalí" are from the original 1942 translation by Haakon M. Chevalier, published in New York by Dial Press.

The reproductions of Dalí's paintings in this book provide a more complete picture of his work than has been attempted in any publication before. At the request of Demart Pro Arte B.V., who own the publishing rights to Dalí's estate, certain paintings have not been included in these volumes.

The publisher and Descharnes & Descharnes wish to thank Christie's and Sotheby's.

The publisher wishes to thank Descharnes & Descharnes and the following institutions for supplying reproduction material:

© Photo: Courtesy of the Salvador Dalí Museum, St. Petersburg, Florida: 28, 31, 76, 77, 88, 117, 123, 172, 178, 208, 225, 240, 242, 277, 284, 299, 300, 318, 327, 330, 341, 344, 388, 395, 406, 407, 423, 434, 450, 451, 480, 508, 526, 540, 579, 583, 585, 656, 701, 731, 765, 841, 863, 864, 867, 958, 973, 998, 1021, 1024, 1025, 1065, 1066, 1079, 1096, 1130, 1131, 1136, 1167, 1185, 1256

© Photo: Philippe Halsman/Magnum/Focus: 1, 464, 757, 826, 930, 931, 1032, 1033, 1034, 1036, 1037, 1038, 1039, 1240, 1633

Photo: Marc Lacroix: 1206, 1314, 1359, 1362, 1363, 1386, 1389, 1400, 1458, 1465, 1466, 1470, 1471

© Photo: Lauros-Giraudon: 697

Photo: Ediciones Poligrafa S. A., Barcelona: Salvador Dalí, Luis Romero, "Tout Dalí en un visage", 1975: 1128, 1129, 1294, 1296

Photo x – All Rights reserved.

Index of works reproduced

Where detailed captions for photographs or works are given in the main section of the book, they are not repeated here. Instead, the reader is referred to the relevant page.
In addition to the information contained in the captions, this index includes alternative titles as well as details of the technique, measurements and provenance. Measurements are in centimetres and give height before width. In the case of sculptures and other objects, the measurements give height before width before depth. Dates are the present authors'. Certain titles and dates may differ slightly from those given in the main text. The index data were compiled by Robert Descharnes and Ingo F. Walther.

37 The Church at Cadaqués and the Beach at Port Alguer Seen from Riba d'en Pitxot, 1919/20
L'église de Cadaqués et la plage de Port Alguer vues de la Riba d'en Pitxot
Oil on canvas, 20.1 x 24.9 cm
Private collection; formerly Collection Anselmo Domenech

38 Calá Pianc, c. 1919
Calá Pianc
Oil on canvas, 38.4 x 27.4 cm
(on the reverse of picture no. 75)
Private collection; formerly Collection P. Garriga

39 Port Alguer, 1919/20
Port Alguer
Oil on canvas, 36 x 38 cm
Figueras, Fundación Gala-Salvador Dalí, Gift of Dalí to the Spanish state

40 Port Dogué – Cadaqués, 1919
Port Dogué – Cadaqués
Oil on canvas, 27 x 20 cm
(on the reverse of picture no. 36)
Private collection

41 The Tartan "El Son" (The Artist at the Rudder of the "El Son"), 1919
La tartane «El Son» (L'artiste à la barre d'«El Son»)
Oil on cardboard, 24 x 19 cm
Gift of Dalí to the Spanish state; held by the Fundación Gala-Salvador Dalí

42 Sailboat with figure. Study for the boat in "El Son", 1919
Barca de vela con figura. Etude de barque pour «La tartane el son»
Chalk on cardboard, 24 x 19 cm
Gift of Dalí to the Spanish state; held by the Fundación Gala-Salvador Dalí

43 Es Poal – Pianque, 1919/20
Es Poal – Pianque
Oil on canvas, 22 x 28 cm
Private collection; formerly Collection Garriga Camps

44 Landscape, 1919/20
Paysage
Oil on canvas, 19 x 26.4 cm
Private collection; formerly Collection Garriga Camps

45 Portrait of Mr. Pancraci, c. 1919
Retrat del senyor Pancraci – Portrait du sieur Pancrace
Oil on canvas, 74 x 42.5 cm
Private collection

46 My Cousin Montserrat, 1919/20
Ma cousine Montserrat
Oil on canvas, 55 x 50 cm
Private collection; formerly Collection Allan Rich

47 Self-Portrait in the Studio, c. 1919
Autoportrait dans l'atelier
Oil on canvas, 27 x 21 cm
St. Petersburg (FL), The Salvador Dalí Museum; formerly Collection E. and A. Reynolds Morse

48 The Three Pines, c. 1919
Les trois pins
Oil on canvas, 28 x 38 cm
Private collection

49 Cadaqués – Garden of Llané, 1919/20
Cadaqués – La horta del Llané
Oil on canvas, 19.6 x 27.2 cm
Private collection; formerly Collection Anselmo Domenech

50 Landscape, 1919/20
Paysage
Oil on canvas, 19 x 26.4 cm
Private collection; formerly Collection Garriga Camps

51 Cadaqués, 1920/21
Cadaqués
Oil on canvas, 41.5 x 52 cm
Private collection

52 Orchard at Llané (Cadaqués), 1919/20
Allée du verger à Cadaqués
Oil on canvas, 20 x 28 cm
St. Petersburg (FL), The Salvador Dalí Museum; formerly Collection E. and A. Reynolds Morse

53 Portrait of Hortensia, Peasant Woman from Cadaqués, 1920
Portrait d'Hortensia, paysanne de Cadaqués
Oil on canvas, 35 x 26 cm
Private collection

54 Tiéta – Portrait of my Aunt, 1920
Tiéta – Portrait de ma tante (Portrait de Catalina Domenech Ferrer)
Oil on canvas, 53 x 41 cm
St. Petersburg (FL), The Salvador Dalí Museum; formerly Collection E. and A. Reynolds Morse

55 A Ball on the Patio of the Mariona, 1919/20
Bal de nuit dans le patio de la Mariona
Charcoal on paper, 59 x 39 cm
Private collection

56 Grandmother Ana Sewing, c. 1920
La grand-mère Ana cousant
Oil on canvas, 52 x 42 cm
Private collection

57 Circus Acrobats, 1920/21
Saltimbanques
Gouache on cardboard, 57 x 51 cm
St. Petersburg (FL), The Salvador Dalí Museum

58 Portrait of the Artist's Mother, Doña Felipa Dome Domenech de Dalí, 1920
Portrait de la mère de l'artiste Doña Felipa Dome Domenech de Dalí
Oil on canvas, 40.1 x 27.2 cm
Private collection

59 Portrait of José M. Torres, c. 1920
Portrait de José M. Torres
Oil on canvas, 49.5 x 39.5 cm
Barcelona, Museo de Arte Moderno

60 Boxer, c. 1920
Boxeur
Oil on canvas, 90 x 65 cm
Private collection

61 Portrait of Joaquín Montaner (Allegory of the Navigator), 1919/20
Portrait de Joaquín Montaner (Alegoría del navegante)
Charcoal, 59.6 x 46.9 cm
St. Petersburg (FL), The Salvador Dalí Museum; formerly Collection Domingo Carlos

62 Still life for the cover of "Per la Musica, Poems", 1921
Nature morte pour la couverture de «Per la Musica, poèmes»
Watercolour, 23.7 x 25 cm
Private collection; formerly Collection Jaume Maurici

63 The Pichot-Costa Trio painted by Ramón Pichot. Left to right: Luis (Violin), Costa (Piano) and Ricardo (Cello), 1920
Technique and dimensions unknown
Whereabouts unknown

64 Untitled – The Artist in his Studio in Riba d'en Pitxot in Cadaqués, 1920/21
Sans titre – L'artiste dans son atelier de la Riba d'en Pitxot à Cadaqués
Oil and gouache on cardboard; dimensions unknown
Private collection

65 Cover of "Per la Musica, Poems", 1921
Couverture pour «Per la Musica, poèmes»
Watercolour, 23.7 x 25 cm
Private collection; formerly Collection Jaume Maurici

66 Portrait of the Cellist Ricardo Pichot, 1920
Portrait du violoncelliste Ricardo Pichot
Oil on canvas, 61.5 x 49 cm
Cadaqués, private collection

67 Still Life, c. 1920
Nature morte
Oil on canvas, 60 x 40 cm
Private collection

68 Still Life by a Window, c. 1920
Nature morte
Oil on canvas, 60 x 40 cm
Barcelona, Collection Ramón Golobart

69 Still Life: Pomegranates, c. 1919
Pomme-grenade rubis
Oil on panel, 14.5 x 26 cm
Perpignan, private collection

70 The Lake at Vilabertrán, 1920
Le lac de Vilabertrán
Oil on canvas, 68.4 x 47.7 cm
Private collection; formerly Collection Garriga Camps

71 The Bay of Nans (Cadaqués), c. 1920
Calanque Nans (Cadaqués)
Oil on canvas, 39.5 x 49.5 cm
Barcelona, Museo de Arte Moderno

72 The Cove at Jonculs (Cadaqués), 1920
Calanque Jonculs (Cadaqués)
Oil on canvas, 33 x 39 cm
Private collection

73 The Kitchen Garden at Little Llané, 1920
Le potager du Llané-Petit
Oil on canvas, 53 x 41 cm
Paris, Collection André-François Petit

74 The Bay at Cadaqués, with Cucurucuc Rock and the Sortell Peninsula, 1920
L'entrée de la baie de Cadaqués avec le rocher de Cucurucuc et la presqu'île de Sortell (Vue de la Fica Pichot)
Oil on canvas, 42.6 x 53.3 cm
Figueras, Fundación Gala-Salvador Dalí

75 Moonlight over the Bay at Cadaqués, c. 1920
Clair de lune sur la baie de Cadaqués
Oil on canvas, 38.4 x 27.4 cm
(on the reverse of picture no. 38)
Private collection; formerly Collection Garriga Camps

76 Port Dogué and Mount Pani
from Ayuntamiento, 1920
*Port Dogué and Mount Pani from
Ayuntamiento*
Oil on canvas, 43.1 x 53.3 cm
St. Petersburg (FL), The Salvador
Dalí Museum; formerly Collection
E. and A. Reynolds Morse

77 View of Cadaqués from Playa
Poal, 1920
View of Cadaqués from Playa Poal
Oil on canvas, 29.2 x 48.3 cm
St. Petersburg (FL), The Salvador
Dalí Museum; formerly Collection
E. and A. Reynolds Morse

78 Landscape near Cadaqués,
1920/21
Paysage de Cadaqués
Oil on canvas, 31 x 34 cm
Gift of Dalí to the Spanish state;
held by the Fundación
Gala-Salvador Dalí

79 Landscape near Cadaqués,
c. 1921
Paysage de Cadaqués
Oil on canvas, 45 x 52 cm
Private collection

80 Landscape near Cadaqués,
1920/21
Paysage de Cadaqués
Oil on canvas, 46 x 53 cm
Private collection

81 The Bay of Nans with
Cypresses, 1920/21
Calanque Nans embellie de cyprès
Oil on canvas, 40 x 52 cm
Private collection

82 Moonlight at Little Llané, 1921
Clair de lune à El Llané-Petit
Oil on canvas; dimensions unknown
Private collection

83 The Garden at Llané, 1920/21
*L'Horta del Llané – Le jardin de
Llané*
Oil on canvas, 40 x 50 cm
Private collection

84 Cf. caption on p. 42

85 The Artist's Father at Llané
Beach, 1920
Le père de l'artiste à Llané
Oil on canvas; dimensions unknown
Private collection

86 Portrait of my Father, 1920/21
Portrait de mon père
Oil on canvas, 90.5 x 66 cm
Figueras, Fundación Gala-Salvador
Dalí, Gift of Dalí to the Spanish state

87 Cf. caption on p. 44

88 Self-Portrait, c. 1921
Autoportrait
Oil on canvas, 36.8 x 41.8 cm
St. Petersburg (FL), The Salvador
Dalí Museum

89 Self-Portrait with the Neck of
Raphael, 1920/21
Autoportrait au cou de Raphaël
Oil on canvas, 41.5 x 53 cm
Figueras, Fundación Gala-Salvador
Dalí, Gift of Dalí to the Spanish state

90 Self-Portrait, 1921
Autoportrait
Oil on panel, 47.5 x 31 cm
Figueras, Fundación Gala-Salvador
Dalí

91 Self-Portrait, 1921
Autoportrait
Oil on canvas; dimensions unknown
Private collection

92 Self-Portrait, c. 1921
Autoportrait (Autorretrato)
Oil on canvas, 52 x 45 cm
Private collection

93 Back View of Cadaqués, 1921
Cadaqués de dos
Oil on canvas, 42 x 53 cm
Figueras, Fundación Gala-Salvador
Dalí, Gift of Dalí to the Spanish state

94 View of Cadaqués from Mount
Pani, c. 1921
*Vue de Cadaqués depuis le mont
Pani*
Oil on canvas, 39.5 x 48.3 cm
St. Petersburg (FL), The Salvador
Dalí Museum; formerly Collection
E. and A. Reynolds Morse

95 Girls in a Garden (The
Cousins), 1921
*Jeunes filles dans un jardin (Les
cousines)*
Oil on canvas, 53 x 41 cm
Paris, Collection André-François
Petit

96 Portrait of Grandmother Ana
Sewing, c. 1921
*Portrait de la grand-mère Ana
cousant*
Oil on canvas, 40 x 62 cm
Figueras, Collection Joaquín Vila
Moner

97 The Bay at Cadaqués, c. 1921
Baie de Cadaqués
Oil on canvas, 40 x 52 cm
Private collection

98 Festival in Figueras, 1921
Fête à Figueras
Oil and gouache on cardboard,
50 x 72 cm
Private collection

99 Santa Creus Festival in Figueras
– The Circus, 1921
*Fête de Santa Creus à Figueras – Le
cirque*
Gouache on cardboard, 52 x 75 cm
Figueras, Fundación Gala-Salvador
Dalí

100 Festival at San Sebastián, 1921
Fête de l'hermitage de San Sebastián
Gouache on cardboard, 52 x 75 cm
Figueras, Fundación Gala-Salvador
Dalí

101 The Picnic, 1921
*Merienda en el campo – Goûter à la
campagne*
Gouache on cardboard,
44.2 x 52.3 cm
Figueras, Fundación Gala-Salvador
Dalí

102 Man Holding up a Baby as
though he Were Drinking from a
Bottle, c. 1921
*Homme soulevant un bébé comme
s'il buvait à la régalade*
Gouache on cardboard,
52.8 x 35.5 cm
Figueras, Fundación Gala-Salvador
Dalí

103 Festival of St. Lucia at
Villamalla, 1921
Fête de sainte Lucie à Villamalla
Gouache on cardboard,
54.9 x 74.1 cm
Private collection

104 Nymphs in a Romantic
Garden, 1921
Nymphes dans un jardin romantique
Gouache and oil on cardboard,
73.5 x 57.5 cm
Private collection

105 A Seated Man and a Dancing
Couple, 1921
*Personnage assis avec au second plan
un couple dansant*
Gouache on cardboard,
43.3 x 27.5 cm
Figueras, Fundación Gala-Salvador
Dalí

106 Romería – Pilgrimage, 1921
Romería – Pélerinage
Gouache on cardboard, 52 x 52 cm
Private collection

107 Man with Porrón, 1921
L'homme au porrón
Gouache on cardboard, 50 x 32 cm
Private collection

108 Voyeur, 1921
Voyeur
Gouache on cardboard, 50 x 32 cm
Private collection

109 Old Man of Port Dogué, 1921
Le vieux de Port Dogué
Watercolour, 11.4 x 12.7 cm
St. Petersburg (FL), The Salvador
Dalí Museum

110 Muse of Cadaqués, 1921
Musa de Cadaqués
Watercolour, 19 x 27 cm
Private collection

111 Portrait of Jaume Miravitlles,
1921/22
Portrait de Jaume Miravitlles
Oil on panel, 41 x 38 cm
Private collection

112 Head of a Gypsy, 1919/20
Tête de gitan – Cabeza de gitano
Oil on canvas, 33 x 24 cm
Private collection

113 Fishermen at Cadaqués, 1922
Pêcheurs de Cadaqués
Oil on canvas, 26 x 33 cm
Private collection

114 Fishing Folk at Cadaqués, 1922
*Pescadores de Cadaqués – Pêcheurs
de Cadaqués*
Oil; material and dimensions
unknown
Private collection; formerly
Collection Subias, Barcelona

115 Portrait of Jaume Miravitlles as
a Footballer, 1921/22
*Portrait de Jaume Miravitlles en
joueur de football*
Oil on panel, 103 x 38.5 cm
Private collection

116 Landscape – Cadaqués, 1922
Paysage – Cadaqués
Oil on sackcloth, 39.5 x 51 cm
Berne, Kunstmuseum Bern

117 The Lane to Port Lligat with
View of Cape Creus, 1922/23
*Le chemin de Port Lligat avec vue
sur le Cap Creus*
Oil on canvas, 55.2 x 67.9 cm
St. Petersburg (FL), The Salvador
Dalí Museum; formerly Collection
E. and A. Reynolds Morse

118 Landscape near Cadaqués, 1922
Paysage à Cadaqués
Oil on canvas, 60 x 82 cm
Private collection

119 Jug, 1922/23
Canti – Cruche
Oil on canvas, 53 x 41.5 cm
Madrid, Museo Nacional Reina
Sofía, Gift of Dalí to the Spanish
state

120 Still Life, 1922
Nature morte
Oil on canvas, 42 x 53 cm
Private collection

121 Still Life with Aubergines, 1922
Nature morte aux aubergines
Oil on canvas, 31 x 33.2 cm
Berne, Kunstmuseum Bern

122 Still Life, 1922
Nature morte
Oil on canvas, 33.7 x 35 cm
Private collection

123 Still Life – Pulpo y scorpa, 1922
Pulpo y scorpa – Nature morte à la rascasse
Oil on canvas, 54.2 x 57.1 cm
St. Petersburg (FL), The Salvador Dalí Museum; formerly Collection E. and A. Reynolds Morse

124 Still Life – Fish with Red Bowl, 1922
Nature morte – Fish with Red Bowl
Oil on canvas, 49 x 55 cm
St. Petersburg (FL), The Salvador Dalí Museum; formerly Collection E. and A. Reynolds Morse

125 Still Life – Fish, 1922
Saupe – Saupa
Oil on canvas, 30.5 x 34.6 cm
Madrid, Centro de Arte Reina Sofía, Gift of Dalí to the Spanish state

126 Cubist Composition – Still Life with Guitar, 1922
Composition cubiste – Nature morte à la guitare
Indian ink, pencil and wash on paper, 20.3 x 18.2 cm
Private collection

127 Untitled – Scene in a Cabaret in Madrid, 1922
Sans titre – Scène de cabaret à Madrid
Gouache on cardboard, 54.9 x 74.1 cm
Private collection

128 Brothels, 1922
Bordels
Indian ink and gouache on Ingres paper, 22 x 15 cm
Madrid, Collection The Estalella Brothers

129 Summer Night, 1922
Nuit d'été
Indian ink and gouache on Ingres paper, 22 x 15 cm
Madrid, Collection The Estalella Brothers

130 Drinker, 1922
Ivrogne
Indian ink and gouache on Ingres paper, 22 x 15 cm
Madrid, Collection The Estalella Brothers

131 Scene in a Cabaret, 1922
Scène de cabaret
Oil on canvas, 52 x 41 cm
Paris, Collection Bénédict Petit

132 Villa Pepita, 1922
Villa Pepita
Oil on canvas, 48.4 x 50 cm
Figueras, Fundación Gala-Salvador Dalí

133 Horse, 1922
Caballo – Cheval
Indian ink on Ingres paper, 15 x 22 cm
Madrid, Collection The Estalella Brothers

134 Bathers, 1918/19
Baigneuses
Charcoal and coloured pencils, heightened with white chalk, 20.5 x 14.5 cm
Private collection

135 Seated Woman, c. 1922
Femme assise
Indian ink and watercolour, 27.5 x 21 cm
Private collection

136 Motherhood, c. 1921
Maternité
Oil on cardboard, 26.2 x 26.2 cm
Private collection

137 Untitled – Landscape near Madrid, 1922/23
Sans titre – Paysage à Madrid
Oil on paper, 30.1 x 35.8 cm
Private collection

138 Madrid, Architecture and Poplars, 1922
Madrid, architecture et peupliers (Madrid, arquitectura y chopos)
Oil on grey Canson paper, 47 x 62.9 cm
Private collection

139 Nude in a Landscape, 1922/23
Nu dans un paysage
Oil on cardboard, 51.6 x 50.1 cm
Figueras, Fundación Gala-Salvador Dalí, Gift of Dalí to the Spanish state

140 Bathers of the Costa Brava – Bathers of Llané, 1923
Baigneuses de la Costa Brava – Baigneuses de Llané
Oil on cardboard, 72 x 103 cm
Private collection

141 The Sick Child – Self-Portrait in Cadaqués, c. 1923
L'enfant malade – Autoportrait à Cadaqués
Oil and gouache on cardboard, 57 x 51 cm
St. Petersburg (FL), The Salvador Dalí Museum

142 The Beach of Llané, 1923
La plage de Llané
Oil on cardboard, 63 x 89 cm
Private collection; formerly Collection José Marin Lafuente

143 Landscape near Cadaqués, 1923
Paysage à Cadaqués
Oil on canvas; dimensions unknown
Private collection

144 Cadaqués, 1923
Cadaqués
Oil on canvas, 95 x 125 cm
St. Petersburg (FL), The Salvador Dalí Museum; formerly Collection E. and A. Reynolds Morse

145 The Jorneta Stream, 1923
El rec de La Jorneta – Le canal de La Jorneta
Oil on canvas, 122.8 x 99.5 cm
Private collection

146 La Jorneta, 1923
La Jorneta
Oil on canvas, 69 x 59 cm
Madrid, Centro de Arte Reina Sofía, Gift of Dalí to the Spanish state

147 Cadaqués (Seen from the Tower at Cape Creus), 1923
Cadaqués vu depuis la tour de Cap Creus
Oil on canvas, 101 x 98 cm
Gift of Dalí to the Spanish state; held by the Fundación Gala-Salvador Dalí

148 The Windmill – Landscape near Cadaqués, 1923
El Moli – Paysage de Cadaqués
Oil on canvas, 75 x 98 cm
Private collection

149 Figures in a Landscape at Ampurdán, 1923
Personnages dans un paysage d'Ampurdán
Gouache on cardboard, 105 x 95 cm
Figueras, Fundación Gala-Salvador Dalí, Gift of Dalí to the Spanish state

150 Untitled – Group of Women, 1923
Sans titre – Groupe de femmes
Pencil on ribbed Ingres paper, 31.7 x 24 cm
Private collection

151 Cottages, 1923
Bicoques
Pencil on paper, 30 x 23 cm
St. Petersburg (FL), The Salvador Dalí Museum

152 Head of a Man with a Child, 1924/25
Tête d'homme avec enfant
Lead pencil on paper, 24 x 16 cm
St. Petersburg (FL), The Salvador Dalí Museum

153 Venus and Memory of Avino, 1923/24
Vénus et réminiscences d'Avino
Pen and ink, 20.5 x 14 cm
Private collection

154 Luis Buñuel with a Toreador, 1923
Luis Buñuel avec un torero
Technique and material unknown, 18.5 x 23 cm
Private collection

155 Family Scene, 1923
Scène familiale
Oil and gouache on cardboard, 105 x 75 cm
Figueras, Fundación Gala-Salvador Dalí, Gift of Dalí to the Spanish state

156 Woman Nursing her Son, 1923
Femme allaitant son fils (Mujer amamantando a su hijo)
Gouache on cardboard, 30 x 42 cm
Gift of Dalí to the Spanish state; held by the Fundación Gala-Salvador Dalí

157 Satirical Composition ("The Dance" by Matisse), 1923
Composition satirique («La danse» de Matisse)
Gouache on cardboard, 138 x 105 cm
Figueras, Fundación Gala-Salvador Dalí, Gift of Dalí to the Spanish state

158 Gypsy of Figueras, 1923
Gitan de Figueras
Oil on cardboard, 105 x 75.2 cm
Madrid, Museo Nacional Reina Sofía, Gift of Dalí to the Spanish state

159 Grandfather Clock, 1923
El rellotge de caixa – L'horloge
Charcoal on paper, 31.5 x 24.5 cm
Private collection

160 Cubist Composition – Portrait of a Seated Person Holding a Letter, 1923
Composition cubiste – Portrait d'un personnage assis tenant une lettre
Oil on cardboard, 74.6 x 52.1 cm
Figueras, Fundación Gala-Salvador Dalí, Gift of Dalí to the Spanish state

161 Still Life, 1923
Nature morte
Oil on cardboard, 50.1 x 56 cm
Madrid, Centro de Arte Reina Sofía,
Gift of Dalí to the Spanish state

162 Still Life, 1923
Nature morte
Oil on cardboard, 50.2 x 65 cm
Madrid, Museo Nacional Reina
Sofía, Gift of Dalí to the Spanish
state

163 All Shapes Derive from the
Square, 1923
Toutes les formes dérivent du carré
Ink on paper, 23 x 21 cm
Private collection

164 Harlequin Sitting at a Table,
1923
Arlequin assis à une table
Watercolour, Indian ink, ink and
chalk; dimensions unknown
Private collection

165 Self-Portrait, 1923
Autoportrait
Indian ink and pencil on paper,
31.5 x 25 cm
Madrid, Collection The Estalella
Brothers

166 Coffee House Scene in Madrid,
1923
Scène de café à Madrid
Indian ink; dimensions unknown
Private collection

167 Cf. caption on p. 73

168 Satirical Portrait of Trotsky,
c. 1923
Portrait satirique de Trotsky
Indian ink and watercolour,
24 x 20.5 cm
Private collection

169 Self-Portrait, 1923
Autoportrait à «L'Humanité»
Oil, gouache and collage on
cardboard, 104.9 x 75.4 cm
Figueras, Fundación Gala-Salvador
Dalí, Gift of Dalí to the Spanish state

170 Cubist Self-Portrait, 1923
Autoportrait cubiste
Gouache and collage on cardboard,
104.9 x 74.2 cm
Madrid, Centro de Arte Reina Sofía,
Gift of Dalí to the Spanish state

171 Portrait of my Sister and
Picasso Figure (added in 1924), 1923
*Portrait de ma sœur et personnage
picassien*
Oil on canvas, 104 x 75 cm
St. Petersburg (FL), The Salvador
Dalí Museum; formerly Collection
E. and A. Reynolds Morse

172 Portrait of my Sister (original
state), 1923/24
Retrato de mi hermana
Oil on canvas; dimensions unknown
St. Petersburg (FL), The Salvador
Dalí Museum; formerly Collection
E. and A. Reynolds Morse

173 Portrait of my Cousin Ana
María Domenech, c. 1923
*Portrait de ma cousine Ana María
Domenech*
Oil on cardboard on panel,
89 x 46 cm
Vaduz, Collection Jean Paul
Schneider

174, 175 Cf. captions on p. 79

176 Port Alguer, Cadaqués, 1924
Port Alguer à Cadaqués
Oil on canvas, 100 x 100 cm
Figueras, Fundación Gala-Salvador
Dalí

177 The Station at Figueras, 1924
La station de Figueras
Oil on canvas, 50 x 51 cm
Private collection

178 Bouquet of Flowers – "The
important thing is the rose", 1924
Bouquet – «L'important c'est la rose»
Oil on cardboard, 50 x 52 cm
St. Petersburg (FL), The Salvador
Dalí Museum; formerly Collection
E. and A. Reynolds Morse

179 Plant, 1924
Plante verte
Oil on canvas, 98.5 x 98.5 cm
Figueras, Fundación Gala-Salvador
Dalí

180 Still Life – Watermelon, 1924
Nature morte – Sandia
Oil on canvas, 49.5 x 49.5 cm
St. Petersburg (FL), The Salvador
Dalí Museum; formerly Collection
E. and A. Reynolds Morse

181 Still Life, 1924
Bodegón – Nature morte
Oil on canvas, 52 x 40 cm
Private collection

182 Pierrot and Guitar, 1924
Pierrot au guitare
Oil and collage on cardboard,
55 x 52 cm
Lugano-Castagnola, Fondazione
Thyssen-Bornemisza; formerly
Collection Montserrat Dalí de Bas

183 Still Life, 1924
Nature morte
Oil on canvas, 125 x 99 cm
Madrid, Fundación Federico García
Lorca

184 Purist Still Life, 1924
Nature morte puriste
Oil on canvas, 100 x 100 cm
Figueras, Fundación Gala-Salvador
Dalí

185 Still Life (one part of the four
into which the work was cut, cf. ill.
no. 205), 1924
Nature morte
Oil on canvas, 106 x 79.2 cm
Montreal, Montreal Museum of
Fine Arts

186 Siphon and Rum Bottle with
Cork, 1924
*Siphon et bouteille de rhum avec
bouchon*
Oil on canvas, 79 x 49 cm
Figueras, Fundación Gala-Salvador
Dalí

187 Cf. caption on p. 84

188 Study for "Manuel de Falla",
1924/25
*Etude pour «Portrait de Manuel de
Falla»*
Pencil on paper, 30 x 28 cm
St. Petersburg (FL), The Salvador
Dalí Museum

189 Bather (Juan Xirau), 1924
*Bañista – Baigneur (Portrait de Juan
Xirau)*
Oil on panel, 100 x 100 cm
Private collection

190 Portrait of Luis Buñuel, 1924
Portrait de Luis Buñuel
Oil on canvas, 70 x 60 cm
Madrid, Museo Nacional Reina
Sofía; formerly Collection Luis
Buñuel

191 Portrait of a Girl in a
Landscape (Cadaqués), 1924-1926
*Portrait de jeune fille dans un
paysage de Cadaqués*
Oil on canvas, 92 x 65 cm
Figueras, Fundación Gala-Salvador
Dalí, Gift of Dalí to the Spanish state

192 Portrait of Ana María, 1924
Portrait d'Ana María
Oil on canvas; dimensions unknown
Private collection

193 Portrait of Ana María, c. 1924
Portrait d'Ana María
Oil on cardboard, 55 x 75 cm
Figueras, Fundación Gala-Salvador
Dalí, Gift of Dalí to the Spanish state

194 Portrait of a Woman, c. 1924
Portrait de femme
Charcoal on paper, 15 x 13.5 cm
Private collection

195 Cf. caption on p. 88

196 Girl Resting on her Elbow –
Ana María Dalí, the Artist's Sister
(Thought), 1925
*Jeune fille accoudée – Ana María
Dalí, la sœur de l'artiste (Pensée)*
Oil on panel, 46 x 48 cm
Private collection

197 Portrait of the Artist's Sister,
1925
Portrait de la sœur de l'artiste
Oil on canvas, 99 x 99 cm
Madrid, Centro de Arte Reina Sofía,
Gift of Dalí to the Spanish state

198 Cf. caption on p. 90

199 Seated Girl from the Back, 1925
*Jeune fille assise de dos – Noia
d'Esquena*
Oil on canvas, 103 x 73.5 cm
Madrid, Museo Nacional Reina Sofía

200 Figure at a Window, 1925
*Personnage à une fenêtre (Jeune fille
debout à la fenêtre)*
Oil on canvas, 103 x 75 cm
Madrid, Museo Nacional Reina Sofía

201 Don Salvador and Ana María
Dalí (Portrait of the Artist's Father
and Sister), 1925
*Retrato del padre y la hermana
(Portrait du père et de la sœur de
l'artiste)*
Pencil on paper, 49 x 33 cm
Barcelona, Museo de Arte Moderno

202 Portrait of my Father, 1925
Portrait de mon père
Oil on canvas, 100 x 100 cm
Barcelona, Museo de Arte Moderno

203 Study, 1925
Etude
Oil on canvas, 100 x 68.6 cm
St. Petersburg (FL), The Salvador
Dalí Museum; formerly Collection
E. and A. Reynolds Morse

204 Study for "Portrait of María
Carbona" (dedicated to Puig
Pujades), 1925
*Etude pour «Portrait de María
Carbona»*
Lead pencil on plant fibre paper,
49 x 32 cm
Barcelona, Museo de Montserrat

205 Portrait of María Carbona (on
the reverse of a still life, cf. ill. no.
185), 1925
Portrait de María Carbona
Oil on panel, 52.6 x 39.2 cm
Montreal, Montreal Museum of
Fine Arts

206 Female Nude, 1925
Nu féminin (Desnudo feminino)
Oil on cardboard, 46 x 48.5 cm
Private collection

207 Female Nude, 1925
Nu féminin
Oil on canvas, 104.2 x 70.1 cm
St. Petersburg (FL), The Salvador
Dalí Museum, on loan from E. and
A. Reynolds Morse

208 Seated Monk, 1925
Moine assis
Oil on canvas, 92.3 x 68.5 cm
St. Petersburg (FL), The Salvador
Dalí Museum; formerly Collection
E. and A. Reynolds Morse

209 Study for "Woman with a
Child", 1923
Etude pour «Femme et enfant»
Charcoal; dimensions unknown
Private collection

210 Girl Reclining on a Bed (Ana
María Dalí), 1925
*Jeune fille allongée sur un lit (Ana
María Dalí)*
Pencil on tinted paper, 32.5 x 49.7 cm
Figueras, Fundación Gala-Salvador
Dalí

211 Nude in the Water, 1925
Nu dans l'eau (Desnudo en el agua)
Oil on cardboard, 50.5 x 47 cm
Private collection

212 Venus and Amorini, 1925
Venus y cupidillos – Vénus et amours
Oil on panel, 23 x 23.5 cm
Private collection

213 Cf. caption on p. 97

214 Landscape near Ampurdán,
1925
Paysage de l'Ampurdán
Oil on cardboard, 22 x 27 cm
Private collection

215 Landscape near Ampurdán,
1925
Paysage de l'Ampurdán
Oil on cardboard, 22 x 27 cm
Private collection

216 Still Life, c. 1925
Nature morte
Oil on canvas, 83 x 62 cm
Figueras, Fundación Gala-Salvador
Dalí, Gift of Dalí to the Spanish state

217 Pierrot Playing the Guitar
(Harlequin with Small Bottle of
Rum), 1925
*Pierrot tocant la guitarra – Pierrot
jouant de la guitare (Arlequin et
petite bouteille de rhum)*
Oil on canvas, 198 x 149 cm
Madrid, Centro de Arte Reina Sofía,
Gift of Dalí to the Spanish state

218 Still Life and Mauve
Moonlight, 1925
Nature morte au clair de lune mauve
Oil on canvas, 148 x 198 cm
Figueras, Fundación Gala-Salvador
Dalí, Gift of Dalí to the Spanish state

219 Cf. caption on p. 99

220 Study for "Venus and Sailor",
1925
Etude pour «Vénus et marin»
Pen and ink on paper; dimensions
unknown
Private collection

221 Venus and Sailor (Girl and
Sailor; unfinished), 1926
*Vénus et marin (Fille et marin;
inachevé)*
Oil on canvas, 197.5 x 148 cm
Private collection

222 Venus and a Sailor – Homage
to Salvat-Papasseit, 1925
*Vénus et un marin – Hommage à
Salvat-Papasseit*
Oil on canvas, 216 x 147 cm
Shizuoka (Japan), Ikeda Museum of
20th Century Art

223 Sailor and his Family, c. 1926
Marin et sa famille
Indian ink on paper, 27.1 x 21.1 cm
Private collection

224 Venus and a Sailor, 1925
Vénus et un marin
Oil on panel, 43 x 31.5 cm
Private collection; formerly
Collection Gudiol

225 The Girl of Ampurdán, 1926
*La noia dels rulls – Jeune fille
de l'Ampurdán*
Oil on plywood, 51 x 40 cm
St. Petersburg (FL), The Salvador
Dalí Museum; formerly Collection
E. and A. Reynolds Morse

226 Sheets of Studies (double-sided
drawing), 1926
*Sheets of Studies (double-sided
drawing)*
Charcoal on cardboard, 32 x 21.5 cm
Private collection

227 Female Nude, 1926
Nu
Lead pencil, 23.5 x 20.3 cm
St. Petersburg (FL), The Salvador
Dalí Museum, on loan from E. and
A. Reynolds Morse

228 The Girl – Study for "The Girl
of Ampurdán", 1926
*La noia – La jeune fille (Etude pour
«Jeune fille de l'Ampurdán»)*
Technique unknown; 32 x 20 cm
Whereabouts unknown

229 Girl Sewing – Study for "Ana
María", 1926
*Fille cousant – Etude pour «Ana
María»*
Pencil on paper, 53 x 32.5 cm
Figueras, Fundación Gala-Salvador
Dalí

230 Ana María, Sewing, 1926
*Ana María cousant – Muchacha
cosiendo*
Oil on copper; dimensions unknown
Private collection

231 Girl from the Back, 1926
Jeune fille de dos
Oil on panel, 32 x 27 cm
St. Petersburg (FL), The Salvador
Dalí Museum; formerly Collection
E. and A. Reynolds Morse

232 Portrait of Señora Abadal de
Argemi, c. 1926
Portrait de la Sra. Abadal de Argemi
Oil on canvas; dimensions unknown
Private collection

233 Portrait of a Woman
(unfinished), 1926
Portrait de femme
Oil on panel, two components,
60.9 x 38 cm
Figueras, Fundación Gala-Salvador
Dalí

234 Study for "Ana María". Cover
of the catalogue for Dalí's second
exhibition at the Dalmau Gallery in
Barcelona, 1926
*Affiche d'exposition: Etude pour
«Muchacha cosiendo» («Ana María
cousant»)*
Pencil; dimensions unknown
Private collection

235 Study for "Girl Sewing", 1926
Etude pour «Noia cusint»
Technique and dimensions unknown
Whereabouts unknown

236 Study for "Girl Sewing", 1926
Etude pour «Noia cusint»
Technique and dimensions unknown
Whereabouts unknown

237 Girl Sewing, 1926
Noia cusint
Oil; material and dimensions
unknown
Private collection

238 Study for "Girl Sewing", 1926
Etude pour «Noia cusint»
Indian ink on buff paper,
27.9 x 24.9 cm
Private collection

239 Woman at the Window at
Figueras, 1926
Femme à la fenêtre à Figueras
Oil on canvas, 24 x 25 cm
Barcelona, Collection Juan
Casanelles

240 Figure on the Rocks (Sleeping
Woman), 1926
*Personnage parmi les rochers
(Femme couchée)*
Oil on plywood, 27 x 41 cm
St. Petersburg (FL), The Salvador
Dalí Museum; formerly Collection
E. and A. Reynolds Morse

241 Women Lying on the Beach,
1926
*Femmes couchées sur la plage
(Figures ajagudes a la sorra)*
Oil on canvas; dimensions unknown
Private collection

242 Woman in a Chemise, Lying
(Study for "Women Lying on the
Beach"), c. 1926
*Femme en chemise, couchée (Dessin
préparatoire pour «Femmes couchées
sur la plage»)*
Pencil on paper, 21.8 x 27 cm
Ontario, Musée des Beaux-Arts

243 Neo-Cubist Academy
(Composition with Three Figures),
1926
*Académie néocubiste (Composition
aux trois figures)*
Oil on canvas; dimensions unknown
Private collection

244 Rocks at Llané (first state), 1926
Rochers du Llané
Oil; material and dimensions
unknown; the picture was
overpainted in about 1936 (cf. ill.
no. 582)

245 Rocks at Llané (Landscape
near Cadaqués), 1926
*Rochers du Llané (Paysage à
Cadaqués)*
Oil on panel, 61 x 46 cm
Private collection

246 Penya-Segats (Woman on the
Rocks), 1926
*Penya-Segats (Femme devant les
rochers)*
Oil on olive panel, 26 x 40 cm
Private collection

247 Cf. caption on p. 111

248 Still Life with Two Lemons,
c. 1926
Nature morte aux deux citrons
Oil on panel, 20 x 28 cm
Private collection

249 Basket of Bread, 1926
Corbeille de pain
Oil on panel, 31.5 x 31.5 cm
St. Petersburg (FL), The Salvador
Dalí Museum; formerly Collection
E. and A. Reynolds Morse

250 Self-Portrait Splitting into
Three, 1927
Autoportrait se dédoublant en trois
Oil on cardboard, 70 x 50 cm
Figueras, Fundación Gala-Salvador
Dalí

251 Untitled (Study for "Honey Is
Sweeter than Blood"), 1926
*Sans titre (Etude pour «Le miel est
plus doux que le sang»)*
Indian ink on paper, 25.1 x 32.6 cm
New York, The Museum of Modern
Art, Gift of Mrs. Alfred R. Stern in
memory of René d'Harnoncourt

252 Harlequin, 1927
Arlequin – Arlequi
Oil on canvas, 190 x 140 cm
Madrid, Museo Nacional Reina Sofía

253 Three Figures, 1926
Trois personnages
Oil on canvas, 148 x 198 cm
Madrid, Museo Nacional Reina
Sofía, Gift of Dalí to the Spanish
state

254 Mannequin (Barcelona
Mannequin), 1926/27
*Le mannequin (Mannequin
barcelonais)*
Oil on canvas, 248 x 198 cm
Figueras, Fundación Gala-Salvador
Dalí, Gift of Dalí to the Spanish state

255 Cubist Figure, 1926
Figura cubista – Personnage cubiste
Oil on canvas, 152 x 90 cm
Figueras, Fundación Gala-Salvador
Dalí, Gift of Dalí to the Spanish state

256 Figure Edged in Flames, 1927
Figure en flamme
Technique unknown; 30.7 x 24.2 cm
St. Petersburg (FL), The Salvador
Dalí Museum

257 Study for "Still Life by the
Light of the Moon", 1927
*Etude pour «Nature morte au clair
de lune»*
Pen and ink on stationery,
22.5 x 17.2 cm
Madrid, Fundación Federico García
Lorca

258 Still Life by the Light of the
Moon, 1927
Nature morte au clair de lune
Oil on canvas, 190 x 140 cm
Madrid, Museo Nacional Reina
Sofía, Gift of Dalí to the Spanish
state

259 Abstract Composition, 1926
Composition abstraite
Indian ink on paper, 18 x 21 cm
Private collection

260 Woman's Head, 1927
Tête de femme
Oil on canvas, 100 x 100 cm
Figueras, Fundación Gala-Salvador
Dalí

261 Head (Draft of a Double
Image), 1927
*Dibuix – Tête (Essai de
double-image)*
Pencil and Indian ink, 24.5 x 21 cm
Private collection

262 Honey Is Sweeter than Blood,
1927
Le miel est plus doux que le sang
Oil on canvas; dimensions unknown
Private collection

263 Study for "Honey Is Sweeter
than Blood" (Automatic Drawing),
1926
*Etude pour «Le miel est plus doux
que le sang»*
Oil on panel, 36.5 x 45 cm
Private collection

264 Apparatus and Hand, 1927
Appareil et main
Oil on panel, 62.2 x 47.6 cm
St. Petersburg (FL), The Salvador
Dalí Museum; formerly Collection
E. and A. Reynolds Morse

265 Little Cinders (Cenicitas),
1927/28
*Cenicitas (Petites cendres ou Forces
estivales)*
Oil on panel, 64 x 48 cm
Madrid, Museo Nacional Reina Sofía

266 Nude Woman Seated in an
Armchair, 1927/28
Femme nue assise dans un fauteuil
Oil on cardboard, 68.5 x 52.5 cm
Figueras, Fundación Gala-Salvador
Dalí

267 Untitled, 1927
Sans titre
Oil on canvas with collage of sand
and pebbles; dimensions unknown
Private collection

268 Cf. caption on p. 124

269 Portrait of Federico García
Lorca, 1928
*Portrait de Federico García Lorca
dessiné par Dalí*
Pen and Indian ink on paper,
22 .2 x 16 cm
Private collection

270 Self-Portrait, dedicated to
Federico García Lorca, 1928
*Autoportrait, dédié à Federico
García Lorca*
Pen and ink on paper, 22 x 16 cm
Mollet (Barcelona), Collection Juan
Abello Prat

271 The Poet on the Beach of
Ampurias – Federico García Lorca,
1927
*Le poète sur la plage d'Ampurias –
Federico García Lorca*
Pen and ink on paper; dimensions
unknown
Whereabouts unknown

272-274 Cf. captions on p. 125

275 The Severed Hand, 1928
La main coupée
Ink on paper, 19 x 21 cm
Private collection

276 Saint Sebastian, 1927
Saint Sébastien – San Sebastián
Pen and ink on paper; dimensions
unknown
Private collection

277 Bather (Feminine Nude), 1928
Beigneuse (sic!)
Oil and pebbles on laminated panel,
63.5 x 75 cm
St. Petersburg (FL), The Salvador
Dalí Museum, on loan from E. and
A. Reynolds Morse

278 Symbiotic Woman-Animal,
1928
Symbiose femme-animal
Oil and gravel collage on panel,
50.2 x 65.5 cm
Figueras, Fundación Gala-Salvador
Dalí

279 Unsatisfied Desires, 1928
Les désirs inassouvis
Oil, sea-shells and sand on
cardboard, 76 x 62 cm
Private collection

280 Inaugural Goose Flesh
(Surrealist Composition), 1928
*Composition surréaliste, baptisée
chair de poule inaugurale*
Oil on canvas, 75.5 x 62.5 cm
Private collection

281 Composition (unfinished), 1928
Composition
Oil and gravel collage on oak panel,
39.2 x 79.5 cm
Figueras, Fundación Gala-Salvador
Dalí

282 Bather, 1928
Baigneur
Oil, sand and gravel collage on
panel, 52 x 71.7 cm
St. Petersburg (FL), The Salvador
Dalí Museum, on loan from E. and
A. Reynolds Morse

283 Untitled, 1928
Sans titre
Oil on panel, 76 x 63 cm
Figueras, Fundación Gala-Salvador
Dalí

284 Anthropomorphic Beach (first
state), 1928
Plage anthropomorphique
Oil, cork, stone, red sponge and
polychrome finger carved of wood
on canvas, 100 x 100 cm
Destroyed (cf. ill. no. 286)

285 Untitled, 1928
Sans titre
Oil on canvas; dimensions unknown
Private collection

286 Anthropomorphic Beach
(fragment of illustration no. 284),
1928
Plage anthropomorphique
Oil, cork, stone, red sponge and
polychrome finger carved of wood
on canvas, 47.5 x 27.7 cm
St. Petersburg (FL), The Salvador
Dalí Museum, on loan from E. and
A. Reynolds Morse

287 Feminine Nude (final state),
1928
Nu féminin
Oil, cork and strings on canvas,
70.5 x 60 cm
Paris, Collection André-François
Petit

288 Feminine Nude (first state),
1928
Nu féminin
Oil on canvas, 70.5 x 60 cm
Private collection

289 Moonlight, c. 1928
Clair de lune
Oil and gravel collage on panel,
63.1 x 75.7 cm
Figueras, Fundación Gala-Salvador
Dalí

290 Untitled (The Sea and the
Fishermen), 1928
Sans titre (La mer et pêcheurs)
Oil on canvas, 185.3 x 199.4 cm
Figueras, Fundación Gala-Salvador
Dalí

291 Fishermen in the Sun, 1928
Pêcheurs au soleil
Oil and strings on canvas,
100 x 100 cm
Barcelona, private collection

292 Soft Nude (Nude Watch),
c. 1928
Le nu mou (Le nu montre)
Oil and sand on canvas, 50 x 40 cm
Private collection

293 Abstract Composition, 1928
Composition abstraite
Oil on canvas, 148 x 198 cm
Madrid, Centro de Arte Reina Sofía,
Gift of Dalí to the Spanish state

294 Fishermen in Cadaqués, 1928
Pêcheurs de Cadaqués
Oil on canvas with collage;
dimensions unknown
Private collection

295 Untitled, 1928
Sans titre
Oil on canvas, 148 x 198 cm
Madrid, Museo Nacional Reina
Sofía, Gift of Dalí to the Spanish
state

296 Sun, Four Fisherwomen of
Cadaqués, 1928
*Soleil, quatre femmes de pêcheurs à
Cadaqués*
Oil on canvas, 147 x 196 cm
Madrid, Centro de Arte Reina Sofía,
Gift of Dalí to the Spanish state

297 Shell, 1928
Coquillage
Oil on plywood, 50.3 x 61 cm
Figueras, Fundación Gala-Salvador
Dalí

298 The Wounded Bird, 1928
L'oiseau blessé
Oil and sand on cardboard,
55 x 65.5 cm
Monte Carlo, Collection
Mizne-Blumental

299 Bird and Fish, 1928
*Guerrier pêcheur – Ocell-Peix
(Oiseau-poisson)*
Oil and pebbles on laminated panel,
61 x 49 cm
St. Petersburg (FL), The Salvador
Dalí Museum; formerly Collection
E. and A. Reynolds Morse

300 Big Thumb, Beach, Moon and
Decaying Bird, 1928
*Big Thumb, Beach, Moon and
Decaying Bird*
Oil and pebbles on laminated panel,
50 x 61 cm
St. Petersburg (FL), The Salvador
Dalí Museum; formerly Collection
E. and A. Reynolds Morse

301 Putrefied Bird, 1928
Oiseau putréfié
Oil on panel, 37.5 x 57 cm
Figueras, Fundación Gala-Salvador
Dalí

302 Bird, 1928
Oiseau
Oil, sand and gravel collage on
panel, 49 x 60 cm
England, private collection;
formerly Collection Sir Roland
Penrose

303 The Spectral Cow, 1928
La vache spectrale
Oil on plywood, 50 x 64.5 cm
Paris, Musée National d'Art
Moderne, Centre Georges
Pompidou

304 The Ram, 1928
Vache spectrale (The Ram)
Oil on panel, 50.2 x 61.7 cm
St. Petersburg (FL), The Salvador
Dalí Museum, on loan from E. and
A. Reynolds Morse

305 The Stinking Ass, 1928
L'âne pourri
Oil, sand and gravel collage on
panel, 61 x 50 cm
Paris, Collection André-François
Petit; formerly Collection Paul
Eluard

306 Portrait of Paul Eluard, 1929
Portrait de Paul Eluard
Oil on cardboard, 33 x 25 cm
Formerly Collection Gala and
Salvador Dalí

307 Retrospective Bust of a
Woman, 1933
Buste de femme rétrospectif
China dummy bust, painted, with
corn cob, cartoon film strip as collar
band, golden-bronzed sponge, and
plastic replicas of the figures and
wheelbarrow from "The Angelus",
with two inkwells and quills,
54 x 45 x 35 cm
Belgium, private collection

308 Amalgam – Sometimes I Spit
on the Portrait of my Mother for
the Fun of it, 1929
*L'amalgame – Parfois je crache par
plaisir sur le portrait de ma mère*
Technique and dimensions unknown
Paris, Musée d'Art Moderne

309 Study for "The Enigma of
Desire – My Mother, my Mother,
my Mother", 1929
*Etude pour «L'énigme du désir – Ma
mère, ma mère, ma mère»*
Reddish brown Indian ink on paper,
19 x 22.5 cm
Private collection

310 Studies for "The Enigma of
Desire" and "Memory of the
Child-Woman", 1929
*Etudes pour «L'énigme du désir» et
«La mémoire de la femme-enfant»*
Reddish brown Indian ink on paper,
31 x 23.5 cm
Paris, Collection André-François
Petit

311 The Enigma of Desire – My
Mother, my Mother, my Mother,
1929
*L'énigme du désir – Ma mère, ma
mère, ma mère*
Oil on canvas, 110 x 150.7 cm
Munich, Staatsgalerie moderner
Kunst; formerly Collection Oskar
R. Schlag

312 The Lugubrious Game, 1929
Le jeu lugubre
Oil and collage on cardboard,
44.4 x 30.3 cm
Private collection

313 Study for "The Lugubrious
Game", 1929
Etude pour «Le jeu lugubre»
Pencil on paper, 19.5 x 25.8 cm
Milan, Collection Arturo Schwarz

314 Print and comment by Georges
Bataille for his article "The
Lugubrious Game" (Le jeu lugubre)
Pencil; dimensions unknown
Whereabouts unknown

315 The Great Masturbator, 1929
Le grand masturbateur
Oil on canvas, 110 x 150 cm
Madrid, Museo Nacional Reina
Sofía, Gift of Dalí to the Spanish
state

316 The Red Tower
(Anthropomorphic Tower), 1930
*La tour rouge (La tour
anthropomorphe)*
Pastel on paper, 64 x 50 cm
Chicago, Mrs. Edwin A. Bergman
Collection

317 Study for "The Great
Masturbator", 1929
*Etude pour «Le grand
masturbateur»*
Watercolour on paper, 14 x 9 cm
Paris, Collection François-Xavier
Petit

318 The Lost Face – The Great
Masturbator, 1930
*Visage perdu – Le grand
masturbateur*
Pastel on paper, 64.8 x 48.9 cm
St. Petersburg (FL), The Salvador
Dalí Museum

319 The Great Masturbator –
Frontispiece for "The Visible
Woman", 1930
*Le grand masturbateur – Frontispice
de «La femme visible»*
Etching after an Indian ink drawing,
28.2 x 22.1 cm
Paris, Editions surréalistes

320 The Kiss – Study for the couple
who are embracing in "The Great
Masturbator", 1929
Le baiser
Pen and ink on paper, 27 x 16 cm
Paris, Collection Jean-Jacques Lebel

321 Study for "The Invisible Man",
1929
Etude pour «L'homme invisible»
Pencil on paper, 28 x 20 cm
Private collection

322 The Invisible Man, 1929
L'homme invisible
Oil on canvas, 140 x 80 cm
Madrid, Museo Nacional Reina
Sofía, Gift of Dalí to the Spanish
state

323 Gradiva (Study for "The
Invisible Man"), 1930
*Gradiva (Etude pour «L'homme
invisible»)*
Pen, ink and pencil on paper,
35 x 25 cm
St. Petersburg (FL), The Salvador
Dalí Museum, on loan from E. and
A. Reynolds Morse

324 Accomodations of Desire, 1929
L'accomodation du désir
Oil on panel, 22 x 35 cm
Private collection; formerly Julien
Levy Collection

325 Man of Sickly Complexion
Listening to the Sound of the Sea,
or, The Two Balconies, 1929
*Homme d'une complexion malsaine
écoutant le bruit de la mer ou Les
deux balcons*
Oil on panel, 23.5 x 34.5 cm
Rio de Janeiro, Museu da Chácara
do Céu, Fundaçao Raymundo
Ottoni de Castro Maya

326 Illuminated Pleasures, 1929
Les plaisirs illuminés
Oil and collage on hardboard,
24 x 35 cm
New York, The Museum of Modern
Art, Collection Sidney and Harriet
Janis, 1957

327 The First Days of Spring, 1929
Les premiers jours du printemps
Oil and collage on panel,
49.5 x 64 cm
St. Petersburg (FL), The Salvador
Dalí Museum, on loan from E. and
A. Reynolds Morse

328 The Butterfly Chase, 1929
La chasse aux papillons
Indian ink on paper, 55.5 x 41.5 cm
Paris, Collection André-François
Petit

329 Phantasmagoria, 1929
Phantasmagora
Oil on panel, 69 x 44 cm
Private collection; formerly
Collection Oberst LeRay Berdeau

330 Profanation of the Host, 1929
Profanation de l'hostie
Oil on canvas, 100 x 73 cm
St. Petersburg (FL), The Salvador
Dalí Museum, on loan from the
Morse Charitable Trust

331 Imperial Monument to the
Child-Woman, 1929
*Monument impérial à la
femme-enfant*
Oil on canvas, 140 x 80 cm
Madrid, Centro de Arte Reina Sofía,
Gift of Dalí to the Spanish state

332 Pyre. Poster design for the 10th
anniversary of the French
Communist Party, 1930
*Bûcher. Projet d'affiche pour le 10e
anniversaire du Parti Communiste
français*
Pencil, Indian ink and watercolour,
11 x 11.6 cm
Turin, Collection Luigi Campi

333 Combinations (or The
Combined Dalinian Phantasms:
Ants, Keys, Nails), 1931
Combinaisons
Gouache on paper, 14 x 9 cm
New York, Collection Klaus G.
Perls

334 The Font, 1930
La fontaine
Oil on plywood, 66 x 41 cm
St. Petersburg (FL), The Salvador
Dalí Museum, Collection E. and A.
Reynolds Morse

335-340 Cf. captions on p. 154

341 The Average Bureaucrat, 1930
Le bureaucrate moyen
Oil on canvas, 81 x 64.8 cm
St. Petersburg (FL), The Salvador
Dalí Museum; formerly Collection
Helena Rubinstein; formerly
Collection E. and A. Reynolds
Morse

342 Cf. caption on p. 156

343 Portrait of Emilio Terry
(unfinished), 1930
Portrait de Monsieur Emilio Terry
Oil on panel, 50 x 54 cm
Private collection; formerly
Collection E. Terry

344 The Hand – Remorse, 1930
La main – Les remords de conscience
Oil on canvas, 41 x 66 cm
St. Petersburg (FL), The Salvador
Dalí Museum, on loan from E. and
A. Reynolds Morse

345, 346 Cf. captions on p. 156

347, 348 Cf. captions on p. 158

349 André Breton, The Great
Anteater, 1929-1931
André Breton le Tamanoir
Pen and ink on paper; dimensions
unknown

350 Cf. caption on p. 158

351 The Bleeding Roses, 1930
Les roses sanglantes
Oil on canvas, 75 x 64 cm
Geneva, private collection

352 Vertigo – Tower of Pleasure,
1930
Vertige – Tour du plaisir
Oil on canvas, 60 x 50 cm
Private collection

353 Study for "Invisible Sleeping
Woman, Horse, Lion" and for
"Paranoiac Woman-Horse", 1929/30
*Etude pour «Dormeuse, cheval, lion
invisibles» et «Femme-cheval
paranoïaque»*
Indian ink, gouache and pencil,
8 x 11.5 cm
Private collection

354 Paranoiac Woman-Horse, 1930
Femme-cheval paranoïaque
Oil on canvas, 50.2 x 65.2 cm
Paris, Musée National d'Art
Moderne, Centre Georges
Pompidou

355 Invisible Sleeping Woman,
Horse, Lion, 1930
Dormeuse, cheval, lion invisibles
Oil on canvas, 52 x 60 cm
Paris, private collection

356 Invisible Sleeping Woman,
Horse, Lion, 1930
Dormeuse, cheval, lion invisibles
Oil on canvas, 60 x 70 cm
Paris, private collection; formerly
Collection Vicomte de Noailles

357 Study for "Invisible Sleeping
Woman, Horse, Lion", 1930
*Etude pour «Dormeuse, cheval, lion
invisibles»*
Indian ink on paper, 47 x 61 cm
New York, Perls Galleries

358 Study for "Invisible Sleeping
Woman, Horse, Lion", c. 1930
*Etude pour «Dormeuse, cheval, lion
invisibles»*
Pencil, coloured pencils and ink,
17.5 x 25 cm
Private collection

359 Premature Ossification of a
Railway Station, 1930
Ossification prématurée d'une gare
Oil on canvas, 31.5 x 27 cm
Private collection; formerly
Collection Countess Pecci-Blunt

360 The Persistence of Memory
(Soft Watches), 1931
Persistance de la mémoire
Oil on canvas, 24 x 33 cm
New York, The Museum of Modern
Art (anonymous gift 1934)

361 Figure Clock, 1931
Figure-horloge
Indian ink on paper, 38 x 28.5 cm
Private collection

362 Partial Hallucination. Six
Apparitions of Lenin on a Grand
Piano, 1931
*Hallucination partielle. Six
apparitions de Lénine sur un piano*
Oil on canvas, 114 x 146 cm
Paris, Musée National d'Art
Moderne, Centre Georges
Pompidou

363 Head of Hair, 1930
La chevelure
Pastel on paper, 62 x 48 cm
Paris, Collection Gianna Sistu

364 Study for "The Dream", 1930
Etude pour «Le rêve»
Pen and ink on paper, 19 x 19.5 cm
Paris, Collection André-François
Petit

365 The Dream, 1931
Le rêve
Oil on canvas, 100 x 100 cm
New York, private collection;
formerly Collection Félix Labisse

366 Remorse, or, Sunken Sphinx,
1931
Remords ou Sphynx enlisé
Oil on canvas, 19.1 x 26.9 cm
East Lansing (MI), Kresge Art
Museum, Gift of John F. Wolfram

367 Untitled – Erotic Drawing,
1931
Sans titre – Dessin érotique
Indian ink and pencil on paper,
28 x 22 cm
Private collection

368 Erotic Drawing, 1931
Dessin érotique
Indian ink and pencil on paper,
23.5 x 18 cm
Private collection

369 Woman Sleeping in a
Landscape, 1931
Femme dormant dans un paysage
Oil on canvas, 27 x 34 cm
Venice, Peggy Guggenheim
Collection

370 Diurnal Illusion: the Shadow
of a Grand Piano Approaching, 1931
*L'illusion diurne – L'ombre du
grand piano approchant*
Oil on canvas, 34.5 x 25.4 cm
Private collection; formerly
Collection Marquis de Cuevas

371 Andromeda, 1930
Andromède
Pencil and ink on paper,
72.5 x 54.5 cm
Buffalo (NY), Albright Knox Art
Gallery, Gift of A. Conger
Goodyear

372 Untitled – Feminine Nude –
Frontispiece of "La femme visible",
1930
Sans titre – Nu féminin
Ink on Japan paper, 28.4 x 22.3 cm
Private collection

373 Shades of Night Descending,
1931
Ombres de la nuit descendante
Oil on canvas, 61 x 50 cm
St. Petersburg (FL), The Salvador
Dalí Museum, on loan from E. and
A. Reynolds Morse

374 Solitude – Anthropomorphic
Echo, 1931
Solitude, l'écho anthropomorphe
Oil on canvas, 36 x 26 cm
Private collection

375 Symbiosis of a Head of
Seashells, 1931
Symbiose de la tête aux coquillages
Oil on canvas, 35 x 27 cm
New York, Collection Selma and
Nesuhi Ertegun

376 Solitude, 1931
La solitude
Oil on canvas, 35.5 x 27 cm
Hartford (CT), The Wadsworth
Atheneum, Gift of Henry and
Walter Keney

377 The Dream Approaches, 1931
Le rêve approche
Oil on canvas, 65.1 x 54.3 cm
New York, Perls Galleries

378 Olive, 1931
Olive
Oil on panel, 21.5 x 79.7 cm
Private collection

379 Untitled (William Tell and
Gradiva), 1931
*Sans titre (Guillaume Tell et
Gradiva)*
Oil on copper plate, 30.1 x 23.9 cm
Private collection

380 First Portrait of Gala, 1931
Premier portrait de Gala
Oil on photocollage, black and
coloured Indian ink on marble
cardboard with deckled edges,
14 x 9 cm
Private collection

381 Erotic Fantasia on the Names
Paul (Eluard) and Gala. Drawing
given by Dalí to Eluard, 1931
*Fantaisie érotique sur les prénoms de
Paul (Eluard) et de Gala. Dessin
donné par Dalí à Eluard*
Pen on paper, 24 x 33 cm
Paris, Collection Jean-Jacques
Lebel; formerly Collection Paul
Eluard

382 Gradiva, 1933
Gradiva, 1933
Pen and Indian ink on
smoothed-down sandpaper,
63 x 45.5 cm
Munich, Staatliche Graphische
Sammlung

383 Gradiva, 1931
Gradiva
Oil; material and dimensions
unknown
Private collection

384 Gradiva, 1932
Gradiva
Pen and ink on paper, 63 x 45.5 cm
Munich, Staatliche Graphische
Sammlung

385 Study for "Large Painting",
1932
Etude pour «Le grand tableau»
Pen; dimensions unknown
Private collection

386 William Tell, 1930
Guillaume Tell
Oil and collage on canvas,
113 x 87 cm
Private collection; formerly
Collection André Breton

387 Gradiva Rediscovers the
Anthropomorphic Ruins –
Retrospective Fantasy, 1931
*Gradiva retrouve les ruines
anthropomorphes – Fantaisie
rétrospective*
Oil on canvas, 65 x 54 cm
Lugano-Castagnola, Fondazione
Thyssen-Bornemisza; formerly
Collection Robert de Saint-Jean

388 Figure study for "William
Tell", 1932
Personnages pour «Guillaume Tell»
Red and black ink, 25 x 14 cm
St. Petersburg (FL), The Salvador
Dalí Museum, on loan from E. and
A. Reynolds Morse

389 William Tell, Gradiva and the
Average Bureaucrat, 1932
*Guillaume Tell, Gradiva et
bureaucrate moyen*
Indian ink on cardboard, 118 x 65 cm
Turin, private collection

390 Nostalgia of the Cannibal, 1932
La nostalgie du cannibale
Oil on canvas, 47.2 x 47.2 cm
Hanover, Sprengel Museum
Hannover

391 Untitled, 1931
Sans titre
Oil, 61 x 46 cm
Private collection

392 Landscape, 1931
Paysage
Oil on canvas, 24 x 33 cm
New York, private collection

393 The Old Age of William Tell,
1931
La vieillesse de Guillaume Tell
Oil on canvas, 98 x 140 cm
Private collection; formerly
Collection Vicomte de Noailles

394 The Feeling of Becoming, 1930
Le sentiment du devenir
Oil on canvas, 32.5 x 26 cm
Private collection; formerly
Collection Mrs. W. Murray Crane

395 On the Beach, 1931
Au bord de la mer
Oil on canvas, 33.7 x 26.4 cm
St. Petersburg (FL), The Salvador
Dalí Museum, on loan from E. and
A. Reynolds Morse

396 Memory of the Child-Woman,
1932
La mémoire de la femme-enfant
Oil on canvas, 99 x 119.5 cm
St. Petersburg (FL), The Salvador
Dalí Museum, on loan from the
Morse Charitable Trust

397 Study for "Memory of the
Child-Woman", 1932
*Etude pour «La mémoire de la
femme-enfant»*
Indian ink, pencil and coloured
pencil, 32.5 x 28 cm
Paris, Musée Picasso

398 Untitled, 1932
Sans titre
Ink on paper, 23 x 16 cm
Whereabouts unknown

399 The Birth of Liquid Desires,
1932
Naissance des désirs liquides
Oil on canvas, 95 x 112 cm
Venice, Peggy Guggenheim
Collection

400 Anthropomorphic Bread –
Catalonian Bread, 1932
*Pain anthropomorphe – Pain
Catalan*
Oil on canvas, 24 x 33 cm
St. Petersburg (FL), The Salvador
Dalí Museum; formerly Collection
E. and A. Reynolds Morse

401 The Knight at the Tower, 1932
Le chevalier à la tour
Oil on panel, 17.8 x 14 cm
Private collection; formerly
Collection Maurice d'Arquian

402 Untitled – Female Figure with
Catalonian Bread, 1932
*Sans titre – Figure féminine avec
pain catalan*
Oil on canvas, 16.2 x 22 cm
Gift of Dalí to the Spanish state;
held by the Fundación
Gala-Salvador Dalí, Figueras

403 Anthropomorphic Bread,
c. 1932
Pain anthropomorphe
Oil on canvas, 23.7 x 16.4 cm
Figueras, Fundación Gala-Salvador
Dalí

404 The Shoe – Surrealist Object
Functioning Symbolically, 1932
*Le soulier – Objet surréaliste à
fonctionnement symbolique*
Assemblage: lady's shoe, modelling
clay, milk glass, brush without
bristles, sugar cubes, spoons etc.;
48 x 24 x 14 cm
Destroyed (Reconstruction by Max
Clarac-Sérou, 1974)
Private collection

405 Average French Bread with
Two Fried Eggs without the Plate,
on Horseback, Trying to Sodomize
a Heel of Portuguese Bread, 1932
*Pain français moyen avec deux œufs
sur le plat sans le plat, à cheval,
essayant de sodomiser une mie de
pain portugais*
Oil on canvas, 16.8 x 32 cm
Rotterdam, Museum Boymans-van
Beuningen

406 The Invisible Man, 1932
L'homme invisible
Oil on canvas, 16.5 x 23.8 cm
St. Petersburg (FL), The Salvador
Dalí Museum; formerly Collection
E. and A. Reynolds Morse

407 Diurnal Fantasies, 1932
Fantaisies diurnes
Oil on canvas, 81 x 100 cm
St. Petersburg (FL), The Salvador
Dalí Museum, on loan from the
Morse Charitable Trust

408 Untitled – Cyclist with a Loaf
of Bread on his Head, 1932
*Sans titre – Cycliste avec un pain sur
la tête*
Pen and black ink on paper,
17 x 11 cm
New York, Isidore Ducasse Fine
Arts

409 Frontispiece for "Le revolver à
cheveux blancs" by André Breton,
1932
*Frontispice pour «Le revolver à
cheveux blancs» d'André Breton*
Etching (after a drawing), 15 x 12 cm
Paris, Collection André-François
Petit

410 Babaouo – Publicity
announcement for the publication
of the scenario of the film, 1932
Babaouo
Gouache and collage, 27 x 37 cm
Private collection

411 Babaouo, 1932
Babaouo
Theatrical box with glass panels
painted with oil,
25.8 x 26.4 x 30.5 cm
Tokyo, Minami Art Museum

412 Surrealist Object, Gauge of
Instantaneous Memory, 1932
*Objet surréaliste indicateur de la
mémoire instantanée*
Oil on canvas; dimensions unknown
Private collection

413 Fried Eggs on the Plate without the Plate, 1932
Œufs sur le plat sans le plat
Oil on canvas, 60 x 42 cm
St. Petersburg (FL), The Salvador Dalí Museum, on loan from the Morse Charitable Trust

414 The Meeting of the Illusion and the Arrested Moment – Fried Eggs Presented in a Spoon, 1932
Œufs frits présentés dans une cuillère – La rencontre de l'illusion et du moment arrêté
Oil on canvas, 23 x 15 cm
New York, private collection

415 Surrealist Architecture, c. 1932
Architecture surréaliste
Oil on panel, 14 x 18 cm
Berne, Kunstmuseum Bern

416 Agnostic Symbol, 1932
Symbole agnostique
Oil on canvas, 54.3 x 65.1 cm
Philadelphia, The Philadelphia Museum of Art

417 Persistence of Fair Weather, c. 1932-1934
Persistance du beau temps
Oil on canvas, 66 x 47 cm
St. Petersburg (FL), The Salvador Dalí Museum, on loan from E. and A. Reynolds Morse

418 Fried Egg on the Plate without the Plate, 1932
Œuf sur le plat sans le plat
Oil on canvas, 55 x 46 cm
Madrid, Galería Theo

419 Fried Egg on the Plate without the Plate, 1923
Œuf sur le plat sans le plat
Oil on canvas, 46 x 46 cm
Rio de Janeiro, Museo de Arte Moderno

420 The Average Fine and Invisible Harp, 1932
La harpe invisible, fine et moyenne
Oil on canvas, 21 x 16 cm
Private collection; formerly Collection Vicomte de Noailles

421 Meditation on the Harp, 1932-1934
Méditation sur la harpe
Oil on canvas, 67 x 47 cm
St. Petersburg (FL), The Salvador Dalí Museum, on loan from the Morse Charitable Trust; formerly Collection André Durst

422 Detail of "Meditation on the Harp", c. 1932-34
Détail de «Méditation sur la harpe»

423 Study for "Meditation on the Harp", 1932/33
Etude pour «Méditation sur la harpe»
Pencil on paper, 30.7 x 22.4 cm
St. Petersburg (FL), The Salvador Dalí Museum, on loan from the Morse Charitable Trust

424 Portrait of the Vicomtesse Marie-Laure de Noailles, 1932
Portrait de la vicomtesse Marie-Laure de Noailles
Oil on panel, 27 x 33 cm
Private collection

425 Preliminary study for "Portrait of Vicomtesse Marie-Laure de Noailles", 1932
Etude préparatoire pour «Portrait de la vicomtesse Marie-Laure de Noailles»
Ink and pastel on cardboard, 31 x 24 cm
Private collection

426 Reverie – Password: Mess up all the Slate, 1933
Rêverie – Consigne: gâcher l'ardoise totale
Pen and ink, 28.2 x 21.3 cm
Private collection

427 The Mysterious Sources of Harmony, 1932/33
Les sources mystérieuses de l'harmonie
Oil on canvas; dimensions unknown
Private collection; formerly Julien Green Collection

428 Arnold Böcklin: The Isle of the Dead, 1880
Arnold Böcklin: L'île des morts
Oil on canvas, 111 x 155 cm
Basle, Kunstmuseum Basel, Öffentliche Kunstsammlung

429 The True Painting of "The Isle of the Dead" by Arnold Böcklin at the Hour of the Angelus, 1932
Vrai tableau de «L'île des morts» d'Arnold Böcklin à l'heure de l'Angélus
Oil on canvas, 77.5 x 64.5 cm
Wuppertal, Von der Heydt-Museum

430 Paranoiac Metamorphosis of Gala's Face, 1932
Métamorphose paranoïaque du visage de Gala
Indian ink on Japan paper, 29 x 21 cm
Figueras, Fundación Gala-Salvador Dalí; formerly Collection Boris Kochno

431 Automatic Beginning of a Portrait of Gala (unfinished), 1932
Commencement automatique d'un portrait de Gala
Oil on laminated panel, 13 x 16 cm
Figueras, Fundación Gala-Salvador Dalí

432 Portrait of Gala, 1933
Portrait de Gala
Oil on panel, 8.5 x 6.5 cm
St. Petersburg (FL), The Salvador Dalí Museum, on loan from E. and A. Reynolds Morse

433 Necrophiliac Fountain Flowing from a Grand Piano, 1933
Fontaine nécrophilique coulant d'un piano à queue
Oil on canvas, 22 x 27 cm
Private collection; formerly Collection Prince J.-L. de Faucigny-Lucinge

434 Suez, 1932
Suez
Oil on canvas, 46.9 x 46.9 cm
St. Petersburg (FL), The Salvador Dalí Museum; formerly Collection E. and A. Reynolds Morse

435 The Birth of Liquid Fears, 1932
Naissance des angoisses liquides
Oil on canvas, 55 x 38.5 cm
Tokyo, Galerie Musashino

436 Surrealist Essay, 1932
Essai surréaliste
Oil on canvas, 110 x 80 cm
Jerusalem, The Israël Museum

437 Masochistic Instrument, 1933/34
Instrument masochiste
Oil on canvas, 62 x 47 cm
Private collection; formerly Collection Countess Pecci-Blunt

438 The Veiled Heart, 1932
Le cœur voilé
Oil on canvas, 24 x 16 cm
Private collection; formerly New York, Perls Galleries

439 Phosphene of Laporte – Homage to the Italian Physicist Giambattista Della Porta, 1932
Phosphène de Laporte – En hommage au physicien italien Giambattista Della Porta
Oil on canvas, 109 x 80 cm
Paris, Collection André-François Petit, and New York, Five Stars Investment Ltd.

440 Ambivalent Image, 1933
Image ambivalente
Oil on canvas, 65 x 54 cm
Paris, Collection André-François Petit

441 The Phantom Cart, 1933
La charrette fantôme
Oil on panel, 16 x 20.3 cm
New Haven (CT), Yale University Art Gallery, Gift of Thomas F. Howard

442 Moment of Transition, 1934
Moment de transition
Oil on canvas, 54 x 65 cm
Private collection

443 The Phantom Cart, 1933
La charrette fantôme
Oil on panel, 19 x 24.1 cm
Geneva, Collection G.E.D. Nahmad; formerly Collection Edward James

444 Sugar Sphinx, 1933
Le sphynx de sucre
Oil on canvas, 73 x 59 cm
St. Petersburg (FL), The Salvador Dalí Museum, on loan from E. and A. Reynolds Morse; formerly Collection Vicomte de Noailles

445 Gala and the Angelus of Millet Preceding the Imminent Arrival of the Conical Anamorphoses, 1933
Gala et l'Angélus de Millet précédant l'arrivée imminente des anamorphoses coniques
Oil on panel, 24 x 18.8 cm
Ottawa, The National Gallery of Canada; formerly Collection Henry P. McIlhenny

446, 447 Cf. captions on p. 200

448 Portrait of Gala with Two Lamb Chops Balanced on her Shoulder, 1933
Portrait de Gala avec deux côtelettes d'agneau en équilibre sur l'épaule
Oil on olive panel, 6 x 8 cm
Figueras, Fundación Gala-Salvador Dalí

449 The Enigma of William Tell, 1933
L'énigme de Guillaume Tell
Oil on canvas, 201.5 x 346 cm
Stockholm, Moderna Museet

450 Study for "The Enigma of William Tell", 1933
Etude pour «L'énigme de Guillaume Tell»
Pen and pencil, 17.2 x 22.3 cm
St. Petersburg (FL), The Salvador Dalí Museum, on loan from E. and A. Reynolds Morse

451 Myself at the Age of Ten When I Was the Grasshopper Child – Castration Complex, 1933
Moi-même à dix ans, lorsque j'étais l'enfant-sauterelle – Complexe de castration
Oil on panel, 22 x 16cm
St. Petersburg (FL), The Salvador Dalí Museum, on loan from E. and A. Reynolds Morse

452 Average Atmospherocephalic Bureaucrat in the Act of Milking a Cranial Harp, 1933
Bureaucrate moyen atmosphérocéphale, dans l'attitude de traire du lait d'une harpe crânienne
Oil on canvas, 22 x 16.5cm
St. Petersburg (FL), The Salvador Dalí Museum, on loan from E. and A. Reynolds Morse; formerly Collection Comtesse de Cuevas de Vera

453 Bureaucrat and Sewing Machine – Illustration for "Les Chants de Maldoror", 1933
Bureaucrate et machine à coudre – Illustration pour «Les chants de Maldoror»
Pencil and ink on paper, 31 x 22.5cm
Formerly Collection Klaus Hegewisch, Hamburg

454 The Triangular Hour, 1933
L'heure triangulaire
Oil on canvas, 61 x 46cm
France, private collection

455 Soft Watches, 1933
Montres molles
Oil on canvas, 81 x 100cm
Private collection; formerly Collection Alain de Léché

456 Geological Destiny, 1933
Le devenir géologique
Oil on panel, 21 x 16cm
Private collection; formerly Julien Green Collection

457 The Phenomenon of Ecstasy, 1933
Le phénomène de l'extase,
Collage, 27 x 18.5 cm
Paris, Collection Vercamer

458 Two Faces of Gala, 1933/34
Deux visages de Gala
Pen and pencil, 30 x 21 cm
Private collection

459 Poster advertising the regular meetings of the Surrealists, 1935
Projet d'affiche – Cycle systématique de conférences surréalistes
Gouache on wrapping paper, 78 x 50cm
Private collection

460 Untitled – Death outside the Head/Paul Eluard, c. 1933
Sans titre – Cette mort hors de la tête/Paul Eluard
Oil on panel; panel: 14.1 x 17.9cm, picture: 11.8 x 15.9cm
Private collection; formerly Collection Paul Eluard

461 The Architectural Angelus of Millet, 1933
L'Angélus architectonique de Millet
Oil on canvas, 73 x 61 cm
Madrid, Museo Nacional Reina Sofía

462 James Pradier: "Feminine Nude". Original sculpture before the transformation by Dalí. Model for "Hysterical and Aerodynamic Nude"
James Pradier: «Nu féminin». Modèle de base pour la sculpture de Dalí «Nu féminin hystérique et aérodynamique»
Plaster, 26 x 40 x 13.5cm
Whereabouts unknown

463 Hysterical and Aerodynamic Nude – Woman on the Rock, 1934
Nu féminin hystérique et aérodynamique – La femme au rocher
Bronze with white mount, 26 x 40 x 13.5 cm
(1973 reconstruction)
Paris, private collection

464 Cf. caption on p. 209

465 Portrait of Gala with a Lobster (Portrait of Gala with Aeroplane Nose), c. 1934
Portrait de Gala au homard (Portrait de Gala au nez en aéroplane)
Oil on panel, 20 x 22.5cm
Paris, private collection; formerly Collection Paul Eluard

466 Surrealist Figures, joint drawing by Dalí and Picasso, c. 1933
Figures surréalistes, dessin conjoint de Picasso et de Dalí
Dry-point engraving, 36 x 42.5cm
Paris, Musée Picasso

467 Cannibalism of Objects (inscribed: Meat Glass, Meat Aeroplane, Meat Spoon, Meat Watch, Meat Head), 1933
Cannibalisme des objets (inscrit: verre de viande, avion de viande, cuillière de viande, montre de viande, tête de mort de viande)
Indian ink on paper, 22.5 x 18 cm
Private collection; formerly Collection Charles Hathaway

468 Cannibalism. Illustrations for "Les Chants de Maldoror" by Lautréamont, 1933
Cannibalisme. Illustration pour «Les chants de Maldoror» de Lautréamont
Etching, 22 x 16.5cm
Whereabouts unknown

469 The Temple of Love, 1933
Le temple de l'amour
Oil; material and dimensions unknown
Private collection

470 Cannibalism of the Praying Mantis of Lautréamont, 1934
Cannibalisme de la mante religieuse de Lautréamont
Oil on panel, 6.7 x 5.2cm
Private collection

471 Melancholy – To Marcel Remy in Friendship, Salvador Dalí, 1934
La mélancolie – Œuvre dédicacée à Marcel Rémy, très amicalement Salvador Dalí
Oil on panel, 6.7 x 5.2cm
Private collection; formerly Collection Marcel Remy

472 Flesh Aeroplane. Illustration for "Les Chants de Maldoror" by Lautréamont, 1933
Avion de chair. Illustration pour «Les chants de Maldoror» de Lautréamont
Etching, 22 x 16.5cm
Whereabouts unknown

473 Illustration for "Les Chants de Maldoror", 1933/34
Illustration pour «Les chants de Maldoror»
Technique and dimensions unknown
Whereabouts unknown

474 Homage to Millet – For Cécile, in Friendship, 1934
Hommage à Millet – Dessin dédicacé à Cécile amicalement
Pen, 19 x 12cm
St. Petersburg (FL), The Salvador Dalí Museum; formerly Collection E. and A. Reynolds Morse

475 The Spectre of the Angelus, c. 1934
Le spectre de l'Angélus
Oil on panel; dimensions unknown
Private collection

476 Untitled – Young Girl with a Skull, 1934
Sans titre – Jeune fille au crâne
Ink and gouache on paper, 50.5 x 32.7cm
Private collection

477 Atavism at Twilight, 1933/34
Atavisme du crépuscule (phénomène obsessif)
Oil on panel, 14 x 18cm
Berne, Kunstmuseum Bern

478 Jean-François Millet: The Angelus, 1859
L'Angélus
Oil on canvas, 55.5 x 66cm
Paris, Musée National du Louvre

479 The Invisible Harp, 1934
Harpe invisible
Oil on canvas, 35 x 27cm
Paris, private collection; formerly Collection Manou Pouderoux

480 The Javanese Mannequin, 1934
Mannequin javanais
Oil on canvas, 65 x 54cm
St. Petersburg (FL), The Salvador Dalí Museum, on loan from the Morse Charitable Trust; formerly Collection Countess of Cuevas de Vera

481 The Spectre of Sex Appeal, 1934
Le spectre du sex-appeal
Oil on panel, 18 x 14cm
Figueras, Fundación Gala-Salvador Dalí

482 Consequences, c. 1934
Cadavre exquis
Pastel on black paper, 27 x 18.5cm
Private collection

483 Consequences, 1934
The drawings were made, top to bottom, by: Dalí, Valentine Hugo, Gala Eluard, André Breton
Cadavres exquis
Pen, ink, Indian ink and pencil on paper, 26.7 x 19.5cm
Paris, Collection André-François Petit

484 Consequences: Dalí, Gala Eluard, Valentine Hugo, André Breton, c. 1930-1934
Ink on paper, 26.7 x 19.5cm
Private collection

485 Consequences: Valentine Hugo, Dalí, André Breton, Gala Eluard, 1934
Ink on paper, 26.7 x 19.5cm
Private collection

486 Consequences: Gala Eluard, Dalí, André Breton, Valentine Hugo, c. 1934
Ink on paper, 26.7 x 19.5cm
Private collection

487 Consequences: Gala Eluard, Valentine Hugo, André Breton, Dalí, c. 1934
Ink on paper, 26.7 x 19.5 cm
Private collection

488 Consequences: Valentine Hugo, André Breton, Gala Eluard, Dalí, c. 1934
Ink on paper, 26.7 x 19.5 cm
Private collection

489 Consequences: Dalí drew part of the pastel. The order in which others contributed to the drawing is unknown.
Pastel on black paper, 27 x 18 cm
Private collection

490 Portrait of René Crevel (Dedicated to Julien Green), 1934
Portrait de René Crevel
Indian ink; dimensions unknown
Private collection; formerly Julien Green Collection

491 Barber Saddened by the Persistence of Good Weather (The Anguished Barber), 1934
Le coiffeur attristé par la persistance du beau temps
Oil on canvas, 24 x 16.5 cm
New York, Collection Klaus G. Perls

492 Bust of Joella Lloyd, 1934
Buste de Joella Lloyd
Painted plaster; height: 39.3 cm (made by Man Ray and painted by Dalí)
Private collection; formerly Collection Mrs. Joella Bayer

493 Portrait of René Crevel (Man with a Cigarette), 1934
Portrait de René Crevel (L'homme à la cigarette)
Pen, ink and gouache on grey paper, 72 x 63 cm
Private collection

494 The Isle of the Dead – Centre Section – Reconstructed Compulsive Image, after Böcklin, 1934
L'île des morts – Cour centrale de « L'île des morts » – Obsession reconstitutive d'après Böcklin
Oil on panel, 99.7 x 72 cm
Geneva, Collection G.E.D. Nahmad; formerly Collection Robert de Saint Jean

495 Night Spectre on the Beach, 1934
Spectre du soir sur la plage
Oil, 65 x 54 cm
Private collection

496 Paranoiac Astral Image, 1934
Image paranoïaque-astrale
Oil on panel, 15.9 x 21.9 cm
Hartford (CT), The Wadsworth Atheneum, Ella Gallup Summer and Mary Catlin Summer Collection

497 Atavistic Vestiges after the Rain, 1934
Vestiges ataviques après la pluie
Oil on canvas, 65 x 54 cm
New York, Perls Galleries; formerly Collection Carlo Ponti, Rome

498 The Ghost of Vermeer van Delft which Can Be Used as a Table, 1934
Le spectre de Vermeer de Delft pouvant être utilisé comme table
Oil on panel, 18 x 14 cm
St. Petersburg (FL), The Salvador Dalí Museum, on loan from E. and A. Reynolds Morse

499 The Knight of Death, 1934
Le chevalier de la mort
Oil on canvas, 65.5 x 50 cm
Geneva, Collection G.E.D. Nahmad; formerly Collection Comtesse Pecci-Blunt

500 The Ghost of Vermeer van Delft, 1934
Spectre de Vermeer de Delft
Technique and dimensions unknown
Whereabouts unknown

501 Ghost of Vermeer van Delft, c. 1934
Spectre de Vermeer de Delft
Oil on panel; dimensions unknown
Private collection

502 The Ghost of Vermeer van Delft, c. 1934
Le spectre de Vermeer de Delft
Oil on canvas, 23 x 19 cm
Switzerland, private collection

503 Title unknown – Ghost, c. 1934
Titre inconnu – Spectre
Oil; material and dimensions unknown
Private collection

504 The Tower, 1934
La tour
Oil on canvas, 66.5 x 53.5 cm
Zurich, Kunsthaus Zürich; formerly Collection Joe Bousquet

505 The Little Theatre, 1934
Le petit théâtre
Wooden box with painted glass panels, 32 x 42 x 31 cm
New York, Perls Galleries

506 Enigmatic Elements in the Landscape, 1934
Paysage avec éléments énigmatiques
Oil on panel, 72.5 x 59.9 cm
Private collection; formerly Paris, Collection Cyrus L. Sulzberger

507 The Weaning of Furniture-Nutrition, 1934
Le sevrage du meuble-aliment
Oil on panel, 18 x 24 cm
St. Petersburg (FL), The Salvador Dalí Museum, on loan from E. and A. Reynolds Morse; formerly Collection Jocelyn Walker

508 Study for the nurse in "The Weaning of Furniture-Nutrition", 1932/33
Etude du personnage de la nourrice dans «Le sevrage du meuble-aliment»
Pencil and ink, 15 x 23 cm
St. Petersburg (FL), The Salvador Dalí Museum, on loan from E. and A. Reynolds Morse

509 The Spectre and the Phantom, 1934
Le spectre et le fantôme
Oil on canvas, 100 x 73 cm
New York, Five Stars Investment Ltd.

510 Figure with Drawers. For a four-part screen, c. 1934
L'homme aux tiroirs. Partie d'un paravent en quatre panneaux
Oil on canvas, 52 x 150 cm
Collection Italcambio

511 Surrealist Knight. For a four-part screen, c. 1934
Cavalier surréaliste. Partie d'un paravent en quatre panneaux
Oil on canvas, 52 x 150 cm
Collection Italcambio

512 Study for "Cardinal, Cardinal!", 1934
Etude pour «Cardinal, Cardinal!»
Pencil, 15 x 20 cm
Private collection

513 Cardinal, Cardinal!, 1934
Cardinal, Cardinal!
Oil and gouache on panel, 16 x 22 cm
Utica (NY), Munson Williams Proctor Institute

514 Omelettes with Dynamic Mixed Herbs, 1934
Omelettes fines herbes dynamiques
Pencil on paper, 23.5 x 31.5 cm
Paris, Collection André-François Petit

515 Untitled, 1933/34
Sans titre
Oil; material and dimensions unknown
Private collection

516 Untitled (Desert Landscape), 1934
Sans titre (Paysage désertique)
Oil on panel, 18.1 x 13.8 cm
Chicago (IL), The Art Institute of Chicago, Gift of M. Reynolds

517 Omelette about to Be Irreparably Crushed by Hands, 1934
Omelette allant irrésistiblement à l'écrasement par les mains
Pencil on paper, 23.5 x 31.5 cm
Paris, Collection André-François Petit

518 Figure-Omelettes, 1934
Figures-omelettes
Pencil on paper, 23.5 x 31.5 cm
Paris, Collection André-François Petit

519 Apparition of my Cousin Carolinetta on the Beach at Rosas – Fluid Premonition, 1934
Apparition de ma cousine Carolinetta sur la plage de Rosas – Pressentiment fluidique
Oil on canvas, 73 x 100 cm
Private collection

520 Apparition of my Cousin Carolinetta on the Beach at Rosas, 1934
Apparition de ma cousine Carolinetta sur la plage de Rosas
Oil on canvas, 73 x 100 cm
Private collection

521 Cf. caption on p. 233

522 Morning Ossification of the Cypress, 1934
Ossification matinale du cyprès
Oil on canvas, 82 x 66 cm
Milan, private collection; formerly Collection Anne Green

523 Fossil Cloud (Lion, Woman and Cypress), 1934
Nuage fossile (Lion, femme et cyprès)
Oil on canvas, 64.8 x 48.9 cm
Private collection; formerly Collection E. and A. Reynolds Morse

524 The Invisible Harp, Fine and Medium, 1932
La harpe invisible, fine et moyenne
Oil on panel, 21 x 16 cm
Private collection; formerly Collection Vicomte de Noailles

525 Untitled (Study for parts of "Invisible Harp, Fine and Medium" and parts of "Skull with its Lyric Appendage Leaning on a Bedside Table…"), c. 1933
Sans titre (Etude contenant des éléments de la «La harpe invisible, fine et moyenne» ainsi que des éléments de «Crâne avec son appendice lyrique reposant sur une table de nuit…»)
Engraving on heavy-duty celluloid, 19.1 x 23 cm
Private collection

526 Atmospheric Skull Sodomizing a Grand Piano, 1934
Crâne atmosphérique sodomisant un piano à queue
Oil on panel, 14 x 18 cm
St. Petersburg (FL), The Salvador Dalí Museum, on loan from E. and A. Reynolds Morse

527 Skull with its Lyric Appendage Leaning on a Bedside Table which Should Have the Exact Temperature of a Cardinal's Nest, 1934
Crâne avec son appendice lyrique reposant sur une table de nuit qui devrait avoir la même température que le nid d'un cardinal
Oil on panel, 24 x 19 cm
St. Petersburg (FL), The Salvador Dalí Museum, on loan from E. and A. Reynolds Morse

528 Soft Cranias and Skull Harp, 1935
Crânes mous et harpe crânienne
Line engraving on paper, 37 x 30.5 cm
Brighton, Brighton Art Gallery, on loan from the Edward James Foundation

529 The Sense of Speed, 1934
Le sentiment de la vitesse
Oil on canvas, 33 x 24 cm
Private collection; formerly Collection Rothschild

530 Eclipse and Vegetable Osmosis, 1934
Eclipse et osmose végétale
Oil on canvas, 63.5 x 52 cm
Private collection; formerly Collection Aubrey Janion

531 The Hour of the Crackled Visage, 1934
L'heure du visage craquelé
Oil on canvas, 62 x 47 cm
Geneva, Collection G.E.D. Nahmad

532 Vegetable Metamorphosis, c. 1934
Métamorphose végétale
Oil on canvas, 41 x 32.5 cm
Paris, private collection; formerly Collection Cecil Beaton

533 Untitled (Dreams on the Beach), 1934
Sans titre (Sueños en la playa)
Oil on panel, 7 x 9 cm
Private collection

534 West Side of the Isle of the Dead – Reconstructed Compulsive Image after Böcklin, 1934
Cour ouest de l'île des morts – Obsession reconstitutive d'après Böcklin
Oil on canvas; dimensions unknown
Whereabouts unknown; formerly Collection Peter Watson

535 The Sign of Anguish, 1934
Le signal de l'angoisse
Oil on panel, 22.2 x 16.5 cm
Private collection

536 Morphological Echo, 1934-1936
Echo morphologique
Oil on panel, 65 x 54 cm
St. Petersburg (FL), The Salvador Dalí Museum, on loan from E. and A. Reynolds Morse

537 Aerodynamic Chair, 1934
Chaise aérodynamique
Oil on panel, 22 x 15.9 cm
Collection De Beers Consolidated Mines, Ltd.

538 Surrealist Figure in the Landscape of Port Lligat, 1933
Personnage surréaliste dans le paysage de Port Lligat
Pencil, 106.6 x 76.2 cm
St. Petersburg (FL), The Salvador Dalí Museum, on loan from E. and A. Reynolds Morse

539 The Judges, c. 1933
Les juges
Indian ink, 49 x 58 cm
Private collection; formerly Julien Green Collection

540 Surrealist Horse – Woman-Horse, 1933
Chevalier surréaliste – Femme-cheval
Pencil and pen, 52.6 x 25 cm
St. Petersburg (FL), The Salvador Dalí Museum, Collection E. and A. Reynolds Morse

541 The Knight of Death (Horseman), 1934
Chevalier de la mort, dit aussi Cavalier
Pen and ink on paper, 102 x 72.5 cm
Private collection; formerly Collection Jean Michel Frank

542 Cf. caption on p. 239

543 Don Quixote, 1935
Don Quichotte
Pen and ink on paper, 45 x 56 cm
Turin, Collection Gianfranco Bellezza; formerly Collection Prince J.L. de Faucigny-Lucinge

544 Surrealist Knights. For a four-part screen, centre right, c. 1934
Chevaliers surréalistes. Partie d'un paravent en quatre panneaux, centre droit
Oil on canvas, 51.8 x 53 cm
Collection Italcambio

545 Surrealist Warriors. For a four-part screen, centre left, c. 1934
Guerriers surréalistes. Partie d'un paravent en quatre panneaux, centre gauche
Oil on canvas, 51.8 x 53 cm
Collection Italcambio

546 Knight of Death (variant), 1933
Variante du «Chevalier de la mort»
Indian ink on paper, 52 x 37 cm
Paris, Collection André-François Petit

547 The Horseman of Death, 1935
Le cavalier de la mort
Oil on canvas, 65 x 54 cm
Paris, Collection André-François Petit

548 Surrealist Poster, 1934
Oil on chromolithographic advertising poster with key, 69 x 46 cm
St. Petersburg (FL), The Salvador Dalí Museum, on loan from E. and A. Reynolds Morse

549 The Surrealist Mystery of New York in 1935
The Surrealist Mystery of New York in 1935
Oil on canvas, 40 x 30 cm
Monte Carlo, Galerie Le Point

550 Woman in a Hat Sitting on a Beach. Drawing for "American Weekly", 1935
Femme au chapeau assise sur la plage
Pencil, 54 x 38.5 cm
Private collection

551 Cf. caption on p. 243

552 Mae West Lips Sofa, 1936/37
Mae West Lips Sofa
Wooden frame upholstered in pink felt to resemble the lips of movie actress Mae West. Made from Dalí's design by Green & Abbott, London, for Edward James, 92 x 213 x 80 cm
Borough of Brighton (Sussex), The Royal Pavilion Art Gallery and Museum; formerly Collection Edward James

553 Cf. caption on p. 244

554 Mae West's Face which May Be Used as a Surrealist Apartment, 1934/35
Visage de Mae West pouvant être utilisé comme appartement surréaliste
Gouache on newspaper, 31 x 17 cm
Chicago (IL), The Art Institute of Chicago

555 The Angelus of Gala, 1935
L'Angélus de Gala
Oil on panel, 32 x 26 cm
New York, The Museum of Modern Art

556 Archeological Reminiscence of Millet's "Angelus", 1935
Réminiscence archéologique de l'«Angélus» de Millet
Oil on panel, 32 x 39 cm
St. Petersburg (FL), The Salvador Dalí Museum, on loan from the Morse Charitable Trust; formerly Collection F. Spitzer

557 Homage to Millet – Study for "The Perpignan Railway Sation", 1965
Hommage à Millet – Etude pour «La gare de Perpignan»
Coloured pencils on paper, 46 x 60 cm
Gift of Dalí to the Spanish state

558 Figure and Drapery in a Landscape, c. 1935
Figure et drapé dans un paysage
Oil on canvas, 55.3 x 45.7 cm
Geneva, Collection G.E.D. Nahmad

559 The Echo of the Void, 1935
L'écho du vide
Oil on canvas, 73 x 92 cm
Private collection

560 Landscape after de Chirico (unfinished), 1935-1938
Paysage à la Chirico
Oil on cardboard on canvas, 20.5 x 25.5 cm
Gift of Dalí to the Spanish state

561 Paranoiac Visage – Postcard sent by Picasso to Dalí, 1931
Visage paranoïaque
Technique and dimensions unknown
Private collection

562 Paranoiac Visage – The Postcard Transformed, 1935
Visage paranoïaque – La carte postale transformée en Picasso
Oil on panel, 19 x 23 cm
Private collection; formerly Collection Edward James

563 Paranoiac Visage, 1935
Visage paranoïaque
Oil, 62 x 80cm
Whereabouts unknown (probably destroyed)

564 Thought Machine – Illustration for "The Secret Life of Salvador Dalí", 1935
Machine à penser – Illustration pour «La vie secrète de Salvador Dalí»
Ink on paper; dimensions unknown
Private collection

565 Apparition of the Town of Delft, 1935/36
Apparition de la ville de Delft
Oil on panel, 31 x 34.5cm
Private collection

566 Autumn Puzzle, 1935
Puzzle d'automne
Oil on canvas, 98 x 98cm
St. Petersburg (FL), The Salvador Dalí Museum, on loan from the Morse Charitable Trust

567 Paranoiac-Critical Solitude, 1935
Solitude paranoïaque-critique
Oil on panel, 19 x 23cm
Private collection; formerly Collection Edward James

568 The Fossilized Automobile of Cape Creus, 1936
L'automobile fossile du Cap Creus
Oil on panel, 31 x 37cm
Geneva, Collection G.E.D. Nahmad; formerly Collection Edward James

569 Singularities, 1935/36
Singularitats
Oil on panel, 40.5 x 51.1cm
Figueras, Fundación Gala-Salvador Dalí

570 Woman with a Head of Roses, 1935
Femme à la tête de roses
Oil on panel, 35 x 27cm
Zurich, Kunsthaus Zürich

571 The Burning Giraffe, 1936/37
Girafe en feu
Oil on panel, 35 x 27cm
Basle, Kunstmuseum Basel, Öffentliche Kunstsammlung, Emanuel Hoffmann Foundation

572 Ant Face. Drawing for the catalogue jacket of Dalí's exhibition at the Alex Reid and Lefevre Gallery in London, 1936
Visage aux fourmis
Gouache on black paper, 24 x 13.5cm
Private collection

573 The Dream Places a Hand on a Man's Shoulder, 1936
Le rêve porte la main sur l'épaule d'un homme
Oil on canvas, 48 x 74cm
Private collection; formerly Collection Matarasso

574 Untitled – Woman with a Flower Head, 1937
Sans titre – Femme à la tête de fleur
Ink and gouache on paper, 38.5 x 50cm
Private collection

575 Necrophiliac Springtime, 1936
Printemps nécrophilique
Oil on canvas, 55 x 65cm
Private collection; formerly Collection Elsa Schiaparelli

576 The Man with the Head of Blue Hydrangea, 1936
L'homme avec une tête d'hortensia bleu
Oil on canvas, 16 x 22cm
St. Petersburg (FL), The Salvador Dalí Museum, on loan from E. and A. Reynolds Morse

577 The Chemist of Ampurdán in Search of Absolutely Nothing, 1936
Le pharmacien d'Ampurdán ne cherchant absolument rien
Oil on panel, 30 x 52cm
Essen, Museum Folkwang; formerly Collection Edward James

578 A Chemist Lifting with Extreme Precaution the Cuticle of a Grand Piano, 1936
Pharmacien soulevant avec une extrême précaution le couvercle d'un piano à queue (A Chemist Lifting with Extreme Precaution the Cuticle of a Grand Piano)
Oil on canvas, 48 x 62cm
Private collection; formerly Collection Ruth Page

579 Three Young Surrealist Women Holding in their Arms the Skins of an Orchestra, 1936
Femmes aux têtes de fleurs retrouvant sur la plage la dépouille d'un piano à queue
Oil on canvas, 54 x 65cm
St. Petersburg (FL), The Salvador Dalí Museum, on loan from the Morse Charitable Trust

580 Landscape with a Girl Skipping, 1936
Paysage avec jeune fille sautant à la corde (Landscape with a Girl Skipping)
Oil on canvas, 293 x 280cm (centre panel), 261 x 84cm (wing panel)
Rotterdam, Museum Boymans-van Beuningen; formerly Collection Edward James

581 Rocks of Llané (first version), 1926
Rochers du Llané
Oil; material and dimensions unknown
Whereabouts unknown

582 Surrealist Composition with Invisible Figures (second version of "Rocks of Llané"), c. 1936
Composition surréaliste avec personnages invisibles
Technique and dimensions unknown
Whereabouts unknown; formerly Collection Joe Bousquet

583 Morphological Echo, 1936
Echo morphologique
Oil on panel, 30.5 x 33cm
St. Petersburg (FL), The Salvador Dalí Museum, on loan from E. and A. Reynolds Morse

584 Beach Scene (detail study), 1936
Beach Scene
Pencil, 75 x 53cm
Santa Barbara (CA), The Santa Barbara Museum of Art

585 Paranoia, 1936
Paranoïa (Paranonia)
Oil on canvas, 38 x 46cm
St. Petersburg (FL), The Salvador Dalí Museum, on loan from E. and A. Reynolds Morse

586 Ampurdán Yang and Yin, 1936
Yang et Yin ampurdanais
Oil on canvas, 64.8 x 53.8cm
Private collection; formerly Collection Marquis de Cuevas

587 Hypnagogic Monument, 1936
Monument hypnagogique
Oil on canvas, 39.3 x 31.2cm
Brussels, Galerie Isy Brachot

588 Sun Table, 1936
Table solaire
Oil on panel, 60 x 46cm
Rotterdam, Museum Boymans-van Beuningen; formerly Collection Edward James

589 South (Noon), 1936
Midi
Oil on canvas, 90 x 115.5cm
Private collection

590 Mediumnistic-Paranoiac Image, 1935
Image médiumnique-paranoïaque
Oil on panel, 19 x 22.8cm
Geneva, Collection G.E.D. Nahmad; formerly Collection Edward James

591 The Forgotten Horizon, 1936
L'horizon oublié
Oil on mahogany, 22.5 x 26.7cm
London, The Tate Gallery; formerly Collection Edward James

592 White Calm, 1936
Le calme blanc
Oil on panel, 41 x 33cm
Geneva, Collection G.E.D. Nahmad; formerly Collection Edward James

593 Geological Justice, 1936
La justice géologique
Oil on panel, 11 x 19cm
Rotterdam, Museum Boymans-van Beuningen; formerly Collection Edward James

594 The Phantom Cart, 1933
La charrette fantôme
Oil on panel, 19 x 24.1cm
Private collection; formerly Collection Edward James

595 Study for "Suburbs of a Paranoiac-Critical Town", 1935
Etude pour «Banlieue de la ville paranoïaque-critique»
Ink and pencil on paper, 32.5 x 20.3cm
Private collection; formerly Collection Edward James

596 Bread on the Head of the Prodigal Son, 1936
Pain sur la tête du fils prodigue
Oil on canvas, 22 x 17cm
Private collection

597 Nostalgic Echo, 1935
Echo nostalgique (Nostalgic Echo)
Oil on canvas, 112.3 x 112.3cm
Private collection

598 Nostalgic Echo, 1935
Echo nostalgique (Nostalgic Echo)
Pencil on paper, 30 x 21cm
St. Petersburg (FL), The Salvador Dalí Museum, on loan from E. and A. Reynolds Morse

599 Suburbs of a Paranoiac-Critical Town: Afternoon on the Outskirts of European History, 1936
Banlieue de la ville paranoïaque-critique: après-midi sur la lisière de l'histoire européenne
Oil on panel, 46 x 66cm
Rotterdam, Museum Boymans-van Beuningen; formerly Collection Edward James

600 The Great Paranoiac, 1936
Le grand paranoïaque
Oil on canvas, 62 x 62cm
Rotterdam, Museum Boymans-van Beuningen; formerly Collection Edward James

601 Messenger in a Palladinian Landscape, 1936
Messager dans un paysage palladien
Indian ink on pink paper, 44.5 x 60 cm
Private collection; formerly Collection Edward James

602 Study of Horsemen, 1936
Study of Horsemen – Etude de cavaliers
Pen and ink on paper, 43.7 x 54.6 cm
New York, The Museum of Modern Art, Gift of Sam A. Lewisohn

603 Head of a Woman in the Form of a Battle – Study for "Spain", 1936
Tête de femme ayant la forme d'une bataille
Oil on panel, 10.2 x 12.7 cm
Private collection; formerly Collection Edward James

604 The Horseman of Death, 1936
Le cavalier de la mort
Oil on canvas, 70 x 59.5 cm
Figueras, Fundación Gala-Salvador Dalí, Gift of Dalí to the Spanish state

605 Our Love, 1936
Our Love
Pencil, 31 x 23.9 cm
Private collection

606 Study for "Geodesic Portrait of Gala", 1936
Etude pour «Portrait géodésique de Gala»
Pencil on paper, 38 x 33 cm
Private collection

607 Gala's Head – Rear View, 1936
Tête de Gala – Vue de dos
Pen and Indian ink, 47 x 41.2 cm
Private collection

608 Geodesic Portrait of Gala, 1936
Portrait géodésique de Gala
Oil on panel, 21 x 27 cm
Yokohama, Yokohama Museum of Art

609 Man with his Head Full of Clouds, 1936
Homme à la tête pleine de nuages
Oil on cardboard, 18 x 13.9 cm
Figueras, Fundación Gala-Salvador Dalí

610 Cf. caption on p. 272

611 Study for "A Couple with their Heads Full of Clouds"(detail), 1936
Etude pour «Couple aux têtes pleines de nuages»
Pencil on paper, 31 x 23.9 cm
Private collection

612 A Couple with their Heads Full of Clouds, 1936
Couple aux têtes pleines de nuages
Oil on panel; dimensions unknown
Private collection

613 A Couple with their Heads Full of Clouds, 1936
Couple aux têtes pleines de nuages
Oil on panel; Man: 92.5 x 69.5 cm; Woman: 82.5 x 62.5 cm
Rotterdam, Museum Boymans-van Beuningen; formerly Collection Edward James

614 Cf. caption on p. 274

615 Aphrodisiac Dinner Jacket, c. 1936
Veston aphrodisiaque
Smoking jacket with liqueur glasses, shirt and plastron on coat hanger, 77 x 57 cm
Destroyed

616, 617 Cf. captions on p. 274

618 Lobster Telephone, 1936
Téléphone-homard
Telephone with painted plaster lobster in the cradle, 15 x 30 x 17 cm
Rotterdam, Museum Boymans-van Beuningen; formerly Collection Edward James

619 Cf. caption on p. 274

620 Cf. caption on p. 276

621 Study for the cover of "Minotaure", no. 8, 1936
Indian ink, 32.5 x 22 cm
Private collection

622 Woman with Drawers. Design for the cover of the catalogue of the Dalí exhibition at the Julien Levy Gallery in New York, 1936
Femme-tiroirs
Gouache on black paper, 35 x 27 cm
Private collection

623 Cover of "Minotaure", no. 8, 1936
Ink, gouache and collage on cardboard, 33 x 26.5 cm
New York, Isidore Ducasse Fine Arts

624 The Anthropomorphic Cabinet, 1936
Le cabinet anthropomorphique
Oil on panel, 25.4 x 44.2 cm
Düsseldorf, Kunstsammlung Nordrhein-Westfalen; formerly Collection Edward James

625 The City of Drawers – Study for the "Anthropomorphic Cabinet", 1936
La cité des tiroirs
Pencil on paper, 26.5 x 43.5 cm
Chicago (IL), The Art Institute of Chicago

626 The City of Drawers – Study for the "Anthropomorphic Cabinet", 1936
La cité des tiroirs – Etude pour «Le cabinet anthropomorphique»
Pen and Indian ink on copper gravure paper, 32 x 41.5 cm
New York, Collection Paul L. Herring; formerly Collection Edward James

627 Bust with Drawers, 1936
Buste à tiroirs
Black Indian ink and white gouache on reddish paper, 75 x 54.5 cm
Private collection; formerly Collection Edward James

628 Venus de Milo with Drawers, 1936
Vénus de Milo aux tiroirs
Dalí designed the drawers and his friend Marcel Duchamp made the sculpture
Bronze with plaster-like mount and fur tassels, 98 x 32.5 x 34 cm
Rotterdam, Museum Boymans-van Beuningen

629 Night and Day Clothes of the Body, 1936
Jour et nuit du corps
Gouache on paper, 30 x 40 cm
Private collection

630 Anatomical Studies – Transfer Series, 1937
Anatomies – Série décalcomanie
Oil on cardboard on panel, 50 x 64 cm
Basle, Galerie Beyeler

631 The Vertebrate Grotto – Transfer Series, 1936
La grotte vertébrée – Série décalcomanie
Gouache on black paper, 24 x 16 cm
Private collection

632 Soft Construction with Boiled Beans – Premonition of Civil War, 1936
Construction molle avec haricots bouillis – Prémonition de la guerre civile
Oil on canvas, 100 x 99 cm
Philadelphia, The Philadelphia Museum of Art, The Louise and Walter Arensberg Collection; formerly Collection Peter Watson

633 Study for "Premonition of Civil War", 1935
Etude pour «Prémonition de la guerre civile»
Pen, ink and pencil on paper, 23 x 18 cm
Private collection

634 Study for "Premonition of Civil War", 1935
Etude pour «Prémonition de la guerre civile»
Pen, ink and pencil on paper, 23 x 18 cm
Private collection

635 Study for "Premonition of Civil War", 1935
Etude pour «Prémonition de la guerre civile»
Pen, ink and pencil on paper, 23 x 18 cm
Private collection

636 Autumn Cannibalism, 1936
Cannibalisme de l'automne
Oil on canvas, 65 x 65.2 cm
London, The Tate Gallery; formerly Collection Edward James

637 Perspectives (Abbreviation for "Premonition of Paranoiac Perspectives through Soft Structures"), 1936/37
Perspectives (Abréviation pour «Prémonition des perspectives paranoïaques par les structures molles»)
Oil on canvas, 65.5 x 65 cm
Basle, Kunstmuseum Basel, Öffentliche Kunstsammlung, Emanuel Hoffmann Foundation

638 Average Pagan Landscape, 1937
Paysage païen moyen
Oil on panel, 38 x 46 cm
Geneva, Collection G.E.D. Nahmad; formerly Collection Edward James

639 Anthropomorphic Echo, 1937
Echo anthropomorphique
Oil on panel, 14 x 52 cm
St. Petersburg (FL), The Salvador Dalí Museum, on loan from E. and A. Reynolds Morse

640 Untitled (Vision of Eternity), 1936/37
Sans titre (Vision de l'éternité)
Oil on canvas, 207 x 118.1 cm
Chicago (IL), The Art Institute of Chicago

641 Enchanted Beach (Long Siphon), 1937
La plage enchantée (Siphon long)
Oil on canvas, 52 x 78 cm
Private collection; formerly Collection Edward James

642 Untitled, 1938
Sans titre
Oil; material and dimensions
unknown
Private collection

643 Swans Reflecting Elephants,
1937
*Cygnes reflétant des éléphants
(Swans Reflecting Elephants)*
Oil on canvas, 51 x 77 cm
Geneva, Cavalieri Holding Co. Inc.;
formerly Collection Edward James

644 Study for "The Metamorphosis
of Narcissus", 1937
*Etude pour «Métamorphose de
Narcisse»*
Indian ink on paper, 54.5 x 43 cm
Private collection; formerly
Collection Edward James

645 The Metamorphosis of
Narcissus, 1937
Métamorphose de Narcisse
Oil on canvas, 50.8 x 78.3 cm
London, The Tate Gallery; formerly
Collection Edward James

646 Cf. caption on p. 291

647 Drawers Cannibalism
(Composition with Drawers), 1937
*Cannibalisme des tiroirs
(Composition aux tiroirs)*
Pen and brush with black and grey
ink on paper, 54.5 x 75.8 cm
Cambridge (MA), The Fogg Art
Museum, Gift of Dr. and Mrs. Allan
Roos

648 Sleep, 1937
Le sommeil
Oil on canvas, 51 x 78 cm
Private collection; formerly
Collection Edward James

649 Untitled – Hysterical Scene,
1937
Sans titre – Scène hystérique
Pen and ink on paper, 43 x 46 cm
Private collection; formerly
Collection Edward James

650 The Invention of the Monsters,
1937
L'invention des monstres
Oil on panel, 51.2 x 78.5 cm
Chicago (IL), The Art Institute of
Chicago, Joseph Winterbotham
Collection

651 Creation of the Monsters, 1937
Formation des monstres
Black ink on pink paper,
23.8 x 15.9 cm
Chicago, Mrs. Edwin A. Bergman
Collection; formerly Collection
Edward James

652 Burning Giraffe, 1937
Girafe en feu
Oil; material and dimensions
unknown
Private collection

653 Queen Salomé, 1937
La reine Salomé
Charcoal and chalk on paper,
63.5 x 93.5 cm
Private collection

654 Herodias, 1937
Hérodiade
Oil on canvas; dimensions unknown
Private collection

655 Cannibalism of Objects –
Woman's Head with Shoe, 1937
*Cannibalisme des objets – Tête de
femme avec soulier*
Gouache and Indian ink on paper,
63.5 x 48.2 cm
Private collection; formerly
Collection Edward James

656 Dinner in the Desert Lighted
by Giraffes on Fire, 1937
*Dîner dans le désert éclairé par les
girafes en feu*
Charcoal, 62 x 46 cm
St. Petersburg (FL), The Salvador
Dalí Museum; formerly Collection
E. and A. Reynolds Morse

657 Surrealist Gondola above
Burning Bicycles (Drawing for a
film project with the Marx
Brothers), 1937
*Gondole surréaliste sur bicyclettes en
feu*
Charcoal, watercolour and pastel on
grey-brown paper, 74 x 54 cm
New York, Fashion Concepts;
formerly Collection Marx Brothers

658 Surrealist Dinner on a Bed
(Drawing for a film project with the
Marx Brothers), 1937
Dîner surréaliste sur un lit
Charcoal and gouache; dimensions
unknown
Whereabouts unknown

659 How Skyscrapers Will Look in
1987 (Drawing for "American
Weekly"), 1937
How Skyscrapers Will Look in 1987
Pen and ink on paper, 29.2 x 36.8 cm
New York, Perls Galleries

660 Untitled – Lamp with Drawers
(Drawing for an interior), c. 1937
*Sans titre – Lampe aux tiroirs (Projet
de décoration)*
Pencil on paper, 16.9 x 11.1 cm
Private collection

661 Untitled – Standard Lamp with
Crutches (Drawing for an interior),
c. 1937
*Sans titre – Lampadaire aux
béquilles (Projet de décoration)*
Pencil on paper, 16.9 x 11.1 cm
Private collection

662 Biactric Collars, c. 1936
Cols biactriques
Charcoal on paper, 67.3 x 48 cm
Geneva, Collection Jacques Benador

663 Portrait of Sigmund Freud,
1937
Portrait de Sigmund Freud
Indian ink and gouache on grey
background, 35 x 25 cm
Private collection

664 Portrait of Sigmund Freud –
Morphology of the Skull of
Sigmund Freud. Illustration for
"The Secret Life of Salvador Dalí",
1938
*Portrait de Sigmund Freud –
Morphologie du crâne de Sigmund
Freud. Illustration pour «La vie
secrète de Salvador Dalí»*
Pen and ink on paper; dimensions
unknown
Chichester (West Sussex), The New
Trebizond Foundation

665 Portrait of Sigmund Freud,
1938
Portrait de Sigmund Freud
Indian ink on blotting paper,
27 x 23 cm
Paris, Collection André-François
Petit

666 Imaginary Portrait of
Lautréamont (Aged 19), Done
Using the Paranoiac-Critical
Method (detail), 1937
*Portrait imaginaire de Lautréamont
à 19 ans obtenu d'après la méthode
paranoïaque-critique (détail)*
Pencil on ivory-coloured paper,
53.3 x 36.2 cm
Chicago, Mrs. Edwin A. Bergman
Collection

667 Study for "The False
Inspection" (False Perspective), 1937
*Etude pour «La fausse inspection»
(aussi: La fausse perspective)*
Pen, 54.6 x 38.1 cm
Brighton, Brighton Art Gallery;
formerly Spain, private collection

668 Cf. caption on p. 300

669 Palladio's Corridor of
Dramatic Surprise, 1938
*Le corridor de Palladio avec surprise
dramatique*
Oil on canvas, 73 x 104 cm
Private collection

670 Palladio's Thalia Corridor, 1937
Le corridor Thalia de Palladio
Oil on canvas, 116 x 89.5 cm
Geneva, Collection G.E.D.
Nahmad; formerly Collection
Edward James

671 Study for the self-portrait in
"Impressions of Africa", 1938
*Etude pour l'autoportrait
d'«Impressions d'Afrique»*
Pencil on paper, 52 x 33 cm
Rotterdam, Museum Boymans-van
Beuningen; formerly Collection
Edward James

672 Impressions of Africa, 1938
Impressions d'Afrique
Oil on canvas, 91.5 x 117.5 cm
Rotterdam, Museum Boymans-van
Beuningen; formerly Collection
Edward James

673 Study for the self-portrait in
"Impressions of Africa", 1938
*Etude pour l'autoportrait
d'«Impressions d'Afrique»*
Pencil and Indian ink on paper,
63 x 48 cm
Rotterdam, Museum Boymans-van
Beuningen; formerly Collection
Edward James

674-677 Cf. captions on p. 304

678 Debris of an Automobile
Giving Birth to a Blind Horse
Biting a Telephone, 1938
*Débris d'une automobile donnant
naissance à un cheval aveugle
mordant un téléphone*
Oil on canvas, 54 x 65 cm
New York, The Museum of Modern
Art, Gift of James Thrall Soby

679 Gradiva, 1938
Gradiva
Pen and Indian ink on blotting
paper, 42.1 x 27 cm
Private collection

680 Coccyx Women, 1938
Femmes-coccyx
Indian ink on blotting paper,
26.5 x 38.5 cm
Private collection; formerly
Collection Edward James

681 Imaginary Figures with a
Background of Spanish Monuments
(Study for the costumes for Coco
Chanel), 1938
*Quatre personnages imaginaires sur
fond de monuments espagnols
(Etude de costumes pour Coco
Chanel)*
Pen, ink and watercolour, 35 x 56 cm
Private collection; formerly
Collection Edward James

682 Composition – Two Women with a Town in the Background, 1938
Composition – Deux femmes et une ville dans le fond
Pen, ink and watercolour, 45.7 x 32.2 cm
Private collection; formerly Collection Edward James

683 Fantastic Beach Scene with Skeleton and Parrot, 1938
Scène de plage fantastique avec perroquet et carcasse de bateau
Indian ink, gouache and watercolour on paper, 33 x 25 cm
Paris, private collection; formerly Collection Edward James

684-686 and 688-690 Subjects for "The Endless Enigma" (L'énigme sans fin), which Dalí drew for the catalogue of his exhibition at Julien Levy's in New York in 1939.

684 Beach at Cape Creus with Seated Woman Seen from the Back Mending a Sail, and Boat, 1938
Plage de Cap Creus avec femme assise vue de dos recousant une voile, et bateau
Pencil on paper, 21.5 x 28 cm
Private collection

685 Philosopher Reclining, 1938
Philosophe allongé
Pencil on paper, 21.5 x 28 cm
Private collection

686 Face of the Great Cyclopean Cretin, 1938
Visage du grand cyclope crétin
Pencil on paper, 21.5 x 28 cm
Private collection

687 The Endless Enigma, 1938
L'énigme sans fin
Oil on canvas, 114.3 x 144 cm
Madrid, Museo Nacional Reina Sofía, Gift of Dalí to the Spanish state

688 Greyhound, 1938
Lévrier
Pencil on paper, 21.5 x 28 cm
Private collection

689 Mandolin, Fruit Dish with Pears, Two Figs on a Table, 1938
Mandoline, compotier avec poires, deux figues sur la table
Pencil on paper, 21.5 x 28 cm
Private collection

690 Mythological Beast, 1938
Bête mythologique
Pencil on paper, 21.5 x 28 cm
Private collection

691 Apparition of Face and Fruit Dish on a Beach, 1938
Apparition d'un visage et d'un compotier sur une plage
Oil on canvas, 114.5 x 143.8 cm
Hartford (CT), The Wadsworth Atheneum

692 Study for "The Image Disappears", 1938
Etude pour «L'image disparaît» (The Image Disappears)
Pencil, Indian ink and wash, 74 x 44 cm
Gift of Dalí to the Spanish state

693 The Image Disappears, 1938
L'image disparaît (The Image Disappears)
Oil on canvas, 55.9 x 50.8 cm
Figueras, Fundación Gala-Salvador Dalí, Gift of Dalí to the Spanish state

694 Apparition of the Figure of Vermeer on the Face of Abraham Lincoln. Study for "The Image Disappears", 1938
Apparition d'une figure de Vermeer dans le visage d'Abraham Lincoln. Etude pour «L'image disparaît»
Pencil on paper, 63 x 48 cm
Private collection

695 Metamorphosis of a Man's Bust into a Scene Inspired by Vermeer – The Triple Image, 1939
Métamorphose d'un buste d'homme en scène inspirée par Vermeer – La triple image
Indian ink and wash, 63.5 x 48.5 cm
Figueras, Fundación Gala-Salvador Dalí

696 Metamorphosis of a Man's Bust into a Scene Inspired by Vermeer – The Triple Image, 1939
Métamorphose d'un buste d'homme en scène inspirée par Vermeer – La triple image
Indian ink and wash, 63.5 x 48.5 cm
Figueras, Fundación Gala-Salvador Dalí

697 Invisible Afghan with the Apparition on the Beach of the Face of García Lorca in the Form of a Fruit Dish with Three Figs, 1938
Afghan invisible avec apparition sur la plage du visage de García Lorca en forme de compotier avec trois figues
Oil on panel, 19.2 x 24.1 cm
Private collection

698 Spain, 1938
Espagne
Oil on canvas, 91.8 x 60.2 cm
Rotterdam, Museum Boymans-van Beuningen; formerly Collection Edward James

699 The Warner, 1938
L'alerte
Oil on canvas, 24 x 19 cm
Berlin, private collection; formerly Collection Jeanne Buchern

700 Study for "Spain", 1936
Etude pour «Espagne»
Indian ink, 77.5 x 57.7 cm
Private collection

701 Enchanted Beach with Three Fluid Graces, 1938
Plage enchantée avec trois grâces fluides
Oil on canvas, 65 x 81 cm
St. Petersburg (FL), The Salvador Dalí Museum, on loan from the Morse Charitable Trust

702 The Transparent Simulacrum of the Feigned Image, 1938
Le simulacre transparent de la fausse image (The Transparent Simulacrum of the Feigned Image)
Oil on canvas, 73.5 x 92 cm
Buffalo (NY), Albright Knox Art Gallery, Heritage A. Conger Goodyear, 1966

703 The Sublime Moment, 1938
Le moment sublime
Oil on canvas, 38 x 47 cm
Stuttgart, Staatsgalerie Stuttgart

704 Beach with Telephone, 1938
Plage avec téléphone
Oil on canvas, 73.6 x 92 cm
London, The Tate Gallery; formerly Collection Edward James

705 Imperial Violets, 1938
Violettes impériales
Oil on canvas, 99.5 x 142.5 cm
Private collection; formerly Collection Edward James; formerly The Museum of Modern Art, New York

706 The Enigma of Hitler, c. 1939
L'énigme d'Hitler
Oil on canvas, 51.2 x 79.3 cm
Madrid, Museo Nacional Reina Sofía, Gift of Dalí to the Spanish state

707 Telephone in a Dish with Three Grilled Sardines at the End of September, 1939
Téléphone sur le plat avec trois sardines grillées à la fin de septembre
Oil on canvas, 45.7 x 54.9 cm
St. Petersburg (FL), The Salvador Dalí Museum, on loan from the Morse Charitable Trust

708 Philosopher Illumined by the Light of the Moon and the Setting Sun, 1939
Philosophie éclairée par la lumière de la lune et du soleil couchant
Oil on canvas, 128 x 160 cm
Paris, private collection

709 Landscape with Telephones on a Plate, 1939
Paysage avec téléphones sur un plat
Oil on canvas, 22 x 30 cm
Madrid, Galería Theo; formerly Collection Edward James

710 Clothed Automobile (Two Cadillacs), 1941
Automobiles habillées (Deux Cadillac)
Oil on cardboard, 39.5 x 27 cm
Figueras, Fundación Gala-Salvador Dalí

711 The Broken Egg, 1943
L'œuf brisé
Indian ink, 19.4 x 15.1 cm
Private collection

712, 713, 714, 716 Cf. captions on p. 321

715 The Sphere Attacks the Pyramid. Cover of the catalogue of the exhibition at Julien Levy's in New York, 1939
La sphère attaque la pyramide
Gouache, 65 x 51.5 cm
Private collection

717, 718 Cf. captions on p. 322

719-720 Cf. captions on p. 323

721 Cf. caption on p. 324

722 Sirens and Graces – Set design for Dalí's "Bacchanale", c. 1939
Sirène et ses grâces – Bacchanale
Pen and Indian ink over photograph on cardboard, 18.5 x 24.5 cm
Private collection; formerly Collection B. Kochno

723 Cf. caption on p. 324

724 Cf. caption on p. 325

725 Set for "Bacchanale", 1939
Bacchanale
Oil on canvas on cardboard, 46 x 61 cm
Zurich, Collection Rita Green

726 Set for "Bacchanale", c. 1939
Bacchanale
Oil on canvas, 40 x 50 cm
Private collection

727 Cf. caption on p. 325

728 Drawing for "Bacchanale": Ludwig II of Bavaria, 1939
Dessin pour «Bacchanale»: Louis II de Bavière
Pen, Indian ink, pencil, watercolour, gouache with collage, 20.2 x 27.6 cm
Private collection

729 Psychoanalysis and Morphology Meet, 1939
Rencontre de la psychanalyse et de la morphologie
Oil on canvas, 25 x 46 cm
Private collection; formerly Collection Mrs. Gérard B. Lambert

730 Gradiva, She Who Advances, 1939
Gradiva, celle qui avance
Pencil, pen, watercolour and wash, 30.2 x 22.8 cm
Private collection; formerly Collection Richard S. Zeisler

731 Tristan Insane, c. 1938
Tristan fou
Oil on panel, 46 x 55 cm
St. Petersburg (FL), The Salvador Dalí Museum, on loan from E. and A. Reynolds Morse

732 The Dream of Venus, 1939
Le rêve de Vénus
Oil on canvas on masonite (four panels), 240 x 480 cm (total size), 240 x 120 cm (each panel)
New York, Fashion Concepts

733 Gradiva Becoming Fruits, Vegetables, Pork, Bread, and Grilled Sardine, 1939
Gradiva devenant fruits, légumes, charcuterie, pain et sardine grillée
Pencil, pen, watercolour and wash, 30.2 x 22.8 cm
Private collection; formerly Collection Richard S. Zeisler

734 Metamorphosis of the Five Allegories of Giovanni Bellini, 1939
Métamorphose des cinq allégories de Giovanni Bellini
Gouache and Indian ink on a photograph, 23 x 15.5 cm
Private collection

735 Shirley Temple, the Youngest, Most Sacred Monster of the Cinema in her Time, 1939
Shirley Temple, le plus jeune monstre sacré du cinéma de son temps
Gouache, pastel and collage on cardboard, 75 x 100 cm
Rotterdam, Museum Boymans-van Beuningen

736 Baby Map of the World, 1939
Bébé-mappemonde
Oil on advertisement, 49.5 x 38.5 cm
Figueras, Fundación Gala-Salvador Dalí, Gift of Dalí to the Spanish state

737 Freud's Perverse Polymorph (Bulgarian Child Eating a Rat), 1939
Le pervers polymorphe de Freud (Enfant bulgare mangeant un rat)
Gouache on a photograph, 40 x 35 cm
Private collection

738 Apparition of a War Scene on the Face of Lieutenant Deschanel. Cover of "Match", 1939
Apparition d'une scène de guerre dans le visage du lieutenant Deschanel. Couverture de «Match»
Pencil and Indian ink on a magazine cover, 35.6 x 27.1 cm
Private collection

739 Study for "Portrait of Gala", 1939
Etude pour «Portrait de Gala»
Pencil on paper, 33.5 x 22.5 cm
Figueras, Fundación Gala-Salvador Dalí

740 Portrait of Gala (unfinished; detail), 1939
Portrait de Gala
Oil on canvas, 56 x 50 cm
Madrid, Centro de Arte Reina Sofía, Gift of Dalí to the Spanish state

741 Untitled – Figure (unfinished), 1938/39
Sans titre – Personnage
Oil on canvas, 292 x 130 cm
Figueras, Fundación Gala-Salvador Dalí, Gift of Dalí to the Spanish state

742 Lady Louis Mountbatten, 1940
Portrait de Lady Louis Mountbatten
Oil on canvas, 63.5 x 52 cm
Private collection

743 Slave Market with the Disappearing Bust of Voltaire, 1940
Marché d'esclaves avec apparition du buste invisible de Voltaire
Oil on canvas, 46.5 x 65.5 cm
St. Petersburg (FL), The Salvador Dalí Museum, on loan from the Morse Charitable Trust

744 Old Age, Adolescence, Infancy (The Three Ages), 1940
Les trois âges (La vieillesse, l'adolescence, l'enfance)
Oil on canvas, 50 x 65 cm
St. Petersburg (FL), The Salvador Dalí Museum, on loan from E. and A. Reynolds Morse

745 Allegory of Sunset Air (Allegory of the Evening), 1940/41
Allegory of Sunset Air (Allegory of the Evening)
Oil on canvas, 25.4 x 18 cm
Private collection

746 Spider of the Evening… Hope!, 1940
Araignée du soir… espoir
Oil on canvas, 40.5 x 50.8 cm
St. Petersburg (FL), The Salvador Dalí Museum, on loan from the Morse Charitable Trust

747 Family of Marsupial Centaurs, 1940
Famille de centaures marsupiaux (Family of Marsupial Centaurs)
Oil on canvas, 35.6 x 31 cm
Private collection; formerly Collection Alfonso Gonzalez Pardo

748 Group of Women Imitating the Gestures of a Schooner, 1940
Trois femmes imitant les mouvements d'un voilier
Oil on canvas, 55 x 65 cm
Private collection; formerly Harold McCormick Collection

749 The Golden Age – Family of Marsupial Centaurs, 1940/41
L'âge d'or – Family of Marsupial Centaurs
Oil; material and dimensions unknown
Whereabouts unknown

750 Centaur (The Triumph of Nautilus), 1940
Centaure (Le triomphe de Nautilus)
Pencil and watercolour on paper, 76.4 x 56 cm (irregular)
Figueras, Fundación Gala-Salvador Dalí

751 Untitled (Three Figures and a Cypress), 1940
Sans titre
Watercolour, 34.5 x 25.2 cm
Montreal, Montreal Museum of Fine Art

752 March of Time Comittee – Papillon, c. 1940
March of Time Comittee – Papillon
Oil on canvas, 6 x 18 cm
Private collection

753 Two Pieces of Bread Expressing the Sentiment of Love, 1940
Deux morceaux de pain exprimant le sentiment de l'amour
Oil on canvas, 82 x 100 cm
Figueras, Fundación Gala-Salvador Dalí, Gift of Dalí to the Spanish state

754 Drawing for the glass hallucination in Hitchcock's film "Moontide (The House of Dr. Edwards)", 1941
Blue ink and pencil, 49.5 x 29 cm
Gift of Dalí to the Spanish state

755 The Face of War, 1940/41
Visage de la guerre
Oil on canvas, 64 x 79 cm
Rotterdam, Museum Boymans-van Beuningen; formerly Collection André Cauvin

756 Ballerina in a Death's-Head, 1939
Ballerine en tête de mort
Oil on canvas, 24.5 x 19.5 cm
Pal, Collection Merz

757 Human skull consisting of seven naked women's bodies. Photograph: Philippe Halsman, 1951, after a drawing by Dalí

758 The Face of War – Drawing for the nightmare scene in the film "Moontide", 1941
Visage de la guerre
Pencil, black Indian ink and wash, 17 x 13.2 cm
Figueras, Fundación Gala-Salvador Dalí

759 Café scene. The figures at the table make a skull – Drawing for the nightmare in "Moontide", 1941
Scène de café
Pencil, black Indian ink and wash, 13.6 x 12.6 cm
Figueras, Fundación Gala-Salvador Dalí

760 Study for "Original Sin", 1941
Etude pour «Le péché originel»
Pencil, Indian ink and pen on smooth, yellowish paper, 48.1 x 63.1 cm
Private collection

761 Original Sin, 1941
Le péché originel
Oil on canvas, 81.2 x 101.5 cm
Private collection; formerly Collection Edward James

762 The Eye of Time, 1949
The Eye of Time (L'œil du temps)
Enamel, diamonds and rubies, 4 x 6.4 x 1.5 cm
Whereabouts unknown

763 Ruby Lips, 1950
Ruby Lips (Les lèvres de rubis)
Rubies, pearls and gold, 3 x 5 x 1 cm
Whereabouts unknown

764 Costume for a Nude with a Codfish Tail, 1941
Costume de nu avec queue de morue
Oil on canvas, 50.8 x 35.6 cm
Private collection; formerly Collection Marquis de Cuevas

765 Disappearing Bust of Voltaire, 1941
Disparition du buste de Voltaire
Oil on canvas, 46.3 x 55.4 cm
St. Petersburg (FL), The Salvador Dalí Museum, on loan from E. and A. Reynolds Morse

766 Study for "Disappearing Bust of Voltaire", 1941
Etude pour «Disparition du buste de Voltaire»
Gouache on paper, 50 x 64 cm
Private collection

767 Actress Betty Stockfeld is Metamorphosed into a Nurse, 1939
L'actrice de cinéma Betty Stockfeld se transformant en nourrice
Gouache on the "Pour vous" programme, 45 x 30 cm
Figueras, Fundación Gala-Salvador Dalí

768 Mysterious Mouth Appearing in the Back of my Nurse, 1941
Mysterious Mouth Appearing in the Back of my Nurse
Gouache on paper, 44.7 x 30.3 cm
Private collection

769, 770 Cf. captions on p. 342

771 Soft Self-Portrait with Fried Bacon, 1941
Autoportrait mou avec lard grillé (Soft Self-Portrait with Fried Bacon)
Oil on canvas, 61.3 x 50.8 cm
Figueras, Fundación Gala-Salvador Dalí

772 Design for "Labyrinth", 1941
Projet pour «Labyrinthe»
Pen, ink, watercolour and pencil, 28 x 38 cm
Whereabouts unknown

773 Design for the set of "Labyrinth", 1941
Maquette de décor pour «Labyrinthe»
Oil on canvas, 39 x 64 cm
Spain, private collection

774 Cf. caption on p. 344

775 Design for the set of "Labyrinth", 1941
Maquette de décor pour «Labyrinthe»
Oil on canvas, 22.7 x 45.3 cm
Private collection

776 Study for the set of "Labyrinth" – Fighting the Minotaur, 1942
Combat avec le Minotaure
Pencil, Indian ink, watercolour and gouache, 58.6 x 73.8 cm
Figueras, Fundación Gala-Salvador Dalí

777 Saint George and the Dragon, 1942
Saint Georges et le dragon
Oil on ivory (?), 7.5 x 10 cm
Private collection

778 Honey Is Sweeter than Blood, 1941
Le miel est plus doux que le sang (Honey Is Sweeter than Blood)
Oil on canvas, 49.5 x 60 cm
Santa Barbara (CA), The Santa Barbara Museum of Art, Gift of Mr. and Mrs. Warren Tremaine, 1949

779 Mural painting for Helena Rubinstein (panel 1), 1942
Décor mural pour Helena Rubinstein
Mural; dimensions unknown
Yokohama, Yokohama Museum of Art; formerly Collection Helena Rubinstein

780 Untitled – Design for the mural painting for Helena Rubinstein, 1942
Sans titre (Maquette pour panneau décoratif pour Helena Rubinstein)
Oil on canvas, 48 x 44 cm
Private collection; formerly Collection Helena Rubinstein

781 Ruin with Head of Medusa and Landscape (dedicated to Mrs. Chase), 1941
Ruine avec tête de Méduse et paysage
Oil on canvas, 36 x 25.4 cm
Madrid, Collection Juan Abelló Gallo

782 Mural painting for Helena Rubinstein (panel 2), 1942
Décor mural pour Helena Rubinstein
Mural; dimensions unknown
Yokohama, Yokohama Museum of Art; formerly Collection Helena Rubinstein

783 Mural painting for Helena Rubinstein (panel 3), 1942
Décor mural pour Helena Rubinstein
Mural; dimensions unknown
Private collection; formerly Collection Helena Rubinstein

784 Nude on the Plain of Rosas, 1942
Nu dans la plaine de Rosas
Oil on canvas, 50 x 50 cm
Yokohama, Yokohama Museum of Art; formerly Collection P. de Gavardie

785 Untitled – Set design (Figures cut in three), 1942
Sans titre – Maquette de décor (Personnages coupés en trois parties)
Oil; material and dimensions unknown
Private collection

786 Temple – Sketch for a set design, c. 1941
Temple
Oil on canvas, 22 x 32 cm
Madrid, Museo Nacional Reina Sofía, Gift of Dalí to the Spanish state

787 Composition (Two Harlequins), 1942
Composition (Les deux arlequins)
Oil on canvas, 23 x 35.6 cm
Private collection

788 Equestrian Parade (possibly set design for "Romeo and Juliet"), 1942
Parade de cavaliers
Oil on canvas, 31 x 51 cm
Private collection

789 The Two on the Cross, 1942
Les deux croisés
Gouache on a photograph; dimensions unknown
Private collection

790 The Triumph of Nautilus, 1941
Le triomphe de Nautilus
Oil on canvas, 23.6 x 27.7 cm
Private collection

791 Study for "Portrait of Mrs. Georges Tait, II", 1941
Etude pour «Portrait de Mrs. Georges Tait, II»
Pencil on paper, 37 x 30.5 cm
Private collection

792 Composition, 1942
Composition
Oil on six glass panels, 55.5 x 173 cm
Tel Aviv, Tel Aviv Museum

793 Portrait of Mrs. George Tait, II, 1941
Portrait de Mrs. George Tait, II
Oil; material and dimensions unknown
Private collection

794 Study for the portrait "Princess Arthchild Gourielli-Helena Rubinstein", 1942/43
Etude pour «Portrait de la Princesse Arthchild Gourielli-Helena Rubinstein»
Pencil, 25.3 x 19.2 cm
Private collection

795 Princess Arthchild Gourielli-Helena Rubinstein, 1942/43
Portrait de la Princesse Arthchild Gourielli-Helena Rubinstein
Oil on canvas, 88.9 x 66 cm
New York, Helena Rubinstein Foundation

796 Design for the set of "Romeo and Juliet", 1942
Maquette de décor pour «Roméo et Juliette»
Oil on canvas, 22.7 x 45.3 cm
Private collection

797 Design for the set of "Romeo and Juliet" – Backdrops and wing flats, 1942
Maquette de décor pour «Roméo et Juliette»
Oil on canvas, 22.7 x 45.3 cm
Private collection

798 Design for the set of "Romeo and Juliet", 1942
Etude de décor pour «Roméo et Juliette»
Gouache, 22.5 x 35.5 cm
Gift of Dalí to the Spanish state

799 Juliet's Tomb, 1942
Le tombeau de Juliette
Oil on canvas, 50.7 x 50.7 cm
Private collection

800 Study for the set of "Romeo and Juliet", 1942
Etude de décor pour «Roméo et Juliette»
Oil on cardboard, 28.6 x 37.4 cm
Private collection

801 Romeo and Juliet Memorial, 1942
Roméo et Juliette Mémorial
Oil on cardboard, 28.6 x 37.4 cm
Private collection

802 Nativity of a New World, 1942
Nativity of a New World (Naissance du Nouveau monde ou Naissance d'une nation)
Oil on canvas, 35 x 44.7 cm
Private collection; formerly Collection Kohn

803 Divine Couple – Sketch for "Nativity of a New World", 1942
Couple céleste – Esquisse pour «Naissance du Nouveau monde»
Oil, Indian ink and watercolour on cardboard, 21 x 28 cm
Private collection

804 The Flames, They Call, 1942
Las Llamas, llaman
Oil on canvas, 145 x 122 cm
Private collection

805 Design for a poster for "The Secret Life of Salvador Dalí". The autobiography was published by Dial Press, New York, 1942
Projet d'affiche pour l'ouvrage «The Secret Life of Salvador Dalí»
Gouache on a photograph,
87 x 88 cm
Private collection

806 Portrait of Mrs. Luther Greene, 1942
Portrait de Mrs. Luther Greene
Oil; material and dimensions unknown
Private collection

807 Study for the campaign against venereal disease: "Soldier Take Warning", 1942
Indian ink, gouache and pencil on brown paper, 44.5 x 31.2 cm
Private collection

808 Untitled – For the campaign against venereal disease, 1942
Sans titre
Oil on canvas, 43.2 x 35.6 cm
Private collection

809 Melancholy – Portrait of Singer Claire Dux, 1942
Mélancolie – Portrait de la cantatrice Claire Dux
Oil on canvas, 80 x 60 cm
Private collection

810 Portrait of the Marquis de Cuevas, 1942
Portrait du marquis de Cuevas
Oil; material and dimensions unknown
Private collection

811 Portrait of Mrs. Ortiz-Linares, 1942
Portrait de Madame Ortiz-Linares
Oil on canvas, 78 x 63 cm
Private collection; formerly Collection G. de Ortiz-Linares

812 Design for the interior decoration of a stable-library, 1942
Projet d'interprétation pour une étable-bibliothèque
Chrome overpainted with gouache and Indian ink, 51 x 45 cm
Figueras, Fundación Gala-Salvador Dalí

813 The Sheep (after conversion), 1942
Les moutons (après la transformation)
Watercolour and chromolithograph, 23 x 34 cm
St. Petersburg (FL), The Salvador Dalí Museum, on loan from E. and A. Reynolds Morse

814 Cf. caption on p. 359

815 Portrait of Mrs. Harrison Williams, 1943
Portrait de Madame Harrison Williams
Oil on canvas; dimensions unknown
Mona Bismark Foundation, Inc.

816 Portrait of Ambassador Cardenas, 1943
Portrait de l'ambassadeur Cardenas
Oil on canvas, 61.3 x 50.8 cm
Private collection

817 The Triumph of Tourbillon, 1943
Le triomphe de Tourbillon
Oil on canvas, 31 x 40 cm
Figueras, Fundación Gala-Salvador Dalí

818 Condottiere (Self-Portrait as Condottiere?), 1943
Condottière (Autoportrait en condottière?)
Indian ink on white paper, 76.3 x 55.8 cm
Private collection

819 Untitled – New Accessoires, 1943
Sans titre – New Accessories
Oil on canvas; dimensions unknown
Private collection

820 Madonna, 1943
La madone
Oil on canvas, 50.7 x 28 cm
Private collection

821 Stage curtain for the ballet "Café de Chinitas", performed by the Ballet Theatre, 1943
Oil on canvas, 90 x 60 cm
Private collection

822 Painting for the backdrop of "Café de Chinitas", 1943
Oil on canvas, 88 x 56 cm
Private collection; formerly Collection Marquis de Cuevas

823 The Madonna of the Birds with Two Angels, 1943
Vierge aux oiseaux, avec deux anges
Watercolour, 62.2 x 47 cm
St. Petersburg (FL), The Salvador Dalí Museum

824 Poetry of America – The Cosmic Athletes, 1943
Poésie d'Amérique – Les athlètes cosmiques
Oil on canvas, 116.8 x 78.7 cm
Figueras, Fundación Gala-Salvador Dalí

825 Geopolitical Child Watching the Birth of the New Man, 1943
Enfant géopolitique observant la naissance de l'homme nouveau
Oil on canvas, 45.5 x 50 cm
St. Petersburg (FL), The Salvador Dalí Museum, on loan from the Morse Charitable Trust

826 Cf. caption on p. 365

827 Allegory of an American Christmas, 1943
Allégorie d'un Noël americain
Oil and gouache on cardboard, 40.5 x 30.5 cm
Private collection

828 Monumental shield for "Hidden Faces". The book was published by Dial Press in New York, 1944
Watercolour and gouache, 277.9 x 121.6 cm
Gift of Dalí to the Spanish state

829 Frontispiece for "Hidden Faces" – I am the Lady…, 1944
Frontispice de «Hidden Faces» – Je suis la dame…
Indian ink, 21.5 x 14.5 cm
Gift of Dalí to the Spanish state

830 Tristan Insane (Tristan as Christ), 1944
Tristan fou (Tristan as Christ)
Watercolour on paper, 63.8 x 50.7 cm
Gift of Dalí to the Spanish state

831 Study for the backdrop of the ballet "Tristan Insane" (Act II), 1944
Etude pour la toile de fond du ballet «Tristan fou» (acte II)
Oil on canvas, 61 x 96.5 cm
Figueras, Fundación Gala-Salvador Dalí

832 Cf. caption on p. 369

833 Study for the set of the ballet "Tristan Insane" (Act I), 1944
Etude pour une toile de fond pour «Tristan fou» (acte I)
Oil on canvas, 28 x 48 cm
Private collection

834 "Tristan and Isolde" – Study for the set of the ballet "Bacchanale", 1944
«Tristan et Iseult» – Etude pour le rideau de scène du ballet «Bacchanale»
Oil and Indian ink, 30.3 x 40.5 cm
Gift of Dalí to the Spanish state

835 "Tristan Insane": Costumes for the Spirits of Death, 1944
«Tristan fou»: costumes pour les esprits de la mort
Technique and dimensions unknown
Private collection

836 Design for the set of the ballet "Tristan and Isolde", 1944
Maquette pour le rideau de scène du ballet «Tristan et Iseult»
Oil on canvas, 26.7 x 48.3 cm
Figueras, Fundación Gala-Salvador Dalí

837 Set of "Tristan and Isolde", 1941
Décor pour «Tristan et Iseult»
Oil on canvas, 64 x 79 cm
Private collection; formerly Collection Edward James

838 Cf. caption on p. 372

839 Victory – Woman Metamorphosing into a Boat with Angels, 1945
Victory – Femme se transformant en bateau avec anges musiciens
Oil on canvas, 33 x 24 cm
Private collection

840 Costume for "Tristan Insane" – The Boat, c. 1944
Costume pour «Tristan fou» – Le bateau
Oil on canvas, 29.5 x 22.5 cm
Private collection; formerly Collection Pecci Blunt

841 Costume for "Tristan Insane" – The Ship, 1942/43
Costume pour «Tristan fou» – Le navire
Watercolour, 63 x 46 cm
St. Petersburg (FL), The Salvador Dalí Museum

842 Study for "Colloque sentimental", 1944
Etude pour «Colloque sentimental»
Oil on canvas, 26 x 47 cm
St. Petersburg (FL), The Salvador Dalí Museum, on loan from E. and A. Reynolds Morse

843 Cf. caption on p. 372

844 Music – The Red Orchestra – The Seven Arts, 1944
La musique – L'orchestre rouge – Les sept arts
Oil on canvas; dimensions unknown
Destroyed in a fire at the Ziegfeld Theatre, New York

845 Women Metamorphosed – The Seven Arts, 1944
Femmes métamorphosées – Les sept arts
Oil on canvas; dimensions unknown
Destroyed in a fire at the Ziegfeld Theatre, New York

846 Untitled – The Seven Arts, 1944
Sans titre – Les sept arts
Oil on canvas; dimensions unknown
Destroyed in a fire at the Ziegfeld
Theatre, New York

847 Dance – The Seven Arts, 1944
La danse – Les sept arts
Oil on canvas; dimensions unknown
Destroyed in a fire at the Ziegfeld
Theatre, New York

848 Untitled – The Seven Arts, 1944
Sans titre – Les sept arts
Photograph on a print; dimensions
unknown
Destroyed in a fire at the Ziegfeld
Theatre, New York

849 Untitled – The Seven Arts, 1944
Sans titre – Les sept arts
Oil on canvas; dimensions unknown
Destroyed in a fire at the Ziegfeld
Theatre, New York

850 Leg Composition. Drawing
from a series of advertisements for
Bryans Hosiery, c. 1944
Composition à la jambe
Watercolour and Indian ink;
dimensions unknown
Whereabouts unknown

851 Paranoia (Surrealist Figures),
1944
*Paranoïa (Figures surréalistes ou
Dame au bord de la mer)*
Oil on panel, 35 x 23.7 cm
Private collection

852 Dream Caused by the Flight of
a Bee around a Pomegranate, One
Second before Awakening, 1944
*Rêve causé par le vol d'une abeille
autour d'une pomme-grenade, une
seconde avant l'éveil*
Oil on canvas, 51 x 40.5 cm
Madrid, Museo Thyssen,
Fondazione Thyssen-Bornemisza

853 Gala Naked. Study for "Dream
Caused by the Flight of a Bee…",
1944
*Gala nue. Etude pour «Rêve causé
par le vol d'une abeille…»*
Pencil on paper, 31 x 44 cm
Private collection

854 Galarina, 1944/45
Galarina
Oil on canvas, 64.1 x 50.2 cm
Figueras, Fundación Gala-Salvador
Dalí, Gift of Dalí to the Spanish state

855 Portrait of Gala, 1941
Portrait de Gala
Pencil on paper, 63.9 x 49 cm
Rotterdam, Museum Boymans-van
Beuningen, on loan from the New
Trebizond Foundation

856 Untitled – Illustration for "50
Secrets of Magic Craftsmanship",
published in 1948 by Dial Press in
New York, 1947
*Sans titre. Illustration pour «Les 50
secrets magiques»*
Technique and dimensions unknown
Whereabouts unknown

857 My Wife, Nude,
Contemplating her own Flesh
Becoming Stairs, Three Vertebrae of
a Column, Sky and Architecture,
1945
*Ma femme, nue, regardant son
propre corps devenir marches, trois
vertèbres d'une colonne, ciel et
architecture*
Oil on panel, 61 x 52 cm
New York, Collection José Mugrabi

858 Study for "Galarina", 1943
Etude pour «Galarina»
Pencil on paper, 72.3 x 53.7 cm
Figueras, Fundación Gala-Salvador
Dalí

859 Three Apparitions of the Face
of Gala, 1945
*Trois visages de Gala apparaissant
sur des rochers*
Oil on panel, 20.5 x 27.5 cm
Figueras, Fundación Gala-Salvador
Dalí

860 Portrait of Gala. Study for
"Galarina", c. 1941
*Portrait de Gala. Etude pour
«Galarina»*
Pencil on paper, 62.8 x 42 cm
Private collection

861 Cf. caption on p. 381

862 The Apotheosis of Homer,
1944/45
L'apothéose d'Homère
Oil on canvas, 63.7 x 116.7 cm
Munich, Staatsgalerie moderner
Kunst; formerly Collection
Gonzales Pardo

863 The Broken Bridge of the
Dream, 1945
Le pont brisé du rêve
Oil on canvas, 65.7 x 86.2 cm
St. Petersburg (FL), The Salvador
Dalí Museum, on loan from E. and
A. Reynolds Morse

864 Fountain of Milk Flowing
Uselessly on Three Shoes, 1945
*Fontaine de lait coulant en vain sur
trois souliers*
Oil on canvas, 18 x 22 cm
St. Petersburg (FL), The Salvador
Dalí Museum, on loan from E. and
A. Reynolds Morse

865 Napoleon's Nose, Transformed
into a Pregnant Woman, Walking
his Shadow with Melancholia
amongst Original Ruins, 1945
*Nez de Napoléon transformé en
femme enceinte promenant son
ombre avec mélancolie parmi des
ruines originales*
Oil on canvas, 51 x 65.5 cm
Geneva, Collection G.E.D. Nahmad

866 Untitled – Scene with Marine
Allegory, 1945
*Sans titre – Scène avec allégorie
marine*
Oil on canvas; dimensions unknown
Private collection

867 Autumn Sonata, 1945
Sonate d'automne
Oil on canvas, 16 x 30 cm
St. Petersburg (FL), The Salvador
Dalí Museum; formerly Collection
E. and A. Reynolds Morse

868 Cf. caption on p. 385

869 Melancholy, Atomic, Uranic
Idyll, 1945
*Idylle atomique et uranique
mélancolique*
Oil on canvas, 65 x 85 cm
Madrid, Museo Nacional Reina
Sofía, Gift of Dalí to the Spanish
state

870 Basket of Bread – Rather
Death than Shame, 1945
*Corbeille de pain – Plutôt la mort
que la souillure*
Oil on panel, 33 x 38 cm
Figueras, Fundación Gala-Salvador
Dalí

871 Resurrection of the Flesh,
1940-1945
*Résurrection de la chair
(Resurrection of the Flesh)*
Oil on canvas, 90 x 72 cm
Collection Bruno Pagliai

872 Untitled – Portrait of a
Woman, 1945
Sans titre – Portrait de femme
Oil; material and dimensions
unknown
Private collection

873 Composition – Portrait of Mrs.
Eva Kolsman, 1946
*Composition – Portrait de Madame
Eva Kolsman*
Oil on canvas, 77 x 92 cm
Private collection

874 Portrait of Mrs. Isabel
Styler-Tas (Melancolía), 1945
*Portrait de Madame Isabel
Styler-Tas (Melancolía)*
Oil on canvas, 65.5 x 86 cm
Berlin, Staatliche Museen zu
Berlin-Preußischer Kulturbesitz,
Nationalgalerie

875 Study for "Portrait of Mrs.
Isabel Styler-Tas", 1945
*Etude pour «Portrait de Madame
Isabel Styler-Tas»*
Pencil on paper, 39.8 x 28.3 cm
Berlin, Staatliche Museen zu
Berlin-Preußischer Kulturbesitz,
Kupferstichkabinett

876, 877 Cf. captions on p. 390

878 Design for the set of the film
"Spellbound", 1945
*Maquette de décor pour le film
«Spellbound»*
Oil on panel; dimensions unknown
Figueras, Fundación Gala-Salvador
Dalí, Gift of Dalí to the Spanish state

879 Untitled – Design for the ball
in the dream sequence in
"Spellbound", 1944
Sans titre
Oil on canvas, 50.5 x 60.5 cm
Private collection

880 Cf. caption on p. 390

881 The Eye – Design for
"Spellbound", 1945
L'œil
Oil on panel; dimensions unknown
Private collection

882 Drawing for "Spellbound",
1945
Dessin pour «Spellbound»
Indian ink and pencil on paper,
15.8 x 20 cm
Whereabouts unknown

883 Spellbound, c. 1945
Spellbound
Oil on panel, 73 x 92 cm
Private collection

884 Study for the dream sequence
in "Spellbound", c. 1945
Oil on panel; dimensions unknown
Figueras, Fundación Gala-Salvador
Dalí, Gift of Dalí to the Spanish state

885 Illustration for "The
Autobiography of Benvenuto
Cellini", 1945
*Illustration pour «L'autobiographie
de Benvenuto Cellini»*
Pen and Indian ink, 18 x 10.5 cm
Gift of Dalí to the Spanish state

886 Illustration for "The Autobiography of Benvenuto Cellini", 1945
Illustration pour «L'autobiographie de Benvenuto Cellini»
Watercolour and red chalk, 24.8 x 14.2 cm
Property of the Spanish state

887 Drawing for Disney's "Destino", 1946/47
Pen and ink on paper, 28.7 x 39.2 cm
Paris, Collection André-François Petit

888 Double Image for "Destino", 1946
Oil and collage on panel; dimensions unknown
Private collection

889 Cf. caption on p. 392

890 Design for "Destino", 1947
Technique and dimensions unknown
Whereabouts unknown

891 Design for "Destino", 1947
Technique and dimensions unknown
Whereabouts unknown

892 One of 13 illustrations for Shakespeare's "Macbeth". Published by Doubleday, New York, 1946
Pen and Indian ink on paper, 28 x 19 cm
Cologne, Galerie Orangerie-Reinz

893 Illustration for "The Autobiography of Benvenuto Cellini", 1945
Illustration pour «L'autobiographie de Benvenuto Cellini»
Pen and Indian ink on paper, 28 x 19 cm
Gift of Dalí to the Spanish state

894 Don Quixote and the Windmills. Illustration for the edition published by Random House in New York in 1945
Don Quichotte et les moulins à vent.
Indian ink and watercolour on paper, 28.5 x 32 cm
Gift of Dalí to the Spanish state

895 Christmas – For the cover of "Vogue" (USA), 1946
Noël (Christmas)
Oil on panel, 36.2 x 25 cm
Private collection

896 Cf. caption on p. 395

897 Desert Trilogy – Flower in the Desert. Painting by Dalí to launch the perfume "Desert Flower" on the market, 1946
Trilogie du désert – Fleur dans le désert
Oil on canvas; dimensions unknown
Private collection

898 Desert Trilogy – Apparition of a Couple in the Desert – For "Desert Flower" perfume, 1946
Trilogie du désert – Apparition d'un couple dans le désert
Oil on canvas; dimensions unknown
Private collection

899 Desert Trilogy – Apparition of a Woman and Suspended Architecture in the Desert – For "Desert Flower" perfume, 1946
Trilogie du désert – Apparition d'une femme et architecture en suspension dans le désert
Oil on canvas; dimensions unknown
Private collection

900 The Stain, 1946
Le crachat
Oil on canvas, 75 x 108 cm
Private collection

901 Untitled (Spanish Dances in a Landscape), 1946
Sans titre (Scène de danses espagnoles dans un paysage)
Oil on canvas, 36.1 x 24.1 cm
Private collection

902 Giant Flying Mocca Cup, with an Inexplicable Five-Metre Appendage, c. 1946
Demi-tasse géante volante, avec annexe inexplicable de cinq mètres de longueur
Oil on canvas, 50 x 31 cm
Basle, private collection; formerly Collection Marquis Georges de Cuevas

903 Cf. caption on p. 398

904, 905 Cf. captions on p. 400

906 The Temptation of Saint Anthony, 1946
La tentation de Saint Antoine
Oil on canvas, 89.7 x 119.5 cm
Brussels, Musées Royaux des Beaux Arts de Belgique

907 Cf. caption on p. 407

908 Dematerialization near the Nose of Nero, 1947
La séparation de l'atome (Dematerialization near the Nose of Nero)
Oil on canvas, 76.2 x 45.8 cm
Figueras, Fundación Gala-Salvador Dalí, Gift of Dalí to the Spanish state

909 Feather Equilibrium, 1947
Equilibre intra-atomique d'une plume de cygne
Oil on canvas, 77.5 x 96.5 cm
Figueras, Fundación Gala-Salvador Dalí, Gift of Dalí to the Spanish state

910 Study for "Dematerialization near the Nose of Nero", 1947
Etude pour «Dematerialization near the Nose of Nero»
Pen and Indian ink on paper, 73.5 x 59.5 cm (sheet format)
Figueras, Fundación Gala-Salvador Dalí, Gift of Dalí to the Spanish state

911 Portrait of Picasso, 1947
Portrait de Picasso
Oil on canvas, 64.1 x 54.7 cm
Figueras, Fundación Gala-Salvador Dalí

912 The Three Sphinxes of Bikini, 1947
Les trois Sphinx de Bikini
Oil on canvas, 30 x 50 cm
Geneva, private collection

913 Cf. caption on p. 411

914 Rock and Infuriated Horse Sleeping under the Sea, 1947
Rock and Infuriated Horse Sleeping under the Sea
Oil on canvas, 19 x 12 cm
Private collection

915 Battle over a Dandelion, 1947
Bataille autour d'un pissenlit
Oil on canvas, 56 x 76 cm
Private collection

916 Cf. caption on p. 413

917 Cf. caption on p. 415

918 The Impossible Model (Drawing for "50 Secrets of Magic Craftsmanship"), 1947
Le modèle impossible (Dessin pour «Les 50 secrets magiques»)
Indian ink and watercolour, 32.1 x 21.6 cm
Private collection

919 Portrait of Mrs. Mary Sigall, 1948
Portrait de Mrs. Mary Sigall
Oil; material and dimensions unknown
Private collection

920 Portrait of Nada Pachevich, 1948
Portrait de Nada Patchevitch
Oil on canvas, 130 x 80 cm
Private collection

921 Untitled (Male Nude in a Landscape), 1948
Sans titre (Nu masculin dans un paysage)
Oil on canvas; dimensions unknown
Gift of Dalí to the Spanish state; formerly Collection Gala and Salvador Dalí

922 Nude in the Desert (Wild Animals in the Desert), 1948
Nu dans le désert (Bêtes sauvages dans le désert)
Oil on canvas, 76.2 x 109.2 cm
Private collection

923 Untitled (Landscape), 1948
Sans titre (Paysage)
Oil on canvas, 60 x 40 cm
Private collection

924 Cathedral of Thumbs (The Thumbs). Illustration for the "Essays" of Michel de Montaigne, published by Doubleday, New York, 1947
Cathedral of Thumbs (Les pouces). Illustration pour «Les Essais» de Michel de Montaigne
Indian ink on paper, 15.8 x 20.8 cm
Bamberg, Kunstkontor R.H. Mayer

925 Hollywood. Cover illustration for "Sunset" magazine. Dual image, to be viewed in two ways, 1947
Hollywood
Pencil, Indian ink, watercolour and collage; dimensions unknown
Private collection

926 Hollywood, 1947 (see ill. no. 925)
Hollywood
Pencil, Indian ink, watercolour and collage; dimensions unknown
Private collection

927 Study for a portrait (unfinished), c. 1948
Etude pour un portrait
Oil on canvas; dimensions unknown
Formerly Collection Gala and Salvador Dalí

928 Untitled (Temple Frontage with Atomic Explosions), c. 1947
Sans titre (Frontispice de temple avec explosions de bombes atomiques)
Oil on canvas; dimensions unknown
Private collection

929 Wheat Ear, 1947
Epis de blé
Oil on canvas (?), 51 x 30 cm
Private collection; formerly Collection Coco Chanel

930, 931 Cf. captions on p. 421

932 The Elephants, 1948
Les éléphants
Oil on canvas, 49 x 60 cm
Private collection

933 Study for "Leda Atomica", 1947
Etude pour «Leda atomica»
Pen and Indian ink, 60.4 x 45.3 cm
Private collection

934 Studies for the air centers and soft morphologies of "Leda Atomica", 1947
Etudes des centres d'air et des morphologies molles de «Leda atomica»
Pen, Indian ink, pencil and coloured pencils on special paper, 54 x 48 cm
Figueras, Fundación Gala-Salvador Dalí

935 Study for "Leda Atomica", 1947
Etude pour «Leda atomica»
Etching, 72.5 x 57.3 cm
Private collection

936 The Annunciation, 1947
L'annonciation
Watercolour and red ink, 36.5 x 42 cm
Private collection; formerly New York, Harry N. Abrams Collection

937 Leda Atomica (first unfinished version), 1948
Leda atomica
Oil on panel, 62 x 48 cm
Figueras, Fundación Gala-Salvador Dalí, Gift of Dalí to the Spanish state

938 Leda Atomica, 1949
Leda atomica
Oil on canvas, 61.1 x 45.3 cm
Figueras, Fundación Gala-Salvador Dalí

939 The Madonna of Port Lligat (first version), 1949
La Madone de Port Lligat
Oil on canvas, 48.9 x 37.5 cm
Milwaukee (WI), Marquette University, Haggerty Museum of Art, Gift of Mr. and Mrs. Ira Haupt, 1959

940 Study for "The Madonna of Port Lligat", 1949
Etude pour «La Madone de Port Lligat»
Indian ink and wash on paper, 19 x 14 cm
Figueras, Fundación Gala-Salvador Dalí

941, 943 Cf. captions on p.429

942 Set design for "El Sombrero de Tres Picos" by Manuel de Falla (Act 2), 1949
Rideau de fond pour «El Sombrero de Tres Picos» (Tricorne) de Manuel de Falla (acte II)
Oil on sackcloth, 900/895 x 1213 cm
Geneva, private collection

944 Set design for the ballet "Los sacos del molinero", 1949
Décors pour le ballet «Los sacos del molinero»
Oil on canvas (for stage sets), 347 x 1045 cm
Private collection

945 Set design for the ballet "Los sacos del molinero", 1949
Décors pour le ballet «Los sacos del molinero»
Oil on canvas, 894 x 317 cm
Private collection

946 Set design for the ballet "Los sacos del molinero", 1949
Décors pour le ballet «Los sacos del molinero»
Oil on canvas, 246 x 140 cm
Private collection

947 Set design for the ballet "Los sacos del molinero", 1949
Décors pour le ballet «Los sacos del molinero»
Oil on canvas, 240 x 281 cm
Private collection

948 Set design for the ballet "Los sacos del molinero", 1949
Décors pour le ballet «Los sacos del molinero»
Oil on canvas, 166 x 271 cm
Private collection

949 Set design for the ballet "Los sacos del molinero", 1949
Décors pour le ballet «Los sacos del molinero»
Oil on canvas, 349 x 960 cm
Private collection

950 Backdrop for "Don Juan Tenorio", 1950
Rideau de fond pour «Don Juan»
Oil on panel, 250 x 550 cm
Madrid, Museo Nacional Reina Sofía

951 Four Armchairs in the Sky, 1949
Quatre fauteuils dans le ciel
Gouache and collage, 9.5 x 17 cm
Private collection

952 Dalí's Moustache, 1950
Les moustaches de Dalí
Technique and dimensions unknown
Private collection

953 Erotic Beach, 1950
Plage érotique
Oil on canvas, 14 x 18 cm
Private collection

954 Myself at the Age of Six when I Thought I Was a Girl Lifting with Extreme Precaution the Skin of the Sea to Observe a Dog Sleeping in the Shade of the Water, 1950
Moi-même à l'âge de six ans, quand je croyais être petite fille, en train de soulever avec une précaution extrême la peau de la mer pour observer un chien dormant à l'ombre de l'eau
Oil on canvas, 27 x 34 cm
Paris, private collection

955 Study for "Myself at the Age of Six...", 1950
Etude pour «Moi-même à l'âge de six ans...»
Gouache, watercolour and pencil, 27 x 35 cm
Private collection

956 Landscape of Port Lligat with Homely Angels and Fishermen, 1950
Paysage de Port Lligat avec anges familiers et pêcheurs
Oil on canvas, 61 x 61 cm
Private collection

957 Cf. caption on p.434

958 Landscape at Port Lligat, 1950
Paysage de Port Lligat
Oil on canvas, 58.5 x 79 cm
St. Petersburg (FL), The Salvador Dalí Museum, on loan from E. and A. Reynolds Morse

959 Angel (Study), 1950
Etude d'anges
Watercolour; dimensions unknown
Private collection

960 Death in Person... The Trumpets of the Last Judgement. Drawing for "On the Verge" (La Limite) by Maurice Sandoz, published by Doubleday, New York, 1950
C'est la mort elle-même... Les trompettes du jugement dernier
Pencil and lead pencil on paper, 39.5 x 27.5 cm
Whereabouts unknown

961 Frontispiece for "La Limite" (On the Verge) by Maurice Sandoz, 1950
Frontispice pour «La Limite» de Maurice Sandoz
Gouache, Indian ink and collage on cardboard, 59 x 49.5 cm (cardboard)
Private collection

962 The Creation of Eve – Gaining Twofold Living Nature from the Sleep of Man, 1950
La création d'Eve – Rendre du sommeil de l'homme la nature vivante redoublée
Ink, pencil, sanguine and watercolour, 31 x 23.9 cm
Private collection

963 Kneeling Figure (Microphysical Phosphenes), 1950/51
Personnage à genou (Phosphènes microphysiques)
Indian ink and wash, 26 x 16 cm
St. Petersburg (FL), The Salvador Dalí Museum

964 The Soft Watch, 1950
La montre molle
Pen and ink on cardboard, 13.7 x 18.6 cm
Private collection

965 Rhinoceros Disintegrating, 1950
Rhinocéros en désintégration
Watercolour and ink, 76.2 x 101.6 cm
Private collection

966 Cf. caption on p.438

967 Design for the death scene in "Don Juan Tenorio", 1950
Escenografía de la muerte «Don Juan Tenorio»
Gouache on black cardboard, 32.5 x 50 cm
Madrid, Museo Nacional Reina Sofía

968 Landscape with Horseman and Gala, 1951
Paysage avec cavalier et Gala
Mixed technique, 54.6 x 78.7 cm
Private collection

969 Untitled (Ants and Wheat Ear), c. 1951
Sans titre (Fourmis et épis de blé)
Gouache and Indian ink, 21.7 x 21.5 cm
Private collection

970 Exploding Flower, c. 1951
Fleur explosive
Gouache and Indian ink on paper, 23.3 x 29.4 cm
Private collection

971 Mystical Carnation, 1950/51
Œillet mystique
Oil; material and dimensions unknown
Private collection

972 Carnation and Cloth of Gold, 1950
Carnation and Cloth of Gold
Oil on canvas, 33 x 43 cm
Private collection

973 Study for the head of "The Madonna of Port Lligat", 1950
Etude pour le visage de «La Madone de Port Lligat»
Sanguine and ink on paper, 49 x 31 cm
St. Petersburg (FL), The Salvador Dalí Museum, on loan from E. and A. Reynolds Morse

974 Metamorphosis and Dynamic Disintegration of a Cuttlefish Bone Becoming Gala (Study for "The Madonna of Port Lligat"), 1950
Métamorphose et désintégration dynamique d'un os de seiche devenu Gala (Etude pour «La Madone de Port Lligat»)
Pencil, Indian ink and gouache on paper; dimensions unknown
Whereabouts unknown

975 Study for the child in "The Madonna of Port Lligat", 1950
Etude pour l'enfant de «La Madone de Port Lligat»
Sanguine, 58.5 x 73 cm
Tokyo, Collection Minami Group

976 Cork (Study for "The Madonna of Port Lligat"), 1950
Liège (Etude pour «La Madone de Port Lligat»)
Oil on canvas, 63.5 x 53.5 cm
Gift of Dalí to the Spanish state

977 Study for the drapery in "The Madonna of Port Lligat", 1950
Etude de drapé pour «La Madone de Port Lligat»
Pen and Indian ink on paper, 51 x 38.3 cm
Gift of Dalí to the Spanish state

978 Piero della Francesca: Madonna and Child, 1470-1475
Piero della Francesca: La Vierge et l'Enfant
Oil on panel, 248 x 170 cm
Mailand, Pinacoteca di Brera

979 Cf. caption on p. 442

980 Study after "Madonna and Child" by Piero della Francesca for "The Madonna of Port Lligat", 1950
Etude à partir de «La Vierge et l'Enfant» de Piero della Francesca pour «La Madone de Port Lligat»
Technique and dimensions unknown
Whereabouts unknown

981 The Madonna of Port Lligat, 1950
La Madone de Port Lligat
Oil on canvas, 144 x 96 cm
Tokyo, private collection

982 Giovanni Paolo Pannini: The Interior of the Pantheon (detail), c. 1750
Washington, The National Gallery of Art

983 Celestial Coronation, c. 1951
Couronnement céleste
Gouache and collage, 26 x 19 cm
Private collection

984 Raphaelesque Head, Exploded, 1951
Tête raphaëlesque éclatée
Oil on canvas, 43 x 33 cm
Edinburgh, Scottish National Gallery, on permanent loan from Miss Stead-Ellis, Summerset

985 The Wheelbarrows (Cupola Consisting of Twisted Carts), 1951
Les brouettes (Panthéon formé par des brouettes en contorsion)
Watercolour and ink on paper, 101.5 x 76.2 cm
St. Petersburg (FL), The Salvador Dalí Museum, Collection E. and A. Reynolds Morse

986 Raphaelesque Head, Exploding, c. 1951
Tête raphaëlesque éclatant
Charcoal on heavy brown paper, 26.7 x 17.7 cm
Private collection

987 Explosive Madonna, 1951
La madone explosive
Gouache on cardboard, 76.4 x 101.6 cm
Private collection

988 "La turbie" – Sir James Dunn Seated, 1949
«La turbie» – Sir James Dunn assis
Oil on canvas, 132 x 89 cm
Fredericton (New Brunswick), Beaverbrook Art Gallery, Beaverbrook Canadian Foundation

989 Portrait of Colonel Jack Warner, 1951
Portrait du Colonel Jack Warner
Oil on canvas, 105.2 x 125 cm
Syracuse (NY), Syracuse University Art Collections

990 Portrait of a Child (unfinished?), 1951
Portrait d'enfant
Oil on canvas, 51.3 x 41 cm
Figueras, Fundación Gala-Salvador Dalí, Gift of Dalí to the Spanish state

991 Portrait of Mrs. Jack Warner, 1951
Portrait de Mrs. Jack Warner
Oil on canvas, 111.1 x 94.6 cm
Private collection

992 Portrait of Katharina Cornell, 1951
Portrait de Katharina Cornell
Oil on cardboard, 76.2 x 101.6 cm
Buffalo (NY), University of Buffalo

993 A Logician Devil – Lucifer. Illustration for Dante's "Divine Comedy". Commissioned by the Italian government, 1951
Un diable logicien – Lucifer. Dessin pour «La Divine Comédie»
Watercolour and pencil; dimensions unknown
Private collection

994 Cf. caption on p. 449

995 The Fallen Angel. Illustration for Dante's "Divine Comedy", 1951
L'ange déchu
Watercolour, 41 x 27.5 cm
Whereabouts unknown

996 The Followers of Simon. Illustration for Dante's "Divine Comedy", 1951
Les Simoniaques
Watercolour and sepia on paper, 43 x 28 cm
Whereabouts unknown

997 Cf. caption on p. 449

998 "Christ on the Cross", drawn by St. John of the Cross (1542-1591) in a state of ecstasy
Sanguine on paper, 75.7 x 101.7 cm
St. Petersburg (FL), The Salvador Dalí Museum

999 Study for "Christ of St. John of the Cross", 1950
Etude pour «Christ de saint Jean de la Croix»
Sanguine on paper, 75.7 x 101.7 cm
St. Petersburg (FL), The Salvador Dalí Museum

1000 Study for "Christ of St. John of the Cross", 1951
Etude pour le «Christ de saint Jean de la Croix»
Gouache on paper, 17.2 x 20.3 cm
Private collection

1001 Velázquez: Study for "The Surrender of Breda", c. 1635
Charcoal on paper, 26.2 x 16.8 cm
Madrid, Biblioteca Nacional

1002 Louis le Nain: Farmers in front of their House (detail), 1642
Oil on canvas
San Francisco, Palace of the Legion of Honor

1003 Christ of St. John of the Cross, 1951
Christ de saint Jean de la Croix (Christ of St. John of the Cross)
Oil on canvas, 205 x 116 cm
Glasgow, The Glasgow Art Gallery

1004 Arithmosophic Cross, 1952
La croix aux iris (Arithmosophic Cross)
Oil on canvas, 84.5 x 53.5 cm (?)
Whereabouts unknown; formerly New York, Carstairs Gallery

1005 The Royal Heart, 1953
Le cœur royal (The Royal Heart)
Gold heart, with 46 17.61 carat rubies, 42 0.57 carat diamonds, and four emeralds; height: 10 cm
Tokyo, private collection

1006 Nuclear Cross, 1952
Croix nucléaire
Oil on canvas, 78 x 58 cm
Spain, private collection; formerly Collection Marquis de Cuevas

1007 Cf. caption on p. 453

1008 The Angel Cross, 1960
La croix de l'ange (The Angel Cross)
Crucifix made of Chinese coral and other materials; height: 76 cm
Tokyo, private collection

1009 Assumpta corpuscularia lapislazulina, 1952
Assumpta corpuscularia lapislazulina
Oil on canvas, 230 x 144 cm
Collection John Theodoracopoulos

1010, 1011 Cf. captions on p. 455

1012 Madonna in Particles, 1952
Madone corpusculaire
Oil on canvas, 20.2 x 14 cm
Private collection

1013 Gala Placida, 1952
Gala Placida
Ink and pastel on paper, 45.7 x 34.6 cm
Tucson (AZ), University of Arizona Museum of Art, The Edward Joseph Gallagher III Memorial Collection

1014 Equestrian Molecular Figure, 1952
Figure équestre moléculaire
Indian ink and watercolour on paper, 76 x 101.5 cm
Gift of Dalí to the Spanish state

1015 Galatea of the Spheres, 1952
Galatée aux sphères
Oil on canvas, 65 x 54 cm
Figueras, Fundación Gala-Salvador Dalí

1016 Raphaelesque Dynamics, 1952
Dynamics raphaëlesques
Ball-point and Indian ink;
dimensions unknown
Private collection

1017 Madonna in Particles, 1952
Madone corpusculaire
Pencil, sepia and Indian ink,
55.8 x 43.2 cm
Birmingham (AL), Birmingham
Museum of Art, Gift of Mr. and
Mrs. Charles W. Ireland

1018 Nuclear Head of an Angel,
1952
Tête nucléaire d'un ange
Black ink, sepia and pencil on paper,
56 x 43 cm
Private collection

1019 Study for the Head of the
Virgin, 1952
Etude pour tête de la Vierge
Pencil, ink and gouache; dimensions
unknown
Whereabouts unknown

1020 Exploding Head, 1952-54
Tête explosive
Pencil, ball-point and Indian ink;
dimensions unknown
Whereabouts unknown

1021 Eucharistic Still Life, 1952
Nature morte évangélique
(Eucharistic Still Life)
Oil on canvas, 55 x 87 cm
St. Petersburg (FL), The Salvador
Dalí Museum, on loan from E. and
A. Reynolds Morse

1022 The Tree, 1952
L'arbre
Oil on canvas, 252.1 x 77.5 cm
Private collection

1023 The Angel of Port Lligat, 1952
L'ange de Port Lligat
Oil; material and dimensions
unknown
Private collection

1024 The Disintegration of the
Persistence of Memory, 1952-1954
*Désintégration de la persistance de
la mémoire*
Oil on canvas, 25 x 33 cm
St. Petersburg (FL), The Salvador
Dalí Museum, on loan from E. and
A. Reynolds Morse

1025 The Angel of Port Lligat, 1952
L'ange de Port Lligat
Oil on canvas, 58.4 x 78.3 cm
St. Petersburg (FL), The Salvador
Dalí Museum, on loan from E. and
A. Reynolds Morse

1026 The Grape Pickers: Bacchus'
Chariot (The Triumph of
Dionysus), 1953
*Les vendangeurs: le char de Bacchus
(Le triomphe de Dionysios)*
Watercolour, 77 x 101.5 cm
Gift of Dalí to the Spanish state

1027 Costume designs for "Le
Ballet des vendangeurs" (The Grape
Pickers' Ballet), 1953
*Projets de costumes pour «Le ballet
des vendangeurs»*
Technique and dimensions unknown
Whereabouts unknown

1028 Tortoise, for "Le Ballet des
vendangeurs", 1953
*La tortue du «Ballet des
vendangeurs»*
Technique and dimensions
unknown
Whereabouts unknown

1029 Costume designs for "Le
Ballet des vendangeurs" (The Grape
Pickers' Ballet), 1953
*Projets de costumes pour «Le ballet
des vendangeurs»*
Technique and dimensions unknown
Whereabouts unknown

1030 Costume designs for "Le
Ballet des vendangeurs" (The Grape
Pickers' Ballet), 1953
*Projets de costumes pour «Le ballet
des vendangeurs»*
Technique and dimensions unknown
Whereabouts unknown

1031 Dalí's design for a fashion
contest under the theme "The
Woman of the Future", 1953
Watercolour and collage on
cardboard, 20.2 x 25.5 cm
Private collection

1032-1039 Cf. captions on p. 465

1040 Crucifixion, 1954
Crucifixion
Oil on canvas, 194.5 x 124 cm
Private collection

1041 Gala Contemplating "Corpus
Hypercubus", 1954
*Gala regardant le «Corpus
Hypercubus»*
Oil on canvas, 31 x 27 cm
Figueras, Fundación Gala-Salvador
Dalí

1042 Portrait of Gala with
Rhinocerotic Symptoms, 1954
*Portrait de Gala avec symptômes
rhinocérontiques*
Oil on canvas, 39 x 31.5 cm
Private collection

1043 Corpus Hypercubus
(Crucifixion), 1954
Corpus Hypercubus (Crucifixion)
Oil on canvas, 194.5 x 124 cm
New York, The Metropolitan
Museum of Art, Gift of Chester
Dale

1044 Cf. caption on p. 466

1045 Anthropomorphic Figure,
1954
Figure anthropomorphe
Pencil and ball-point, 23.6 x 14.3 cm
Private collection

1046 Grey Head of an Angel,
1952-1954
Tête d'ange gris
Pencil, Indian ink and watercolour;
dimensions unknown
Whereabouts unknown

1047 Head Bombarded with Grains
of Wheat (Particle Head over the
Village of Cadaqués), 1954
*Tête bombardée par des grains de
blé (Tête corpusculaire sur le village
de Cadaqués)*
Oil on cardboard, 26.6 x 17.8 cm
Private collection

1048 The Maximum Speed of
Raphael's Madonna, 1954
*La madone de Raphaël à la vitesse
maximum*
Oil on canvas, 81.2 x 66 cm
Madrid, Museo Nacional Reina
Sofía, Gift of Dalí to the Spanish
state

1049 Soft Watch at the Moment of
First Explosion, 1954
*Montre molle au moment de sa
première explosion*
Oil on canvas, 20.5 x 25.7 cm
Private collection

1050 Microphysical Madonna, 1954
Madone microphysique
Oil on canvas, 41 x 28.5 cm
Whereabouts unknown; formerly
Collection Marquis de Cuevas

1051 Madonna and Particle Child
(Nuclear Drawing), 1954
*Madone et enfant corpusculaires
(Dessin nucléaire)*
Ball-point on paper, 19.4 x 23.5 cm
Private collection

1052 Sketch for "Soft Watch
Exploding into 888 Pieces after
Twenty Years of Complete
Motionlessness", 1954
*Esquisse pour «Montre molle
explosant en 888 morceaux après
vingt ans de complète immobilité»*
Ink and pencil, 14 x 19 cm (?)
Private collection

1053 Rhinocerotic Disintegration
of Illissus of Phidias, 1954
*Figure rhinocérontique de l'Illisos de
Phidias*
Oil on canvas, 100 x 129.5 cm
Figueras, Fundación Gala-Salvador
Dalí, Gift of Dalí to the Spanish state

1054 Dalí Nude, in Contemplation
before the Five Regular Bodies
Metamorphized into Corpuscles, in
which Suddenly Appear the Leda of
Leonardo Chromosomatized by the
Visage of Gala, 1954
*Dali nu, en contemplation devant
cinq corps réguliers métamorphosés
en corpuscules, dans lesquels
apparaît soudainement la Léda de
Léonard chromosomatisée par le
visage de Gala*
Oil on canvas, 61 x 46 cm
Private collection

1055 Galatée, 1954-1956
Galatée
Oil on canvas; dimensions unknown
Private collection

1056 Cf. caption on p. 471

1057 Ayne Bru (Lucius de Brun):
Martyrdom of St. Cucufa,
c. 1504-1507
Oil on panel, 172 x 132 cm
Barcelona, Museu d'Art de
Catalunya

1058 The Colossus of Rhodes, 1954
Le colosse de Rhodes
Oil on canvas, 68.8 x 39 cm
Berne, Kunstmuseum Bern

1059 The Lighthouse at Alexandria,
1954
Le phare d'Alexandrie
Oil on cardboard; dimensions
unknown
Private collection

1060 The Lighthouse at Alexandria,
1954
Le phare d'Alexandrie
Oil on cardboard, 17.9 x 12 cm
Private collection; formerly
Collection Carlos Alemany

1061 The Walls of Babylon, 1954
Les murs de Babylone
Oil on canvas, 27 x 77 cm
Private collection

1062 The Pyramids and the Sphinx
of Gizeh, 1954
Les pyramides et le sphinx de Gizeh
Oil on canvas, 25 x 55 cm
Private collection

1063 Symphony in Red, 1954
Symphonie en rouge
Oil, pen and Indian ink on
cardboard; dimensions unknown
Private collection

1064 Statue of Olympic Zeus, 1954
Statue de Zeus olympien
Oil on canvas, 18 x 18 cm
Private collection

1065 Noon (Barracks at Port
Lligat; detail), 1954
Midi (détail)
Oil on canvas, 37.5 x 42.5 cm
St. Petersburg (FL), The Salvador
Dalí Museum; formerly Collection
E. and A. Reynolds Morse

1066 Two Adolescents, 1954
Deux adolescents (Two Adolescents)
Oil on canvas, 56 x 65 cm
St. Petersburg (FL), The Salvador
Dalí Museum, on loan from E. and
A.Reynolds Morse

1067 Equestrian Fantasy (Portrait
of Lady Dunn-Beaverbrook), 1954
*Fantaisie équestre (Portrait de Lady
Dunn-Beaverbrook)*
Oil on canvas, 118 x 135.2 cm
Fredericton (New Brunswick),
Beaverbrook Art Gallery,
Beaverbrook Canadian Foundation

1068 Portrait of Mrs. Reeves, 1954
Portrait de Mrs. Reeves
Oil on canvas, 147 x 92 cm
Private collection

1069 Portrait of Mrs. Ann
Woodward, 1954
Portrait de Mrs. Ann Woodward
Oil; dimensions unknown
Private collection

1070, 1071 Cf. captions on p.476

1072 The Lacemaker (Copy of the
painting by Vermeer van Delft), 1955
La Dentellière
Oil on canvas, 24 x 21 cm
Gift of Dalí to the Spanish state

1073 Cf. caption on p.476

1074 Rhinocerotic Bust of
Vermeer's "Lacemaker", 1955
*Buste rhinocérontique de la
«Dentellière» de Vermeer*
Patinated plaster,
50.5 x 35.4 x 38.5 cm
Paris, private collection

1075 Young Virgin Auto-Sod-
omized by her Own Chastity,
1954
*Jeune vierge autosodomisée par les
cornes de sa propre chasteté*
Oil on canvas, 40.5 x 30.5 cm
Los Angeles, Playboy Collection

1076 Paranoiac-Critical Painting of
Vermeer's "Lacemaker", 1955
*Peinture paranoïaque-critique de la
«Dentellière» de Vermeer*
Oil on canvas on panel,
27.1 x 22.1 cm
New York, The Solomon R.
Guggenheim Museum, Anonymous
gift

1077 Cf. caption on p.480

1078 Rhinocerotic Figures, 1955
Figures rhinocérontiques
Oil on canvas, 99 x 93 cm
Private collection

1079 Combat (Microphysical
Warriors), 1955
Combat (Guerriers microphysiques)
Pen, ink and wash on paper,
16 x 23 cm
St. Petersburg (FL), The Salvador
Dalí Museum, on loan from E. and
A. Reynolds Morse

1080 Blue Horns. Design for a
scarf, 1955
Cornes bleues
Gouache, 67.5 x 69 cm
Private collection

1081 Untitled (The Amazing
Adventure of Vermeer's
"Lacemaker"), 1955
*Sans titre (Histoire prodigieuse de la
«Dentellière» de Vermeer)*
Oil, 100 x 100 cm
Whereabouts unknown (probably
destroyed)

1082 The Ascension of St. Cecilia,
1955
Sainte Cécile ascensionniste
Oil on canvas, 81 x 66 cm
Figueras, Fundación Gala-Salvador
Dalí, Gift of Dalí to the Spanish state

1083, 1085 Cf. captions on p.482

1084 Rhinocerotic Portrait of
Vermeer's "Lacemaker", 1955
*Portrait rhinocérontique de la
«Dentellière» de Vermeer*
Oil on canvas, 102 x 105 cm
Private collection

1086 Still Life – Fast Moving, 1956
Nature morte vivante
Oil on canvas, 125 x 160 cm
St. Petersburg (FL), The Salvador
Dalí Museum, on loan from E. and
A. Reynolds Morse

1087 Study for a fruit bowl in "Still
Life – Fast Moving", 1956
*Etude de compotier pour «Nature
morte vivante»*
Oil on canvas, 61 x 50.8 cm
Figueras, Fundación Gala-Salvador
Dalí, Gift of Dalí to the Spanish state

1088 Vase of Flowers, 1956
Vase de fleurs
Watercolour, gouache and Indian
ink on cardboard, 101 x 76.2 cm
Private collection

1089 The Motionless Swallow.
Study for "Still Life – Fast Moving",
1956
*L'hirondelle immobile. Etude pour
«Nature morte vivante»*
Oil on canvas, 46 x 36 cm
Private collection; formerly New
York, Carstairs Gallery

1090 Wine Glass and Boat, 1956
Verre de vin et bateau
Oil on canvas, 20.5 x 25.7 cm
Private collection; formerly New
York, Carstairs Gallery

1091 Portrait of Laurence Olivier
in the Role of Richard III, 1955
*Portrait de Laurence Olivier dans le
rôle de Richard III*
Oil on canvas, 73.7 x 63 cm
London, private collection

1092 The Skull of Zurbarán, 1956
Le crâne de Zurbarán
Oil on canvas, 100.3 x 100.3 cm
Washington, The Hirshhorn
Museum and Sculpture Garden

1093 Untitled (Landscape with
Butterflies), c. 1956
Sans titre (Paysage aux papillons)
Oil on canvas, 34.5 x 40 cm
Formerly Collection Gala and
Salvador Dalí

1094 Assumpta Canaveral, 1956
Assumpta Canaveral
Gouache and watercolour,
151 x 102 cm
Figueras, Fundación Gala-Salvador
Dalí, Gift of Dalí to the Spanish state

1095 Saint Surrounded by Three
Pi-Mesons, 1956
Saint entouré de trois pi-mésons
Oil on canvas, 42 x 31 cm
Figueras, Fundación Gala-Salvador
Dalí

1096 St. Helen of Port Lligat, 1956
Sainte Hélène à Port Lligat
Oil on canvas, 31 x 42 cm
St. Petersburg (FL), The Salvador
Dalí Museum, on loan from E. and
A. Reynolds Morse

1097 Anti-Protonic Assumption,
1956
Assomption anti-protonique
Oil on canvas, 71.2 x 62.5 cm
Private collection

1098 The Last Supper, 1955
La cène
Oil on canvas, 167 x 268 cm
Washington, The National Gallery
of Art, Chester Dale Collection

1099 The Infant Jesus, 1956
L'enfant Jésus
Oil on canvas, 17.8 x 13.3 cm
Private collection; formerly
Collection Clara Boothe Luce

1100 Swallow, 1957
Hirondelle
Pen and brush, Indian ink and
sanguine on paper, 15.9 x 14.9 cm
Private collection

1101 Rhinocerotic Gooseflesh, 1956
Chair de poule rhinocérontique
Oil on canvas, 93 x 60 cm
Private collection; formerly
Collection B. Pagliai

1102 St. John, 1957
Saint Jean
Watercolour and pen, 15 x 12 cm
Private collection

1103 The Space Elephant, 1961
L'éléphant spatial
18 carat gold, two 0.10 carat
diamonds, two 4 carat emeralds and
one 14 carat emerald; dimensions
unknown
Tokyo, Minami Art Museum

1104 Untitled (Surrealist
Landscape), 1957/58
Sans titre (Paysage surréaliste)
Gouache on cardboard, 142 x 53 cm
Private collection; formerly
Collection Alexander Fargas

1105 Metamorphosed Women –
The Seven Arts, 1957
*Femmes métamorphosées – Les sept
arts*
Oil on canvas, 72 x 92 cm
Private collection

1106 Butterfly Landscape (The
Great Masturbator in a Surrealist
Landscape with D.N.A.), 1957/58
*Paysage aux papillons (Grand
masturbateur dans un paysage
surréaliste avec A.D.N.)*
Gouache on paper on canvas,
139 x 104 cm
Private collection

1107 Celestial Ride, 1957
Chevauchée céleste
Oil on canvas, 185 x 83 cm
Private collection

1108 The Grand Opera, 1957
Grand opéra
Oil on canvas; diameter: 93 cm
Private collection; formerly Galerie
Alex Maguy

1109 Sorcery – The Seven Arts, 1957
Ensorcellement – Les sept arts
Oil on canvas, 84 x 114 cm
Private collection

1110 Modern Rhapsody – The Seven Arts, 1957
Rhapsodie moderne – Les sept arts
Oil on canvas, 84 x 114 cm
Private collection

1111 Dance – The Seven Arts, 1957
La danse – Les sept arts
Oil on canvas, 84 x 114 cm
Private collection; formerly Billy Rose Collection

1112 Music – The Red Orchestra – The Seven Arts, 1957
La musique – L'orchestre rouge – Les sept arts
Oil on canvas, 84 x 115.5 cm
Geneva, Collection G.E.D. Nahmad; formerly Galerie Alex Maguy

1113 St. James of Compostela, 1957
Saint Jacques le Grand (Santiago el Grande)
Oil on canvas, 400 x 300 cm
Fredericton (New Brunswick), Beaverbrook Art Gallery

1114 Cf. caption on p. 495

1115 The Golden Age (Don Quixote), 1957
L'âge d'or (Don Quichotte)
Watercolour and Indian ink on paper, 45 x 65.5 cm
Bamberg, Kunstkontor R.H. Mayer

1116 Don Quixote, 1956/57
Don Quichotte
Colour lithograph, 41 x 32.5 cm
Boston, The Boston Museum of Fine Arts

1117 Don Quixote, 1956/57
Don Quichotte
Colour lithograph, 40.5 x 32.5 cm
Whereabouts unknown

1118 Don Quixote, 1956/57
Don Quichotte
Colour lithograph, 41 x 33 cm
Whereabouts unknown

1119 Don Quixote, 1956/57
Don Quichotte
Colour lithograph, 41 x 32.5 cm
Whereabouts unknown

1120 Portrait of Chester Dale and his Dog Coco, 1958
Portrait de Chester Dale et de son chien Coco
Oil on canvas, 89 x 59 cm
Washington, The National Gallery of Art, Chester Dale Collection

1121 Portrait of Reinaldo Herrera, Marquis de Torre Casa, 1959
Portrait de Reinaldo Herrera, Marquis de Torre Casa
Oil on canvas, 84 x 64 cm
Private collection

1122 Portrait of Sir James Dunn, 1958
Portrait de Sir James Dunn
Oil on canvas, 96.5 x 72.4 cm
Fredericton (New Brunswick), Beaverbrook Art Gallery

1123 The Duke of Urbino (Portrait of Count Theo Rossi di Montelera), 1957
Le Duc d'Urbino (Portrait du Comte Theo Rossi di Montelera)
Oil on canvas, 75 x 60 cm
Private collection

1124 The Pope's Ear, 1958
L'oreille du Pape
Indian ink on paper, 41 x 33 cm
Private collection

1125, 1126 Cf. captions on p. 503

1127 The Sistine Madonna (The image appears abstract and almost completely grey when viewed close to, but at a distance of two metres it becomes Raphael's Sistine Madonna and at a distance of fifteen becomes the one-and-a-half-metre high ear of an angel), 1958
La madone sixtine
Oil on canvas, 223 x 190 cm
New York, The Museum of Modern Art, Collection H.J. Heinz

1128, 1129 Cf. captions on p. 503

1130 Velázquez Painting the Infanta Margarita with the Lights and Shadows of his Own Glory, 1958
Vélasquez peignant l'infante Marguerite avec les lumières et les ombres de sa propre gloire (Velázquez Painting the Infanta Margarita with the Lights and Shadows of his Own Glory)
Oil on canvas, 153 x 92 cm
St. Petersburg (FL), The Salvador Dalí Museum, on loan from E. and A. Reynolds Morse

1131 Pi-Mesonic Angel, 1958
Ange pi-mésonique (Pi-Mesonic Angel)
Watercolour on paper, 40.6 x 30.5 cm
St. Petersburg (FL), The Salvador Dalí Museum, on loan from E. and A. Reynolds Morse

1132-1134 Cf. captions on p. 505

1135 Vase of Cornflowers, 1959
Le vase de bleuets
Oil on canvas, 41 x 30 cm
Private collection

1136 Dionysus Spitting the Complete Image of Cadaqués on the Tip of the Tongue of a Three-Storied Gaudinian Woman, 1958
Dionysios crachant l'image complète de Cadaqués sur le bout de la langue d'une femme à trois étagères
Oil on panel, 31 x 23 cm
St. Petersburg (FL), The Salvador Dalí Museum, on loan from E. and A Reynolds Morse

1137 Meditative Rose, 1958
Rose méditative
Oil on canvas, 36 x 28 cm
Private collection; formerly New York, Arnold Grand Collection

1138 Clown, for "The Amazing Adventure of the Lacemaker and the Rhinoceros", 1958
Paillasse pour «L'histoire prodigieuse de la dentellière et du rhinocéros»
Gouache and collage on two photographs, 23.9 x 33.3 cm
Private collection

1139 Cf. caption on p. 508

1140 Detail from "Moonlit Landscape with Accompaniment", 1958 (revolved through 90°)
Détail de «Paysage au clair de lune avec accompagnement»
Oil on canvas, 25.5 x 31 cm
Private collection

1141 Metamorphosis of Hitler's Face into a Moonlit Landscape with Accompaniment, 1958
Métamorphose du visage d'Hitler en paysage au clair de lune avec accompagnement
Oil on canvas, 25.5 x 31 cm
Private collection

1142 Landscape near Port Lligat, 1958
Paysage de Port Lligat
Oil on canvas, 58.4 x 76.2 cm
New York, private collection; formerly Collection William Benton

1143 Port Lligat at Sunset, 1959
Port Lligat au coucher du soleil (Port Lligat at Sunset)
Oil on canvas, 57.2 x 69.7 cm
Private collection; formerly New York, Arnold Grand Collection

1144 The Discovery of America by Christopher Columbus (The Dream of Christopher Columbus), 1958/59
La découverte de l'Amérique par Christophe Colomb (Le rêve de Christophe Colomb)
Oil on canvas, 410 x 284 cm
St. Petersburg (FL), The Salvador Dalí Museum, on loan from the Morse Charitable Trust

1145 Of the Very Monarchical Education of the Young, 1959
De la très Monarchique Education de la Jeunesse
Oil, Indian ink and ball-point on parchment, 139 x 109 cm
Private collection

1146 Study for "The Discovery of America by Christopher Columbus", 1958
Etude pour «La découverte de l'Amérique par Christophe Colomb»
Ball-point on paper, 70 x 48 cm
Gift of Dalí to the Spanish state

1147 Christ on a Pebble, 1959
Christ au galet
Oil on a polished oval pebble, 5.1 x 4.6 cm
Private collection

1148 Cosmic Madonna, 1958
Cosmic Madonna
Oil; material and dimensions unknown
Private collection

1149 Ascension, 1958
L'Ascension
Oil on canvas, 115 x 123 cm
Private collection

1150 The Virgin of Guadalupe, 1959
La Vierge de Guadalupe (La Virgen de Guadalupe)
Oil on canvas, 200 x 130 cm
Private collection

1151 The Maid of the Disciples of Emmaus, 1960
La servante des disciples d'Emmaüs
Oil on canvas, 25 x 22.5 cm
Private collection

1152 The Trinity (Study for "The Ecumenical Council"), 1960
La Trinité (Etude pour «Le concile œcuménique»)
Oil on canvas, 58.4 x 66 cm
Città del Vaticano (Rome), Musei Vaticani, Collezione d'Arte Religiosa Moderna

1153 St. Anne and the Infant, 1960
Sainte Anne et l'enfant
Watercolour, 26.2 x 20 cm
St. Petersburg (FL), The Salvador Dalí Museum

1154 Religious Scene in Particles, c. 1958
Scène religieuse corpusculaire
Oil on cardboard, 26.7 x 18.2 cm
Private collection

1155 St Anne and St. John, 1960
Sainte Anne et Saint Jean
Watercolour and gouache, 24 x 18 cm
Private collection

1156 San Salvador and Antoni Gaudí Arguing over the Crown of the Virgin, 1960
San Salvador et Antoni Gaudí se disputant la couronne de la Vierge
Gouache, 18.2 x 24.3 cm
Formerly Collection Gala and Salvador Dalí

1157-1159 Cf. captions on p. 519

1160 St. Peter's in Rome (Explosion of Mystical Faith in the Midst of a Cathedral), 1960-1974
Basilique de Saint Pierre de Rome (Explosión de fe mística en el centro de una catedral)
Oil on canvas, 225 x 163 cm
Figueras, Fundación Gala-Salvador Dalí

1161 Portrait of St. Jerome, 1960
Portrait de Saint Jérôme
Oil on canvas, 20 x 25 cm
Private collection

1162, 1163 Cf. captions on p. 520

1164 Cover of "The Apocalypse of St. John", 1958-1961
Couverture de «L'Apocalypse de Saint Jean»
Beaten bronze with precious stones and forks in a perspex bubble, 80 x 70 cm; weight: 150 kg
Private collection

1165 Christ. From "The Apocalypse of St. John", 1958-1960
Le Christ de l'Apocalypse
Technique and dimensions unknown
Private collection

1166 Pietà. From "The Apocalypse of St. John", 1959
La Pietà de l'Apocalypse
Etching, 46.7 x 37.5 cm (plate), 76.3 x 56.3 cm (sheet)
Private collection

1167 Beatrice, 1960
Béatrice
Oil on canvas, 40.5 x 30.5 cm
St. Petersburg (FL), The Salvador Dalí Museum, on loan from E. and A. Reynolds Morse

1168 Two Religious Figures, 1960
Deux figures religieuses
Oil on plywood, 25.6 x 20.4 cm
Figueras, Fundación Gala-Salvador Dalí, Gift of Dalí to the Spanish state

1169 A Fate of the Parthenon, 1960
Une Parque du Parthénon
Oil on canvas, 42.5 x 30.7 cm
Figueras, Fundación Gala-Salvador Dalí, Gift of Dalí to the Spanish state

1170 Madonna, 1960
Madone
Oil/gouache (?) on mahogany (print), 19.1 x 10.9 cm
Figueras, Fundación Gala-Salvador Dalí, Gift of Dalí to the Spanish state

1171 Continuum of the Four Buttocks –… Five Rhinoceros Horns Making a Virgin – Birth of a Deity, 1960
Déesse s'appuyant sur son coude – Le continuum à quatre fesses ou Cinq cornes de rhinocéros formant une vierge ou Naissance d'une divinité
Oil on canvas, 92.5 x 153 cm
Barcelona, Generalitat de Catalunya, Departament de Cultura, Gift of the artist, 1980

1172 Hyperxiological Sky, 1960
Ciel hyparxiologique
Oil on canvas with nails and inlaid gold tooth, 31 x 43 cm
Private collection

1173 The Life of Mary Magdalene, 1960
Vie de Marie-Madeleine
Oil on canvas, 59 x 59 cm
Private collection

1174 Portrait of Juan de Pareja Repairing a String of his Mandolin, 1960
Portrait de Juan de Pareja réparant une corde à sa mandoline
Oil on canvas, 76.5 x 87.6 cm
Private collection

1175 The Maids-in-Waiting (Las Meninas; detail), 1960
Les Ménines
Oil on canvas, 18 x 16 cm
Germany, private collection

1176 The Maids-in-Waiting (Las Meninas), 1960
Les Ménines
Gouache, 23 x 18 cm
Bridgewater, Collection Mr. and Mrs. Julien Levy

1177 Numerical Composition (unfinished), c. 1960
Composition numérique
Oil on canvas, 40 x 30.7 cm
Figueras, Fundación Gala-Salvador Dalí, Gift of Dalí to the Spanish state

1178 Figure in the Shape of a Cloud, c. 1960
Personnage en forme de nuage (Cuerpo de nubes)
Oil on canvas, 31 x 43.5 cm
Figueras, Fundación Gala-Salvador Dalí, Gift of Dalí to the Spanish state

1179 Cf. caption on p. 527

1180 A Propos of the "Treatise on Cubic Form" by Juan de Herrera, 1960
A propos du «Discours sur la forme cubique» de Juan de Herrera
Oil on canvas, 59.5 x 56 cm
Madrid, Museo Nacional Reina Sofía, Gift of Dalí to the Spanish state

1181 Woman Undressing, 1959
Femme se déshabillant (Muchacha desvistiendose)
Oil on canvas, 17.8 x 14 cm
Private collection; formerly Collection Carlos Alemany

1182 Female Seated Nude, c. 1960
Nu féminin assis
Oil on canvas; dimensions unknown
Formerly Collection Gala and Salvador Dalí

1183 Study for "Woman Undressing", 1959
Etude pour «Femme se déshabillant»
Oil on canvas, 18 x 15 cm
Private collection

1184 Gala Nude, Seen from behind, 1960
Gala nue de dos
Oil on canvas, 42 x 32 cm
Figueras, Fundación Gala-Salvador Dalí

1185 The Ecumenical Council, 1960
Le concile œcuménique
Oil on canvas, 300 x 254 cm
St. Petersburg (FL), The Salvador Dalí Museum, on loan from the Morse Charitable Trust

1186 The Ecumenical Council, 1960
Le concile œcuménique
Oil on cardboard, 74 x 100 cm
Private collection

1187 Cathedral (unfinished), c. 1960
Cathédrale
Oil and pencil on canvas, 33 x 40.5 cm
Figueras, Fundación Gala-Salvador Dalí, Gift of Dalí to the Spanish state

1188 Portrait of a Man (They Were Three), 1960
Portrait d'homme (They Were Three)
Oil on canvas (?), 61 x 51 cm
Private collection

1189 Portrait of a Woman – Grey Jacket, Wearing a Pearl Necklace, c. 1961
Portrait de femme – Veste grise porte un collier de perles
Oil on paper on cardboard, 45 x 60 cm
Private collection

1190 Portrait of "Bobo" Rockefeller (unfinished), 1960
Portrait de «Bobo» Rockefeller
Oil on canvas, 59.9 x 56 cm
Figueras, Fundación Gala-Salvador Dalí, Gift of Dalí to the Spanish state

1191 Birth of a Deity, 1960
Naissance d'une divinité
Oil on panel, 36 x 26 cm
Private collection

1192 Portrait of Countess Ghislaine d'Oultremont, 1960
Portrait de la Comtesse Ghislaine d'Oultremont
Oil on canvas, 74.3 x 61.6 cm
Private collection; formerly New London, Connecticut College

1193 Portrait of Mrs. Fagen, 1960
Portrait de Mrs. Fagen
Oil on canvas, 124 x 94 cm
Private collection

1194 Untitled (The Lady of Avignon), c. 1960
Sans titre (La dama d'Avinyo)
Oil and collage on cardboard, 71 x 27 cm
Private collection

1195 Cf. caption on p. 534

1196 Leda's Swan (Leda and the Swan), 1961
Le cygne de Léda (Léda et le cygne)
Gouache, 6.6 x 6.7 cm (oval)
Figueras, Fundación Gala-Salvador Dalí, Gift of Dalí to the Spanish state

1197 Cf. caption on p. 534

1198 The Head of the Medusa, 1962
Tête de méduse
Watercolour, 50 x 64 cm
Private collection

1199 Makrophotographic Self-Portrait with Gala Appearing as a Spanish Nun, 1962
Autoportrait macrophotographique avec apparition de Gala en religieuse espagnole
Gouache on a colour photograph, 78 x 48 cm
Private collection

1200 Cf. caption on p. 537

1201 Study for "The Battle of Tetuán", 1961
Etude pour «La bataille de Tétouan»
Gouache on cardboard, 10 x 38 cm
Private collection

1202 Arabs. Study for "The Battle of Tetuán", 1961
Arabes. Etude pour «La bataille de Tétouan»
Oil on cardboard, 12.5 x 75 cm
Private collection

1203 Study for "The Battle of Tetuán", 1961
Etude pour «La bataille de Tétouan»
Gouache on cardboard, 12.5 x 21 cm
Private collection; formerly Collection John Studevant

1204 Arab, 1962
Arabe
Indian ink, sepia and wash on paper, 48 x 38 cm
Gift of Dalí to the Spanish state

1205 Arabs. Study for "The Battle of Tetuán", 1960
Arabes. Etude pour «La bataille de Tétouan»
Mixed technique on cardboard, 25.5 x 38.5 cm
Private collection

1206 Study for "The Battle of Tetuán", 1962
Etude pour «La bataille de Tétouan»
Oil on panel, 18.5 x 23.5 cm
Figueras, Fundación Gala-Salvador Dalí

1207 The Battle of Tetuán, 1962
La bataille de Tétouan
Oil on canvas, 308 x 406 cm
Tokyo, Minami Art Museum

1208 Mohammed's Dream (Homage to Fortuny), 1961
Rêve de Mahomet (Hommage à Fortuny)
Oil on paper, 41 x 43 cm
New York, Collection Pierre Schlumberger

1209 Arab, 1962
Arabe
Mixed technique on crumpled paper, 73 x 53 cm
Figueras, Fundación Gala-Salvador Dalí, Gift of Dalí to the Spanish state

1210 Arabs – The Death of Raimundus Lullus, 1963
Arabes – Mort de Raymond Lulle
Oil on panel, 11 x 29 cm
Chicago, Abel E. Fagan Collection

1211 Desoxyribonucleic Acid Arabs, c. 1963
Arabes acidodésoxyribonucléiques
Oil on canvas, 131.5 x 180 cm
Madrid, Centro de Arte Reina Sofía, Gift of Dalí to the Spanish state

1212 Mohammed's Dream, 1963
Le songe de Mahomet
Oil on cardboard, 64 x 46 cm
Private collection

1213 Study for "Fifty Abstract Paintings which as Seen from Two Yards Change into Three Lenins Masquerading as Chinese and as Seen from Six Yards Appear as the Head of a Royal Bengal Tiger", 1963
Study for "Fifty Abstract Paintings which as Seen from Two Yards Change into Three Lenins Masquerading as Chinese and as Seen from Six Yards Appear as the Head of a Royal Bengal Tiger"
Gouache on cardboard, 51 x 76 cm
Figueras, Fundación Gala-Salvador Dalí, Gift of Dalí to the Spanish state

1214 The Infanta (Standing Woman), 1961
Infante (Standing Woman)
Oil, gouache, watercolour and Indian ink on cardboard, 25.5 x 25.5 cm
Private collection

1215 Twist in the Studio of Velázquez, 1962
Twist dans l'atelier de Vélasquez
Oil on canvas, 127 x 178 cm
Private collection

1216 Fifty Abstract Paintings which as Seen from Two Yards Change into Three Lenins Masquerading as Chinese and as Seen from Six Yards Appear as the Head of a Royal Bengal Tiger, 1963
Fifty Abstract Paintings which as Seen from Two Yards Change into Three Lenins Masquerading as Chinese and as Seen from Six Yards Appear as the Head of a Royal Bengal Tiger
Oil on canvas, 200 x 229 cm
Tokyo, Minami Art Museum

1217 Madonna with a Rose, 1964
Madone à la rose
Indian ink, sepia, gouache and watercolour on paper on panel, 59 x 46 cm
Private collection

1218 The Sacred Heart of Jesus, 1962
Cœur Sacré de Jésus
Oil on canvas, 86.5 x 61 cm
Private collection

1219 St. George and the Dragon, 1962
Saint Georges et le dragon
Oil on canvas, 22.9 x 30.5 cm
Private collection

1220 Madonna with a Mystical Rose, 1963
Madone à la rose mystique
Oil on canvas, 71 x 71 cm
Private collection

1221 The Alchemist, 1962
L'alchimiste
Oil on canvas, 60 x 40 cm
Paris, Collection Société Roussel-Uclaf

1222 Portrait of Mr. Fagen, 1962
Portrait de Mr. Fagen
Oil on canvas, 121 x 89.5 cm
Private collection

1223 Galacidalacidesoxyribonucleicacid, 1963
Galacidalacidesoxyribonucleicacid
Oil on canvas, 305 x 345 cm
Boston, The Bank of New England

1224 Female Nude (after restoration), 1964
Nu féminin (Reconstitution)
Cork on canvas, 45.8 x 38 cm
Private collection

1225 Hercules Lifts the Skin of the Sea and Stops Venus for an Instant from Waking Love, 1963
Hercule soulevant la peau de la mer demande à Vénus d'attendre un instant avant d'éveiller l'Amour
Oil on canvas, 41.9 x 55.9 cm
Nagaoka (Japan), Museum of Contemporary Art

1226 Untitled (Still Life with Lilies), 1963
Sans titre (Nature morte aux lys)
Oil on canvas, 50 x 61 cm
Private collection

1227 The Judgement of Paris, 1963
Le jugement de Pâris
Technique and dimensions unknown
Whereabouts unknown

1228 Untitled. Female Nude on a Palette, 1964
Sans titre (Dessin de femme nue exécuté sur une palette de peinture)
Oil (?) on palette, 29 x 25 cm
Collection Riera

1229 Portrait of my Dead Brother, 1963
Portrait de mon frère mort
Oil on canvas, 175 x 175 cm
Switzerland, private collection

1230 The Sun of Dalí, 1965
The Sun of Dalí
Oil, 101 x 75.7 cm
Private collection

1231 Landscape with Flies, 1964
Paysage avec mouches
Oil on gilded metal, 35.5 x 35.5 cm
Formerly Collection Gala and Salvador Dalí

1232 Untitled (St. John), 1964
Sans titre (Saint Jean)
Oil on plastic with lens-like grid, 15.2 x 11.5 cm
Private collection

1233 Odalisque by a Bath (Harem Scene), 1965
Odalisque devant un bassin (Scène dans un patio de harem)
Watercolour and gouache on cardboard, 36 x 31 cm
Private collection

1234 Religious Scene, 1963
Scène religieuse
Indian ink and wash, 42.5 x 59 cm
Private collection

1235 The Duke d'Olivares, 1965
Le Comte-duc de Olivares (El Conde Duque de Olivares)
Pencil, Indian ink, watercolour and gouache on paper, 152.5 x 101.5 cm
Private collection

1236 Philipp II Taking Communion, 1965
La communion de Philippe II
Watercolour, 39.4 x 59.7 cm
Private collection

1237 The Apotheosis of the Dollar (Salvador Dalí in the Act of Painting Gala in the Apotheosis of the Dollar in which You Can See on the Left Marcel Duchamp Masquerading as Louis XIV behind a Vermeerian Curtain which Is the Invisible Face, but Monumental, or Hermes by Praxiteles), 1965
L'apothéose du dollar
Oil on canvas, 400 x 498 cm
Figueras, Fundación Gala-Salvador Dalí; formerly Museo Perrot-Moore, Cadaqués

1238 Disguised Personage Pinning a Butterfly, 1965
Personnage déguisé en train de clouer un papillon
Oil on laminated panel, 12 x 9 cm
Figueras, Fundación Gala-Salvador Dalí, Gift of Dalí to the Spanish state

1239 Portrait of Gala (Gala against the Light), 1965
Portrait de Gala (Gala à contre-jour)
Oil on panel, 37.9 x 34.8 cm
Madrid, Centro de Arte Reina Sofía, Gift of Dalí to the Spanish state

1240, 1241 Cf. captions on p. 558

1242 The Railway Station at Perpignan (Gala Watching Dalí in a State of Weightlessness above his "Pop, Op, Yes-Yes, Kitsch" Work where two Awesome Figures from Millet's "Angelus" Appear to Us in an Atavistic State of Hibernation, Seen against a Sky which Can Suddenly Be Transformed into a Gigantic Maltese Cross, and at the Centre the Railway Station at Perpignan, where the Entire Universe Converges), 1965
La gare de Perpignan
Oil on canvas, 295 x 406 cm
Cologne, Museum Ludwig

1243 Yellow Astronaut (clerical). Design for a summer evening dress, 1965
Yellow Astronaut (clerical)
Watercolour, pencil and ball-point, 46 x 34 cm
Private collection

1244 Extra Flat. Design for a bikini, 1965
Extra flat
Gouache, pencil and Indian ink, 46 x 36 cm
Private collection

1245 Dalinian Empire. Design for a summer cocktail dress, 1965
Dalínienne Empire
Watercolour, pencil and collage, 46.5 x 34 cm
Private collection

1246 Coming Back. Design for a beach two-piece, 1965
Coming Back
Watercolour, gouache, pencil, charcoal, sanguine, felt-tip pen and Indian ink, 46.5 x 34 cm
Private collection

1247 Barcelona. Beachwear design, 1965
Barcelona
Watercolour and pencil, 46.5 x 34 cm
Private collection

1248 Fifty-Fifty. Swimsuit design, 1965
Fifty-Fifty
Watercolour, ball-point, gouache and charcoal, 46.5 x 34 cm
Private collection

1249 Portrait of Mrs. Ruth Daponte, 1965
Portrait de Mrs. Ruth Daponte
Oil on canvas, 85.1 x 59 cm
Private collection

1250 ODalísque. Design for a summer evening dress, 1965
ODalísque
Watercolour and pencil, 46.5 x 34 cm
Private collection

1251 Tennis. Design for a tennis dress, 1965
Tennis
Watercolour and ball-point, 46.5 x 34 cm
Private collection

1252 Night in the Hotel (Abstract in black and white), 1965
Nuit à l'Hostal (Abstraction en noir et blanc)
Acrylic on canvas, 200 x 400 cm
Private collection

1253 Moses and the Pharaoh, 1966
Moïse et le Pharaon
Oil on canvas, 103.5 x 91 cm
New York, Syracuse University Art Collection

1254 Untitled (Apocalyptic Christ; Christ with flames), 1965
Sans titre (Christ apocalyptique; Christ au moiré)
Oil on optical plastic panel, 40.5 x 40.5 cm
Private collection

1255 Untitled (St. John from behind), 1965
Sans titre (Saint Jean de dos)
Oil on plastic with lens-like grid, dimensions unknown
Whereabouts unknown

1256 The Anatomy Lesson, 1965
La leçon d'anatomie
Pen and ink on paper, 34 x 46 cm
St. Petersburg (FL), The Salvador Dalí Museum, on loan from E. and A. Reynolds Morse

1257 Laocoon Tormented by Flies, 1965
Laocoon tourmenté par les mouches
Oil on plastic with lens-like grid, 50.8 x 40.5 cm
Private collection

1258 Crucifixion (Dedication: For Gala Queen of the Divine Dalí), 1965
Crucifixion (Dédicacé: Pour Gala du Divin Dalí)
Oil on canvas, 24 x 18.5 cm
Private collection

1259, 1260 Cf. captions on p. 564

1261 Ernest Meissonier: The Battle of Friedland, 1807 (detail), 1888
Ernest Meissonier: 1807 Friedland
Oil on canvas, 133 x 242 cm
New York, The Metropolitan Museum of Art

1262 Homage to Meissonier, 1965
Hommage à Meissonier
Oil on panel, 120 x 140 cm
Figueras, Fundación Gala-Salvador Dalí, Gift of Dalí to the Spanish state

1263 Study for "Tuna Fishing", c. 1966/67
Etude pour « La pêche aux thons»
Pen, ink and watercolour, 38 x 51 cm
Private collection

1264 The progress of "Tuna Fishing", c. 1966/67
La pêche aux thons
Oil on canvas, 304 x 404 cm
Ile de Bendor, Fondation Paul Ricard

1265 Tuna Fishing (advanced state), c. 1966/67
La pêche aux thons
Oil on canvas, 304 x 404 cm
Ile de Bendor, Fondation Paul Ricard

1266 Tuna Fishing (advanced state), c. 1966/67
La pêche aux thons
Oil on canvas, 304 x 404 cm
Ile de Bendor, Fondation Paul Ricard

1267 Tuna Fishing (advanced state), c. 1966/67
La pêche aux thons
Oil on canvas, 304 x 404 cm
Ile de Bendor, Fondation Paul Ricard

1268 Study for "Tuna Fishing", 1966/67
Etude pour « La pêche aux thons»
Technique and dimensions unknown
Whereabouts unknown

1269 Study for "Tuna Fishing", 1966/67
Etude pour « La pêche aux thons»
Technique and dimensions unknown
Whereabouts unknown

1270 Large Figure for "Tuna Fishing", c. 1966/67
Grande figure pour « La pêche aux thons»
Pencil and watercolour on paper, 153 x 103 cm
Gift of Dalí to the Spanish state

1271 Large Figure for "Tuna Fishing", c. 1966/67
Grande figure pour « La pêche aux thons»
Pencil and watercolour on paper, 153 x 103 cm
Gift of Dalí to the Spanish state

1272 Tuna Fishing, c. 1966/67
La pêche aux thons
Oil on canvas, 304 x 404 cm
Ile de Bendor, Fondation Paul Ricard

1273 Pimp, undated
Le maquereau
Technique and dimensions unknown
Whereabouts unknown

1274 Tap (Grill), undated
Le robinet (La grille)
Technique and dimensions unknown
Whereabouts unknown

1275 Emblem of Wounded Pride, undated
Emblème de l'orgueil meurtri
Technique and dimensions unknown
Whereabouts unknown

1276 The Mountains of Cape Creus on the March (LSD Trip), 1967
Les montagnes du Cap Creus en marche (L.S.D. Trip)
Watercolour and Indian ink, 57 x 82 cm
Ile de Bendor, Fondation Paul Ricard

1277 The Flower Show – Carnation, 1967
Les floralies – Les œillets aux clés
Mixed technique on paper, 56 x 38 cm
Whereabouts unknown

1278 Cf. caption on p. 570

1279 Behind, 1973
Cul
Indian ink on paper, 25 x 25 cm
Whereabouts unknown

1280 Untitled (Erotic Drawing), 1932
Sans titre (Dessin érotique)
Indian ink on paper, 16 x 8 cm
Private collection

1281 Untitled (Erotic Scene with Seven Figures), c. 1966
Sans titre (Scène érotique à sept personnages)
Black and blue ball-point, 16 x 24 cm
Private collection

1282 Figure Climbing a Stair, 1967
Personnage montant un escalier (Figure Climbing a Stair)
Mixed technique on paper, 98 x 58.8 cm
Private collection

1283 Mad Mad Mad Minerva – Illustration for "Memories of Surrealism", c. 1968
Folle folle folle Minerva
Oil, gouache and Indian ink with photo collage on paper, 61 x 48 cm
Vienna, Galerie Kalb

1284 The Patio of Port Lligat, 1968
Le patio de Port Lligat
Oil on canvas, 60.1 x 77.6 cm
Figueras, Fundación Gala-Salvador Dalí, Gift of Dalí to the Spanish state

1285 Fisherman of Port Lligat, Mending his Net, 1968
Pêcheur de Port Lligat réparant ses filets
Oil on canvas, 32 x 45 cm
Private collection

1286 Cosmic Athlete, 1968
Athlète cosmique
Oil on canvas, 300 x 200 cm
Madrid, Palais de la Zarzuela, Property of the State

1287 Tauromachia I – The Torero, the Kill (third and final round of the bullfight), 1968
Tauromachie I – El Torero, Suerte de Matar
Gouache, 70 x 43 cm
Private collection

1288 Light and Shadow, 1968
Soli i sombra, 1968
Collage, gouache and Indian ink on cardboard, 101 x 101 cm
Private collection

1289 Study for "Cosmic Athlete", 1968
Etude pour «Athlète cosmique»
Pencil on cardboard, 24 x 18 cm
Private collection

1290 The Hallucinogenic Toreador, c. 1968-1970
Le torero hallucinogène
Oil on canvas, 398.8 x 299.7 cm
St. Petersburg (FL), The Salvador Dalí Museum, on loan from the Morse Charitable Trust

1291 Sketch for "The Hallucinogenic Toreador", 1968
Croquis pour «Le torero hallucinogène»
Technique and dimensions unknown
Whereabouts unknown

1292 Cf. caption on p.579

1293 Study for the toreador's face in "The Hallucinogenic Toreador". The likeness suggests that it could well have become Gala's face, 1968
Essais pour le visage virtuel du «Torero hallucinogène»
Pencil and ball-point on sketch pad; dimensions unknown
Private collection

1294-1296 Cf. captions on p.580

1297 Cf. caption on p.582

1298 Cf. caption on p.583

1299 Study of flies for "The Hallucinogenic Toreador", 1968
Etude des mouches pour «Le torero hallucinogène»
Indian ink on a photograph, 9.9 x 12.9 cm
Private collection

1300 Cf. caption on p.584

1301 Seven Flies and a Model, 1954
Sept mouches et un modèle
Pen; dimensions unknown
Private collection

1302 Cf. caption on p.584

1303-1306 Cf. captions on p.587

1307 Dalí as a Child with his Father, 1971
Dalí enfant avec son père
Indian ink; dimensions unknown
Whereabouts unknown

1308 The Hour of Monarchy, 1969
L'heure de la monarchie – Plafond du Palacio Albéniz de Montjuïc, Barcelone
Oil; diameter: 300 cm
Barcelona, Property of the City of Barcelona

1309 The Pool of Tears. Illustration for "Alice in Wonderland" by Lewis Carroll, in an edition published by Maecenas Press, New York, 1969
La mare aux larmes
Gouache, 56 x 40 cm
Private collection

1310 Untitled (Surrealist Angel), c. 1969
Sans titre (L'ange surréaliste)
Oil on canvas, 40 x 30 cm
Private collection

1311 Untitled (Still Life with White Cloth), 1969
Sans titre (Nature morte au drapé blanc)
Oil on canvas, 57 x 44 cm
Private collection; formerly Collection Juan Ferrer Perez

1312 Study of a Female Nude, c. 1962
Etude de nu féminin
Oil on canvas, 129.5 x 96.7 cm
Figueras, Fundación Gala-Salvador Dalí, Gift of Dalí to the Spanish state

1313 Study of a Male Nude – Saint Sebastian, 1969
Etude de nu masculin – Saint Sébastien
Oil on canvas, 145 x 97 cm
Figueras, Fundación Gala-Salvador Dalí, Gift of Dalí to the Spanish state

1314 Roger Freeing Angelica (St. George and the Damsel), 1970-1974
Roger délivrant Angélique (Saint Georges et la demoiselle)
Oil on canvas, 291 x 144.7 cm
Figueras, Fundación Gala-Salvador Dalí

1315 Portrait of John Theodoracopoulos, 1970
Portrait de John Theodoracopoulos
Oil on canvas; dimensions unknown
Private collection

1316 Untitled (Michelangelo Head with Drawers), c. 1970
Sans titre (Tête de Michel-Ange au tiroir)
Oil on plywood; dimensions unknown
Figueras, Fundación Gala-Salvador Dalí

1317 Patient Lovers (Apparition of a Stereoscopic Face in the Ampurdán Landscape), 1970
Patient Lovers (Apparition d'un visage à tendance stéréoscopique dans un paysage de Ampurdán)
Watercolour, ink and collage, 56 x 76 cm
Private collection

1318 Nude Figures at Cape Creus, 1970
Cap Creus con desnudos
Oil on copper, 39 x 49 cm
Private collection

1319 Winged Victory, 1970
Les ailes de la victoire (Winged Victory)
Mixed technique, 150 x 100 cm
Private collection

1320 Apparition of Venus, 1970
Apparition de Vénus
Oil and ink on paper and cardboard, 30 x 19 cm
Private collection

1321 Silhouette of a Tightrope Walker and Clown, c. 1970
Silhouette d'équilibriste et bouffon
Oil and Indian ink on copper, 40.5 x 30.1 cm
Figueras, Fundación Gala-Salvador Dalí, Gift of Dalí to the Spanish state

1322 Christ, 1970
Christ
Watercolour and mixed technique, 96.5 x 58.4 cm
Private collection

1323 Les demoiselles d'Avignon (The Girls of Avignon), 1970
Les demoiselles d'Avignon
Mixed technique, 209.4 x 149.4 cm
Madrid, Museo Nacional Reina Sofía, Gift of Dalí to the Spanish state

1324 View of Púbol, 1971
Vue de Púbol
Watercolour, 20 x 56.3 cm
Gift of Dalí to the Spanish state

1325 Hannibal Crossing the Alps, 1970
Hannibal traversant les Alpes
Gouache and watercolour on brown-grey fibred cardboard, 73 x 99 cm
St. Petersburg (FL), The Salvador Dalí Museum, on loan from E. and A. Reynolds Morse

1326 View of Púbol, 1971
Vue de Púbol
Oil on stone, 9 x 20.5 cm
Gift of Dalí to the Spanish state

1327 Cf. caption on p.595

1328 The Dalinian Senyera (Catalonian National Flag), 1970
La senyera Dalíniana
Oil on panel, 244 x 122 cm
Private collection

1329 Clauilegnio – The Flaming Horse (Dalí's Horses), c. 1971
Clauilegnio – The Flaming Horse (Les chevaux de Dalí)
Gouache and watercolour, 55.9 x 40.6 cm
Private collection

1330 Trajan on Horseback, 1972
Trajan à cheval
Oil on canvas, 46 x 38 cm
Private collection

1331 The Second Coming of Christ, 1971
The Second Coming of Christ
Oil on canvas, 53.3 x 34.3 cm
Private collection

1332 Caligula's Horse (Dalí's Horses), c. 1971
Le cheval de Caligula (Les chevaux de Dalí)
Gouache; dimensions unknown
Whereabouts unknown

1333 The Christian Knight (Dalí's Horses), 1971
Le chevalier chrétien (Les chevaux de Dalí)
Gouache; dimensions unknown
Whereabouts unknown

1334 Lady Godiva (Dalí's Horses), 1971
Lady Godiva (Les chevaux de Dalí)
Gouache and watercolour, 56 x 41 cm
Whereabouts unknown

1335 The Horseman of the Apocalypse, 1970
Cavaliers de l'Apocalypse
Gouache on paper, 55 x 75 cm
Private collection

1336, 1337 Cf. captions on p. 598

1338 Self-Portrait (Photomontage with the famous "Mao-Marilyn" that Philippe Halsman created at Dalí's wish), 1972
Autoportrait
Oil, mixed technique and collage, 118 x 96 cm
Private collection

1339, 1340 Cf. captions on p. 599

1341 Marilyn Monroe, 1972
Marilyn Monroe
Oil on perspex, nylon thread and panel on metal, 104.1 x 53.3 cm
Private collection

1342 Cf. caption on p. 600

1343 Radiators, Radiator-Covers, c. 1972
Radiateurs cache-radiateurs
Oil on iron panel, 229 x 105 cm
Gift of Dalí to the Spanish state

1344 Open doorway in *trompe l'œil*, c. 1972
Porte en trompe-l'œil (Les pierres sont réelles)
Oil on canvas, 220.5 x 115.7 cm
Gift of Dalí to the Spanish state

1345 Ceiling of the hall of Gala's castle at Púbol, 1971
Plafond du hall du château de Gala à Púbol
Oil on primed canvas, irregularly painted, 12.17 x 6.25 m
Gift of Dalí to the Spanish state

1346 Cf. caption on p. 600

1347 Armchair with Landscape painted for Gala's castle at Púbol, c. 1974
Fauteuil à paysage peint pour le château de Gala à Púbol
Oil on canvas; diameter: 45 cm
Púbol, private collection

1348 The Face, 1972
Le visage
Oil on paper, 58.5 x 44 cm
Figueras, Fundación Gala-Salvador Dalí

1349 Space Eve, 1972
Eva espacial
Oil on canvas, 58.7 x 76.3 cm
Collection Italcambio

1350 Now it is evening (Amazon), 1971
Maintenant c'est le soir (Amazone)
Indian ink, 53.3 x 43.1 cm
Private collection

1351 Quantification of Leonardo da Vinci's "Last Supper", c. 1972
Quantification de «La Cène» de Léonard de Vinci
Oil on synthetic panel, 30.3 x 40.5 cm
Madrid, Museo Nacional Reina Sofía, Gift of Dalí to the Spanish state

1352 Figure with Flag. Illustration for "Memories of Surrealism", c. 1971
Personnage au drapeau
Oil, gouache and collage, 61 x 47 cm
Private collection

1353 "Dalí" palette. Frontispiece for the outline of "The Key Dalí Paintings", 1972
Palette «Dalí». Frontispice pour le projet d'ouvrage «Les dessins clés de Salvador Dalí»
Oil on panel, 26.7 x 36.7 cm
Private collection

1354 The Banker (series of eleven gouaches on different professions), 1971
Le banquier
Watercolour, 47 x 35 cm
Private collection

1355 Design for the pool at Port Lligat, 1971
Projet pour la piscine de Port Lligat
Oil on cardboard, 12.5 x 10 cm
Figueras, Fundación Gala-Salvador Dalí, Gift of Dalí to the Spanish state

1356 Dalí from the Back Painting Gala from the Back Eternalized by Six Virtual Corneas Provisionally Reflected in Six Real Mirrors (unfinished), c. 1972/73
Dalí de dos peignant Gala de dos éternisée par six cornes virtuelles provisoirement réfléchies par six vrais miroirs
Oil on canvas, stereoscopic work on two components, 60 x 60 cm each
Figueras, Fundación Gala-Salvador Dalí

1357 Gala's Dream (Dream of Paradise), c. 1972
Le rêve de Gala (Rêve de paradis)
Oil, gouache, pastel and collage on paper, 62 x 44.5 cm
Private collection

1358 Dalí from the Back Painting Gala from the Back Eternalized by Six Virtual Corneas Provisionally Reflected in Six Real Mirrors (unfinished), c. 1972/73
Dalí de dos peignant Gala de dos éternisée par six cornes virtuelles provisoirement réfléchies par six vrais miroirs
Oil on canvas, stereoscopic work on two components, 60 x 60 cm each
Figueras, Fundación Gala-Salvador Dalí

1359 Sfumato. Dalí developed a new technique using paper scorched and smoked with a candle, 1972
Sfumato
Paper burned and charred with a candle, 59 x 45 cm
Figueras, Fundación Gala-Salvador Dalí

1360 Cf. caption on p. 607

1361 Polyeder. Basketball Players Metamorphosing into Angels (Montage for a hologram – central portion), 1972
Polyèdre. Joueurs de basket-ball se transformant en anges (montage pour un hologramme – élément central)
Oil on panel, 37.5 x 39.5 cm
Private collection

1362 The Sleeping Smoker, c. 1972/73
Le fumeur endormi
Stereoscopic work on two components, 60 x 60 cm each
Geneva, Collection G.E.D. Nahmad

1363 The Sleeping Smoker, c. 1972/73
Le fumeur endormi
Stereoscopic work on two components, 60 x 60 cm each
Geneva, Collection G.E.D. Nahmad

1364 Holos! Holos! Velázquez! Gábor!, c. 1972/73
Holos! Holos! Vélasquez! Gábor!
Hologram, the first three-dimensional collage, 42 x 57 cm
Figueras, Fundación Gala-Salvador Dalí

1365 Untitled (Stereoscopic painting), 1972
Sans titre (Peinture stéréoscopique)
Oil on canvas, 21.8 x 22.8 cm each
Private collection

1366 Cf. caption on p. 609

1367, 1368 Cf. captions on p. 611

1369, 1370 Cf. captions on p. 612

1371-1373 Cf. captions on p. 613

1374-1377 Cf. captions on p. 615

1378, 1379 Cf. captions on p. 617

1380 Head (stairway in the museum), 1977
Plywood; technique and dimensions unknown
Figueras, Teatro Museo Dalí

1381 Sketch for a ceiling of the Teatro Museo Dalí, 1970
Esquisse pour un plafond du Teatro Museo Dalí
Pencil, watercolour and gouache on cardboard, 104.4 x 75 cm
Figueras, Fundación Gala-Salvador Dalí

1382 Palace of the Winds (ceiling painting in the Teatro Museo Dalí; detail), 1972/73
Palais des vents
Oil on canvas (five canvas-backed panels), 210 x 399 cm
Figueras, Fundación Gala-Salvador Dalí

1383-1386 Cf. captions on p. 620

1387-1389 Cf. captions on p. 622

1390-1395 Cf. captions on p. 626

1396, 1397 Cf. captions on p. 628

1398, 1399 Cf. captions on p. 629

1400 Christ Twisted, 1976
Christ twisté, 1976
White wax and brass cross; height:
125 cm
Figueras, Fundación Gala-Salvador
Dalí

1401, 1403 Cf. captions on p.631

1402 Pomona, Autumn, 1973
Pomone, automne
Watercolour, gouache, pastel,
sanguine and Indian ink on paper,
97 x 57 cm
Private collection

1404 Nude (transfer technique),
1974
Desnudo de Calcomania, 1974
Mixed technique on cardboard;
dimensions unknown
Private collection

1405 Three Hyper-Realist Graces
(Anti-Racism), 1973
*Trois grâces hyperréalistes
(L'antiracisme)*
Watercolour and gouache on
cardboard (relief-like), 56.5 x 77.5 cm
Private collection

1406 Standing Female Nude, 1974
Nu féminin debout
Gouache with prints, pencil and
sanguine, 152 x 102 cm
Private collection

1407 Gala's Foot – Stereoscopic
work (left component), 1973
*Le pied de Gala – Œuvre
stéréoscopique (image de gauche)*
Oil on canvas; stereoscopic work,
60 x 60 cm
Figueras, Fundación Gala-Salvador
Dalí

1408 Gala's Foot – Stereoscopic
work (right component), 1973
*Le pied de Gala – Œuvre
stéréoscopique (image de droite)*
Oil on canvas; stereoscopic work,
60 x 60 cm
Figueras, Fundación Gala-Salvador
Dalí

1409 Portrait of Dr. Brian Mercer,
1973
Portrait du Docteur Brian Mercer
Oil; material and dimensions
unknown
Private collection

1410 Gala's Castle at Púbol, 1973
Le château de Gala à Púbol
Oil on canvas, 160 x 189.7 cm
Gift of Dalí to the Spanish state

1411 Las Galas of Port Lligat, 1973
Las Galas de Port Lligat
Oil on canvas, 165 x 195 cm
Barcelona, Museo Estrada

1412 Cranach Metamorphosis
(Woman in a Mirror), 1974
*Transformation Cranach (Femme au
miroir)*
Oil on panel, 83.5 x 61 cm
Cadaqués, Museo Perrot-Moore

1413 Figure with Swan, 1974
Paraje con Cisne
Oil, watercolour and Indian ink on
primed paper, 105 x 76 cm
Private collection

1414 Wounded Soft Watch, 1974
Montre molle blessée
Oil on canvas, 40 x 51 cm
Private collection

1415 The Black Mass, 1974
La messe noire (La misa negra)
Oil, watercolour and Indian ink on
primed paper, 76 x 105 cm
Private collection

1416 Equestrian Portrait of
Carmen Bordiu-Franco, 1974
*Portrait équestre de Carmen
Bordiu-Franco*
Oil on canvas, 160 x 180 cm
Private collection

1417 Lilith (Homage to Raymond
Roussel), 1966
*Lilith (Hommage à Raymond
Roussel)*
Painted plaster, hairpins, two
equestrian statuettes by Meissonier,
54 x 63 x 24 cm
Figueras, Fundación Gala-Salvador
Dalí

1418 "Lilith", detail: Hairpin
genitals
Painted plaster, hairpins, two
equestrian statuettes by Meissonier,
54 x 63 x 24 cm
Figueras, Fundación Gala-Salvador
Dalí

1419 Untitled (Object for Gala),
c. 1972
Sans titre (Objet pour Gala)
Spider crab shell with inlaid
polished agate on which Gala's face
is painted, 19.4 x 15.9 x 6.9 cm
Private collection

1420 Bust of Dante (adorned with
golden spoons), 1964
*Buste de Dante (orné de cuillères en
or)*
Bronze with green patina and gold
spoons; height 26.5 cm
Duisburg, Wilhelm-Lehmbruck
Museum

1421, 1422 Chair with the Wings of
a Vulture (A playful object that
might be used for cultic or erotic
purposes), 1960
*La chaise aux ailes de vautour
(Objet ludique et sexuel, pouvant
être utilisé tantôt pour un culte,
tantôt à des fins érotiques)*
Wood and decorative assemblage,
120 x 35 x 35 cm
Private collection

1423 Death Mask of Napoleon –
Can Be Used as a Cover for a
Rhinoceros, 1970
*Masque funèbre de Napoléon –
Pouvant servir de couvercle à un
rhinocéros*
Gilded bronze, 22 x 19 x 28 cm
Paris, private collection

1424 Death Mask of Napoleon,
1970
Masque funèbre de Napoléon
Gilded bronze, 22 x 19 x 28 cm
Paris, private collection

1425 Death Mask of Napoleon –
Can Be Used as a Cover for a
Rhinoceros, 1970
*Masque funèbre de Napoléon –
Pouvant servir de couvercle à un
rhinocéros*
Gilded bronze, 22 x 19 x 28 cm
Paris, private collection

1426 Otorhinological Head of
Venus, 1970
Tête otorhinologique de Vénus
Painted plaster; height: 65 cm
Gift of Dalí to the Spanish state

1427 Michelin's Slave – Can Be
Used as a Car, 1965
*L'esclave de Michelin – Pouvant
servir d'automobile*
Bronze, 30 x 18 x 18 cm
Verona, Fondaria Bonvincini

1428 Michelin's Slave, 1965
L'esclave de Michelin
Bronze, 30 x 18 x 18 cm
Verona, Fondaria Bonvincini

1429 Christ Twisted, 1976
Christ twisté
White wax and brass cross
(electrolytically copper-plated);
height: 125 cm
Figueras, Fundación Gala-Salvador
Dalí

1430 Swan-Elephant and Serpent –
Can Be Used as an Ashtray, 1967
*Cygnes-éléphants et serpent –
Pouvant servir de cendrier*
Limoges porcelain, 8.6 x 12.8 x 16 cm
Private collection

1431 Figurine Nike, 1973
Figurine Niké
Metal-plated paper with overprinted
circuitry, 27.3 x 9.5 x 7.8 cm
Private collection

1432 Bust of Velázquez Turning
into Three Figures Conversing, 1974
*Buste de Vélasquez se
métamorphosant en trois
personnages conversant*
Painted bronze, 90 x 70 x 38 cm
Figueras, Fundación Gala-Salvador
Dalí

1433 Homage to Newton, 1969
Hommage à Newton
Patinated bronze, 132 x 70 x 40 cm
Madrid, Plaza Dalí

1434 White Eagle, 1974
Aigle blanc
Patinated bronze overpainted in
several colours of oil,
52.5 x 47.5 x 25 cm
St. Petersburg (FL), The Salvador
Dalí Museum, on loan from E. and
A. Reynolds Morse

1435 Cf. caption on p.645

1436 Cf. caption on p.647

1437 "The Poetry of America" or
"The Cosmic Athletes"
*«Poésie d'Amérique» ou «Les
athlètes cosmiques»*
Oil on canvas, 116.8 x 78.7 cm
Figueras, Fundación Gala-Salvador
Dalí

1438 Cf. caption on p.648

1439-1440 Cf. captions on p.649

1441 Architectural Design (Eye
Catching Economy), 1976
*Projet d'architecture (Eye Catching
Economy)*
Gouache and ink on newspaper,
29.5 x 18.5 cm
Private collection

1442 The Giraffe (The Giraffe of
Avignon), 1975
La girafe (La girafe d'Avignon)
Pastel, watercolour, gouache and
stuck-on paper, 43 x 63.5 cm
Private collection

1443 Homage to Philosophy, 1976
Hommage à la philosophie
Watercolour on cardboard,
66.2 x 48.8 cm
Collection Italcambio

1444 Lullus – Homage to
Raimundus Lullus (Design for a
ceiling painting), 1975
*Lulle – Hommage à Raymond Lulle
(Projet pour un plafond)*
Gouache on cardboard, 52 x 59cm
Private collection

1445 Musical Harmony, 1976
Harmonie musicale
Watercolour on cardboard,
66.5 x 49cm
Collection Italcambio

1446 Gala Contemplating the
Mediterranean Sea which at Twenty
Meters Becomes the Portrait of
Abraham Lincoln – Homage to
Rothko (first version), c. 1974/75
*Gala regardant la mer
Méditerrannée qui a vingt mètres se
transforme en portrait d'Abraham
Lincoln – Hommage à Rothko*
Oil on photographic paper,
445 x 350cm
Figueras, Fundación Gala-Salvador
Dalí

1447 Gala Contemplating the
Mediterranean Sea which at Twenty
Meters Becomes the Portrait of
Abraham Lincoln – Homage to
Rothko (second version), 1976
*Gala regardant la mer Méditerranée
qui a vingt mètres se transforme en
portrait d'Abraham Lincoln –
Hommage à Rothko*
Oil on canvas, 252.2 x 191.9cm
Tokyo, Minami Art Museum

1448 Soft Monster, 1976
Monstre mou (Soft Monster)
Oil on canvas, 55 x 70.5cm
Private collection

1449 White Monster in an Angelic
Landscape, 1977
*Monstre blanc dans un paysage
angélique*
Oil on canvas; dimensions unknown
Cittá del Vaticano (Rome), Musei
Vaticani, Collezione d'Arte
Religiosa Moderna

1450 The Happy Unicorn, 1977
L'unicorne allègre
Oil on copper, 28 x 42cm
Private collection

1451 The Unicorn (unfinished),
1976
L'unicorne
Oil on copper, 28 x 42cm
Private collection

1452 Soft Skulls with Fried Egg
Without the Plate, Angels and Soft
Watch in an Angelic Landscape, 1977
*Têtes molles avec œuf sur le plat sans
le plat, anges et montres molles dans
un paysage angélique*
Oil on canvas, 61 x 91.5cm
Private collection

1453 Nike, Victory Goddess of
Samothrace, Appears in a Tree
Bathed in Light, c. 1977
*Niké, Victoire de Samothrace,
apparaissant dans un arbre baigné
de rayons lumineux*
Oil on plywood, 183 x 100cm
Figueras, Fundación Gala-Salvador
Dalí

1454 Aurora's Head, after
Michelangelo (detail of a figure on
the grave of Lorenzo di Medici),
1977
*Tête de l'Aurore d'après
Michel-Ange*
Oil on plywood, 139.2 x 79cm
Figueras, Fundación Gala-Salvador
Dalí

1455 Surrealist Angel, c. 1977
L'ange surréaliste
Oil on canvas, 197 x 197cm
Figueras, Fundación Gala-Salvador
Dalí

1456 Untitled, 1977
Sans titre
Ink and pencil on paper, 20 x 24cm
Private collection

1457 Fertility, 1977
Fecondidad (Fertilité)
Oil on canvas, 48.5 x 65.4cm
Collection Italcambio

1458 Woman with Egg and
Arrows, c. 1978
Femme avec œuf et flèches
Oil on laminated panel, 200 x 100cm
Figueras, Fundación Gala-Salvador
Dalí

1459 Spanish Knight, 1977
Chevalier espagnol
Watercolour on cardboard,
67.7 x 50.1cm
Collection Italcambio

1460 Daphne: the Tree Woman,
1977
Daphné: la femme arbre
Watercolour on cardboard,
65.5 x 49cm
Collection Italcambio

1461 Virgin with Swallows, 1977
La vierge aux hirondelles
Watercolour on cardboard,
67.9 x 49.9cm
Collection Italcambio

1462 Eight Pieces of the Angelus –
Man in Pieces, 1977
*Ocho trozos de Angelus – Homme
en morceaux*
Watercolour on cardboard,
65.5 x 48.7cm
Collection Italcambio

1463 Cf. caption on p.659

1464 Preparatory drawing for "The
Chair", 1976
Dessin préparatoire pour « La chaise »
Ball-point on paper with collage,
77 x 57.5cm
Private collection

1465 The Chair (Stereoscopic
work, left component), 1975
*La chaise (Œuvre stéréoscopique,
image de gauche)*
Oil on canvas, stereoscopic work on
two components, 400 x 210cm
Figueras, Fundación Gala-Salvador
Dalí

1466 The Chair (Stereoscopic
work, right component), 1975
*La chaise (Œuvre stéréoscopique,
image droite)*
Oil on canvas, stereoscopic work on
two components, 400 x 210cm
Figueras, Fundación Gala-Salvador
Dalí, Gift of Dalí to the Spanish state

1467 Study for "The Chair", 1975
Etude pour « La chaise »
Black felt-tip pen, 24.2 x 16.9cm
Private collection

1468 The Wash Basin (Stereoscopic
work, left component), 1976
*Les lavabos (Œuvre stéréoscopique,
image de gauche)*
Oil on canvas, stereoscopic work;
dimensions unknown
Private collection

1469 The Wash Basin (Stereoscopic
work, right component), 1976
*Les lavabos (Œuvre stéréoscopique,
image de droite)*
Oil on canvas, stereoscopic work;
dimensions unknown
Private collection

1470 The Chair (Stereoscopic
work, left component), 1976
*La chaise (Œuvre stéréoscopique,
image de gauche)*
Oil on canvas, stereoscopic work;
dimensions unknown
Private collection

1471 The Chair (Stereoscopic
work, right component), 1976
*La chaise (Œuvre stéréoscopique,
image de droite)*
Oil on canvas, stereoscopic work;
dimensions unknown
Private collection

1472 Study for "Las Meninas"
(Stereoscopic work, left
component), 1976
*Etude pour « Les Ménines » (Œuvre
stéréoscopique, image de gauche)*
Watercolour, stereoscopic work;
dimensions unknown
Private collection

1473 Study for "Las Meninas"
(Stereoscopic work, right
component), 1976
*Etude pour « Les Ménines » (Œuvre
stéréoscopique, image de droite)*
Watercolour, stereoscopic work;
dimensions unknown
Private collection

1474 Las Meninas (The
Maids-in-Waiting) – First
metaphysical hyper-realist painting
(unfinished), 1977
*Les Ménines – Première peinture
hyperréaliste métaphysique*
Oil on canvas, 100 x 81cm
Figueras, Fundación Gala-Salvador
Dalí

1475 Portrait of Gala, 1976/77
Portrait de Gala
Oil on copper, 35 x 27cm
Figueras, Fundación Gala-Salvador
Dalí, Gift of Dalí to the Spanish state

1476 Las Meninas (The
Maids-in-Waiting: Stereoscopic
work, left component), 1976/77
*Les Ménines (Œuvre stéréoscopique,
image de gauche)*
Oil on canvas, stereoscopic work,
35.6 x 25.1cm
Madrid, Centro de Arte Reina Sofía,
Gift of Dalí to the Spanish state

1477 Las Meninas (The
Maids-in-Waiting: Stereoscopic
work, right component), 1976/77
*Les Ménines (Œuvre stéréoscopique,
image de droite)*
Oil on canvas, stereoscopic work,
35.6 x 25.1cm
Madrid, Centro de Arte Reina Sofía,
Gift of Dalí to the Spanish state

1478 Randomdot correlogram – The Golden Fleece (Stereoscopic work, left component; unfinished), c. 1977
Randomdot correlogram – La Toison d'Or (Œuvre stéréoscopique, image de gauche)
Oil on cardboard, stereoscopic work, 72.8 x 101.8 cm
Figueras, Fundación Gala-Salvador Dalí, Gift of Dalí to the Spanish state

1479 Randomdot correlogram – The Golden Fleece (Stereoscopic work, right component; unfinished), c. 1977
Randomdot correlogram – La Toison d'Or (Œuvre stéréoscopique, image de droite)
Oil on cardboard, stereoscopic work, 72.8 x 101.8 cm
Figueras, Fundación Gala-Salvador Dalí, Gift of Dalí to the Spanish state

1480 Dalí's Hand Drawing Back the Golden Fleece in the Form of a Cloud to Show Gala the Dawn, Completely Nude, Very, Very Far Away Behind the Sun (Stereoscopic work, left component), 1977
La main de Dalí retirant une Toison d'Or en forme de nuage pour montrer à Gala l'aurore toute nue très, très loin derrière le soleil (Œuvre stéréoscopique, image de gauche)
Oil on canvas, stereoscopic work on two components, 60 x 60 cm
Figueras, Fundación Gala-Salvador Dalí, Gift of Dalí to the Spanish state

1481 Dalí's Hand Drawing Back the Golden Fleece in the Form of a Cloud to Show Gala the Dawn, Completely Nude, Very, Very Far Away Behind the Sun (Stereoscopic work, right component), 1977
La main de Dalí retirant une Toison d'Or en forme de nuage pour montrer à Gala l'aurore toute nue très, très loin derrière le soleil (Œuvre stéréoscopique, image de droite)
Oil on canvas, stereoscopic work on two components, 60 x 60 cm
Figueras, Fundación Gala-Salvador Dalí

1482 Study for "Dalí Lifting the Skin of the Mediterranean Sea to Show Gala the Birth of Venus", 1977
Etude pour «Dalí soulevant la peau de la mer Méditerranée pour montrer à Gala la naissance de Vénus»
Watercolour, pencil, ball-point, Indian ink and wash, 26.3 x 37.3 cm
Private collection

1483 Dalí Lifting the Skin of the Mediterranean Sea to Show Gala the Birth of Venus (Stereoscopic work, left component), 1977
Dalí soulevant la peau de la mer Méditerranée pour montrer à Gala la naissance de Vénus (Œuvre stéréoscopique, image de gauche)
Oil on canvas, stereoscopic work on two components, 101 x 101 cm
Figueras, Fundación Gala-Salvador Dalí

1484 Dalí Lifting the Skin of the Mediterranean Sea to Show Gala the Birth of Venus (Stereoscopic work, right component), 1977
Dalí soulevant la peau de la mer Méditerranée pour montrer à Gala la naissance de Vénus (Œuvre stéréoscopique, image de droite)
Oil on canvas, stereoscopic work on two components, 101 x 101 cm
Figueras, Fundación Gala-Salvador Dalí

1485 Gala's Christ (Stereoscopic work, left component), 1978
Le Christ de Gala (Œuvre stéréoscopique, image de gauche)
Oil on canvas, stereoscopic work on two components, 100 x 100 cm
Private collection

1486 Gala's Christ (Stereoscopic work, right component), 1978
Le Christ de Gala (Œuvre stéréoscopique, image de droite)
Oil on canvas, stereoscopic work on two components, 100 x 100 cm
Private collection

1487 The Eye of the Angelus (Stereoscopic work, left component, unfinished), 1978
L'œil de l'Angélus (Œuvre stéréoscopique, image de gauche)
Oil on canvas, stereoscopic work, 100 x 100 cm
Figueras, Fundación Gala-Salvador Dalí, Gift of Dalí to the Spanish state

1488 The Eye of the Angelus (Stereoscopic work, right component, unfinished), 1978
L'œil de l'Angélus (Œuvre stéréoscopique, image de droite)
Oil on canvas, stereoscopic work, 100 x 100 cm
Figueras, Fundación Gala-Salvador Dalí, Gift of Dalí to the Spanish state

1489 Stereoscopic Composition Based on Millet's "Angelus" (unfinished), c. 1978
Composition stéréoscopique sur l'«Angélus» de Millet
Oil on photographic paper, 49.3 x 63 cm
Figueras, Fundación Gala-Salvador Dalí

1490 Stereoscopic Composition Based on Millet's "Angelus" (unfinished), c. 1978
Composition stéréoscopique sur l'«Angélus» de Millet
Oil on photographic paper, 51 x 62 cm
Figueras, Fundación Gala-Salvador Dalí, Gift of Dalí to the Spanish state

1491 Battle in the Clouds (Stereoscopic work, left component), 1979
Bataille dans les nuages (Œuvre stéréoscopique, image de gauche)
Oil on canvas, stereoscopic work, 100 x 100 cm
Madrid, Centro de Arte Reina Sofía, Gift of Dalí to the Spanish state

1492 Battle in the Clouds (Stereoscopic work, right component), 1979
Bataille dans les nuages (Œuvre stéréoscopique, image de droite)
Oil on canvas, stereoscopic work, 100 x 100 cm
Madrid, Centro de Arte Reina Sofía, Gift of Dalí to the Spanish state

1493 Athens Is Burning! – The School of Athens and The Fire in the Borgo (Stereoscopic work, left component), 1979/80
Athènes brûle! – L'école d'Athènes et L'incendie du Borgo (Œuvre stéréoscopique, image de gauche)
Oil on panel, stereoscopic work, 32.2 x 43.1 cm
Figueras, Fundación Gala-Salvador Dalí

1494 Athens Is Burning! – The School of Athens and The Fire in the Borgo (Stereoscopic work, right component), 1979/80
Athènes brûle! – L'école d'Athènes et L'incendie du Borgo (Œuvre stéréoscopique, image de droite)
Oil on panel, stereoscopic work, 32.2 x 43.1 cm
Figueras, Fundación Gala-Salvador Dalí

1495 The Harmony of the Spheres, 1978
L'harmonie des sphères
Oil on canvas, 100 x 100 cm
Figueras, Fundación Gala-Salvador Dalí, Gift of Dalí to the Spanish state

1496 Pentagonal Sardana (Stereoscopic work, left component), 1979
Sardane pentagonale (Œuvre stéréoscopique, image de gauche)
Oil on canvas, stereoscopic work, 100 x 100 cm
Figueras, Fundación Gala-Salvador Dalí, Gift of Dalí to the Spanish state

1497 Pentagonal Sardana (Stereoscopic work, right component), 1979
Sardane pentagonale (Œuvre stéréoscopique, image de droite)
Oil on canvas, stereoscopic work, 100 x 100 cm
Figueras, Fundación Gala-Salvador Dalí, Gift of Dalí to the Spanish state

1498 Pierrot lunaire (Stereoscopic work, unfinished), 1978
Pierrot lunaire (Œuvre stéréoscopique)
Oil on panel, stereoscopic work, 111 x 244 cm
Figueras, Fundación Gala-Salvador Dalí, Gift of Dalí to the Spanish state

1499 Cybernetic Odalisque – Homage to Bela Julesz, 1978
Odalisque cybernétique (Hommage à Bela Julesz)
Oil on canvas, 200 x 200 cm
Figueras, Fundación Gala-Salvador Dalí, Gift of Dalí to the Spanish state

1500 Long Live the Station at Perpignan, Long Live Figueras, 1979
Vive la gare de Perpignan – Viva Figueras
Oil on cardboard on canvas, 55.1 x 46 cm
Figueras, Fundación Gala-Salvador Dalí, Gift of Dalí to the Spanish state

1501 Landscape near Ampurdán, 1978
Paysage de l'Ampurdán
Oil on canvas, 61 x 50.8 cm
Private collection

1502 Landscape near Ampurdán (Dedicated to Sabater), 1978
Paysage de l'Ampurdán (Paisantje Empordanes, dédicacé à Sabater)
Oil on copper, 24 x 30 cm
Private collection

1503 Allegory of Spring, 1978
Allégorie du printemps
Oil on panel, with a frame of plastic cherries and Catalonian espadrilles, 122 x 244 cm
Figueras, Fundación Gala-Salvador Dalí

1504 Dark Tapeworms, c. 1978
Planaires lugubres
Oil on canvas, 100 x 100 cm
Figueras, Fundación Gala-Salvador Dalí, Gift of Dalí to the Spanish state

1505 Phosphene, 1979
Phosphène
Oil on canvas, 146 x 97 cm
Madrid, Centro de Arte Reina Sofía

1506 Copy of a Rubens Copy of a Leonardo, 1979
Copie d'un Rubens copié d'un Léonard
Oil on panel, 18 x 24 cm
Figueras, Fundación Gala-Salvador Dalí, Gift of Dalí to the Spanish state

1507 Cf. caption on p. 675

1508 Searching for the Fourth Dimension, 1979
A la recherche de la quatrième dimension
Oil on canvas, 122.5 x 246 cm
Figueras, Fundación Gala-Salvador Dalí, Gift of Dalí to the Spanish state

1509 A Soft Watch Put in the Appropriate Place to Cause a Young Ephebe to Die and Be Resuscitated by Excess of Satisfaction (unfinished), 1979
Une montre molle posée à l'endroit adéquat faisant mourir et ressusciter un jeune éphèbe par excès de satisfaction
Oil on panel, 122 x 244 cm
Figueras, Fundación Gala-Salvador Dalí, Gift of Dalí to the Spanish state

1510 Dawn, Noon, Sunset, and Twilight, 1979
Aurore, midi, couchant et crépuscule
Oil on panel, 122 x 244 cm
Figueras, Fundación Gala-Salvador Dalí

1511 Raphaelesque Hallucination, 1979
Hallucination raphaëlesque
Oil on plywood, 120 x 244 cm
Figueras, Fundación Gala-Salvador Dalí, Gift of Dalí to the Spanish state

1512 Untitled (Landscape with Celestial Beings), 1980
Sans titre (Paysage avec personnages célestes)
Oil on canvas, 43.6 x 56.9 cm
Madrid, Centro de Arte Reina Sofía, Gift of Dalí to the Spanish state

1513 Nude and Horse with Metamorphosis (unfinished), c. 1979
Nu et cheval avec métamorphose
Oil on canvas, 76 x 101.5 cm
Figueras, Fundación Gala-Salvador Dalí, Gift of Dalí to the Spanish state

1514 Three Graces of Canova (unfinished), 1979
Trois grâces de Canova
Oil on copper, 32.1 x 24.3 cm
Figueras, Fundación Gala-Salvador Dalí, Gift of Dalí to the Spanish state

1515 Study for "Compianto Diabele" by Canova (unfinished), c. 1979
Etude pour «Compianto Diabele» de Canova
Oil and pencil on copper, 37.8 x 25.8 cm
Madrid, Centro de Arte Reina Sofía, Gift of Dalí to the Spanish state

1516 More Beautiful than Canova, 1979
Plus beau que Canova
Oil on copper, 32 x 24 cm
Figueras, Fundación Gala-Salvador Dalí, Gift of Dalí to the Spanish state

1517 The Cheerful Horse, 1980
Le cheval gai
Oil on panel, 122 x 245 cm
Figueras, Fundación Gala-Salvador Dalí

1518 Sleeping Young Narcissus, 1980
Narcisse jeune endormi
Oil on panel, 120 x 120 cm
Private collection

1519 Untitled (Bridge with Reflections; sketch for a dual image picture, unfinished), 1980
Sans titre (Pont avec reflets; projet pour double-image)
Oil on canvas, 50 x 61 cm
Figueras, Fundación Gala-Salvador Dalí, Gift of Dalí to the Spanish state

1520 Arabs, 1980
Arabes
Oil on panel and collage with toothpicks, 32 x 43 cm
Private collection

1521 Group Surrounding a Reclining Nude – Velázquez, 1980/81
Groupe de personnages entourant un nu allongé – Vélasquez
Oil on canvas, printed, 26 x 36 cm
Gift of Dalí to the Spanish state

1522 Arabs, 1980
Arabes
Oil on panel and collage with toothpicks, 17 x 23 cm
Private collection

1523 Hermes, 1981
Hermès
Oil on copper, 22.8 x 17.8 cm
Madrid, Centro de Arte Reina Sofía, Gift of Dalí to the Spanish state

1524 Apparition of the Visage of Aphrodite of Cnidos in a Landscape, 1981
Apparition du visage de l'Aphrodite de Cnide dans un paysage
Oil on canvas, 140 x 96 cm
Figueras, Fundación Gala-Salvador Dalí, Gift of Dalí to the Spanish state

1525 The Garden of Hours, 1981
Le jardin des heures
Oil on canvas, 65.3 x 54.1 cm
Figueras, Fundación Gala-Salvador Dalí, Gift of Dalí to the Spanish state

1526, 1527 Cf. captions on p. 683

1528 Tower, Grand Piano and Fountain, 1981
Tour, piano à queue et fontaine
Oil on copper, 76.5 x 56 cm
Madrid, Centro de Arte Reina Sofía, Gift of Dalí to the Spanish state

1529 The Towers, 1981
Les tours
Oil on copper, 76.1 x 56.1 cm
Madrid, Centro de Arte Reina Sofía, Gift of Dalí to the Spanish state

1530 Great Tapeworm Masturbator Appears behind Arcades, 1981
Grand masturbateur-planaire apparaissant derrière des arcades
Oil on copper, 14 x 19 cm
Madrid, Centro de Arte Reina Sofía, Gift of Dalí to the Spanish state

1531 The Tower of Enigmas, 1971-1981
La tour des énigmes
Oil on copper, 35 x 27 cm
Figueras, Fundación Gala-Salvador Dalí, Gift of Dalí to the Spanish state

1532 Seated Figure Contemplating a "Great Tapeworm Masturbator", 1981
Personnage assis contemplant un «Grand masturbateur-planaire»
Oil on copper, 35 x 27 cm
Madrid, Centro de Arte Reina Sofía, Gift of Dalí to the Spanish state

1533 Tower, 1981
Tour
Oil on copper, 42.1 x 28.1 cm
Madrid, Centro de Arte Reina Sofía, Gift of Dalí to the Spanish state

1534 Ready-to-wear Fashion for Next Spring: "Garlands, Nests and Flowers", 1981
Le prêt-à-porter du prochain printemps: «des guirlandes, des nids et des fleurs»
Oil, collage, felt-tip pen and gouache on copper, 42 x 28 cm
Private collection

1535 The Gaseous Swan, 1981
Le cygne gazeux
Oil on copper, 24 x 32.1 cm
Madrid, Centro de Arte Reina Sofía, Gift of Dalí to the Spanish state

1536 Amphitrite, 1981
Amphitrite
Oil on copper, 17.7 x 22.6 cm
Madrid, Centro de Arte Reina Sofía, Gift of Dalí to the Spanish state

1537 The Path of Enigmas (first version), 1981
Le chemin de l'énigme
Oil on canvas, 65.2 x 54.1 cm
Madrid, Centro de Arte Reina Sofía, Gift of Dalí to the Spanish state

1538 The Path of Enigmas (second version), 1981
Le chemin de l'énigme
Oil on canvas, 139 x 94 cm
Figueras, Fundación Gala-Salvador Dalí

1539 Argus, c. 1981
Argus
Oil on canvas, 97.1 x 146.5 cm
Figueras, Fundación Gala-Salvador Dalí, Gift of Dalí to the Spanish state

1540 Medea or Jason Taking Possession of the Golden Fleece, 1981
Médée ou Jason se saisissant de la Toison d'Or
Oil on canvas, 88.9 x 129.8 cm
Figueras, Fundación Gala-Salvador Dalí, Gift of Dalí to the Spanish state

1541 Landscape, 1981
Paysage
Oil on polarized plastic; dimensions unknown
Gift of Dalí to the Spanish royal family

1542 Mercury and Argos (after "Mercury and Argos" by Velázquez, Museo del Prado), 1981
Mercure et Argos (d'après «Mercure et Argos» de Vélasquez, Musée du Prado)
Oil on canvas, 140 x 95 cm
Figueras, Fundación Gala-Salvador Dalí, Gift of Dalí to the Spanish state

1543 Landscape with Rock in the Shape of a Triumphal Arch, 1981
Paysage avec un rocher en forme d'arc de triomphe
Oil on copper, 37 x 53 cm
Madrid, Centro de Arte Reina Sofía, Gift of Dalí to the Spanish state

1544 Jason Carrying the Golden Fleece (unfinished), c. 1981
Jason portant la Toison d'Or
Oil on canvas, 130 x 89 cm
Figueras, Fundación Gala-Salvador Dalí, Gift of Dalí to the Spanish state

1545 The Exterminating Angels, 1981
Les Anges exterminateurs
Oil on plywood, 122 x 122 cm
Figueras, Fundación Gala-Salvador Dalí

1546 Untitled (Female Bust with Draped Cloth), 1981
Sans titre (Buste de femme drapé)
Oil on copper, 42.1 x 28 cm
Madrid, Centro de Arte Reina Sofía, Gift of Dalí to the Spanish state

1547 Figures (Scene after Goya), 1981
Personnages (Scène goyesque)
Oil on copper, 32.1 x 24 cm
Madrid, Centro de Arte Reina Sofía, Gift of Dalí to the Spanish state

1548 Woman on a Ram, 1981
Femme sur un bélier
Oil on copper, 24 x 32 cm
Madrid, Centro de Arte Reina Sofía, Gift of Dalí to the Spanish state

1549 Untitled (Head of a Woman; unfinished), 1981
Sans titre (Tête de femme)
Oil on copper, 42.1 x 28 cm
Madrid, Centro de Arte Reina Sofía, Gift of Dalí to the Spanish state

1550 Untitled (Skin of a Beach), 1981
Sans titre (Peau d'une plage)
Oil on canvas, 96 x 139.5 cm
Figueras, Fundación Gala-Salvador Dalí, Gift of Dalí to the Spanish state

1551 Reading, Family Scene by Lamplight, 1981
Lecture, scène familiale sous la lampe
Oil on copper, 12.8 x 17.7 cm
Madrid, Centro de Arte Reina Sofía, Gift of Dalí to the Spanish state

1552 Untitled (Imaginary Landscape at Púbol), 1981
Sans titre (Paysage imaginaire de Púbol)
Oil on canvas, 61 x 46 cm
Figueras, Fundación Gala-Salvador Dalí, Gift of Dalí to the Spanish state

1553 Spanish Nobleman with a Cross of Brabant on his Jerkin, 1981
Noble espagnol portant la croix tréflée sur son pourpoint
Oil on copper, 22.8 x 17.7 cm
Madrid, Centro de Arte Reina Sofía, Gift of Dalí to the Spanish state

1554 The Pearl, 1981
La perle
Oil on canvas, 140 x 100 cm
Figueras, Fundación Gala-Salvador Dalí, Gift of Dalí to the Spanish state

1555 Velázquez and a Figure, 1982
Vélasquez et personnage
Oil on canvas, 92 x 117 cm
Figueras, Fundación Gala-Salvador Dalí, Gift of Dalí to the Spanish state

1556 The Infanta Margarita of Velázquez Appearing in the Silhouette of Horsemen in the Courtyard of the Escorial, 1982
L'infante Marguerite de Vélasquez apparaissant dans la silhouette des chevaliers dans la cour d'un Escorial
Oil on canvas, 73 x 59.5 cm
Figueras, Fundación Gala-Salvador Dalí, Gift of Dalí to the Spanish state

1557 Three Female Figures in Festive Gowns, 1981
Trois figures féminines en vêtements d'apparat
Oil on copper, 28 x 42 cm
Madrid, Centro de Arte Reina Sofía, Gift of Dalí to the Spanish state

1558 Untitled – Equestrian Figure of Prince Baltasar Carlos, after Velázquez, with Figures in the Courtyard of the Escorial, 1982
Sans titre – Figure équestre du Prince Baltasar Carlos, de Vélasquez, et personnages dans la cour d'un Escorial
Oil on canvas, 57.3 x 60 cm
Figueras, Fundación Gala-Salvador Dalí, Gift of Dalí to the Spanish state

1559 Gala in a Patio Watching the Sky, where the Equestrian Figure of Prince Baltasar Carlos and Several Constellations (All) Appear, after Velázquez, 1981
Gala dans un patio observant le spectacle du ciel où surgit le portrait équestre du prince Baltasar Carlos et apparaissent plusieurs Argo (tous) de Vélasquez
Oil on canvas, 140.5 x 100 cm
Figueras, Fundación Gala-Salvador Dalí, Gift of Dalí to the Spanish state

1560 Don José Nieto Velázquez from "Las Meninas" by Velázquez, Museo del Prado, Madrid, 1982
D'après l'«Aposentador» Don José Nieto Vélasquez de la peinture «Les Ménines» de Vélasquez au Prado, Madrid
Oil on canvas, 140 x 100 cm
Figueras, Fundación Gala-Salvador Dalí, Gift of Dalí to the Spanish state

1561 Untitled (Composition – The Courtyard of the Escorial with Figure and Sebastián de Morra, Velázquez's Dwarf), 1982
Sans titre (Composition – La cour d'un Escurial avec personnage et Sebastián de Morra, le nain de Vélasquez)
Oil on canvas, 73 x 60 cm
Figueras, Fundación Gala-Salvador Dalí, Gift of Dalí to the Spanish state

1562 In the Courtyard of the Escorial, the Silhouette of Sebastián de Morra, in which the Face of Gala Surrounded by Catastrophic Signs Appears (Stereoscopic work, unfinished), 1982
Dans la cour d'un Escurial, la silhouette de Sebastián de Morra dans laquelle apparaît le visage de Gala entouré de signes catastrophéiformes (Œuvre stéréoscopique)
Oil on canvas, stereoscopic work, 75 x 59.5 cm
Figueras, Fundación Gala-Salvador Dalí, Gift of Dalí to the Spanish state

1563 Sebastián de Morra with Catastrophic Signs (Stereoscopic work, unfinished), 1982
Sebastián de Morra avec des signes catastrophéiformes (Œuvre stéréoscopique)
Oil on canvas, stereoscopic work, 75 x 59.5 cm
Figueras, Fundación Gala-Salvador Dalí, Gift of Dalí to the Spanish state

1564 Velázquez Dying behind the Window on the Left Side out of which a Spoon Projects, 1982
Derrière la fenêtre, à main gauche, d'où sort une cuillère, Vélasquez agonisant
Oil on canvas with collages, 75 x 59.5 cm
Figueras, Fundación Gala-Salvador Dalí, Gift of Dalí to the Spanish state

1565 Pietà, 1982
Pietà
Oil on canvas, 100.2 x 100 cm
Figueras, Fundación Gala-Salvador Dalí

1566 Othello Dreaming of Venice, 1982
Othello rêvant de Venise
Oil on canvas, 99.8 x 90.2 cm
Figueras, Fundación Gala-Salvador Dalí

1567 Classic Figure and Head (unfinished), 1981/82
Figure et tête classiques
Oil on canvas, 43.3 x 31 cm
Figueras, Fundación Gala-Salvador Dalí, Gift of Dalí to the Spanish state

1568 Untitled (first study for "The Three Glorious Enigmas of Gala"), 1982
Sans titre (première étude pour «Les trois énigmes glorieuses de Gala»)
Oil on canvas, 76 x 71 cm
Figueras, Fundación Gala-Salvador Dalí, Gift of Dalí to the Spanish state

1569 Study for "Olé" (unfinished), 1982
Etude pour «Olé»
Oil on canvas, 60 x 73 cm
Figueras, Fundación Gala-Salvador Dalí, Gift of Dalí to the Spanish state

1570 The Three Glorious Enigmas of Gala (first version), 1982
Les trois énigmes glorieuses de Gala
Oil on canvas, 130 x 140 cm
Madrid, Museo Nacional Reina Sofía

1571 Olé, 1982
Olé
Oil on canvas, 60 x 73 cm
Figueras, Fundación Gala-Salvador Dalí, Gift of Dalí to the Spanish state

1572 The Three Glorious Enigmas of Gala (second version), 1982
Les trois énigmes glorieuses de Gala
Oil on canvas, 100 x 100 cm
Figueras, Fundación Gala-Salvador Dalí, Gift of Dalí to the Spanish state

1573 Enigma (unfinished version of "The Three Glorious Enigmas of Gala"), 1982
Enigme (version inachevée des «Trois énigmes glorieuses de Gala»)
Oil on canvas, 100 x 99.8 cm
Figueras, Fundación Gala-Salvador Dalí, Gift of Dalí to the Spanish state

1574 Figure Inspired by Michelangelo's Adam on the Ceiling of the Sistine Chapel, Rome, 1982
Oil on canvas, 60 x 75 cm
Figueras, Fundación Gala-Salvador Dalí, Gift of Dalí to the Spanish state

1575 After Michelangelo's "Night" on the Medici Tomb, Florence, 1982
D'après «La nuit» de Michel-Ange pour le «Tombeau de Julien de Médicis» à Florence
Oil on canvas, 67 x 95 cm
Figueras, Fundación Gala-Salvador Dalí, Gift of Dalí to the Spanish state

1576 After Michelangelo's "Day" on the Medici Tomb, Florence, 1982
D'après «Le jour» de Michel-Ange pour le «Tombeau de Julien de Médicis» à Florence
Oil on canvas, 67.2 x 95 cm
Figueras, Fundación Gala-Salvador Dalí, Gift of Dalí to the Spanish state

1577 After the Head of "Giuliano di Medici", Florence, 1982
D'après la tête de «Julien de Médicis», Florence
Oil on canvas, 140 x 95 cm
Figueras, Fundación Gala-Salvador Dalí, Gift of Dalí to the Spanish state

1578 Head, after Michelangelo's "Giuliano di Medici", 1982
Tête inspirée par le «Julien de Médicis» de Michel-Ange
Oil on canvas, 75 x 75 cm
Figueras, Fundación Gala-Salvador Dalí, Gift of Dalí to the Spanish state

1579 Exploded Head, 1982
Tête éclatée
Oil on canvas, 140.3 x 100 cm
Figueras, Fundación Gala-Salvador Dalí, Gift of Dalí to the Spanish state

1580 Topological Study for "Exploded Head", 1982
Etude topologique pour «Tête éclatée»
Oil on laminated panel, 109.6 x 79.4 cm
Private collection

1581 Warrior, 1982
Le guerrier
Oil on canvas, 99.8 x 100 cm
Figueras, Fundación Gala-Salvador Dalí, Gift of Dalí to the Spanish state

1582 After Michelangelo's "Squatting Child", 1982
D'après «L'enfant accroupi» de Michel-Ange
Oil on canvas, 95.3 x 65 cm
Figueras, Fundación Gala-Salvador Dalí, Gift of Dalí to the Spanish state

1583 "Giuliano di Medici" by Michelangelo, Seen from behind, 1982
«Julien de Médicis» de Michel-Ange vue de dos
Oil on canvas, 140 x 95 cm
Figueras, Fundación Gala-Salvador Dalí, Gift of Dalí to the Spanish state

1584 After Michelangelo's "Moses", on the Tomb of Julius II in Rome, 1982
D'après «Moïse» de Michel-Ange, Tombeau de Jules II
Oil on canvas, 100 x 100 cm
Figueras, Fundación Gala-Salvador Dalí, Gift of Dalí to the Spanish state

1585 Rock Figure after the Head of Christ in the "Pietà" of Palestrina by Michelangelo, 1982
Figure rocheuse – D'après la tête du Christ de la «Pietà» de Palestrina de Michel-Ange
Oil on canvas, 95 x 65.1 cm
Figueras, Fundación Gala-Salvador Dalí, Gift of Dalí to the Spanish state

1586 Pietà, 1982
Pietà
Oil on canvas, 95 x 65 cm
Figueras, Fundación Gala-Salvador Dalí, Gift of Dalí to the Spanish state

1587 Untitled – Nude Figures after Michelangelo, 1982
Sans titre – Figures nues d'après Michel-Ange
Oil on canvas, 95 x 75 cm
Figueras, Fundación Gala-Salvador Dalí, Gift of Dalí to the Spanish state

1588 Figure in the Water – After a Drawing by Michelangelo for the "Resurrection of Christ", 1982
Personnage aquatique inspiré par un dessin de Michel-Ange pour «La Résurrection du Christ»
Oil on canvas, 75 x 60 cm
Figueras, Fundación Gala-Salvador Dalí, Gift of Dalí to the Spanish state

1589 Saint Sebastian, 1982
Saint Sébastien
Oil on canvas, 74.5 x 60 cm
Figueras, Fundación Gala-Salvador Dalí, Gift of Dalí to the Spanish state

1590 Untitled (Figures, Pietà, Catastrophic Signs), 1983
Sans titre (Figures, Pietà, signes catastrophéïformes)
Oil on canvas, 73 x 60 cm
Private collection

1591 Figure after Michelangelo's "Dawn" on the Tomb of Lorenzo di Medici, 1982
Personnage inspiré par l'«Aurore» de Michel-Ange du tombeau de Laurent de Médicis
Oil on canvas, 75 x 59 cm
Figueras, Fundación Gala-Salvador Dalí, Gift of Dalí to the Spanish state

1592 Scene in the Courtyard of the Escorial with a Figure in the Foreground Inspired by Michelangelo's "Evening" on the Tomb of Lorenzo di Medici, 1982
Scène dans la cour d'un Escurial avec, en avant-plan, un personnage inspiré par «Le crépuscule», statue de Michel-Ange du tombeau de Laurent de Médicis
Oil on canvas, 75 x 59 cm
Figueras, Fundación Gala-Salvador Dalí, Gift of Dalí to the Spanish state

1593 The Escorial Contorted in Disorderly Fashion and Metamorphosing into a Woman, 1982
Un Escurial se contorsionnant de façon désordonnée pour parvenir à se transformer en femme
Oil on canvas, 60 x 73 cm
Figueras, Fundación Gala-Salvador Dalí, Gift of Dalí to the Spanish state

1594 Twofold Victory of Gaudí, 1982
Double victoire de Gaudí
Oil on canvas, 75 x 60 cm
Figueras, Fundación Gala-Salvador Dalí, Gift of Dalí to the Spanish state

1595 Landscape with Hidden Image of Michelangelo's "David", 1982
Paysage avec l'image cachée du «David» de Michel-Ange
Oil on canvas, 74.7 x 59.8 cm
Figueras, Fundación Gala-Salvador Dalí, Gift of Dalí to the Spanish state

1596 Catastrophic Architecture and Calligraphy, 1982
Architecture et calligraphie catastrophéïforme
Oil on canvas, 130 x 140 cm
Figueras, Fundación Gala-Salvador Dalí, Gift of Dalí to the Spanish state

1597 Atmospherocephalic Figures, 1982
Personnages atmosphéricocéphales
Oil on canvas, 100 x 100 cm
Figueras, Fundación Gala-Salvador Dalí, Gift of Dalí to the Spanish state

1598 Head Inspired by Michelangelo, 1983
Tête inspiré par Michel-Ange
Oil on canvas, 75 x 75 cm
Figueras, Fundación Gala-Salvador Dalí, Gift of Dalí to the Spanish state

1599 Mirror Women – Mirror Heads, 1982
Femmes-miroirs – Les têtes à miroirs
Oil on canvas, 99.7 x 90.4 cm
Figueras, Fundación Gala-Salvador Dalí, Gift of Dalí to the Spanish state

1600 Martyr – Inspired by the Sufferings of Dalí in his Illness, 1982
Martyr
Oil on canvas, 75 x 60 cm
Figueras, Fundación Gala-Salvador Dalí, Gift of Dalí to the Spanish state

1601 Bed and Two Bedside Tables Ferociously Attacking a Cello (last state), 1983
Lit et deux tables de nuit attaquant férocement un violoncelle
Oil on canvas, 73 x 92 cm
Madrid, Museo Nacional Reina Sofía, Gift of Dalí to the Spanish state

1602 Cf. caption on p. 714

1603 Bed and Bedside Table Ferociously Attacking a Cello, 1983
Lit et table de nuit attaquant férocement un violoncelle
Oil on canvas, 130 x 140 cm
Figueras, Fundación Gala-Salvador Dalí, Gift of Dalí to the Spanish state

1604 Bed and Two Bedside Tables Ferociously Attacking a Cello, 1983
Lit et deux tables de nuit attaquant férocement un violoncelle
Oil on canvas, 59.9 x 73 cm
Figueras, Fundación Gala-Salvador Dalí, Gift of Dalí to the Spanish state

1605 St. George Overpowering a Cello, 1983
Saint Georges terrassant un violoncelle
Oil on canvas, 72 x 93 cm
Figueras, Fundación Gala-Salvador Dalí, Gift of Dalí to the Spanish state

1606 Bed, Chair and Bedside Table Ferociously Attacking a Cello, 1983
Lit, chaise et table de nuit attaquant férocement un violoncelle
Oil on canvas, 60 x 73 cm
Figueras, Fundación Gala-Salvador Dalí, Gift of Dalí to the Spanish state

1607 Warrior Mounted on an Elephant Overpowering a Cello, 1983
Guerrier sur un éléphant terrassant un violoncelle
Oil on canvas, 60.2 x 73 cm
Figueras, Fundación Gala-Salvador Dalí, Gift of Dalí to the Spanish state

1608 Pietà, 1983
Pietà
Oil on canvas, 60 x 73 cm
Figueras, Fundación Gala-Salvador Dalí, Gift of Dalí to the Spanish state

1609 The Truck (We'll be arriving later, about five o'clock), 1983
El camión (Llegaremos más tarde, hacia las cinco)
Oil on canvas with collages, 73 x 60 cm
Madrid, Museo Nacional Reina Sofía, Gift of Dalí to the Spanish state

1610 Topological Contortion – Bed and Two Bedside Tables Ferociously Attacking a Cello, 1983
Contorsion topologique – Lit et deux tables de nuit attaquant férocement un violoncelle
Oil on canvas, 60 x 73 cm
Figueras, Fundación Gala-Salvador Dalí, Gift of Dalí to the Spanish state

1611 Topological Contortion of a Female Figure, 1983
Contorsion topologique de figure féminine
Oil on canvas, 60 x 73 cm
Figueras, Fundación Gala-Salvador Dalí, Gift of Dalí to the Spanish state

1612 Topological Contortion of a Female Figure Becoming a Cello, 1983
Contorsion topologique d'une figure féminine devenant violoncelle
Oil on canvas, 60 x 73 cm
Madrid, Museo Nacional Reina Sofía, Gift of Dalí to the Spanish state

1613 Topological Detachment of Europe – Homage to René Thom, 1983
Enlèvement topologique d'Europe – Hommage à René Thom
Oil on canvas, 60 x 73 cm
Figueras, Fundación Gala-Salvador Dalí, Gift of Dalí to the Spanish state

1614 Cutlet and Match – The Chinese Crab, 1983
Côtelette et allumette – Le crabe chinois
Oil on canvas, 73 x 92 cm
Figueras, Fundación Gala-Salvador Dalí, Gift of Dalí to the Spanish state

1615 Untitled – Head of a Spanish Nobleman, Fashioned by the Catastrophe Model from a Swallow's Tail and Two Halves of a Cello, 1983
Sans titre – Tête de noble espagnol formée par le modèle de catastrophe de la queue d'aronde et deux demi-violoncelles
Oil on canvas with newspaper collage, 73.2 x 60 cm
Madrid, Museo Nacional Reina Sofía, Gift of Dalí to the Spanish state

1616 Untitled – Series on Catastrophes, 1983
Sans titre – Série des catastrophes
Oil on canvas, 73 x 92 cm
Figueras, Fundación Gala-Salvador Dalí, Gift of Dalí to the Spanish state

1617 The Swallow's Tail – Series on Catastrophes, 1983
La queue d'aronde (Série des catastrophes)
Oil on canvas, 73 x 92.2 cm
Figueras, Fundación Gala-Salvador Dali, Gift of Dalí to the Spanish state

1618 The Tomb of Francesco Pujols, 1982
Le tombeau de Francesc Pujols
Black felt-tip pen on cardboard, 28.3 x 31.3 cm
Private collection

1619 "Bracceli" the Warrior with a Corpse – Torero Series, 1985
Guerrier «Bracceli» près d'un cadavre – Série Torero
Indian ink on white paper, 24 x 18 cm
Private collection

1620 Two Phoenixes in Combat – Torero Series, 1985
Combat de deux phénix – Série Torero
Indian ink on white paper, 18 x 22 cm
Private collection

1621 Head of Europa – Torero Series, 1985
Tête d'Europe – Série Torero
Indian ink on white paper, 21 x 27 cm
Private collection

1622 Cf. caption on p. 728

1623-1627 Cf. captions on p. 729

1628-1631 Cf. captions on p. 730

1632-1636 Cf. captions on p. 733

1637, 1638 Cf. captions on p. 734

1639-1642 Cf. captions on p. 735

1643-1647 Cf. captions on p. 736

1648 "The Prince of Sleep" (The Principle of Sleep) after an official portrait of King Juan Carlos I, 1973/74
«Le prince du sommeil» (El principe de ensueño), d'après une photographie officielle du roi Juan Carlos Ier
Oil on canvas, 248 x 180 cm
Madrid, Palais de la Zarzuela, national heritage